THE LIFE OF GIAN LORENZO BERNINI

THE LIFE OF

Gian Lorenzo Bernini

by DOMENICO BERNINI

A TRANSLATION AND CRITICAL EDITION, WITH INTRODUCTION AND COMMENTARY,
BY FRANCO MORMANDO

The Pennsylvania State University Press
University Park, Pennsylvania

This publication was assisted by a grant from the
Trustees of Boston College.

Library of Congress Cataloging-in-Publication Data
Bernini, Domenico, 1657–1723.
[Vita del cavalier Gio. Lorenzo Bernino. English]
The life of Gian Lorenzo Bernini : a translation and critical
edition, with introduction and commentary, by Franco
Mormando / Domenico Bernini.
 p. cm.
Includes bibliographical references and index.
Summary: "A critical translation of the unabridged Italian
text of Domenico Bernini's biography of his father,
seventeenth-century sculptor, architect, painter, and
playwright Gian Lorenzo Bernini (1598–1680). Includes
commentary on the author's data and interpretations,
contrasting them with other contemporary primary sources
and recent scholarship"—Provided by publisher.
ISBN 978-0-271-03749-3 (pbk : alk. paper)
1. Bernini, Gian Lorenzo, 1598–1680.
2. Sculptors—Italy—Biography.
I. Bernini, Gian Lorenzo, 1598–1680.
II. Mormando, Franco.
III. Title.

NB623.B5B4713 2011
709.2—dc22
[B]
2010030675

To

JOSEPHINE VON HENNEBERG
con stima e gratitudine

Contents

Acknowledgments

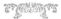

The completion of this volume would not have been possible without the generous assistance of, above all, two learned colleagues, who, in addition to being good personal friends and native speakers of Italian, are also well-seasoned specialists in, respectively, the art and literary culture of Baroque Rome: Josephine von Henneberg, Professor Emerita of Fine Arts, Boston College, and Eraldo Bellini, Professor of Italian, Università Cattolica, Milan. Over the past several years, I have turned to them on numerous occasions to discuss the many perplexities of translation raised by Domenico's prose, and they have been unflagging with their patient help in solving these linguistic puzzles. I acknowledge their contribution with great gratitude, while pointing out that the ultimate editorial decisions were all my own. Next, my grateful thanks go to Sheila Barker (Medici Archive Project, Florence), who read the finished manuscript and offered many valuable observations, which are gratefully acknowledged in my notes. Sheila's broad-ranging erudition and original insight far exceed her chronological years; she too is currently working on Bernini in the form of a book entitled *Bernini in the News: Gian Lorenzo Bernini and Roman Avvisi in the Medici Granducal Archive*.

Among the other learned and generous friends and associates to whom I have turned in my hour of need during this project and to whom I now give further public and heartfelt thanks are Pamela Jones, John W. O'Malley, T. Frank Kennedy, Saul Engelbourg, Mary Jane Harris, Sonja Calabi, Deborah Contrada, and Adeane Bregman, director of the Bapst Fine Arts Library at Boston College, who, together with her fine staff (Arlene Feinberg, Laurie Mayville, and Johnie Winfrey), patiently helped me secure so many books and articles needed for this study. Vital help of the same kind came as well from Anne Kenny and her obliging staff in the Interlibrary Loan Office at Boston College's O'Neill Library. I also render thanks to my university, Boston

College, which, through the offices of the Dean of the College of Arts and Sciences (especially former dean Joseph Quinn and current dean David Quigley) and the Provost (Dr. Cutberto Garza), has provided me with research funds and other resources to enable me to carry out to completion this long, arduous project. Over the past years I have also learned much about Bernini and his world from the probing questions and discussions of the students in my graduate seminar, "The Culture of Rome in the Age of Bernini": they are too numerous to mention by name, but I happily record my debt to them all. A special word of thanks, finally, goes to Professor David Gill of Boston College's Classics Department, who translated into splendid English for me Domenico's long Latin poem on his father's *Louis XIV Equestrian* (pp. 151–52).

A Note on the Commentary, Sources, Translations, Abbreviations, and Currency

The amount of historical information about and studies of Bernini and seventeenth-century Rome is staggering, and grows by the day. My principal goals in commenting on the text have been, first, to supply the most essential background information needed to understand Domenico's narrative, cultural allusions and linguistic choices, and, second, to compare what he says with what we find in the other primary sources. The latter sources are, above all, Filippo Baldinucci, Pietro Filippo Bernini, and Paul Fréart de Chantelou (for these three texts, see below), but I cite the entire range of available original documentation as well.

In order not to encumber the notes, I have given little or at times no background information on well-known historical figures and events (such as the Thirty Years' War). This information is readily available in many sources, including, with lightning speed, via the Internet. However, regarding Bernini and his works, I have sometimes supplied information that will seem obvious or superfluous to experts in the field but will be necessary for the rest of the nonexpert public. Though some bibliography for many of Domenico's topics (persons, works of art, events) is supplied by my Introduction, fullest coverage will always be found in the commentary accompanying the primary (usually the first) reference to the topic within Domenico's narrative.

Many of Bernini's works, even noteworthy ones like the obelisk–elephant monument in the Piazza della Minerva, are not mentioned by Domenico. It is beyond the scope of this edition to supply a complete catalogue and critical discussion of Bernini's numerous works. I have noted, however, our author's more egregious omissions in this regard. Even in the case of well-known and intensely studied works, such as the Palazzo Barberini or the Scipione Borghese busts, extant primary-source evidence is often sparse, fragmentary, frustratingly contradictory, and thus difficult to summarize in a few lines.

Nonetheless, my commentary provides a succinct but thorough summary of the essential primary-source documentation as well as of the prevailing scholarly opinion from secondary sources, often adding my own evaluation and conclusions.

The commentary usually cites only the most recent bibliography on any given topic, but I have always confirmed that the works cited supply an adequate survey of the most important of the earlier studies. For quotations from Baldinucci's *Life of Bernini* and Chantelou's *Journal*, I have usually used, respectively, the 1966/2006 Enggass and the 1985 Corbett translations (for which see below). However, I have always consulted the original Italian and French texts, revising the English translations as necessary and at times supplying my own from scratch. Unless otherwise specified, all other translations are my own.

Please note: in the Introduction and commentary, all page references to Domenico are to the original 1713 pagination, which is indicated throughout the English text in boldface within square brackets.

For greater ease of reading, I have divided Domenico's dauntingly large blocks of uninterrupted prose into smaller portions, but I have not introduced new paragraph indentation. Original marginal subheadings have been kept (but moved to the main body of the text). Most of the original italicization intends to signal a "direct" quotation, even though delivered in the third person. To avoid confusion in the latter cases, I have inserted quotation marks and eliminated the italics, according to modern (but not Domenico's) usage.

The following abbreviations are used in the commentary:

ARSI	Archivum Romanum Societatis Iesu (Jesuit Archives, Curia Generalizia, Borgo Santo Spirito, Rome)
Baldinucci	Filippo Baldinucci, *Vita del cavaliere Gio. Lorenzo Bernino, scultore, architetto, e pittore*, first published in Florence, 1682. Page numbers preceded by the letter "i" refer to the 1948 Italian edition edited, with partial modernization of punctuation and orthography, by Sergio Samek Ludovici (Milan: Edizioni del Milione); those preceded by the letter "e" refer to Catherine Enggass's translation of *The Life of Bernini* (University Park: Pennsylvania State University Press, 1966, repr. 2006).
BALQ	Franco Borsi, Cristina Acidini Luchinat, and Francesco Quinterio, eds., *Gian Lorenzo Bernini. Il*

testamento. La casa. La raccolta dei beni (Florence: Alinea Editrice, 1981).

BAV Biblioteca Apostolica Vaticana.

BNP, Ms. ital.

2082, 2083, 2084 These three "manuscripts" in the Bibliothèque Nationale, Paris, since the 1890s represent separately (and haphazardly) bound collections of original letters (including most of those cited by Domenico), memoranda, and other documents from Bernini's own personal collection, with various items pertaining to the affairs of his eldest son, Monsignor Pietro Filippo. Pagination for ms. 2082 and ms. 2084 is by folio number (recto and verso), for ms. 2083 by page number. Many of the items have been published over the years, but a catalogue raisonné is wanting. Of the three, only ms. 2083 seems to have been put together with some coherence: its contents concern almost exclusively Bernini's interactions with the French court in the 1660–70s (the Louvre commission, his 1665 trip to Paris and its aftermath, the *Louis Equestrian* statue, etc.).

Chantelou Paul Fréart de Chantelou, *Journal de voyage du Cavalier Bernin en France* (in English known as *Diary of the Cavaliere Bernini's Visit to France*), cited by the entry date, with page numbers given for both the 2002 French edition by Milovan Stanić, published by Macula L'Insulaire, Paris (pagination preceded by "f."), and the 1985 English edition by Corbett, Blunt, and Bauer, published by Princeton University Press (pagination preceded by "e."). For the editorial history of the *Journal,* see Chantelou, f.27–32; and the 2007 Italian edition of Chantelou, ed. and trans. Daniela del Pesco, 185–200.

DBI *Dizionario biografico degli italiani.* Rome: Istituto della Enciclopedia Italiana, 1960–present.

DLO/Intro "Introduction" by Maarten Delbeke, Evonne Levy, and Steven F. Ostrow to the 2006 reprint of the 1966 Enggass translation of Baldinucci's *Life of Bernini* (see "Baldinucci" above).

DLO/Pro "Prolegomena to the Interdisciplinary Study of Bernini's Biographies," by Maarten Delbeke, Evonne Levy, and Steven F. Ostrow, in *Bernini's Biographies: Critical Essays*, 1–72, edited by the same three scholars (University Park: Pennsylvania State University Press, 2006).

Domenico Domenico Bernini, *Vita del Cavalier Gio. Lorenzo Bernino descritta da Domenico Bernino suo figlio*. Citations within my Introduction and commentary are to the original 1713 pagination, indicated within the text of the present translation (in boldface and within square brackets).

EncPapi *Enciclopedia dei Papi,* 3 vols. (Rome: Istituto della Enciclopedia Italiana, 2000). One of the best and most recent encyclopedias of the papacy, with much detailed information and bibliography.

Fagiolo/*IAP* Maurizio Fagiolo dell'Arco, *Immagine al potere: Vita di Giovan Lorenzo Bernini* (Rome: Laterza, 2001). I cite this mostly for the primary-source materials published in its appendix. The historical information in the narrative itself, written in an informal, conversational style, is not always impeccably indicated.

M&MFagiolo Maurizio and Marcello Fagiolo dell'Arco, *Bernini. Una introduzione al gran teatro del barocco* (Rome: Bulzoni, 1967). This work attempts, *inter alia*, to give a complete catalogue of all known works produced by Bernini, in every genre, known at that point.

Nascita *Bernini scultore. La nascita del barocco in Casa Borghese,* ed. Anna Coliva and Sebastian Schütze (Rome: Edizioni De Luca, 1998).

Pietro Filippo The handwritten sketch of Bernini's life, found among the Bernini family papers in Paris (BNP, Ms. ital., 2084, fols. 132–35), and attributed to his eldest son, Pietro Filippo. The original is without a title; for the sake of convenience, I have titled it *The Vita Brevis*: see Appendix 1 for text and commentary. It is the oldest biographical narrative on Bernini.

Regista *Gian Lorenzo Bernini. Regista del Barocco,* ed. Maria Grazia Bernardini and Maurizio Fagiolo dell'Arco (Milan: Skira Editore, 1999).

Regista/Restauri	*Gian Lorenzo Bernini. Regista del Barocco, I restauri,* ed. Claudio Strinati and Maria Grazia Bernardini (Milan: Skira Editore, 1999).
Rossi/*Avvisi*	Contemporary Roman *avvisi* (handwritten and usually anonymous news bulletins prepared by private individuals) published by Ermete Rossi in the 1930s and '40s in the now-defunct periodical *Roma* under the rubric "Roma Ignorata." Cited by journal volume number, year, and page(s).
Wittkower	When not followed by a year of publication, this refers to Rudolf Wittkower's indispensable catalogue, *Bernini: The Sculptor of the Roman Baroque,* 3rd rev. ed. (London: Phaidon Press, 1981).

Early Modern Currency, Wages, and Cost of Living

In most cases, Domenico indicates the value of objects, monetary rewards, and expenditures in the form of the Roman (or, more specifically, papal) *scudo* (shield). Two types of *scudi* were in use in Rome at the time: a gold coin that weighed 3.391 grams and a silver *scudo* weighing 31.788 grams. Unlike today, the weight of a coin (its gold or silver content) determined its value. The gold *scudo* was more rare in its circulation, and Domenico mentions it by name only once (172). Hence, in all other cases, we presume, his references are to *scudi* in silver. The *doppia* (plural, *doppie*), also mentioned by Domenico (64), was a gold coin of exactly double the weight of the gold *scudo*.

At times Bernini, we are told (Domenico, 67, 90), was paid also in the form of the Spanish *dobla* (presuming our author is being precise in his numismatic terminology), a gold coin equaling in value two *escudos d'oro*. As with all transnational currency-exchange values, what that represents in Roman money is difficult to pinpoint with precision, but at that point in time and place, the *dobla* seems to have been the equivalent of three papal *scudi*. On one occasion, Bernini was paid in the form of gold *ungheri* of Modena, for which see Domenico, 64 and commentary. The small coin, the *baiocco* (plural, *baiocchi*), another monetary unit encountered in Domenico's narrative (170), was one one-hundredth of a silver *scudo*. For the bewildering variety of early modern Italian coinage and its value, see the numismatic dictionary compiled by Martinori, *La moneta* (under the name of each coin).

As proof of his father's great status and the esteem shown him by his patrons, Domenico will frequently specify the monetary value of the remuneration he

received (whether in the form of cash or material goods like jewelry). In order to have meaning for readers today, these figures must be put into the context of the cost of living and wages in seventeenth-century Rome, figures that did not change significantly over Bernini's lifetime. To cite just a few representative examples (taken from Spear, 312), "a family of five in Rome around 1600 could live modestly on 90 *scudi* a year." In the period 1606–7, "a field worker made . . . about 50 *scudi* a year; a *muratore*, or skilled mason, earned . . . about 85 *scudi* annually; in 1627, a tailor made half as much." In the early part of the century, working-class apartment rents in Rome ranged from 12 to 40 *scudi* per month, whereas in 1600 a dozen eggs cost one *baiocco* and a pair of shoes, 50 *baiocchi*, the latter roughly equivalent to what a worker earned in two days (ibid.). To contrast ordinary wages against a larger screen: the cost of the entire Saint Peter's Colonnade project (begun in 1657) is estimated at one million *scudi*, representing "nearly half of the annual revenue of the Church in this period," whereas the annual salaries of the ordinary worker on the job ranged from 60 to 120 *scudi* per year; a "poor" cardinal of the period, in contrast, had an annual income of at least 5,500 *scudi* (Rietbergen, 1983, 150–51, 154–55). For the seventeenth-century Italian economy in general, which, outside Rome, declined dramatically over the course of Bernini's lifetime, see, for example, Ago; and Malanima.

The Anatomy of Baroque Biography:
Domenico Bernini's Life of Gian Lorenzo Bernini

Baroque studies having come into their own in the last generation, the literature on Bernini has become so vast that it is increasingly difficult to keep a check on it. The editor of a textual source is always faced with the problem of how far to go in his commentary; he has to incorporate all new research without making his commentary too heavy and cumbersome.

—Rudolph Wittkower, 1949

1. Reading Domenico in the Twenty-first Century

This is the first English translation, unabridged, of Domenico Bernini's biography of his famous artist-father, originally published in Rome, 1713, under the title *Vita del Cavalier Gio. Lorenzo Bernino descritta da Domenico Bernino suo figlio.* It is, in fact, the first translation from the Italian into any language and represents the first new edition of Domenico's work in any form since 1713, apart from simple facsimile reprints issued in recent decades.[1] Given the historical importance of its subject and his celebrity status today—among the general public, Bernini is, after Caravaggio, perhaps the best-known and most popular Italian Baroque artist—one might wonder why it has taken nearly three hundred years for this unique and indispensable primary source to make a more widely accessible reappearance in print. After all, Filippo Baldinucci's *Life of Bernini,* first published in 1682 and written by a "foreigner" from Florence who had never even met Bernini, was reedited twice in the twentieth century and received its English translation (recently reprinted) over forty years ago.[2] Why the neglect of a biography written by the artist's own son?

The reasons for this seemingly strange state of affairs will be described in the pages that follow: the vicissitudes of Domenico's *Life of Gian Lorenzo Bernini* is, one could say, the case of a literary "ugly duckling" transformed into a handsome swan. Also conveyed in these introductory pages is the most important background information necessary for a more profitable reading of this Baroque biography by a twenty-first-century audience.[3] In contrast, the individual notes appended to the text will comment on the specific data and assertions encountered in Domenico's narrative, completing, correcting, or corroborating his information by means of reliable contemporary documentation, as well as offering more recent alternative interpretations of the facts and events.[4]

Regarding those facts and events, at the beginning of chapter 1, Domenico makes what appears to be a reassuringly modern claim about historical accuracy:

> It is our intention, therefore, to record in the present work the life of this illustrious personage, whom talent [*virtù*] alone rendered glorious and celebrated throughout the world. It is, furthermore, our intention to do so with that accuracy demanded of all those who describe events to which almost everyone still alive today has been an eyewitness. Such eyewitnesses could easily contradict an author each time he, in order to garner more admiration for his writing, embellishes the facts and departs from the truth, for truth is the sole merit of history and history is truth alone.[5]

However, as this Introduction and subsequent notes to the text will make clear, what Domenico considers historical accuracy at times turns out to be something quite less than that. This is occasionally because of the sheer lack of information on his part, but even more frequently, because of his pious need to cast Bernini in the best light possible. No less determinant in the shaping of Domenico's account of his father's life is the fundamental nature of all early modern biography, especially art biography: as modern scholarship has by now amply demonstrated, a good deal of such biography in fact represents not "truth alone" but, rather, the more or less fictionalized recasting of the historical data in accordance to the dictates of literary-rhetorical convention and with recourse to an abundant supply of time-honored thematic commonplaces. Why all of this recasting and manipulation? To make the biographical narrative conform to contemporary expectations of how the life of (in this case) an artist should unfold and how that artist, especially a great one like Bernini, should think, feel, and act. As Philip Sohm reminds

us, "Early modern biographies elide the boundaries between fact and fiction in order to conceptualize the category of artist and to mythologize individual artists."[6] In this, literary biography was similar to the sculpted portraiture of the age: not only must the sculptor capture the likeness of the sitter as he was as an individual, but the artist must also confer upon the bust those qualities pertaining to the sitter's official state in life—pope, king, prince, or prelate— whether he genuinely possessed them or not. As Bernini says in Paris about the challenge of creating his portrait of Louis XIV, "[I]n this kind of head one must bring out the qualities of a hero as well as make a good likeness." Equally determinant of the content and tone of early modern art biography is its essential nature as a form of the rhetorical genre of panegyric: accordingly, the fundamental purpose of the artist's *vita* is to praise its subject and to offer to the reader inspiring examples of exceptional human achievement.[7]

Nonetheless, as Sohm also observes, "Historical truth can coexist with mythologized biography." And so it does in the present *Life of Gian Lorenzo Bernini,* even if Domenico's principal goal is by no means to furnish a complete, detailed account of the basic historical facts regarding his father's life and works.[8] *The Life of Gian Lorenzo Bernini* is an engaging, at times even entertaining, story that is for the most part intelligently composed and skillfully written with the goal of informing, delighting, and capturing the allegiance of the reader.[9] Despite the mythologizing to which Bernini's curriculum vitae and personality have been subjected by Domenico, his narrative, nonetheless, conveys much correct information, as we find confirmed by other primary sources. It is, furthermore, an extensive record of what were most likely often-repeated anecdotes and assertions—valid or otherwise—from the mouth of Gian Lorenzo himself, all or most of which no doubt were heard by the author at the family dinner table and other household gatherings. It thus represents a valuable source of information and insight for us today.

Yet Domenico's text requires a careful, discerning approach by modern readers: as in his father's art, so too in Domenico's biography, appearances can often be deceiving, and not all that he says can be taken at face value. Indeed, what Domenico describes as a central characteristic of his father's theatrical-artistic talent is at times the case with his own editorial comportment, that is, it sometimes "consist[s] in making what is, in fact, artificial [*finto*], appear real" (Domenico, 57). Again, Domenico's *Life of Gian Lorenzo Bernini,* like all Baroque biographies, is a product of a specific, now remote, age and "mentality," constructed upon philosophical premises, literary conventions, and rhetorical mechanisms alien, if not inimical, to our own practice of the art of history and its subsidiary genre, biography. This Introduction will spell out

the most important of those principles and practices, but first a word is in order about the biography of our biographer, Domenico Bernini.

2. Domenico Bernini (1657–1723): The Known Facts of His Life

In the annual Easter census (the so-called *stati delle anime*) of their Roman parish of Sant'Andrea delle Fratte, Domenico first appears as a member of the Bernini family in 1658, described there as a *putto,* an infant.[10] He was born on August 3, 1657, named after his paternal uncle, who had died of plague the year before his birth, a year that earlier saw Gian Lorenzo himself seriously ill with a protracted case of *febbri terzane doppie,* double tertian fevers, presumably a form of malaria. Baptized at home on the same day of his birth because of grave illness, Domenico Stefano—or Stefano Domenico, as also named in the documentation—was the last of the eleven children of Gian Lorenzo and his Roman wife, Caterina Tezio, who had married in 1639.[11] Ironically enough for the son of an artist-father celebrated for his many portraits, we possess no visual (or even verbal) record of Domenico's likeness. The only Bernini sibling for whom a certifiable portrait exists is Domenico's oldest brother, Monsignor Pietro Filippo (1640–1698), who made for himself—or, rather, had one made for him by his father—a respectable career in the upper echelons of the Roman ecclesiastical bureaucracy.[12]

Bernini's progeny may have been large in size, but it proved small in talent, none of the children even remotely approaching the level of achievement and worldly renown, in any field, of the *paterfamilias*. Primacy, such as it is, in this case in fact goes to our Domenico on the basis of his several published works of ecclesiastical history and devotional biography: albeit not exactly enduring classics in their genres, Domenico's writings are, nonetheless, respectable enough in terms of the informed intelligence of their conception, execution, and content. These several volumes (discussed below) gained him the attention and esteem of his contemporaries, even if the preface of the Venice 1737 edition of Domenico's *Historia di tutte l'heresie* exaggerates in calling him "one of the famous writers of our century."[13]

Like his older brother Pietro Filippo, Domenico too had first envisioned— or, as is quite possible, was obliged by his father to envision—a priestly vocation as his life's work: in the summer of 1671, at the tender age of fourteen, he entered the Jesuit novitiate, not long before his father began his involvement in the great enterprise of the decoration of the vault and cupola of the Jesuit mother church of the Gesù.[14] Three texts document this event. First,

the notarized legal instrument of July 1671, first made known by Stanislao Fraschetti, by which Domenico transferred to his father all his earthly possessions, in preparation for his entrance into the novitiate. Second, in the Jesuit archives, the *Ingressus Novitiorum,* a register of those who entered the Jesuit novitiate in Rome in this period: this register officially confirms that the boy, "Stefano Domenico Bernino," arrived on July 1, bringing with him a scant supply of basic clothing, duly listed, a list to which Domenico affixed his own clear, elegant, confidently written, and surprisingly mature signature.[15] And, third, his mother's will, dated September 30, 1672, which mentions that "Stefano Domenico has become a Jesuit, and is today known as 'Father Domenico.'"[16]

Domenico's religious vocation, however, was only temporary, as he himself explains in *The Life of Gian Lorenzo Bernini* (52–53): "Domenico was likewise called to the ranks of the Roman prelature, but by mysterious disposition of the heavens, having fallen in love with a respectable and well-bred Roman maiden, joined and is still joined in holy matrimony with her." The statement calls for two comments. First, to describe one's vocation in the Society of Jesus—if that were, indeed, to which he here refers—as "a call to the prelature" (that is, to the privileged upper echelons of the Roman clergy holding the more important curial offices) would betray a profound lack of synchronicity with the fundamental reform spirit of the Jesuit order, whose members, as per explicit mandate from their founder, Saint Ignatius Loyola, were to shun all ecclesiastical honors. In reality, as we shall see, Domenico is not referring to his entrance into the Society of Jesus. Second, as extant documentation obliges us to conclude, the onset of marital love was not what put to an end Domenico's Jesuit vocation: his father's last will and testament, drawn up in November 1680, refers to Domenico at all times as *Signore,* a lay, not clerical, title, thus indicating that by that date *Signor* Domenico had already left clerical life and was thus a layman once again. He was, furthermore, still unmarried, with no immediate prospects in sight, as one infers from the clause in that will, "should Domenico take a wife and have children."[17] As we shall shortly see, it was a *second* religious vocation on Domenico's part that was terminated by "the mysterious disposition of the heavens," calling him instead to matrimony.

Domenico's departure from the Society of Jesus must have occurred before January 1, 1674, since the boy's name is missing from the membership list in the catalogue of the Roman Jesuit Province, compiled "*sub fine* 1674," that is, at the end of that year. The further fact that his name is not included even in the *Dimissi* list of that same catalogue, recording all those who had left the Society

(voluntarily or involuntarily) during the calendar year 1674, suggests that he had departed in the previous year, 1673. He probably left at the end of his two-year novitiate sometime in the late summer, as a result of the formal discernment process that normally takes place before official approval for the taking of vows in August.[18] However, upon leaving the order, the young, financially dependent man presumably would have returned home to his own family on the Via della Mercede—unless his notoriously choleric father had punished him by banishing him from the family fold, but that seems unlikely given the boy's tender age and his lack of culpability in simply coming to the realization that a Jesuit vocation was not for him. There is certainly no indication whatsoever of rancor or resentment toward Domenico in Gian Lorenzo's will of November 1680; that will, in fact, expresses the desire that all the Bernini sons live together under the same roof.[19] Yet the fact is that, absent from the annual parish census since 1672, Domenico does not reappear on that list as resident of the Bernini household until 1681.[20] The question now becomes: Where was Domenico living and what was he doing in the nine-year period between his departure from the Jesuit novitiate and his return to the family fold?

The July 22, 1686, last will and testament of longtime, faithful Bernini *maggiordomo, Cosimo Scarlatti*—a document drawn up, as it states, right in the Bernini home—suggests an answer. In that document, Scarlatti appoints Domenico as his universal heir and, in so doing, refers to him with the clerical title of *Abbate: "Ill.o Sig.r Abb.e."*[21] The appellation *abbate* (in modern Italian spelled *abate*) is in this case to be translated not as "abbot" (the head of an abbey), but rather, as we do in English, with the French term *abbé,* designating a member of the secular clergy who may only be in minor orders and without formal ecclesiastical duties, whether living on his own or in the family household. Given the formal, legal status of Scarlatti's will, it is unlikely that his use of this clerical title is simply a mistake or represents some sort of domestic nickname. Recall, as we heard, that Domenico himself said that he had been called to the "prelature," a term normally reserved for, again, the secular clergy (as opposed to those in religious orders, such as the Jesuits, Franciscans, or Dominicans, who pronounce vows of poverty, chastity, and obedience). This detail would lead us to conclude that, upon leaving the Jesuit novitiate, Domenico embarked on another and likewise temporary career in the secular clergy with the hopes of entering the exalted higher ranks of the clergy holding the more important and more lucrative offices in the papal administration.[22] In so doing, he was presumably living in one of the residential colleges of Rome, if not outside the city, until returning to the family residence. The fact that his father's will makes no reference to Domenico's

clerical state again suggests that, after his several years of residential college study (of presumably the usual curriculum of philosophy, theology, or canon law), the young man had given up on the idea of a clerical vocation and returned home by November 1680 (when the will was drawn up). At the same time, however, the Scarlatti will leads us to conclude that Domenico had, subsequently and once again, pursued and successfully attained this clerical goal sometime before 1686 (the date of the Scarlatti will referring to him as *abbate*). Domenico's status in the late 1680s is further confirmed by another legal document relating to the Bernini family, dated January 1687, in which he again is given the title of *abbate*.[23]

It would have been sometime after January 1687 that, as Domenico tells us in *The Life of Gian Lorenzo Bernini,* "Providence" struck, causing him to fall in love with and marry his "respectable and well-bred Roman maiden."[24] Be that as it may, having mentioned this supposedly heaven-sent love and marriage, Domenico does not bother to even supply us with the name of his wife. He specifies only that he is father of one son and two daughters, one of whom, Caterina, was a nun in the monastery of Santa Rufina in Rome, together with two of her paternal aunts (Domenico, 53). Apart from an amusing but not terribly self-revealing anecdote regarding his flustered behavior as a boy during a visit to the Bernini home by Pope Alexander VII (Domenico, 105–6), Domenico tells us nothing further about his personal life. He does point out with pride the fact of his authorship of several published works, these representing, as he declares (Domenico, 53), "the more noble [offspring] of his mind," more noble, that is, than the offspring of his body, a remark that strikes our modern ears as rather disparaging of his own flesh-and-blood children and their nameless mother.

3. Domenico's Career as Professional Author: Works, Recurrent Themes, Ideology

His Published Works

Since a considerable financial inheritance from his millionaire father afforded him (and his brothers) a life of leisure, Domenico took up the profession of a gentleman writer and went on to produce six literarily respectable tomes, which gained him some notoriety in the cultured circles of early eighteenth-century Italy. He inaugurated his writing career with the *Memorie historiche di ciò che hanno operato li Sommi Pontefici nelle guerre contro i Turchi* (vol. 1, 1685;

vol. 2, 1695), composed, he says in its preface, "in sì fresca età" (at such a "fresh," tender, age), and documenting the military campaigns undertaken or encouraged by the popes to oppose Turkish expansion into Europe.[25] Several years later came the four-volume *Historia di tutte l'heresie* (1st ed., 1705−9), a monumental work, issued with special papal privilege, which had been twenty years in the making, as he informs us in its preface. These four densely packed volumes describe in detailed fashion and chronological order the entire series of heresies that struck the Roman Church from its foundation onward, all of which, however, the author would have us believe, were successfully refuted and repelled. Declaring in his dedicatory letter to Pope Clement XI that he had always had an appetite for ecclesiastical history "sin dalla mia più fresca età" (from the time of my earliest youth), Domenico gives demonstration of his erudition and mastery over a daunting amount of primary and secondary sources synthesized in clear, methodical, if not always accurate (and never nonpartisan) fashion. Domenico's efforts were rewarded with the subsequent, three-time republication of *Historia di tutte l'heresie* and its appearance in abridged form, an edition that also went through several printings. This pro-papal, staunchly apologetic publication, followed others of similar ilk, probably earned Domenico from a grateful Holy See the later title of *Conte* (Count), a title that passed on to his son, Giovanni Lorenzo.[26]

Domenico's next literary production, *Il Tribunale della S. Rota Romana* (1717), is much less ambitious in its scope: a scrupulously documented history of one single but august papal judicial institution. Though soon superseded as a work of reference, this volume, nonetheless, we are told, has the merit of being one of the very first systematic histories of any branch of the ancient and complex Roman curial bureaucracy.[27] Earlier, in 1713, the same year that saw the publication of the present biography of his father Gian Lorenzo, Domenico had been asked by Pope Clement XI to compile information on the life and character of the saintly Cardinal Giuseppe Maria Tomasi for the purposes of his future canonization. In 1722, Domenico's initial succinct "report," the *Ragguaglio della vita del venerabile D. Giuseppe Maria Tomasi,* written (as the author's preface reveals) in only thirty-four days, was expanded into a full-size biography and published as the *Vita del venerabile D. Giuseppe Maria Tomasi.* In that same year, 1722, Domenico also published his final work, another pious biography, the *Vita del venerabile Giuseppe da Copertino,* this too written in order to gratify the wishes of the reigning pope, Innocent XIII, in whose former episcopal diocese the Venerable Giuseppe (famous for his feats of levitation) had long labored.[28] Domenico died the following year, 1723; his only other known literary effort is a long Latin poem, included in his *Life of*

Gian Lorenzo Bernini (151–52), composed in polished dactylic hexameters, in honor of his father's equestrian statue of Louis XIV, perhaps written in 1677 (the year the statue was completed).

Three Conclusions About Domenico: Historian, Apologist, Hagiographer

Closer study of Domenico's published works would undoubtedly reveal more about the man and his modus operandi as historian and biographer. However, just from this quick survey and brief description of Domenico's works, one can draw certain useful conclusions about his authorial practice and ideology that appear to have been constants in his adult life and are, thus, directly relevant to our reading of his *Life of Gian Lorenzo Bernini*. First, by the time of the final redaction of that biography (undertaken in 1711), Domenico was an accomplished writer and professional historian who appears reasonably well acquainted with the theory and praxis of his trade. He had had significant practice in the difficult task of reconstructing the past from its remaining fragments, using primary as well as secondary sources. He knew precisely how he wished to construct, shape, and color his various historical-biographical narratives, including that of his father's career and teachings.

As is evident in the passage quoted above from the exordium of *The Life of Gian Lorenzo Bernini,* Domenico was specifically aware of the important question of historical accuracy and authorial point of view and "objectivity," even if, in actual practice, within the *vita* of his father, he most often chooses to set objectivity aside. In another work, Domenico's abandonment of authorial objectivity is explicit and conscious, as he confesses in the preface to his *Memorie historiche di ciò che hanno operato li Sommi Pontefici:* "In order to secure the confidence of their readers, historians are wont, at the very beginning of their works, to declare that they are completely free of any form of bias with respect to those subjects and those issues they are about to discuss. I myself, in contrast, declare that I am so personally invested in the present history that I could perhaps be carried away by an excess of adulation [for the revered Vicars of Christ]."[29] Even if he admits himself "carried away" by personal allegiance (in this case, to the Roman pontiffs), what is important to note is Domenico's conscious awareness of the principles of his trade, that is, he knows that historians should be editorially impartial. Hence, in *The Life of Gian Lorenzo Bernini,* we are not dealing with the simple, literarily, or historically naive reminiscences of an amateur son, but rather the deliberately, self-consciously constructed narrative of a professional man of letters. It is as such that we can and will interrogate Domenico's work in the pages that follow.

A second conclusion that one can safely draw from an examination of Domenico's professional career concerns its ideological allegiance: not only does Domenico prove to be devoutly, faithfully, and exclusively Roman Catholic in the choice of the subjects of his books, but his religious politics are decidedly and consistently pro-papal in the most rigidly partisan, apologetic fashion. This political allegiance, by the time of Domenico's adulthood, was probably a firmly entrenched feature of the psyche and modus operandi of the Bernini family. The Bernini heirs would have been well aware that the family's fortunes had had their origins in the patronage of a pope, that is, in the 1606 summoning of Pietro Bernini from Naples to Rome by the Borghese pope Paul V to work on the Cappella Paolina in Santa Maria Maggiore. Pietro's descendents would have also been aware of the fact that thereafter, throughout the lives and careers of Gian Lorenzo and some of his siblings (such as Luigi and Vincenzo) and sons (such as Pietro Filippo), the Bernini family had derived much of its continued employment, financial enrichment (not the least in the form of numerous benefices and other papal sinecures), and social status, directly and indirectly, from the papacy. All of this came as a result not only of Gian Lorenzo's artistic talent and celebrity status but also the clan's unwavering political allegiance. The sincerity of his religious beliefs aside (which, in any case, at this point one cannot either prove or disprove), Domenico knew, like his father, on what side his bread was buttered. We have already heard Domenico speak of his adulation for the popes, "adorati Vicari di Cristo," in his work on the Turkish wars: in that same volume, he signs his dedicatory letter to Pope Innocent XIII with the self-description "Your Most Humble, Most Obedient, and Most Obligated Subject" (Humilissimo Ubbidientissimo Obbligatissimo Suddito), a fulsome display of obeisance, even by the groveling Baroque standards of the day.

The ardent pro-papalism characteristic of Domenico's other published works is a trait of his *Life of Gian Lorenzo Bernini* as well. This is especially evident when one compares it to its 1682 counterpart, Baldinucci's *Life of Bernini:* Domenico devotes much more attention than Baldinucci to the institution of the papacy and to the personalities and *gesta* of the pontiffs, especially with regard to their efforts for the greater glory of the city of Rome (through, of course, the indispensable instrument of Bernini's genius). Not only does Domenico have much more to say about the popes, but what he does say is also, when not openly encomiastic, then certainly free from any shadow of criticism. Indeed, this represents one of the major goals of *The Life of Gian Lorenzo Bernini,* namely, to praise the popes at the same time it praises Bernini.

Domenico says as much in a statement made in 1722, at the end of his career, when summarizing the subjects of his published works:

> [T]he practice of our profession, we have never, over the span of fifty-five years and up through the present day, taken up pen in hand except in order to sanctify it in accounts of ecclesiastical matters, be they clamorous as in the wars waged against the Turks, or laborious as in the toilsome rebuttal of heretics, or honorably pleasurable as in the descriptions given of the embellishments, both sacred and profane, made to the city of Rome of which the sacred primacy of the Roman papacy can boast no less than the august magnificence of the Roman principate.[30]

Among the several volumes of Domenico's authorship, the book here in question containing those "honorably pleasurable descriptions" of the embellishment of Rome by the popes and "princes" (above all, Cardinal Nephews and other cardinal patrons) can only be *The Life of Gian Lorenzo Bernini*. At first glance, this might strike one as a curious way to describe the contents or goal of the biography of his father, but amid all the data and commentary referring to Gian Lorenzo in Domenico's narrative, this is indeed what we find there—a highly flattering portrayal of papal enterprise for the greater glory of God and the Eternal City.

Even outside the topic of their efforts on behalf of Rome, Domenico's tone in describing the character and behavior of the popes is ever respectful of their persons. His interpretation of their behavior is, accordingly, always favorable and, where need be, diplomatically whitewashed. This is so even in the face of abundant evidence to the contrary that would have been certainly known to both him and his contemporaries (such as the perilous exhaustion of the papal treasury caused by that monumental "embellishment" program); it is so even in the case of those popes who treated Bernini with less regard than he deserved, namely, Innocent X (initially), Clement X, and Innocent XI. In Domenico's eyes, it seems, popes (and cardinals too, especially the Bernini patrons among them) could do no wrong. Also included under the same umbrella of infallibility, in Domenico's eye, was the notorious Holy Office of the Inquisition. This we hear, most notably, in his commentary on the fate of Galileo Galilei:

> [B]ut we, to whom every decree of the Holy Inquisition is venerable, whether it be promulgated or merely described, submit to [those

decrees], without critique constructed upon subtleties and distinction-making; Pope Urban, who kept watch over the preservation of the purity of our religion, on earth and in heaven, had Galileo incarcerated in the prisons of the Holy Office and held him there for five years, that is, until, both in writing and by his spoken word, he recanted of his error, thus dying in communion with the Church, at nearly eighty years of age, as a good Catholic and a great astrologer [*Astrologo*], had he not attempted to arrest the sun in its grand movement.[31]

Now, as far as Domenico's *Life of Gian Lorenzo Bernini* is concerned, it is true that one of the conventions governing Baroque biography was its conscious and deliberate aim of offering examples of active virtue to praise and emulate, rather than displays of vice to avoid or error and foolishness to condemn. But again, even by the standards of the day, the degree of Domenico's wholesale deference to his papal—and, in general, ecclesiastical—subjects goes beyond the pale, as I shall have further occasion to point out in the notes to the text.

A third and final conclusion pertinent to our reading of *The Life of Gian Lorenzo Bernini* that can be drawn from Domenico's publication record is his obvious taste and talent for hagiography, that is, the recounting of the edifying lives of the heroically virtuous, whether canonized or not. True, Domenico's published works of hagiography all postdate his *Life of Gian Lorenzo Bernini,* but I daresay that when Pope Clement XI first called upon Domenico in 1713 to compose the life of the Venerable Tomasi, the pontiff had good reason to expect that our author had both the literary skills and proper ideological credentials for such a genre of literature.[32] Certainly, in reading *The Life of Gian Lorenzo Bernini,* the pope (or whoever of his advisers recommended Domenico for the Tomasi assignment) would have understood that Domenico indeed possessed the necessary qualifications not only of a biographer, but more specifically of a hagiographer. That is to say, an author who could properly identify and persuasively describe—according to the acceptable conventions of the day—the moral virtues of an individual in the myriad ways, small and large, obvious and not so obvious, in which such virtues manifested themselves in his or her life. Of course, not just any kind of moral virtue was necessary, but virtue that conformed to and confirmed official Roman Catholic orthodoxy. This took an eye trained in and faithful to that orthodoxy, as well as steeped in the rhetorical conventions of such literature. In *The Life of Gian Lorenzo Bernini,* Domenico's goal is as much as that of illustrating, proving, and praising the moral virtue of the man as that of demonstrating the talent and accomplishments of the artist. Thus, when Domenico terminates the biography with

the proclamation, printed in emphatic capital letters, that his father, in every aspect of his life, was "A GREAT MAN," Domenico is making a spiritual-moral claim about Bernini, as well as an artistic-professional one.

Given the tenor of his family life, Domenico was likely to have received in childhood a solid serving of hagiographic literature of all varieties (biographies, sermons, theatrical plays, poetry). This initial training would have been subsequently reinforced by his two years of Jesuit novitiate since such works of edifying piety and moral exhortation typically represented a large part of the novices' education. Hence, by the time he came to write or definitively redact his *Life of Gian Lorenzo Bernini,* Domenico would have been thoroughly conversant with the theory and praxis of the genre of hagiography. To be sure, whatever his previous schooling, it is no surprise that in the account of his father's life, Domenico's tone is "hagiographical," that is, idealizing and idolizing. Contemporary notions of filial piety would not have permitted otherwise. Furthermore, even in secular biography, one of the primary goals was to offer readers "useful" examples of eminent virtue with which to inspire in the reader a sense of awe and a desire for emulation. This represents the very first guideline offered to would-be writers of *vite* by Agostino Mascardi, author of *De arte historica,* one of the most widely disseminated, influential manuals on the art of historiography of seventeenth-century Italy. It is not difficult to see how such advice would encourage a hagiographic approach to the writing of biographies.[33] Furthermore, at that time, of all forms of contemporary biography, as Rubin reminds us, "Saint's Lives were the most common"; hence their influence on biographers was pervasive, if not inescapable, in early modern Italian culture, especially to someone as piously predisposed as Domenico.[34] One need not be an expert in hagiographic literature to readily recognize in Domenico's text some of the classic recurrent themes (or variations thereupon) that are staples of traditional lives of the saints, such as, most famously (especially in seventeenth-century Rome), those of Francis of Assisi and Ignatius Loyola. Among the topoi in question are the following:[35]

(a) the future saints' coming into the world was decreed by the will of Providence for the benefit of humankind (Domenico, 1–2);

(b) eschewing the usual childish pursuits of play and pleasure, they exhibit in their youth adultlike maturity (the *puer-senex* topos) and astounding display(s) of their future heroic virtue (Domenico, chapters 1 and 2, passim);

(c) their future greatness is heralded by the prophecies of elder authoritative figures, such as those uttered by Pope Paul V (Domenico, 9) and Annibale Carracci (Domenico, 9–10, 37–38);

(d) a prolonged, near-fatal illness or some such traumatic event leads to a major change in the direction of their life, putting an end to the carefree, often dissolute ways of youth, if not indeed occasioning an outright dramatic spiritual conversion (Domenico, 48);[36]

(e) they patiently suffer unjust, severe persecution in the process of realizing their divinely ordained mission (Domenico, 80), protected along the way by God, who quietly disposes people and circumstances in their favor (Domenico, 11, 93);

(f) they work miracles as proof of their special status (Domenico, *passim*, in the form of works of art);

(g) they exhibit at times superhuman degrees of physical strength and endurance (Domenico, 12–13, 15, 178);

(h) their work ultimately (if not immediately) serves to enhance the status of the ecclesiastical orthodoxy and authority (Domenico, *passim*); and, finally,

(i) they experience a piously edifying final illness and death, as further confirmation of the genuine holiness of their life (Domenico, chapter 23).

So much does Domenico cast his father in the guise of the traditional Catholic saint that it is almost as if our author wishes in the end to move his readers to exclaim, "San Gian Lorenzo, prega per noi!" Saint Gian Lorenzo, pray for us!

4. The Genesis and Critical Fortune of Domenico's *Life of Gian Lorenzo Bernini*

The Publisher's Testimony

In his letter to the reader prefacing Domenico's *Life of Gian Lorenzo Bernini,* Roman publisher Rocco Bernabò informs us how he came to produce the volume:[37]

> On the occasion of the publication of the *History of All Heresies Recounted by the Illustrious Signor Domenico Bernini,* in the course of my frequent examination of the manuscripts accumulated by that indefatigable and erudite individual, I was fortunate to come upon *The Life of the Cavalier Gian Lorenzo Bernini* his father, composed by him as well, many years previous, in his most florid youth, that is to say, before he undertook that great labor of the four volumes of the aforementioned history of heresy. I requested this work from him, in order that I might once again ennoble

my presses with another of his fine compositions; he graciously granted
my request, making some corrections as well as additions to the text.

The account seems plausible enough, but, in light of the many other manipu-
lations of fact that we find in *The Life of Gian Lorenzo Bernini,* we are obliged
to wonder: Is it true? Might it instead be a smoke screen? That is, was it
instead Domenico himself who had taken the initiative to ask Bernabò to
publish the biography, but, out of modesty or editorial uncertainty, wanted to
hide the fact behind the cloak of this "official" tale told by his publisher? The
latter suspicion is impossible to prove, but not beyond the realm of the pos-
sible. In any case, if the title page is to be believed, it was Bernabò who pub-
lished the volume at his own expense (a spese di), and not Domenico—nor
presumably Cardinal Pico della Mirandola, to whom the volume is dedicated.

Given what other evidence the text affords us, the publication chronol-
ogy here indicated by Bernabò would appear correct: the decision to publish
The Life of Gian Lorenzo Bernini was made shortly after the publication of the
quattro tomi, the four volumes, of the *Historia di tutte l'heresie,* the last volume
of that work appearing in 1709.[38] We know—for it is printed on the "Impri-
matur" page of the biography—that the formal judgment of the ecclesiastical
censor of Domenico's text, Jesuit Father Francesco Maria Guelfi, was dated
January 16, 1712. The manuscript was thus probably submitted to the cen-
sor sometime in 1711, after Domenico had had sufficient time to revise the
text. Indeed, Domenico tells us, in his catalogue of Bernini's children given in
chapter 7, that he, the author of the present work, is writing (in reality, *revis-
ing*) it "at the still vigorous age of fifty-four" (Domenico, 53), namely, 1711.

In the same preface to the reader, publisher Bernabò also happens to men-
tion that Domenico composed this biography "in the full flower of his youth
['nella sua più florida età'], that is to say, even before he undertook his great
labor of the four aforementioned volumes on heresy." Albeit vague, this is an
important piece of information. But how to evaluate that absolute superla-
tive, "nella sua più florida età" (literally, "in his most florid age"), in terms of
actual chronology? In the preface to his work on heresy, Domenico tells us
that he began that historical enterprise twenty years before the publication of
its first volume (1705): this would take us to 1685. In that same year of 1685,
Domenico published his first work, the *Memorie istoriche,* and in its preface
uses a similar expression to refer to his age at the time of publication: "in sì
fresca età" (at such a fresh [young] age). Bernabò's decidedly more emphatic
expression, "nella sua più florida età"—which may have come directly from
Domenico—would seem to indicate that the composition of *The Life of Gian*

Lorenzo Bernini predated even his 1685 volume on the popes and the Turks, perhaps by several full years. This could thus take us back to the same period in which Filippo Baldinucci was composing his *Life of Bernini,* published in 1682. If correct, this chronology lends significant support to the now-current assumption that not only was Baldinucci's *Life of Bernini* based upon extensive materials supplied to the Florentine historian by Bernini's sons, but that these latter materials also may have included a rather well-elaborated biographical narrative written by Domenico, possibly some earlier version of his *Life of Gian Lorenzo Bernini,* comprising a great deal of the same text found in the 1713 edition.

Filippo Baldinucci and His Life of Bernini (1682)

But why would Domenico have supplied Baldinucci with such an elaborate text in the early 1680s? Why did Domenico not simply publish his own work under his own name at that time? In order to answer those questions, we need to take up the story of the origins of the Baldinucci biography.[39] The "official" account of the early history of Baldinucci's biography of Bernini is to be found, with significantly differing details, in two sources: first, Baldinucci's preface to the later, abridged version of the *vita* of Bernini included in one of the posthumously published volumes of his collection of artists' lives, *Notizie dei professori del disegno da Cimabue in qua* (6 vols., 1681–1728), and, second, the biography of the same Filippo Baldinucci (1625–1696) written by his son, Francesco Saverio (1663–1738).[40] In the original 1682 edition of the Bernini biography, let us note, the Florentine author is virtually silent about the issue of its origins, except to the extent that he gives the reader—in his letter of dedication—the distinct impression that the publication was occasioned by the direct and sole request of Queen Christina of Sweden. As we shall see shortly, this silence was in fact meant to help perpetrate a diplomatic lie.

The official story in any case is simple: according to the posthumously published preface to Baldinucci's *Notizie,* in 1681, the year following Bernini's death, Christina (known to all as a great friend and defender of Bernini) asked Filippo through an unidentified ecclesiastical intermediary ("per mezzo di degnissimo prelato") to compose the story of the artist's life and to dedicate the volume to her.[41] Baldinucci next mentions a subsequent trip to Rome, undertaken, he says, "*almost* expressly" (*quasi* apposta [emphasis added]) for the purpose of receiving this commission directly from Christina herself, of examining the artist's works firsthand, and of collecting the necessary information from persons in a position to dispense such information, especially

Bernini's disciple and assistant of twenty-five years, Mattia de' Rossi. In the later biography of his father, Francesco Saverio instead tells a different story: there is no mention of the initial, indirect commission through the afore-mentioned anonymous prelate. Rather, according to Francesco Saverio, the commission came, first and only, in the course of a visit by Filippo to the Roman residence of Queen Christina. Furthermore, the primary motivation for Filippo's journey to Rome had nothing to do with Bernini; it was instead undertaken to escort his fifteen-year-old son Antonio to the Jesuit novitiate there. (We know from other sources that the trip to Rome took place in April and May of the same year reported by Filippo, 1681.)[42] Learning that Filippo was in Rome, Francesco Saverio then tells us, Queen Christina invited him to her residence. This first visit to Palazzo Riario was occupied by long "various and erudite conversations about all the beautiful and noble things found in Florence and Rome." Then came a guided tour of her extensive art collection, with no mention of a Bernini biography during any of this lengthy visit.

This initial visit was followed, some unspecified time later, by a second one by Filippo to Christina's home. Francesco Saverio does not note whether this second visit was also the result of the queen's summons or Filippo's request. He simply observes: "Having returned, thereafter, one day to the queen, he was received by her in the same welcoming manner." On that occasion, the queen "immediately led" Baldinucci to see her prized treasure, Bernini's bust of the *Savior*, "his most beautiful and final work," and after having discoursed at length about that work and its creator, only then did the queen pronounce her desire that Baldinucci write Bernini's biography, promising to procure for him "an abundance of reliable information." Why was Baldinucci chosen for this task? Because, according to Francesco Saverio, the queen "knew that he had already composed the lives of other artists." Although he had not previ-ously visited Rome to see Bernini's works, Baldinucci presumably would have already had some contact with them in the form of prints and the Bernini drawings in the famous collection of Cardinal Leopoldo de' Medici. (The latter collection, let us note, was under the care of the same Baldinucci who had also published an inventory of its contents in 1673).[43]

Among the sources of the "reliable information" promised by Christina were the sons of Bernini themselves, who, summoned at that point by the queen, were persuaded to assist in this biographical project ("tanto fece [la regina] che avendo a sè i virtuosi figli del Bernino"). Baldinucci accepted and began his work immediately in Rome. A large part of his work at that point consisted in interviewing "prominent architects" in order to refute the calumny spread (beginning in April 1680) against Bernini over the infamous

affair of the cracks in the cupola of Saint Peter's, supposedly caused by his work on the four piers sustaining that imposing structure, during the pontificate of Urban VIII.[44] At the end of his Roman visit—which included two audiences with Pope Innocent XI—Baldinucci took his leave from the queen and from certain other Roman acquaintances, "who had become very fond of him." The latter acquaintances included Cardinal Girolamo Casanate (1620–1700, after whom Rome's Biblioteca Casanatense is named) and Monsignor Pietro Filippo Bernini, "with whom he had spent many hours together." Returning to Florence, Baldinucci finished the biography "with the greatest concentration and in a few months," dedicating it to Christina.

This "official account" of the origins of the Baldinucci biography, wherein Christina is prime mover, seems to have been universally accepted and unquestioned until relatively recent times. This is the case despite the discrepancies between the two sources, which were either not noticed or were minimized as to their implications. Thus, to uncritical readers, uninformed of the true facts, Domenico's own biography, published thirty-one years later, from the pen of a pious son and without the cachet of a royal seal of approval, could only be judged a derivative, highly partisan, less reliable, and therefore far less valuable version of the same facts. Furthermore, the same readers, seeing significant portions of the "earlier" Baldinucci biography repeated verbatim or nearly verbatim in Domenico's text, could only consider the latter a gross example of plagiarism, whether or not they attached to the act of plagiarism the same stigma of moral culpability that our society does today. To tell the truth, however, between the time these two biographies were published and the year 1900—the publication date of Stanislao Fraschetti's monumental *Il Bernini,* which marks the beginning of modern Bernini biographical scholarship—we know little or nothing about the response to either Baldinucci's or Domenico's biography.[45] Until well into the twentieth century, there seems to have been scarce interest in the intimate biographical data and thus documentary sources of Bernini's life, especially in the wake of the precipitous, long-term decline in the artist's reputation, itself part of the European-wide repudiation of the Baroque. Nonetheless, the disdainful, dismissive treatment of Domenico's text by eminent Italian art historian Adolfo Venturi (1856–1941), in his preface to the 1900 Fraschetti biography, undoubtedly echoes the sentiments of many readers who had enough interest in Bernini's life to read both biographies but not enough to then ask the proper critical historical and philological questions. True, Venturi's judgment of Baldinucci's "hastily written" biography, "filled with errors and uncertainties," is also disparaging, but far less so than his treatment of Domenico, who is simply made to appear ridiculous: Domenico

represents merely a "beadle," says Venturi, in comparison to Baldinucci, "the Florentine scholar dressed in his august academic robes."

1966: The "Ugly Duckling" Turns into a Handsome Swan

Such was the editorial situation that prevailed until 1966, a situation in which Baldinucci's biography was accorded absolute priority over that of Domenico's by virtue of its presumed far earlier birth and royal seal of approval. Even the better-informed and more critical Sergio Samek Ludovici, responsible for the 1948 annotated edition of Filippo Baldinucci's *Life of Bernini* (published together with Francesco Saverio's biography of Filippo), declared that Domenico's text represents "for the most part, a plagiarized version of the present [*vita*] by Baldinucci." In the same work, Samek Ludovici also completely dismisses as "unsustainable" (né appar sostenibile) the "Domenico-came-first" thesis advanced in 1919 by the eminent art historian Erwin Panofsky, who appears to have been the lone voice defending Domenico in the pre-1966 period.[46] That year, 1966, marks the critical turning point in the fortunes of Domenico's biography—the beginning of the transformation of this "ugly duckling" of a text into a handsome swan—brought about by the publication of Cesare D'Onofrio's seminal article, "Priorità della biografia di Domenico Bernini su quella del Baldinucci."[47]

Popular historian of the city of Rome and assiduous frequenter of the local archives, D'Onofrio did what no other previous scholar (except possibly Panofsky) seems to have done. That is to say, he read both Baldinucci's and Domenico's texts with a truly (though not infallibly) critical eye and asked some fundamental, really, commonsense questions: Why would Domenico, in publishing an account of his father's life, have ever done the "absurd" thing of simply "slavishly" copying large portions of the Florentine author's text, "without, furthermore, worrying about appearing in public as a brazen and foolish plagiarist"? Why, D'Onofrio further asks, would Domenico, a well-known, competent, professional historian, who had just published four "formidable" volumes on the history of heresy, and so was capable of doing his own research and writing, have had to plunder an equally well-known biography written by another distinguished author about a person who was no less than his own father? And why in doing so would Domenico then dare dedicate it to such an eminent, respected personage of contemporary Rome, Cardinal Lodovico Pico della Mirandola?[48]

Troubled by such questions, D'Onofrio was able to find archival documentation that confirmed his suspicions about the veracity of the "official"

Baldinucci story. These included, above all, unpublished letters from Baldinucci in Florence to Mons. Pietro Filippo in Rome, both dating from well before the April–May 1681 visit to Rome—indeed, one was written barely two weeks after Bernini's death in 1680. This correspondence attests to the fact that the Florentine author was already firmly engaged, before April 1681, in writing the life (a *memoria,* Baldinucci calls it) of the recently deceased artist. It also reveals that the Bernini sons were actively and intimately involved in its preparation, supplying what was likely much more than just skeletal notes about their father's life and works: given the amount of textual overlap between Baldinucci's 1682 *vita* and Domenico's 1713 volume, it is assumed that in fact the family supplied some form of extensively elaborated manuscript account composed by Domenico. At the same time, D'Onofrio was able to show that as a matter of course this represented common editorial practice for Baldinucci in composing the *vite* of the artists for his *Notizie dei professori del disegno,* namely, to simply copy (either verbatim or closely so) and weave together the disparate memoranda, reports, descriptions, and other (at times rather lengthy) texts prepared at his request by family and friends of the artist in question and publish them instead under his own name, with no acknowledgment of his sources.[49]

In reconstructing the circumstances in which Domenico's biography came to be, D'Onofrio made mistakes (such as misreading the date of one of Baldinucci's letters)[50] and did not uncover all the pieces of the puzzle (and as a result, for example, still believed that Christina had taken the initiative in commissioning Baldinucci to write the full-fledged biography of Bernini). Nonetheless, to him goes the credit of first deconstructing the mendacious official story given by the two Baldinucci men (Filippo and son Francesco Saverio) and thus beginning the process of Domenico's rehabilitation. Consequently, as Delbeke, Levy, and Ostrow explain, "D'Onofrio's radical assessment of Domenico's priority was understood as a judgment on the truth value of his text. Baldinucci's biography lost its authenticity, historical accuracy, and coherence. Thus, the critical condemnation that had befallen Domenico was simply reversed."[51] This is not to say, however, that scholars immediately learned and fully absorbed the lesson of D'Onofrio's article and thus ceased to consult or cite Baldinucci's story: this is not at all the case; but it did mean from then on that Domenico's version of his father's life could no longer be ignored.

But why would both Filippo and Francesco Saverio Baldinucci falsify the story of the origins of the 1682 Bernini biography? Why would Queen Christina lend her name to this deception?[52] And why would Domenico, in printing his own biography in 1713, remain completely silent on the issue? It took

thirty more years after the publication of D'Onofrio's 1966 article to arrive at a satisfactory answer—or, at least, a reasonable, persuasive conjecture—and that answer was supplied by Tomaso Montanari's 1998 essay "Bernini e Cristina da Svezia: Alle origini della storiografia berniniana."[53] As important and as revelatory as D'Onofrio's essay was, it seems neither to have garnered great attention nor inspired a big, immediate rush to explore the issue further, for there was still insufficient interest in the problem of the biographical sources of Bernini's life. That interest slowly developed over the years, along with the gradual rekindling and eventual full reflowering of Bernini's artistic reputation, provoked in part by the anniversaries of his death (1980) and birth (1998), which brought much new attention to his accomplishments in the form of numerous exhibitions, conferences, and other public events before, during, and right after the actual anniversary dates. The resurgence of Bernini's popularity also came as a result in a significant change in the zeitgeist of late twentieth-century Western society, which once again found the Baroque aesthetic and mentality both highly appealing and directly relevant to the spirit and concerns of the contemporary world. Certainly the 2002 international conference in Rome, *Bernini's Biographies,* organized by Delbeke, Levy, and Ostrow, was a clear sign that the study of the Bernini biographical sources as literary texts unto themselves had come of age and now occupied a secure, recognized niche of its own within the larger edifice of Bernini scholarship.

The Bernini Family Biographical "Workshop" of the Early 1670s

Be that as it may, in 1998, having uncovered significant new documentation and reevaluated previously known sources, Montanari was able to confirm and expand D'Onofrio's case against the Baldinucci official story, arguing persuasively that indeed the Bernini clan (under the direction of Mons. Pietro Filippo) had been actively engaged in the production of its own, family-sponsored biography of the artist, from at least 1674. These new (or newly analyzed) archival sources attest to the fact that Pietro Filippo's efforts were directed at establishing a basic catalogue of his father's works, a chronological narrative of the essential facts of his life (interspersed with illustrative anecdotes and entertaining *bons mots*) and an anthology of the flattering published notices of the artist's works by *eruditi* and other prominent contemporaries. The new documentation also led to the conclusion that both Christina and Baldinucci came into the picture only after what Montanari calls the Bernini family biographical "workshop" (*officina*) had initiated its activity: Bernini's longtime ally Christina was recruited perhaps sometime in late 1675 or

1676, and the apparently equally pro-Bernini Baldinucci in 1678. Both were recruited—the one, as the fictitious initiator of the project; the other, as the supposedly autonomous, sole author of the biography—to cover up the compromising fact of the direct connection between the adulatory, apologetic biography and the machinations of the Bernini family.[54]

Bernini himself, we note, is nowhere to be seen in any of the extant documentation as an active, front-stage participant. But certainly some form of contribution on his part to this initiative is not to be excluded: How could he—who for his entire life had maintained an anxious, imperious control over all his affairs, professional and domestic—keep silent and passive in this matter, living, let us recall, in the same house as the would-be biographers, his sons? There is nothing in the documentation to warrant Bernini's exclusion from this enterprise, as perhaps its behind-the-scenes instigator and orchestrator, who was careful, however, to leave no direct paper trail pointing to his role. If this is true, that Bernini played some sort of active role in the compiling of an official biography, then the inevitable conclusion is that both the Baldinucci and Domenico texts could be read in a certain sense as quasi-autobiographies.[55]

As for Domenico's role, the newly uncovered documentation (like the older, already known texts) nowhere gives mention of his name. Nonetheless, Montanari reaffirmed the D'Onofrio thesis that he, the youngest of the Bernini boys, was ultimately and in large part (if not solely) responsible for supplying Baldinucci with some rather substantial biographical narrative. This thesis, again, derives from the fact of the extensive textual overlap between the Baldinucci and Domenico *vite,* and of what has been demonstrated about Baldinucci's usual modus operandi in composing his lives of the artists, namely, by wholesale, verbatim repetition of text supplied by friends, family members, and other contemporary eyewitnesses. Yet, as the same Montanari rightly remarks, "What is instead difficult to understand is why at this point even the very young Domenico Bernini became involved in the project; it was he who must have written out, at least in good part, the manuscript sent to Florence, given the fact that later he was able to reprint it under his own name without even mentioning that of his older brother, who had by then died."[56] Montanari does not answer the question he raises, but a reasonable conjecture would be that of the entire family Domenico, with his solid education in the humanities and self-avowed passion for history, was identified as the one who most securely possessed the necessary intellectual skills for the successful completion of such a task. And equally important, being young, unmarried, and unemployed, he also had the free time in which to do so. Furthermore,

and finally, as a loyal member of the Bernini clan, Domenico would have willingly accepted the conditions of complete anonymity imposed upon his authorship of the text for the greater glory of his father and his family.

For the older Domenico, years later, in revising his manuscript (in 1711) for publication and supplying its preface, silence on the question of the origins of his composition remained the best option, rather than expose in enduring print all the details of his family's original cover-up. Yet, at the same time, the mere publication of his text, with its many echoes of Baldinucci's, was in itself an exposure of sorts, certain to provoke uncomfortable questions, as Domenico must have known. Let us recall the already-quoted passage from chapter 1 about historical accuracy and surviving eyewitnesses to the truth: "It is, furthermore, our intention to do so with that accuracy demanded of all those who describe events to which *almost everyone still alive today has been an eyewitness*. Such eyewitnesses could easily contradict an author each time he, in order to garner more admiration for his writing, embellishes the facts and departs from the truth." Perhaps Domenico saw his defense in the fact (as we shall see below) that the 1713 version, for all its similarities to Baldinucci's biography, is, nonetheless, a significantly longer, recast presentation of the same historical data and memorable dicta included in the 1682 text, with much new material added to the mix (especially in the form of personal anecdotes).

Certainly, the further fact that in his own work (168) Domenico refers the reader to Baldinucci's biography (as source of additional information about the cracks-in-the-cupola controversy) would seem to indicate that he feared no comparison with the Florentine's text. Indeed, Baldinucci makes a second appearance, by name, elsewhere in Domenico's narrative (81), as author of a long poem about Bernini's statue of *Truth Uncovered by Time*. Moreover, a much different attitude toward authorial originality prevailed in those days, which allowed for the wholesale, verbatim borrowing of material by one author from another, without necessarily provoking indignant cries of plagiarism or threats of lawsuits. In the end, however, it is impossible at this point to know what was on Domenico's mind when he made the decision to publish his *Life of Gian Lorenzo Bernini* and what reaction he expected from his readers over the question of its rapport with the Baldinucci text.

Among the active collaborators of the Bernini family in its biography enterprise was Carlo Cartari (1614–1697), a well-known Roman curia lawyer and *erudito,* who also served as archivist and librarian of the papal Altieri family. As the extant documentation indicates, Carlo gathered various materials for Pietro Filippo and, more important, for the present discussion of origins,

recorded in his diary the first notice of the biographical intentions of the Bernini family:

> The 3rd of January 1674 Monsignor Bernini told me that he wanted to write and publish the biography of his father, and have engraved all of the statues made by his father, which amount to about seventy, all with explanatory captions, and that for this book he would spend at least 8,000 *scudi;* but he decided not to publish it while his father, now seventy-six years old, was living. He has just finished the equestrian statue of the King of France. He told me that his biography would be very unusual, and he recounted to me various intriguing details.[57]

As the diary entry reveals, it was initially Monsignor Pietro Filippo who was to write the biography (if Carlo's words are to be taken literally). In fact, Pietro Filippo did compose a brief, rather literarily primitive biographical sketch, extant among the Bernini family papers now in the Bibliothèque Nationale, Paris (Ms. italien, 2084, fols. 132–35), known since 1844, when it was first published by Paolo Mazio, and republished in a corrected version by Felicita Audisio in 1985. The sketch, copied out at least in part in the Monsignor's own hand, was evidently begun in 1674, but updated on later occasions, the last update inserted during the final year of his father's life by Pietro Filippo himself. It contains many of the facts, anecdotes, and linguistic expressions that will show up in the Baldinucci and Domenico biographies, but also a small amount of material not found in either biography. Given its importance, it is included here in an appendix, translated into English for the first time. For the sake of convenience, I have titled it *The Vita Brevis* (see Appendix 1).[58]

Cureau de La Chambre and the First Published Bernini "Biography"

Another important figure in any discussion of the earliest written accounts of Bernini's life is the Abbé Pierre Cureau de La Chambre (1641–1693), a member of some standing at the French court and Parisian intellectual milieu, whose father, Marin Cureau de La Chambre (d. 1669), was personal physician to King Louis XIV.[59] La Chambre's friendship with Bernini dates back to the artist's return trip from Paris to Rome in October 1665: the young man had succeeded in gaining permission to accompany Bernini on his return trip from Paris to Rome. He remained in residence in Rome for a year, continuing his frequent and friendly contact with Bernini during that period. To date, the earliest uncovered document containing any mention of a Bernini

biography project is a Roman *avviso* (a notice in a handwritten, publicly circulating, anonymous newsletter),[60] dated December 1673, which states that "a certain abbé and dear friend" of the Cavaliere was writing his life. Scholars are largely in agreement that the cleric biographer in question is the same La Chambre.

Several years later and shortly after Bernini's death, in 1681, La Chambre published an "Éloge de M. le Cavalier Bernin," in the February 24 issue of the prestigious *Journal des Savans* (*Sçavans*). Four years later, on January 2, 1685, he then delivered before the French Academy (of which he had been a member since 1670) a discourse entitled "Préface pour servir à l'histoire de la vie et des ouvrages du Cavalier Bernin" (Preface to serve toward the history of the life and works of the Cavalier Bernini), a prospectus for his intended biography of the Italian artist. Several months later, the "Préface" was issued in print, together with a revised version of the 1681 eulogy. But the announced full-length biography never came to be. An acquaintance of the Abbé's, the well-known editor of the *Mélanges d'histoire e de literature,* "M. de Vigneul-Marville" (pseudonym of the Carthusian literary historian Dom Bonaventure d'Argonne), offered this explanation for the failure of the project: "It was [La Chambre's] plan to publish the life of this illustrious sculptor and architect, but Bernini's reputation in France, where tastes easily change, had suddenly fallen into decline, and rather than losing himself in a defense of [Bernini's life] against those envious of him, M. l'abbé de La Chambre abandoned his plan and never spoke of it again. Moreover, this abbé was lazy and not one who readily undertook great enterprises."[61]

Brief and preliminary as it may be, La Chambre's "Éloge" has been publicized as "the first biography of the artist ever published." In effect, it may be thus considered, even though its primary purpose, of course, is not to set forth the facts of Bernini's life and career, and indeed (at least in its original version) offers just a meager portion of the latter information.[62] However, La Chambre's "Éloge" does not represent the first formal public tribute to Bernini published after the artist's death: that distinction, as far as we know, belongs to the eulogy composed by yet another Frenchman of rank within Parisian courtly circles, Jean Donneau de Visé (Vizé), who printed his "Éloge du Cavalier Bernin" in the January 1681 issue of the *Mercure Galant,* that popular (if not especially intellectual) periodical of French court life and miscellaneous cultural-social news edited by the same Donneau de Visé.[63] Significant not only for its early date—it appeared less than two months after Bernini's death—the *Mercure Galant* eulogy is noteworthy for its entirely positive, indeed unconditionally celebratory, account of Bernini's talent and

accomplishments. The eulogy does not reveal anything new about Bernini or his works (apart from a reference to his verse-making), but nonetheless it is of great interest: it comes, let us note, from a periodical that was extremely close to the French court. Thanks to its enthusiastically pro-royal editorial policy, the *Mercure*'s offices were housed in the Louvre itself by special concession of Louis XIV, and its masthead boasted of the patronage of the king's eldest son. Hence, it would seem to provide confirmation of the continuing esteem for Bernini on the part of the French monarchy, despite the great anti-Bernini sentiment in other parts of that court, which had its origins in the Italian artist's unhappy and diplomatically unsuccessful residence there in 1665. The *Mercure Galant* eulogy, a text not easily accessible, is reprinted here, unabridged, in English translation for the first time (see Appendix 2).

5. What Motivated the Biography Project?
Bernini's Career in the Early 1670s

Although it is regrettable that La Chambre never wrote the promised full-length biography, the two texts that he did publish are invaluable primary sources. Strangely enough, however, as Montanari points out, Domenico, who dedicates many pages to Bernini's supposed success at the French court, includes not even the briefest reference to either of La Chambre's two essays in honor of the artist. Is this an indication of less-than-warm feelings toward the Frenchman on Domenico's part? Such a suspicion arises from the fact that La Chambre had openly and emphatically announced in the "Préface" his intention of describing Bernini just as he was, a fallible human being, warts and all, not suppressing even "what was reproached in him by his enemies and by those envious of him."[64] Report of the intended tenor of this French biography is sure to have reached the Bernini family rather quickly—probably even before the formal public delivery and subsequent printing of La Chambre's January 1685 Academy discourse. As is well known, there were many points and agents of incessant contact between Rome and Paris (with a reasonably efficient postal system between the two capitals). Furthermore, with the fate of the Louis Equestrian statue still up in the air (only in March 1685 did it finally arrive in Paris), the Bernini sons maintained a vested interest in their father's reputation at the French court.

Indeed, if may be that, even years before Gian Lorenzo's death and La Chambre's first published eulogy, the Bernini family had had some role in actively recruiting a biography from the French abbé, announced in the

Roman *avviso* of December 9, 1673. If this assumption is true, it would mean that there probably had been before that date, and continued to be thereafter, direct communication between the family (if not with Bernini himself) and the would-be biographer about his plans.[65] Assuming La Chambre did not hide his true intentions to them, news of the French abbé's "warts-and-all" biography would have gravely troubled the artist's sons, who, in turn, must have shared their concerns with the man they eventually hired to compose a more obsequious "authorized" biography, Filippo Baldinucci. It is thus tempting to see La Chambre as the anonymous target of Baldinucci's vitriolic condemnation inserted in the "Statement of the Author" at the conclusion of his *Life of Bernini:*

> I wish to make it clear to everyone that, before setting out to write not only of Bernini but of any celebrated man, I made a pact with my pen that it must, as if it were an amorous bee, follow the trail of the melliflu-ous parts of the flowers, leaving the opposite course to some poisonous spider, born in filth and nourished by garbage, who now or after I shall have published my account wants to sink his teeth into the less appetiz-ing, from which I kept my respectful lips, and feed upon it. According to rumor, one such has already wished to do so — even as I wrote of this great artist. He struggles to draw from those same shoots from which I extracted the sweetest and gentlest substance some imperfection and then, mixing it with the sordid humor of his own substance, to vomit forth poison. His only prudence lies in not wishing to commit his own name to print (a name still unknown to me) so as not to reap the infamy that such an ugly and detestable labor merits.[66]

However, the thoroughly antagonistic intent of this rumored biography and the specification (if true, and not simply a strategic falsehood) that the unfriendly, would-be biographer did not want "to commit his own name to print" would seem to exclude La Chambre as Baldinucci's target: the French abbé was after all a sincere, proven admirer of Bernini's who had made no secret of his intentions of writing a biography (as we deduce from the above-quoted 1673 *avviso*) and would not seem to deserve such a scathing attack.[67]

Nonetheless, the acerbic tone of Baldinucci's protestation is an important reminder of the hostile environment (hostile to Bernini, that is) in which the Florentine's biography — and that of Domenico — came to be. It was not merely filial piety that would have made Domenico and his siblings bemoan the news of a text (La Chambre's) that promised to publicize to the world the

less-than-flattering aspects of the artist's personality: it was also the painfully acute awareness that, even if fundamentally favorable to the artist, such a document would have inevitably contributed fuel to the anti-Bernini fires that raged in Rome in the last decade of the artist's life and thereafter. Bernini's phenomenal success in Rome—artistic, social, and economic—had since the 1620s always been met with a fair amount of jealousy and resentment, some of the latter no doubt justifiable, in view of the artist's talent for shrewdly manipulating people and circumstances to his own advancement. The phenomenal success of the extensive Bernini workshop, especially at the papal court, understandably created hostility among those who were not a part of his enterprise nor had any wish to be, such as Francesco Borromini or Pietro da Cortona. But Bernini had always managed to keep himself fundamentally invulnerable to attacks by the opposition or else recover rather quickly from any loss of status, again thanks to skillful maneuvering on his part and the enlistment of powerful allies, such as he had done, for example, during the early years of the papacy of the initially antagonistic Innocent X.

Fortune Turns Against Bernini: The Family Responds

Nonetheless, as Montanari has pointed out, in the early 1670s—from 1670 to 1673, to be precise—there occurred a series of unfavorable events, professional and personal setbacks, that would have certainly caused the artist, now in advanced old age, to wonder whether his usual luck might have begun to fail him and whether he himself might no longer be capable of neutralizing the hostility of rivals or dodging the fatal blows of fortune.[68] More important, it would have caused him and his family to fear for his posthumous reputation: What lasting memory would he leave behind in the wake of these reversals? Would the damaging vicissitudes of his last decade cancel out the glory of the preceding seven? And, finally, this series of events would have inspired, if not compelled, them to take matters into their own hands to counteract these malevolent forces and ensure that posterity would remember Bernini in the most flattering light possible. How to accomplish this? By commissioning a formal, thoroughly hagiographic book-length biography of the artist.

What was the series of events that occasioned and fueled the Bernini family biographical enterprise? To begin with, in 1670 there ascended to the throne of Peter a new pope, Clement X Altieri, who had little or no real appreciation for art and poetry and little or no appreciation for Bernini. His successor, the austere Innocent XI Odescalchi, was even worse on this account. To be fair to these two men, their art-loving and Bernini-loving predecessors had

left the papal treasury all but bankrupt with their monumental building and decorating projects and hence, even if they had been so inclined, Altieri and Odescalchi simply could not have afforded to spend further money on Bernini projects of the same proportions. One ambitious project being conducted by Bernini in the early 1670s, left over from the previous papacy (that of the artist's old friend Clement IX, to the world, Giulio Rospigliosi) was the redesign of the tribune of Santa Maria Maggiore. Bernini's design, which at one point was to incorporate the tomb monuments of Alexander VII and the same Clement, involved huge sums of money as well as the destruction of some of the basilica's most venerable mosaics, rousing the great ire of the Roman public. The new pope, Clement X, not only quickly suspended the project but also soon thereafter dismissed Bernini from the job, replacing him with the younger Carlo Rainaldi, who produced a more affordable and less complicated design. That he was replaceable at this stage in his career must have come as quite a shock to the aged Bernini, who found himself publicly condemned by popular opinion as "the one who instigates the popes into undertaking useless expenditures in such calamitous times" (istigatore de Pontefici a fare spese inutili nei tempi sì calamitosi).[69]

The Stoning of Palazzo Bernini

Also in this period, as we learn from an *avviso* dated January 4, 1670, the person and property of Bernini were direct targets of hate-filled hostility in a most physical manner. This attack occurred in the interim months between the papacies of the two Clements, IX and X, the so-called *sede vacante,* when in the absence of a pope all manner of civic disorder frequently occurred, including the settling of old debts and the exacting of revenge by acts of extreme violence, including homicide. In Bernini's case, the windows of his house were smashed by angry stone-throwers, while his coach was forcibly detained and searched by several armed men of ill intention toward the *Cavaliere.* Fortunately Bernini happened not to be in the coach at the time of this aggression and survived this particular round of *sede vacante* unharmed, if not unshaken. Although the extant documentation gives no motive for these attacks on Bernini, it is likely no mere coincidence that the aforementioned report about Bernini is delivered together with similar news of violent physical assault by several armed men upon a certain Abbate del Gallo (identified as *Maestro di Camera* of Donna Caterina Rospigliosi), presumably, the anonymous *avviso* reporter speculates, because of the "hatred" (*odio*) provoked in certain men of rank (*diversi cavalieri*) by the cleric's arrogance (*superbia et arroganza*).[70]

Later, sometime after the inauguration at the Vatican (November 1, 1670) of his equestrian statue *The Vision of Constantine,* further aggression, this time of an editorial kind, was aimed at Bernini in the form of an anonymous vitriolic critique, "Del Costantino del Cav.re Bernini," condemning the statue and its maker. That the sentiments expressed in that text were not merely those of one individual can be deduced from another contemporary *avviso* that speaks of Bernini's "little applauded' [*poco applaudito*] *Constantine.*"[71]

The French "Cabal" Against Bernini

Cause for grief and anger also came to Bernini from his strained relations with the French court, especially on account of Bernini's other equestrian statue of these years, that of Louis XIV. The work had been conceived in 1665 but was not begun by Bernini until 1670 and, though largely finished by 1673, was not fully completed until 1677: this was due in part to continuing conflict between him and his bête noire, Colbert, who failed to keep his word on payment of the artist's French pension, as well as to the pernicious influence of the "cabal" of French architects linked to the court, who had been seeking to thwart the realization of Bernini's artistic designs in Paris since 1665.[72] The first payment of the pension promised to Bernini upon his departure from Paris in October 1665 did not begin arriving until well into 1671 and ended abruptly and without explanation sometime after October 27, 1673. So too did correspondence between the artist and the minister. As Wittkower conjectures: "Colbert's silence indicates that the same camarilla in Paris which had prevented the execution of Bernini's Louvre designs had won a new victory," though this victory surely was also a matter of the conscious volition on the part of the powerful, strong-willed minister. Once finished, the Louis XIV statue was not even sent for by the French court until 1684, four years after the artist's death. Laboring on the statue in the early 1670s, Bernini thus had every reason to fear that this project would meet the same destiny of his Louvre east-facade design: after so much time, negotiation, and intense toil expended on the task, Colbert had simply set aside his grandiose Louvre plans in favor of a French solution, as communicated by the minister to the artist in a letter of July 1667.[73]

Bernini, "That Dragon of the Hesperides"

Bernini (who, on top of everything else, experienced a brief but violent and near-mortal illness in midsummer 1672) would have thus found no pleasure in

learning that the same Colbert was the dedicatee of the *Vite de' pittori, scultori e architetti moderni* published in that same year by an *erudito* of significant and growing cultural-artistic authority in Rome, Giovanni Pietro Bellori. Much more bitter to Bernini, however, was the fact that he himself was completely excluded from this survey of the eminent artists of the century, a deliberate slap in the face by Bellori, who bore little love for Bernini's aesthetic ideals, if not for the man himself. Not only does Bellori exclude Bernini from his collection of biographies, but he also declares (in the introduction to his life of the Flemish sculptor François Duquesnoy), as a further insult to Bernini, that "not even in modern centuries has sculpture come close to reviving or renewing its ancient appearance." True, Michelangelo's art, Bellori concedes, represents a new apex in the history of sculpture (albeit still inferior to that of the ancients), but there is no one in the present century—not even Bernini, we are meant to conclude—capable of matching, let alone surpassing, the accomplishments of Michelangelo in sculpture.[74]

Not long thereafter, another collection of artists' lives, Giovanni Battista Passeri's *Vite de' pittori, scultori ed architetti che hanno lavorato in Roma,* began to circulate in Rome in manuscript form, in which through random remarks scattered throughout Passeri presents an extremely unflattering portrait of Bernini. (There is no separate *vita* of Bernini in Passeri's work since, as its title declares, the collection is restricted to artists who died in the period 1641–73.) Most notoriously, while discussing the career of Guido Ubaldo Abbatini, one-time member of the Bernini workshop, Passeri applies to our artist a most uncomplimentary image that was destined to have a long life in the memory of posterity, just as it must have immediately caught the attention of his delighted enemies, whom we can easily imagine gleefully repeating it throughout the city and beyond. For Passeri, Bernini, with his fierce and jealous protection of his professional turf and privileges, was no less than "that dragon custodian who kept watch over the gardens of the Hesperides," referring to the ferocious, repulsive beast that guarded Juno's golden apples and that was eventually slain by Hercules in the eleventh of his twelve famous labors.[75]

Brother Luigi's Crime

Not only did grief and threat to his social and artistic reputation come from a hostile outside world in last decade of Bernini's life, but they also came from within his very own family: in early December 1670, his older brother, Luigi, a talented and invaluable collaborator in so many important projects,

sodomized a young male assistant behind the fencing that screened off the Constantine statue worksite at the Vatican, and the crime immediately became a matter of public knowledge and outcry. Leaving the young man with serious physical injury (not to speak of the emotional harm inflicted upon him), Luigi was forced to flee from Rome under the threat of arrest and a trial; his personal property was also confiscated by the authorities. (Let us recall that Luigi lived under the same roof as his brother and extended family.) For Bernini and his clan, as we can easily imagine, the resultant scandal must have been of calamitous proportions and certainly served to add fuel to the general anti-Bernini hostility in the Roman air at the time.[76] Loved or hated might he be by the general population, it was nonetheless up to *paterfamilias* Gian Lorenzo to remedy the situation, which he eventually did, with the payment of a certain sum of money to the boy's father and, more important, with the production of a whole series of artworks for the pope (Clement X Altieri) and the Altieri family, all free of charge, including the celebrated *Blessed Ludovica Albertoni* statue.[77]

Another source of grief experienced on the domestic front in these same years, by the way, although of a different kind and not reflecting on Bernini's public status, was the death of his wife, Caterina Tezio, which occurred on July 12, 1673, and which sent Bernini into retreat for several days at the Jesuit house at Sant'Andrea al Quirinale.[78] We have few details about the emotional or psychological quality of the "arranged" marriage between Gian Lorenzo and Caterina: however, one fact that stands out comes from Paul Fréart de Chantelou's *Journal de voyage du Cavalier Bernin en France,* which reports that while in Paris in 1665, the artist received news of his wife's grave illness and possible death, news that reduced Bernini to tears of bitter grief and into a state of depression for days until further news brought word of her recovery.[79] Certainly we are to see in this reaction a sign of genuine love. However, unfortunately, by 1673 husband and wife had gotten embroiled in a battle of sorts with each other over the terms of the inheritance of one of their daughters, clear public evidence of which is registered in both of their last wills and testaments: amazingly, Bernini's anger over this one, quantitatively trivial, financial disagreement lasted until his own death seven years later. This was an unpleasant note upon which to end a marriage and represented another dose of bitterness added to the host of other sources of suffering Bernini was made to endure in the early years of what was to be the last decade of his life.[80]

This is not to say that in this period Bernini's professional activity was simply at a standstill or that he was deprived of sincere public applause for his continuing artistic accomplishments: in 1670, the decoration of his architectural

gem, the church of Sant'Andrea al Quirinale, was essentially completed; in the following year the refurbished Ponte Sant'Angelo, redesigned under Bernini's direction, was inaugurated and work began on another of his celebrated papal tomb monuments, that of Alexander VII, and on the Cappella del Sacramento at Saint Peter's. Three years later he conceived and began execution of what was to become one of his most influential *invenzioni* for princely palace interior design, the stately *Galleria* of the Palazzo Colonna,[81] while during the years 1671–74 he produced his magnificent statue of *Ludovica Albertoni* (together with the redesign of the chapel housing it), which, despite the distressing circumstances of its origins (executed free of charge in the hope of gaining exoneration for the exiled Luigi), ranks as one of the artist's most dramatically powerful and most acclaimed sculptural creations. These were all successful projects, artistically and popularly, which proved that despite the bitter adversity under which he had to labor, Bernini, though battered, was far from defeated, either professionally or personally.

Not surprisingly, Domenico's narrative makes no reference at all to any of the series of adverse events that marked Bernini's life in the early 1670s. According to that narrative, Bernini's star, once reaching its most brilliant zenith and despite temporary dimming of its light (during the initial years of Pope Innocent X's reign), is never seen really to decline, especially in his final years. Even gravely problematic projects, such as that of the *Louis XIV Equestrian,* whose failure in the eyes of its patron would have been a matter of public knowledge in 1713, are presented with no admission of blemish or defect—even though reading between the lines of Domenico's description, one can discern the author's apologetic pen at work, defending the controversial artistic *concetto* informing the design of the statue. There is likewise no mention of these unhappy vicissitudes in any of the documentation, cited earlier, that speaks directly or indirectly of the Bernini family's involvement in the biography project that presumably began in late 1673. These documents offer no explanation of any sort as to why the family had decided to undertake this editorial enterprise. It was certainly not because—it behooves us to note—that was simply and conventionally the thing to do in seventeenth-century Italy once a famous artist reached old age. On the contrary, unlike today, biographies of any sort were in that period usually reserved for people already deceased.

Moreover, there was, even by the late seventeenth century, still no tradition of separate book-length biographies of artists, dead or alive, despite the many collections of briefer artists' lives (most famously that of Giorgio Vasari) then in circulation. For this reason, as Delbeke, Levy, and Ostrow

remind us, Domenico's *Life of Gian Lorenzo Bernini* and its Baldinuccian coun-
terpart "stand apart as two rare examples in the rare genre of the indepen-
dently published life of one artist," Ascanio Condivi's *Vita di Michelagnolo
Buonarroti* (1553) being the sole conspicuous precedent in this category.[82] The
latter work by Condivi, produced while its subject was still alive and contrib-
uting to its contents and with strong apologetic intent, no doubt represented
a powerful stimulus to the Bernini sons in their own editorial endeavor. This
was not in the least because one of the themes near and dear to their hearts—
and that of Bernini himself—is the portrayal of Bernini as the "Michelangelo
of his age," a theme that surfaces quite explicitly in Domenico's and Baldinuc-
ci's texts.[83] Hence, in the absence of a tradition of freestanding biographies
of artists, especially ones who were still living, there must have been some
other motivation compelling the Bernini sons forward with their biographi-
cal enterprise. Though not provable beyond a doubt given the current state
of extant documentation, Montanari's conjecture that this enterprise came in
fact as a direct, proactive, and apologetic response to the unfavorable turn of
Bernini's fortune in the early 1670s remains quite reasonable.

6. Domenico Versus Baldinucci: A Comparison and Contrast of Texts

A Most Complicated Case of Intertextuality

To recapitulate, we now possess sufficient documentation to be certain of
the intimate involvement on the part of the Bernini sons in the genesis of
Baldinucci's biography. The same body of evidence also justifies the hypoth-
esis that the textual similarities between the Florentine's biography and that
of Domenico are the result of a direct derivation of the former from the lat-
ter. However, in view of the differences between the two biographies (even
within parallel passages), on the one hand, and the certainty, on the other, that
Baldinucci also had at his disposal further, independent sources for his narra-
tive, one might wonder: How much of Baldinucci's published text represents
Domenico's own words? And how much, instead, did Baldinucci revise and
transform what Domenico presumably gave him? Likewise we might ask of
Domenico: To what degree did Domenico himself later revise and transform
what he had originally written for Baldinucci's use, when preparing his own
biography for its 1713 publication, with perhaps Baldinucci's published text in
hand?[84] Can we, in other words, reconstruct the "archetype" (as Montanari
calls it), putatively penned by Domenico, that stands at the origins of both

biographies?[85] Will a close comparison of the two texts as published supply us with answers to these questions?

In preparing the notes to the present English translation, which entailed comparing Domenico's information and assertions with what we know from other primary sources, Baldinucci principal among them, I undertook the kind of contrastive analysis necessary for formulating answers to these questions regarding intertextuality. As a result of this investigation, I believe a single answer can be given to all the questions posed: it is simply that we will never know. That is to say, the more diligently one compares Baldinucci with Domenico, the more one realizes what a dauntingly complicated puzzle their reciprocal textual relationship represents, a puzzle that will never be solved, barring discovery of new documentation. Even if the two biographers started out with one and the same Domenico-authored "Ur-text" of the late 1670s or very early 1680s, both men, in readying the texts for publication, departed so far from this imagined "archetype" that a reconstruction of the latter is impossible, except perhaps in the most limited, fragmentary, and tentative fashion. Likewise, any conclusions about which of the two authors is ultimately responsible for the various statements we now encounter in the two texts can only be highly conjectural.

An excellent statement of the problem is given by Delbeke, Levy, and Ostrow, who compared one set of brief parallel texts from the two biographies, namely, the two authors' prefatory remarks to letters that are reproduced as proof of their assertions about Bernini's great success in France (Domenico, 141; Baldinucci, i.120, e.54). Despite certain small differences stemming from the fact of having been produced by two distinct authorial voices, the two short passages make the same point in the same context, with an overlap of language that cannot be coincidental. Delbeke, Levy, and Ostrow wonder as to the meaning of this textual overlap and, in doing so, aptly identify the nature and complexity of the challenge one faces in attempting to separate the Domenico strand from the Baldinucci strand in the two biographies: "Did Baldinucci, as D'Onofrio would have it, use a phrase from Domenico? Did Baldinucci borrow the language from a manuscript provided to him by the Bernini clan? Did Domenico later leave the passage as already written? Or did parts of Baldinucci's phraseology end up in his life?"[86] In other words, the situation here can almost be described as a case of "which came first, the chicken or the egg?" In the absence of the supposed "archetype" against which to compare the texts, no answer is possible.

Another example of this problem of intertextuality is the corresponding passages in the two biographies that concern the affection and esteem for

Bernini on the part of the newly elected Alexander VII (and members of his inner circle), as well as the revelation of the pope's ambitious plans for the further embellishment of Rome. Both accounts of this "episode" begin with the expression "The sun had not set on that day," and both contain conspicuously similar lines about the communication of Alexander's grand schemes to Bernini on that first day of his pontificate. Time and space do not here permit detailed analysis of the two texts, but let us note that the similarities inevitably point to a common origin, possibly the "archetype," while the differences indicate a self-conscious desire on the part of at least one author (if not both)[87] to distinguish his text from the other. Complicating the picture is not only language itself but also the placement of that language: in Baldinucci, the line in question about the communication of the pope's grand plans comes at the beginning of the section in question, while in Domenico it comes at its conclusion. Thus, to cite the texts themselves, Baldinucci (i.108, e.42) tells us that on the very first day of his pontificate Alexander summoned the artist and "with expressions of the utmost affection he encouraged Bernini to embark upon great things in order to carry out the lofty plans [*alte idee*] that his mind had conceived for the greater embellishment [*abbellimento*] of God's temple, the glory of the papacy, and the prestige of Rome,"[88] while Domenico (99) concludes the corresponding passage in his narrative with the clincher: "Therefore, from the very beginning of his pontificate, Alexander, seeing that he had at his disposal a man of such rare genius, shared with Bernini those grand ideas [*grandi idee*] he had been nurturing in his mind for the adornment [*abbellimento*] and glory of the temple of Saint Peter's, of Rome, and of the State."

With regard to this same episode, let us further note, that which occupies several pages in Domenico (95–99) is found in condensed form in just a few lines in Baldinucci (i.108, e.42), who omits all the anecdotes and direct quotations found in the former. Thus we must ask, echoing the query of Delbeke, Levy, and Ostrow: Did Baldinucci take Domenico's richer, more developed account and reduce it to one small portion of text, maintaining a couple of key sentences, which he both revised and transposed in the process? Or did Domenico, in the 1711 revision process, take his own originally succinct description and expand upon it, also revising and transposing some of the same language found in the Baldinucci counterpart? Or was Domenico's point of departure in 1711 not his own original account, but, instead, Baldinucci's 1682 published text? Of course, the same questions can be raised about the entirety of the two biographies in their length, structure, and specific content. Domenico's account is nearly double the size of Baldinucci's: not including

the front matter (table of contents, prefaces, etc.) and index, Domenico's text amounts to circa 46,800 words, against Baldinucci's circa 27,900 (excluding the final technical report on Saint Peter's cupola and the appended catalogue of Bernini's works). Did Baldinucci reduce Domenico's original text? Or did Domenico expand his own text, with or without borrowings from Baldinucci? Given the family's presumed haste to produce a biography before or within a short time after Bernini's death, one assumes that Domenico's original text (the "archetype") was shorter, rather than longer, than the 1713 published version, but there is nothing to exclude completely the possibility of its being quite lengthy as well, obliging Baldinucci to abridge it for his purposes.

As for formal structure and disposition of material, Domenico divides his narrative into twenty-four distinct chapters of varying length, with long descriptive titles and marginal subheadings, whereas Baldinucci's text is one large undifferentiated, unannotated mass: Was the archetype likewise as editorially "primitive"? Domenico, furthermore, intersperses throughout his chronological narrative much of the strictly nonbiographical material (special topics such as Bernini's art theory or discussion of his disciples) that Baldinucci, following the more conventional format found in Vasari, places much later in his text, at the conclusion of the strictly chronological account. If Baldinucci's texts reflects the order of the material as found in the Domenico-authored archetype, why did Domenico feel obliged to later undertake a major, time-consuming overhaul of the disposition of all of his material? The answer, one presumes, is: in order to produce what was in his mind a separate, distinct, and literarily richer work, and thus clearly to differentiate his efforts from Baldinucci's. Finally, Domenico adds much more by way of historical background (especially regarding the popes) and humble anecdote (especially of an amusing kind), whereas Baldinucci's text is spare and dry in this regard: was any of this in the archetype, only to be eliminated by Baldinucci? Or was it all new material subsequently added by Domenico to render his account more informative, more engaging, and more entertaining?[89] We cannot know the answers to such questions, but raising them at least serves to disabuse us of any notion of a simple relationship between the texts of the two biographies.

Similar Language but Different Meaning

In the case of the specific examples just cited in this discussion of intertextuality—the preamble to the letters and the conversation with the newly elected Alexander—the differences in question do not amount to a significant difference in meaning and hence the same ultimate message is communicated

in both versions. However, in other instances, despite a striking degree of linguistic similarity between the two texts, two decidedly different messages are conveyed: we shall see a noteworthy illustration of this in the discussion below of the parallel passages from Domenico and Baldinucci dedicated to the famous notion of Bernini's "marvelous (or beautiful) composite" (*maraviglioso* or *bel composto*). Elsewhere, textual overlap between the two authors, involving very similar language, occurs not only in differing contexts, but to differing purposes as well. For example, both biographers mention the fact that many eminent personages came to observe the artist at work, respecting the artist's rule of complete silence while in his studio: in Domenico (149), this detail occurs as an aside to the discussion of the great concourse of people who came to marvel at the *Louis XIV Equestrian* statue in progress, whereas Baldinucci (i.139, e.73) makes the observation in the course of a description of Bernini's total absorption in his work apart from any reference to that statue. Elsewhere, to cite another example of this textual (or intertextual) phenomenon, the same observation, in similar language but in different contexts, is made in both accounts to the effect that Bernini so desired to give life to his statues that it seemed as if his own spirit, that is, his life force, were being forced out through his eyes and into the marble.[90]

In Domenico (48), this remark comes as an explanation of the great illness that overtook the exhausted young Bernini, whereas in Baldinucci (i.139, e.73) it comes in the midst of the discussion of Bernini's total absorption in his work. Were these two details about Bernini's devotion to his art included in the putative archetype? If so, why do they appear in such differing circumstances in each biography? Or perhaps they were both absent from the archetype, and subsequently each author, having independently heard these observations made about the artist, devised a different manner in which to weave them into his text.

In any event, and in conclusion to this discussion of how the one text relates to the other, these further examples oblige us to realize not only that, contrary to what D'Onofrio assumed in his 1966 article, Baldinucci did not simply copy Domenico wholesale, but also that the Florentine did not merely rearrange intact, as it were, smaller but still rather sizable blocks of original building materials. Baldinucci, instead, at times "thinly" sliced what he found into minute pieces and then spliced them onto very different portions of his text. What Domenico subsequently did, in returning to his original text for the 1711 revisions, in the face of such slicing and splicing is beyond knowing and perhaps even beyond imagining.

Whom to Believe, Domenico or Baldinucci?

Related to this issue of intertextuality, but also representing a separate problem, is the fact of contradictory information given by the two authors. Though in the end there are not many such cases, the more pressing question thus (in the absence of independent documentary sources) becomes: Whom to believe? Who is the more reliable witness to truth? A good example is Bernini's self-deprecatory remark "This is the least bad work I have done," reported by the biographers with respect to different items in the Bernini inventory: in Domenico (83) it is said of the statue of Saint Teresa, whereas in Baldinucci (i.109, e.43) the comment is applied to the Scala Regia. In his January 30, 1667, letter to Chantelou, Bernini will instead refer to his design for the new Louvre as "the least bad thing I have ever done."[91] Probably Bernini at one point or another said the same of all three works to different interlocutors.

To cite another example, both men (Domenico, 176; Baldinucci, i.137, e.71) in parallel passages give similar accounts (similar language, similar construction) of the specific works of art that Bernini left in his last will to various ecclesiastical patrons: however, not only is some contradictory information given (what did Pope Innocent XI receive?), but there is also a small example of the same "slicing and splicing" of text described above (a significant detail is the differing placement of the same expression, "non avendo altra cosa di marmo" [not having anything else in marble]). Elsewhere in Domenico (73), a poem about Urban's tomb is attributed to Cardinal Panciroli, whereas Baldinucci (i.87, e.22) identifies its author as Cardinal Rapaccioli.

At the same time, in the case of the latter poem on Pope Urban's tomb and other poetry found in the biographies—as with some of the original letters as well—the texts supplied by our two authors are not identical, even though presumably there existed an independent source, the original manuscript in the Bernini family archives or elsewhere within ready reach. Some of the linguistic differences seen in the transcriptions of these poems and letters are reflective of regional linguistic variations (Domenico follows Roman grammar, diction, and spelling, while Baldinucci reflects Florentine usage). Others are the result of the occasional textual modernization by Baldinucci's 1948 editor, Samek Ludovici. But that still leaves other divergences unexplained. How do we account for them? Various conjectures can be devised for the individual cases, which, again, time and space do not allow us to explore. The important point here, however, is that, in view of this complicated array of textual similarities and at times intricately articulated differences, we are

obliged to exclude from the imagined possibilities any simple reconstruction of the relationship between these two Bernini biographies and of their intertwined textual histories.

7. A Closer Look at Domenico's Text: Structure, Contents, Themes, Agenda

Having examined thus far the career and ideological mind-set of Domenico-the-author, the genesis of the biography of his father, the vicissitudes of the artist's career in the last decade of his life (when Domenico most likely first conceived his narrative), and the Domenico–Baldinucci textual relationship, we can now take a closer look at some of the specific features and details of the text itself of *The Life of Gian Lorenzo Bernini*. Our goal in doing so will be twofold: first, to further uncover the historical context and "mentality" out of which the biography was produced; and, second, to identify some of the important dynamics, both psychological and editorial, that determined the selection of its contents and the mode of its delivery.[92]

The Dedication to Cardinal Pico della Mirandola

We begin with the title page. The first thing one might perhaps notice in looking at the original 1713 title page is that the most visually prominent element, in terms of sheer font size, is the baptismal name, "Lodovico," of its dedicatee, Cardinal Lodovico Pico della Mirandola. It is larger in size even than that of the book's subject, "Gio. Lorenzo Bernino." Although this might strike modern readers as somewhat strange, for the original seventeenth-century audience, ever conscious of living in a rigid social hierarchy, it was simply a matter of respecting diplomatic protocol: in that hierarchy, a cardinal outranked an artist, no matter how famous the latter or how personally undistinguished the former, especially one attempting to further win his good graces through a book dedication. Hence the physical prominence of Lodovico's name on the title page. Now, often enough, the identity of the dedicatee of an early modern book—whether or not that person actually sponsored the publication with a cash gift—can afford insight into the author himself, for example, his political or theological allegiances or his objectives in writing the work. Not so, however, in this case. First, we possess little personal, detailed information about the life, personality, and career of Cardinal Lodovico (1668–1743), for

the most part just a few bare generic facts about the ecclesiastical offices he held since initiating his Roman career around the turn of the century.[93] Second, and more important, as is clearly explained on the title page, it was not our author Domenico who chose the dedicatee but rather the printer, Rocco Bernabò: "E dallo Stampatore dedicata . . ." In confirmation of this, the flattering, if formulaic, letter of dedication that immediately follows the title page is written in the first-person singular and signed solely by Bernabò himself.

Bernabò, moreover, makes no mention of any connection between the dedicatee and the book's author or subject and suggests no parallels between their lives and activities. Nor has my own research into the biography of Cardinal Lodovico uncovered any compelling connections or parallels, beyond the mere coincidence that the epithet "la fenice degl'ingegni" (the phoenix of geniuses), applied to Bernini by Cardinal Pallavicino (Domenico, 97), was first and most famously applied to Lodovico's fifteenth-century ancestor, the celebrated philosopher Giovanni Pico della Mirandola.[94] Likewise is Domenico himself silent on the same topic (namely, the possible Bernini–Pico connections or parallels), not referring even in passing—in either his own preface or the main text itself—to the illustrious patrician cardinal whose name adorns the front cover of his work. With respect to this silence on Domenico's part, however, it behooves us to keep in mind that Bernabò had not yet chosen the book's dedicatee by the time Domenico had finished his revisions and submitted the final text to the ecclesiastical censors in 1711, that is, before Lodovico's nomination to the cardinalate at the end of September 1712.

The Author's Preface

After the printer's preface to the reader ("Lo Stampatore a Chì legge"), in which, as we saw earlier, Bernabò describes how he came to publish the work, the reader is addressed by Domenico himself ("L'Autore al Lettore"). The main purpose of this second preface seems to be that of justifying—upon the authority of Church Father Saint Gregory of Nazianzen—the fact of a biography being written by a member of the subject's own family: this, in Domenico's day, was a matter of much rarer occurrence than today and thus might have seemed to border on the indecorous. The author's preface also gives Domenico the opportunity of delighting (hopefully) his audience with the first of many clever (at least to him) literary conceits and other forms of attention-getting rhetorical devices with which, in quintessentially Baroque fashion, the author craftily adorns his text:

It will perhaps seem an unusual new phenomenon for a son to be the author of the life of his father, or that a deceased father could so entrust himself to the living pen of his son that he, the father, must acknowledge the gift of immortal life among future generations granted him by the same son, to whom he had given mortal life among the living. Nonetheless, the miracles wrought by art are not so restrained by the narrow limits of nature that they do not at times exceed them.

Domenico, however, reserves the full force of his Baroque rhetorical skills for the biography's exordium, the introductory paragraph of chapter 1, where, as was conventional for the opening volley of a seventeenth-century text of ambitious literary pretension, language and imagery both reach for the heavens. Bernini is there introduced as nothing less than the deliberate and direct manifestation of the will of "Heavenly Providence Most High," sent into the world to teach men an important lesson about talent (*virtù*) and merit (*merito*) as the only true basis for worldly glory (*gloria*).[95] At the same time, Bernini is also proclaimed as one of the greatest artists of all ages, past, present, and future. One outstanding proof of this is the recognition, applause, and, not least important, "magnificent" monetary reward accorded him by the leading potentates of Europe, all of whom busily competed among themselves to secure some tangible fruit of his artistic genius. Domenico terminates his exordium with the firm, unconditional statement, discussed above, about his commitment to historical accuracy in the recounting of his father's career. However, the bombastic tenor and cosmic claims of the preceding lines of this first paragraph will have already undoubtedly sown in the mind of the reader (at least the twenty-first-century reader) the seeds of skepticism about Domenico's ability to maintain such a promise.

Bernini and God, Genius, Glory, and Gold

True to his word in the exordium, Domenico will devote a great deal of the narrative that follows to an illustration and defense of these opening propositions about Bernini and God,[96] genius, glory, and gold. By "gold," I mean the abundance of material rewards bestowed upon Bernini by his patrons: these rewards or "gifts"—the vulgar term "payment" is never used to describe them—came in various forms, whether actual money (in outright cash or long-term pensions), jewelry, luxury household items (such as basins and trays) in silver and gold, or costly fabrics. Domenico usually specified these items in some detail, for such remuneration was considered a concrete sign

and necessary proof of not only the worth of the recipient, but the status and virtue of the donor as well. As Delbeke, Levy, and Ostrow observe, both Domenico and Baldinucci in their biographies "prove equally excellent accountants of Bernini's esteem as measured in *scudi.*"[97]

Theologians and social philosophers alike had long inculcated into the collective European psyche the Aristotelian-Thomistic concept of *magnificentia* as a necessary moral virtue of public leaders, both civic (kings, princes, dukes) and ecclesiastical (popes, cardinals, and other prelates), this virtue being manifested in very material ways, such as through the building (and inhabiting) of lavish structures and the generous distribution of alms and other gifts.[98] This well-ingrained belief explains, let us note, the particularly effective and offensive choice of calumny that Bernini's Parisian detractors shrewdly disseminated about him in 1665, namely, the rumor (reported by Domenico, 145–46) that he left Paris openly dissatisfied with the "rewards" given him by Louis XIV. The direct connection posited in that age between remuneration and princely virtue also lies behind the remark by Queen Christina upon hearing the estimation of the monetary value of the estate Bernini left behind upon his death (Domenico, 176)—"I would be ashamed if he had been in my service and had left so little"—a bit of sarcasm on the queen's part aimed against the then-reigning Pope Innocent XI, for whom she decidedly harbored no tender affections.

As for Domenico's theme of "Bernini the supreme genius of his century," it may strike our ears today as somewhat strange to see how intensely our author belabors this point throughout *The Life of Gian Lorenzo Bernini* in his attempt to convince his readers of such a claim: Why so much effort? Nowadays Bernini's primacy among Baroque Roman sculptors and architects is a matter of virtually unanimous consensus, but this was not the case in the period when Domenico both initially wrote and later revised his text. Apart from those who despised and dismissed Bernini purely out of jealousy of his talent or resentment over his domination of the Roman market, many contemporaries believed, rightly or wrongly, that there were other artists of the century whose talent rivaled that of Bernini: above all, François Duquesnoy or Alessandro Algardi in sculpture and Pietro da Cortona in architecture.[99] Furthermore, there were those of a more rigid classicizing ilk who refused to concede any sort of primacy to Bernini on purely aesthetic-philosophical grounds; this was the case especially in the last years of the artist's life, when prevailing tastes were effectively and increasingly evolving in favor of a more sober classicism, whose triumph in the eighteenth century, as already mentioned, resulted in a dramatic decline in Bernini's reputation—and of the

Baroque—lasting well into modern times. While in Paris, Bernini himself had predicted this collapse of reputation, though he never specified its reason: "He replied with great modesty that he owed all his reputation to his star which caused him to be famous in his lifetime, that when he died its ascendancy would no longer be active and his reputation would decline or fail very suddenly."[100] Once the pendulum of aesthetic taste shifted back again enthusiastically toward the Baroque—a process that began in the mid-twentieth century—not only did Bernini regain his former status, but he also, arguably, surpassed it, just like Caravaggio, who is today very much the popular superstar artist as never, indeed, in his own lifetime.

Bernini, "The Michelangelo of His Century"

Inasmuch as he was the supreme genius of the age, Bernini is also and more specifically, as Domenico presents him, the Michelangelo of his century. Domenico himself, however, does not say this outright; he instead has a figure of great authority, no less than Pope Paul V, say it for him, not once, but twice: "[The young Bernini] finished the drawing, in fact, with such mastery that the pope stood there in admiration and was moved to simply exclaim to several cardinals who happened to be present on this occasion, 'This child will be the Michelangelo of his age'" (Domenico, 9); "Imparting this command [to care for the young Bernini] upon the cardinal [Maffeo Barberini] in solicitous and honorific manner, the pope repeated what he had previously remarked, 'that Bernini would become the Michelangelo of his age'" (Domenico, 11–12).[101] As has been described in previous studies of the Bernini biographical sources, this leitmotif of "Bernini as the new Michelangelo"—and, hence, the unfolding of his life as a continuous *imitatio Buonarroti*—is one of the principal recurrent themes we find in many of these early texts. It is most likely to have its origins in Bernini's own "self-mythologizing" (to use D'Onofrio's term). Certainly, as we know from Chantelou's *Journal,* Bernini was constantly quoting or referring to Michelangelo in his conversation, evidence that he was intimately familiar with the life, legends, and utterances of his sixteenth-century predecessor. It also suggests Bernini's strong sense of self-identification with Michelangelo, despite any reservations he may have had with regard to Buonarroti's art.[102]

In addition to the reporting of explicit papal pronouncements about Bernini's destiny as the new Michelangelo, there is another, less explicit but nonetheless effective way in which *The Life of Gian Lorenzo Bernini* conveys the same message about the two artists: namely, the manner in which the

facts of Bernini's biography and the artist's utterances mirror or echo—or are made to do so—those recorded in the two well-known Buonarroti *vite* by Ascanio Condivi (1553) and Giorgio Vasari (1550; rev. ed. 1568). One wonders how conscious was this process of textual mirroring and echoing on Domenico's part (the same could be asked of Baldinucci, who does likewise). Or did Domenico simply repeat what he heard from his father and other family members and friends without realizing the frequent convergence between the accounts of the two artists' lives? If the latter is true, the question then becomes: How conscious was Bernini of his own Michelangelesque self-mythologizing? Or is it simply a historical coincidence that Bernini's life and utterances happened to mirror and echo those of Michelangelo, much as we find in these texts? Or, instead, is the relevant factor here the fundamentally predetermined, rhetorically conventional nature of all early modern artistic biography, beginning with and in emulation of Giorgio Vasari, the father of this literary genre? The answer in this case, as in most questions of human history, is most likely "all of the above," with historical coincidence, rhetorical conventions, and mythologizing (conscious or unconscious) on both Bernini's and Domenico's parts all playing a role in shaping *The Life of Gian Lorenzo Bernini*. Be that as it may, the fact is, as Delbeke, Levy, and Ostrow rightly point out, "Even if the conventional nature of artistic biography is taken into account, when Bernini's *vite* are read alongside Michelangelo's *vite* [the biographies written by Vasari and Condivi], one can discern like chains of topoi in the texts," and the three scholars go on to provide a list of salient examples, culled from a comparison between the Condivi text and that of Domenico.[103]

Independently of their efforts, in my own research into the sources of Domenico's text, I systematically compared Vasari (the revised 1568 edition of his life of Michelangelo) and Domenico and found many further points of close similarity, which for reasons of economy of space must be here summarized in a footnote.[104] This phenomenon of intertextuality most likely, of course, extends beyond just the works of Condivi and Vasari. Consider, for example, the remark made by Michelangelo reported in Donato Giannotti's *Dialogi* (ca. 1548): "[W]henever I see anyone who has talent and shows some acuity of mind, who knows how to do or say something more effectively than others, I am compelled to fall in love with him and I give myself to him as his prey, so that I am no longer my own, but completely his." A clear echo of Giannotti's Michelangelo can be heard in Domenico's description of his father's similarly compulsive attraction to artistic talent (in this case that of the young sculptor Giulio Cartari, one of Bernini's favorite studio assistants): "[Cartari] won the deep affection of the Cavaliere, whose own genius drew

him with overwhelming force [*con violenza*] to anyone in whom he recognized talent and determination."[105] Merely a coincidence, we wonder, or, instead, yet another case of the explicit grafting of Michelangelo lore onto Bernini's *persona*?

Bernini and the "Maraviglioso Composto"

A detailed exposition of all the points of contact between the biographies of Michelangelo and Bernini is beyond the purview of this Introduction, but there is one feature of both men's achievement that merits special attention: their supreme mastery of all three forms of art: painting, sculpture, and architecture. In the *Life of Michelangelo,* developing a theme announced in his exordium, Vasari tell us that the artist "as was clearly recognized, achieved in the three arts a perfect mastery that God has granted no other person, in the ancient or modern world, in all the years that the sun has been spinning round the world."[106] So too Domenico in his exordium speaks of the "marvelous composite of most exceptional talents" (maraviglioso composto di pregiatissime doti) possessed by Bernini. He returns to this notion of the *maraviglioso composto* in chapter 5 (32–33), at the conclusion of a lengthy discussion of his father's teachings on painting, sculpture, and architecture:

> That Bernini himself achieved perfection in such described faculties [sculpture, painting, and architecture], the works we are about to describe will clearly demonstrate. Let us here simply state that it is a matter of quite universal opinion, and one not easily contradicted, that Bernini was among the foremost of artists [*fra' Primi*], even including those of antiquity, in knowing how to unite together the fine arts of sculpture, painting, and architecture and, of all of these three, to create in himself a marvelous composite, while possessing all of these arts to an eminent degree. He arrived at this state of perfection by means of indefatigable study and by sometimes departing from the rules without, nonetheless, ever violating them, for his motto was "He who does not at times depart from the rule never exceeds it." This, however, is not something for just anyone to attempt.

As Domenico here describes his father's artistic talent, Bernini is, thus, both a little less than Michelangelo and something quite more than Michelangelo. Michelangelo's perfection in all three arts in Vasari's estimation was simply supreme over all other artists, whereas Domenico's claim about his father is

more modest: Bernini, in possessing all three arts *in eminenza,* was "*among* the foremost of artists," not "*the* foremost of artists." Yet Bernini achieved something above and beyond this, something beyond and above Michelangelo, namely, that interior (*in se,* "within himself") "composite" or "fusion" (*composto*) of the three arts, which resulted in a new style or form of art excelling those delineated by the traditional rules.

Unfortunately, Domenico never explains further what he means by this "composite" (or "fusion" or "blend"), and it is a matter of debate as to what exactly he intends to convey by the term.[107] Since the issue of this *maraviglioso composto* is so important to Domenico's presentation of his father's achievement in art, a brief digression on the topic is warranted, though the intent here is not to solve the puzzle of Domenico's claim; it is simply to elucidate the question. Whatever he means by *maraviglioso composto,* what Domenico does *not* mean, as a close, careful reading of the text reveals, is what recent art historians and critics have meant by this often-employed term in the vocabulary of modern Bernini studies, that is, the creation of a large, complex work of art, such as the Cornaro Chapel in Santa Maria della Vittoria, in which all three forms of art are expertly employed together, blending seamlessly with one another so as to create an aesthetically unified, integral whole. In the just-cited passage (or anywhere else), Domenico gives no specific examples from his father's oeuvre to illustrate his point. Significantly, when later discussing two Bernini works that are considered noteworthy exemplars of the *maraviglioso composto,* the same Cornaro Chapel and the Altieri Chapel (in San Francesco in Ripa), Domenico not only makes no mention of the term, but he focuses his attention merely on the individual marble statues (the *Saint Teresa in Ecstasy* and *Blessed Ludovica Albertoni*) and nothing else. Finally, despite Domenico's claim that this is a matter of "universal opinion," neither his term nor the idea itself is to be found in any other seventeenth-century primary sources, except for Baldinucci.[108]

Ambiguity reigns as well in the parallel passage in Baldinucci's biography, where he expounds briefly on this notion of what he calls Bernini's "bel composto":

> It is an opinion quite universal that Bernini was the first [*egli sia stato il primo*] to attempt to unite architecture with sculpture and painting in such a manner that together they make a beautiful whole. This he accomplished by removing certain repugnant uniformity of poses [*alcune uniformità odiose di attitudini*], sometimes breaking them up [*rompendole*], without violating good rules, although he did not bind himself to any

rule. His usual words on this subject were that those who do not some-
times go outside the rule never go beyond it. He thought, however,
that those who were not skilled in both painting and sculpture should
not put themselves to that test but should remain rooted in the good
precepts of art. (Baldinucci, i.140, e.74)

Like Domenico's, Baldinucci's understanding of the term also differs from our
conventional definition today and is likewise never illustrated by reference
to the Cornaro Chapel or any other similarly complex, mixed-media monu-
ment. However, to further complicate the matter, Baldinucci's understand-
ing also differs from Domenico's. For example, Baldinucci omits Domenico's
pointed and important qualification, *in se* (in himself), that qualification iden-
tifying the true locus of this *composto* within the mind of the artist himself and
not necessarily in the individual works of art, as Baldinucci instead seems to
say. Even more noteworthy, in contrast to Domenico's characterization of
his father's historical status in this regard ("Bernini was among the foremost
of artists, including those of antiquity," to unite the three arts), the Floren-
tine instead claims that Bernini was "the first" ever to achieve this *composto*;
this crucial, but easily missed, difference in language (that is, the addition of
an absolute superlative) changes quite substantially the nature of the entire
discourse.

Furthermore, unlike Domenico, Baldinucci adds a specific technical expla-
nation of how Bernini achieved this *composto*: the key to Bernini's creation of
his *composto* consisted in the removal of a "certain repugnant uniformity" of
what he calls, in Italian, *attitudini*. Another of those challenging, polysemous
terms in the vocabulary of early modern art history, *attitudini* (singular, *attitu-
dine*) is applicable to both people and things: it can be variously rendered as
"poses," "placement," "configuration," or, of course, also "attitudes," even
though the latter English word is used only rarely with reference to nonhu-
man entities.[109] Whatever be the proper translation, the removal of uniformity
of *attitudini* is not mentioned or even alluded to by Domenico. Finally, both
men report that Bernini believed this feat beyond the ability of the average
artist: but why, we wonder, does Baldinucci at this juncture specify as the
necessary prerequisite here a mastery of only painting and sculpture, and not
architecture, the third element of this *bel composto*?[110] It is beyond the scope
of this Introduction to decide this complex matter; here the important phe-
nomenon to observe is how, employing very similar language, both biogra-
phers convey different messages in their respective discussions of the *composto*.

Furthermore, as Maarten Delbeke rightly observes, the significant differences between Domenico's and Baldinucci's descriptions of this new achievement of Bernini's art in the end oblige us to "call into question whether the *bel composto* is a neutral, well-defined, and unequivocal art theoretical notion."[111]

To return to our Bernini–Michelangelo comparison, the achievement of this *maraviglioso composto* "within himself" is not the only way in which, according to Domenico, Bernini surpasses the great Florentine artist of the previous century. There are two other important motifs in Domenico's description of his father's talent that, for our author, represent further manifestations of an artistic genius exceeding that of Michelangelo: first, Bernini's unflagging and uncanny ability, in the execution of his many challenging commissions, to transform daunting handicaps, defects, deficiencies, and scarcity of a very material kind into inherently desirable, aesthetically pleasing, and functionally operative features of his works of art and, second, his achievement of a never-before-seen degree of *tenerezza* in his works, especially those of sculpture.

Unlike much of what we find in Bernini's biographies, and as Domenico's original readers would have certainly known, these two themes are absent from the well-publicized Michelangelo lore of the day, as they were indeed two traits absent from the execution of the great Florentine's art. (Michelangelo, to be sure, overcame great difficulties of all types in his art, but the routine turning of handicaps into aesthetic assets within a work of art is not a topos of the literature celebrating his achievements.) In underscoring these two accomplishments in Bernini, Domenico is thus presenting further proof of his father's superior talent. Illustrations of the former phenomenon—the conquest of material obstacles—abound in Domenico's account, whether in the series of fountains suffering from low water pressure (58–60), the pre-existing windows in the spaces destined for the 1634–36 commemorative inscription on the counterfacade of Santa Maria in Aracoeli (60) and for the *gloria* of the Cathedra Petri in Saint Peter's (110), the structural reinforcement cleverly hidden within the facade ornament of the Palazzo of the Propaganda Fide (61), the sacristy door enclosed by the tomb of Alexander VII (166), or the numerous defects and impediments ingeniously overcome in the construction of the magnificent Scala Regia (101). As Bernini himself remarks to one of his Parisian interlocutors in Chantelou's *Journal:* "If you want to see what a man knows, put him in a difficult position."[112] Certainly in this long list of "difficult positions" over which his genius enabled him to triumph, Bernini surpassed even the superhuman labors of Michelangelo in the Sistine Chapel, or so Domenico wished his readers to conclude.

Bernini's *Tenerezza*

The next of Bernini's artistic achievements, that of *tenerezza,* also represents the overcoming of impediments to the creation of art posed by material circumstances, in this case the materials used to create that art: hard, cold marble and bronze. Literally translating as "tenderness," the term *tenerezza* in the artistic parlance of the Italian Baroque can refer to either of two realities, separately or at the same time. On the one hand, it describes the tangibly physical, visual, technical quality of a work of art, especially sculpture—namely, smooth, soft, "warm" surfaces that more faithfully reflect the appearance of things in nature (above all, the surfaces and contours, the "feel," of human flesh). Alternatively, on the other hand, it identifies the deeply stirring emotional effect that a thus-executed work of art has upon its viewers, that is to say, its *poignancy* or *pathos.* (In modern Italian, one still says *mi fa tenerezza* to mean that he, she, or it "moves or warms my heart," or "inspires compassion, sympathetic pity, or affection in me.") Since the term *tenerezza* can convey simultaneously both of these meanings (physical and emotional), and there is no one adequate word in English that does so as well, by default we are stuck with the literal translation, "tenderness," even though it may at times sound strange to our modern ears, especially when applied to the mechanics of artistic technique.

"Tenderness," in any case, is a characteristic trait of Bernini's style, indeed one of the great achievements of that style. It is, furthermore, one of the necessary qualities of art, as we learn from Domenico's text, in both his descriptions of his father's statues (the *Apollo and Daphne,* the *Santa Bibiana,* and the *Saint Teresa in Ecstasy* [Domenico, 18, 42, and 83, respectively]) and in the various reports of his father's teachings on art.[113] For example, Domenico repeats this piece of advice given by his father about old age and the artist: "An artist who excels in design did not have to fear, with the approach of old age, any deficiency in vivacity *and tenderness* in his art because the practice of design is of such efficacy that it alone suffices to compensate for any deficiency in one's forces that languish in one's advanced years" (Domenico, 167, emphasis added).

Somewhat surprisingly, we find that Bernini applies the term *tenerezza* even to works of architecture: "On the subject of architecture, the Cavaliere advised this by way of general instruction to his disciples: that it was necessary to give one's attention, first, to the material to be used; then to the design; then to the ordering of the various parts; and then, finally, to the conferral of grace *and tenderness* upon them" (Domenico, 39, emphasis added).

Unfortunately, Domenico fails to explain what his father specifically meant by this: What finishing elements confer upon a work of architecture the quality of "tenderness"? (In any case, the roots of Bernini's dictum about architectural *tenerezza* can be found in earlier theorists, Serlio and Scamozzi: see my commentary to Domenico, 39, below.) In the corresponding passages in his biography (including that regarding architecture), Baldinucci closely mirrors Domenico in his emphasis of Bernini's achievement of *tenerezza,* but he adds a further, more general, and more explicit pronouncement to the effect that "[b]efore Bernini's and our own day there was perhaps never anyone who manipulated marble with more facility and boldness. He gave his works *a marvelous tenderness* from which many great men who worked in Rome during his time learned."[114] As for Michelangelo, neither Domenico nor Baldinucci ever explicitly says that this quality was absent from his art, but the lack of precisely this "tender" or "soft" quality in the great Florentine's very muscular figures (painted and sculpted) was well known and generally criticized. Bernini himself notes disapprovingly this defect on the part of Michelangelo (albeit without using the specific term *tenerezza*) in Chantelou's *Journal* ("in sculpture and painting he had not the gift of making creatures of flesh and blood") and in so doing was simply echoing a common sentiment of the time.[115]

Bernini and Annibale Carracci

A brief word is here in order about another artist who, having loomed large in the early seventeenth-century Roman art scene, especially during the first phase of Bernini's professional formation there, also plays an important role in Domenico's text as vehicle for the confirmation and magnification of Bernini's glory: Annibale Carracci (1560–1609), one of the creators of the new, revitalized style of painting that we call the Baroque, whose fresco cycle in the Galleria of the Palazzo Farnese had firmly secured his status as one of the supreme painters of his age. Though not to the same extent as with Michelangelo, Domenico also makes a point of associating his father's name with that of Annibale so as to enable Bernini to bask in the reflected light of the universally lauded Bolognese master. Here again, Domenico, no doubt, is simply following in the footsteps of Bernini's own example, as can be deduced from Chantelou's *Journal,* that valuable third-party record of Bernini's utterances, in which we find Bernini making many a reference to Carracci, praising him "in extreme terms" among painters, and, in general, manifesting a similar degree of familiarity with the Bolognese artist's life and dicta as with those of Michelangelo.[116]

Carracci makes only two but extremely significant appearances in *The Life of Gian Lorenzo Bernini:* once to make a solemn pronouncement about the boy prodigy's achievements in art at the mere age of ten, and then again to deliver a likewise solemn prediction (in the boy's presence) about the completion of the decoration of Saint Peter's that was to be fulfilled by Bernini himself (Domenico, 9–10 and 37–38; on 29 he is briefly cited as among Bernini's most esteemed modern painters). However, it is with some skepticism that one must treat these reports—and the one from Bernini himself in Chantelou's *Journal* (June 16) claiming another encounter between Annibale and the young Gian Lorenzo: the Bernini family did not arrive in Rome until the end of 1606, by which time Annibale had already withdrawn from active, public life, pursuant to the attack of apoplexy in early 1605 that left him much debilitated and helped cause the severe depression that afflicted his final years, lasting until his death in July 1609.

Nonetheless, giving some possibility of credence to Bernini's claims is the fact that for some stretch of time both the Bernini family and Annibale Carracci were living in close proximity in the same Roman parish of San Lorenzo in Lucina. Hence, some interaction could have indeed taken place between the old master and the young prodigy, though we must not assume, as Domenico (and Bernini himself) would like us to, that their interaction was necessarily frequent, intimate, or in any way substantial.[117] Again, whether true or false, Domenico's anecdotes involving Annibale serve well the purposes of aggrandizement of his subject (and self-aggrandizement, of course, on the part of Bernini, who told the same or similar tales). Let us note, finally, that although Bernini, according to Chantelou, had accorded such "extreme" praise to Annibale, instead, in Domenico's account (29), the same Annibale is ranked only fourth on his father's list of the most eminent painters ("i primi Pittori"), after Raphael, Correggio, and Titian.[118]

"The Titian of Our Times, Cavalier Bernini"

As far as the latter painter, Titian, and Bernini are concerned, much has been made of an anonymous Roman *avviso* in the Barberini archives, dated November 30, 1680, that is, two days after the death of Bernini, announcing that "the Titian of our times, Cavalier Bernini, expired last Saturday evening." For example, according to Francesco Petrucci, in his recent exhaustive, if debated, catalogue of Bernini's paintings, this *avviso* would be proof of "the high esteem with which Bernini's work as painter, even though pursued as a mere sideline activity, was held by his contemporaries."[119] The author of the

1680 *avviso* never explains the label he bestows upon Bernini—would it have been self-explanatory to his readers?—but Petrucci's interpretation of it seems less than convincing. Despite the exalted estimations of the quality and reputation of Bernini's paintings found in Domenico and Baldinucci, in reality we know that the artist's work on canvas received little and fleeting notice in the documentation of his times, just as not one of his numerous paintings (most of them unfinished, rapid sketches) achieved any sort of public recognition as a true "masterpiece," or anything even approaching that rank, during his lifetime. In fact, however much we might value even the least of his canvases today and despite the artist's own obvious facility for painting, Bernini pursued painting as hardly more than a private pastime or as an ancillary exercise to the development of his skill in other media, rather than as an end in itself.[120] Many of his paintings were, furthermore, simple, stark portraits and never the more challenging, complex historical scenes by which truly ambitious painters proved their artistic *virtù*. Certainly, of the very few devotional scenes within his painted oeuvre, none was of sufficient quality or physical size to be fit for display in any of the churches or other public spaces of Rome. (*The Martyrdom of Saint Maurice* altarpiece in the Vatican, despite pointed claims to the contrary by Domenico and Baldinucci, was in fact commissioned from and executed by disciple Carlo Pellegrini, though with some oversight and intervention by his master.)[121]

Instead, the meaning of the curious and unexplained *avviso* reference to Bernini as "the Titian of our times" is to be found, I believe, in another Roman *avviso* of December 9, 1673, already cited for the news it conveys about the biography being written by Bernini's French *abate* friend, Pierre Cureau de La Chambre. After giving news of the projected biography, that same *avviso* goes on to mock Bernini for his pretensions to grandeur in expecting a direct, personal response to his letter from one of the most powerful crowned heads of Europe, King Louis XIV. In doing so, Bernini, says our anonymous *avviso* author, was attempting to imitate Titian, whose exalted status as artist earned him such a response from no less than Emperor Charles V.[122] In fact, we know that Bernini had indeed had the honor of receiving letters directly from not only Louis XIV, but also Charles I of England and his wife, Queen Henrietta Maria, as well as personally handwritten notes from the pope (Domenico, 121, 65–66, 98, who reproduces some of this correspondence). Precisely because of such deferential treatment by royalty, Antoine Coypel was later to place Bernini in the same august group of artists as Titian and Leonardo in his *Discours sur la peinture* pronounced before the Royal Academy of Painting and Sculpture in the early eighteenth century.[123] In short, in calling Bernini the

"Titian of our times," the writer of the 1680 *avviso* was most likely referring not to Bernini's accomplishments as painter, but rather to his public status as celebrity artist who enjoyed the privileged patronage of, and intimate relationships with, the supreme political powers of the age.

As far as the many master artists alive and active in Rome during his own lifetime are concerned, there was not one, according to Domenico's account, with whom Bernini had any kind of ongoing, mutually respectful and reciprocally inspiring, peer-to-peer relationship. Indeed, with the exception of Annibale Carracci and the members of the large Bernini workshop, who decidedly worked as his subordinates, no matter how talented they might be, no other living artist plays an effective role in Domenico's account of his father's personal life and artistic development. Yes, to be sure, Domenico (14) acknowledges the influence of earlier Italian masters—meaning *dead* masters—with the one exception of Guido Reni, whose works, together with the sculpture of antiquity, the boy Gian Lorenzo studiously examined and copied at the Vatican. However, once this period of youthful training was over—and this, we are to believe, happened prodigiously early in life—Gian Lorenzo was his own man and shared the stage with no one else. In reality, we know that even the mature Bernini, as was inevitable, learned and copied from the work of his contemporaries (in architecture, most notably Francesco Borromini and Pietro da Cortona), as did they from his, but Domenico is silent on this, for acknowledgment of such borrowing from other *professori d'arte* would detract from Bernini's status as supreme genius sufficient unto himself.

Domenico's Silence: Bernini Beyond Time and Change

The nature of Bernini's peer relationships is only one of the many silences in Domenico's version of his father's life story (and likewise that of Baldinucci). As John Lyons has observed: "There is, in general, little attention given to Bernini's relationship to his family; almost no account of Bernini's relation to other artists; no evocation of a particular evolution or trajectory in Bernini's mastery of his primary disciplines of sculpture and architecture, or of the changes in his emotional state or character after his childhood." Indeed, the biggest "silence" in the Bernini biographies, as Lyons further observes, is that regarding time itself and its effect on Bernini. That is to say, once reaching its seeming full maturity in his young adulthood, Bernini's artistic talent, as described by Domenico and Baldinucci, simply knew no further growth, no further change, no evolution over the years, for none, our authors imply, was needed: "To measure time, as to measure achievement, we need points of reference,

and Bernini is shown here to have none outside of himself. . . . Bernini moves without changing."[124] Once he completed his training in his youth, Bernini had no need of further education and experienced no further growth because, we are to understand from Domenico, such is the nature of true genius: once identified and released from within, given some basic discipline and external academic practice, it soon springs forth all but fully formed and remains ever true to itself thereafter. Other mere mortals attempting to be teachers to such genius, as Pietro, his father, discovered (Domenico, 5), will understand the futility of their efforts; they simply step aside and let nature take its course.

The only change wrought by time recorded by Domenico and Baldinucci is the progressively greater public recognition of Bernini's talent by successive popes and other eminent patrons, culminating in the summons to Paris by Louis XIV. The meeting of Bernini and Louis XIV is portrayed as, furthermore and in effect, an encounter between two peers: "In the case of Louis XIV—as recounted in the *vite*—Bernini seems to have found the perfect 'mirror.'" Between supreme artist and supreme sovereign, it was a case of "a double admiration, a dual narcissism."[125] Yet, as we know from Chantelou's *Journal,* this "mutual admiration society" had its tensions: however well matched they were, "dual narcissism" does not at all necessarily preclude the simultaneous presence of mutual disdain, as Jeanne Morgan Zarucchi has argued.[126] Whether in reality the king felt disdain or adoration, as far as Domenico's version of the story is concerned, with Louis's publicly professed approbation and rewarding of Bernini, *The Life of Gian Lorenzo Bernini* reaches its zenith. If one had to identify more specifically the precise moment of that zenith, it would arguably be Bernini's last, emotion-laden audience with the king, during which Louis confesses, "This great man loves me, but I am even more in love with him than I show" (Domenico, 140). After the detailed description of Bernini's *séjour* at the French court and the description of the subsequent execution of the *Louis XIV Equestrian* statue—together representing by far the longest "episode" in Domenico's narrative—the biography moves rather quickly to its close.

Bernini and the Theater

As Domenico also relates, Bernini's genius was not confined to the realm of the visual arts alone, but manifested itself in "marvelous" fashion in other domains as well. Principal among these is that of the theater, in which our artist excelled as playwright, director, scenographer, stage machinery ("special effects") designer, and actor.[127] There is a great deal that we still do not

know about Bernini's multifaceted theatrical activity—for example, the script of only one, incomplete play has, to date, surfaced. But what we do know from various contemporary reports is that it by no means represented merely an occasional, purely recreational enterprise, pursued as an amusing pastime. Instead, Bernini's theatrical work involved a major, serious, utterly professional commitment on his part throughout a large portion of his adulthood. The artist was so invested in this dimension of his creative self, because it served as a valuable and valued, indeed necessary vehicle of self-expression on all manner of subjects, including art and politics; according to a recent hypothesis, it may have even been pursued as a vehicle of further training in the expression of the *affetti*—the array of emotional states—the convincing, genuine, and stirring depiction of which was, in turn, one of the goals of his sculpture and painting.[128] Most of Bernini's theatrical works were produced annually for the brief, pre-Lenten period of Carnival (hence, usually in February); often staged in the artist's own home, they were, in keeping with the spirit of the season, noteworthy, if not notorious, for their daringly blunt social satire and risqué humor. The performance season may have been short, but its preparation, as biographer Passeri tartly remarks, held Bernini's production and acting crew (mostly members of his workshop) in virtual slavery for a whole year's time, further indication of how much importance Bernini invested in this dimension of his life.[129]

As far as Domenico's contribution to this subject is concerned, although supplying important details not found in other sources or confirming what is elsewhere conveyed, his account of the origins, nature, and extent of his father's work in the theater unfortunately is incomplete, vague in significant details, and at times inaccurate. Domenico, for example, would have us believe that his father first took to writing plays while recovering from a protracted, life-threatening illness that struck him at the age of "nearly thirty-seven," that is, ca. 1635 (Domenico, 47, 53). In fact, his theatrical debut occurred earlier: as we know from a February 5, 1633, report from the Roman agent of the Duke of Modena, Bernini produced a Carnival play already in that year, a stinging satire aimed at some members of the papal court and "the corrupt mores of our century." Likewise, a later letter from Rome, dated February 25, 1634, by Bernini's literary friend Fulvio Testi (then in the service of the same Duke of Modena), mentions that the artist's Carnival play of that year was another mordant comic satire, "just as he has done in previous years": the latter plural ("years") would indicate that Bernini had also produced plays in at least the previous two years, that is, beginning in 1632.[130] Domenico also neglects to tell us that his father's theatrical activity was not confined to the

Barberini papacy years (as one might conclude from his few pages on the topic), but rather extended—in intense, regular, if not annual, fashion—for several decades across his life, apparently well into the 1670s.[131] However, from what we know about Bernini's theater from other contemporary reports, Domenico (54) is correct in remarking that the "truly appealing and marvelous aspect of these plays consisted, for the most and best part, in their satirical and facetious remarks and in the inventiveness of their stage sets."

Bernini the Courtier

Entertaining and instructive displays of ingenious verbal wit on Bernini's part, be they satirical, facetious, or otherwise, were not confined to the theater; rather, they were a conspicuous feature of his everyday social interaction, particularly when in the appreciative company of other *virtuosi,* men of creative intellectual-artistic talent like himself, or patrons. The latter, in Bernini's case, were all individuals of highly exalted social and political status and thus equally appreciative of the gift of fine speech, especially during those socially privileged moments of postprandial *conversazione civile* (see, e.g., Domenico, 95–99). As promulgated by the handbooks of courtly behavior, beginning with Baldassarre Castiglione's *Book of the Courtier* (1528), the ability to entertain, instruct, and delight one's patron and his entourage through "witty," clever, spontaneous discourse was one of the most appreciated of the courtier's talents.

In addition to the many other roles he played, the loquacious Bernini was also the courtier par excellence: hence in remarking, as reported by Domenico (87), that "the Cavalier Bernini was indeed a man born to be in the company of great princes," Pope Innocent—after having been successfully wooed by a clever "courtly" stratagem on Prince Niccolò Ludovisi and Bernini's part—was in effect saying that he was a true courtier, in addition to being a great man himself.[132] As Chantelou confirms in his *Journal,* Bernini was a "good talker," and when he talked he poured on both the charm and wit in order to impress and captivate his audience.[133] Domenico's biography contains an ample catalogue of his father's clever remarks, dispersed throughout the narrative, examples of which date back to his very boyhood (Domenico, 5).

The recording of such memorable statements, let us note, was not only a feature of conventional biography, inasmuch as it served to further reveal the personality of the subject while entertaining the reader; it was also, in Domenico's case, part of a larger effort on the author's part to convince his readers that Bernini, in addition to being a great artist, was as well a sublime

intellect. In Baroque culture, as publicized especially by Emanuele Tesauro's *Cannocchiale aristotelico* (Aristotelian telescope) and similar theoretical literature, wit—*arguzia* or *acutezza*—was considered simply one of the most direct and indisputable manifestations of genius.[134] "Not only was every action of Bernini's worthy of being recorded for posterity, but his every word as well," we hear Cardinal Azzolino declare in chapter 13 (Domenico, 99). Furthermore, Bernini's powerful genius, as described by Domenico, was such that it amazed his contemporaries to see (as Pope Alexander was wont to declare) "how, by sheer force of his intellect alone, Bernini could arrive at the same depth of understanding in any discussion on any subject, where others had barely arrived after many years of study" (Domenico, 95). This assessment of Bernini's intellect receives perhaps its most authoritative confirmation from someone then deemed one of the supreme intellects of Rome, Sforza Pallavicino—it takes one to know one—who confesses that even he himself learned from, and was intellectually inspired by, his conversation with Bernini (Domenico, 97).

Bernini, "Man Without Letters"?

Yet in all of this insistence upon his father's intellectual genius, one wonders whether perhaps Domenico "doth protest too much," that perhaps our author emphasizes this topic so much because in real life Bernini was, instead, somewhat lacking on this front. He might have even been considered by some of his contemporaries to be *uomo senza lettere* (to use Franco Borsi's term), that is, a person without substantial formal academic training or genuine interest in the world of books or in the abstract realm of ideas and formal theory.[135] Borsi clearly subscribes to the latter, somewhat dismissive evaluation of Bernini, but the artist does not merit such an extreme characterization. Certainly, as his abundant theatrical production and the famously witty, erudite nature of his social conversation bear witness, Bernini was a man of above-ordinary intelligence with a great appreciation for language, literature, and the world of ideas, even if he was by no means a professional intellectual like, for example, his friend Sforza Pallavicino. What is further worthy of note is that Bernini arrived at this level of literary-intellectual refinement and achievement despite the fact that in his boyhood or after he seems to have had no amount of nonartistic study beyond that required for basic literacy. We know, for example, that as an adult Bernini even received some tutoring in basic Latin and Italian grammar from Alexander VII.[136] In this regard, he stands in great contrast to his well-schooled contemporary and northern counterpart, Peter Paul Rubens.

A further, possibly relevant fact to our discussion of Bernini's intellectual life is that in the detailed inventory of the Bernini household possessions left at his death we find no mention whatsoever of a personal library or of any individual books (whereas even small mundane household objects like wine casks are carefully registered). One conclusion might be that his heirs, in drawing up the inventory, simply did not attach much value or pay much attention to books because their father had not while he was alive. Certainly our artist owned books, such as those reference works like Vitruvius or Serlio needed for the exercise of his profession, those received as gifts (especially by authors for whom he had supplied frontispieces), or those used in his later active devotional life, in particular those cited by name in Chantelou's *Journal*. And certainly the family owned and used books: three of Bernini's sons were pursuing ecclesiastical careers that required advanced, continuing education, and hence a personal reference library.[137] But, as for Bernini himself, it is also appropriate to ask, in the midst of his frenzied schedule as head of an enormous, busy workshop and in a large, noisy household with nine children and numerous servants and dependents, how often would he ever have had the time simply to sit down and carefully read a book, cover to cover? Let us recall Bernini's own declaration (a lament or a boast?), recorded by Domenico (178), that the amount of leisure he had had in his entire lifetime would barely equal a month's worth of time. This is not to say that Bernini was some sort of intellectual fraud who simply managed to impress his contemporaries with flashy witticisms or smatterings of information and insight culled from the conversation of others, such as Sforza Pallavicino. Bernini was extremely intelligent, to be sure, but that intelligence may not have always been communicated in necessarily refined literary or scientific fashion.

The force of Bernini's intellect, Domenico further claims, was especially operative in the realm of theology. Again thanks to his native, universal genius and his habitual frequenting of clerics, Bernini, "who had not dedicated his life to letters," nonetheless "could so often not only succeed in intimately penetrating these most sublime mysteries [of theology], but also raise probing questions about and offer logical accounts of the same" (Domenico, 171). And again, confirmation of this fact comes from no less than one of the leading theological authorities of late Baroque Rome, Gian Paolo Oliva, Superior General of the Society of Jesus, preacher to the papal court and author of learned commentaries on the Bible. Father Oliva himself confesses that "in discussing spiritual matters with the Cavaliere, he (Oliva) felt obliged to prepare himself carefully, just as if he were going to a doctoral thesis defense" (Domenico, 171). To be sure, both out of sincere spiritual curiosity and

professional-social necessity, Bernini was probably reasonably well versed in and engaged by matters of religion, but we must not be tempted to read into Domenico's hyperbolic words more than what their author intended, that is, we must not conclude that Bernini's theological speculation was in any way original, innovative, and pioneering in nature. Let us recall that Bernini moved, lived, and operated in the innermost circles of papal Rome, in which the spirit and discipline of the Counter-Reformation continued to reign supreme and theological "novelties" were all suspect, especially on the part of laypeople. All publications were still subject to censorship and required the official "Imprimatur" from the Church, including Domenico's biography of his father. Furthermore, although there were during Bernini's lifetime very few clamorous trials for heresy like that of Galileo, a sufficient number of persons were, nonetheless, routinely brought to the attention and disciplining of the Inquisition, for there to prevail a decided, pervasive atmosphere of caution and anxiety regarding religious orthodoxy.[138]

Hence, one can be quite sure that any "probing questions" that Bernini might raise about religious matters were completely innocuous, falling safely within the realm of orthodoxy, that is to say, his questions would never have suggested any shadow of doubt or disagreement on his part about Church doctrine and would have restricted themselves to issues that the Church itself considered areas of legitimate discussion. In this regard, two passages in Chantelou's *Journal* (September 15 and October 11)—Bernini's unquestioning, naive acceptance of the "true relic" of Jesus' blood at Saint-Denis and his losing argument with Charles Le Brun over the "Three Wise Men" of the Nativity story (Bernini, unlike Le Brun, is unaware that Scripture identifies them not as kings, but as astrologers)—are revealing of our artist's less-than-critical and less-than-informed approach to matters of religion. Again, one must not formulate too exalted an image of Bernini's theological or scriptural acumen on the basis of Domenico's description. At the same time, let us keep in mind, whatever the artist knew or did not know about the Christian religion, we can be sure that in this realm Bernini comported himself like a good, safe, "company man," at least in public, whether it be out of sincere intellectual conformity to the established order or out of pure self-protective dissimulation, living as he did in a vigilantly totalitarian theocracy.

8. Bernini's Religion: Myth and Reality

Any discussion of Bernini's religion, that is, his personal faith and the practice of devotional life, must open with a word of caution: we have absolutely no

reliable, nonpartisan (that is, not coming from Bernini, his family, or apologetic biographers) documentation on the topic until 1665, when Chantelou began writing his diary, which contains many references to Bernini's piety. In 1665, Bernini was all of sixty-seven years old and clearly a man of devout, traditional Roman Catholic faith. About this there is no dispute. As for the younger Bernini and the nature and quality of his religious beliefs, there is much ground for dispute because all that we now know on the issue is what we find in Domenico and Baldinucci. There are simply no other sources testifying to the nature and extent of his religious beliefs and practices. His works of art themselves are not reliable sources; even the most nonbelieving of artists can create stirringly devout works of religious art. With respect to Domenico and Baldinucci, the same universally recognized mythologizing forces at work in describing every other aspect of Bernini's life—it is safe to say—color as well their descriptions of the artist's faith life. Their claims about Bernini and religion must be subject to the same cautious, reasonable "hermeneutic of suspicion" that we use on every other front. On the sheer level of documentation, these are the straightforward, sobering facts about the constraints we face in undertaking any discussion of Bernini's faith and the relationship between that faith and his art, particularly of his earlier life. A further constraint of a different type is the highly subjective nature of "sincere" religious faith: How does one measure what is inside a human being from what we observe on the outside? Complicating matters, it behooves us to note, is the highly polemical nature of any discussion of religion. This is especially true in the case of an artist who, for many devout believers, was and is a revered trophy of their institutional faith. The devout, of all creeds, do not like having their "trophies" held under a clinically skeptical and potentially desacralizing light.

As for our Domenico, the subject of religion is so important a theme in his narrative, as it effectively was in Bernini's life and art and is in modern scholarship on Bernini, that it merits a separate discussion of its own. In view of all that has already been said above about Domenico's hagiographic "mentality" and ultraconservative Catholic piety, it comes as no surprise to find that in his account of his father's life and art, religion is present as an abiding, relevant, all-pervasive factor. More specifically, according to what Domenico says or intimates, Bernini's art was a direct manifestation of his own personal faith, his deeply poignant works of religious art coming as a result of that faith. This is true from the time of his first major independent sculpture as a young adult, the *Martyrdom of Saint Lawrence,* "the first fruit of his devotion," executed, Domenico claims, "out of devotion toward the saint whose name he bore" (Domenico, 15), and remains true all the way through to Bernini's final work,

the marble bust of the *Savior* (Domenico, 167).[139] In the intervening years, just to cite one further example of the intimate connection Domenico makes between art and personal piety, there is Bernini's statue of *Santa Bibiana,* created during the pontificate of Urban VIII, which "is for both its tenderness and devotion indeed a miracle of art," and about which the artist "used to claim that 'it was not he who had created the statue, but the saint herself who had sculpted and impressed her features in the marble'" (Domenico, 42–43).

As in his description of Bernini's artistic genius, technique, and style, Domenico likewise nowhere mentions or alludes to any sort of evolution or growth or change on the part of his father's faith. He instead leaves readers with the impression that the unfolding of Bernini's faith life was a matter of a simple, unchanging continuum, one undifferentiated powerful current of piety, beginning, presumably, from childhood and enduring until the final moments of his earthly existence. Unlike Baldinucci (as we shall see), Domenico makes no mention of a spiritual conversion or moral turning point at any stage of his father's life, much less the need for one. True, he does acknowledge the fact of his father's misbehavior in the Costanza affair, but does so in patently dismissive or otherwise minimizing terms, as if considering it an isolated act of youthful foolishness: "Boys will be boys," his attitude seems to be, even though at that point Bernini, then forty years old, was decidedly no longer a boy.[140] Why does Domenico mention the scandal at all? Because, our author says, this episode was in the end the occasion for a glorious, public, formal expression of unconditional support and fulsome praise for Bernini on the part of the pope himself. As Evonne Levy points out, even though Domenico does not say this explicitly, we here have an example in Bernini's personal life of what he so often accomplished in his professional life: the transformation of a defect or a handicap into an artistic advantage or triumph.[141] A further reason compelling Domenico to mention the affair might simply have been its continued notoriety in the memory and lively oral tradition of contemporary Rome. It was too egregious a stain on Bernini's record and too delectable a piece of gossip for Romans to forget; hence Domenico was obliged to address the issue, with the hope of nullifying some, if not all, of the opprobrium attached to it.

Baldinucci on Bernini's Religion

The situation is different when we turn to Baldinucci's biography. Baldinucci contributes little or nothing to the melding of art and religion that we find in Domenico; the phenomenon is by and large absent in the Florentine's version

of Bernini's life. Not only does Baldinucci never describe a work of art as a reflection of Bernini's own piety (with just one brief, understated exception), but he also never describes any work by Bernini in religious or theological terms.[142] Furthermore, even though, as we know, for example, from his *Spiritual Diary,* Baldinucci was himself a man of profound (if not somewhat neurotic) piety, he restricts his discussion of Bernini's devotional life to what amounts to no more than one page of text, placed at the very end of his narrative, just before the account of the artist's final sickness and death.[143] One need only compare, for instance, what Baldinucci says about the statues of the two saints, *Lawrence* (i.77−78, e.12) and *Bibiana* (i.85, e.19), with Domenico's accounts to realize the significant difference between the two biographers in this regard. Unlike Domenico, Baldinucci does explicitly acknowledge the fact of a moral turning point in Bernini's life, thus confronting head-on what, again I would submit, was probably still a matter of active anti-Bernini gossip, the lingering, shameful memory of the indiscretions of his prematrimonial years that had to be somehow neutralized for posterity:

> But before speaking of his last illness and death, which to our eyes truly seemed like his life, we should here mention that, although it may be that up until his fortieth year, the age at which he married, Cavalier Bernini had some youthful romantic attachments without, however, creating any impediment to his studies of the arts or prejudicing in any way that which the world calls prudence, we may truthfully say that his marriage not only put an end to this way of living, but that from that hour he began to behave more like a cleric than a layman. So spiritual was his way of life that, according to what was reported to me by those who know, he might often have been worthy of the admiration of the most perfect monastics. (Baldinucci, i.134, e.68)

Though slightly more honest on this issue than Domenico, Baldinucci is, nonetheless, equally disingenuous in minimizing the extent of that supposedly "youthful" misbehavior (and, in Chantelou's *Journal,* we catch Bernini in the same disingenuous whitewashing of the behavior of his earlier life, when exhorting Colbert's young brother-in-law on the virtue of temperance).[144] We know, for example, from independent documentation how shockingly violent and felonious the Costanza affair proved to be in the end. And the affair was not the sole experience of fornication, adulterous or otherwise, of Bernini's life, prior to his marriage in 1639, as we can easily assume and as is implied in Baldinucci's use of the plural "attachments" in his just-cited reference to

Bernini's premarital misconduct. True, there is a difference between religious belief and moral conduct—one can occasionally slip into bad behavior and still be considered a sincere believer. However, the Costanza affair, in its duration and enormity (she was married to Bernini's collaborator), does not strike me as having simply been one unpremeditated, brief, and isolated moral lapsus in the artist's earlier life. Rather, there is good reason to suspect that it exemplifies the behavior of a religiously lukewarm, if not indifferent, adult whose sexual-affective life in general was hardly dictated or moderated by the counsels of contemporary religion.

Confirming this impression is the description of the shockingly narcissistic Bernini, ca. 1638, in his wild bachelor days, contained in his mother's famous letter to Francesco Barberini, first published by Pio Pecchiai in 1949:

> The Cavaliere, her son, having no respect for the law or Your Eminence's authority, yesterday arrived here fully armed, in the company of other men, in order to kill his brother, Luigi. . . . He searched the rectory [of Santa Maria Maggiore] in every corner, with disdain for God and the proprietors of that house, as if he were the master of the world. . . . His sense of power, it seems, has today reached a degree whereby he has no fear whatsoever of the law. Indeed, he goes about his affairs with an air of complete impunity. . . . [His mother] throws herself at your feet, full of tears, in order to beg you to move to act on behalf of so distraught a mother as she, and restrain the fury of this son of hers who, by now, considers anything he chooses to do perfectly licit, as if over him there were neither masters nor law.

As for the supposedly near-monklike piety of the older Bernini, both Domenico and Baldinucci are equally guilty of exaggeration in this regard. All of Bernini's unbridled sexual aggression, given free reign for decades, simply did not disappear overnight into thin air. This flies in the face of all that we know about the human psyche, except perhaps in the case of a very few exceptional saintly souls in whose number Bernini is decidedly not to be counted, given what we know of his life. There may perhaps have been, post-1639 (the year in which he wed), no repetition of violent adulterous affairs such as the one with Costanza, as far as we know; nonetheless, what is known, for example, of the content of Bernini's many theatrical productions is sufficient indication that the picture of the utterly devout older Bernini painted by the official biographies is quite overstated. Persons of monklike religiosity do not write and produce plays that contain scandalously "gross" content

or that otherwise feature unedifying moral behavior, comic though it might be, as Bernini often did in his theater, in keeping with the Dionysian spirit of the Carnival season for which he wrote and produced his plays. About the at-times questionable content and tone of the latter, we are sufficiently informed by both the extant *avvisi* disseminated from Rome and the artist's own, sole-surviving script, *The Impresario*.[145] The latter, lo and behold, features a playwright-scenographer and married man who lusts after a younger maidservant and one of whose previous plays (as another servant remarks) was deemed licentious by his audience: some autobiographical self-revelation here on Bernini's part? It also contains vulgar sexual double entendres.

Again, deeply pious persons of the ilk presented by Domenico and Baldinucci do not write and produce such plays; they write and produce plays on explicitly religious themes with explicitly moral goals of the genre that came from the pens of the truly pious Giulio Rospigliosi (the future Pope Clement IX) or the many Jesuit playwrights supplying their colleges with spiritually edifying musical dramas of irreproachable taste and stainless morals. Furthermore, even in Baroque Rome, deeply pious, ascetic men of the monastic type, as depicted by Domenico and Baldinucci, who have supposedly transcended the flesh by dint of prayer and self-abnegation, do not produce art, especially for churches and other religious settings, featuring bare-breasted women flaunting their voluptuous, protuberant breasts in the very faces of the spectators, such as we see, for instance, in the female allegorical figures adorning Bernini's tomb for Alexander VII and his memorial for the De Sylva Chapel, which were later subjected to prudent "cover-up" operations to avoid further scandal and the near occasion to sin.[146] The anonymous author of the vitriolic anti-Bernini pamphlet *Il Costantino messo alla berlina* must not have been alone in his criticism that with his *Saint Teresa in Ecstasy* statue Bernini had "dragged that most pure Virgin down to the ground" while "transforming her into a Venus who was not only prostrate, but prostituted as well."[147] In the view of such a reaction and the suspicious speculation about the artist's own psyche and religiosity that both that statue and his Carnival plays must have inevitably provoked, it is no wonder that both Domenico and Baldinucci, in their counteroffensive, had to insist on the "monklike" piety of the older Bernini.

Bernini's Art as an Expression of His Piety?

Unfortunately, modern scholars, even those coming from strictly secular environments, have not responded to this official, "authorized" picture of Bernini's

religion with the necessary skepticism and critical analysis. In general, Domenico's version of his father's faith and the determinant role it played in his art has been accepted without much question. For instance, in a recent biography of Bernini, published in both German and Italian, we read, "Bernini apparently sculpted this statue [the *Saint Lawrence*] for his own personal devotion and veneration toward the Early Christian martyr. And this is probably the case since it is documented that Bernini was a fervent Catholic."[148] The author of this biography does not identify the documentation in question but clearly has Domenico's text in mind (since Domenico alone gives this report of the origins of that statue). Yet it behooves us to point out again that no contemporary documentation whatsoever exists, apart from Domenico (if indeed his biography can, on this issue, be called "documentation"), that describes Bernini's religiosity before he reached the age of sixty-seven, that is, when the artist traveled to Paris and had many details of his devotional life recorded by the observant eye of Chantelou.

Even a Bernini scholar of such towering acuity as Rudolph Wittkower lapses into an unqualified, sweeping statement about Bernini's religion and art when, in his still-much-consulted catalogue of Bernini's sculpture, he states: "It is impossible to divorce Bernini's views on art from his religious belief. This unity of art and life, work and personality, rational convictions and devout self-surrender finds expression in the exalted vitality of his performance. It is worth recalling that he went to Mass each morning and among other devotions recited the Little Office." Though likewise supplying no footnote to this pronouncement, Wittkower was in fact citing the testimony of, again, Domenico (172–73), who alone among the primary sources reveals this specific information about his father's devotional practices.[149] But Domenico there was describing the older Bernini: Do we find no "exalted vitality" in the artistic "performance" of the younger, less pious Bernini? Is his *Saint Lawrence* or *Bibiana* or *Longinus*—all produced, let us note, during his sexually unbridled and, one suspects, religiously lukewarm premarital years— any less convincingly or poignantly spiritual than his much later *Gabriele Fonseca* or *Vision of Constantine* or *Bust of the Savior?*[150] To be sure, the question of Bernini's personal faith is an important factor to be included in any discussion of his artistic production; however, as a thorough, conscientious, and critical study of his life, works, faith, and psychology concludes, there can be not one, simple, all-encompassing formula devised to guide the discussion of the genesis and meaning of so vast an array of works spread across an entire lifetime, certainly not the hagiographic reduction of art to personal religiosity that Domenico would have us accept.

9. Translating Domenico into English: Challenges, Decisions, and Definitions

Despite the chronological distance between the texts, what Patricia Rubin has observed about Giorgio Vasari's *Lives of the Most Eminent Painters, Sculptors, and Architects* fully applies to Domenico's *Life of Gian Lorenzo Bernini* as well: "History was a literary art for Vasari and his contemporaries. It demanded eloquence. What was said gained importance by how it was said."[151] Eloquence was clearly one of the concerns that guided Domenico as he transformed the rudiments of his facts and figures into the language of print. As will be obvious to anyone familiar with the history of the Italian language, Domenico's prose, albeit not without its moments of simple directness, is for the most part a solemn, stately, learned, ornate, and complex fabric that attempts, through poetic conceits, rhetorical flourishes, and other feats of verbal acrobatics, to delight and dazzle readers as it attempts to instruct and persuade them. It is, in other words, "Baroque." In addition to emphasizing the importance of its subject, the eloquence of such a prose style was also meant to impress the reader with the *gravitas* and linguistic virtuosity of its author. Readers today instead might find Domenico in his original Italian idiom annoyingly pompous and overbearing.

Furthermore, the effect of Domenico's prose upon modern readers—even Baroque scholars who are native speakers of Italian—is, unfortunately, often one of perplexity, if not at times bafflement. Domenico seems often to favor embellishment of rhetorical style over clarity of meaning. Translating Domenico into English is indeed an arduous task. Fortunately, my own many years of study of Italian texts of the premodern eras have rendered the task somewhat easier for me, with the assistance of the many historical dictionaries at our disposal (La Crusca, Baldinucci, Florio, Baretti, Tommaseo-Bellini, Battaglia). In the nine years that it has taken me to complete this annotated translation, I have also made a point of immersing myself further in the texts (especially those relating to the arts) of early modern Italy in order to enter more intimately into Domenico's own "mentality," linguistic or otherwise. I have also had the extreme good fortune to be able to consult, whenever necessary, good friends and colleagues of great expertise in early modern Italian language, history, and art history (see the Acknowledgments).

My principal goal in producing this translation was, above all, that of ease of reading, that is, to render Domenico's text into modern English prose that is both easy to understand and pleasurable (or at least not laborious) to read. Though attempting to render some of the flavor of Domenico's original grand

prose style, I have been more concerned with intelligibility. Hence, I have broken up his long, complex Ciceronian periods into smaller, more easily digestible sentences with modernized punctuation, while I have physically divided the extended masses, page after page, of uninterrupted prose into smaller, less fatiguing blocks of text upon the page.

Questions of Vocabulary

Domenico's text as here translated is complete, except for the omission of the original index. At times, even when his syntax or vocabulary is completely clear, Domenico's meaning is ambiguous: in such cases, I have preferred to translate the text faithfully, leaving its ambiguity intact, while in the accompanying note, pointing out (and, in virtually all instances, resolving) the ambiguity of the expression, phrase, or sentence in question. In these situations, as in cases where there may be some, smaller lingering doubt as to the best translation of a word or phrase, I have supplied the original Italian text in the notes. Ambiguity in Domenico arises from a variety of causes: the use of verbs without specified subjects; the accumulation of pronouns in close proximity to each other without clear antecedents; the multiple possible meanings of many words, especially technical terms; the author's verbose rhetorical flourishes, with their redundancies and obfuscating conceits; and, a particular challenge, his frustratingly elliptical manner of expression, compressing too much into too few words.

Furthermore, although the Italian language has changed less than English in the past three hundred years, it nonetheless has indeed evolved: individual words, especially, have changed denotation or, at least, primary denotation, even as their morphology has remained the same. For example, the adjective *grazioso* and the noun *successo* in Domenico are rarely used to mean "gracious" or "success," as they do in modern Italian. In Domenico's Italian, the former most often means "amusing" or "entertaining" (and also at times "exceptional" or "remarkable"), while the latter simply means "episode," "incident," or "occurrence," as in the case in the marginal subheading on page 33, "Grazioso successo nella malattia mortale di Urbano VIII." Hence, often mistranslated in Bernini studies in English is Domenico's adverb *graziosamente,* encountered on page 16: in viewing the marvelously wrought marble bust of Monsignor Montoya, Cardinal Maffeo does not "graciously" approach the Spanish prelate to deliver his famous witty remark; instead, he approaches him "playfully" or "in a spirit of jest," that is, *graziosamente.* Similarly, later in the narrative Domenico will report that the much-talked-about Bernini writes in a spirit of amusement

(*graziosamente*) to Cardinal Pallavicino from Paris that "[t]here was no other fashion in Paris than the Cavalier Bernini" (Domenico, 130).

As mentioned, certain technical terms of art and architecture pose a particular challenge to the English translator. As is well known to scholars in the field, and as has been pointed out many times in other studies or translations of art-historical primary sources,[152] many terms within the artistic vocabulary of Renaissance and Baroque Italy defy simple, clear, exact rendering into English. This is either because they express concepts that our language is incapable of translating in a single word or a conveniently brief expression, or because they bear more than one simultaneous meaning, not always easily separated one from the other in any given context. We have already discussed the cases of *tenerezza* and *attitudine*. Another example is *disegno*, which can either mean "drawing" in the physical, mechanical sense (hence draftsmanship) or "design" in the theoretical, conceptual sense of composition or plan, as in "He conceived a design for the chapel that was then executed by his assistants." (It can of course also refer to a specific art object on paper or other medium, as in, for example, Bernini's "drawings" that were purchased and collected.)

Some scholars have preferred to leave such terms untranslated at every occurrence. I have chosen not to do so, not only because it is unhelpful and frustrating to the nonexpert reader, but also because I have concluded that defensible, adequate English renderings are indeed possible, even if they fall short of perfection. At least as encountered in Domenico's narrative, let us note, furthermore, that the problematic technical terms in question are not as intractable as they might be in other texts, inasmuch as Domenico is composing a popular, nonscholarly narrative intended for a broad, general audience, not an erudite work of art theory or criticism for experts in the field. Hence his use of technical vocabulary is for the most part more straightforward, that is, less fraught with or dependent upon subtlety and nuance. In my notes to the text, the reader will find discussion of this problematic vocabulary, but let me comment briefly on some of the most important, most challenging, and most frequent examples—*ingegno, genio, virtù,* and *virtuoso*. I caution, however, that the semantic complexities (acquired over centuries of usage) of these troublesome terms would require many more pages of discussion to do them full justice.

Ingegno, Genio, Virtù, and Virtuoso

In the present context, the word *ingegno* can be rendered in English as "genius," as long as we keep in mind that in the vocabulary of early modern Italian—Domenico's included—it means, primarily and generically as it were, what

it then meant in contemporary English. That is, to quote the unabridged *Oxford Dictionary of the English Language* (*OED*): "genius" in early modern English denoted a "natural ability or capacity; quality of mind; the special endowments which fit a man for his peculiar work; natural aptitude, coupled with more or less of inclination." This corresponds to the meaning of its Latin root, *ingenium,* and to the definition of "genius" we find, for example, in the contemporary (1706) London edition of Roger de Piles's *The Art of Painting and the Lives of the Painters* (translating the French equivalent, *génie*):

> 'Tis in vain for Men to endeavour with all their might to reach the point of Perfection, in the Art of Painting, or in any other Art, if they are not born with a particular Talent for the Science they profess. They will always be uncertain of attaining the end they propose to themselves, Rules and Examples may shew 'em the means of reaching it, but that is not sufficient. . . . This facility is only found in those, who before they learn the Rules of Art, or see the Works of other Men, have consulted their own Inclination, and examin'd whether they were put upon the choice of their Profession by some inward Light, which is indeed Genius, and is what guides them by the nearest and easiest way to Perfection. . . . *Genius therefore is that Light of the Mind, which conducts us to the end by the most easy Means.* 'Tis a Present which Nature makes to a Man at the hour of his Birth, and tho' she commonly gives it for one thing only, she is sometimes so liberal as to make it general in one Person. There have been several Men on whom she has bestow'd this *Plenitude of Influences,* who have with ease perform'd whatever they attempted, and always succeeded in what they undertook. (Piles, 9–10, emphasis in original)

Present in the mind at birth and hence not acquired through experience or study, *ingegno* or genius is, more specifically, "an imaginative capacity, an ability to invent or to fashion the new."[153] In today's English, the term's originally generic or "neutral" definition has been overtaken by one with more "judgmental," more circumscribed implications; that is, again according to the *OED,* it more specifically indicates "native intellectual power of an *exalted* type, such as is attributed to those who are esteemed *greatest* in any department of art, speculation, or practice; instinctive and *extraordinary* capacity for imaginative creation, original thought, invention, or discovery" (emphasis added). The same word "genius" today is of course also applied to individuals possessing such exceptional talent; so too in early modern Italian. In Domenico,

we find the word in this sense, referring to persons of genius, most notably in Pallavicino's praise of Bernini as "la fenice degl' ingegni" (the phoenix of geniuses, Domenico, 97). Since, as Domenico would have us believe, Bernini's *ingegno,* from the moment of birth, was precisely of the "exalted" or "extraordinary" kind that today's use of the word always implies, it creates no problem to translate *ingegno* as employed in *The Life of Gian Lorenzo Bernini,* with the English word "genius" with its current connotations.

Indeed, even beyond Domenico's text, there is reason to believe that in early modern artistic discourse, the *ingegno* of any artist worth discussing in print was also presumed to possess something decidedly beyond the ordinary by way of talent, at least to some limited degree and operative in one specific area of creative activity, even if it did not possess the same prodigious depth and versatile breadth of Bernini's genius. Again we turn to the same description of "genius" in the 1706 English edition of Piles's *Art of Painting:* "Genius is the first Thing we must suppose in a Painter; 'tis a part of him that cannot be acquired by Study or Labour. *It should be great to answer the greatness of an Art, which includes so many Sciences, and requires so much Time and Application to be Master of, as Painting does*" (Piles, 1, emphasis added). In a similar vein, for Bernini's contemporary Emanuele Tesauro, author of the already cited influential treatise on "witty and ingenious elocution applicable to all forms of art, oratorical, lapidary, and symbolic," the *Cannocchiale aristotelico,* "genius [*ingegno*] is a *marvelous* force of the intellect," representing nothing less than the human person's direct participation in divine creative power: through the exercise of his *ingegno,* the artist or poet produces *ex nihilo* something completely new and original, in emulation of the Almighty's own initial act of creation.[154]

The same Latin word *genius,* which gives us our English word "genius," is likewise the root of the Italian word *genio.* The classical Latin term refers to "the tutelary god or attendant spirit allotted to every person at his birth, to govern his fortunes and determine his character" (*OED*). From this derived one of the primary meanings of *genio* in the early modern Italian, that is, the characteristic and fundamental temperament, nature, or disposition with which you are born and which, for obvious reasons, has much influence on your destiny in life.[155] Hence, like *ingegno, genio* originally had a generic, "neutral" sense in its primary connotation. *Genio* in early modern usage can at times be confusingly similar to *ingegno,* inasmuch as *ingegno* too represents a fundamental congenital disposition, abiding natural temperament, or innate quality of mind.

At some point in the evolution of the Italian language and as is true today, *genio* went on to acquire the meaning of *ingegno* in its "exalted" sense, and

in doing so largely superseded *ingegno* as the term designating "extraordinary creative talent" or a person in possession of such talent.[156] During Domenico's lifetime, however, this was not yet the case. Moreover, in this era the term was frequently and within the same text also used to refer to a wide range of other, more specific interior qualities or more momentary states of mind, which, depending on context, would be translated in English as inclination, inspiration, desire, passion, mind-set, pleasure, liking, attraction, and so forth. Domenico's usage of the term (14, 17, 22, 49, 77, 112, 114, and 155) covers this entire array of denotations and connotations, and hence the same variety of English translations has been employed for *genio* in this edition.

When we turn to the noun *virtù,* part of the problem we face is that in early modern Italian this one word has two denotations. It can mean "virtue" in a moral sense. But it can also be used to denote some other special, praise-worthy quality of mind or spirit, with no moral, ethical, or religious con-notations whatsoever. In this second sense, *virtù* can be rendered in English variously as "talent" or "valor" or "excellence" or "prowess."[157] The latter list represents closely related but nonetheless distinct entities, and this fact is a second part of the problem faced by English translators of the term: which to choose? *Virtù* maintains all of these denotations (moral and nonmoral) in modern Italian, but native speakers of Italian today easily understand its mean-ing from context. (A sports announcer in Italy, for example, can say that a soccer player demonstrated his outstanding *virtù* on the playing field, without listeners taking that as a moral judgment.) Not necessarily so for us when we encounter the word in Domenico's *Life of Gian Lorenzo Bernini* and in most other contemporary texts.

This is yet another part of the problem we face: context is not always suf-ficient to overcome all hesitation in attempting a translation. More specifi-cally, the pervasively hagiographic tone and vocabulary of Domenico's text, on the one hand, and its constant melding of art and personal devotion, on the other, may make it difficult for today's readers to resist the temptation of always endowing moral connotations upon the word, that is, of translating it as "virtue" when the author really means "talent" or "valor" or some syn-onym thereof. Nonetheless, although the word *virtù* may have more than one meaning, in Domenico—I have concluded after reading his text, word for word, many times—it does not mean all things at the same time. As it turns out, in most cases (even amid the spiritualized language of his exordium), Domenico's *virtù* simply refers to Bernini's (or some other personage's) tal-ent. But, let us note, the talent in question is always of a specifically refined, creative type, be it artistic or intellectual, not merely artisanal or mechanical

(see the discussion of *virtuoso* below). Hence, unless the immediate context is explicitly or implicitly religious (as on Domenico, 25, 35, and 171), I have usually translated the term as "talent."[158] True, the word "talent" seems a bit anemic and colorless compared to the robust and sonorous Italian *virtù*, but so too does much of the rest of English vocabulary when juxtaposed with even the most quotidian of Italian vocabulary.

The situation is even more complicated when we turn to the derivative noun *virtuoso*, used to designate a certain type of person or category of persons. The label made its first appearance in general circulation in the early sixteenth century, thanks to Castiglione's *Book of the Courtier*. A truly proper, exhaustive discussion of its meaning in early modern Italian—that is, from the time of its coinage in the 1520s to the early eighteenth century (the time of the publication of Domenico's *Life of Gian Lorenzo Bernini*)—would require an entire essay, if not volume, unto itself.[159] Across this broad span of years and across the various genres of literature and cultural discourse, the meaning of *virtuoso* evolved and indeed constantly shifted in both its denotations and connotations, often retaining in any given moment more than one meaning or shade of meaning accrued to it by dint of usage by different writers in disparate cultural contexts. In this two-hundred-year period, it can mean anything from "refined, erudite courtier" to "man of excellence or achievement" to "lover of fine arts and letters" to scientist or savant to antiquarian to connoisseur of art or music and multitalented visual artist. The early modern Italian *virtuoso* as "multitalented artist" is one whose abilities are manifest not only in more than one of the fine arts (painting, sculpture, architecture), but also extends into the domain of letters, science, and other areas of cultural pursuit.[160] The latter meaning of the term—as artist of versatile talent—may represent one of its more common denotations in art literature of seventeenth-century Italy, yet this claim cannot be made with complete certainty in the absence of thorough, methodical study of contemporary usage.

But the important question for us now is: What does *virtuoso* mean for our author, Domenico? A survey of all its occurrences in the original text of *The Life of Gian Lorenzo Bernini* (where it is always capitalized) leads one to conclude that even here the answer is not simple.[161] At times the term clearly has a broad meaning, designating (to use my own formulation) "all men of creative talent, excellence, or achievement, intellectual or artistic." Such were the individuals who would gather around Pope Alexander's postprandial table and entertain him with their stimulating and instructive conversation (Domenico, 97). Among them were to be found Bernini and that man of letters and theology, Cardinal Sforza Pallavicino, as well as disparate other nonartist *virtuosi*

whose names are recorded in that pope's extant diary.[162] When the term is later employed (Domenico, 155) to refer to those enjoying the patronage of Cardinal Antonio Barberini, it undoubtedly likewise comprises this larger, more diverse category of men of cultural achievement. On the same page, Giulio Rospigliosi, described and praised specifically as a poet, is also given the label of *virtuoso* (Domenico, 155). However, in other instances, it would seem, our author uses the term to refer only to artists; he may have had this more restricted category in mind, for example, when he tells us that the pope had placed his collection of ancient statues "for the public benefit of *virtuosi*" (Domenico 13; see also 50, 65, 76, 104, 105, and 113). But elsewhere one wonders: When Annibale Carracci made his prognostication about the future embellishment of Saint Peter's by some genius to come (Domenico, 37), were the other *virtuosi* in his company just artists, or did they include men of letters and science as well? By contrast, in yet another passage, the *virtuosi* who attributed the scripts of Bernini's theatrical plays to Terence or Plautus were, one suspects, specifically men of letters (Domenico, 51).

In view of this mixed usage, I have translated the term in various ways, as best befits the context, though favoring the simple English expression "men of talent." That phrase, like the Italian original, is both all-encompassing and, for better or worse, safely ambiguous. For Domenico's purposes—writing, as he was, for the general, nonexpert public—any further semantic specificity was and is not always essential. Here too, granted, the wonderful Italian word *virtuoso* might please our ears more and stimulate our imagination more richly than any English equivalent, but, alas, such are the limitations of our mother tongue. Naturally, it is impossible for any translation in any language, no matter how expert, to render all of the color, nuance, and flavor of the original idiom. Those who know Italian sufficiently well are of course encouraged to read Domenico in his mother tongue—obfuscatingly ornate and dense though it may at times be. Certainly any scholar seeking to analyze Domenico's narrative on a more critical, microscopic level will be obliged to enter the Baroque linguistic labyrinth of the original 1713 edition. The present English translation is a simpler, more easily negotiable terrain; though with fewer rhetorical flowers and twists and turns, it is much more easily traversed.

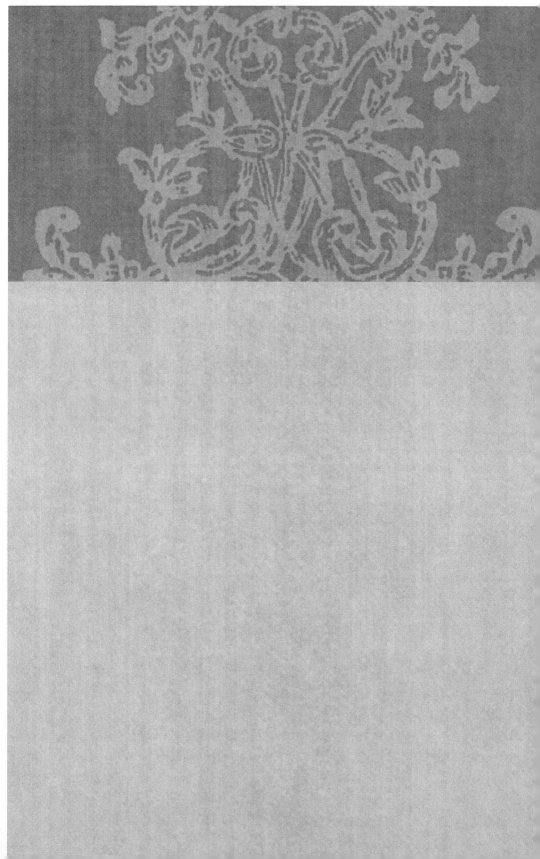

THE LIFE OF GIAN LORENZO BERNINI

THE LIFE

OF THE CAVALIER

GIO. LORENZO BERNINO

DESCRIBED BY

DOMENICO BERNINO

HIS SON

And Dedicated by the Publisher

TO THE MOST EMINENT AND MOST REVEREND

LORD CARDINAL

LODOVICO
PICO
DELLA MIRANDOLA

ROME: At the expense of Rocco Bernabò, 1713

WITH PERMISSION OF THE ECCLESIASTICAL AUTHORITIES

Most Eminent and Most Reverend Lord,[1]

If a gift acquires value from the rarity of the object bestowed, certainly in presenting to Your Excellency The Life of the Cavalier Bernini, *I can assure you that it is indeed a precious gift that I give you, one of such rarity that it lacks little to render it simply unique. Singular and extraordinary was this illustrious man, and proclaimed as such by eight pontiffs, two kings of France, a king of Spain, two rulers of England, and, in general, by all the princes of Europe. They, the crowned heads of our world, all seemed to be in competition with each other in attempting to secure for themselves some work of his hand and to admire his person. The rarity and grandeur of this gift match in full the grandeur of its recipient. Your Excellency will justifiably be able to receive in his embrace Bernini, who returns in glory from the other world, satisfied to see his reputation in this world assured by Your Excellency's invincible name. From your illustrious ancestors, you have inherited not only the splendor of your blood but also the role of protector of men of talent, as well as an innate predilection for talent. It is certainly a matter of great merit—perhaps uniquely so among all that of which any potentate of Europe can boast—to be able to claim descent, as you can, from the Emperor Constantine, whose granddaughter, Euride, daughter of the Emperor Constantius,*[2] *was wed to Prince Manfred, the foundation of your ancient family.*[3]

However, this fact of your family's origins is, in my view, by no means the element most worthy of either the greatest or the highest part of praise. Something else instead, with well-deserved admiration, seizes my mind and, with even greater reason, causes me to repeat the words of Emperor Constantius, who, after learning of the vicissitudes of his daughter, Euride, and her husband, Manfred, exclaimed in astonishment, "O res miranda!" O wonder of wonders! (from which exclamation his land of Mirandola later took its name): it is the fact that, throughout the course of your embattled fortunes, Your Excellency endured it all with the constancy and virtue of a prince, so much so that it seems as if greatness came forward to meet you, and not vice versa,[4] *and has raised you to that exalted dignity that at present you enjoy in the ecclesiastical hierarchy.*[5] *May Your Excellency therefore live ever happily in the good fortune that you, through your own efforts, have so honorably created for yourself. Accustomed as you are of fixing your eyes upon the pages of learned men, may you graciously receive this gift that I now present to you. And may you continue to increase the capital already accumulated by your ancestors, by not only rendering works worthy of publication but also by protecting works that are indeed published, using that abundant profit of glory that brings acclamation to the one to whom these works are dedicated, as well as to him who publishes them. With all due respect and homage, I kiss your sacred vestments and remain Your Excellency's*

Most Humble and Most Devoted Servant,
Rocco Bernabò

The Publisher to the Reader

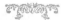

On the occasion of the publication of the *History of All Heresies Recounted by the Illustrious Signor Domenico Bernini,* in the course of my frequent examination of the manuscripts accumulated by that indefatigable and erudite individual, I was fortunate to come upon *The Life of Gian Lorenzo Bernini,* his father, composed by him as well, many years previous in his most florid youth,[6] that is to say, before he undertook that great labor of the four volumes of the history of heresy. I requested this work from him in order that I might once again ennoble my presses with another of his fine compositions; he graciously granted my request, making some corrections as well as additions to the text. This work therefore I present to you, gentle Reader, the fruit of the labor of a son no less famous than his father, the fame of whose talent has been disseminated throughout Europe. Of the one man and the other did he aptly sing, that poet who wished to give account of both of these individuals with the following epigram:

> For the good of Rome and the majesty of their parents,
> Each of the two Berninis fights with mighty hand:
> But the Son surpasses the Father by as much as renowned Faith
> is firmer than stone, and nobler.[7]

So much and no more must I add in praise of these two men, because of whom, on the one hand, Rome is seen more splendid in the magnificence of its adornment, and, on the other, the Roman papacy finds itself better defended against the slander of its enemies, and the Church of God from the evil of the heretics.[8] May you live happy.

The Author to the Reader

It will perhaps seem an unusual, new phenomenon that a son be the author of the life of his father, or that a deceased father could so entrust himself to the living pen of his son that he, the father, must acknowledge the gift of immortal life among future generations granted him by the same son, to whom he had given mortal life among the living.[9] Nonetheless, the miracles wrought by art are not so restrained by the narrow limits of nature that they do not at times exceed them. This is particularly the case in those works of art where the liveliness of genius is more operative than the labor of one's hand. The former, genius, although enclosed within man, surpasses and soars above him, revealing and transcending the very secrets of nature. Therefore, it should not be a cause of wonder if the life of the Cavalier Bernini, the father, is brought to the light of publication by his son, stirred by filial affection, persuaded by gratitude, and seized by admiration for the excellence of his father's qualities. Above all, a sense of justice obliges him in this task: since he has already fulfilled, by means of other publications, his duty to that primary and supreme responsibility—impressed in us with our very birth—to our religion and our God, it is only fitting that he should fulfill, by means of the present work, his duty to that secondary responsibility, to the one who, in raising him, cultivated in him the light of religion and the knowledge of God.

To these general considerations may be added the example set by authors of the past, both sacred and profane, who, in their commentaries, have widely recounted facts relating not only to their parents and relatives but also to themselves. In so doing, they encountered no censure; indeed, their works were met with applause and praise from men of letters. "In praising my sister," writes Saint Gregory Nazianzen in his funeral oration for his sister, Gorgonia, "I shall be honoring my own family. Yet, while she is a member of my family, I shall not on that account praise her falsely, but because what is true

is for that reason praiseworthy. Moreover, this truth is not only well founded but also well known."[10] For many reasons, therefore, this work cannot but be pleasing to those who recognize what is honorable and who delight in what is seemly. Its author is hopeful that he can attain the goal he has set for himself, as long as he can compose his work in such a way that its length will not be a cause of fatigue, nor its brevity a source of confusion.[11] If he achieves this, may there thus accrue to the author as well a share of glory for having prolonged, in these few pages, the life of the one to whom he owes his own. At the same time, the author has, in a certain sense, prolonged his own life by virtue of the consolation he experienced in the weaving together of this book. While reviewing those years past, he felt as if he were also reliving his own life and, with the evocation of the memory of those events, had once again become young. Those events, being matters pertaining to his own family life, could not but be a source of delight to him. May the reader be pleased with this work and its intention, and may you live happy.

Imprimatur,[12]

By the order of the Most Reverend Father Master of the Sacred Palace, Father Gregorio Sellari, I have read the Life of Signor Cavaliere Gio. Lorenzo Bernini recounted by Signor Domenico Bernini, his son; in this work, I have found nothing that is contrary to good morals or our holy faith. I, in fact, admired the fine way in which, in this book, the great deeds of the father find most adequate expression through the felicitous pen of the son: the former, renowned for the many things he created; the latter, famous for the many things he has written. The former deserves so worthy a writer, just as the latter deserves so worthy a subject about which to write. Thus, in the son, the great talent and mastery of the father will have renewed life, for as Solomon has said, "Filius sapiens doctrina Patris."[14] And, in the father, who is once again brought forth into the light, the learning and devoted love of the son will be perpetuated. I therefore judge this work worthy of publication, for the glory of so great a father and the praise of so learned a son, as well as, furthermore, for the inspiration that such a publication will provide for the arts and sciences and, in outstanding fashion, for the education of children in the love and gratitude owed by them to their parents. From Rome. 16 January 1712.

Francesco Maria Guelfi of the Society of Jesus[15]

Imprimatur,

Table of Contents

THE LIFE OF
GIAN LORENZO BERNINI

Chapter I

BIRTH, UPBRINGING, AND STUDIES OF GIAN LORENZO
IN THE CITY OF NAPLES UNTIL THE AGE OF TEN.
HIS ARRIVAL IN ROME.

(Introduction to the Book.)[1] If ever in times past Heavenly Providence Most High has perchance desired to demonstrate how capable supreme talent[2] be in securing the attainment of supreme glory, and how stable and sublime be the foundation of merit alone in elevating persons to the plenitude of honor, certainly that day arrived when It brought into this world the Cavalier **[2]** Gian Lorenzo Bernini.[3] For the excellence of his accomplishments and the magnitude of the acclamation bestowed upon him, the Cavalier Bernini truly had, and has, no equal in our times. His fame can rightfully count him among the most remarkable men of genius of times past, so much so that his memory remains glorious even in these present times and will endure as such likewise in the future. Thus is his renown, for he was so able to equip his mind with a marvelous composite of most exceptional talents, each of which alone could have rendered any man great and admirable. His greatest distinction was not that of being acclaimed as excellent merely in his profession, for he possessed within himself, and to an excellent degree, all those elements that can produce a man of great vision and talent. It is no wonder, therefore, that the leading potentates of Europe, so stirred by his talent, competed with each other, as it were, in admiring his genius and in rewarding him for the tangible expressions of that genius with the bestowal of gifts worthy of royal magnificence.[4] It is our intention, therefore, to record in the present work the life of this illustrious personage, whom talent alone rendered glorious and celebrated throughout the world. It is, furthermore, our intention to do so with that accuracy demanded of all those who describe events to which almost everyone still

alive today has been an eyewitness.[5] Such eyewitnesses could easily contradict an author each time he, in order to garner more admiration for his writing, embellishes the facts and departs from the truth, for truth is the sole merit of history and history is truth alone.

(His Homeland and Birth, Upbringing, and Character.) Gian Lorenzo Bernini was born in the city of Naples on the seventh day of December in the year 1598, thus rendering illustrious by his life span, not one but two centuries.[6] He was raised in the first rudiments of letters with good discipline by [3] Pietro,[7] his father, and by Angelica Galante,[8] his mother, the former born in Florence, the latter in Naples. Pietro had moved from Florence[9] to Naples to satisfy the desire of the viceroy, who wished to make use of his talents as sculptor in the decoration of the Royal Church of San Martino.[10] Gian Lorenzo, from the very beginning, became so enamored of this same profession that, abandoning the usual childish pastimes, he would spend entire hours completely transfixed in observing his father's works. Following his father's example, at the age of eight he carved a small marble head of a little *putto*[11] to the great admiration of Pietro, who thereby realized that, in view of such beginnings, only great expectations could be conceived for his son's future. Perceiving in his son a most noble vision and the capacity for any form of work, Pietro dedicated himself entirely to procuring for Gian Lorenzo that work which most conformed to the boy's inclination. Accordingly, he asked the abbot of the monastery of San Martino, a most intimate friend of his and person of elevated mind, to attempt to discover in some effective manner that branch of learning or profession to which Gian Lorenzo's spirit inclined and could thus be therein honorably employed.[12] The abbot gladly accepted the task since, given his friendship with the Bernini family, he had already had the opportunity of observing the boy's behavior. In order to come to know it even more fully, however, the abbot met with the boy on different occasions, conversing with him on various subjects and paying strict attention to his responses. He allowed Gian Lorenzo to pursue whatever topic he proposed, so that the boy's every, and most hidden, inclination might thereby be more easily identified. In the event, [4] even at so tender an age, the intellect of Gian Lorenzo proved both universal and profound.

(His Aptitude for Every Field of Learning and Every Profession, Even in Boyhood.) Thereupon, the abbot solemnly reported to the boy's father that he had observed in Gian Lorenzo a veritable gold mine of genius,[13] so lively, so fertile, that no matter what subject was broached for discussion, the boy showed

himself most interested in it. Moreover, he was able to converse on each topic with such solidity of thought that if he were to undertake further study of those topics, he would indeed acquire a marvelous foundation in all of them. As a result of these frequent colloquies with the boy, the abbot could arrive at no other conclusion than that Gian Lorenzo would achieve greatness in whatever profession to which he applied himself. The conclusion of this great examiner of minds was confirmed years later by that other arbiter of men, indeed, the greatest of arbiters, Pope Alexander VII. As a result of his long association with Cavalier Bernini, the pope had had even more opportunity of recognizing his superb genius and was thus accustomed to saying that "the Cavalier Bernini would have been superior to anyone in any field of learning, had he applied himself to it as much as he, in accordance with divine will, had applied himself to his chosen profession."[14] For this reason, the boy's father allowed him to choose his own path in life, assured that the boy's nature would have channeled the vivacity of his spirit into whatever field and profession to which he applied his energies.

However, since a living role model usually serves as incentive and norm for our behavior, just as a small piece of charcoal, close at hand, burns more than the entire but faraway sun, it thus easily happened that, with a father more drawn to works of sculpture, Gian Lorenzo directed his own inclination as well to the same activity and asked Pietro to teach him the principles of that art. **[5]** With his heart so enamored of Gian Lorenzo's exceptional qualities, Pietro now began, with incredible dedication, to do his best in providing for the training of his son. Nonetheless, it soon became apparent that those foundations of learning that others acquire through study were present in Gian Lorenzo simply as natural traits and that the boy, it seemed, had received as a gift from nature what others obtained only through much sweat. Pietro shortly thereafter came to realize that his son possessed a marvelous aptitude for the apprehension of beauty and an equal talent for depicting it in his drawing. Being a prudent master, however, Pietro would at times praise Gian Lorenzo's exercises, while at other times criticize them. This he did in order to keep the boy in constant competition with himself and indefatigably engaged in new studies; with an ever-changing manner, Pietro kept the boy continuously challenged by exercises of increasingly greater significance.[15]

(Gian Lorenzo's Clever, Quick-Witted Reply to His Father.)[16] One day Pietro noticed that in copying a drawing the boy had changed the foreshortening of one of the figures, rendering it in the process more natural and more lively. Believing this change to have been simply a haphazard move on the boy's

part, rather than the studied decision of a master, the father scolded him for being faulty in his work and not paying attention to the original that had been given him for imitation. Gian Lorenzo in all modesty replied that "His own enthusiasm for the exercise had caused him to act in this way and perhaps go beyond what he was obliged to do. However," he added, "if he were obliged, always and simply, to follow what others had done, he would never easily be able to surpass any of them."[17] Hearing this reply, the father at that point understood that the only worthy teacher of such a disciple was the boy's own genius.[18] He therefore gave his son the freedom to work as he wished, since he realized what higher aspirations were at work motivating the youth to make such great progress. And in fact, from that moment on, Gian Lorenzo so well comprehended and was so enamored **[6]** of the greatest difficulty in art— which consists solely in perceiving the ease of nature[19]—that it is no wonder that within a few years, in the works he executed in the capital city of Rome, he was so adept at imitating, without affectation, what was most perfect[20] in nature that anyone who studied his works was left in doubt as to which was greater, his artistry or his mastery in hiding it.[21]

(His Departure from Naples.) These therefore were the foundations upon which Gian Lorenzo was to erect the great edifice of his profession and these the principles with which he felicitously initiated the course of his studies. But Heaven, which had destined a theater more appropriate to the talent of this man, so disposed events that Pietro, his father, was summoned to Rome by the pontiff, Paul V, in order to put his skills to work in creating a large narrative scene in marble that he intended to have placed on the facade of the Pauline Chapel in Saint Peter's.[22] The pope, through his nuncio, made his request to the viceroy of Naples, who graciously granted it. Taking his entire family with him, Pietro thus departed for Rome.[23] Pietro was keenly desirous of arriving in the papal capital, for he wished his son to encounter in the field of Rome that fortune which, accompanied by merit, very often exalts her disciples in that great city of talent and does so to a degree simply beyond all belief.

Chapter II

GIAN LORENZO'S FIRST ENTRANCE INTO THE PAPAL PALACE.
HIS AUDIENCE AND INTERACTIONS WITH PAUL V
AND CARDINALS OF THAT COURT.
HIS FIRST STUDIES IN ROME.

(Paul V, Lover of Talent; Conditions in Rome During This Period.) Reigning at
that time in the city of Rome under the name of Paul V was Camillo Bor-
ghese. This was a pontiff among the most blessed in centuries past, the most
meritorious in the present, and whose memory in the future will remain ever
illustrious. Under this pontiff, a most vigilant promoter of men of talent, that
great court was flourishing more so than ever before, through the great abun-
dance of excellent individuals in every profession, the majesty of its edifices,
and everything capable of procuring exceptional fame for that pontificate. In
the heart of this great prince, occupying a place equal to any other expression
of creative talent, were sculpture and architecture and by these two means Paul
greatly amplified the ecclesiastical and secular magnificence of Rome. For the
adornment of the city, Paul spent perhaps more than five million *scudi,* but
did so to no detriment whatsoever to the states under his care.[1] These matters
are well known and, hence, there is no need to go into further detail about
them here. Equaling Paul's love for all things beautiful and glorious was that
of his nephew, Cardinal Scipione Caffarelli, son of one of the pope's sisters,
who, when promoted to the cardinalate, assumed the name and coat of arms
of the Borghese family.[2] He, too, held in the greatest esteem those same arts
and likewise kept in continual occupation the talent **[8]** of their practitioners.
It was therefore commonly believed that perhaps the only factor preventing
this period of history from being considered equal to the most illustrious and
most renowned epochs of antiquity was simply age.[3]

(The Cavaliere's First Audience with the Pope. And a Witty Remark of His.) In this theater of talent, Gian Lorenzo made his first appearance at the age of ten.[4] And since talent opens up for itself the path to social connections and honors, a short while later Cardinal Scipione Borghese, having heard about the arrival in Rome of Pietro Bernini and his family, summoned him to his presence. At that meeting the cardinal ordered Pietro to bring to the papal palace on the very next day Gian Lorenzo, his son, whose reputation for possessing a mind that far transcended his actual physical age had already reached that court.[5] The reality lived fully up to their expectations. To the cardinal's welcome, the boy responded with such an admixture of vivacity and modesty, of deference and alacrity, that the cardinal prince was quite enthralled by him and wanted immediately to introduce him to the pontiff. Gian Lorenzo was not the least bit apprehensive in seeing himself admitted into the presence of His Majesty the Pope. Rather, it was as if he, over a long course of years, had accustomed his sight to the splendors of that realm. With a face unperturbed and a steady pace, Gian Lorenzo went forward and bowed to kiss the pontiff's foot, begging his blessing with great devotion.

Venerable by nature in his appearance, the pontiff wished to test the boy's courage by affecting a severe demeanor during the audience. Addressing the boy with a grave tone of voice, he commanded Gian Lorenzo to draw a human head right then and there in his presence.[6] With great confidence Gian Lorenzo took pen in hand [9] and, having spread his paper over the little table before the pope, began to make the first strokes. However, he paused for a moment and, turning his head modestly in the direction of the pope,[7] inquired of him, "What kind of head did he want, that of a man or a woman, of a young person or old? And if one of these, then in what disposition did he want it, happy or sad, pompous or pleasant?" "If that's the case," the pope remarked, "then he must know how to draw them all."[8] So His Holiness ordered him to draw the head of Saint Paul.[9] With a few strokes and an admirably confident hand, the boy quickly brought the drawing to completion. He executed the drawing in fact with such mastery that the pope stood there in admiration and was moved to exclaim to several cardinals (who happened to be present on this occasion) simply, "This child will be the Michelangelo of his age."[10] Thereupon the pope, with tender affection, embraced Gian Lorenzo; he then opened a small chest that contained gold medals bearing his image and instructed the boy to take as many of them as he could. Gian Lorenzo gave due sign of his gratitude for so great an honor; but,[11] since it behooved him to obey the pontiff's command, he took twelve of them,

which was as many as he could take with his little hands. To this day these same medals are kept in the house of his sons as a memento of this occasion.[12]

(His Works in Rome Under Paul V.) This first, distinguished entrance into the Apostolic Palace, the welcome extended by the cardinal, and the praise received from the pope rendered Gian Lorenzo so famous throughout Rome that from then on he was universally acclaimed and pointed out as a young person of extraordinary promise. He had already begun working as a sculptor: his first piece was a marble bust located in the Church of Santa Potenziana. **[10]** He had also carved other small statues such as his age permitted him to accomplish, for he was then only ten years old.[13] All of these works appeared so masterfully executed that on one occasion, having happened to see one of them, the famous Annibale Carracci remarked that the boy "had in tender youth reached the same point in his art that others could boast of reaching only in their old age."[14]

(Remarkable Episode of the Two Portraits of the Cardinal.)[15] Cardinal Borghese asked Bernini to do his portrait in marble, and so the artist set himself to work, bringing it to completion in a short period of time.[16] The cardinal himself went to examine the portrait in the studio where Gian Lorenzo usually worked; so much did the work please the cardinal that he ordered it to be polished and finished so that he could have it brought on a specified day to the Apostolic Palace and shown it to his uncle, the pope. Bernini obeyed the cardinal's orders, but while they were being carried out, a new and unexpected incident occurred.[17] In finishing the face of the portrait with their pumice-stone, the polishers uncovered a vein in the marble, or, as we say, a "hair," that crossed the entire forehead and noticeably altered the likeness of the sitter.[18] This turn of events greatly troubled the heart of Gian Lorenzo's father, so anxious for his son's success. The studio assistants, well aware that the pope was anxiously awaiting the portrait, strove in vain to eliminate the blemish, which, in fact, was a natural feature of the marble itself.

Amid this great agitation on the part of his father and assistants, Gian Lorenzo arrived upon the scene. Having been apprised of the situation, dauntless he asked for a new block of marble. Eager to transform the very defects of nature into a motive for his own glory,[19] Bernini simply set out to re-create the same portrait in a different block of marble and, except to replenish his energy with a bit of food, did not rest from this labor for the space of three days,[20] when he brought the work to completion. On the appointed day, it

was transported **[11]** before the pontiff. However, from a certain livelier quality of expression in this new version, the cardinal easily recognized that this work was not the same one he had seen some days earlier. It was necessary therefore for Gian Lorenzo to reveal what had transpired; hearing the report, the pope wanted the first portrait brought before him. The amount of praise accorded Gian Lorenzo after the subsequent comparison of the two portraits was simply beyond belief, as was, moreover, the well-merited honor heaped upon the little artist[21] by that illustrious gathering of men.[22]

(Beginning of the Friendship Between Cardinal Barberini and the Cavalier Bernini.) Among the individuals who witnessed this remarkable episode was Cardinal Maffeo Barberini, who happened to arrive on the scene by chance — by chance, that is, if we wish to judge reality by mere external appearances alone.[23] But, in fact, we can justly conclude that the circumstances had been orchestrated by Heavenly Providence Most High, which, from that moment on, desired to prepare the hearts of future popes to be favorably disposed toward Gian Lorenzo.[24] This individual was a person of lofty intelligence, a lover of the noble and fine arts, and a well-known patron of men of letters. Cardinal Maffeo had already heard of the talent of the youth, and and he too was extraordinarily pleased by the reports received about him. Thus, when the cardinal saw the two sculptures, his admiration for the artist's conception was as great as the cardinal's own sublime ability to apprehend it. Whereupon, as he would later say with the passing of years, he felt himself from that moment on drawn by affection for Bernini, stirred by a certain interior impetus of most benevolent propensity toward him and especially desirous of assuring every success for the youth.[25] The cardinal's desire soon became reality, for the pope subsequently entrusted Gian Lorenzo to his protection. Imparting this command upon the cardinal in a solicitous and honorific manner, the pope repeated what he had previously remarked, "that Bernini would become the Michelangelo **[12]** of his age." The cardinal was quite pleased with the pontiff's confidence in him, so that this new papal directive had the effect of intensifying the impetus of his heart already so favorably disposed toward Gian Lorenzo. Reckoning that he had been given as a gift that which was only a temporary consignment, Cardinal Maffeo took complete possession of Bernini as if he were one of his own and, with great dedication, worked to secure every advantage for him.[26] The cardinal's affection seemed indeed clairvoyant inasmuch as it knew to carefully nurture that same youth who, later in life, was to render Barberini's own pontificate renowned through illustrious and glorious enterprises.

(His Studies in Rome.) With all of this, however, Gian Lorenzo's spirit did not become swollen with pride; on the contrary, praise simply served as a goad to greater effort. Applause, which usually renders people vainly self-complaisant, in his case, instead, merely ignited a most ardent desire to render himself even more meritorious of praise by the actual fruit of his labor. There now opened before him in Rome a marvelous field in which to cultivate his studies through the diligent observation of the precious remains of ancient sculpture. It is not to be believed with what dedication he frequented that school and with what profit he absorbed its teachings. Almost every morning, for the space of three years,[27] he left Santa Maria Maggiore, where Pietro, his father, had built a small comfortable house,[28] and traveled on foot to the Vatican Palace at Saint Peter's. There he remained until sunset, drawing, one by one, those marvelous statues that antiquity has conveyed to us and that time has preserved for us, as both a benefit and dowry for the art of sculpture. He took no refreshment during all those days, except for a little wine and food, saying that the pleasure alone of the lively instruction supplied by those **[13]** inanimate statues caused a certain sweetness to pervade his body, and this was sufficient in itself for the maintenance of his strength for days on end. In fact, some days it was frequently the case that Gian Lorenzo would not return home at all. Not seeing the youth for entire days, his father, however, did not even interrogate his son about this behavior. Pietro was always certain of Gian Lorenzo's whereabouts, that is, in his studio at Saint Peter's, where, as the son used to say, his girlfriends (that is, the ancient statues) had their home.

The specific object of his studies we must deduce from what he used to say later in life once he began to experience their effect on him. Accordingly, his greatest attention was focused above all on those two most singular statues, the *Antinous* and the *Apollo,* the former miraculous in its design, the latter in its workmanship.[29] Bernini claimed, however, that both of these qualities were even more perfectly embodied in the famous *Laocoön* of Athenadorus, Hagesander, and Polydorus of Rhodes, a work of so well-balanced and exquisite a style[30] that tradition has attributed it to three artists, judging it perhaps beyond the ability of just one man alone.[31] Two of these three marvelous statues, the *Antinous* and the *Laocoön,* had been discovered during the time of Pope Leo X amid the ruins of Nero's palace in the gardens near the church of San Pietro in Vincoli and placed by the same pontiff in the Vatican Palace for the public benefit of artists and other students of antiquity.[32]

(Statue of Pasquino; Its Excellence.) With equal attention did Bernini also direct his study to an examination of the features of those two famous torsos of

Hercules[33] and *Pasquino*,[34] the former recognized for its mastery by Buonarroti, the latter by Bernini himself, who was the first in Rome to accord a place of high esteem to this most noble statue. Indeed, **[14]** it once happened that, having been asked by a foreign nobleman from beyond the Alps, "What statue in Rome was the most remarkable?" Bernini answered, "It was the Pasquino."[35] Believing himself mocked by our artist, the gentleman took great offense at this answer and nearly came to blows with him. Bernini used to say that these two statues contained within them all that which was most perfect in nature without any affectation of art.[36]

With no less devotion did he study the paintings around him, but not so much in order to learn their manner of coloring and those qualities that would seem more relevant to a painter.[37] Rather, the young Bernini studied those exceptional figures—with which every room in the Vatican is adorned—in order to extract their design and manner of expression, both of which could be useful to him as attributes of his sculpture.[38] Not only did he extract the marrow from the *Stanze* and *Logge* painted by Raphael, the *Last Judgment* by Buonarroti, the *Battle* by Giulio Romano, and the works of Guido Reni, but he also copied the design of every part of the individual figures of which those great paintings are composed.[39] He indeed made so many copies of each design that whoever were to examine these innumerable sketches (which in large part remain in the possession of the author of the present book) could not help but agree that, in the long course of an entire life, no man would have been able to observe with his eyes as much as Gian Lorenzo had drawn with his hand in the space of these three years in which, however, as was mentioned, his principal activity was the study of ancient sculpture. All of this was the result of his tireless dedication and an ardent desire to distinguish himself; this drive was all the more inflamed in him by the sight of those noble examples of art, whose excellence he seemed, with a certain particular light, to be able to recognize more clearly. **[15]** Thus, as the boy advanced in age, a desire to arrive at the perfection of his art so grew in him that Pietro, his father, was obliged to make the youth sleep in the same room with him in order to prevent Gian Lorenzo from returning to his study during those hours that should be dedicated to the repose of one's body.[40]

(Statue of Saint Lawrence in the Act of Being Burned.)[41] Out of devotion toward the saint whose name he bore,[42] Gian Lorenzo wished to depict in marble Saint Lawrence in the act of being burned naked on the grill. In order to adequately reflect in the saint's face the pain of his martyrdom and the effect that the fire must have had on his flesh, he placed his own leg and bare thigh near

burning coals. Thus coming to feel in himself the saint's suffering, he then drew with his pencil,[43] before a mirror, the painful contortions of his face and observed the various effects that the heat of the flame had on his own flesh. Even more meritoriously than the ancient Scaevola, who placed his hand in fire in order to punish himself for having erred, our Gian Lorenzo caused his own flesh to be burned out of a desire not to fall into error.[44] It happened by chance that just at that moment his father came upon this scene. Seeing his son in the throes of this suffering and learning its reason, Pietro was moved to shed tears of tender affection, for he then understood how great was the desire for excellence in Gian Lorenzo: at the tender and youthful age of fifteen, in striving for that excellence, the boy had re-created in himself the torment of a real Saint Lawrence in order to sculpt an artificial one. This, the first fruit of his devotion, was so successful in satisfying the expectations of the public that on two occasions the pope's Cardinal Nephew[45] himself paid a visit to the artist in his own house in order to see the statue. Among those **[16]** numerous personages who flocked there was Leone Strozzi, a most noble Roman, who was so enthralled by the statue that he acquired it for himself, and thus at present it can be seen in Strozzi's delightful villa on the Viminal Hill.[46]

(*Other Works by the Cavaliere.*) At the end of the same aforementioned year of his life, Gian Lorenzo did the marble portrait of Monsignor Giacomo Montoya, which was to be placed, as indeed did occur, above this prelate's tomb in the Church of San Giacomo degli Spagnoli.[47] He executed the work with such spirit and verisimilitude that those wishing to delight themselves by carefully comparing both the original and the copy were obliged to conclude either that both were artificial or both real, for Bernini had so realistically captured Montoya in stone that the statue had no need of a soul in order to appear alive. Such was the sentiment of Cardinal Maffeo Barberini, who was among those flocking to the church to see the portrait. Hearing someone remark that "this is Montoya turned to stone" at the moment in which Monsignor Montoya himself happened to arrive on the scene, Cardinal Maffeo approached the prelate in a spirit of jest and touched him, saying: "This is the portrait of Monsignor Montoya," and, turning to the statue, added, "And this is Monsignor Montoya."[48] With no less vividness did Bernini in the same period also portray in marble Cardinal Roberto Bellarmino and, alongside him, a figure representing Religion. Both of these works were placed on the tomb of that venerable prelate in the Church of the Gesù, and both likewise drew to themselves awestruck praise from all the cultural eminences of Rome.[49]

Chapter III

SOME OF GIAN LORENZO'S WORKS EXECUTED AT THE
REQUEST OF PAUL V. THE ACCOLADES
HE RECEIVED FOR THEM.

(Other Works of the Cavaliere During the Pontificate of Paul V.) The pope had
already been informed of the progress that Gian Lorenzo was making in his
studies and of the applause that he received for the aforementioned works.
Greatly pleased by these reports, Paul therefore summoned Gian Lorenzo to
his presence and first requested that he execute his portrait in marble. He then
ordered him to create, according to his own inspiration, four noble statues
that were to adorn the palace of his Villa Pinciana, where they were to be
placed.[1] In little time Gian Lorenzo produced a finished portrait of such fine
style[2] that the pope kept it in his own room until the day of his death.[3] But of
greater concern in Gian Lorenzo's mind was his work on the statues destined
for the palace in the pope's villa.[4] He was well aware of the significance of
the commitment he had undertaken, that is, the execution of the orders of a
pontiff involving the adornment of one of the most famous villas of Europe.

(Villa Pinciana and a Description.) This villa is located outside the ancient city
gate, *Porta Collina,* also called *Pinciana,* and is completely surrounded by walls
that embrace the expanse of a most noble garden, five miles in circumfer-
ence. In its very center rises a palace whose exterior is entirely decorated
with ancient bas-reliefs, constructed according to the architectural design and
supervision of Giovanni Vasanzio the Fleming.[5] The palace is home to a veri-
table population of ancient statues, almost all intact, preserved for us against
the fury of the barbarians amid the very ruins of Rome. Among the principal
works of highest quality in that collection are the *Seneca in the Bath* and the

Venus and Cupid (these two statues believed to be the work of **[18]** Praxiteles); the *Gladiator* of Agasius, celebrated sculptor of the city of Ephesus; the *Hermaphrodite* found in the gardens of Sallust near the Quirinal Hill during the pontificate of the same Paul V; and the head of *Alexander the Great* in bas-relief.[6] Such was the company in which Bernini had to add his own works. The competition with these celebrated artists, the comparison that would be made between the statues, and the expectations on the part of all created great apprehension in him.

(The Cavaliere's Works of Sculpture in This Villa.) However, Gian Lorenzo's spirit, which loved arduous and noble challenges, did not for a moment doubt his success, and he thus took on and completed the work on the four statues, only one of which by itself would have worthily occupied any senior artist. The works[7] in question were the group of Aeneas, Anchises, and Ascanius, who, with their household gods, flee from the conflagration of Troy;[8] David who, with slingshot in hand, is in the act of hurling his volley against the giant Goliath;[9] the third, the group of Daphne who flees Apollo her pursuer and is beginning, in splendid fashion, to be transformed into a laurel tree;[10] and, last, the sculpture of Pluto, which, together with the rape of Proserpina, displays an admirable contrast of tenderness and cruelty.[11] In addition to the beautifully proportioned design[12] of each of these statues, what caused great wonder in the artists of the time was the fact that Gian Lorenzo brought all four groups—which in their scale were much larger than life—to completion in just two years. To those who, marveling over this fact, questioned him about it, he would respond that "Whenever he was working, he felt himself so inflamed by and so in love with what he was doing, that he would devour, rather than merely work, the marble."[13] Moreover, as he would say in his older years, "In his youth, he never made a wrong stroke," so superior was he in his art, even at that age. In fact, **[19]** it happened once that, visiting the same villa forty years later with Cardinal Antonio Barberini[14] and examining these works of his, Bernini sighed aloud, exclaiming, "Oh, what little progress I have made in my art from the time of my youth when I could work marble in this way!"[15]

(Cardinal Borghese's Witty Remark.) The degree of perfection and mastery contained in each of these four statues must be judged by one's eye in observing them, rather than by reading descriptions of the pen consisting of a vain hyperbole of words.[16] Suffice it to say that when the statues were made accessible to public viewing by those in the profession, a great crowd of artists,

along with the most eminent of the Roman nobility, flocked to see the works. As a result, Cardinal Borghese used to remark that "His villa had decreased in value from the moment that Bernini's works entered it." What he meant was that, uninterested in the other lovely delights therein contained, visitors to his home would now go immediately to the rooms where the statues were located; satiating themselves fully on the sight of the beauty of Bernini's sculptures, they did not even deign to look at the many other works of art scattered throughout that most exquisite garden of delights. From there, people would then head directly to Bernini's house, for some wanted to see him face to face, others wanted to note his mannerisms, while still others wanted to confirm for themselves his age, since the grandeur of those works caused them to believe that he was in fact older than they had been told. In the end, as usually happens in the case of great marvels, Bernini was pointed out by all as a monster of genius.

As far as the statue of David is concerned, in carving its face, Bernini, with the help of a mirror, depicted his own features, doing so with an expressivity completely and truly marvelous. And it was Cardinal Maffeo Barberini himself, a frequent visitor to the artist's studio, who many times held the mirror with his own hands.[17] The same cardinal feared that the figure of Daphne, [20] a female nude, albeit of stone but from the hand of Bernini, could perhaps offend the modest eye. He therefore had inscribed below the statue the following verses and thus rendered the work even more famous by the addition of this felicitous issue of his most noble hand:

> Any lover who of the pleasure of a fleeting outward form is in pursuit will fill his hands with mere branches and seize only bitter fruit.[18]

(Esteem and High Opinion in Which the Cavaliere Was Held by All.) These were the first manifestations of his studies that Gian Lorenzo made public in Rome, producing them at the age of approximately nineteen years.[19] Great esteem for him thus grew among the people, so much so that, this esteem evolving into respect, the artist was revered by all and treated with exceptional demonstrations of their regard. Monsignor Alessandro Ludovisi, who was later raised to the papal throne after the death of Paul V, was among those bearing such esteem for Gian Lorenzo.[20] This prelate was so favorably inclined toward him that, obliged to depart from Rome in order to assume the episcopal see of Bologna—which Cardinal Borghese had given up and passed on to him—he first commissioned a portrait of himself from the hands of Gian Lorenzo.[21] Ludovisi, furthermore, kept in continuous communication with Bernini by

letter throughout the entire period of his residence in Bologna and again dur-
ing his tenure as papal nuncio in Lombardy and Piedmont, where he had been
sent by the pope in order to resolve certain difficulties that had arisen between
Spain and the Duke of Savoy. After his return to Rome, already made a car-
dinal, this same prelate was so desirous of Bernini's excellent company that
he continually visited him in his home, together with Cardinal Barberini, his
old companion. This fact provoked great marvel in those who, after awhile,
noticed how often Bernini received in his home, and at the same time no less,
two individuals who in the space of little more than two years were both [21]
successively raised to the papal throne. Therein lay the patent beginnings of
the artist's future fortune.

Chapter IV

DEATH OF PAUL V AND ELECTION OF GREGORY XV.
THE NEW POPE'S DISPLAYS OF ESTEEM TOWARD
GIAN LORENZO. HE BESTOWS UPON HIM THE
TITLE OF CAVALIERE. GIAN LORENZO'S ACTIVITIES
UNTIL THE DEATH OF THIS PONTIFF.

(Gregory XV Assumes the Papacy.) In the meantime, at the end of January of the year 1621, the pontiff, Paul V, arrived at the end of his days. Provoking great agitation throughout the Roman court, however, was not the memory of the deceased prince (which always diminishes with the subsequent succession of new events), but rather the anticipation surrounding the future government. To the collective mourning over this loss, Gian Lorenzo added his own personal tears, acknowledging that pontiff as his first benefactor (for this is the name that he afterward would always use to address him).[1] At the same time, he worried about the outcome of the imminent election of a new pope. His fears were very soon quieted by the elevation of Cardinal Alessandro Ludovisi to the papal throne. This prelate had been in the past among the greatest as far as esteem accorded him, while, in the present, he was so outstanding in merit that he faced no competition whatsoever within a full conclave of fifty-two cardinals. He was thus proclaimed pope on the second day of the conclave by the common consent of all. It is not to be believed how greatly Bernini rejoiced in seeing elected as his prince the same person who had shown such enthusiasm for his artistic efforts and who just a short while before, as already mentioned, **[22]** had been a guest in the artist's own home with that liberty and open familiarity with which the prelate would have obligated unto himself not only Bernini, but his blocks of marble as well.[2]

(Affection and Esteem of the New Pope Toward the Cavaliere.) Gian Lorenzo requested, and was immediately admitted to, the kissing of the papal feet with

a tender display of affection on the part of the new pope. On this occasion, the pontiff kept Bernini in his company for a considerable amount of time, treating him with his customary affability, not at all altered by his newly exalted status. Not long afterward, the pope decided to honor Gian Lorenzo with the title of "Cavaliere" and with the noble insignia of the Cross of Christ.[3]

(The Cavaliere's Dedication to His Study.) This first demonstration of esteem for Bernini on the part of the pope, together with the honorable rank to which the artist had been raised, resulted in an even greater reputation for the Cavalier Bernini among the people. It served, at the same time, as an even more acute stimulus to him in the progress of his studies. In pursuit of those studies, the artist—as if he were only just beginning his training—showed himself so indefatigable and so uninterested in any other distraction, however licit, that it used to be said that "[d]uring the first twelve years after his arrival in Rome, Bernini never saw any other street except the one that led to his usual place of study."

(Affection and Esteem of the Pope Toward Him; Portraits That the Cavaliere Made of Him.) Having in the past grown accustomed to the sight of Bernini, the pope sent for him and commanded him to pay a visit every Sunday at the dinner hour—that was the moment of the week when many eminent personages from the Roman court usually crowned the pope's table. Since Gregory was of most humane and easygoing temperament, he exceedingly enjoyed the Cavaliere's company, particularly at that hour during which, free of his more burdensome cares, he would seek the solace of pleasurable and worthy conversation. Given his long acquaintance with Bernini's talents, the pope valued his works above those of all other artists and thus commanded him to sculpt his portrait both in marble and in bronze, of which portraits **[23]** three are now to be seen in the Ludovisi residence.[4]

(Villa Ludovisi.) In imitation of the Villa Pinciana, Cardinal Ludovisi,[5] nephew of the pope, had as well undertaken the construction of a villa on the same Pincio Hill.[6] The villa was completed under the direction of Domenichino in most noble fashion and in the space of thirty months. Cardinal Borghese had sent as a gift to the Cardinal Nephew one of the four statues by the Cavaliere, that is, the Pluto and Proserpina group. The pope, wanting to render this new villa equally as famous [as the Villa Pinciana], had the work installed there. To Bernini, the pontiff sent a gift as munificent as if the artist had created that statue just for him.[7]

(Death of the Pope.) From that moment onward, the Cavaliere would have certainly been kept occupied with great commissions from that same pontiff, had Heaven not given us Gregory so late in life or taken him away from us so soon. Gregory survived his election by only thirty months, leaving behind a reputation as great as it was applauded and the perpetual memory of a brief pontificate. Throughout the course of Gregory's illness, which was protracted and painful, the Cavaliere kept vigil at the very bedside of the pope, who reciprocated with extraordinary signs of appreciation for his presence. When in the end the pope passed to a better life, Bernini left his room, tearful and grief-stricken.[8] *(Noteworthy Remark of Cardinal Barberini in Praise of Bernini.)* Cardinal Barberini happened by chance to encounter the Cavaliere just at that moment. Seeing him in such a state of sorrow and judging him—as was indeed the case—to be in a state of acute grief over the death of his benevolent pontiff, Barberini spoke these words to him in the presence of many cardinals: "Cavalier Bernini, whoever next becomes pope will simply be obliged to love you, in order not to be guilty of injustice to himself, to you, and to all those who hold men of talent in esteem." **[24]** Bernini did not have to wait long to see the superabundant fulfillment of that promise.

Chapter V

CARDINAL MAFFEO BARBERINI ASSUMES THE PAPACY
WITH THE NAME OF URBAN VIII. HIS PRAISE
FOR THE CAVALIER BERNINI. HOW THE POPE WISHED TO BE TREATED
BY HIM. STUDY OF PAINTING AND ARCHITECTURE BY THE
CAVALIERE AT THE REQUEST OF THE PONTIFF.
HIS TEACHINGS ON THE SUBJECT OF THOSE TWO ARTS.

(Election of Urban VIII; His Words to the Cavaliere and Close Relationship with Him.) After Gregory died, as already mentioned, on July 8, 1623, a little more than half a month passed when the cardinals, secluded in conclave, readily recognized the merit of Cardinal Maffeo Barberini, who, on August 6, was by common consent raised to the papal throne. At the time, Barberini was at the vigorous age of fifty-five, of elevated spirit and noble intellect and therefore all the more capable of illustrious and glorious undertakings as well. On the very same day of his election, the new pope had the Cavaliere summoned to his presence and addressed him with these words: "It is a great fortune for you, O Cavaliere, to see Cardinal Maffeo Barberini made pope, but our fortune is even greater to have Cavalier Bernini alive during our pontificate."[1] From that first day onward, Urban made it clear to Bernini that he wanted to be treated by him with the same familiarity with which the artist had treated him while **[25]** a cardinal. Urban gave orders that Bernini was always to be granted free access to his own quarters without prior appointment. The pope, moreover, wanted him at the dinner hour to join him at table and remain there until it came time for his afternoon repose. In fact, it was the Cavaliere's custom to accompany Urban to his very bed, close the shutters for him, and only then take his leave from the pontiff.[2]

(The Cavaliere's Skill in Interacting with the Popes.) Urban maintained this close relationship with Bernini throughout the long course of his pontificate, as will be seen in what we are about to relate. This was a source of wonderment

to all those who know how easily undermined is the benevolence of a prince toward his subjects, subjects, that is, who are not of the same ilk as our artist. Valuing the reward of his own conscience alone and endowed with the virtue of deep respect for his superiors and a modest manner of speech, Bernini lived so completely free of envy from the court that he was able to enjoy inalterable, close familiarity successively with other supreme pontiffs.[3] One pontiff, indeed, gave orders that not even his own chief minister was to be admitted to his presence while he was in the company of Bernini. Despite this, there was no one, either from among the relatives of the popes or the intimates of the papal court, in whom this close relationship caused even the shadow of displeasure or suspicion, for all recognized Bernini as a person of certain unique qualities that rendered him above and beyond any sinister thoughts and therefore all the more deserving of this honor.

(*His Study of Painting and Architecture.*) But Urban, who valued Bernini as such a person of honor even more so than anyone else, did not want to lose a moment of time in employing the Cavaliere's talent for the benefit of his pontificate, for this prince of great and glorious ideas was nurturing within himself most noble projects and grand visions. **[26]** Since he believed that Bernini's mind was ready and able to receive any excellent impression, the pontiff ordered the artist, from the very start, to apply some part of his time to the study of painting and architecture in order to execute the projects that Urban intended to accomplish.[4] Urban was eager for Bernini to add in equal eminence these admirable skills to his other talents.[5] Bernini did not hesitate a moment in seconding the advice and in carrying out the commands of his benevolent pontiff. In doing so, with respect to the one field—architecture— the only masters he followed were the ancient buildings themselves, while in the other—painting—the modern works of Raphael.[6] These works, Bernini declared, all served as if they were living, paid masters for whoever wished to apply himself to such studies.[7] For two continuous years therefore, he focused his attention on painting; but since he had already mastered all of the challenges of design in his previous studies, he now focused solely on the technique of applying color. And what we call his "studies" in painting were of such exquisite manner, in both coloring and design, that they were on a par with the principal figures executed by the most famous painters of his time.[8]

(*Paintings Done by the Cavaliere.*) In addition to those of which we have no information, more than one hundred fifty of Bernini's canvases are extant.[9] Some are to be found in the famous gallery of the Most Serene Grand Duke

of Tuscany; others in the collections of Princes Barberini and Chigi of Rome, and still very many others in possession of the Bernini family, without counting those that have been snatched away from Italy and taken to France.[10] In the Chapel of the Blessed Sacrament in Saint Peter's, one can see the beautiful altarpiece he painted depicting the deeds of Saint Maurice.[11] Above all, there remain two famous self-portraits, one of which is still to be found in the Bernini home, [27] the other instead in a more worthy theater, that is, the famous gallery of portraits of the Grand Duke, which contains self-portraits executed by the very hands of the most eminent artists of our age.[12] The much acclaimed portrait of a certain Costanza is in the Bernini family collection, while a marble bust of the same woman is in the gallery of the Grand Duke. Both the painted and the marble portrait of Costanza are done in such a fine style and lively manner that even in these copies of her likeness the Cavaliere revealed how much he was in love with the original.[13]

(*Singular Display of Papal Esteem Toward the Cavaliere.*) This Costanza was the woman who had quite captivated the Cavaliere, and even if, because of her, he brought upon himself a certain degree of culpability, the episode in question at the same time brought him the honor of being publicly declared a great man and an excellent artist.[14] It happened that, either out of jealousy toward Costanza or for some other reason, having been sent into a fit of anger—for thus does love blind us—he ordered one of his servants to carry out some sort of affront to her person.[15] The deed was carried out, and, as it was both public and damaging, it warranted punishment of no small measure. Having learned of the matter, the pope gave orders that the servant be condemned to exile, while to the Cavaliere he sent a letter through one of his valets, written on parchment, imparting his absolution for this crime. The letter also contained words of praise for Bernini's talent, which are worthy of recording for posterity. According to the papal letter, Bernini was being absolved for no other reason than because he was excellent in his art, nor were any terms used therein to describe him other than "an exceptional human being, a sublime genius, born by directive of Divine Providence, in order to bring illumination to this century for the glory of Rome."[16]

(*His Drawings in Pencil[17]and Their Value.*) Although during those two years Bernini was occupied in his study of painting, he nonetheless rather frequently changed the focus of his work as a means of pleasant diversion. He thus produced a large number of drawings, which to this day have enriched [28] the principal residences of the most illustrious princes of Europe.[18] The

drawings that merit the greatest praise are those contained in the volumes of the Grand Duke of Tuscany, collected by Cardinal Leopold de' Medici, and likewise those very many sent to France destined for the collections of the most excellent princes of that kingdom, as well as his own self-portrait in pencil, sent as a gift to Charles II, King of Spain, by the Marquis of Carpio. Carpio, Spanish ambassador to Rome, had seen this work in the house of the sons of the Cavaliere and took such a fancy to it that he asked to have it; the portrait was presented to him by he who is writing these words.[19]

(Portraits Done by Him Called Caricatures.) One should not pass over in silence the fact that in this same period and afterward as well, Bernini to a singular degree engaged in that type of drawing commonly called *caricature*.[20] This was a unique product of his spirit, for in these works he would draw in a distorted manner—in jest, as it were—the likenesses of other people, distorting, however, only those features that nature had in some way made defective. Without taking away any of their resemblance, Bernini captured his subjects on paper in a most true-to-life fashion, just as they were in their essence, even though one feature of theirs may be notably altered and exaggerated. This was a genre[21] rarely practiced by other artists, since it is not within the aptitude of all to be able to derive beauty from deformity and harmony from disproportion. Bernini created many portraits of this type. He above all enjoyed caricaturing the likenesses of princes and other eminent personages for the pleasure that they too derived from seeing themselves—and yet not themselves—in these portraits; while admiring the great genius of the artist, his subjects felt flattered by such treatment at his hand. Many of these caricatures can be **[29]** seen in the gallery of San Pastore, that famous villa within the territory of Gallicano, under the custody of the Dominican fathers. In recent times, the villa has been notably enriched in things of beauty and fertile lands through the efforts of Antonino La Cloche, Master General of that Order, which holds it in appanage, to whom the author of the present book gave these caricatures as a pious donation.[22]

(The Cavaliere's Views About the Excellence of Eminent Painters Who Preceded Him and His Statements on the Subject of Painting.) Since the recounting of our story has brought our attention to the paintings of this illustrious individual, it would not be to the detriment of the present work to report for the benefit of others the various observations about the painter's profession that Bernini was wont to make over the long course of his years.[23] Among the foremost of painters Bernini always placed Raphael, likening him to a great sea that

collected in itself waters from all rivers, that is to say, he blended together that which was perfect in all other painters.[24] Second place he gave to Correggio, followed by Titian, and, last, Annibale Carracci.[25] Regarding Guido Reni, he would deliver a judgment in general terms, saying that Reni had been extremely rich in his ideas and therefore all the more appealing in his paintings.[26]

(The Difference Between Painting and Sculpture.)[27] Having once been asked about the difference between sculpture and painting, Bernini replied: "Sculpture shows what is there, painting shows what is not." What he meant was that sculpture is founded upon certain rules of dimension and is obliged to render large what must appear large and to form its subjects in precisely the way they require. Painting, instead, proceeds differently; it knows how and is able to make nearby objects seem distant, render small what is large, and give relief to what is flat. For this reason, painting enjoys a greater facility than sculpture in portraiture. **[30]** This is so not only for the aforementioned reason, which places artists in a greater state of freedom, but also because, thanks to the variety and liveliness of color, painting can more easily arrive at a true likeness of the sitter and render white that which is white, and red that which is red. Sculpture, instead, deprived of the convenience of the array of colors and obliged to work in stone, has the task of rendering its figures lifelike in a most lively but stark fashion without the assistance of artificial color.[28] By virtue of design alone, the sculptor must portray in white marble a face that is in fact reddish and make his creation resemble the original. Our normal experience tells us otherwise: take the case of a man whose face was to be completely deprived of its color; even though his features themselves do not change, he no longer resembles himself.[29] And yet this is precisely what the sculptor must do, achieve a resemblance in white marble. Moreover, Bernini added, a painter can correct errors on his canvases, but the sculptor cannot, for painting consists *of adding,* whereas sculpture, *of subtracting.*[30]

Bernini, furthermore, wanted his students to fall in love with what is most beautiful in nature, for the whole point of art consists in that, the ability to recognize and find this beauty.[31] In executing someone's portrait, the artist must take some quality that is truly characteristic of that person, one that nature has not given to another; however, this must be a beautiful, not an ugly, quality.[32] Finally, Bernini used to remark also that painters who were excellent in imitation were also excellent in art, because it is in imitation that the whole beauty of art resides. Imitation alone renders objects delightful and endearing to viewers; so that, for example, a disgusting old woman seen in

real life provokes nausea, whereas when seen in a well-executed painting, the same woman is a source of delight.[33] **[31]**

(The Cavaliere's Reluctance to Criticize the Works of Others.) In the course of his study of painting, Bernini came to love this noble faculty to such a degree that, had he not already understood after so much direct evidence that his forte consisted in sculpture alone, he would have applied his energies to painting.[34] Nonetheless, such was his esteem for painting and those who practice this art that nothing gave him greater pleasure than to look admiringly at paintings and praise their artists.[35] However, when it was not possible to praise a work, he preferred to remain silent, rather than to speak ill of it. When it was absolutely necessary for him to comment about a painting, he found ways to say nothing even while saying something. For example, it happened one day that he was asked by a cardinal to give his opinion about a cupola that had been painted by an artist in the employ of the same cardinal and who in fact had not done such a good job in this case.[36] Finding it distasteful either to stay silent or to speak the truth, Bernini simply remarked, "The work speaks for itself," repeating that line three times with great energy. The cardinal, who was fond of the artist in question, readily interpreted Bernini's remark as one of praise for the author of this work, whereas many artists who happened to be present laughed silently among themselves, exchanging telling glances with one another.

When later questioned by one of his disciples as to why he preferred not to criticize bad works of art, only beautiful ones, he replied that "it was not necessary to criticize badly executed works because they are in themselves their own censure; beautiful works, instead, can be criticized for their blameworthy features since in criticizing some part of a work, one was in effect praising the whole, for perfection is to be sought by reflecting on the defects that a fundamentally good work possesses.[37] However, in order to bestow great praise on a work, it was not enough that the work have few defects, but, rather, many merits."[38] **[32]**

(His Study of Architecture and Noteworthy Remarks Concerning This Profession.) With equal interest and no less profit, Bernini also devoted himself to the study of architecture.[39] In so doing, he focused his entire attention on the examination of ancient buildings, fragments of which, despite the passage of time, still remained standing amid the ruins of these structures. Of these monuments, Bernini used to say, students must pay more attention not so much to the whole, but to the individual parts, since the ancients placed more

value on the external magnificence and majesty of their buildings than on the personal convenience of those who were to inhabit them.[40] However, he added, "The praiseworthy architect is the one who knows how to combine the beauty of a building with the convenience and comfort afforded to its inhabitants," showing with numerous examples that a great many buildings are for the most part defective in either one or the other of these qualities, and that rare indeed are those buildings that unite both elements.[41] Instead, "the supreme merit of art consists in knowing how to utilize to one's advantage that which is inadequate, defective, and unwieldy in order to create things of beauty, using these features in such a manner that what was originally a handicap is transformed into something useful, so that had it not been there to begin with, one would have been obliged to insert it."[42]

However, Bernini used to say that the true foundation of architecture was the study of antiquity. There was a certain illustrious personage who could not suffer the fact that Borromini[43] had strayed so far from what he learned in Bernini's school and from the good designer he used to be and had instead adopted the Gothic style, rather than that of ancient Rome and the fine modern manner. To this complaint Bernini replied with a smile, "I believe it is a lesser evil to be a bad Catholic than a good heretic."[44] That Bernini himself achieved perfection in such faculties, the works we are about to describe will clearly demonstrate. Let us here simply state that it is a matter of quite universal opinion, **[33]** and one not easily contradicted, that Bernini was among the foremost of artists, even including those of antiquity, in knowing how to unite the fine arts of sculpture, painting, and architecture and, of all of these three, to create in himself a marvelous composite while possessing all of these arts to an eminent degree.[45] He arrived at this state of perfection by means of indefatigable study and by sometimes departing from the rules without, nonetheless, ever violating them, for his motto was "He who does not at times depart from the rule never exceeds it." This, however, is not something for just anyone to attempt.

(Amusing Episode During the Grave Illness of Urban VIII.) During the time in which Bernini was beginning his studies, an episode occurred, which, although provoked by the common folk and therefore in substance much less worthy of reflection, will, nonetheless, not be disagreeable to the reader in its retelling.[46] Gregory XV, as mentioned, had died during a period of great, indeed extraordinary, summer heat that was making itself felt in Rome that year. The cardinals—some fatigued from the preceding functions,[47] others agitated over the imminent papal election—were almost all in a poor state of

health when on July 19 they secluded themselves in conclave. The conclave was expected to be lengthy in its duration, not so much because of the men who were the most favored candidates for the papal throne, as much as for the new ordinance emitted by the deceased pontiff. An idea, in times past, applauded by all of his predecessors and desired by many, but until then promulgated by no one, Gregory's new ordinance called for secret, not public, ballots during papal elections.[48] Therefore, given the agitation created by this new law, added to the great heat of the season, not many days later [34] two cardinals fell gravely ill, Cardinals Cesare Gherardi and Alessandro Peretti Montalto, the one dying before the election of the new pope and the other before his coronation.[49] Cardinal Maffeo Barberini, although of vigorous age and strength of health, nonetheless came in contact with that same disease disseminating among his peers and, immediately upon entering the conclave, fell ill. His illness, if not mortal, was severe enough so that one could reasonably fear the worst. Worsen it did indeed as a consequence of the situation that then transpired.

The eighteenth day of the conclave had already passed when, having eliminated the obstacle of the other competitors, the majority of the cardinals united and agreed upon the election of Barberini. They therefore proceeded with the casting of ballots, enough of which were in his favor. However, after the ballots had been counted, one of them was found missing. Whether this disappearance was because of a deliberate maneuver to block the expected election or some other reason, it opened the way for Barberini's rivals at least to prolong the proceedings. The cardinals in conclave, however, did not make much of the missing ballot except Cardinal Barberini himself, who, the closer he approached that hoped-for dignity, the more ready he showed himself to refuse it. Cardinal Odoardo Farnese, bishop of Sabina, pointed out that the missing ballot, even if it were a contrary one, could not prevent the election, and most of the rest of the Sacred College was also of this opinion.[50] Nonetheless, Cardinal Barberini insisted that Pope Gregory's bull be observed and that they hold a completely new *accessus*.[51] However, the matter did not proceed otherwise than had been widely predicted by all. The cardinals who were already in favor of Barberini came to be even more [35] enamored of his virtue, while those opposed to him were so admiringly impressed by this heroic act of his that in the end, leaving aside his own vote, of the fifty-three ballots cast, fifty concurred in electing him supreme pontiff. Unfortunately, the exertion through which the cardinal put himself in this affair and the physical debilitation that usually occurs in such cases left him at that point so internally deprived of strength that, given his already depressed state of

physical health for the reasons described above, it was inevitable that he would succumb to a full-blown, grave illness, as indeed did happen two days later.

Reports of this illness—believed more deadly than it was, inasmuch as it was so unexpected—spread throughout Rome. The common masses of people with their particular appetite for the latest news (news that then just sends them into a state of confusion) spoke of the illness as already beyond all hope and remedy. Since the coronation of the new pope had to be postponed because of his condition, the people grew even more anxious over the desperate state of Urban's health and thus began to give credit to the new rumor that had begun to spread, namely, that he was already dead and that his relatives, for various motives, were preventing public announcement of that death. Within a few days, this suspicion grew even stronger and the news was no longer discussed as a matter of doubt. On the contrary, indeed, as is usually the case with rumors that rise without foundation and grow without measure, there were even those who claimed to have seen the new pope in his tomb. This belief so grew among the masses that, in order to avoid public disturbance, it was decided that the pope should, as soon as possible, make an appearance at the window of his room, so that all, with their own eyes, could be disabused of this unfounded suspicion.

Word of the scheduled papal appearance was officially announced [36] and there was nobody who, either stimulated by curiosity or desirous of verifying the truth, did not betake himself to Saint Peter's Square, onto which gave the window chosen for the papal benediction. Rising from his bed, the pope made his way to the appointed window, holding on, and not without extreme effort, to the arms of his assistants. However, the gesture was in vain, for the people began to shout that "this was not their Pope Urban, but rather his corpse, which, thanks to some artifice on Bernini's part, was being held intact and moved about as if alive; that they had seen the Cavalier Bernini just a few moments before at that very window and this, therefore, could be nothing more than an invention of his for giving motion to an already dead body." A belief truly worthy of the common masses, but one that nonetheless put no less than a pontiff through much inconvenience. Nor would the people had been shaken from this belief had Urban, restored somewhat to health by the benevolence of heaven, not published notice of his coronation on the forthcoming Feast of Saint Michael the Archangel.[52] With the expectation of this event, confirmed by the event itself, came, finally, recognition of how defective was the comprehension of the masses who have ignorance as their teacher. In any case, Urban thereafter would often remind Bernini in jest of this amusing episode.

Chapter VI

WORK OF THE FOUR METAL COLUMNS CALLED THE "CONFESSIO" OF
SAINT PETER, PORTRAITS OF THE POPE, STATUE OF SAINT BIBIANA,
EMBELLISHMENT OF THE PIERS UNDER THE CUPOLA OF SAINT PETER'S,
AND TOMB OF COUNTESS MATILDA: ALL WORKS EXECUTED
BY BERNINI UNDER ORDERS FROM THE POPE.

(Annibale Carracci's Prediction.) Now, to return to the point from which we digressed, the pope ordered the Cavaliere, as was mentioned, to undertake the study of painting and architecture with the intention of having him paint the great Benediction Loggia and to erect some grand structure that would fill the empty space under the cupola of Saint Peter's.[1] The pope already knew of Annibale Carracci's prediction and was desirous of making it become reality. Annibale had come across Bernini in the temple of Saint Peter's when our artist, still a young lad of about fourteen, was returning from his usual study in the Belvedere.[2] Carracci was in the company of many other distinguished artists and learned men, all of whom, upon exiting the church, turned to gaze upon the vast edifice of that great basilica, which had just been enlarged by Paul V according to the plans of Carlo Maderno with the addition of the nave and the portico. In contemplating the appearance of the church, Carracci declared to his companions, Bernini included among them, "Believe you me, there is to come one day some prodigious genius who, in the center of this basilica and at its far end, will create **[38]** two great structures befitting the vastness of this temple."[3] The young Bernini heard the remark and became lost in thought. Seized by the majesty of such an idea, he was moved to exclaim to himself with his whole heart, "O that I could be that person, that such a wonderful prediction could come true in me!" From this desire was thus born within him the idea that was afterward felicitously transformed into concrete reality during Urban's pontificate.

(The Pope's Orders for the Erection of the Great Structure of the "Confessio" of Saint Peter;[4] Funds Given by the Pope to the Cavaliere.) This prophecy was already known to the pope, and the Cavaliere had offered his services for the accomplishment of this goal. However, no lesser a prince than Urban could have commanded such a work and no lesser an artist than Bernini could have executed it. Bernini communicated his idea to the pope, who, in turn, was so enchanted by it that neither the great expense nor the duration of the project could impede him from ordering its commencement. Urban immediately ordered Bernini to set to work on the project with all due haste, assigning him two hundred fifty *scudi* per month for this purpose.[5]

(Description of the Structure.) Although history would require that we supply a detailed description of this stupendous edifice, we are certain that words alone could never succeed in adequately representing it to the light of the intellect. We have thus decided to pass over this work in silence and do so for two reasons.[6] First, this marvelous structure is not noteworthy so much in itself, that is, for what it contains within itself, as much as for what surrounds and accompanies it.[7] The human eye, therefore, can be its only worthy judge, taking in, all at once, the site, the structure itself, the vastness of the surrounding space (which the work fills without encumbering it), the beauty of the reliefs, and the richness of the materials. Seeing all that it is **[39]** and its proportions, in harmony with everything around it, the eye remains gratified and content. *(The Cavaliere's Modest Remark.)* However, in this process, with the eye transmitting the species[8] of the structure to the imaginative faculty of the mind, the intellect must necessarily affirm the truth of what the Cavaliere used to remark out of modesty, that is, "This work came out well by chance."[9] With this exceptional understatement, Bernini wished to show that he indeed judged the work to be good, but was admitting this with a certain detachment, as if someone else had created the structure.[10] To the aforementioned reason for not giving a description of the *Confessio,* we can add a second: recognizing the truth of what we have just said about the work, many have by now already supplied images of the work in the form of most noble engravings for viewing by even the most faraway nations. In such engravings, however, in my opinion, there is missing the most beautiful and most admirable element, that is to say, the proportion and measure with which the structure harmoniously relates to the basilica. Nonetheless, transmitting to the eye, as if in a mirror, the species of the original, these engraved images, we would like to believe, can create a much greater impression on the imagination than any description furnished by historians.

(Material and Workmanship of the "Confessio.") On the subject of architecture, the Cavaliere advised this by way of general instruction to his disciples: that it was necessary to give one's attention, first, to the material to be used; then to the design; then to the ordering of the various parts; and then, finally, to the conferral of grace and tenderness upon them.[11] He himself therefore, in the execution of this great work, dedicated much thought to each of these components. First of all, regarding the material to be used, Bernini thought that bronze would be quite appropriate and suitable for the majesty of the temple. He thus recommended this material to Urban, suggesting further that they use the bronze architraves still in place in the ancient portico of the Church of the Rotonda.[12] These beams had been preserved by a special act of Divine Providence from the voracity of the Emperor Constans. **[40]** Constans, having removed the tiles, likewise of bronze, with which the Pantheon was covered, was not able, however, to remove the beams as well, since, as we can wisely conclude, Heaven was saving them for a better purpose, in honor of the Prince of the Apostles.[13]

The design was no less precious than the material chosen for the structure. Bernini wanted four immense but well-proportioned columns, along with their foundations and pedestals, to rise up from the floor under the great space of the cupola. These weighty columns would hold up a great baldachin, which in turn was to cover the altar known as the *Confessio*. Surmounting this baldachin and rising in graceful projection from its center would be affixed the cross.[14] Bernini wished to ennoble this design with a miraculous arrangement of all its individual parts, this representing, it seemed, the most difficult aspect of the project. He realized that in so immense an amount of space it would have been futile to attempt to measure out diligently the various dimensions, which would have not easily harmonized with the rest of that temple in its entirety. It was necessary, therefore, to depart from the rules of the profession, a step Bernini resisted taking since he feared that he would find himself lost without their guidance. Nonetheless, he so well reconciled all these contrasting components that in deciding the proportions of the structure, Bernini, in the end, was able to depart from the rules without violating them. Indeed, he himself, on his own, arrived at just the right measurements, for which one would have searched the rules in vain.

(Another Remark of the Cavaliere's Concerning the Same Work.) Regarding this same work, thirty years later Bernini was once asked by Cardinal Sforza Pallavicino,[15] his intimate, dear friend, who, in admiring the structure, wondered "What measure he had used in ordering its parts in so well-proportioned a

fashion, so that from whatever direction in the temple one examined them, they all appeared to have been specifically designed for any viewpoint." **[41]** "The measure of the eye," Bernini replied. "And how could your eye," responded that most astute cardinal, "have been sure of the proportions of the parts before they had been decided and fixed in place?" At that point the Cavaliere either admitting defeat [by the cardinal's logical challenge] or, desiring to appear convinced by it, was concerned only with showing that he had understood Pallavicino; he, therefore, merely bowed his head and gave no response. But the cardinal responded for him, observing that Bernini "had need of no other eyes than those of his own head."[16] Of equal success was the perfection of grace and beauty that Bernini gave to the work: whether one considers the individual parts or the structure as a whole, it strikes one as extraordinary in the former and simply unique in the latter. The testimony of one's own sight alone, to the exclusion of everything else, is enough to confirm the truth of this statement.

This being the case—and it is most true indeed—it is no wonder that as soon as Urban looked at the plans, he was so captivated by them that he ordered the Cavaliere to refrain from spending his time on any other project, the pope fearing that given the magnitude of the project it would be extremely difficult to ensure its realization. However, as eager to be busy at work as he was capable of ever new and splendid works, Bernini undertook many other projects at the same time, these too at Urban's request, because the pope would not, or perhaps could not, frustrate such an exceptional talent as his. *(Praise Received for This Work.)* It was nine years before this splendid work was completed.[17] As for the acclamation that the artist received from the city of Rome, which, thanks to his labors, saw itself adorned with so majestic an edifice, we would like to describe it using the pen of Monsignor Lelio Guidiccioni. In his book, Guidiccioni, a most eminent personage in that period, praised Bernini's structure with the title of "Worthy House of the Apostles, **[42]** Treasury of Heaven, Eternal Edifice, and Shrine of Devotion."[18] *(Remuneration Given the Cavaliere.)* It pleased the pope to convene a special committee in order to hear the opinion of various persons, all of great dignity, as to "the nature of the reward with which the pope should honor the Cavaliere?" It was reported to Urban that one member of this group recommended that "the Cavaliere be given a necklace or chain of gold worth five hundred fifty *scudi*." The pope responded with a smile, saying, "Yes, the gold shall be given to Bernini, but the chain will go to whoever gave this advice."[19] In addition to his usual provision, the pope had ten thousand *scudi* in cash given to the Cavaliere, as well as conferring upon him the title of

Chief Architect of Saint Peter's.[20] Comporting himself both in word and deed as befits the great monarch that he was, Urban furthermore bestowed upon Bernini's brother Vincenzo a canonry in Saint John Lateran, while his brother Domenico received a benefice in Saint Peter's.[21]

(Other Works by Bernini During This Pontificate.) But, as we mentioned earlier, this was not the only project undertaken by the Cavaliere in this period. The pope also ordered his portrait to be done by Bernini, both in marble and in metal, of which he subsequently had to make many others. One of these portraits, full-length, was done by Bernini at the request of the Roman Senate, destined, as indeed happened, for the Campidoglio, to be placed among the worthy heroes of the Roman people.[22] *(Statue of Saint Bibiana.)* However, the statue of Saint Bibiana, which Bernini also created in this period, is for both its tenderness and devotion indeed a miracle of art.[23] Bernini always placed particular value on this work of his, so that even later in life when he was an established master in his profession, he would claim that "it was not he who had created the statue, but the saint herself who had sculpted and impressed her features in the marble." The pope had called for the refurbishment of the saint's church, which, built on the very ruins **[43]** of the ancient palace of Lucian by the Roman matron Olympia, was threatening collapse on more than one side.[24] Since that same site also housed a catacomb extremely rich in the precious bodies of the martyrs, during the excavation of certain portions of the church's foundation, the pope's devotion was rewarded by the discovery of the bodies of the saint and her companions. Not far from that location was also unearthed the statue of the *Hatted Bear,* which from ancient times had given the name to that quarter of Rome. The pope ordered the bear's statue to be placed on the wall of the piazza close to the church, while the body of the saint was transported, with great solemnity and great jubilee on the part of the Roman people, to the Liberian Basilica of Santa Maria Maggiore, where the pope ordered that it remain until repair work on her own church reached its completion. Urban had Bibiana's body put on public display for veneration by the faithful in the church bearing her name, which he had also enriched with paintings by Pietro da Cortona.[25] At the central altar one can see the statue of the saint sculpted by Bernini, who was rewarded for it in a manner truly worthy of such a pontiff.[26]

(Adornment of the Four Piers of the Cupola of Saint Peter's.) Of equal consideration and beauty was the decoration, ordered by the pope, of the four piers that support the great cupola of Saint Peter's.[27] This splendid work of the

Cavaliere's was to be blamed fifty years later by certain persons, either out of malice or ignorance, for causing some sort of movement within the same cupola. This movement had in fact occurred as a result of the settling of the cupola already twenty years before Bernini's birth. But since he who raised this charge did not possess vision capable of penetrating that far into the past, he instead preferred to identify as the guilty party the artist who happened to be closer in sight and place the blame for these defects on his shoulders. Bernini's accuser perhaps did not know that such movement is natural in any large construction because of the settling **[44]** that normally occurs soon after its completion. However, it brings no merit to our present work to indulge in a rebuttal of the charges of those who, in order to acquire glory by challenging an adversary, invent pure fantasies with absolutely no basis in reality. Hence, we will simply describe Bernini's work on the piers and then move on with our narrative, without further ado.[28]

In each of the four piers or pilasters there were two niches, one at the floor level of the basilica and another toward the top of the pier itself. Each of these two niches was in perfect alignment with the other, one immediately above the other. From the lower niche one descended by means of a spiral staircase to the grottoes below the temple, while behind the staircase there was a corridor that extended through the pier itself, terminating in the bottom of a shaft, whose height reached the upper niche of the church. The configuration of these niches and the construction of the pilasters were just as we have here described them, which is just as they are also seen in old drawings made during the time of Julius II by Bramante Lazzari and, after the latter's death, by Baldassarre Peruzzi, and, during the time of Paul III, by Antonio da Sangallo, and, in times closer to us, by Michelangelo Buonarroti and Carlo Maderno. If Bernini's critics, whose words went beyond what they knew or saw, had known of these plans or had seen them, they would not have so easily fallen into an error that is greater and more massive than the cupola itself.

With all of this in mind, the Cavaliere concluded that the upper niches had been reserved for no other purpose than to render them worthy receptacles of some eminent relic, while the lower ones were meant either to serve the same purpose or for some other sort of embellishment.[29] Since large **[45]** construction projects, and that of Saint Peter's in particular, because of their long duration, are rarely brought to termination by the same initial master, those illustrious architects, therefore left the spaces of the shafts empty in order that in time spiral staircases could be constructed in each of them, by means of which one could ascend from the lower to the upper niche. Prudently motivated by these considerations, Bernini decided to bring to completion his

predecessors' design; using as his model the one staircase that they had already built in the pier that presently holds the *Holy Face,*[30] he had the other staircases built, reducing them by two *palmi* with respect to the prototype.[31] With the same caution, he proceeded with the decoration of the niches, having made them more shallow and further reinforced their surface area by means of a substantial revetment.[32] Before doing any of this, however, he had first communicated his intentions to the Congregation of the Fabbrica of Saint Peter's and had received both their approval and praise.[33] He thereby proceeded in earnest with the embellishment, endowing the niches with a majesty that truly befits their surroundings. The four upper niches he decorated with a design both beautiful and noble, while the lower ones were adorned with four colossal statues of marble.[34]

(Statue of Saint Longinus.) In one of these niches can be seen the figure of Saint Longinus with lance in hand, the work of the Cavaliere himself; in the niche immediately above is kept the actual lance itself that pierced the side of our Lord Jesus Christ, donated by Bajazet, King of the Turks, to Pope Innocent VIII.[35] In another niche was placed the statue of Saint Andrew, the work of François Duquesnoy, and in the niche above it is kept the head of that saint, **[46]** transported from the Morea as a gift to Pius II from Thomas Palæologus, the brother of Emperor Constantine of Constantinople.[36] In the third is the colossal statue of Saint Helen, sculpted by Andrea Bolgi,[37] serving as a reminder of a fragment of the true cross of Our Savior unearthed by this saint, while in the last niche there appears, in a beautiful pose, the statue of Saint Veronica, worthy labor of Francesco Mochi.[38] Veronica bears in her hand the image of the *Holy Face,* which had been placed in the niche above by Paul V sixteen years before the addition of this new work. Therefore, not only are these interventions of the Cavaliere's not to be subject to blame, as we shall see more clearly in the remainder of this book, but they also represented an exceptional adornment of this great temple, for which he received great applause from men of culture and admiration on the part of all.

(Tomb of the Countess Matilda.) However, one project had barely been completed, so to speak, when the pope would order the beginning of yet another—if not, as often happened, many new ones—thus keeping the Cavaliere's mind and hands in continual activity. Ever since his days as a cardinal, Urban bore a profound veneration for the illustrious memory of Countess Matilda, who had generously endowed the Apostolic See with the addition of many states, which were called the Patrimony of Saint Peter. Therefore,

arriving at the papal throne and emulating his predecessor, Urban II, by tak-
ing his name, Urban desired from the very beginning of his pontificate to
equal him in deed as well, for that namesake, full of paternal affection for the
countess, had bestowed upon her extraordinary displays of esteem during his
lifetime. Urban VIII's zeal could suggest to him no other means of tangible
expression than that of having close to himself at least the ashes **[47]** of that
princess, whose memory he had always held so deeply impressed in his heart.
Therefore, having had her ashes solemnly transported to Rome from the
monastery of Saint Benedict in Mantua, Urban ordered that they be interred
in no other place than that same church that she had served so meritoriously,
and that in the same temple of Saint Peter's a noble tomb be erected for her.
The latter task was given, as usual, to Bernini, who brought it to completion
in a short time.[39] His contribution to the project was more in its design than
in the execution since the bas-relief was sculpted by Stefano Speranza,[40] his
disciple; the putto above the sarcophagus by Andrea Bolgi; the other on the
right by his brother, Luigi Bernini, who also did the statue of the countess,
with the exception of her head, which was entirely executed by the Cavaliere;
and the two putti above, bearing the coat of arms, by Matteo Bonarelli.[41] It is
not to be doubted, however, that Bernini himself gave to each of these statues
some finishing touches with his own hand. For this project, the artist gained
the affection of the city of Rome, which thereby saw the memory of that
worthy benefactress perpetuated in its great basilica.

Chapter VII

THE CAVALIERE'S ILLNESS AND THE SOLICITUDE OF THE POPE,
WHO PAYS A VISIT TO HIS HOME.
HIS MARRIAGE, CHILDREN, AND COMEDIES.

(The Cavaliere's Illness.) The Cavaliere was about thirty-seven years old when, having completed the aforementioned projects, he was asked by the pope to undertake yet another one.[1] This new project promised to be **[48]** as lengthy in its duration as it was outstanding in its significance: the painting, by his own hand, of the great Benediction Loggia.[2] However, a new circumstance interrupted this wonderful plan and, what is even worse, nearly terminated the Cavaliere's life, namely, a great illness that forced him to his bed with an extremely high fever and life-threatening seizures. This illness was the result of the artist's endless laboring, his habit of undertaking more than one project at the same time—all of them arduous—and, above all, his incessant working of marble, which absorbed him so intensively that he indeed seemed to be in a state of ecstasy and as if he were sending out through his eyes his own spirit[3] in order to give life to his blocks of stone.[4]

(Grave Concern of the Pope and the Roman Court for His Health.) It was indeed now that, faced with the fear of losing Bernini, Rome was given the opportunity of manifesting its great esteem for this man. Distraught beyond measure by the news of Bernini's illness were not only the cardinals and the princes, but the pope himself as well. With great solicitude, Urban saw to it that proper care was procured for the artist, for as the pope later used to remark, if the Cavaliere had died, the greatest asset of his pontificate would have been lost in Rome. The pope therefore ordered his own physician to visit Bernini two times a day, and after each visit appear before him to report on the course of

the Cavaliere's illness.[5] Furthermore, Urban sent Cardinal Francesco Barberini (son of Carlo, his brother and Superintendent General of the Ecclesiastical State),[6] to bestow in his name his blessing upon the Cavaliere and to inquire whether there was anything he needed from His Holiness. Cardinal Antonio, younger brother of Cardinal Francesco,[7] could be found almost continuously at Bernini's home, not without, however, a certain respectful protestation on the part of the Cavaliere in seeing himself in the close company of, and on such utterly familiar terms with, a cardinal prince, nephew **[49]** of the reigning pope and individual of such eminent qualities as Antonio.[8] It often happened, indeed, that all three of the Barberini cardinals found themselves together in Bernini's room, that is to say, the two aforementioned prelates and the other Cardinal Antonio, younger brother of the pope, commonly called the Cardinal of Sant'Onofrio.[9] In this remarkable response to Bernini's illness, it was not merely the case that everyone was simply behaving in conformity with the mind of his prince; instead, there was truly on the part of all a singular esteem for Bernini, so that there was no one who did not at that time display toward the Cavaliere the most particular expressions of affection and solicitude.

(The Pope's Gift.) Because of his long illness, Bernini found himself exceedingly low in spirits. Learning of this, the pope had delivered to him a small vial sufficient in size to store only what could be held by one half of a walnut and containing, tightly sealed inside, a certain liquid. A single drop of this liquid, simply coming in contact with one's lips, would revive the vital forces in marvelous fashion.[10] A gift truly worthy of the affection of that pontiff, who, had it been possible, would have wanted Bernini embalmed and rendered eternal. The Cavaliere subsequently gained each day a greater degree of health. Recovering but not yet strong enough to be able to return to work, Bernini had brought to his room, as if for his own diversion, a few small blocks of marble. Like a convalescent seeking the delights of some garden, he entertained himself, but moderately so, in the carving of various figures, some of which are still to be found in the Bernini family residence.[11]

(The Pope's Visit to Bernini's Home.)[12] The pope was as impatient to see Bernini again as he was to honor him, for Urban well knew that honor is a most potent stimulus to those of noble spirit. He therefore resolved to satisfy this desire of his and, at the same time, reward **[50]** Bernini's talent with an exceptional demonstration of esteem. Accordingly, the pope summoned Paolo Alaleone,[13] his chief Master of Ceremonies, and informed him that "he

wanted that day to go to Bernini's home in order to refresh himself a bit with the sight of his works." He then asked him, "What did he think of such an idea?" Paolo replied that "such a visit did not seem to him to be something that was much in accord with decorum and he thus would not praise this idea." The pope, in turn, replied, "Well then, We shall go to the house of Our nephews and amuse Ourself with their little children." "Oh, yes, I like that idea," responded Alaleone. At that the pope retorted, "You are mistaken in not recognizing the fact that Our going in person to enjoy Ourself with those children would indeed be a true act of childishness, whereas bringing honor of this sort to a man of talent of this caliber will be an act worthy of a prince, an act through which all talent will likewise be honored in both the Cavalier Bernini and others." So, without further ado, that very day, Urban went to visit Bernini's house, in the company of sixteen cardinals, an ample retinue of numerous other escorts, and an infinite crowd of people who had quickly gathered to witness this novelty.[14] In response to this honor, the Cavaliere remained all the more obligated to the pope inasmuch as he discerned in Urban not only a desire to honor him but also a certain particular attraction toward him, which the artist deemed affection, but which, on Urban's part, was, in substance, esteem for Bernini's talent.[15] The Cavaliere, accordingly, threw himself at Urban's feet to receive his blessing. The pope, in turn, commanded him to rise, reminding him, as he had done at the beginning of his pontificate, that he was to be treated with the same degree of familiarity that he, while cardinal, had earlier enjoyed with Bernini. He then asked to see Bernini's house and the works of art that **[51]** at the time were to be found there.

(*His Marriage.*)[16] From that day forward, not only intent on promoting Bernini's best interests, but also desirous of having the artist completely free for himself and less distracted by the domestic concerns of his family, Urban raised the subject of marriage with the Cavaliere, offering to employ his own resources in identifying every possible advantageous match for him in Rome. The Cavaliere responded that "his works of art were to be his only children" and, with that, the discussion came to an end for the moment. But Urban, who had promoted Bernini's career not without purpose, sent for him several days later: through the coaxing of a friend, rather than the authority of a prince, the pontiff succeeded in getting Bernini to agree to take a wife, declaring that it was as his loving friend that he advised this step. As a prince, Urban added, he would, by means of his power, clear whatever obstacles stood in the way of this objective. The Cavaliere was won over by this persuasion and thus

gave his consent. At the same time, however, in order that the matter not be a source of trouble, rather than solace, to him, Bernini begged the pope to leave the selection to him.

(*Qualities of the Bride.*) A short time thereafter, Bernini was made to find precisely the kind of woman he desired, so much so that, as he later said to Urban, he could not have been able to create a better one on his own, had he been able to sculpt her of wax according to his own taste: docile without blame, prudent without guile, beautiful without affectation, and with such a mixture of gravity, affability, goodness, and industry that one could well call her a gift reserved by Heaven for some great man. The woman in question was the daughter of Paolo Tezio, a Roman, whose ancestors had enjoyed singular privileges and offices in the city from the time of Paul III and continued to do so under Urban VIII.[17] The Tezio family had been honored as well by the Senate with Roman citizenship in an ample **[52]** statement of endorsement in which Tommaso Tezio, son of the late Pietro, is described thus: "Born of noble family, he merited election into the order of the Senators; and to his children, grandchildren, and descendants [is given] in perpetuity [the right] to enter the Senate, hold civil office, etc." The same is more amply recorded in the *Senatus Consulta*[18] under the date of March 20, 1601, when the Capitoline Senate was under the leadership of Alessandro Cardelli, Stefano Margano, and Cavalier Muzio Eugenio, and bearing the signatures of the scribes Curzio Martholi and Angelo Fusci. The preceding information was originally communicated to us by Giacomo Tezio, our most beloved cousin, who, along with his extensive family, at present enjoys in Rome the protection, munificence, and favor of the reigning pope, Clement XI.[19]

(*The Children He Had from This Wife and Left at His Death.*) Caterina was the woman's name and she was not more than twenty years of age when given in matrimony to the Cavaliere. Bernini survived her by nine years and at his death left four sons and five daughters whom he had from Caterina,[20] namely, Pietro Filippo,[21] who, having spent thirty-five of his years holding distinguished offices in the Roman prelature, died at approximately the age of sixty toward the end of the pontificate of Innocent XII as judge of the Holy Office; Paolo, who, joined in matrimony to Maria Laura Maccarani, was granted primogeniture by his father's last will and testament and through his noble spouse had two male descendants;[22] Francesco, who, after the death of Pietro Filippo, distinguished the family in similar fashion by receiving the prelate's habit; and, finally, Domenico, who was also granted in his father's

will primogeniture of the family, in case of the extinction of the other frater-
nal lines. Domenico was likewise called to the ranks of the Roman prelature,
[53] but by mysterious disposition of the heavens, having fallen in love with
a respectable and well-bred Roman maiden, joined and is still joined in holy
matrimony with her.[23] Domenico is father of one son and two daughters, as
far as the offspring of his physical body is concerned; but as far as the more
noble offspring of his mind is concerned, he is the author of many published
works, as well as of the present work, which he is writing at the still-vigorous
age of fifty-four.[24] Of Bernini's five daughters, Agnese and Cecilia[25] conse-
crated themselves to God as nuns in the monastery of Santa Rufina in Rome,
where Caterina, daughter of Domenico, also still lives in monastic habit along
with them. Of the three remaining daughters, Angelica was joined in mat-
rimony to Count Giovanni Battista Landi of Velletri, Maria Maddalena to
Marchese Giovanni Francesco Luccatelli of Bologna, and Dorotea to Antonio
de Filippo, a Neapolitan nobleman. De Filippo survived his wife and, because
of his legal expertise, was promoted by Innocent XII to the rank of voting
judge within the two *Segnature,* and was by the same pontiff honored with a
canonry at Saint Peter's.[26]

(*Comedies Composed and Presented by the Cavaliere in His Own Home.*) At a
certain point, the Cavaliere found himself somewhat healed of the long illness
that had afflicted him, but his physical strength still did not permit him to
labor with his hands. Having grown impatient with this state of idleness, he
decided to put his mind instead to work.[27] Since his depressed spirits seemed
to cheer up at the thought of pleasant things, he conceived the idea of com-
posing a few comedies, as respectable as they were exceptional. These he then
showed, in an opportune moment, to Cardinal Antonio Barberini, who not
only gave his full approval of them but also successfully persuaded the Cava-
liere to have them performed on stage.[28] The cardinal was given convenient
opportunity of stimulating Bernini even further **[54]** in this endeavor when
the artist, delighting in his offspring, seemed particularly amenable to some
display of good cheer.[29] Therefore the Cavaliere, either persuaded or com-
pelled, gave his consent to the production.

It is not our intention, nor will it enhance the value of the present vol-
ume, to describe these plays; it will suffice for us simply to comment on
some of their distinctive qualities in order to then conclude with a general
statement about the Cavaliere's theatrical production as a whole.[30] The truly
appealing and marvelous aspect of these plays consisted, for the most and best
part, in their satirical and facetious remarks and in the inventiveness of their

stage sets.[31] The former were so expressive, witty, and rooted in truth that many learned men attributed some of them to Plautus or Terence, and various other authors whom the Cavaliere had never even read, for everything had simply flowed from his own genius.[32] And particularly noteworthy is the fact that often the objects of Bernini's satire were themselves present in the theater, which was filled each night with the most eminent nobility of Rome, both ecclesiastical and secular. Not only were these personages not offended by what they heard, but they also all but boasted of being made the targets of Bernini's clever and penetrating remarks, recognizing therein a conjunction of decency and truth.[33] Bernini's clever remarks would subsequently be repeated by all the mouths of Rome; indeed, many times they reached the ears of the pope himself that very same evening. Seeing Bernini the next day, the pope would have him repeat his witticisms again, giving unconcealed signs of pleasure over them.[34]

Not only did Bernini place much effort in composing his comedies, but he also went through no small amount of trouble to ensure that the individuals chosen to play the parts did so with utter naturalness and verve. Most of the actors were in fact members of his own household, with no experience of the stage.[35] In this, Bernini was as a master to them all, and all of them therefore went on to perform as if veteran [55] professionals in the field. When it came to having to mix the fruit of his genius with the work of his hand, that is to say, in the invention and creation of the stage sets, the Cavaliere proved himself to be not only exceptional but also truly unique.[36] In his famous play, *The Flooding of the Tiber,* he made great quantities of actual water come forth from the distance, which, at the most appropriate moment within the action of the play, burst through their barriers at certain points that the Cavaliere's clever handiwork had already weakened for precisely this purpose. The water then flowed across the stage and spilled over with a rush toward the seats of the spectators. The latter, in turn, taking this simulation for a real flood, became so terrified that, believing an accident that which was in fact done artfully on purpose, rose in haste to escape; some climbed atop the benches in order to raise themselves above danger and in the general chaos trampled over everything between them. Then, all of a sudden, with the opening of a trap door, all of that great quantity of water was drained away, without any further harm to the spectators beyond the fright they had experienced.[37]

In another play, entitled *The Fair,* Bernini re-created on stage a carnival parade float, accompanied by large open-air torches.[38] One of the torchbearers, responsible for executing the practical joke, kept brushing the scenery with his torch as if he were swinging it in the air in order to increase its flame,

as is usually done atop city walls. Some of the spectators, as well as others behind the scenery, began to shout out loudly for him to stop, given the danger of possibly setting fire to the canvases. The behavior of the torchbearer and the shouting of these individuals provoked in the audience a spark of fear that soon erupted into full-fledged terror [56] as they saw the scenery and most of what else was on the stage burning with a deliberately created but innocent flame that, slowly spreading, threatened to ignite a universal conflagration. Such was the terror of those witnessing this scene that someone actually died in the rush to escape the anticipated peril. However, at the height of the confusion and conflagration, with marvelous orderliness, the scenery was transformed, and the fire that appeared to be burning on stage became a most exquisite garden. Among the spectators, a sense of wonder prevailed over the terror caused by the blaze, and everyone, in a state of astonishment, dismissed his fear, breaking into praise for the clever deception.[39]

In another play, Bernini set up two theaters, with two audiences, one opposite the other: the one that was the true audience faced the stage, while the other, the fake one, was placed at the rear of the stage, leaving the stage itself to appear as if it were in the middle of two theaters. Amid the simulated audience were actors resembling some of the more noteworthy personages sitting in the real audience, and what a delight it was for all to see the latter individuals pointing to one another and to see the real personages reflected in the fake ones as if in a mirror. Then, in the end, the real audience watched the fake one leave its theater, some in carriages, some on horseback, and others on foot, the curious sight of this new play lasting a full hour after the play itself. Bernini later replicated this same device in a more majestic performance in the house of the Rospigliosi during the pontificate of Clement IX.[40]

(His Clever Response to the King of France.) No less delightful was the clever machinery of the *Rising of the Sun* that he staged in the play known as *The Marina.* So great was the praise that the Cavaliere won for himself for this piece of scenery and so much did it enhance the quality of the play that [57] Louis XIII, King of France, requested, through Cardinal Richelieu, a model of the machinery. Bernini sent it immediately along with precise instructions. However, at the end of his instructions, with his usual wit, he added the following words: "This machinery will work successfully only if I send you my own hands and my own head as well."[41]

In addition to these plays, Bernini also produced one called *The Palace of Atlantis and Astolfus.*[42] He said, furthermore, that he had in his head some wonderful ideas for a play in which all the mishaps that occur in the working

of the machinery were acted out, but followed by a demonstration of the appropriate remedies.[43] He also had in mind ideas for another and no less delightful play about *How to Regale the Ladies in the Theater.*[44] *(Remark by Bernini Regarding All of His Plays.)* And Bernini used to say that the best part of all of his comedies and their sets consisted "in making that which was, in fact, artificial appear real."[45]

Chapter VIII

Now, if Bernini showed himself so exceptionally capable in what was not his profession, how capable must we believe him to have been in that domain where his true talent, refined by study and by practice, resided? *(Another of His Notable Sayings.)* And as he used to say, "The good artist is the one who knows how to create things of beauty by finding ways to make use of what is deficient and defective."[1] He himself was truly marvelous **[58]** in proving the truth of this statement in his own works.

(Fountain in the Piazza di Spagna.)[2] Below the Pincio Hill, in the piazza that bears the name of Spain, an outlet for the Acqua Vergine had been devised in order to construct a fountain for the embellishment of that locale. However, the extremely low level of the water made it difficult to create a fountain that would bring opulence and majesty to that most exquisite site.[3] Urban assigned this task to Bernini so that the usual inventiveness of the Cavaliere's genius would thereby shine forth and would, by means of some artful form of gradient, find a way to get the water to rise up higher from the ground. To this request the Cavaliere wisely replied that "In this case one had, instead, to adapt the task and the fountain to the water, and not the water to the fountain."[4] He therefore conceived the idea of an attractive and noble structure that would have required limiting the height of the water, had it not already been low. Bernini explained to the pope that he would excavate as much soil as necessary to create a cavity into which a large basin would be inserted: filling up with the water of the fountain, this basin on ground level would

represent the sea. In the middle of this sea, he wished to have floating a noble, appropriately designed ship made of stone, which from multiple directions would shoot forth an abundance of water in the manner of military cannon fire. *(Pope Urban's Verses About That Fountain.)* The plan exceedingly pleased the pope, who without further delay gave orders for its execution and who himself condescended to ennoble the design with the following verses:

> The war machine of the popes does not shoot forth flames,
> but sweet water by which the fire of war is extinguished.[5]

(An Anonymous Reply to the Pope.) Bernini's brilliant solution to the challenge of this fountain was praised by all, while the two papal verses were received with great applause by men of letters. One of the *literati,* however, was either sincerely impressed by **[59]** the acuity of this poetic conceit (so appropriate to the fountain that it seemed impossible for it to have been born after the fact), or else was disposed to thinking the worst. And in thinking the worst, he went on actually to believing it, and, in believing it, to finally publishing what he thought. So he replied with the following clever but audacious distich:

> A fountain for his verses, and not his verses for a fountain,
> did Urban the Poet fashion: thus does everyone please himself.[6]

(Fountain for the Villa Mattei.) Bernini encountered the same challenge in a fountain that he had to design under commission from Duke Girolamo Mattei. The fountain in question was intended for the duke's villa, located on the Celio Hill and known as the *Navicella,* the "Little Ship," taking its name from a small stone boat erected there in the period when Leo X served as titular cardinal of the nearby church of Santa Maria in Domenica.[7] The jet of water coming from this fountain was likewise incapable of reaching any significant height. Bernini therefore fashioned the fountain as Mount Olympus, surrounded at its base by clouds, which, unable to reach the summit of that most high mountain, instead emitted forth at that lower level an abundant supply of water. Above the mountain, he placed an eagle poised in sublime flight, an allusion not only to the coat of arms of the Mattei family but also, and most appropriately, to the mountain.[8]

(Fountain in the Barberini Garden at the Bastions.) But Bernini did not display his genius only when faced with the challenge of water of low elevation; his brilliant solutions were likewise rewarded with no less glory when water itself

was in short supply and the artist, by dint of his own skill, had to make what little water there was appear more copious. In the garden of Cardinal Antonio Barberini "at the Bastions," Bernini, faced with a scarcity of water, designed a charming fountain in the form of a woman who, with her hands, is squeezing the water out of her just-washed hair. Fom her hair flowed, in the form of most delicate sprays, as much water as **[60]** the fountain was capable of emitting, which was, at the same time, as much as the statue itself required.[9]

(And Another Fountain in the Vatican.) When creating a fountain in the Vatican garden, Bernini was constrained by the same scarcity of water. The said fountain featured three bees that represented the Barberini coat of arms and that, from cleverly juxtaposed positions, emitted from their mouths the most minute sprays of water. Underneath the bees, Urban himself, it is said, had these two most noble verses engraved:

> Why do you marvel if the bee, which draws honey from flowers,
> pours from its throat honey-sweet water for you?[10]

(Clever Play of Bernini's Genius in a Window of the Aracoeli.) Bernini made use of the same play of bees on Urban's coat of arms in the church of the Aracoeli in quite a different context, though in an equally ingenious fashion. Obliged to place the coat of arms in a location already occupied by a window, he designed the work in such a way whereby, if a window had not been there in the first place, it would have been necessary to insert one. The Cavaliere colored all the window glass blue and depicted on it three bees that appeared to be flying gracefully through the air; and above this large window he placed the papal tiara.[11]

However, when the Cavaliere's art was given what it required in order to allow free rein to his genius, that is to say, an abundance of water and an appropriate site, there was no one who equaled him as far as fountains were concerned, for the beauty of their design, the magnificence of their construction, and the skill of their workmanship. We will not, for the moment, speak of the marvelous fountain of the Piazza Navona, about which we will have a great deal to say in the course of our discussion of a later pontiff. *(Fountain in the Piazza Barberini.)* The pope had ordered from Bernini the design for his nephews' palace, which is the one that at present is seen near the Quirinal Hill rising up upon the ruins of the ancient *Circus of Flora,* exceptional and majestic beyond all **[61]** that its reputation is able to convey.[12] For the square, which draws its name—Barberini—from this palace, Urban also wanted a design

for a noble fountain, whose construction was completed even before that of the palace.[13] For this project, the Cavaliere put both his genius and his own hands to work: he designed a fountain that depicted three dolphins holding a large basin and, above the basin, the handsome, lofty figure of Glaucus, who, blowing into a resonating conch shell, sends forth from the shell an abundance of water, together with a pleasant murmuring sound. Although by then old and feeble, Urban had himself carried to the fountain in order to admire it with his own eyes. The fountain earned fame and applause for Bernini from all those who marveled at how rich his mind was in beautiful ideas, so that on every occasion he knew how to be true to himself, that is to say, to be great in all things.[14]

(*Other Works by the Cavaliere.*) In a city like Rome, desirous of novelties, and under a pope like Urban, promoter of exceptional enterprises, and, further, with the convenient presence of an artist both indefatigable and outstanding in his art, new marvels were never lacking in those years. The Cavaliere had at this point finished the bas-relief situated above the main door of Saint Peter's, in which he sculpted the figure of Jesus Christ saying to the Prince of the Apostles, "Feed my sheep."[15] At the same time, he also had produced a design for the palace of the College for the Propagation of the Faith, that is, for the facade facing the Piazza di Spagna, which threatened collapse.[16] For the facade, Bernini conceived a most noble plan by means of which the weak portion of the wall that was the source of apprehension came to be both embellished and fortified. He devised his design in such a way that its ornamentation actually served the practical need at hand, so what was born out of necessity added beauty to the design. This is a fact that those uninformed **[62]** of the particulars of the project would never even suspect.

(*Bell Towers on the Facade of Saint Peter's and the Cavaliere's Vigilance and Caution in Their Construction*). Bernini had completed these two projects when, all intent on rendering ever more exceptional the temple of Saint Peter, Urban ordered Bernini to bring to completion, in conformity with the old plans for the basilica, the two bell towers on either side of the facade. The towers had been begun by Paul V but were raised no farther than the level of the balustrade, with which the summit of the facade terminates.[17]

This was a project of great significance and, hence, the planning process was all the more vigilant. The bell towers were going to be seen alongside other, most splendid structures, such as the great cupola, the facade, and indeed the entirety of that magnificent edifice. The thought of having to compete

with the work of so many other famous architects on this, the principal temple of Christianity, together with the universal expectations of all, rendered this project extremely laborious and challenging for the Cavaliere. However, lifting themselves above the common understanding of other people, great minds uncover in their work difficulties never approached by others and, in overcoming these difficulties and bringing to fruition works of complete perfection, they thus render themselves all the more outstanding. This was true also of the Cavaliere: for him, the challenges encountered in this new project served simply as a whetstone upon which to sharpen his mind while creating these admirable structures. He resolved therefore to devise a most beautiful design for the towers together with a model, which received the approval of this wise pontiff and the general applause of all the cardinals of the Congregation of the Fabbrica.[18] The design was composed of three orders of columns and pilasters—the first, *Corinthian;* the second, *Composite;* and the third, of smaller height, *Attic*—in addition to the pyramidal finial that completed **[63]** the bell tower.[19]

However, before putting his design into execution, Bernini did not want to set his hand to work without first testing in some fashion the solidity of the foundations. Although it seemed to him safe and prudent to raise the structures upon foundations constructed for that very purpose by Carlo Maderno, he nonetheless requested that the Congregation of the Fabbrica summon for formal consultation two of the leading master masons in the city, one by name of Giovanni Colarmeno and the other, Pietro Paolo.[20] Both were men of great expertise in their profession and both had, at the time of Paul V, been present at the laying of these foundations. Each attested to the complete structural integrity of the foundations, which had been expressly commissioned from so eminent an architect as Carlo Maderno in order to serve as a base for the erection of bell towers. The two master masons themselves had worked on the building of the foundations and, therefore, saw no cause for doubting their stability. The Congregation formally declared its complete agreement with their assessment and ordered the Cavaliere to begin his work. The pope, paying close attention to this entire affair, was also of the same mind.

The first of the two bell towers—the one on the right-hand side of the church—was thus erected; a pyramidal finial was then constructed out of wood in order to see what appearance it would have.[21] The tower succeeded in so nobly complimenting the facade and the marvelous entirety of that temple that it was universally applauded by all of Rome.[22] All that was then lacking to satisfy the public's desire was to see this one tower matched by its counterpart, still to be built. But Death came and seized the life of Urban, thus

delaying the construction of the second tower, which undoubtedly would have taken place under his successor, were it not for the most unjust conditions of princely realms, wherein it often happens that the jealousy **[64]** of one individual prevails over the virtue of many, to the detriment of the public good and the traducement of truth.[23]

Chapter IX

WORKS COMMISSIONED OF BERNINI BY THE KING OF SPAIN,
THE DUKE OF MODENA, THE KING AND QUEEN OF
ENGLAND, AND CARDINAL RICHELIEU. INVITATIONS FROM
THE KING OF FRANCE AND CARDINALS RICHELIEU AND MAZARIN
TO GO TO PARIS.

Nonetheless, Bernini's reputation continued to grow ever greater in all parts of Italy. Indeed, with each passing day his name became more famous throughout the world, thus attracting to him the greatest potentates of Europe, who seemed to be in competition among themselves to obtain some work of his hand. *(Bronze Crucifix for the King of Spain.)* Philip IV, King of Spain, requested and obtained a bronze crucifix, larger than life-size, which he placed in the great chapel of the tombs of the kings; as an honorarium for this work, Bernini received a large gold chain.[1] *(Portrait in Marble for the Duke of Modena.)* Francesco d'Este, Duke of Modena, commissioned a portrait of himself from Bernini's hand;[2] Cosimo Scarlatti, a member of the Cavaliere's household who delivered the bust, received a gift of two hundred *ungheri,* while the artist himself received a thousand *doppie.*[3] *(And for the King of England; His Letter to the Cavaliere.)* Charles I, King of England, likewise desired his portrait in marble from the hand of Bernini[4] and sent his most gracious request by means of a letter, whose contents we would like to relate and are as follows: **[65]**

Signor Cavalier Bernini,

The fame of your sublime genius and of the illustrious works that you have so felicitously brought to fruition has extended beyond the frontiers of Italy and, indeed, nigh beyond those of Europe itself, and has brought to our England your glorious name, exalted above those of all men of talent who have exercised your profession to this day. Thus, eager to have some share of your talent so rare and encouraged, as well, by your

goodness, We have been moved to ask you, as We now do, if you would so kindly agree to execute Our portrait in marble. Said portrait would be based on a painted version that We shall send to you as soon as We have been made certain of your kind intention to do so. We assure you that it is Our desire to make Our tangible response[5] proportionate to Our great esteem for you. May the Lord God hold you in His holy safekeeping.

Charles, King of England

Whitehall, 27 March 1639.[6]

Bernini executed the portrait with the pope's permission, the king having sent beforehand his portrait on canvas. The latter was admirably painted by Anthony van Dyck from three different perspectives, one *en face* and two in profile. It is currently to be found among the other pictures in the Bernini family collection.[7] Once he had completed the commissioned likeness with his usual solicitude and mastery, Bernini shipped it to His Majesty in England, sending one of the members of his household, by the name of Bonifazio, to accompany it on the voyage.[8] The king received the portrait with a satisfaction that was as intense as the eagerness with which he had first desired it. After having examined the bust with great admiration and pleasure, he removed from his finger a diamond ring worth six thousand *scudi* and presented it to Bonifazio, saying: "Crown that hand that has created so splendid a work."[9] **[66]** The king, moreover, sent to the Cavaliere copious gifts in the form of most precious fabrics, and to Bonifazio he gave a gratuity of one thousand *scudi*.[10]

(The Queen's Request for Her Portrait; Her Letter to the Cavaliere.) The queen[11] as well was so delighted with the king's portrait that, desirous of having one of her own person, hastened to request it by means of this letter:[12]

Signor Cavalier Bernini, the esteem that my Lord the King and I have for the statue that you have executed for him is commensurate with the satisfaction that We derive from it as an object deserving the approval of all who gaze upon it. Such esteem obliges me now to inform you that, in order to render my satisfaction complete, I would greatly desire likewise to have one of myself executed by your own hand, using as your model the portraits that shall be delivered to you by Mr. Lomes.[13] I am depending upon the same gentleman to assure you more specifically of the gratitude that I shall have for the pleasure I expect of you on this occasion. I pray that God may keep you in His protection.

Henrietta Maria, Queen

Whitehall, 4 August 1639.

However, new turmoil of rebellion arose in that ever-disputatious kingdom, followed by those woeful events that are, unfortunately, well known to us; these diverted the attention of the queen and the preparations of the Cavaliere, so that the portrait in question was never completed.[14]

(*Portrait of an English Lord.*) After Lord Coniik had seen the bust of the king, there was inflamed in his heart so ardent a desire for a similar portrait of himself that he betook himself expressly from England to Rome in order to commission the work.[15] **[67]** However, advised to ascertain before undertaking the journey as to whether he could have some assurance of a positive response to his request (since Bernini did not accept commissions from just anyone), he replied: "I shall reward him just as the king has done, and not a penny less." He arrived in Rome and not without effort managed to obtain the desired portrait; presenting the Cavaliere with a gift of two thousand *doble,* he returned to his homeland, much satisfied.[16]

(*Portrait in Marble of Cardinal Richelieu.*) A little less than a year before his death, Cardinal Armand de Richelieu wrote from Paris most pressing letters to Cardinal Antonio Barberini (who, as he knew, enjoyed a most intimate friendship with the Cavaliere), seeking to obtain from the artist his portrait in marble.[17] Cardinal Barberini was obliging in this service and succeeded in obtaining the desired work. Once Bernini had completed the bust, which shows the cardinal at the age of approximately fifty-seven years, he had the work presented to Richelieu in Paris by Giacomo Balsimelli, a member of the artist's household, with the following letter:[18]

Most Eminent and Most Reverend Lord and Most Venerable Master,[19]

My Lord, the Most Eminent Lord Cardinal Antonio, with extraordinary gravity, expressed his wish that I undertake the sculpting of a statue of Your Eminence. In so doing, his authority found my spirit most accommodating since it had already been prepared by the earnest ambition I have indeed always nurtured of demonstrating my devotion to Your Eminence's sublime greatness. Nor would I ever have reckoned myself to have counted for anything in this century if I had neglected to be of service to one who has rendered it so illustrious. The impatience that I feel for arriving at such glory has expedited the completion of the present portrait, so that if Your Eminence will judge this modest effort of **[68]** *mine worthy of your chamber, you might have something in Your presence to serve as a constant reminder of my devotion. It behooves me at the same time to make an appeal to your benevolence, in seeking to excuse myself by beseeching*

Your Eminence to be so kind as to bear in mind the disadvantages created by the long distance between us.[20] *If I have succeeded in worthily serving Your Eminence, do believe that in so doing I have been assisted by the holy God whose favor You have known how to obligate to yourself by means of your own virtue. May Your Eminence's grace permit that I continue to call myself*

> *Your Eminence's*
> *Most humble and most obligated Servant,*
> *Gio. Lorenzo Bernini*

Rome, 16 March 1642.[21]

(*Remuneration He Received for It.*) That prince was greatly pleased with the portrait and manifested his pleasure with a gift that he sent to the Cavaliere in the form of a piece of jewelry containing thirty-three diamonds, seven of which weighed fourteen grains each.[22] He presented Balsimelli with a gratuity of eight hundred *scudi* and, through the two cardinals, Antonio Barberini and Jules Mazarin,[23] requested from the Cavaliere another statue of himself, complete and in full figure. (*Another Letter from the Cavaliere to the Cardinal.*) The Cavaliere confirmed his intention of executing the latter work with the letter that follows:

Most Eminent and Most Reverend Lord and Most Venerable Master,

I knew not how to bring myself to thank Your Eminence for the most precious gift you have deigned to bestow upon me since, aware of my scant merit, I feared that in so attempting I would offend your greatness, which conducts its affairs with no other measure or standard than itself. However, it behooves me, for my own sake also, to draw the attention of all upon so bountiful a display [of largesse], in the hope that the value of such remuneration might perhaps accrue **[69]** *to the portrait that I sculpted of Your Eminence. Thus the work itself might in turn acquire that value which the hand of its maker was incapable of bestowing upon it on his own. More than any other jewel, I hold in greater esteem the praise that I receive from he who is now alone the object of universal encomium. And even though I am aware of being quite undeserving of such praise, I nonetheless dare not be the sole man in this age to contradict Your Eminence's most refined judgment. Nor must I do other than believe that you were satisfied with the bust, since through Lord Cardinal Mazarin I have learned that Your Excellency desires that I have the consummate honor of executing a full statue of you. I hold vividly in my mind the commission already delivered to me by Lord Cardinal Antonio regarding this work and am pleased to receive further confirmation thereof in the form of Lord Cardinal*

Mazarin's own entreaties of me. Most powerful a stimulus within me will ever be the ambition that I nurture to have myself known as

> *Your Eminence's*
> *Most humble and most obliged Servant,*
> *Gio. Lorenzo Bernini*

Rome, 24 May 1642.

However, the death of the cardinal intervened at the beginning of the last month of that same year, and this second portrait never came to its desired fruition.[24]

(First Requests from Louis XIII, King of France, to Come to Paris.)[25] The greatest praise of which the first portrait proved worthy was, however, the admiration of the King of France himself, to whom the cardinal had shown the bust. The kingdom of France was at that time under the rule of Louis XIII, called "the Just," who, having defeated the heretics[26] and many other enemies, was working, with abounding success, toward the establishment of those arts that are wont to render all dominions blessed and glorious in time of peace, no less than in time of war. **[70]** Desirous, therefore, of having in his kingdom a man of such renown as Bernini, the king several times made known this desire to Cardinal Richelieu, who, in turn, engaged the services of Mazarin, in order that an invitation be extended to the Cavaliere to come to Paris, with an annual provision of twelve thousand *scudi,* together with the king's promises of every other form of most substantial assistance. Louis became even more determined to dedicate all of his resources toward this goal when he set eyes upon the marble portrait of the cardinal and could see sculpted therein the talent of the Cavaliere. Perhaps they were not so far from the truth those who said that Cardinal Richelieu had asked the Cavaliere for a full-figure portrait of himself precisely in order to satisfy the king's desire and effectively lure Bernini to France, since a statue of such dimensions would have been difficult to execute at so great a distance. On more than one occasion, Cardinal Mazarin strove to communicate this sentiment to the Cavaliere in the many letters that the prelate wrote to the artist from Paris.[27]

(Reciprocal Friendship Between Cardinal Mazarin and the Cavaliere.) Since both men possessed talent of similar degree, Mazarin had cultivated a most special friendship with Bernini from the time when, having withdrawn from the position of papal vice-legate at Avignon, Mazarin was residing in Rome with

no particular employment, but not without great opposition from those jealous of his favor in the eyes of the pope.[28] Mazarin was subsequently called to France by the king, Louis XIII, and, not long thereafter, promoted to the cardinalate, thanks to the efforts of the same monarch. The cardinal at that point began to attempt to persuade Bernini even more insistently to come to France, taking advantage of the intimacy that had long existed between them. *(A Noteworthy Remark by the Pope.)* Truly the Cavaliere would have accepted the invitation of so great a monarch had he not wished to respect the will of the pope, of whose benevolent protection the artist was ever mindful. The pope, for his part, was decidedly against Bernini's accepting such an invitation [71] and told him so directly, repeatedly insisting—using an expression whose intended message went beyond the literal words—that the Cavaliere "had been made for Rome and Rome for him." Therefore, to the entreaties of Mazarin, who every day further pressed for a decision, the Cavaliere yielded only somewhat: he did not promise to go to France, but in order to cease having to refuse and having to be begged, he simply deferred the matter, believing that he could in this way avoid the journey altogether. In any event, King Louis died at the height of these negotiations, just as five months before him Cardinal Richelieu had died as well. With the attention of the French court focused upon other matters, the issue was dropped after a short while, only to be renewed, if in vain, after the death of the pope.

(Cardinal Mazarin's Letter to the Cavaliere.) All of this is rather clear from a letter, among the many written by Cardinal Mazarin himself, dated 27 August 1644, that is, twenty-nine days after Urban's death. The letter states:[29]

Signor Cavalier Bernini,

Signor Cavaliere, Your Lordship would have committed an offense against your own merit by doubting my ever constant goodwill on your behalf. Wherefore I would be pleased to believe that you, aware of the grave matters that without respite have occupied me, will have pardoned the tardiness with which I send you the enclosed letters of commission. I have asked my agent, Benedetti,[30] to deliver the letters to you together with the most lively expressions of my affection and esteem, as well as my reassurance that at every time and in every place, I will embrace with particular pleasure all opportunities to advance your interests and glory when you are here in His Majesty's service, as Your Lordship will very much have occasion to recognize. I shall be here awaiting you in the near future, on the basis of the expectations that your own letter of the 16th of last

month raised in me **[72]** *and as has been reported to me by my agent, on whom I now rely to extend to you my most sincere wishes for every true happiness.*

With most heartfelt affection,
Cardinal Mazarin

Paris, 27 August 1644.

However, the Cavaliere, grateful to Urban's memory and in that moment occupied with the sculpting of the same pope's tomb, deferred his departure. That journey did in fact take place at a later date, as we shall see, during the pontificate of Alexander VII, resulting in even greater glory for Bernini.

Chapter X

THE TOMB OF URBAN VIII DONE BY
THE CAVALIERE. DEATH OF THE SAME PONTIFF.

(The Pope's Speech to Bernini.) While these matters were being pursued, Urban himself, already of unstable health and elderly, was turning his thoughts to life's end and decided to give thought as well to his own tomb. One day, therefore, with an unusual degree of intimacy, his spirit moved by presages of his own approaching death, Urban broke forth in a manifest expression of tender affection toward Bernini, speaking to him in the following terms: "Cavaliere, you have accomplished great things in so little time, through which both Our pontificate and your name have been rendered glorious. But now that We find Ourself in Our declining years, all that remains is for you to prepare Our tomb and for Us to prepare for death. We are certain that there will have been no other commission from Us to you more solemn than this."[1] At this point, the pope gave utterance to sentiments of such great affection toward Bernini, and continued on with so great a love in extended discourse with him, that in the end the Cavaliere could well comprehend how constant had **[73]** been the heart of that pontiff in its predilection for him. Bernini, therefore, arrived at a design for the tomb, in which, it seemed, he had gathered all of his inner resources in order to create something truly superior to any work of art. As a result, anyone who might undertake the journey to Rome merely to see the singular qualities of this one monument can be certain of putting to excellent use not only his time but also his money and energies.

(Pope Urban's Tomb in Saint Peter's; Description Thereof and Acclaim Received.) Urban's tomb is situated to the left of the great chapel of the *Cathedra* within

a spacious niche opposite the tomb of Pope Paul III, which at the orders of Paul V had been moved there from the niche of the *Holy Face,* where it had previously been located.[2] By the writers of that age, the tomb was celebrated as a "Miracle of Art," "a Design never before seen," and "of insuperable Mastery." "Marvelous is the artist," it was also exclaimed, "who conceived and sculpted such a work."[3] When two years after the death of Urban the tomb was unveiled in the presence of Innocent X, even this pope, who in that period bore little affection for Bernini, as we shall later see, was moved by the sight to remark to Cardinal Panciroli, his secretary of state, "People speak ill of Bernini, but in fact he is a great and rare specimen of a man."[4] *(A Noble Madrigal upon the Same Tomb.)* Accordingly, the cardinal, who was instead well disposed toward the Cavaliere, was inspired to compose the following verses, which all will be pleased to read, inasmuch as they represent the fruit of a most elevated mind:[5]

> Bernini has crafted the great Urban so alive
>> And has so infused these rigid bronzes with the soul of the deceased,
> That, in order to dispel anyone's mistaken belief, Death itself
>> Stands on the tomb to show that the pope is in fact truly dead.

(The Cavaliere's Response to Someone Besmirching Urban VIII's Reputation.)[6] Likewise we must not neglect to record a most clever reply that, in testimony of his unalterable devotion to Urban, the Cavaliere gave to a **[74]** personage of high rank, who had indeed little affection for the Barberini family. Here and there on the urn of the pope's tomb, Bernini had placed an array of bees, as a pleasant allusion to Urban's coat of arms. Observing this decoration, the personage, in the presence of other company, turned to the Cavaliere and said with a smile: "Signor Cavaliere, by placing these bees all over the urn, Your Lordship intended to make reference to the dispersal of the Barberini family." (In that period, the members of that house had taken up residence in France, out of their antipathy for the reigning pope.)[7] Without missing a beat, Bernini retorted, "Your Lordship, however, must well know that these bees, at the next sounding of the Big Bell, will return to reconvene once again," the latter being an allusion to the great bell of the Capitoline Hill that rings at the death of each pope. For this remark the Cavaliere won much praise, since, as anyone who reflected on the matter knew, given the circumstances of that time and place, it was at great personal peril that Bernini continued to be faithful to the memory of his benefactor.

(Death of Urban VIII.) Urban himself was able to admire the tomb's design, but he never lived to see the finished work itself. Construction of the tomb began at the beginning of the month of March 1644, and on July 26 of the same year the pope died, having lived for seventy-seven years and reigned for twenty-one. The memory of his pontificate was celebrated with great praise by the most distinguished ranks of society, but the common masses were little pleased with Urban's reign. This was so because, looking at the mere surface of things, the masses are wont to attribute the prosperity of a principality to its ministers, while all blame for its adversities they instead place on the shoulders of the prince alone.[8]

Chapter XI

ELECTION OF INNOCENT X. THE CAVALIERE'S ENEMIES
IN THE PAPAL COURT. DEMOLITION OF THE BELL TOWER OF SAINT PETER'S.
THE CAVALIERE'S TEMPERANCE AND VALOR.
HIS WORKS EXECUTED IN THIS PERIOD.

(Reputation of Urban VIII's Pontificate.) But with the change in government, Rome saw changes in fortune beyond what one would normally expect. Urban's memory was hateful to some who unfairly blamed that prince for the length of his pontificate, and offensive to many who focused their attention upon those calamities—memory of which was fresher in their minds—that had kept Urban's government in a state of agitation during the last years of his reign.[1] Yet for most people, especially those of more discerning minds, the late pope's memory was a glorious one for many years of his reign and negative only for a small portion of it, since they knew how to distinguish the actions of the ruler from the evil and constraints of the times. Consequently, as one usually finds in courts, everyone talked not as he should, but rather as swayed by his own passions. *(Election of Innocent X.)* However, even greater was the agitation that stirred the conclave convened for the election of the new pontiff. The cardinals present there were, almost to a man, all creations of the deceased Urban. Thus they would have easily been favorably disposed toward the Barberini, had not the competition among them for that same office and the present equality of their status caused the memory of the benefits they had received from that family to turn cold in the hearts of some of their number. The Barberini could not truly find consensus in the person of Cardinal Giovanni Battista Pamphilj and so for a while kept him excluded from the papal threshold. **[76]** However, the persuasive discourses and labor of Cardinal Giovanni Giacomo Panciroli, supporter of the latter [Cardinal Pamphilj] but also friend of the former [the Barberini], led to their coming to

agreement and thus to the elevation of Pamphilj to the papal throne with the name of Innocent X.

(Innocent's Aversion Toward the Barberini.) Subsequently, it easily happened that, for whatever motive—it is not the role of the present work to investigate these motives—Innocent made moves against the Barberini in such frequent and grave form, as it is well known, that it behooves us here to mention them. Out of his disdain for the Barberini, Innocent's antipathy grew as well for all those who were affectionate toward and dependent upon that family. Counted among such persons, indeed foremost among them, was Bernini himself. Thus, in the early years of Innocent's reign, the Cavaliere was either seen in a negative light or met with little approval by that pope. *(Persecution of the Cavaliere.)*[2] Since from the unexpected blows of adverse fortune not even the innocent are able to protect themselves, it so easily happened that the Cavaliere as well remained exposed to the blasts of that storm, which kept the Roman court and all of Italy in great upheaval for several years.[3] This storm only grew in strength since, as always occurs in such cases, there was no lack of aggravating winds coming from rivals and from all those who sought to extract some personal advantage from this agitated state of public affairs. Among such people, and indeed the principal one, was the Cavalier Borromini, who believed that Bernini had robbed him of all the greatness that was rightfully his.[4] Borromini had also degenerated into a completely different manner, departing from the rules of good architecture that he had learned in his former master's school. At the same time, he proved himself extremely ungrateful to his master, as well as being reckoned an architect of little merit by many of the leading practitioners of that profession.[5]

Even before Innocent was elevated to the papal throne, Borromini had already insinuated himself into his good graces. Once Innocent's election had taken place, **[77]** as if his own talent automatically increased in proportion to the increase in stature of another person, Borromini was all the more goaded by an ancient itch and the present controversy. Taking advantage of the favorable circumstances, he silently resolved to employ all his ability in replacing Bernini in the office of Chief Architect of the great Fabbrica of Saint Peter's. No longer capable of tolerating delay, he found most welcome incentive in those initial manifestations of disdain toward Bernini and indeed received encouragement in this goal of his, but only to be reproached later when repentance was by then useless.[6] As previously described, the Cavaliere had already erected, on the basis of his own design, the bell tower on the right-hand side of the facade of Saint Peter's.[7] Shortly thereafter, while the tower

was settling, as is usually the case with any construction, it happened that the facade came to feel some of the effects of this settling, specifically in that same area where, since the time of Paul V, cracks had appeared in the stucco decoration of the atrium vault.

(Malicious Rumors Disseminated About the Cavaliere.) Borromini, whose reputation had grown with the change of princes, responded with exaggerated alarm to the situation, claiming in desperate words: "These are the fine results brought about by Urban! Despite the presence in Rome of so many men of most singular talent, he instead insisted on placing everything in the hands of one man alone. The great facade of Saint Peter's has already begun to show signs of the threat of complete collapse. And along with it, will go, as well, a good deal of that famous temple itself—a temple for whose construction the treasuries of so many pontiffs had been consumed over the course of several centuries. The instigator of so great an evil must be recognized as none other than Bernini, who in order to maintain the good graces of that pope, encouraged him to undertake new projects, day after day, without any due consideration for their proper execution."[8] As it happened, these lamentations easily reached the ears of Pope Innocent and penetrated his heart **[78]** all the more keenly since they were not entirely unwelcome. The pope therefore summoned Bernini to his presence for the express purpose of interrogating him about these matters.[9]

(The Cavaliere's Steadfastness and Self-Defense.)[10] The Cavaliere was not perturbed in the least, for his conscience was at peace thanks to the good faith with which he had always conducted himself. In a fearless but respectful manner, he responded to the pope, explaining that "he had constructed the tower above the very foundations laid by Carlo[11] Maderno, and this fact alone should suffice for believing that he had indeed proceeded with complete prudence. Nonetheless, he had not wanted to begin construction without the formal judgment of two of the foremost master masons of Rome, who having worked on laying the foundations, affirmed that they were of firm stability and solidity. There had furthermore been issued both an express decree of the Congregation and an even more specific order from the pope authorizing the erection of the structure.[12] He also added that in his judgment the cause of the cracks in question was the settling of the most recently constructed part of the basilica, because his own tower stood completely in plumb, leaning in none of the four directions. However, it seemed to him that in order to reassure His Holiness, two soundings should be undertaken of the foundations, so that visual corroboration could be obtained of his explanation.

This most prudent response on the part of the Cavaliere pleased the wise pontiff, who immediately gave orders for the undertaking of the two recommended soundings, which subsequently identified the cause of the shifting of the structure.[13] The Cavaliere gave an account of these results to the pontiff, who convened a congregation for this purpose. The experts reported that the small defect in the portico's vault was the result of the inevitable settling of the new construction,[14] and that the bell tower had itself remained perfectly in plumb, not having experienced any shifting because of the condition of the foundations. They added that, should any shifting occur in the foundations themselves—already at the time of Maderno they had indeed sunk, **[79]** despite the fact of having been further fortified with the digging of sixteen wells—the remedy would be extremely easy and thus there was no need for a sense of urgency about the matter.[15] This report to the congregation was met with approval by the wiser among these men. However, in contrast to those who expressed their disagreement or misgivings in terms of utmost respect and esteem, Borromini alone, eager to be contrary, inveighed publicly and quite vehemently against Bernini in the presence of the pope himself.[16] Consequently, beset by doubt, the pontiff went ahead and gave orders for the removal of the tower's attic story and the lessening of the weight of the structure in order to gain time for the convenient application of a remedy.[17]

(Demolition of the Bell Tower.) The pope's order was about to be put into execution when, in the course of Innocent's travel to one of his estates called San Martino[18] near Viterbo, a certain minister of his, ill-intentioned toward the Cavaliere and likewise provoked by Borromini, took advantage of this convenient opportunity for filling the pope's ear with much chatter.[19] The result was the issuing of a new order for the demolition of not only the attic story but also the remainder of the tower and work done by Bernini. The order was carried out with extreme rapidity, since the Cavaliere's opponents were well aware that he would have been able to remedy the imagined danger with little effort.[20] *(The Pope's Remark in Exoneration of Bernini.)* The city of Rome mourned the destruction of so beautiful a work and shortly thereafter the pope as well regretted his mistake in heeding the advice of that minister. That same minister, Innocent admitted, "had under similar circumstances caused him to make three precipitous decisions. One of these was the demolition of the bell tower of Saint Peter's, a decision that could only be mourned, not excused."[21]

[80] *(Audacity of the Cavaliere's Opponents.)* It is hard to believe to what extent Borromini gloried in these developments. Believing the Cavaliere either was

defeated or was at least capable of defeat, Borromini, with mouth wide open, fed himself on that air, most favorable to him, which was circulating at that moment. However, even his own supporters never approved of these machinations of his; the most astute among them kept silent, while those least impassioned argued that Borromini's objections would not be able to be sustained for any length of time.

(Steadfastness of the Cavaliere and a Noteworthy Remark of His.) Instead, the Cavaliere, the subject of all this talk, alone kept silent. Although he received renewed and attractive inducements from the King of France and cardinals living in that country to leave Rome and place himself at the service of that monarch, he refused all such offers, remarking that "although Rome at times suffers from poor vision, it never completely loses its sight."[22] By this he meant that "it was a city in which talent was sometimes battered by jealousy but never overwhelmed." Throughout these four years—a brief space of time in which his enemies had free play—Bernini endured this bout of ill fortune not with the false ostentation of a steady spirit or with useless laments, which usually neither defend nor offend.[23] Rather, he made use of his own talent in securing consolation and remedy for those evils.

(The Statue of Truth; A Description.) It was, consequently, in this same period when he appeared to have been abandoned by fortune that the Cavaliere put forth, for all of Rome to behold, the most splendid works he had ever produced. Through these he gave tangible proof of his own worth, which his adversaries had discredited with their chatter. In so doing, Bernini labored under the conviction that, just as mendacity is wont to gather strength from rapidity of movement, so the truth about his own good faith would rise to the fore, even more resplendent, with slow, deliberate activity and with the passage of time. Visible manifestation of this same belief—which proved to be of **[81]** genuine consolation to him—the artist gave to us in a marvelous statuary group depicting Time in the act of revealing the Truth.[24] In it, he depicted in marble a most beautiful woman (in size much larger than life), who, charmingly seated upon a rock, is divested of her clothes by Time, an old, winged man hovering above her.[25] She is nude and seen with the sun in her hands and a smiling face; her gracious eyes are modestly turned toward Time, as if to acknowledge and thank him as her benefactor. After his death, the Cavaliere bequeathed this memorial in perpetual trust to his children, as if to show that he found it more gratifying to pass on to them his Truth, rather than his wealth. The beauty of this work attracted visits from many supreme

pontiffs,[26] as well as, on several occasions, Christina, Queen of Sweden, and all the princes then living in Rome. Indeed, there is no sovereign or other individual, who, coming to Rome either out of devotion or for business, does not inquire about Bernini's Truth immediately upon setting foot in the city and does not visit his home to admire her, as one of the world's rarest treasures.[27]

Of this sculptural group, only the figure of Truth was executed. Although the Cavaliere had seen to the procurement of a large and most splendid block of marble in order to create the figure of Time, the marble, however, remained unused, having been quarried in vain. This was either because of the disdain of Time itself, which of its own nature is ever in motion and thus did not wish to be fixed eternally through the hands of Bernini, or to some other serious occupation that took the Cavaliere away from this project. *(Poem by Filippo Baldinucci About the Aforementioned Statue of Truth.)*[28] One day Filippo Baldinucci, a Florentine nobleman, happened to see this block of marble, and sympathizing with its misfortune, had the marble speak thus in a poem of his:[29]

> From my ancient cliff,
> in order to give me spirit and voice **[82]**
> nay, not only voice and spirit, but also movement and flight
> a Master Craftsman, unique in this world,
> brought me forth one day, and his hand was ready,
> with industrious chisel
> and prudent hammer,
> to let descend upon me life-giving strokes
> in order to fashion a stupendous effigy of Time.
> But then, content and satisfied
> for having conceived in his mind such a design,
> he turned to himself and spoke in this fashion:[30]
> "Accustomed to rendering heroes eternal,
> will your hands be thus able
> to display here among us
> the honors offered to a cruel tyrant
> who procures the destruction of whatever beauty art and nature create?
> Do your works, most beautiful,
> fear perhaps the violence
> of his voracious teeth,
> and, seeking truce from him,
> must[31] you pay him such an honor?

Nay, because true talent,
despite the passage of time, remains ever intact."
Therefore he directed
his hand and his gaze to another object,
taking them away from me, without a further thought.
Along with them did also thus depart my hope
of having long life, alas!
And what I had always been, I remained, mere stone.[32]

(Statue of Saint Teresa.)[33] In this period, not only did he have Time unveil Truth to the world **[83]**, but also with equal poignancy—albeit greater devotion—he sculpted that so celebrated statue of Saint Teresa in circumstances we are about to describe. In the same year of Urban's death, Cardinal Federico Cornaro[34] renounced the patriarchy of Venice, his homeland, after fulfilling the duties of that office with an outstanding display of virtue for the space of twelve years. He subsequently returned to Rome, where he lived as a true mirror of probity to the world in the continual exercise of works as pious as they were glorious. Already of advanced age, the cardinal attended to nothing more assiduously than to preparing himself for that first and last great journey that is death. Since he bore special devotion to Saint Teresa, he resolved to honor this saint by erecting a magnificent chapel in the Church of Our Lady of Victory of the Discalced Carmelite Fathers, in which chapel he would also construct his own tomb. He accordingly gave the commission for this chapel to the Cavaliere, who produced a design beautiful and noble beyond any of those he had thus far created. The cardinal wished the chapel to include a statue of the saint executed by Bernini's own hand and graciously made this request of him. The Cavaliere was happy to oblige the cardinal in this; and in the opinion of all, there never came forth from his hands a marble statue executed with greater poignancy and of greater design than this.

(Description of the Statue.) Bernini depicted the saint in the throes of a most sweet ecstasy: beside herself in rapture and abandoned unto herself, she lies in a swoon. Close to her is an angel, who, hovering in the air with its wings, sweetly wounds her heart with the golden arrow of divine love. *(The Cavaliere's Judgment of This Statue.)* Bernini used to say that "this was the least bad work that he had ever done."[35] But this modest manner of speaking of his **[84]** was easily contradicted by the universal and public consensus of Rome, which claimed that "with this sculptural group the Cavaliere had surpassed himself, having completely mastered his art with this object of exceptional marvel."

(Madrigal by Monsignor Pietro Filippo Bernini About the Statue.)[36] Accordingly, one of his children, the oldest, to be precise, admiring this most worthy fruit of his father's labor, composed the following madrigal in its honor:

> Languishment so sweet
> Immortal must be,
> Yet in its pain does not ascend
> To the Divine Presence;
> In this stone, Bernini rendered it eternal.

Chapter XII

(The Pope's Reconciliation with the Cavaliere.) The time has come, however, for Time to reveal the Truth. Once peace was made between the pope and the Barberini, all that had previously been cause for contempt between the two parties instead became a bond of love.[1] Accordingly, so too did Bernini's reputation again begin to rise in Rome, his talent now praised as heartily as it had once been vituperated. In the process, always true to himself, Bernini demonstrated to the world that his merit was not subject to the vicissitudes of fortune.[2] *(Obelisk of the Piazza Navona.)* The pope was desirous of raising in the center of **[85]** the Foro Agonale, now called Navona, the obelisk that had been transported from Egypt by Emperor Antoninus Caracalla.[3] The same emperor had this obelisk erected outside the Porta Capena near the Valle Egeria in the center of the famous Cerchio Castrense, where Tiberius had placed the Praetorian barracks. This locality is today known as "Oxhead" because of some images of these animals sculpted in the frieze of the tomb of Cecilia, daughter of Cretus Metellus, who became the wife of Crassus and whose tomb can be seen on the Via Appia not far from the barracks.[4] The obelisk in question had lain buried amid its own ruins many years when, as we said, Innocent decided to raise it up again, in a show of majestic resolve, in the center of the Piazza Navona as the crowning element of a most noble fountain.[5] He thus commissioned various designs for this monument from the foremost architects of Rome, without, however, extending the invitation to Bernini. Borromini produced a design and everyone else labored intensely to do likewise in a spirit of competition with each other. The pope examined all the submitted designs: some met with his praise, but in the end none was chosen.[6]

(Specific Circumstances and Cause of the Reconciliation.)[7] Niccolò Ludovisi, Prince of Piombino, had only recently contracted marriage with the pope's niece, Donna Costanza Pamphilj.[8] This prince was held in the greatest esteem and love by Innocent, not only because of the bond of their new relationship but also because of the pope's long-abiding memory of Gregory XV, uncle of the prince, who had promoted Innocent in his youth to the papal nunciature in Naples. For his part, Niccolò regarded Bernini with no less esteem than the pope nurtured for the prince himself, the latter being mindful of the great affection that both his uncle, Pope Gregory, and the late Cardinal Ludovisi, the prince's older brother, had borne for the artist. Believing the pope's aversion toward Bernini to be due more **[86]** to the pressures of those times rather than to some fault of the Cavaliere's, the prince therefore resolved to promote Bernini's career in any way possible for the benefit of the city of Rome. Cognizant as he was, however, of the pope's rather stubborn and intractable temperament, he was doubtful whether his plan would come to happy fruition. Nonetheless, employing ingenuity when he could not apply force, he summoned Bernini and secretly requested from him a design of his own creation for the Navona fountain, claiming that the design would be for his own personal pleasure and by no means for the eyes of the pope.

(The Cavaliere's Design for the Fountain of the Piazza Navona.)[9] The Cavaliere could not refuse to satisfy the request of so worthy a prince, believing the requested design to be intended solely for Niccolò's own private gratification and in no way for public display. He therefore proceeded to create a design, which he then sent to the prince, having also prepared a *modello*[10] of his idea. The prince, who had waited for the work in anxious expectation, received it with great pleasure, finding its underlying conceit most beautiful indeed and its design majestic. He thus wasted no time in arranging an occasion for Innocent to see the *modello* in some seemingly accidental fashion. Little time passed before the desired opportunity presented itself. After the ceremonial cavalcade traditionally held on the Feast of the Most Holy Annunciation, the pope was expected for dinner in the residence of his sister-in-law, Donna Olimpia, in Piazza Navona.[11] Accordingly, Prince Niccolò placed the *modello* strategically on a small table in a room through which the pope was obliged to pass after the meal. The prince was certain that, upon seeing the *modello,* the pope would at least inquire as to the identity of its creator. However, much more was accomplished than was hoped for: the pope indeed saw the *modello* and, upon seeing it, was sent into a state of near ecstasy for half an hour's time, admiring the composition, nobility, and monumentality of the structure. *(The Pope's Remark upon Seeing the Design.)* He then turned to the Cardinal

Nephew[12] and Donna Olimpia, his sister-in-law, and in the presence of his entire Privy Council [87] burst forth with the following words: "This design could have come from no one else but Bernini and this maneuver staged by no one else but Prince Ludovisi. We now have no choice but to employ Bernini despite the opposition against him because anyone who does not want to use Bernini's designs must simply keep from even setting eyes on them."[13]

As a result, that very same day the pope summoned Bernini to his presence.[14] With a display of affection, esteem, and majestic manner, Innocent explained to him—as if to excuse himself in the artist's regard—the various reasons and circumstances that had prevented him until that moment from making use of his services. Then and there, Innocent granted Bernini the commission for the fountain to be executed according to the artist's own model. The Cavaliere was completely unaware of what had occurred earlier and had had far different expectations of this summons from the pope.[15] However, in reacting to the pontiff's praises, excuses, and orders that we have just described, Bernini desired to appear ingenuous rather than meritorious. Pretending therefore to forget the pope's previous comportment toward him, the Cavaliere instead displayed timorous reverence. With an air of incomprehension toward these lively demonstrations of benevolence on the part of the pope, the artist placed himself completely at his service. *(Further Words in Praise of the Cavaliere.)* From that moment on and for the entire duration of Innocent's pontificate, Bernini was held in esteem by the pope; indeed, he had secured the good graces of that pontiff to such an extent that once a week—and many times in between—Innocent desired his presence in the Apostolic Palace, engaging him in most worthy conversation. As a result, the pope was often heard to remark that "the Cavaliere was truly a man born to be in the company of great princes."[16]

(The Cavaliere's Moderation in the Face of Universal Acclamation.) Among those of lesser rank, it is not to be believed how—as is usual with members of a court, who regulate their behavior according to that of their prince—Bernini grew in esteem and how, among those for whom talent is the true measure of merit, his fame rose again more glorious than before. Now such persons could openly praise the artist without fear of repercussion, for the passing of time had again made it permissible for them to say things just as they understood them. [88] The Cavaliere realized at that point that he lacked nothing to achieve great fortune other than knowing how to properly respond to it. He therefore accepted with great reserve the beckonings of this supreme honor and knew so well how to make use of this recognition that, as a result, equal praise was bestowed upon both his modesty and the choice of that

prince.[17] Bernini consequently devoted his energies entirely to the execution of the orders he received for the construction of the fountain, which is to be counted among the most outstanding ornaments of Rome and among the most marvelous creations of the world.

(Description of the Fountain of the Piazza Navona.)[18] In the middle of that vast piazza lies a great basin, which, raised a bit from ground level, is meant to represent a great sea. Within it can be seen several large fish in the act of darting through the waters, which are pouring down in abundance from four sides. The fish appear to be opening their mouths in order to sustain their life with those waters, but, at the same time, in so doing they are also—an original invention indeed—drawing off the excess amount of water. From the center of this basin rises a mass of stone, representing a rocky crag, artfully perforated on all four sides, so that spectators are not impeded in their view of the magnificence of the forum. This assemblage of rocks, which join together at the summit, widens out in the lower regions where it first emerges from the water, giving place to four platforms upon which rest four great colossal statues. These statues depict the four parts of the world represented by their respective principal rivers. For Europe, we have the Danube with its head raised in the act of staring and marveling at the stupendous obelisk and with a lion at its feet that appears to be drinking those waters, which from all sides the rocky mass is spouting forth into that great basin. Africa is represented by the Nile, which, with its head partially covered by a cloth, **[89]** gives the impression of wishing to hide the identity of its source from us; a palm tree accompanies it at its side. The Ganges represents Asia, holding a leafy branch in its hand denoting the fertility of its land; adjacent to this figure one sees a most spirited horse with its forelegs raised a bit from the ground. And last, for America, we see the Rio de la Plata in the guise of a Moor with coins scattered about him representing the riches of its mines; below that figure can be seen the armadillo, an animal of the Indies. In the very center, then, at the meeting point of the four segments of this marvelously fashioned mount there stands the obelisk, eighty *palmi* in height, upon a great pedestal. A rich finial of metal crowns the summit of the obelisk, upon which we see in glorious display the dove with an olive branch in its beak, heraldic device of the Pamphilj family. Of this great work, the rocky mount, the palm tree, the lion, and the horse come from the hand of the Cavaliere himself;[19] the Nile is the work of Antonio Fangelli; the Ganges, of Monsù Adamo; the Danube, of Andrea Lombardo; and of Francesco Baratta, the Plata, which, together with the figure of the Nile, also received many strokes directly from the hand of Bernini.[20]

(The Pope Inspects the Fountain.) This work had already been brought to completion when the pope decided to go and examine it. So, Innocent, together with his secretary of state, Cardinal Panciroli, and fifty of the most intimate members of his court, entered the construction site, which wooden fences and tents had kept hidden from view.[21] What the pontiff saw exceeded his expectations and surpassed what it had been reputed to be. The pope strolled around the fountain, taking admiring note of each individual part, and then remained there for another half hour marveling at the entirety of the structure, which from **[90]** every angle presented an equally majestic appearance. What, above all, inspired sheer wonderment was how that vast structure of the obelisk, together with its pedestal, could be supported by a mass of stone perforated on every side, so that it appears not only to hover over a void but also to have beneath it, serving as its effective support, a base that seemed capable of sustaining only a moderate weight and not a monument of such great dimensions. The Cavaliere explained that since all the adjoining surfaces of the blocks of stone composing the rocky mount were cut with extreme accuracy, they rested tightly amassed, one upon the other, so that the one was, in effect, tightly bonded to the other and all of these tightly adjoining parts worked marvelously in conjunction to sustain the entire structure.

(An Amusing Occurrence During That Visit.) Twice the pope made an attempt to return home, and twice instead turned back to continue marveling at the fountain. He finally inquired, "When would it be possible to see the water flowing?" Bernini with regret replied that "it was too soon for that, more time was needed to prepare its way, but that he would attempt to satisfy the desire of His Holiness as quickly as possible." With that, Innocent imparted his blessing upon the artist and made his way to leave. However, just as the pope reached the exit of the surrounding fence, all of a sudden a certain sonorous murmur began to be heard—the Cavaliere, with marvelous ingenuity and secrecy, had devised a means whereby at a prearranged signal from him water would begin to rush forth in abundance from the fountain. At this sound the pope turned around and a spectacle so marvelous appeared before his eyes that it sent him into a state of complete ecstasy. He stood there at that distance for a while and then drew nearer to inspect close at hand the various streams of water, remarking to the Cavaliere, "Bernini, in all that you do, you are true to who you are **[91]** and by giving Us this unexpected joy, you have prolonged Our life by ten years."[22] Whereupon Innocent immediately sent someone to his sister-in-law's palace to fetch one hundred doubloons, which he wished to be distributed among the lower ranks of workers on that project.

Once the tents covering the monument had been removed, it was incredible to see how great a crowd of people swarmed to view it. Equally incredible was to hear, for a long time thereafter, all the praise bestowed upon the Cavaliere in the various academies of Rome, as well as to witness the resultant utter discomfiture of his adversaries.[23]

(Rumor Spread Among the People of the Obelisk's Imminent Collapse.)[24] However, a short time later there occurred an episode of public note that was likewise a source of amusement, the narration of which, although departing from the dignity of the present volume, can, nonetheless, offer some lighthearted respite for the reader. Much wonder was provoked in Rome by the placement of the obelisk upon the perforated rock. The wiser of men found in this fact good reason to admire the genius of such an invention, but those more ignorant or less experienced with such matters—and thus more hasty in their judgments—maintained that the obelisk, for want of adequate support, would soon topple and fall to the ground. Out of ignorance arose a fear that was fed by the common masses of people and only grew in strength. In fact, it grew to such dimensions that some even began to claim that they had actually seen the obelisk tremble on account of some movement of the rocks beneath it. While such thoughts were fermenting in the minds of the people, it happened that Rome was struck by a fierce storm. The violence of its wind caused several houses to collapse and seemed, as well, to threaten the destruction of those that remained standing. This storm gave greater impetus to the rumor already circulating about the imminent collapse of the obelisk and as a result an urgent cry rose throughout Rome that the structure was already tilting over **[92]** and was going to collapse at any moment. At this point, even the wisest in the population began to find reason for concern, and so one of their number immediately sent a word of warning to the Cavaliere. The Cavaliere felt pity for the frailty of the masses and, informed that a large crowd of people had gathered in the piazza, deemed it opportune to make an appearance there himself. With his usual ingenuity, he would disabuse them—among whom were also the remnants of his opponents—of their naïveté.

(Remedy Devised by the Cavaliere.) When the crowd saw in the distance Bernini's carriage approaching the piazza at full speed, they began to take for a genuine danger that which, until then, they had perhaps believed merely out of the suggestion of their fear or the secondhand reports of their neighbors. All the greater did their alarm grow as they watched the Cavaliere, in a somewhat perturbed state, descend from his carriage and with measuring

instruments inspect the obelisk from a safe distance, as if he truly feared that it would collapse upon him. Having finished this visual inspection, Bernini ordered all the people to leave the immediate vicinity and in a tone of great preoccupation asked for some ladders and rope, with the intention of preventing the collapse. It is not possible to describe the various outcries and the sundry emotions that agitated the crowd of people filling the entire piazza, or the expectation on everyone's part that they would witness the feared collapse before any effective remedy could be applied. *(And Applause He Received for It from Both the Gentry and the Common Masses.)* Bernini gave orders for four pieces of thin rope to be tied, on one end, to the obelisk at the point where it rests on its pedestal and, on the other, attached, with the same number of nails, to four nearby houses. Once this was accomplished, a serene expression came over the Cavaliere's face and he departed the scene, in a state of complete jubilation, as if he had just successfully overcome some enormous challenge. Through this amusing contrivance, the people realized the error of their belief and everyone began to distance himself from his former fear by pointing to his neighbor as the culprit; at the same time, they praised **[93]** the genius of the Cavaliere, who, with so little, was able to bring remedy to so much turmoil.

(Other Works by the Cavaliere During This Pontificate.) But to return now to our story, at the same time in which Bernini carried out the work on this fountain, the pope requested from the artist several portraits of himself. (Some of these portraits of Innocent can be seen today in the Pamphilj residence, while one other remains in the Bernini home.)[25] The pontiff then ordered from Bernini the colossal equestrian statue of the Emperor Constantine. About the latter work, however, since it was only blocked out during Innocent's pontificate, we will speak later, when we arrive at the reign of Alexander VII, under whom the statue was completed.[26] Innocent also commissioned Bernini to design that noble pavement of variegated stone in the new addition to Saint Peter's built by Paul V, along with bas-reliefs of putti and medallions on the side pilasters in the same location;[27] the columns of the nave are of *pietra cottanella,* a stone that takes its name from the quarry located near a castle of the same name in the Sabine hills.[28] Also dating to this pontificate were the *modello* of the altar of the Church of Santa Francesca Romana[29] and the restoration of the fountain in front of the Pamphilj palace in the Piazza Navona, of which the statue of Triton with the dolphin was done entirely by the hand of the Cavaliere himself.[30] However, it was at the request of the Prince Ludovisi that Bernini created the design for that majestic palace with five facades that,

brought to completion during the pontificate of Innocent XII, is at present seen on the site where the Column [of Antoninus Pius] stood in antiquity, in the place called Montecitorio.[31]

(Elevation of Monsignor Fabio Chigi to the Cardinalate and Then the Papacy.)[32] There is no doubt, however, that, although the works of this eminent artist were indeed magnificent and excellent, Fortune also wished to further his success, for through a marvelous disposition of circumstances she maintained ever disposed in Bernini's favor **[94]** the hearts of certain men, whom she kept hidden for a while, only later to raise them up to the papacy. It was at that moment, in the early days of September 1651, that occurred the death of Cardinal Giovanni Giacomo Panciroli, Innocent's secretary of state, who had been likewise a friend to the Cavaliere. With this death, the pope was deprived of an individual to whom he had always been grateful for his elevation to the papacy as well as a skillful minister whom he trusted greatly.[33] Innocent therefore summoned Monsignor Fabio Chigi from Cologne, where he was serving as papal nuncio, and appointed him secretary of state to replace Cardinal Panciroli. (Monsignor Chigi was a most respected man who, within three years, was to be promoted to the cardinalate and thereafter to the papacy as Innocent's successor.) The very same day that Monsignor Chigi visited the Apostolic Palace for the first time upon his return to Rome, he happened to meet the Cavaliere in the antechamber of Cardinal Camillo Astalli.[34] (The latter, having assumed the arms and name of the Pamphilj, lived in the Papal Palace with the title of Superintendent General of the Ecclesiastical State.)[35] Upon meeting for the first time, the one readily recognized the other, for the two knew each other not so much by sight, but by the great reputation that each man had spread about the other.[36] Such were the greetings and displays of esteem exchanged between the two men that one could well comprehend, from that moment on, the depth of the hitherto hidden mutual attraction with which talent binds the spirits of her disciples. From this reciprocal esteem there was readily born between the two men a most tenacious reciprocal bond of friendship and affection, which was then to grow, ever advantageously, with the passing of the years. Having thus entered the service of the pope in the role of **[95]** secretary of state, Chigi was one month later promoted to the dignity of cardinal and three years later, upon the death of Innocent, was raised to the throne of Peter on April 7, 1655, with the name of Alexander VII.

Chapter XIII

ESTEEM OF POPE ALEXANDER VII AND THE ROMAN COURT
FOR THE CAVALIERE IN THIS PERIOD.
THE PORTICO AND THE SCALA REGIA OF SAINT PETER'S.

(Demonstrations of Esteem Toward the Cavaliere on the Part of the New Pontiff.)
The sun had not yet set on that propitious day on which the election of the
new pontiff took place when the Cavaliere was summoned by Alexander and
received with great displays of esteem and affection that were in conformity
with both his new status as pope and old friendship with Bernini.[1] Alexander
appointed Bernini Architect of the *Camera,* a position that until then had nor-
mally been given to those who had served in that role within the household
of each pontiff before the latter had ascended the papal throne.[2] Bernini was
thereafter to maintain the same office continuously through the pontificates
of all of Alexander's successors out of a certain special respect they held for the
artist. The pope also invited Bernini to join his dinner table in the company
of other distinguished personages who would fill the ears of that prince with
excellent discourses. *(The Pope's Praise of Bernini.)* Regarding Bernini and these
gatherings, Alexander would often remark that "He was amazed at how, by
the sheer force of his intellect alone, Bernini could arrive at the same depth
of understanding in any discussion on any subject, where others had barely
arrived after many years of study."[3]

On one of these occasions there occurred an episode most certainly wor-
thy of narration.[4] The meal having come to an end, the pontiff was being
shown several portraits of himself **[96]**—variously executed in profile, *en face,*
seated, and standing, some painted in oil, others drawn in pencil[5]—by some
of the most eminent artists in Rome. At this moment in Alexander's day, it
was customary for the most prominent men of talent in Rome to visit with

the pope and keep him company; from the discourses of these men, the pope, in the midst of all his cares, derived nourishment that was as noble as it was entertaining. Among their number were always to be found Cardinal Sforza Pallavicino and our Cavalier Bernini. Now, examining the portraits, each man was giving his opinion as to which was the most faithful to the one portrayed therein, that is, the pope, who was there present. It just so happened that at that moment a fly entered the room and came to rest on the pope's table. Immediately upon seeing it, Bernini remarked that "This fly bore greater similarity to the pope in both power and beauty than any mute portrait done by the most talented artist." Alexander and Pallavicino, quickly understanding the profound observation just pronounced by the Cavaliere, immediately applauded his remark. Most elevated were the philosophical reflections that the cardinal, inspired by this remark, then went on to impart in a long disquisition, discoursing on the regularity of the fly's movement, the configuration of its parts, the harmony of its activities, and the sensitivity of its external and internal organs. It was in light of these features, concluded the cardinal, that, in the hidden principles of its being, this animate little creature resembled that living monarch, Alexander, much more than every and any insensate canvas created by means of skillfully applied, but nonetheless inanimate, paint.

Now this pontiff valued the apprehension of truth more than he did the delighting of the eye; he thus found all of the preceding discourse extremely satisfying and applauded it heartily. And since the new pontiff believed that there was nothing so lofty that the Cavaliere's talent was incapable of reaching it, Bernini came to merit an exceedingly high place of esteem in Alexander's mind, **[97]** so much so that the pope would frequently engage the artist in conversation about subjects completely outside his own profession. In his grasp of all these subjects, Alexander found the Cavaliere of such solidity of thought that he remarked on more than one occasion, "If Bernini had trained, by study and by practice, in any branch of learning or profession, he would have surpassed every other man in this century, no matter how illustrious that person may have been."[6]

(Esteem of the Entire Court for the Cavaliere.) The remainder of the court and other personages of high dignity likewise held Bernini in the same degree of esteem as shown to him by the pope. All treated the artist in a manner of great distinction, receiving his every word as an oracle. *(And That of Cardinal Pallavicino in Particular.)* In confirmation of this, the most learned Cardinal Pallavicino would often declare that "in interacting with the Cavaliere, not only did he, in the end, find himself completely satisfied and fulfilled, but,

moreover, on such occasions felt himself in some way more greatly impassioned for the subtleties of discourse, stimulated by the acuity of Bernini's own speech." One day the Cavaliere entered the cardinal's apartment, where he found the smoke and fragrance of precious spices wafting through the air in great abundance, for that prelate used to delight in the burning of such incense. The Cavaliere thereupon drolly remarked, "My Lord Cardinal, I feel as if I have entered the forests of Arabia." To which the cardinal immediately responded: "Yes, that is what they indeed are, now that the phoenix of geniuses has arrived."[7]

And precisely as such did Pallavicino proclaim Bernini. In the company of the pope and in every gathering of men of talent and accomplishment, the cardinal would affirm that not only was the Cavalier Bernini the most excellent practitioner of his profession, but he was also, in a word, simply a great man.[8] Although in this world one values above all a great orator, a great military leader, and a great doctor, because they represent the most useful or most necessary professions, nonetheless, in the present century, there is neither orator, [98] nor military leader, nor doctor who has achieved the same heights of perfection in his respective field of expertise as Bernini had in his own, possessing at the same time a marvelous aptitude for all fields of endeavor.[9] Accordingly, the Cavaliere's home was the continuous gathering place of the most eminent personages in Rome, who flocked there unceasingly, either out of admiration for his works or a desire to spend time with him in profitable conversation. As a result, it was many times necessary for Bernini to refuse these honors and not receive visitors at home, since his works intended for the benefit of the public were of far greater importance than the private satisfaction of a few individuals.

(*Further Displays of Papal Esteem for the Cavaliere.*) The pope himself several times encountered the same reluctance on the part of Bernini to interrupt his work. Thus, in order not to be the cause of distraction to the artist by summoning him to his presence for the discussion of some important matter, the pontiff instead would honor Bernini by sending many personal messages. Such messages were written in *pencil* by the pope's own hand, signed with his own name, Alexander VII, and closed with a small seal of his own pontifical coat of arms, adding upon them, likewise in *pencil* and with his own hand, the words "*To Signor Cavalier Bernini.*" The author of the present book has diligently gathered these handwritten notes and, together with many other original letters sent to the Cavaliere by kings, queens, and the principal potentates of Europe, has created a small volume of them, currently

kept among the manuscripts in the library of the Bernini family to serve as testimony to the truth of what is here being recounted.[10] It was, moreover, Alexander's habit, on suitable days in autumn, to travel for some simple relaxation to the lovely refuge of Castelgandolfo. Although Bernini on those days was extremely occupied with the execution of his various projects—projects that we will shortly describe—the pope nonetheless insisted that he join his company, assigning to him **[99]** for his convenience a separate apartment in the papal residence.

(Honors from Other Cardinals and Personages of the Roman Court.)[11] Cardinal Rinaldo d'Este, worthy prince of most affable manner, very often brought Bernini with him to his famous villa at Tivoli.[12] However, even though the Cavaliere would perhaps never spend more than two successive days away at the villa, it still happened that on a couple of occasions the pope summoned him back to Rome in order to address some matter of not small importance. Cardinal Antonio Barberini[13] (who, it seemed, had inherited from Urban the role of the Cavaliere's protector) also would spend much time in Bernini's company, engaging in friendly conversation with him, whether in the form of pleasurable reminiscence of times past or in discussion of more urgent matters of the present. *(Words of Cardinals Azzolino and Ottoboni in Praise of the Cavaliere.)* Ever joined with the Cavaliere in unalterable friendship were, likewise, Cardinals Decio Azzolino[14] and Pietro Ottoboni.[15] The latter, elevated after the death of the Cavaliere to the papal throne with the name of Alexander VIII, would often describe him as "an exceptional man, worthy of the company of great princes," whereas the former, Cardinal Azzolino, was so enthusiastic an admirer of Bernini's talent that he used to say, "Not only was every action of Bernini's worthy of being recorded for posterity, but his every word as well."[16] And in this same tenor did the Cavaliere's reputation advance in everyone's estimation from that moment onward. Therefore, from the very beginning of his pontificate, Alexander, seeing that he had at his disposal a man of such rare genius, shared with Bernini those lofty ideas he had been nurturing in his mind for the adornment and glory of the temple of Saint Peter's, of Rome, and of the state.[17]

(The Cavaliere's Design for the Portico of Saint Peter's; A Description.) Now here indeed does a new order of achievement present itself, in the form of works, all splendid in their magnificence and arduous in their execution, which the Cavalier Bernini so felicitously completed during the twelve years of this pontificate.[18] The first **[100]** of these works, through which the pope desired

to render his own pontificate even more glorious, was the great portico of Saint Peter's, a monument that has few peers among those of antiquity,[19] none at all among those of modern times, and, with difficulty, will ever be equaled by those of the future. The portico projects from the two sides of the church's facade, and after extending in a long straight line, opens out to form a great bosom that majestically embraces and encloses the large piazza. Nearly four hundred columns support it, each of which, together with its base, pedestal, finish, and frieze, reaches a value of five hundred *scudi*. Above the columns runs a rich architrave, with its cornice and beautiful fascia, surmounted at regular intervals by numerous pilasters, which in turn support an equal number of statues of the holy martyrs and confessors of larger-than-life-size.[20] The structure is made entirely of travertine, a large part of which was sent down to us by the ancient and noble city of Tivoli from the inner recesses of its mountains. The lower section of the portico is considered as majestic as it is useful. The aforementioned columns are aligned in four rows around the entire length of the portico; all the columns are equal in size and proportion, but different in the spacing between them. In the middle there is an ample, wide-open space well suited to every use, while on the sides the space between the columns, narrower and tighter, is even more serviceable and beautiful. The design, as mentioned, was by Bernini himself, who brought the work to completion in the course of five years, although the arm of the portico on the side of the square closer to the Holy Office was terminated under the successive pontificate of Clement IX.[21] **[101]** The pope assigned the supervision of the construction of the portico to the Cavaliere, providing him with a monthly stipend of one hundred *scudi,* in addition to a gift proportionate in size to the dimensions of that project.[22]

(Design for the Scala Regia; A Description; The Challenges It Presented.)[23] This was by no means the only project carried out by the Cavaliere at this time, nor was it the only commission he received from Alexander. Even though the construction of the portico demanded the most exacting attention on the part of the artist and commanded unto itself the entirety of the pontiff's treasury,[24] nonetheless, both the spirit of the former and the resources of the latter proved superior by far to the challenges of every endeavor. It seemed to Alexander that the external appearance of the Scala Regia did not correspond at all to the majesty of the venues that this staircase served to link: beginning in the temple of Saint Peter, it led to the Sala Regia and the famous chapel of Paul III.[25] Along its length, ambassadors and foreign princes would process on their way to public audiences with the pope; indeed there was no more

convenient and more decorous a means of transit than this for the many and highly solemn functions of the Papal Palace. The pope therefore gave orders to Bernini to bestow a more noble aspect upon this staircase with a design of his own creation.

However, although at first glance this project seemed a relatively simple affair, in reality it proved so challenging for the Cavaliere that he thereafter would often declare that "this had been the most daring project he had ever undertaken; and that if, before working on the staircase, he had ever read a description by someone else of what it entailed, he would never have believed it." A large portion of the Sala Regia, and of the Pauline Chapel as well, was being sustained by the walls of that staircase: in order to widen the staircase, Bernini was obliged to tear down these walls and devise an alternative system of support for the two enormous structures above. He then created for the new staircase a mighty vault, over which rested the two aforementioned structures. [102] The staircase, however, was unavoidably wider at its beginning than at its end. Bernini nonetheless conceived a most ingenious way by which to hide this deformity: he did so by erecting on each side of the staircase two rows of columns that, placed in a straight line, render the staircase of equal proportion and width in the intervening space.[26] These columns, at the same time, serve to strengthen and support the vault, which sustains the weight of those prodigious edifices above. Furthermore, he embellished the entire staircase with the appropriate illumination and elegant stucco work and in the end rendered its appearance most worthy of its name, "Royal."

Chapter XIV

ARRIVAL IN ROME OF QUEEN CHRISTINA OF SWEDEN.
HER INTERACTIONS WITH THE CAVALIERE.
SEVERAL VISITS TO HIS HOME BY THE QUEEN,
AND, ON TWO OCCASIONS, BY THE POPE.
THE STATUE OF CONSTANTINE AND THE MANY OTHER WORKS
EXECUTED BY HIM AT THIS TIME UNDER ORDERS FROM THE POPE.

(Arrival in Rome of Christina, Queen of Sweden.) While the Cavaliere was attending, with bounteous success, to the above-described works, Queen Christina of Sweden, now cloaked in a new and beautiful light, arrived in Rome. Having renounced her heretical religion and her throne, the queen, all the more illustrious inasmuch as she was now rich in her own person alone, had come to place herself at the feet of the pope.[1] She had long resolved to do so already from the time of Innocent X's pontificate, but since arduous tasks are always susceptible to delay, and because of a variety of other circumstances and considerations, in the end she was unable to make her appearance in Rome before Alexander's election. **[103]** Christina was stimulated to hasten her voyage to Rome all the more by Alexander's reputation of sanctity, which was great even among his enemies in the lands of the heretics.[2] In turn, report of Christina's intentions allowed time for the pope to make preparations to receive her none otherwise[3] than as if, the northern lands having been conquered, she were entering Rome triumphant. *(Tasks Given to the Cavaliere in Preparation for the Reception of the Queen.)* The coach that, even before her arrival, the pope had presented to Christina was decorated in marvelous fashion according to the design of Bernini himself, who also had no small part in the renovation of the majestic lodgings assigned to her in the Vatican Palace.[4]

(The Queen Sees Bernini in a Crowd and Recognizes Him.) The Cavaliere's name was already known to the queen, for even in her remote lands the fame and glory of that name resounded far and wide. She was thus all the more desirous

of seeing the man himself. Upon Christina's arrival, her eye happened to fall upon him in the midst of the multitude of illustrious personages who filled the antechamber of the Papal Palace on that occasion. As if already having imagined for herself his facial features, she pointed to him and promptly declared: "That is Bernini."[5] Both Cardinal Giovanni Carlo de' Medici and Cardinal Friedrich, Landgrave of Hessen,[6] replied, "Yes, that is indeed he," whereupon the queen summoned Bernini to her presence. Satisfying for the moment her desire to communicate to him some expression of her esteem, she compelled him to pay her a visit that very same evening. *(Expressions of the Queen's Esteem for the Cavaliere; Her Remarks on the Subject.)* This initial encounter, together with the high regard for the Cavaliere that had already occupied her royal mind, gave rise to a most special predilection on the queen's part for Bernini. For the remaining twenty-five years of his life, Bernini ranked among the very foremost in the queen's mind as far as the objects of her esteem were concerned, so much so that she was wont to say, "Whoever does not esteem Bernini is not worthy of esteem himself."

(She Visits His Home Many Times.)[7] The Cavaliere had received from Alexander **[104]** a new order to complete the colossal sculpture of the Emperor Constantine on horseback that he had begun under Innocent's reign and was already fully absorbed in this great work. The queen came to learn of this and one day, while the Cavaliere was least expecting such an honor, she herself, along with a multitudinous retinue, came to pay him a visit in his home. Bernini, who was at that moment absorbed in his work, received her, dressed just as he was, wearing the clothes of his profession, even though he had had the time to change into something different. To those who had advised him to change his clothing, the artist replied that "he had no attire more appropriate with which to receive a queen wishing to visit an artist than this coarse, rough garb, which was indeed proper to that talent that had elevated him to the status of artist in the estimation of the world."[8] The sublime mind of that great lady was able to penetrate the significance of this gesture on Bernini's part and not only did her opinion of him consequently rise all the more, she, as a further demonstration of her esteem, actually touched the garment with her own hands.[9] The queen then remained in his house for a good portion of that day, inspecting the beautiful works therein, and was so filled with admiration for what she saw that on three further occasions she decided to pay him the same honor. Christina, furthermore, publicly declared that, as a result of her continual interaction with Bernini, she discovered him to be of a mind so elevated and of acumen so perfect that painting, sculpture, and

architecture—the three arts he possessed in full eminence—were actually the lesser part of the excellence with which God had endowed that great man.[10]

(The Pope Likewise Pays a Visit, with Pageantry and Entourage.)[11] Two months had not passed from this occasion when the pope himself decided likewise to pay a personal visit to Bernini's home. His intent was that of bestowing honor upon not only Bernini's talent, **[105]** but at the same time the talent of all artists, by means of an official visit that was as spectacular as it was rare.[12] And so Alexander arrived with a great entourage, composed of twelve cardinals and twenty prelates, in addition to a group of the most illustrious nobility of Rome, who, at the pope's request, had readily placed themselves at his disposal for the occasion. The crowd of spectators was proportionately as large as the papal entourage, so that the Cavaliere's house saw itself that day surrounded by an infinite number of people, of soldiers, and of all those elements that usually accompany the majesty of a prince when he wishes to make display of his grandeur.

In the procession from the Quirinal Palace to his own home, Bernini was to be seen at all times right beside the pope's chair. Alexander entered the home, affable in his manner toward the Cavaliere while maintaining his air of majesty with the remaining company. He inspected with great pleasure the many works of art there, going from room to room to view them carefully. Afterward, at the conclusion of his visit, the pontiff paused to meet the Cavaliere's wife. Genuflecting with her two small sons at her side—Francesco and he who is writing the present account—she respectfully awaited the blessing of the pope as he passed. The pontiff, venerable in appearance and comely in face, approached her. Having pronounced some words of esteem for and in praise of the Cavaliere, he inquired of the woman, "Who might be these two little boys who also were genuflecting at her side?" She replied, "Two of my sons." Then the pope, turning to the younger of the two, who was six years old, asked him, with the friendly informality of a prince, "Which of you two is the more naughty?" Domenico (the name of the one to whom the question was addressed) began to panic. Disconcerted by the unusual solemnity of that visit and frightened by **[106]** the suspicion raised in him by such an unexpected question, he began to wonder about his fate, fearing that his older brother had already prepared an answer. The boy therefore blurted out, with a mixture of both solicitude and trepidation, "Checco,[13] Mister Pope." Having made his reply, the little boy remained with his eyes fixed, awaiting the result of this public self-exculpation. But he was more fortunate in the

subsequent reaction than he expected. Smiling at the candidly spontaneous response of the youth, Alexander took a gold chain worth five hundred *scudi* from the hands of his maggiordomo, Giacomo Filippo Nini, who, at the pope's order, had it kept ready under his cloak. Placing the chain around Domenico's neck, Alexander remarked, "You get the reward, therefore, since you are the better-behaved one." The gold chain is still kept in the Bernini home as commemoration of this event and as testimony of the magnificence of that pontiff.[14]

(Statues of Saint Jerome and Saint Mary Magdalene.) The honor of the first visit was again confirmed by a second one paid by the pope.[15] The Cavaliere had finished sculpting, at the pontiff's behest, two larger than life-size statues, those of Saint Jerome and Saint Mary Magdalene, as well as creating the *modello* for a statue of the pope himself, in full figure, which was later carved in marble by Antonio Raggi, known as the Lombard.[16] For this reason, the pope returned to Bernini's home for a second visit, carried out with equal pageantry, before the statues were shipped off to their destination in Siena. (The statue of the pope was intended for the cathedral of that town, while the other two were created for the Chigi family chapel within the same cathedral.)[17] *(Statue of Constantine Equestrian; A Description.)* However, there was further motivation that drew the pontiff to the Cavaliere's house for a second time: Alexander was also eager to see the colossal equestrian statue of the Emperor Constantine, which Bernini had completed.[18] This was truly a work of grandeur for the subject that it represents, **[107]** for the site to which it was destined, and for the material of which it was made. The latter consisted of one massive block of stone, thirty "cartloads" (to use the proper terminology) in weight, the likes of which the city of Rome, even in ancient times, had rarely seen within its walls.[19] With this stone Bernini depicted, completely with his own hands, the Emperor Constantine seated upon a mighty horse. The emperor is shown in a state of wonderment, provoked in him when, in course of his famous battle against Maxentius, he saw the holy Sign of the Cross appear in the sky, together with that omen of good fortune, the motto *In hoc Signo vinces.*[20] Innocent had destined this colossus for Saint Peter's but had not determined its specific placement within the church. Therefore, Alexander, before deciding where it was to be installed, wanted to examine the statue freely in the artist's own house. He subsequently had it placed at the foot of the Scala Regia, looking across the atrium of Saint Peter's.[21] And there he, that Defender of the Church and of Christianity, is presently to be seen.

(Restoration and Embellishment of the Church of Santa Maria del Popolo and of the Porta del Popolo; Other Works Executed During This Pontificate.)[22] However, Alexander's zeal would not allow Bernini's spirit a moment of rest; it was as if the pope could not set his eyes upon the artist without ordering some new commission from him.[23] Even before his election to the papacy, Alexander had obtained from Bernini a splendid design for the restoration of the Chigi family chapel in the church of Santa Maria del Popolo.[24] Once promoted to the papal throne, Alexander further embellished the same chapel by adorning it with two most beautiful statues carved by the Cavaliere himself, one of the prophet Habakkuk and the Angel who seizes him by the hair, and the other of Daniel among the lions.[25] He also renovated, according to Bernini's design, the entire church, of which he had been titular cardinal.[26] Alexander likewise decorated the nearby Porta Flaminia, which takes its name, **[108]** Porta del Popolo, from this same church.[27] Anyone entering the city through this gate cannot help but be awed by the marvel of those three beautiful vistas, which the Cavaliere artfully divided into three grand streets, forming one of the most noble perspectives through which one could render majestic the entrance into any royal city.[28]

Moreover, with Bernini's own continual involvement, Alexander erected the church and cupola of San Nicola in Castelgandolfo; in the same town, the galleria of the Papal Palace and the facade that faces the sea;[29] the church of Ariccia, fief of Prince Chigi, his nephew;[30] and an addition to the Quirinal Palace for members of the papal household.[31] Furthermore, he opened a beautifully designed passage between the Sala Regia and the Sala Ducale, and began—and during his reign also completed—the palace of Cardinal Flavio Chigi at the Santissimi Apostoli.[32] Alexander, moreover, constructed the Arsenal at Civitavecchia,[33] in addition to the many, many portraits of himself that he requested from the hand of our artist.[34]

In addition, Bernini produced other designs at the request of various eminent personages, among them that marvelously beautiful and rich design of the church of Sant'Andrea, the novitiate of the Jesuit Fathers on Monte Cavallo, which Prince Camillo Pamphilj constructed from its foundations.[35] It was this same church that, one day, Bernini's son—he who is writing the present book—entered to make an act of devotion and inside came upon his father, the Cavaliere, withdrawn by himself in a corner. In a state of genuine satisfaction, the Cavaliere was gazing admiringly upon all the parts of that small temple. His son respectfully asked him, "What was he doing there, silent and all alone?" The Cavaliere replied: "My son, it is only from this one work of architecture that I derive some particular gratification **[109]** in the

depths of my heart, and often, seeking respite from my labors, I come here in order to derive consolation in this work of mine." This was a novel sentiment for the Cavaliere, since he was never able to be truly satisfied with any of the numerous works he created, believing that they all fell very short of that beauty that he knew and conceived within his mind.[36] Thus, it comes as no surprise to hear that one day, passing across the Piazza Navona, he abruptly closed the shutters of his carriage windows in order not to see the fountain there, remarking, "Oh, how ashamed I am of having done such bad work."[37]

(Cathedra of Saint Peter: Design and Work by the Cavaliere.)[1] The works that we have described above were commissioned by the pope from Bernini almost all at the same time. They were also, almost all of them, brought to felicitous completion by the artist within the span of six years.[2] But so intense a degree of productivity created certain expectations in the public, who was unhappy if Bernini allowed himself a brief period of rest and did not face constant challenges in the form of new and ever more sublime projects. Another such project of his involved the wooden chair from which the Prince of the Apostles used to preach the Gospel to the Roman people and which was located in the first chapel on the left when one enters the church of Saint Peter's. At the time, the chair was worthy of attention only inasmuch as it was an object of devotion on the part of the pious faithful.[3] It therefore seemed to Alexander, ever dutifully attentive to the divine cult and the **[110]** greater glory of the saints, that so great a relic merited a setting more noble and more proportionate to its significance. The pope subsequently discussed these intentions of his with Bernini, who immediately recalled to mind the earlier-mentioned prophecy of Annibale Carracci regarding the completion of the apse of that great temple with the addition of some opulent, majestic structure.

(Description of the Cathedra.) The Cavaliere lost no time in putting pen to paper and coming up with a design, which came forth from him in so noble a form that it could not fail to please Alexander's sublime intellect. Bernini included in his design the four doctors of the Church, that is to say, the two Greeks, Gregory Nazianzen and Athanasius, and the two Latins, Augustine and

Ambrose. They were depicted twice life-size and made entirely of bronze, seen in the act of veneration while supporting a great throne made of the same material. Above the Cathedra, the Glory of Paradise bursts forth in majestic fashion, accompanied by a great cluster of angels, who, disposed in a beautifully and artfully random manner among themselves, are seen in an attitude of humble reverence in the presence of that precious relic. Since it was not possible to remove the large window that happened to be located right in the middle of the *Gloria,* Bernini converted this defect into an asset: on the glass panes of the window, he depicted the Holy Spirit in the form of a dove, seen as if emerging from a place of ineffable light. With this final detail, the artist gave felicitous completion to the entire work.

The pope examined the design, and although from the start it was understood that the project would require much time and money for its execution, Alexander nonetheless ordered the work to be undertaken immediately, since it is more difficult to conceive such plans than to carry them out.[4] He assigned to the Cavaliere two hundred and fifty *scudi* per month until the completion of the project.[5] *(Monsignor Bernini Made a Canon of Santa Maria Maggiore.)* Three years and eight months later the Cathedra was finished,[6] **[III]** and just as Urban had conferred upon Vincenzo Bernini, brother of the artist, a canonry in Saint John Lateran for the work in bronze known as the *Confessione,* so too did Alexander likewise confer such a position in Santa Maria Maggiore upon Monsignor Pietro Filippo, the Cavaliere's son. Monsignor Bernini, who had already been promoted to the Prelature of Rome, went on to fill that role with irreproachable comportment and admirable erudition.

The two projects, that of the Portico and that of the Cathedra, were, so to speak, the beginning and the end of the magnificence of that great basilica: there the eye remains no less astonished at the church's entrance through the portico as at its terminal point in the Cathedra. Extraordinary praise therefore will ever adorn the name of Alexander VII, both for the royal spirit with which he embraced the ideas of these works and for the disbursement of the funds with which he made their realization possible.[7] Indeed, the Cavaliere, our father, used to remark about this great pontiff that, if Heaven had given him energy proportionate to his desires, Alexander alone would have spent, for the embellishment and decorum of Saint Peter's Basilica, all the gold that had been consumed until that point by his many predecessors for the same purpose. (The latter sum, on one occasion, Bernini calculated to have reached the prodigious amount of forty million Roman *scudi.*)[8]

(Bernini's Students in Sculpture and Architecture.)[9] However, given the excellence of this work of the Cathedra and those we shall later describe, it behooves us

to make some mention of the individuals whom the Cavaliere employed in the aforementioned projects or who were to lend not little assistance to him in future works when his energies began to wane as a result of advancing age. Bernini had many students who, under his direction, tirelessly endeavored to advance [112] in their profession.[10] Some made above-ordinary progress in architecture, such as the Cavalier Borromini, the Cavalier Mattia de' Rossi, the Cavalier Carlo Fontana, and Giovanni Battista Contini.[11] Others, many more, did likewise in sculpture; among them are François Duquesnoy, known as The Fleming;[12] Giuliano Finelli;[13] Francesco Mochi; Lazzaro Morelli, Giacomo Antonio Fancelli, Stefano Speranza, Andrea Bolgi, Giovanni Antonio Mari, Giulio Cartari,[14] and, finally, Niccolò Sale the Frenchman, who, having placed himself in the service of the Cavaliere in the position of steward, subsequently showed himself much more inclined toward sculpture.[15] With an aptitude for sculpture deriving from an innate disposition, which he in turn developed through diligent practice, Niccolò began on his own to study that art in the free time remaining after the completion of the duties of his office. In just a few years, under the direction of such a master as Bernini, the Frenchman was able to produce many works, among them the putti and medallions that adorn the pilasters of Saint Peter's and some bas-reliefs for the Raimondi chapel in S. Pietro in Montorio.[16] However, Niccolò was a man of exemplary character, who led his life almost entirely like that of a vowed religious. His belief that all other men were of similar virtue led him to give two thousand *scudi* to a certain individual who was to deliver the sum to one of Niccolò's sisters back home. Unfortunately, for some reason, not able to find a trace of the man again, Sale fell into a state of deep depression and passed away sadly from this life, to the great sorrow of the Cavaliere. Among Bernini's students, Francesco Mochi, who sculpted the statue of Saint Veronica in one of the piers of Saint Peter's, showed himself on many occasions most ungrateful toward his Master, while the Cavalier Borromini became an outright enemy.[17] [113]

Two men, however, we can say were longtime, beloved disciples of Bernini's, and about them it is only just that we here make a most special mention. This is the case not so much for the sake of the history we are relating, as for that which one must more greatly appreciate in an artist: these two individuals were outstanding both for the progress they made in their profession (the one in architecture, the other in sculpture) and for the unflagging devotion and filial love each demonstrated toward the Cavaliere over a span of thirty years. The two men in question were the Cavalier Mattia de' Rossi and Giulio Cartari: Romans both of them, the first, a great name in architecture, the second, of fine manner in sculpture. The former was the son of Marc'Antonio

de' Rossi, a good architect in his day, who after his death left his son, Mattia, in an honorably comfortable state of material well-being. Under Bernini's discipline, Mattia advanced in his profession with such solidity of ideas and expertise of design that his master judged him capable of supervising all those works to which he himself could not attend, being absorbed by other important projects. Bernini made use of Mattia in the construction of the Portico, the Scala Regia, the Cathedra, and many of the other works that we have mentioned above. His master was deeply satisfied with Mattia and therefore judged the young man worthy of those highly prestigious tasks done in the service of the King of France, which the Cavaliere entrusted to him. Mattia proved himself equally worthy of the other commissions that his talent then secured for him in the service of many supreme pontiffs, such as certain projects that remained unfinished at the death of the Cavaliere and that were assigned to him.[18]

Giulio Cartari was of not dissimilar merit in his profession. **[114]** Cartari, having hardly reached his eighteenth birthday, subjected himself to the severe rigors of working with marble under the direction of the Cavaliere; possessed by such a love of his profession and so ardent a desire to advance within it that he came close to death many times because of his unceasing labor. He contracted a chest ailment, which often caused him to cough up extraordinary amounts of blood. Nonetheless, the strength of determination of Giulio's spirit was greater than his physical strength. Resolved to die in the practice of his profession rather than abandon it, he won the deep affection of the Cavaliere, whose own genius drew him with powerful impetus to anyone in whom he recognized talent and determination.[19] Therefore it was easy, as indeed happened, for Giulio to be restored to a good state of health. Giulio's health was compensated in great part by his virtuous tenacity and, hence, the young man made such felicitous progress in his profession that, among all of Bernini's students of sculpture, he alone merited the honor of working right alongside the master himself. This was true even in the carving of those works in marble over which Bernini normally kept a most jealous guard.

In addition to these two men, also included among the most senior disciples of Bernini—if not by measure of time, then certainly by depth of affection and esteem—was Giovanni Battista Contini. Contini, a figure of renown in the field of architecture, was perhaps the only one, among all those who frequented the Cavaliere's school, to truly love and be loved by his master.[20] He swore by Bernini's every word of instruction no less than he faithfully carried out, in the works of his own hand, both the defense and the teachings of his master.

Chapter XVI

REQUESTS MADE TO THE POPE BY LOUIS, THE GREAT KING OF FRANCE,
TO HAVE THE CAVALIERE AT HIS SERVICE IN PARIS. DIFFICULTIES, LETTERS,
AND NEGOTIATIONS RELATED TO THIS AFFAIR. BERNINI'S DESIGN
FOR THE ROYAL PALACE OF THE LOUVRE.

(Request from King Louis the Great to Have the Cavaliere in His Service.)[1] The
preceding information was supplied for the sake of the future clarity of this
account. It is now time to turn our attention to the joust, so to speak, over
Bernini's talent that was being waged among the major potentates of Europe.
They, it seemed, were all in jealous competition with one another as to who
could most intimately enjoy for themselves the manifestations of that talent.[2]
We mentioned previously how, already during the reign of Louis XIII in
France, an attempt was made to entice the Cavaliere into going to Paris and
how, after Urban's death, negotiations were again initiated by Cardinal Jules
Mazarin, who, in his role as prime minister, governed that country before the
coming of age of the currently reigning Louis XIV the Great. However, at
the time, no progress was made in calling Bernini to France, either because
the popes did not want to be deprived of Bernini or because the rulers of
that country, distracted by the civil uprisings of those years, were not able
adequately to pursue these difficult negotiations. Once the turbulence of that
kingdom had been quieted and King Louis had come of age, it is amazing
to see how quickly he renewed the negotiations and with what passion he
worked to achieve their successful outcome.[3]

(Difficulties from the Pope.) Despite repeated requests from the French royal
house, the Cavaliere could not accept these invitations, whether because he
was engaged in Alexander's service and in the **[116]** illustrious works of the
Portico and the Cathedra, or because the pope did not wish him to. In the

end, to extract Bernini from Rome, it took nothing less than a war, a war that held Italy for three years in a state of agitation and disarray. A chance skirmish occurred in Rome between the Corsican soldiers and some members of the household of the Duke of Créqui, the King of France's ambassador to Rome.[4] The unfortunate result of this brawl was the death of one member of the French party. In addition to the complaints he issued forth in Rome, the ambassador made sure that vociferous expressions of grievance and accusation reached the ears of the king, so that in the end he inflamed the otherwise most Christian spirit of that monarch against the pope.[5] From suspicion and anger was born, as is usually the case, distrust; and that distrust soon led to an open rupture of relations. It is not our intention to describe all that subsequently took place—events of which, in any case, we unfortunately have even too fresh a memory. It was in the city of Pisa that all concerned parties gathered to negotiate a peace, which, once finally obtained, brought serenity to all of Italy, hitherto groaning under the burden of this armed conflict.

(The Pope Finally Grants Permission.) At the peace negotiations, it was secretly agreed that the pope would concede permission to the Cavalier Bernini to go to France and remain there for at least three months in the service of His Majesty.[6] On this one point the king so insisted with Cardinal Flavio Chigi (who had gone to Paris with the title of papal legate *a latere* in fulfillment of the terms of the peace concordat) that he demanded oral confirmation of this detail directly from the cardinal's mouth.[7]

The king had become impatient with the unending delay in securing for himself the services of Bernini and, thus, a short time before these particular negotiations, wrote to the Cavaliere. In a letter sent by **[117]** the Marquis de Colbert, his minister, the king asked Bernini for a design for the royal palace of the Louvre, the construction of which he wanted to begin in his metropolis, Paris.[8] The tenor of the letter is as follows:[9]

Signor Cavaliere, the exceptional creations of your spirit, which earn for you the admiration of the entire world and of which my master, the King, has perfect knowledge, are such that he could not allow himself to finish construction of his superb and magnificent palace of the Louvre without submitting the designs for examination by the eyes of so excellent a man as yourself and thereof receive your opinion. Accordingly, he commanded that I write you these lines in order to entreat you most earnestly on his behalf to spare some of the time you are devoting, with so great glory, to the embellishment of the premier city of the world, and examine the plans that will be delivered to you by Signor Abate Elpidio Benedetti.[10] Regarding the latter plans, His Majesty would desire that you not only communicate your opinion of them, but that you would also be willing

to set down on paper some of those admirable conceptions that spring so readily from you and of which you have given so much demonstration. His Majesty also desires that you give full credence to all that which Signor Abate will communicate to you on behalf of the King regarding this matter; hence, if it please you, I entrust the remainder of this communication to him. And please rest assured, through these few lines, that I am truly

Your Most Humble and Most Observant Servant,
Colbert

This letter reached the Cavaliere just at the time in which he was deeply engaged in the project **[118]** of the Cathedra; it arrived, as well, during that period in which humors had not yet returned to a state of benign disposition and there was hence still a certain degree of awkwardness between the pontiff and the French king. Bernini nonetheless petitioned the pope for authorization to fulfill the king's request and the desired permission was subsequently granted.[11] *(Bernini's Design for the Royal Palace of the Louvre.)* Bernini conceived a design for so noble an edifice that it could have indeed been considered the residence of one of the greatest monarchs of our century. He then forwarded his plans to the Marquis de Colbert, who showed them to the king. The Cavaliere's design was greeted with so much applause by the king's sublime intellect that as a sign of his gratitude, Louis sent Bernini a gift in the form of a most lavish piece of jewelry, composed of forty diamonds, surrounding his portrait, with a value of eight thousand *scudi.*[12]

(Another Letter from M. de Colbert to the Cavaliere.) However, lest one suspect that this gift had been given merely as a reflex of His royal and unique liberality, Louis then ordered the same Marquis de Colbert to write another letter to Bernini expressing the following sentiments:[13]

Signor Cavaliere, I thought it best not to write to you regarding the magnificent design you sent me for the Palace of the Louvre until the King had had the time to examine it diligently and His Majesty had expressed his opinion thereof. And since he has just recently given us to understand how perfectly the beauty of your imagination corresponds to that great and universal reputation of yours, I believe I would be committing an offense against the judgment of so great a Prince, and against you as well, if I did not report this news to you. Thus have I been moved to write the present letter to you. I also wish to inform you that Lord Cardinal Chigi, here on official mission, has been shown both your design and the observations upon that design, which I, by royal order, was asked to make. Accordingly, His Eminence has assumed the responsibility of speaking

to you about this issue upon his return to Rome, as well as of encouraging you to new and further effort in so great a project as this. **[119]** *I, therefore, place the matter, if it please you, in the hands of His Eminence, who will be holding due conference with you about said matter. At the same time, I remain, with the sincerest of esteem,*

<div align="right">

Your Most Humble and Most Affectionate Servant,

Colbert
</div>

Vincennes, 3 October 1664.

This letter, as is clear from its contents, was written to the Cavaliere during the time Cardinal Chigi was still residing in Paris.[14] *(The King Dispatches Couriers and Letters Regarding the Cavaliere's Expedition to Paris.)* Therefore, as soon as the cardinal returned to Rome and the king received confirmation of the pope's intention to grant the Cavaliere's services for three months, Louis sent, by means of an extraordinary courier, letters to the pontiff, Cardinal Chigi, the Cavalier Bernini, and his ambassador. Each of these letters concerned Bernini's expedition to France.[15] As documentation of the truth that I here report, I am pleased to faithfully reproduce all of the letters:

Letter of the Most Christian King to the Pope:[16]

Most Holy Father: Having already received from Your Holiness two designs for my palace at the Louvre done by so famous a hand as that of Cavalier Bernini, I should be thinking of extending thanks to You for this grace, rather than requesting of You further favors. However, since in question here is an edifice that for several centuries has been the principal residence of kings who have been the most zealous supporters of the Holy See in all of Christendom, I therefore believe I can make recourse to Your Holiness in all confidence. I beg You, if the circumstances of his service to You permit it, to give orders to the said Cavaliere that he undertake a journey here in order to finish the work he has begun. Your Holiness could not grant me a greater favor **[120]** *in the present situation, nor, might I add, could You at any time grant a favor to anyone who is with more veneration and more cordially than I, Most Holy Father,*

<div align="right">

Your Most Devoted Son,

Louis
</div>

Paris, 18 April 1665.

Letter of the Most Christian King to Cardinal Chigi:[17]

My Cousin:[18] *I took the liberty of writing to His Holiness in order to thank him for the designs done by the Cavalier Bernini for the building of my Louvre and, furthermore,*

to beg him to please give orders to the Cavaliere that he make a journey here so that he might finish his work. I do hope that His Holiness will indeed vouchsafe to emit such orders. I have sent these letters of mine in advance so that, upon entering my kingdom, the Cavalier Bernini might begin to receive demonstration of the esteem that I bear for his merit through the manner in which he will be treated. You have obliged me thus far with such grace in the matter of these designs that I cannot hope for anything but the fulfillment of my prayers from the continuation of your good services before His Holiness. I entreat you earnestly to bear the latter in mind; let me also confirm, moreover, that I hold ever in your regard all of the affection and esteem that you could desire, together with my prayers to God that He keep you in His care.

My Cousin

Louis

Paris, 19 April 1665.

[121]

Letter of the Most Christian King to the Cavalier Bernini:[19]

Signor Cavalier Bernini. I bear such singular esteem for your merit that my desire is indeed great to see and come to know closer at hand so illustrious a personage, provided that my wish be compatible with both the service of our Most Holy Father and your own convenience. It is such a desire that moves me to send this extraordinary courier to Rome in order to entreat you to grant me the satisfaction of your undertaking a journey to France on the favorable occasion of the return of my Cousin, the Duke of Créqui, my Extraordinary Ambassador. He will explain to you in greater detail the urgent cause for my desire to see you and to discuss with you the splendid designs that you have sent for the construction of the Louvre. For the rest, I leave it to the aforementioned cousin of mine to describe in further detail my benevolent intentions in your regard. I pray the Lord God that He keep you, Signor Cavalier Bernini, ever in His holy custody.

Louis
De Lionne[20]

Paris, 11 April 1665.

(*The Cavaliere's Journey to France.*) These letters from the king reached their destinations just as the Duke of Créqui, royal ambassador to the papal court, having taken his official leave from the pope and the court, was preparing for his return to France. It was necessary, therefore, for him formally to present himself once again at the Apostolic Palace and, with all due ceremony, deliver

the letters of his king to the pope and to Cardinal Chigi. He then proceeded to the Cavaliere's house to give him the letter addressed to him [122] and explain in his own voice the wishes of his lord. Such an exalted summons inspired in Bernini both hope and fear at the same time. On the one hand, the first of those two sentiments coaxed him to go and gather the fruit of his incessant labors, in the achievement of the great honor that the king was offering him in summoning him to this royal service. On the other hand, he was troubled at the thought of the imminent dangers of the very long journey to which he was exposing himself at the advanced age of sixty-seven.

To one in the grips of fear, every decision is plagued by doubt; thus Bernini one day went to see, as was his custom, Father Giovanni Paolo Oliva, Superior General of the Society of Jesus and a close friend of his, in order to obtain his advice in the matter.[21] The priest, he found, was of no other mind than to persuade him to undertake the journey. Indeed, even before Bernini mentioned the purpose of his visit, Father Oliva broached the topic himself at the very beginning of their conversation. The Jesuit General had received many letters from Cardinal Antonio Barberini[22] in Paris, written at the request of the king, in which the cardinal begged Oliva to persuade Bernini to agree to the journey; he also entreated Oliva to take an active role himself in these negotiations. The pressure exerted upon him was so great that Father General consented to the wishes of the cardinal, as long as the Cavaliere's attempt to undertake the journey was not delayed by a contrary order from the pope. Oliva agreed to assume so great a task since he knew the Cavaliere to be as easily disposed to accepting advice as he was capable of dispensing it. Father General more than abundantly fulfilled his promises. Once the opportunity arose of the visit from Bernini, Oliva, with his usual eloquence, succeeded so well in clearing Bernini's mind of any of his imagined fears that the artist thereafter showed himself [123] well disposed and indeed resolved to undertake the journey.[23]

Bernini thereupon went to see the pope to request the necessary orders. Alexander received him with such poignant and lively affection that it was quite evident how much esteem the pontiff bore for that man and how begrudgingly he gave him to the king on loan, so to speak, for those three months alone. Persuaded to grant the desired permission, especially in view of the conditions that had just been agreed upon, the pope therefore said nothing further to Bernini other than to wish him a "Brief Absence and Speedy Return."[24] *(Papal Brief to the King Regarding the Cavaliere's Expedition to France.)* In response to the letter written him by the king, the pope sent the following brief:[25]

To Our Beloved Son in Christ, Louis, Most Christian King of the French.
Alexander VII Pope

Our Beloved Son in Christ, greetings, etc. Our Beloved Son, the Noble Duke of Créqui, Your Majesty's Ambassador, delivered Your letter to Us and very diligently communicated Your wish that for three months We grant to You the service of Our beloved son, the Cavalier Bernini. Although, indeed, in this period, it is scarcely possible to do without the Cavaliere's necessary assistance in the construction of the Vatican Portico and other important projects of the Fabbrica of Saint Peter's, nonetheless, the magnitude of Our love for You overcomes all objections and We thus grant Your request with a willing spirit. We, furthermore, impart upon Your Majesty Our apostolic blessing especially prompted by all the affection of Our paternal heart. From Rome, in Santa Maria Maggiore, under the Seal of the Fisherman, 27 April 1665. In the eleventh year of Our Pontificate.

Chapter XVII

THE CAVALIERE'S DEPARTURE FROM ROME. HONORS RECEIVED
DURING HIS JOURNEY FROM THE PRINCES OF ITALY AND
IN THE KINGDOM OF FRANCE. HIS ARRIVAL IN PARIS AND
FIRST ENCOUNTER WITH THE KING.

(His Departure from Rome.) Seized away rather than freely released, the Cavaliere thus departed Rome on April 29 in the year 1665,[1] not without distress and fear on the part of the entire city, which believed that it would lose him completely, either to the dangers of that long journey or to the enticements which that powerful monarch would offer him in order to keep him permanently in his service. To accompany him, Bernini chose Paolo, his second-born son, then eighteen years old; his students, the Cavalier Mattia de' Rossi and Giulio Cartari; Cosimo Scarlatti, his maggiordomo; and three other members of his household staff.[2] By royal order, at Bernini's service for the entire journey were Monsieur Mancini, a courier from His Majesty's Cabinet, as well as a quartermaster, who, at the king's expense, traveled from locality to locality making due preparations for the lodging of Bernini's entourage.[3]

(The Journey and Honors Received Wherever He Passed.) In just a few days, he arrived in Siena, where Prince Don Mario Chigi, the pope's brother, who happened to be in residence there, insisted on receiving him in his house and dining with him.[4] After the meal, Don Mario told Bernini that he had received orders from His Holiness that he was not to delay Bernini's departure from Siena beyond that day, and in doing so was meant to set an example for the other princes to follow, as a reminder of the pope's eagerness for the Cavaliere's return. As soon as Bernini arrived within the gates of Florence, Ferdinand, Grand Duke of Tuscany, ordered him to be accompanied [125] in his own coaches by his chief maggiordomo, Gabriello Riccardi, the Marchese of Rivalto.[5] Likewise, under orders from His Highness, Riccardi brought Bernini

to his own noble palace on the corner of the Via Larga, where he was treated in grand style during the three days necessary for this layover.[6] Grand Duke Ferdinand engaged the Cavaliere many times in worthy discourses and after extending to him many public displays of esteem, that most excellent prince insisted that Bernini make use of his personal litter for the remaining portion of the journey through Italy.

(The Cavaliere's Amusing Remark.) Bernini's brief stops at these various resting places gave time for word to disseminate about his journey, so that entire towns were depopulated, so to speak, of their residents, who desired to see with their own eyes that man whose greatness had already been widely publicized through his own works. Indeed, Bernini himself used to say in jest that "the elephant was then traveling around," the sight of which usually makes everyone run to see it as it passes by.[7] The Cavaliere was the dinner guest of Carlo Emanuele, Duke of Savoy, who gave him a tour of the city of Turin in his own carriage, insisting on his remaining there for two days.[8] So great a number of the nobility of that city assembled on this occasion that the duke himself was flabbergasted at the sight, as well as by the many displays of jubilation with which that city received Bernini. Finally, the Cavaliere took his leave from his host, having received the same honor of the use of the duke's litter, which accompanied him to the borders of Savoy.

(Displays of Honor Received by Him in France by Royal Command.) In France, orders from the king had already been disseminated to all those cities through which Bernini was to pass, prescribing the protocol with which each of them was to honor the Cavaliere while in Louis's kingdom. This protocol, in fact, almost matched the manner with which a city would have welcomed the visit of some great monarch. Behold the esteem in which talent is held by most excellent princes![9] **[126]** Upon entering the kingdom of France, Bernini was met by the magistrates of Pont-de-Beauvoisin and one of their number, under orders of the king, extended greetings to him with a most elegant oration.[10] Another presented the artist with a tray bearing the keys to the town, while a third offered him a most sumptuous gift. Bernini received similar honors in all other cities of that most fortunate kingdom. But it was Lyon that distinguished itself on this account far above all others and in its reception of the Cavaliere truly lived up to its reputation of nobility and grandeur. Four miles from the city, Bernini was met by entire guilds, divided into their separate corps and bearing their own insignia, according to the profession or craft that they exercised.[11] Some on horseback, others on foot, each of them

individually greeted him with a brief but skillful oration. Amid the acclamation of all these assembled bodies, the Cavaliere was accompanied to the residence that was to serve as his place of lodging.

Bernini was obliged to remain in Lyon for a few days in order to rest from his journey thus far. However, there was such an uninterrupted succession of visits from the city's nobility and other men of distinction that, in order to spare himself the inconvenience of receiving those of somewhat inferior status, it was necessary to have Cosimo Scarlatti, his maggiordomo, dress up in Bernini's clothes and don his Cross of the Knighthood of Christ.[12] Scarlatti was not much dissimilar in either age or facial features from his master and was readily taken as Bernini by those who did not know him to begin with. Bernini was showered with gifts in great abundance, but these he donated to charitable institutions.[13] Under orders from the king, moreover, the city's magistrates and governor came in person to see Bernini, asking whether there was anything he desired to command of them. *(His Words in Response to These Displays of Honor.)* In a letter from that city on May 22, Bernini wrote: "So many are the honors that are being shown me **[127]** in this kingdom, that I am beginning to doubt that I will be able to live up to the exalted image that I know the King has formed of me."[14]

(His Arrival in Paris; Visits Paid; and Encounter with the King at Saint-Germain.) Three days before his arrival in Paris, the king's litter, bearing members of the royal household, came to meet him. They were hardly three miles from that city when the Apostolic Nuncio, Monsignor Carlo Roberti, appeared with his coaches and three other coaches belonging to the king and filled with knights of the court.[15] They had all come to accompany Bernini to the Palace of the Louvre, where most noble lodgings had been prepared for him. Monsignor the Papal Nuncio had not yet taken his leave from Bernini when, at the orders of the king, the Marquis de Colbert arrived to greet him and communicate the impatience with which that monarch awaited him at Saint-Germain. The Cavaliere was thus taken there the following day, again served by the royal carriages and household staff.[16]

Upon his entrance into the antechambers of the palace, the honors extended to Bernini by the nobility there awaiting him were commensurate with the esteem, love, and high regard with which he had hitherto been received in that country. Unable to endure the delay in seeing him, the king simply peeked his head out from behind a doorway; curious to see where Bernini was and what he looked like, his eyes scanned the room searching for the artist amid that multitude of knights.[17] Bernini, for his part, having noticed that

bit of movement from behind the doorway, turned his eyes in that direction and immediately remarked, "That's the king." The Maréchal de Turenne[18] expressed his amazement that Bernini was able to recognize Louis since he had never seen him before that moment; to which the Cavaliere replied that he "had recognized in that face, at his very first glance of it, a greatness and a majesty that could belong to no one else but a great king."[19] **[128]** Bernini was then escorted into the king's presence and remained in conversation with him for a half hour. The subject of conversation was, for the most part, the great regard that His Majesty bore for the artist, and, in so remarking, the king gave public attestation to all the nobility present on that occasion. Turning to them, the king declared, "I find the Cavalier Bernini to be greater than I had imagined and greater than I had believed."[20] He subsequently gave orders to the Marquis de Colbert that Bernini be assigned an apartment in the same palace at Saint-Germain whenever necessity took him there, and that in Paris he be served in a manner befitting a nobleman, in the Palace of the Louvre, which was to be his residence. That morning, places were made for him and his son at the table of the princes when the dinner hour arrived.[21] Thereafter, he made his return to Paris, where for many days he was housed in the Palace of the Louvre until he moved, out of necessity, to the Palais Mazarin, since the latter residence was more remote and would thus eliminate the inconvenience of so many visits, which were a significant source of distraction from his labors.[22] In both venues, the king assigned one of his own maggiordomos to the service of the Cavaliere and his entourage.

Chapter XVIII

THE CAVALIERE'S ACTIVITIES IN PARIS.
HIS INTERACTIONS WITH THE KING AND
OTHER NOBILITY OF THAT COURT.

(His Work in Paris in the King's Service.) Once he arrived in Paris and had satisfied his ceremonial obligations, Bernini immediately began discussion with the king regarding those specific tasks for which **[129]** he had undertaken the journey. Those tasks, in short, consisted in the creation of a design for the Louvre and in beginning the actual construction. As was mentioned, the Cavaliere had already sent from Rome one design for which he not only received that monarch's approval and remuneration, but also now again, in person, further praise and an abundance of applause. Nonetheless, inspecting with his own eyes the actual site and its surroundings, Bernini judged it best to create another design, just as majestic as the first, but more appropriate in its features to the place that the building was to occupy.[1] He showed this new plan to the king, who, in examining it, remarked to him that the popes were completely justified in the jealousy with which they kept the Cavaliere for themselves, for "Bernini truly was a man of magnificent ideas, one born with the ability to give expression to every one of the most lofty notions of a sublime monarch."[2]

Since Bernini's design showed only the facade of the building, the king wanted the other sides to be drawn as well in order to see as soon as possible the beginnings of its construction.[3] Bernini therefore created designs for the other sides of the building in satisfaction of the request of the king, who wholeheartedly ordered that work on the project be commenced. They then summoned from Rome three masons, skilled in their profession, who would supervise the many local workers hired in Paris.[4] And here too, as on every

other occasion, did the talent of the Cavaliere Mattia de' Rossi manifest itself, for Mattia was assigned, at Bernini's order, the direction of this project, duties that he executed with a comportment that was both diligent and wise.

(Continuation of the Honors Received by the Cavaliere from That Monarch and His Court.) While Bernini's attention was entirely focused on the construction of that great edifice, the leading knights and most eminent ladies of Paris were running to him at every hour; **[130]** and throughout that city, they spoke of nothing else but the Cavaliere. Whereby Bernini wrote in a spirit of amusement to his great friend, Cardinal Pallavicino, that "there was no other fashion in Paris than the Cavalier Bernini."[5] However, he was a man quite used to the ever-shifting behavior of courts, having been educated in the matter for the long space of almost sixty years and through most exceptional lessons in the court of Rome. Consequently, from the very first moment, he nurtured the suspicion that all of this great acclamation could one day give birth, instead, to effects most contrary to the public's expectations,[6] since he well understood that a certain individual did not look gladly upon all the esteem shown to him by the king and the rest of the court and was gnawed in his viscera by unspoken jealousy.[7] However, preferring to be envied rather than pitied, he resolved within himself to fulfill the king's orders with all due solicitude and thus return to Rome as early as possible. The king, for his part, recognizing in Bernini the presence of a lofty mind and a combination of talents, all of them excellent, instead wanted to keep him in his company, all the more so since Louis's own desires coincided well with the endeavors of the artist.[8]

(Discussion Between the King and the Cavaliere: The Latter's Quick-Witted Replies.) One day the king learned that Bernini was in the royal antechamber. Although the Cavaliere had not requested his usual audience with the king (since he knew that Louis was confined to bed with some small indisposition), His Majesty nonetheless asked that Bernini be admitted to his presence.[9] They spent two hours together in congenial conversation about the Roman court, the theater, and his profession. At one point the king asked Bernini, "What did he think of his palace at Versailles?" (In the palace there is a most noble gallery filled with small, even miniature, objects, but of great value.) The Cavaliere adroitly replied, "Sire, I believed that **[131]** Your Majesty was great in great things; now I see that you are exceedingly great even in small things."[10] Some of the ladies in the king's household likewise asked his opinion, "Who were more beautiful, Italian women or French?" "You both are all extremely beautiful," he replied, "but there is this difference: under the skin of Italian women

there is blood, while underneath that of French women, there is milk." The king and his brother, the Duke of Orléans,[11] who happened to be at his bedside, were enormously delighted by these replies, the king adding that he was much obliged to Our Holy Father for allowing Bernini to be with them for this short period of time.

(Altar Design by the Cavaliere for the Queen Mother.) The Queen Mother learned that Bernini had gone to observe the construction of the monastery and church that she was having built as an act of devotion; the venue in question was called the "Valley of Grace," a well-known district of Paris, to which she herself would often withdraw to spend time with the pious nuns living there.[12] She thus sent her first officer to Bernini, requesting a design for the main altar then in the process of being planned.[13] Bernini replied, by way of excuse in declining the request, that since the Parisian architects had thus far labored on the construction and design of that church, he did not think it appropriate for him to interfere, unless His Majesty thought otherwise. At that the officer departed. However, the sun had barely risen on the following day when, having summoned the Cavaliere to her presence, the queen, upon his arrival, asked, "And is it possible, Signor Cavaliere, that in my church there is to be no design of yours?" Bernini repeated those same sentiments to the queen, whose response was that "he was indeed to do a design for her."[14] This he did, the result bringing no ordinary consolation **[132]** to that great princess.[15]

(The King's Portrait.) That same morning another request was made of Bernini by the king, doing so in so humble and respectful a manner that he obligated the Cavaliere unto himself much more than through all the other displays of royal magnificence with which he had hitherto honored the artist.[16] The king said that it would be his exceptional pleasure to have him in his presence at Saint-Germain in order to more easily enjoy conversation with him. He then added, almost fearing to make the request, "And you, Your Lordship, could in turn use that opportunity of satisfying my further desire, which is to have my portrait done in marble by your own hands." To the first request, the Cavaliere replied that it did not serve His Majesty's best interest to have him constantly at Saint-Germain since he necessarily had to oversee the construction of the Louvre, whose foundations were already reaching their completion. To the second request, with a similar tone of humble deference and with the same degree of courtesy with which it had been made, he replied that "although his advanced age rendered him nowadays unfit for such work because of the weakness of sight and hand, he nonetheless would devote himself completely

to the fulfillment of this request, feeling more confident of himself in the presence of one who would reinvigorate his spirits." Thereupon the king, having almost fully obtained that which he could desire, repeated his orders that the Cavaliere be furnished with any convenience that a royal command was capable of providing.

(The King's Request That Bernini Remain in Paris.) Bernini therefore returned to Paris and no sooner had he arrived but the Marquis de Colbert came calling.[17] The minister informed the Cavaliere that, should he decide to remain in continued service to the king, His Majesty would see to the transporting of the rest of his household from Rome, as well as **[133]** make other provisions that were by no means insignificant. His Majesty was prepared to provide Bernini with a sizable income from the royal treasury and join his son in matrimony with a woman of wealth and nobility. He would also promote the career of Monsignor Pietro Filippo, his other son, with all those advantages that a king is able to acquire for an ecclesiastic whenever (as he said) he really set his mind to it. He would, furthermore and finally, protect the Cavaliere's family through every means possible. The Cavaliere extended his thanks to the marquis, but in expressing his appreciation for the esteem and affection with which the king held him, he replied only in general terms that it was impossible not to declare himself and his entire progeny perpetually obligated to His Majesty. This first assault went no further; but it was subsequently followed by many others similar in nature, and indeed others more vigorous, as we shall have occasion to describe later in this account.

(His Stay at Saint-Germain.) Having received the commission of the king's portrait, Bernini made no delay in getting to work on it, stimulated day after day by repeated, anxious reminders from the pope that he return home. He therefore paid another visit to Saint-Germain in order to make drawings of the royal likeness. He created two of them, one in profile, another *en face,* both of them so true to life that the king, along with the entire court, remained astounded. After executing these sketches, he created many others in clay and finally began the portrait in marble.[18] However, he found it necessary to change plans twice since he was unable to locate suitable blocks of marble in that region.[19]

(The Cavaliere's Method in Doing Portraits.) The Cavaliere had a method in doing portraits, whether in marble or in drawing, that was quite different from the common way of proceeding: he did not want his subjects to remain

immobile, but rather he wished them to move about and converse in their usual natural manner. In this way, he said, he was able to see all of the beauty that was theirs and to imitate it, just as it was.[20] **[134]** Bernini claimed that in posing for an artist completely immobile, a person was never as true to himself as when in motion, for it was then that all those qualities that are his alone and not of another, become evident and give true likeness to a portrait. This notwithstanding, however, he would ask his subjects many times to remain motionless, in order to be better able to draw those features that require an unmoving, careful examination by the eye. And in these various states he thus asked the king to pose for him on several occasions. *(Curious and Noteworthy Circumstances of the Creation of the King's Portrait in Marble.)* It was his constant practice, moreover, on such projects, to first draw many sketches, especially many of the figure he had to depict.[21] However, once he set to work on the marble itself, he removed all these sketches from his sight, as if they were of no use to him. Marveling at his behavior, the king asked him one day the reason for this practice. In reply, Bernini explained that "The preliminary studies served to introduce into his imagination the features of the one whose portrait he had to create, but once he had conceived them inside himself and was about to give birth to actual portrait, they were no longer necessary to him. Indeed, they became detrimental to his goal, which was to produce a portrait true to life, and not to the models."[22] This explanation enormously pleased the king, who was moved to simply remark, "I have never met a man with such a mind as yours." To which the Cavaliere replied, "And I, Sire, I have never met a mind more capable of apprehending beauty as that of Your Majesty's."[23]

On ten separate occasions the king was pleased to make himself available to sit and pose for Bernini.[24] While on his way to these sessions, His Majesty would say that he approached them most willingly because on each occasion **[135]** he would hear many fascinating and ingenious things come forth from the mouth of the Cavaliere. It happened one day that the king remained completely immobile while posing for the artist for the length of a full hour; at the end of that hour, Bernini, in a state of marvel over this fact, suddenly interrupted his work and shouted aloud, "It's a miracle, a miracle!" Asked by the king the reason for this exclamation, he replied, "For a king, so exalted, young, and French, to stay still for a full hour, why, that's a miracle!"[25] The king delighted so immensely in these clever remarks made by the Cavaliere that very often, with the excuse that he needed to rest, he would order Bernini to interrupt the sitting in order that he might have the pleasure of conversing further with him. *(Hairstyle "à la Bernini.")* On another occasion,

it happened that during one of the above-described sittings, the Cavaliere approached the king and gently made a part in the locks of his hair that was covering his forehead. He did so in such a way that some of the king's forehead was exposed and therefore displayed to better advantage in the portrait. In so doing, Bernini remarked, in an almost peremptory fashion, "Your Majesty is a king: you can show your forehead to the whole world." It was rather amusing to see how immediately thereafter the entire court copied that way of arranging one's hair, which from that day onward was called "hairstyle à la Bernini."[26]

As he progressed in the work on this portrait, Bernini began to fear that the marble block that he was carving might one day reveal some unsightly veining or other defect as more stone was cut away from it. He therefore decided to prepare a second one, as he had done in the past, giving orders to his student Giulio Cartari to begin blocking out the outline in another piece of marble, which, should the first prove defective, he could then finish himself. However, fortunate was that first block of stone, which never revealed any stain whatsoever in itself [136] and could fittingly receive the great image of so revered a monarch.[27] The Cavaliere was thus able, with greater ease, to complete work on the portrait. (In the execution of the king's portrait, let us mention, the aforementioned Giulio Cartari also distinguished himself through the continual assistance he lent to his master).

(Other Noteworthy Occurrences Involving the Same Portrait Bust.) The portrait was afterward placed in the Palace of the Louvre in a most opulent room near the hall used for the reception of ambassadors.[28] While it was being installed, the king arrived on the scene, along with his wife the queen,[29] and the usual retinue of the most eminent nobility of Paris. The Cavaliere himself happened still to be present at their arrival. That noble diadem of illustrious personages showered the artist with even greater words of praise, and to these the queen added her own with special emphasis, never tiring of gazing admiringly upon that portrait and singing its praises. After listening for quite a while, Bernini remarked to her: "Your Majesty has so much praise for this copy because you are so in love with the original."[30] This remark struck the queen as so novel and therefore so pleasing that she, together with the king and all of those noblemen, responded to it with exceptional applause and even greater admiration for Bernini's mind, which was ever equipped to respond to all circumstances with such fecundity of wit. Thereafter, there arrived from Rome a splendid, witty poem from a clever poet who in these few verses sang the praises of the artist, of the subject of the portrait, and of the portrait itself:

Bernini entered into profound thought
　　In order to create a fitting base for his royal bust.
Not finding any of worth, he at last exclaimed:
　　For such a monarch the globe is so paltry a pedestal.[31]

To which, in turn, Bernini immediately responded in admiration and praise for both the king and his court:[32]

[137]

Never did that profound thought occur to me
　　to search for a pedestal worthy of so great a king:
Such a thought would have been vain,
　　for he who supports the world has need of no support.

(New, More Vigorous Attempts by the King to Persuade the Cavaliere to Remain in His Service in Paris.) Quite enamored of the splendid creations of both the hand and the mind of the Cavaliere, the king took Bernini aside and with all of his energies attempted again to persuade the artist to remain in Paris, promising even greater rewards than those described earlier.[33] Bernini, in response, declined the offer. In excusing himself, he reminded the king of his prior commitment to the pope, to whom he had given his promise to return to Rome and from whom he was receiving repeated, urgent reminders to hasten that return. Mindful of the latter, Bernini used to work even on Sundays and other religious holidays, by order of the pope himself, who wanted to see the rapid completion of that work.[34] The king, in turn, promised that he would take it upon himself to get the pope to agree to change his mind. *(Bernini's Respectful Reply.)* To this the Cavaliere, with terms of utmost and humble respect, replied that "even if His Holiness were to agree to his remaining in Paris, the love that he bore toward so enormous a work as the Cathedra of Saint Peter, which was not yet completed, would compel him not to obey the king. However, His Majesty should rest assured that although it was impossible for him to stay in this moment, it could easily happen that he would return." The same offers were later repeated by the Marquis de Lionne, His Majesty's chief secretary of state. However, all of these efforts were in vain, for the Cavaliere was resolved to return home.

(The Cavaliere's Reasons for Not Yielding to This Royal Entreaty.) The principal reason for which the Cavaliere was moved to decline such advantageous offers from so great a crowned head was his prior commitment to the service of the

popes in Rome. **[138]** In this he was mindful not so much of the memory of past pontiffs, who had been so benevolent toward him, as of the thought of the reigning pope, Alexander VII, in whose service he was employed with most special regard, bound to him both by a long-standing obligation as well as by present responsibilities. Also weighing heavily on his mind was a concern that we have previously mentioned: as Bernini wrote to a friend in Rome, his glory in Paris had by now reached its zenith and could go no higher; nor, however, could it remain stable. Given the nature of things, it could only and inevitably reverse itself and decline. He said this because he had already noticed that a certain minister had become jealous of him for the remarkable displays of esteem with which the king in every public statement exulted him. This minister now feared that the Cavaliere might be given a position in that court, which would be greatly damaging to his own status there.[35] Moreover, in such a kingdom, so noble and so rich in men of great talent, there would be considerable reluctance to accept any foreigner, even one of great authority, without jealousy on the part of both the practitioners of the various arts and their disciples, who tend to be numerous in any large city.[36] Thus he was quite resolved to depart, as if foreseeing certain future events that soon thereafter took place and confirmed the truth of his pronouncements.

(Continuation of Visits and Honors That Bernini Received.) However, in the meantime, Bernini represented the single subject of the most clever literary compositions and discussions within the most eminent academies. Cardinal Antonio Barberini and Monsignor the Apostolic Nuncio[37] were constantly at his residence and, as they were on more familiar terms with Bernini, engaged in even more personal conversation with him. From such conversations, as well as from letters that he received from Rome, **[139]** Bernini was constantly reminded of the impatience of that city to see him once again within its walls, every day of his absence seeming a century. The Roman Court and, to some extent the pope as well, had already conceived the suspicion that Bernini might yield to the enticing offers that the French monarch was extending to the artist. The discussions of the entire Roman court were focused on anticipating the outcome of these negotiations, which, in any case, as all agreed, would be glorious for the Cavaliere, for everyone already judged it to be to Bernini's supreme glory the fact that two of the greatest potentates of Europe were competing over who would have Bernini for himself. All of this could be deduced by various testimonies, but it certainly will appear most evident from the one we are about to report. It is a letter from the same Cardinal Chigi, who writes to Bernini the following lines:[38]

I rejoice infinitely with Your Lordship for having produced so splendid a design for the Louvre, which has been received with such pleasure by His Majesty, whose approval, coming as it does from a person of most perfect taste, is thus all the more noteworthy. I hear that you are about to begin work on the king's portrait; I am sorry to learn that you lack the appropriate marble for this, even though Your Lordship's talent will show through no matter what marble you use. I hope that your labor on this portrait will not detain you in France longer than the term granted by His Holiness, since without your presence here in Rome, not only are your construction projects languishing, but likewise are we who are deprived of your company. Work on the new facade of my home is progressing nicely, thanks to the great pains that Signor Luigi, your brother, is taking with it. I can give you excellent news about Monsignore, your son, whose **[140]** *great mind is most evident in the work he is doing in the Segnatura.*[39]

At the end of his letter, Cardinal Chigi adds:[40]

Your Lordship continues to send me news of your health, for which I thank you; I rejoice indeed with you over this news. But even more, I rejoice for the applause accorded you by all of France. This applause, however, is intensifying our jealousy and our desire to see you here again. Nonetheless, the time approaches for you to return and once again see our fair Italy and your loved ones, who await you with impatience.

Chapter XIX

THE CAVALIERE TAKES LEAVE OF THE KING. GIFTS RECEIVED FROM HIM.
ARRIVAL IN ROME AND WELCOME ACCORDED HIM THERE.
MALICIOUS GOSSIP ABOUT BERNINI
SPREAD BY HIS ENEMIES IN FRANCE
AND HIS RESPONSE TO IT.

(The Cavaliere's Departure from Paris; The King's Affectionate Sentiments Toward Him.) The Cavaliere remained in Paris a little less than five months. Having had the foundations for the Louvre built according to his design[1] and having satisfied in full His Majesty's desires, he went to Saint-Germain and petitioned the king for his gracious permission to take his leave and return to Rome. On that occasion, since in the act of making his request, Bernini displayed some expression of tender emotion, noticeable even in his eyes, the king turned to the Abbé Buti,[2] one of his confidants, and in a somewhat lowered voice said in French, "This great man loves me, but I am even more in love with him than I show."[3] Bernini received the permission requested and thus made his way back to Paris in order **[141]** to prepare for his departure for Rome. *(Ample and Generous Remuneration Received from the King.)* That same evening,[4] the king had delivered to Bernini a cash gift worth 20,000 *scudi* in the form of *louis d'or* coins. He also granted him an annual pension of two thousand *scudi* together with one of five hundred for his son, Paolo.[5] To Cavalier Mattia de' Rossi the king sent 2,500 *scudi,* with the obligation of his returning to France in order to oversee the ongoing construction of the palace, as indeed the young man did.[6] A gift of one thousand *scudi* was given to Giulio Cartari, and the same to Bernini's maggiordomo; the Cavaliere's servants were likewise all recipients of gifts truly worthy of the munificence of great prince in whose mind true esteem and appreciation for talent ever held sway. During the return voyage, at royal expense, Bernini's entire entourage was again cared for and served by the same quartermaster and courier from His Majesty's household.[7]

(*Letter of Father Oliva, Superior General of the Society of Jesus, to the Marquis de Lionne*) The honors that Bernini received in France matched the esteem in which he was held by all in that country. In order to eliminate any suspicion of exaggeration with regard to the description just given, I would like to confirm the nature of these honors by means of the letters written by the aforementioned Father Oliva in reply to the Marquis de Lionne and the Cavalier Bernini. Father Oliva writes thus:[8]

Most Illustrious and Most Excellent Lord and Most Venerable Master,

With a much too generous display of honor and sentiment has the Most Christian King shown his recognition of that modest homage paid by me to the greatness of his crown and the sublimity of his person. It is true that I firmly insisted with the Cavalier Bernini that it behooved him to enter into the service of so great a monarch, even if he were certain of losing his life upon the Alps.[9] However, so self-evident a counsel was undeserving of either the affectionate gratitude of His Majesty or the great expression of thanks on Your Excellency's part. **[142]** *Anyone who is simply alive and breathing, and not a lifeless tree trunk, would have readily recognized the incomparable honor redounding to the credit of the Cavaliere's name by so glorious a summons. I derive unspeakable joy from the knowledge that once Bernini was in His Majesty's presence, he did not fail to live up to expectations nor did his reputation suffer any diminishment.[10] I am much indebted to that great man for the most tender affection he bears for me and for the grace that he has gained for me from so exalted a monarch, to whom he revealed that his decision to travel to France was due above all to me. While all others were trying to dissuade him from such a journey because of the dangers involved, I alone urged him forward so forcefully that in his mind all of the ice of Mont Cenis[11] disappeared in the warm breeze of that royal invitation. I cannot help but rejoice seeing him now held there in the same esteem that he has always enjoyed here in the court of Rome. And although in the splendor of his glorious art he is a prince among all men, nonetheless, so many other forms of understanding and knowledge reside in his mind that they almost eclipse that excellence for which the world admires him. Furthermore, I am indebted to your kindness no less for the assurance you have given me in what you have written of the king's satisfaction with regard to my person than for the news you have reported to me about the Cavaliere and the great advancement of his glory.*

Letter of the same Father Oliva to the Cavalier Bernini:[12]

Most Illustrious Lord and My Most Esteemed Master,

I have already confessed myself indeed most obligated to your hand, which has crowned my volume with the miracle of a drawing.[13] However, now I find myself even

more indebted to your tongue, which has gained for me the gratitude of a king of France.
[143] *It was too exquisite an act of love on your part to have reported to his royal ear that which I advised you in that so grave and so private a conversation of ours in which we both concluded that there was no doubt whatsoever about the necessity of your traveling to Paris, even if the journey were to cost you your life. It never even occurred to me that the effort with which I released you from the embrace of your children and wiped from you the tears of your family could have been revealed to anyone,*[14] *for the price of doing so was to have served your own person and to have thrust you into that theater of honor and that immortality of reputation. These you would never have been able to enjoy, had you not offered yourself personally to the service of so venerated a sovereign. Let your own perspicacity imagine what fortunes I desire for you. They shall prove greater than what I could yearn for, since they depend upon a king who in his magnificence exceeds both the imagination of those whom he loves and the merit of those who serve him, as you are doing in preparing for him a royal residence that will bury in its foundations the ancient memories of the palaces of the Caesars, etc.*[15]

(Reception of the Cavaliere in Rome.) The jubilation with which Rome received the Cavaliere again within its walls was no less than that of France when it had greeted him as he passed within her borders.[16] Once word of Bernini's return spread throughout the city, there was no member of the nobility who did not desire to send forth his coaches to meet him on the way. There would have been, in fact, an excessive quantity of such vehicles, had his family, while showing their gratitude for such offers, not courteously declined the honor. In the end, six coaches, sufficient for the number of his relatives and members of his household, set out to meet him and accompany him back to his home. The day following his return, the Cavaliere paid a visit to the Apostolic Palace, where he was **[144]** received by Alexander with a graciousness that was accompanied by an equal display of esteem and affection.[17] In its welcome of the Cavaliere, the entirety of the Roman court, moreover, was in conformity with the demeanor of the pontiff. *(His Apt Assessment of the Incomparable Personal Qualities of the King of France and the Greatness of His Court.)* For his part, the Cavaliere preached throughout Rome the incomparable praises of that monarch's personal qualities. He did so with such enthusiasm that he let it be understood that merely being able to see Louis with one's own eyes renders all difficulties of the journey well worthwhile, for so great did the king appear in the vastness of his intellect, in the fecundity of his genius, in the magnificence of his court, and in all those assets that could render illustrious a great prince of the same stature as he.

(Father Oliva's Letter to the Marquis de Lionne.) Therefore, Father Oliva saw fit to write a letter to the aforementioned Marquis de Lionne in these terms:[18]

The Cavalier Bernini has returned to Rome transformed into the trumpet of the Most Christian King, who has turned our sculptor almost into a block of stone, so much does Bernini show himself astounded by the incomparable qualities of His Majesty. This stupor—brought about by the immensity of his gratitude for the extraordinary honors and enormous assistance received from His Majesty, as well as by his admiration for the grandeur and magnanimity of so great a king—has precipitated Bernini into a state of prodigious ingratitude,[19] for in order to celebrate a monarch of such merit, he despoiled him of both his birth and dominion, protesting that the king is much more sublime for the capacity of his mind, for the prudence of his tongue, for the splendor of his hand, for the generosity of his heart, for the justice pursued in his tribunals, and for the majesty of every facet of his being, that it is not for the immensity of his dominion nor for the might of his armies that we judge him the equal of the most renowned kings of the ancient chronicles. I truly know not if any beneficiary could, with greater tenderness of affection or reverence of feeling, show both love and gratitude toward **[145]** *his benefactor as much as the Cavalier Bernini is now doing in his unceasing and impassioned testimonials, having been rendered immortal by His Majesty in the memory of posterity and in the pages of the chroniclers, etc.*

(Malicious Gossip About the Cavaliere Spread in Paris by Malevolent Tongues.) However, hardly had the Cavaliere exited from the gates of the city of Paris, when, just as he expected, certain voices made themselves heard, reporting falsehoods to the ears of the French court that were more pleasing to the malevolent than they were true.[20] The rumor was disseminated that "Bernini, dissatisfied with the king and his precious gifts, openly complained about them, and in Rome in undisguised fashion denigrated the majesty of that prince; that such were the results of royal munificence in extending honors and riches to a foreigner who in the end did not appreciate them. It was for this reason that he had hastened his departure and could not be detained by so many royal offerings because, from that moment, he had nothing but hatred for the court and little respect for the king's greatness."[21] These rumors, so contrary to the Cavaliere's true feelings, were reported to him by a most intimate friend of his in that city, who thought it best to alert Bernini. For his part, upon hearing this news Bernini was not moved in the least, having well anticipated it in any case. In the manner of one who moves forward without giving the least attention to the barking of dogs, he replied to his correspondent with these few lines:

Regarding that which Your Lordship writes of the malicious gossip raised against me in Paris, instead of feeling grief over it, I almost find it a cause for boasting: not able to find me blameworthy for any of my actual deeds, those malevolent enemies of mine are attempting, with extremely weak foundation, to discredit me for what I have allegedly said. I therefore do not know whose is the greater foolishness: those who **[146]** *fabricated these stories or those who believe them. The greatness of the gifts with which I have been honored by the king is well known, and I can affirm that my labors were remunerated more in just six months in Paris, than in six years in Rome.*[22] *However, in order to be worthily rewarded by gifts befitting kings, there had to come the myrrh of such sinister mendacity, since I had already received in abundance the gold of riches and the frankincense of honors. Time will reveal the truth, just as it did to my benefit at other times in the past, etc.*[23]

(*Marble Equestrian Colossus of King Louis the Great.*)[24] In these same terms did the Cavaliere express himself not only in several other letters—it would not be appropriate to repeat them here—but also in his discourses in all of the courts of Rome.[25] He likewise wished to offer proof of his sincerity by means of tangible labor: while still in Paris, he had promised the king that, if heaven granted him sufficient life and strength, he would create an equestrian statue of him, larger in size than the one he already executed of the Emperor Constantine.[26] Therefore, although weak in bodily strength and more than seventy years of age, he began the work with great fervor. To those who advised him not to undertake the project, arguing that the execution of such a colossus required the life and energy of a young man, and not that of the old man that he was, Bernini replied that "No one was going to deny him the honor of at least having commenced so great a work for so great a king, even if he were obliged to abandon it along with his own life."

The lies circulating in Paris either did not reach the king's ears, or if indeed they did, as is to be expected, found him so well disposed in the Cavaliere's favor that Louis was not in the least deterred from continuing to reward the artist. Rather, with renewed solicitation the king went on to encourage Bernini anew in the project he had undertaken.[27] **[147]** (*Medal Struck in Paris in the Cavaliere's Honor.*) Louis therefore sent Bernini and his son their promised pensions and a most splendid medal that he had struck with the Cavaliere's portrait on one side and, on its reverse, personifications of Painting, Sculpture, Architecture, and Mathematics. The latter were all depicted in comely poses, each with its own appropriate attributes and distinctive traits, along with the motto alluding to subject of the portrait, "SINGULARIS IN

SINGULIS, IN OMNIBUS UNICUS."[28] All of this had the effect of inspiring the Cavaliere to apply himself with even more intense effort in sculpting this great colossus. Although the statue was finished two years before Bernini's death and transported to Paris five years after his death, at this juncture the flow of our narration here compels us to make special mention of it.[29]

Chapter XX

DESCRIPTION OF THE MAJESTIC EQUESTRIAN COLOSSUS
OF KING LOUIS THE GREAT. REFLECTIONS UPON THE SAME STATUE.
INFORMATION REGARDING LUIGI BERNINI, BROTHER OF THE CAVALIERE,
AND THE DEATH OF POPE ALEXANDER VII.

(Description of the Aforementioned Colossal Equestrian Statue of the King.) Coming together in the creation of that great monument, therefore, were both the royal order and a most special desire and affection on the part of the Cavaliere. Defying his own energies, Bernini, moreover, wanted to ennoble the final chapter of his life with a work of extraordinary eminence. This statue, whether we take into consideration its material or its form, must be deemed the greatest work of its kind ever to come forth from an industrious chisel, even in those most fortunate times when sculpture had reached its apex and its precious remnants from antiquity **[148]** render the memory of that era more clear to us.[1] In an extraordinarily massive single block of marble, larger in size than all that the city of Rome had ever seen,[2] Bernini depicted King Louis XIV of France, gracefully seated upon a most noble horse, seen in the act of resting on the summit of a steep mountain, the latter being a symbol for glory. Bearing a scepter in his right hand, the king gives the appearance of restraining the horse with his left; with a charming turn of his head, he displays on his face a completely jubilant expression, like one who, after so many glorious campaigns, has finally reached the summit of glory and is enjoying the fruit of his victorious labors. The design is noble and handsome, but equally admirable is the masterful quality of its workmanship. The Cavaliere devoted eight years to the completion of this work; although already absorbed by so many other admirable projects, he seemed to summon forth all of his life force and the liveliest portion of his art and place them all together in so worthy a statue.[3] The question therefore remains as to which was greatest:

his intrepidness in first undertaking this work in the near frailty of advanced age, his determination in carrying it forward, or his perseverance in bringing it to completion? All of this was the consequence of his most ardent desire to make manifest his gratitude to so great a king, for whose service he had happily subjected the last days of his glorious old age to heavy labor. He would die happy, he declared, once he saw this great work brought to completion.

(Anecdotes Regarding the Creation of the Statue.) For the convenience of being close to Saint Peter's, Bernini worked on the statue in a large studio near that same temple and there, for the space of twelve years, one could witness a concourse of the finest aristocracy not only of Rome but of all Europe as well.[4] **[149]** Indeed, no reigning sovereign, no illustrious personage, no knight, entered the gates of Rome without repeatedly petitioning Bernini to be allowed entrance into that studio, in order to admire his person and contemplate his art. He, for his part, gracious with all, willingly granted access to his workspace. However, in order not to distract him from his work, all those who entered, even those of high social status, had to remain silent during their visit, and, likewise, in silence would they depart.[5] It happened on one occasion that Bernini overheard a visitor remarking under his breath to a friend that he did not approve of a certain inert lock of hair in the king's coiffure, which, as he said, was incongruous with the movement displayed by the horse. Whereupon, turning to this individual in a spirit of jest, the Cavaliere replied, as if laughing: "Your Lordship, it would seem, is annoyed because I am not properly splitting hairs in this work."[6] And another gentleman, who was on more intimate terms with Bernini, pointed out to him that "the king's drapery and the horse's mane had too many folds and were too deeply cut, which was not in accordance with the rule left to us by the sculptors of antiquity." To this individual Bernini promptly replied that "this feature, which was being criticized as a defect in fact represented the best product of his chisel, with which he had conquered the difficulty of rendering marble as pliable as wax and at the same time had succeeded in a certain way in combining both painting and sculpture. As to why the ancient artists never did so, perhaps it is because they never put their heart into rendering blocks of stone as obedient to the human hand as if they were made of dough."[7]

(Bernini's Intention in Depicting the King with a Cheerful and Jovial Face.) This, however, is not how Bernini reacted to the criticism of an otherwise intelligent French knight on another occasion. The Frenchman in question, accustomed to seeing his king in a majestic pose, in the guise of a military

commander, **[150]** did not approve that the king, although wearing military armor and seated upon a warrior's horse, bore a cheerful, pleasant expression on his face, as if he were ready to dispense favors rather than inspire terror in his enemies and subjugate provinces. In this case, Bernini instead took the time to carefully explain his intentions, which, although adequately expressed in the work itself, somehow escaped the comprehension of this viewer. He therefore explained that:[8]

He had not depicted King Louis in the act of commanding armies, something that in the end is proper to all princes; rather he wished to display the king in a state that he and he alone had been capable of reaching and having done so by means of his glorious campaigns. And since, as the poets depict her, Glory resides atop a lofty and steep mountain—on whose summit only the rarest of men are easily able to stand—it is reasonable that those who are indeed fortunate in arriving there, after having overcome all challenges in their way, joyfully breathe in the air of that most sweet glory. Having cost them calamitous travails, that glory is all the more dear to them, to the same degree that the painful effort of the ascent had been dolorous. King Louis, after so long a series of many illustrious victories, had already overcome the steep ascent of that mountain and thus Bernini had placed him there on its summit, seated upon that horse, as the unchallenged proprietor of the glory that at the price of blood his name had acquired. Therefore, since anyone in a state of bliss naturally displays a jubilant expression on his face and an attractive smile on his mouth, he in this fashion had depicted the monarch. Moreover, although this idea of his could be completely grasped from the entirety of that majestic colossus, it would appear all the more evident once **[151]** the statue was installed in its destined setting: there, from another block of marble, a craggy peak, proportionately steep and rocky, was to be sculpted, upon which, in appropriate fashion, the Cavaliere would position the horse, according to a design of his own creation.

The French knight was so satisfied by this discourse of Bernini's that not only did the lighthearted expression of the face no longer appear inappropriate to him, but he began as well to praise to the skies the artist's invention as unique and fitting for so great a king alone. *(Applause Received by the Work from All Quarters.)* Therefore, it happened that, brought to complete perfection, the work became so famous among all of the academies of Rome that no other

statue had ever been so celebrated by orators nor so applauded by the brilliant compositions of poets.[9] A certain accomplished gentleman afterward decided to gather together a selection of the aforementioned compositions in verse and compiled in quite a thick volume the most eminent and majestic among them, this volume lacking in no other virtue than that of availability to a wider audience through publication.[10] *(Poem in Praise of the Colossus Composed by the Author of This Book in His Youth.)* The author of the present book as well desired to presume to enter into the company of these noble academicians and in his youth thus sang the praises of the same object:[11]

The Equestrian Statue of Louis XIV King of the French
Wrought by the Cavalier Bernini

Look here, stranger, and perhaps you will see how very grand is the blessed Louis, both in peace and in war. From high Olympus, Bernini brought the massive rock, envy of every stone, and fit it to this great purpose. Whom should I admire more? You, Bernini, to whom good fortune granted to carve the wondrous features of the King? Or you, Louis, who alone in all the world has deserved **[152]** to be sculpted by this hand? True, your great nobility was already lifting you to join your ancestors among the stars. True, your virtues beggar any form of art. Still, take my word for it, you do become yet more divine through this work: your person makes its form more precious, while its form lends ornament to you. Behold how the horse even seems to feel the burden of his king! How fierce he is under such a weight, how proud and majestic in every way! How he turns his head to salute his king! If he were not made of stone, his nostrils would be snorting. And if Louis, who holds the bridle, were giving him free rein, as is his wont, you might see him swimming through rivers, fearless against all foes under such a king, routing the rebel Batavians[12] on every front, and stirring up the River Elbe with his merest neighings. Do you not see how like to living flames his eyes are? How he prances with his hooves? How his high steps menace the ground before him? How he pants and, through the fray, peers wildly for paths over which he may reach the stars and gain for Louis his proper place on Olympus? Go happily, Louis, to where the glory of your right hand lifts you. But go not yet, nor deprive our eyes of those eyes of yours with which you survey the entire world. The time will come when in that part of heaven that is reserved for you—a star among the stars, a deity among ancestral gods—you will

receive that crown which you deserve, the wreath which long since the Gnoscian maiden[13] has prepared for you. Meanwhile, accustom yourself to being called upon by the prayers of men and to comforting your kingdom with your happy and powerful presence.

(Transportation of This Great Statue to Paris.) However, the sentiments of Bernini's enemies in Paris were completely contrary to those that began at once to spread in his favor throughout the rest of Europe. Nonetheless, for whatever reason—and it is not licit for us to investigate the reason—in the three-year period by which the **[153]** Cavaliere survived the completion of the colossus, he never received any request for news of the project from the Court of Paris, nor did any arrive in the five years following his death. Then, one day, after the Marquis de Colbert, too, had come to the end of his life, and the Marquis de Louvois had succeeded him in his office, an order was sent from the king to the Cavaliere's children for the transportation of this great monument to France;[14] three ships were sent expressly to guarantee the safety of its journey.[15] At the conclusion of the long journey by sea, the statue traveled on the River Seine finally to enter Paris; from there it was transported to Versailles, where it remains, the object of the world's admiration, as are likewise both the artist who created it and the monarch whom it depicts.[16]

(Luigi Bernini, Brother of the Cavaliere; His Personal Qualities.) But, to return to our story, having arrived back in Rome amid the welcoming receptions of the court and the embraces of his family, Bernini returned once again, after a brief period of repose, to those projects whose supervision he had left to his brother, Luigi.[17] Luigi was just slightly younger than the Cavaliere; however, in his talent for calculating measurements and the force of the weight of masses, he was, if not superior to his brother, then at least his equal.[18] It was Luigi who, to the admiration of all for his expertise, devised the wonderful mobile tower, one hundred *palmi* in height, that we see employed throughout the great church of Saint Peter's, in order to facilitate work on the uppermost reaches of the basilica. Also of his invention is that piece of equipment for moving the basilica's great portable organ, as well as another apparatus, at present kept in the Munitions Storage of the Fabbrica of Saint Peter's, which is capable of pulling objects up to 36,000 pounds in weight, by means of a small steelyard of ten-pound capacity, placed upon another one of iron, twenty *palmi* in length. With this machine the four great colossal bronze statues of the **[154]** Cathedra of Saint Peter were weighed with utmost ease.[19] The Cavaliere consequently made use of Luigi's services in all of his architectural projects, as if he were his

Achilles. When preparing for his departure for France, the Cavaliere placed into his brother's hands supervision of the Fabbrica of Saint Peter's and all matters pertaining to the completion of Cardinal Flavio Chigi's palace at Santissimi Apostoli.[20] Thanks to his talent, Luigi, in turn, lived up perfectly to everyone's expectations; and he did so with such diligence and expertise that all that was left for his brother to do was to simply ratify Luigi's decisions.

(Unveiling of the Cathedra of Saint Peter.) It was at this time that the Cavaliere brought to final completion the Cathedra, construction of which had been partially suspended because of his absence from Rome. Once the Cathedra was completed, the pope ordered all the coverings removed from it so that the grandeur of that work could be revealed to the public. On that occasion, the majesty of the monument was further increased by the presence of the pontiff himself.[21]

(Commission for the Tomb of the Pope; The Latter's Death.) It was Alexander's further intention to have his own tomb sculpted by the hand of the Cavaliere.[22] However, death, which shortly thereafter overtook him, prevented him from seeing the achievement of this desire.[23] After having examined and approved its design, the pope gave the commission of the project to the Cavaliere and orders to his Cardinal Nephew for its execution.[24] A pontiff of truly lofty vision, Alexander is worthy of being counted among the most meritorious heroes of Rome, which, thanks to him, saw itself ennobled by means of so many ornaments of outstanding quality.

Chapter XXI

SUCCESSION TO THE PAPACY BY CLEMENT IX,
FOLLOWED THEN BY CLEMENT X.
VISIT OF THE FORMER TO THE CAVALIERE'S HOME
AND WORKS COMPLETED BY THE ARTIST
UNDER THESE TWO PONTIFFS.

(Election of Clement IX and His Worthy Qualities.) Alexander's successor as pope was Cardinal Giulio Rospigliosi, who assumed the name of Clement IX. Even before becoming a prelate, this man, too, had been bound in special friendship to the Cavaliere.[1] His was a mind endowed with most splendid gifts, and to these had been added a wonderful talent for poetry most noble in nature. After his studies at the University of Pisa, he moved to Rome to enter the service of Cardinal Antonio Barberini; through the latter prince—a great friend to all men of talent—Rospigliosi was also introduced into a certain degree of intimacy with Pope Urban. Accordingly, on one occasion when Cardinal Barberini commissioned the production of some theatrical pieces for the honorable entertainment of the public, the pope asked that Rospigliosi be given the task of composing the script, which he did with noble and delightful results. Since these involved stage sets and machinery designed by the Cavaliere as well as his direct assistance, it easily happened that thanks to their repeated, close interaction, each of these two men of talent came to form a high opinion of the genius of the other; and from this was subsequently born a most special mutual esteem.[2] That esteem grew all the more with the passing of the years and the accumulation of honors by both men. It went on to become an intimate friendship when Rospigliosi, having been engaged in prestigious assignments within the Roman prelature **[156]** during the reign of the same Urban and his successor, was eventually promoted by Alexander to the office of secretary of state and then, in the first round of promotions, created cardinal.

(Honors Received by the Cavaliere from Clement.) Unbelievable was the Cavaliere's joy, first, in seeing Rospigliosi elevated to the papal throne, and, then, in experiencing the manifestations of the esteem and love with which he was held by the new pope. Following the example of his predecessors, Clement admitted Bernini to that group of intimates who gathered around the papal table for social conversation at the dinner hour. The difference now, however, was that most often Clement would choose Bernini to be his sole companion on these occasions, as if he found in the Cavaliere alone all the erudite recreation that he desired.[3] Since the pontiff was accustomed to take his meal very late, at the end of such sessions, before sending Bernini home, he would always be sure to add some affectionate word of apology for having detained him for so long, showing his compassion for the artist's advanced age and for the discomfort that such prolonged visits must have caused him.[4] It happened one day that, distracted by some other matter, the pope granted Bernini leave with his usual blessing but nothing further. The Cavaliere was on his knees to receive the blessing, but after it was imparted, he made no move to leave. Noticing this and wondering about this unexpected behavior, Clement asked the Cavaliere "if he were in need of something." Bernini replied, "Holy Father, please be patient with me, I've become so used to taking my leave only after hearing some words of consolation from Your Holiness that I cannot bring myself to depart without them."[5] Clement was most pleased with this display of appreciation shown by that man of talent for the honor accorded him by the pope and so sent him home with the consolation he desired.

(The Cavaliere's Invention to Assist the Pope in Falling Asleep.) This pontiff was of such poor health and had such great difficulty in falling asleep that, already long before, he was used to **[157]** procuring sleep for himself with the help of external means, in particular by sleeping in bedrooms that afforded him close proximity to the sweet murmur of running water. Therefore, on the same day in which he was raised to the papacy,[6] Clement charged the Cavaliere with the task of redirecting, by that very evening, all the water that flowed in the various fountains in the Belvedere garden to a single fountain that stood immediately below the windows of his bedroom so that he could better hear the sonorous noise of the cascading waters and thus more easily achieve a state of repose. It so happened that not only was it not possible to carry out this task by the evening of that same day, but it was also discovered that even the small quantity of water from the fountain under the bedroom windows was being lost. Whether it was the fault of the workers or simply a matter of bad

luck, this situation was thus the cause of great distress to the Cavaliere, for he had given his word to the pope that the matter would be taken care of by that same evening.

Nonetheless, although water was lacking, genius was not: Bernini quickly invented a machine in which the movement of a wheel worked in concert with a series of carefully placed paper spheres, which, in receiving a multiplicity of strikes, produced a sound imitating that of falling water. He installed this machine in the room adjacent to the one in which the pope was to sleep that night and thus, in the form of this ingenious invention, found a remedy for the pope's indisposition. The following morning, upon learning of what had been devised, the pope could never cease to exclaim that "Bernini's genius was ever true to itself, whether it be in small matters or large." *(The Pontiff's Affectionate Words to Bernini.)* Therefore, on the next occasion in which he saw the Cavaliere, Clement, with his usual affability, remarked to him: "Truly, Signor Cavalier Bernini, We would never have **[158]** believed that We would be deceived by you on the very first day of Our pontificate." *(His Conscientiousness Even in Matters of Lesser Importance.)* On this same subject, the Cavaliere used to explain that "no matter what project was assigned to him, no matter how small it might be, he applied himself completely to it, so that in his own way he devoted as much care to the design of a lamp as he did to that of the most noble building, because," he would add, "in their state of perfection all works are equal and that whoever knew beauty in things small in quantity and dimension could also depict it just as easily in those of large quantity and dimension."[7] He therefore had applied in the execution of the above-described invention that same diligence that he would have had he been asked to create yet another Navona Fountain.

(The Cavaliere's Design for the Decoration of the Ponte S. Angelo.) Clement was just as desirous as his predecessors of increasing the magnificence of the temple of Saint Peter's, the adornment of the city of Rome, and the glory of his pontificate. He thus ordered the Cavaliere to decorate through some noble design that bridge near the castle from which the crossing takes its name (that is, "of the Holy Angel"). The pope judged this bridge worthy of special embellishment, not only because of the grandeur of Hadrian's Tomb—which looms directly in front of those who cross the river at that point—but also because it represents the most important thoroughfare leading to the great basilica of Saint Peter's.[8] Bernini was able to conceive an idea most fitting for the site and as majestic in appearance as can be described in words.[9] It was a very familiar saying of his that "the good architect, when working on fountains

or any project involving water, should always ensure an unobstructed view of the water, whether the latter be cascading or flowing by. **[159]** Since the sight of water is extremely pleasurable to our eyes, to block or diminish that sight is to deprive such a work of its most delightful quality."[10] *(Description of the Bridge.)* With this intention in mind, in embellishing the bridge, the Cavaliere designed the parapets (which usually are constructed as solid masses of wall) with a series of appropriately sized openings, each one protected by an iron grille; through these grilles the passersby are conveniently afforded a sight of the flowing of those waters above which they happily walk. Upon the parapets, on either side, five appropriately designed pedestals were erected and, on these, in turn, an equal number of large statues of angels majestically stands. Each angel, in an attitude of pious devotion, holds an instrument of Our Lord's Passion. The Cavaliere insisted on executing two of the statues entirely by his own hand, namely, the one holding the superscription of the cross and another holding the crown of thorns.[11]

(The Pope's Visit to the Cavaliere's Home.) Having been apprised of the matter, Clement, accompanied by a considerable retinue, paid a visit to Bernini's house and insisted that such beautiful works of art not be exposed to the damaging effects of the weather.[12] He thus ordered copies to be made of the two statues in question and had them instead installed on the bridge. However, the Cavaliere, unwilling that the project of a pontiff for whom he bore such affection should lack some work of his own hand, secretly sculpted yet another angel of the same size as the previous ones, this new statue being the one bearing the superscription of the cross, which was then installed on the bridge along with all the others.[13] Learning of this, the pope was pleased by Bernini's act of disobedience and simply quipped: "So, Cavaliere, you want to oblige us to order yet another copy of this statue?" And to those with an understanding of the art of sculpture, this fact was a **[160]** cause of sheer amazement, that is to say, that it had been possible for a man so advanced in years to execute within the short space of just two years three larger-than-life-size statues, especially during a period of his life in which many princes, for their own advantage, were keeping all of his energies divided among various other projects.[14] Bernini brought to completion the embellishment of the bridge according to the previously described plans. Clement, eschewing applause as much as he was deserving of it, however, would not permit placement on the newly renovated bridge of either of his family's coat of arms or the inscription of his name. Clement, in the end, increased the fame of his modesty by fleeing from such fame inasmuch as his successor ordered a

memorial to Clement's own disdain for self-aggrandizement to be carved in marble on the same bridge, thus rendering his name even more glorious.[15]

(The Pope's Kind and Generous Gesture Toward the Cavaliere's Family.) While Clement was taking his leave from the Cavaliere's home, there occurred an incident truly worthy of the incomparable kindness of that pontiff.[16] The pope had satisfied his virtuous curiosity in the course of his visit to the house, and the hour had arrived for his departure. The Cavaliere's wife and family— including two daughters, both nuns of Santa Rufina (a monastery without the rule of cloister)[17]—wished to take advantage of so convenient an opportunity and thus presented themselves on their knees before the pope in order to receive his blessing and permission to kiss his feet. Upon seeing them, Clement appeared to have become somewhat perturbed, but the reason for that perturbation was not explained until later that evening: as soon as Clement reached the papal palace, he sent one of his valets with a pouch filled with gold medals to the Cavaliere's house in order that they be distributed as gifts to his little family.[18] In giving these orders, the pope explained that "it had been a source of pain to His Holiness that he had not been able, right then and there, to display to the Cavaliere's family some **[161]** sign of his paternal love and royal generosity."

(Other Works by the Cavaliere During This Pontificate.) By orders of this pontiff, Bernini brought to completion, as was mentioned elsewhere, the arm of the portico of Saint Peter's that extends toward the headquarters of the Holy Office.[19] He likewise created the design for that beautiful and useful pavilion or, shall we say, *cordonata,* in front of the church of Saint Peter's: by means of this addition, any large carriage can more easily reach the entrance of that temple, something that previously had been a matter of great inconvenience and trepidation.[20] Another project close to Clement's heart, and whose beginnings he happily set in motion, was the embellishment, through the addition of majestic ornamentation, of the tribune and rear external facade of the basilica of Santa Maria Maggiore, where he had served as canon. For this Bernini created a noble design, which—had not death subsequently and importunely deprived the pope of his life and interrupted the work—would have certainly been counted as among the most splendid ornaments of Rome.[21]

(Drawings by the Cavaliere's Hand and Their Value.) This same pontiff, furthermore, so valued and so esteemed any little drawing done by the Cavaliere that the artist, almost as a matter of custom, at Christmas and other times of the

year, would present Clement with a drawing of his on paper depicting the figure of a saint in devout pose or some such similar composition.[22] Clement, in turn, would very often reciprocate with gifts of enormous value, even, on one occasion, with two large basins and two large vases of silver worth six hundred *scudi*. Moreover, this same esteem for Bernini's drawings and *modelli* was so universally shared by others that a servant of his house once confessed that he and his family had been maintained in Rome for the space of twenty years with the proceeds of **[162]** the sale of some of these drawings, a sufficient supply of which he had cleverly procured for himself while in the Cavaliere's service.[23] Likewise, that sublime genius of Cardinal Rinaldo d'Este, son of Duke Alfonso of Modena—with whom, since the time of Urban's pontificate, as already mentioned, Bernini enjoyed a most sincere friendship—so valued a single touch of the artist's hand that, for a quick bit of work done by Bernini upon some stucco ornamentation of one of the fountains of his famous garden at Tivoli, he rewarded the Cavaliere with the gift of a ring worth four hundred *scudi*. Later, on another occasion, for some similarly minute amount of work, the cardinal presented him with a silver basin of the same value.[24]

(Loss of Candia, Cause of the Death of Clement IX.) The life of Clement, who deserved to reign in happier times, was cut short by the anxieties deriving from the unhappy fate of the city of Candia.[25] At the pope's request, Louis, King of France, had sent to Candia François de Vendôme, Duke of Beaufort, chief admiral of the French kingdom, with a mighty fleet of military ships and twelve regiments in order to reinforce the defenses of that city, then still enduring the tenacious siege of the Turks. Trusting greatly in this expedition, Clement promoted—in gratification of the king's desire—the Duke of Bouillon to the cardinalate and sent to Beaufort an exquisite standard bearing an image of the Cross under which, as the papal ensign, the king wished his troops to wage this war.[26] However, as fortune would have it, all these men, including Beaufort himself, were wretchedly killed in the ensuing combat. This loss was a source of unspeakable grief to the pontiff, a grief rendered all the more dolorous because nothing was known of exactly how or where the duke had met his own cruel fate. Clement therefore commissioned Bernini **[163]** to erect in the church of the Aracoeli a noble catafalque of his own design.[27] Our artist received the praise due him for this work in the universal mourning of all, who were moved to intense compassion for that late and great lord by the majestic and funereal poignancy of that monument. Not more than two months later, the pope himself, still in a state of immense grief and sorrow, departed this life. What may have seemed unfortunate can

instead be reckoned fortunate inasmuch as, had Clement lived longer, he would have hardly been able, in any of his subsequent undertakings, to maintain the exalted reputation he had left behind at that point in his life. *(Before Dying, the Pope Admits Monsignor Bernini into the Congregation of the Sacra Consulta.)* Before his death, Clement, as a token of his affection for the Cavaliere, admitted Monsignore, his son, into the Congregation of the Sacra Consulta, a position he filled for the long course of twenty years.[28]

(Election of Clement X.)[29] Everyone else was believed destined to next occupy the papal throne except the person whom God was secretly reserving as his prince: just a few hours before taking his last breath, Clement had promoted Monsignor Emilio Altieri to the cardinalate and, in so doing, created his own successor as well, thus giving to the world a pontiff most affable in nature and most capable of fulfilling the responsibilities of that exalted position.[30] Altieri had already had experience in most distinguished assignments for the Holy See and was serving in the role of chief chamberlain at the time he was made a cardinal. In the conclave following the death of his predecessor, he was elected pontiff with the name of Clement X. Younger years were wanting in both him and the Cavaliere to be able to carry out great works equal to those of past pontificates; instead, the one man (Clement) had just passed the eighty-year mark, while the other (Bernini) was not far from it. Therefore, Clement was content at least to retain the Cavaliere in the same esteem and in the same offices that he had happily enjoyed during **[164]** the pontificates of his predecessors.[31]

(Works Done by the Cavaliere During This Pontificate.) The heavy weight of his years, together with that other, even heavier weight of the papacy, did not permit the pope to distinguish himself in any other works besides that of the mixed-marble pavement in Saint Peter's and, also in Saint Peter's, that even more majestic work of the tabernacle, made of metal and lapis lazuli, for the chapel of the Most Holy Sacrament, featuring two angels, likewise in metal, seen in the act of adoration of the body of Christ enclosed in the same tabernacle.[32] Clement wished all of this to be executed by the Cavaliere himself according to his own design and under his supervision. Cardinal Paluzzo Altieri rendered his personal piety all the more outstanding by erecting, through the work of the Cavaliere, a renowned chapel in the church of S. Francesco a Ripa in honor of the Blessed Ludovica Albertoni.[33] For the chapel, he commissioned from Bernini a statue of that saint, which the Cavaliere created, depicting Ludovica in the throes of death.[34] For this work, he received those

same acclamations which, by now, after so many years of success, everyone was accustomed to witnessing, but which the Cavaliere, at that age, still found distasteful. *(Monsignor Bernini Promoted to the Secretariat of the Congregation of the Waters.)* As a result of these labors, Bernini received remuneration for himself from Clement, his prince, as well as an office of honor for Monsignore, who was promoted by the same pontiff to the position of Secretary of the Congregation of the Waters.[35]

Chapter XXII

ELECTION OF INNOCENT XI AND HIS ESTEEM FOR THE CAVALIER BERNINI.
TOMB OF ALEXANDER VII, BUST OF THE SAVIOR, AND
RESTORATION OF THE PALAZZO DELLA CANCELLERIA.

(Election of Innocent XI; His Worthy Qualities.) During two conclaves, Cardinal Benedetto Odescalchi had been among those closest to the papal threshold; finally, in this latest one in which the cardinals had gathered after the death of Clement X, he was with general consensus promoted to the papacy.[1] All his efforts were thereafter directed toward regulating, through the strictest parsimony, the income of the papal treasury, perhaps because he foresaw the need of the large amount of capital that was later to be expended for the defense of the faith, which found itself during his pontificate under great assault by the Turks. He began his fiscal reform with himself and his family: all those funds that were formerly disbursed as gifts or income for papal relatives he applied toward the relief of the Church's treasury. The remaining funds he employed, with apostolic impartiality, for the profit of the Christian faith. *(His Esteem for the Cavaliere.)* However, in moderating these expenditures and in the aforementioned reform of payments to those attached to the papal household, Innocent ordered, with expressions of great esteem and words of complete love, that those pertaining to the Cavaliere should remain intact, exactly as they had been previously.[2] This was the consequence of the great regard with which Bernini was held by that pontiff, who was otherwise austere, and for whom merit alone represented motive for the granting of rewards.

[166] *(Tomb of Alexander VII; A Description.)* We mentioned previously that not only had Bernini made a design for the tomb of Alexander VII, which was to be placed in Saint Peter's, but he had also received the pope's formal

commission for the project, as well as the approval of his nephew, Cardinal Flavio Chigi.³ Accordingly, out of gratitude for the memory of that prince, the Cavaliere resolved to carry out the actual work on the project, despite his advanced age and diminishing strength, which each day rendered him less capable of confronting labors of this type. He boldly undertook the beginnings of this monument, placing it, with the usual liveliness of his genius, in a large niche above the door leading to the church's sacristy. In doing so, he transformed what was originally a handicap into a necessary component of his intended design. He covered the door in question with a great shroud of Sicilian jasper and made it appear as if the figure of Death (in gilded metal) were flying out through that same door and, with one hand, were holding up the shroud, as if to cover its head with it in shame. With the other hand, Death holds forth an hourglass, whose time has already run out for Alexander. The pope himself is depicted above, in the center of the niche, in marble and twice life-size, in the act of genuflection. On either side of the lowest portion of the tomb are the figures of Charity and Truth, likewise in marble; above are Justice and Prudence, and finally, the pope's coat of arms, held in place by a large pair of wings, which gives a finishing touch to the entire monument. Among these statues, one of them, the figure of Truth, was formerly nude except for a small part, which, through a certain play of the shroud, was covered by drapery. However, since this was not in conformity with Innocent's most saintly views, **[167]** the statue was covered by the Cavaliere, under orders of the same pope, with a dress fashioned of metal whose surface he had treated so as to give it the appearance of white marble. This caused Bernini a great deal of difficulty, inasmuch as he had to reconcile one feature with another that had been designed with a different intention.⁴

*(Statue of the Savior, the Cavaliere's Last Work.)*⁵ However, approaching the time of his death and at the advanced age of eighty, the Cavaliere wished to bring honor to his life and bring to termination the practice of his profession—thus far so well conducted—with the creation of a work of such a nature that truly fortunate can we reckon that man who, with it, thereby ends his days.⁶ The work in question was an image of our Savior, in half-figure but larger than life-size, with his right hand slightly raised, as if in the act of imparting a blessing. *(His Famous Saying About the Practice of Good Design.)* In this work, Bernini summarized and condensed all of his art,⁷ and although the weakness of his pulse did not match the liveliness of his conception, it did nonetheless serve to prove that which he had previously often said, namely, that "an artist who excels in design⁸ did not have to fear, with the approach of old age, any

deficiency in vivacity and tenderness in his art because the practice of design is of such efficacy that it alone suffices to compensate for any defect in one's forces that languish in one's advanced years." He destined the work for his so well-deserving Queen of Sweden, but she elected to refuse it rather than be untrue to her royal beneficence, since it was impossible for her to compensate Bernini properly for its value. Nonetheless, Christina was later obliged to accept the statue two years later, when it was bequeathed to her by the Cavaliere in his will.

(Renewal of Calumny Against the Cavaliere.) At this time, during which his spirit was less deserving of agitation, there arose throughout the city of Rome a rumor that, given the object that it concerned, was a matter of grave importance that could not be ignored. **[168]** Born from base beginnings, the rumor ascended to the heights of the cupola of Saint Peter's, spreading the tale that some cracks had appeared in the cupola as a result of the work done by the Cavaliere at the time of Urban for the embellishment of the piers, which we described in chapter VI of this book.[9] Since the presumed movement[10] was not apparent to everyone, nor could everyone easily confirm for themselves that it had indeed occurred, this idle chatter grew in the customary fashion of those matters that, being out of actual sight, are made by rumor to seem of grave consequence and rendered credible by fear rather than by truth. This rumor so grew in strength that it stirred the most prudent mind of the pope to give orders to Monsignor Giannuzzi, secretary and treasurer of the Fabbrica, to seek out the truth. This he did with the assistance of Mattia de' Rossi, the Cavalier Carlo Fontana, and Giovanni Antonio de' Rossi, all men of great reputation in the field of architecture.[11] They attested that the cracks in the cupola were indeed what was seen by that individual who had first given rise to the rumor;[12] however, close inspection of the cracks and of the oldest documents on file showed that the same cracks had already been there many years before the work was executed under Pope Urban and had been caused by the cupola itself in the process of its own settling. Since we have already discussed the matter in chapter VI—where one will find a straightforward recounting of the facts sufficient to dissipate this cloud of malevolence—we refer the reader to those pages without further ado. Nonetheless, if the curious reader would like to be further convinced of the groundlessness of this rumor, let him read Filippo Baldinucci in the concluding pages of his biography of the same Cavalier Bernini, where he treats this issue at length.[13]

[169] *(The Cavaliere's Repair of the Deteriorating Palazzo della Cancelleria.)* However, that which some people falsely imagined in the cupola of Saint Peter's was actually about to happen to the great Palazzo della Cancelleria in Rome.[14] Deterioration of the palace had advanced to such an extent that the threat of its imminent collapse was quite apparent. The pope thus requested an immediate remedy from the Cavaliere. The subsequent repair work proved so demanding of him that it was considered the cause of the great illness that shortly thereafter brought him to the end of his days. Bernini applied himself with great intensity of spirit and with a great outpouring of energy to this labor, which required him, an old man, each day to ascend and descend the workers' dangerous scaffolding. This, in turn, resulted in an abnormal rise in temperature in his head and a loss of sleep. To his children, who begged him not to expose himself in his declining years to so much danger and strain, he, with determined spirit, responded: "This, and nothing less than this, is what the gravity of this situation, proper service to the pope, and my personal reputation all require; and I wish to give each its due, even at the cost of my own life."

Chapter XXIII

THE CAVALIERE'S PIETY.

HIS FINAL ILLNESS AND DEATH.

(The Virtuous Life of the Cavaliere.) Before we enter into a discussion of the topics proposed for this chapter, it behooves us to interrupt the flow of our narration for a while and demonstrate how singular was the goodness of the Cavalier Bernini's life and how the **[170]** many splendid gifts of his mind were rendered outstanding by their great conformity to Christian principles.[1] Bernini was a man of sublime genius, who ever aspired to great things; but he was not content with any form of greatness unless it represented the maximum degree of achievement. This same innate attitude brought him to exalted heights also in his meditation on matters of piety; not satisfied with mere common notions, he adhered to those more sublime ones, which represent, so to speak, shortcuts to Paradise. *(His Pronouncements Regarding Trust in God and Piety.)* Accordingly, he used to say that "in giving account of his conduct, he was dealing with a Lord who, infinite and supreme in His attributes, would not worry, as they say, about small change."[2] He further explained his attitude in this by saying that "God's goodness is infinite and infinite is the merit of the precious blood of His Son; and thus it is an offense to these attributes to doubt divine mercy."

(His Image of Jesus Christ on the Cross in a Sea of Blood; His Design of and Devotion Toward This Work.) To this effect, he had, for his personal devotion, reproduced as both an engraving and a painting a wonderful drawing that depicted Jesus Christ on the cross with a sea of blood at its base, the blood gushing copiously from his most holy wounds.[3] Therein one also sees the

Most Blessed Virgin in the act of offering her son to the Eternal Father, who appears above, his arms extended, moved to tender compassion by so piteous a scene. "In this sea," Bernini used to say, "all of his sins were drowned and could not otherwise be found by Divine Justice than amid the blood of Jesus Christ; Jesus' blood would have either caused these sins to change color or else, through its merit, would have obtained mercy for them." His trust in this was so deep that he used to refer to the Most Holy Humanity of Christ as the "Cloak of Sinners." He all the more trusted that he would not be struck [171] by divine vengeance since the latter, before reaching him, would necessarily have to pass through this garment; thus, in order not to pierce the innocence of that cloak, God would, instead, forgive him his sin.[4] *(His Fervent and Lofty Discourses About God.)* For many, many years before his death, it was Bernini's habit to spend much time in extensive conversation with learned and outstanding religious. So much did he become inflamed with these spiritual sentiments and so high did the acuity of his genius ascend, that the aforementioned men were astounded that someone who had not dedicated his life to letters could so often not only succeed in intimately penetrating these most sublime mysteries, but also raise probing questions about and offer logical accounts of the same, as if he had spent his entire life in school. *(Confirmation of This in the Words of Father Oliva, Superior General of the Society of Jesus.)* Father Giovanni Paolo Oliva, Superior General of the Society of Jesus, used to say that "in discussing spiritual matters with the Cavaliere, he (Oliva) felt obliged to prepare himself carefully, just as if he were going to a doctoral thesis defense."[5]

Furthermore, it was not in vain that Bernini nurtured these most noble thoughts in his mind; on the contrary, his life was a continual exercise of virtue in the form of concrete action.[6] Every Friday, for the space of forty years, he attended the devotions of the Good Death at the Church of the Gesù,[7] where very frequently, at least once a week, he received Most Holy Communion.[8] For the same long space of time, every day, after finishing his work, he would visit that same church where the Most Holy Sacrament was exposed for adoration, and while there would leave generous alms for the poor. Beyond the many dowries that he provided throughout the year for unwed indigent girls, he contributed one in particular annually on the Feast of the Most Holy Assumption; in his will, he furthermore obligated his children to make provision for six more of such dowries.[9] However, in order to gain spiritual merit from the avoidance of public acclaim, he would very often distribute generous alms instead [172] through one of his servants, obliging the latter not to reveal the name of the true benefactor. The practice

of almsgiving was indeed for Bernini something with which he, so to speak, was born and raised. Nonetheless, during the last years of his life, it became a matter of even greater concern for him, so much so that, considering himself incapable of properly identifying needy individuals for his benefactions, he instead gave that task, along with the necessary money, to various religious, asking them to administer this assistance to the poor.

Since, in the execution of such works of charity, he loved secrecy, we can be sure that there are many more that he carried out beyond those about which we have direct knowledge. From some notes taken down in his own hand in a small book regarding household affairs, we learn that three months before his death, the Cavaliere had placed two thousand gold *scudi* inside a prie-dieu, of which only two hundred were later found: this money he ordered his children to donate—as indeed they did—to a specific pious organization, doing so in such terms that it was evident that the rest of the original two thousand *scudi* had been expended in similar fashion. *(Remark of His About Almsgiving.)* Moreover, in a letter written from Paris, Bernini ordered Monsignore, his son, to double the amount of alms that he, in a separate instruction, had asked him to distribute, "Because God is a lord who does not let himself be won over by mere courtesy."[10] Many times during the year, the Cavaliere used to bring his family to a hospital and had his children, following their father's example, bring comfort to the patients by distributing various kinds of confections that he had prepared especially for them. It was, furthermore, a source of amazement that a man, involved in so many projects of such considerable importance, would each morning devoutly hear Mass, each day visit the Most Blessed Sacrament, and each evening recite the rosary of our Most Holy Lady and, on his knees, recite her office as well, together with [173] the seven penitential psalms, all of this being his constant habit until his death.

(His Preparation for Death.) When he then saw himself approaching death, his thoughts concentrated on nothing but that passage, and of nothing else did he talk.[11] In talking of death, he would do so not with the distress and horror that is usual among old people, but with an incomparable steadfastness of spirit, ever reminding himself of its approach so as to prepare to meet it properly. To this end, he was in continual conversation with Father Francesco Marchese, priest of the Oratory of Saint Filippo Neri at the Chiesa Nuova in Rome, son of Beatrice Bernini, his sister, an individual worthy of veneration for the goodness of his life and eminent for his learning.[12] The Cavaliere prevailed upon Father Marchese to agree to attend to him at his death. And since as Bernini would say, "That transit was a difficult one for all because for all it was

an entirely new experience," he spent much time imagining for himself what it would be like, in order that through this rehearsal he might become more accustomed to it and thus better prepared to do battle with the real thing. It was in this state of mind that he asked Father Marchese to suggest to him all of those usual devotions recommended to whoever is undertaking this passage. Doing the latter exercises, Bernini deepened his preparation for that great, ever-approaching moment. Moreover, anticipating that, as usually happens with the dying, he might be deprived of his speech in those last days of life and thus suffer the distress of those who cannot make themselves understood, the Cavaliere devised with Father Marchese a special way of communicating at that stage even without the use of speech. And so, having made all these diligent preparations, with a completely reassured spirit, Bernini arrived, finally, at the test.[13]

(*His Final Illness and Expressions of His Devotion.*) We have already described how debilitated was the strength of the Cavaliere and how agitated in the rest of his body did he find himself, as a result of having undertaken the restoration of the Palazzo della Cancelleria. Consequently, he eventually fell sick with a low-grade fever, **[174]** followed thereafter by a fit of apoplexy that snatched him from life.[14] During the entire course of his illness, which lasted fifteen days, he asked that there be erected at the foot of his bed a kind of altar and upon it displayed the painting that depicted the Blood of Jesus Christ. The nature of the discourses he subsequently held, with either Father Marchese or other religious who came to his assistance, about the saving power of that most precious blood and his trust therein, can be more readily imagined than described. There was no one coming into his presence at this time who did not shed copious tears upon hearing the solidity of thought with which that man now discoursed. In him, neither old age nor sickness—both of them fierce, powerful enemies—had been able to obfuscate that clarity of intellect that he possessed and that remained constant and mighty until his very last breath. Seeing that he was no longer able to move his right arm because of the fit of apoplexy, he remarked, "It is only right that even before death this hand should take a little bit of rest, since it has labored so hard in life."[15]

(*Message Sent by Bernini to the Queen of Sweden.*) Cardinal Azzolino honored the Cavaliere several times with personal visits during these last days and one evening Bernini requested of Azzolino: "In his name the Cardinal beg Her Majesty the Queen to offer up an act of love to God on his behalf, since he believed that great lady had a special language with which to make herself

understood by the Lord God, just as in turn with her God made use of a language that only she was capable of understanding." *(The Queen's Response to That Message.)* The cardinal relayed the request to the queen, who replied with the following note: "I beg you to inform Lord Cavalier Bernini that I promise to use all my energies in carrying out **[175]** that which he desires of me, on the condition that he promise me in return that he will beg God on my behalf and yours to grant us the grace of perfect love for Him, so that one day we might meet all together again in the bliss of love and enjoy the presence of God for eternity. And tell him that I have in the past served him as best I was able and that I will continue to do so."[16]

(His Final Hours.) In the meanwhile, the Cavaliere's house was a continual coming and going of the most illustrious personages of Rome. Surpassing the usual formulas of conventional etiquette, all gave or sent expression of their profound, personal esteem for Bernini and their regret over the loss of so great a man.[17] Eventually Bernini was deprived of his speech. As he was also extremely afflicted by catarrh, he signaled to Cavalier Mattia de' Rossi and Giovanni Battista Contini (who, along with Giulio Cartari, another of his disciples, were constantly at his bedside): as if to express his surprise that they could not find a means to free him of the catarrh in his chest, he attempted with his left hand to describe for them an instrument most capable of lifting exceedingly heavy loads.[18] Before the onset of his illness (as mentioned) he had devised with Father Marchese a means of making himself understood without speaking, and for everyone it was now a cause of wonder how well he could communicate with the priest merely by movement of his left hand and eyes. This was indeed a clear sign of that great liveliness of spirit of his, which not even then, when his life was failing, showed any sign of surrender. Two hours before dying, he imparted his blessing upon all of his children (of which he left nine, as already reported, four boys and five girls). He himself thereafter received the pope's blessing, which arrived by means of one of the papal valets. **[176]** *(His Death.)* Then, at the commencement of the twenty-eighth day of November of the year 1680 and in the eighty-second year of his life, Bernini breathed his last.[19] He died as he lived, a great man, leaving open the question whether his life was more admirable for all of its accomplishments or his death more commendable for its piety.

(His Bequests.)[20] In his will, Bernini left to the pope a most beautiful painting of the Savior from the hand of Giovanni Battista Gaulli, the subject of his last work in marble,[21] while the bust itself he left to the queen;[22] to Cardinal

Altieri he gave the portrait of Clement X;[23] to Cardinal Azzolino, the one of Innocent X;[24] and to Cardinal Giacomo Rospigliosi, another painting likewise of his own hand, not having in his house any other work in marble, except for his statue of Truth, which he left in perpetual trust to his descendants.[25]

Universal was the mourning in the city of Rome for the loss of this man, well aware that it had been further endowed with great majesty by means of his untiring labors. Within the academies, Bernini, as in life, so in death, was the subject of many brilliant literary compositions.[26] *(The Queen of Sweden's Remark About the Estate Left by the Cavaliere.)* The following day, taking advantage of the opportunity offered by the pope's presentation of a gift to her, Queen Christina asked His Holiness's servant, "What are they saying about the estate left by Cavalier Bernini?" "He left," the servant replied, "about four hundred thousand *scudi*." To that the queen remarked, "I would be ashamed if he had been in my service and had left so little."[27]

(His Funeral and Burial.) The Cavaliere's body was waked with all due pomp in the basilica of Santa Maria Maggiore, followed by a funeral and the distribution of candles and alms to the poor. There was so great a multitude of people who came that it was necessary to defer burial until the following day.[28] **[177]** Bernini had already made provisions for his burial, alongside his deceased family members, in the same church; accordingly, his body was interred there in a lead casket, with an inscription bearing his name and the date of his death.[29]

(Description of His Physical Appearance.)[30] The Cavalier Bernini was of average physical stature, his complexion rather swarthy, his hair black, turning white in advanced age; eyes likewise black and with such a piercing look that by his glance alone he could instill terror;[31] eyebrows long and full; wide, majestic forehead, and his fingers rounded at their tips as if nature had formed them just as needed for his profession. He was abstemious in eating, accustomed to having only simple food at table.[32] However, he had a great appetite for fruit, this appetite being, as he would say, a trait of all those born in Naples. He was healthy in body, except for the migraines that he suffered until his fortieth year.[33] Rather stern by nature even in matters that were well done, he was driven in his work and passionate in his wrath, which used to inflame him more so than others. But it was to the force of this wrath that he attributed his ability to work much more than others.[34] He, finally, encompassed that combination of physical traits, character, constitution, and natural aptitude, which all worked together to form a man of great ideas and great accomplishments.

Chapter XXIV

SOME REFLECTIONS UPON THE LIFE AND WORKS OF
THE CAVALIER GIAN LORENZO BERNINI.

(Epilogue and Reflections upon What Has Been Thus Far Recounted in This Book, with Some Notable Sayings of the Cavaliere.) In response to all that has thus far been recounted, whoever would wish to direct his attention to and reflect upon the life and works of the Cavalier Gian Lorenzo Bernini will be obliged **[178]** to believe either that the former (his life) was of much greater length or that the latter (his works) were of much smaller number, for it is difficult to accept as truth the fact that one man alone in the course of seventy years was able to bring to completion so many arduous projects. (I say seventy years, subtracting the twelve years of his childhood, if one indeed can subtract the childhood years in the case of someone who was producing by the age of ten.) Bernini's statues, both in marble and bronze, almost all larger than life-size and all executed by his own hand, add up to more than one hundred forty in number; up to fifty in number are his works of architecture, all of them large-scale and of great fame; more than two hundred canvases were executed by him, as well as a larger quantity of drawings than can be counted.[1] It is thus no wonder that he used to say that "If he could gather together all of the hours of leisure he had had during his entire life, they would barely add up to a month's worth of time."[2]

However, what must truly inspire amazement is how he could have conceived so many great ideas with his mind and completed so many great works with his hand. The mere thought of all of this is sufficient to exhaust the imaginations of those who ponder the accomplishments of a man of whom every prince, even in the most remote lands, wanted a share, who was also head of

a very large family, and thus all the more distracted by domestic affairs, and who was, as well, continually and actively involved in many projects that were not even his own. For this reason, the widely celebrated Cardinal Pallavicino was moved to remark: "The Cavalier Bernini had been endowed by nature with an energy far superior to that of common men, which compensated in a marvelous way for the insufficiency of time."[3] The Cavaliere recognized the truth of this statement in himself; and that which others attributed to his own talent he instead attributed to the special assistance of the Prince of the Apostles, Saint Peter, [179] to whom he was extremely devoted and in whose service he had been able to erect so many monuments and whose temple he had rendered more splendid with so many outstanding ornaments.[4]

Nonetheless, although it be quite true that nature had given him this particular ability, it is also an unquestionable fact that he himself had successfully cultivated it with his own unceasing exercise. He was constantly at work, interrupted only by his usual devotional practices or the necessary sustenance of his body or by the benefit he derived from satisfying the desire of eminent personages who all vied, so to speak, for his company. As for the rest of the time, he was so engrossed in his work that to those who sought to convince him to get some rest, he would anxiously respond, "Let me stay here, for I am in love."[5] It was utter necessity, rather than his own free will, that would instead have to separate him from his work, for he would leave it aside only when he found himself in a state of complete depletion of his strength. However, thanks to his robust constitution, that strength was easily restored with a small amount of food. In the last years of his old age, he required, nonetheless, the presence of a young assistant who stood ever at his side, for it was feared that, so absorbed in his work, Bernini would completely exhaust his strength, causing an irreparable collapse.[6]

And although he seemed to be ever in love with his projects while he was working on them, once he saw them in their completed state, he abhorred them to such a degree that he would not even deign to cast a glance in their direction.[7] This was so perhaps because his great mind was able to conceive greater things than art was capable of materializing and this impossibility of reaching supreme perfection thus rendered his works defective in his eyes. Or perhaps it is simply the habit of those of superior knowledge to protest that they instead know nothing. From this derived the extremely low opinion he harbored of himself: he was accustomed to saying that "he had committed more errors than others because, since [180] errors were inevitable in everyone's work, he who had produced more works than others had committed more errors."[8] And on the same subject, he would add: "The humility of an

artist adds as much value to his work as the zero digit adds to the size of any number."[9] What he meant was that, just as the more zeros that are added to a numeric unit, the more that number grows, likewise does an artist acquire more prestige from a work of his, the more humility he shows in its regard after bringing it to completion. Accordingly, he used to declare, not in a vain display of false modesty but as the honest truth: "If all the works he had ever done were still in his custody, he would smash all of them to the most minute of pieces." This aversion he felt toward the fruits of his labors—originating as it did in a clear perception of Beauty and Perfection on his part—operated, furthermore, in such a way that whenever he began some new project, he would always conceive for it the most noble ideas, and in attempting to realize them in tangible form, he so exhausted his nature that it seemed as if he were dying in the act of infusing into that work all of his vital life forces in order to bring life to it.

All the other endowments of his spirit were of similar excellence. The good name and praise accorded him were the well-deserved result of great challenges well-met, of material riches acquired without blame and enjoyed without ostentation, of pious devotion practiced with decorum, of a perfect sense of judgment, and of profound genius, thanks to which every form of greatness was within his grasp. They were also the result, finally, of that which is rarely found in princely courts, that is, the ability to sustain—with scant envy and beyond all arrogance—both the external appearance and the true bond of friendship with so many princes of Europe, who were, for him, both instruments of glory and admirers of his talent. Thus can we indeed conclude that the Cavalier Bernini had been in each and every action of his A GREAT MAN.[10]

Appendix 1

Pietro Filippo Bernini (attrib.), *The Vita Brevis of Gian Lorenzo Bernini* (Bibliothèque Nationale, Paris, Ms. italien, 2084, fols. 132–35)

This brief sketch of Bernini's life is now generally presumed to have been written by the artist's eldest son, Monsignor Pietro Filippo Bernini. It was he who, as mentioned in the Introduction (section 4) to this volume, guided the family's endeavor to publish a formal, book-length biography of Bernini, a project that was finally realized in the form of Filippo Baldinucci's 1682 *Life of Bernini*. Yet, though prepared by someone who was himself a playwright and the holder of distinguished ecclesiastical offices requiring an above-average degree of learning, this series of biographical data and "sound bites" is, literarily, to say the least, quite undistinguished, with no trace of the rhetorical polish that one would expect in a man of his education and professional experience.[1]

Nonetheless, the text contains much of the information (or, at times, misinformation) and many of the anecdotes, quotations, and turns of phrases that also appear in the biographies by Domenico Bernini and Baldinucci. We know from extant sources that the Bernini family supplied Baldinucci with a good deal of the necessary documentary material for his volume, perhaps even to the extent (as I argue in the Introduction, and as have other scholars) of producing for his use a rather lengthy biographical narrative composed by Domenico, the family's young, aspiring historian. Presumably, the present sketch served as one of the earlier stepping stones to the production of the full-fledged biography. Hence it is an important point of reference for any discussion of either Domenico's or Baldinucci's *vita* of Bernini. As is immediately obvious, however, the crude, bare prose style of this sketch is completely different from those of either Domenico or Baldinucci.

The final portions of the original manuscript version of this text—extant among the Bernini family papers in the Bibliothèque Nationale, Paris—are in Pietro Filippo's own hand, representing separate addenda to a neatly written, formal copy of the initial narrative, the contents of which were also, we assume, of the monsignor's compiling.[2] The manuscript bears no title; for convenience's sake, I have entitled it *The Vita Brevis*. The last of the addenda mentions that the artist is now in the eighty-second year of his life, hence the biographical sketch was last revised in 1680. The text was first published in 1844, with various inaccuracies, by Paolo Mazio in the Roman periodical *Il Saggiatore,* when still in possession of the Bernini heirs; it was republished in 1985 in a more faithful transcription by Felicita Audisio.[3] All the information and anecdotes reported here are included in Domenico's text, except for the two remarks about Saint Peter's being stripped bare with the removal of Bernini's works and about the artist's drawing in his sleep. Not all the information is correct or complete: for instance, specific chronology is usually wanting, and in one case the title of an early Bernini work is incorrect (the *Saint Lawrence* is mistakenly called a *Saint Sebastian*). On the other hand, regarding the boy Bernini's supposed first work in Rome (an otherwise unidentified portrait bust), Pietro Filippo gives the correct location, the church of Santa Prassede, in contrast with both Domenico and Baldinucci.[4] Again, although we are still in the dark regarding the specific role this sketch played in the genesis of the final, full-fledged biographies of Domenico and Baldinucci, it unquestionably was at their disposal as a primary source when the two men created their narratives; thus it is of direct importance to the editorial history of Domenico's *Life of Gian Lorenzo Bernini.*[5]

Translation of the Text

The Cavalier Gian Lorenzo Bernini was born on December 7, 1698 [*sic*],[6] in Naples, son of Pietro, who was born in Florence, as were all of his ancestors, and of the Neapolitan Angelica Galante. Employed in various occupations[7] according to the custom of his town, Pietro went to Naples, where he married,[8] and since he above all enjoyed sculpting in marble, he was much valued by the viceroys and left many outstanding works in that city. Paul V then requested Pietro's services from the viceroy in order to employ him in the sumptuous chapel that he was then constructing. He went to Rome, bringing with him Gian Lorenzo and the rest of his large family. He had a house built near Santa Maria Maggiore and lived there until his death.

At the time he moved to Rome, Gian Lorenzo was —— years old.[9] Since there was discovered in him an extremely lively genius and very great talent for learning design[10] and sculpture, he trained in the latter profession and, in Naples, at the age of eight, carved a small marble head of a *putto*;[11] and after arriving in Rome, more according to his own good taste[12] and with study of ancient statuary and the paintings of Raphael and his father's instruction, he began to lay the foundations of his profession, spending, for the space of three continuous years, the entire day from the morning's dawn to the Ave Maria hour enclosed in the rooms of the Vatican. And whenever he would show his drawings to his father, Pietro would express displeasure over them, always responding that what Gian Lorenzo was showing him would never be surpassed by the next one he would do, and this served as a stimulus to the boy to strive for ever higher achievement.

The first work he created in marble, when he was ten years old, was a bust of etc.[13] in Santa Prassede, and since a most enthusiastic report had spread throughout the academies and entire city of Rome about this young lad whose talent far exceeded his years and who gave great hope of becoming a true master, Paul V wished to see him for himself. Having summoned him to his presence, the pope asked the boy, as if in jest, if he could draw a head for him with his pen. Gian Lorenzo, in reply, asked him what kind of head he desired; to which the pope remarked, if that is the case, then he knows how to do all types. The pope then commanded him to do one of Saint Paul, which he finished in a half hour with great confidence,[14] to the delight and admiration of the pontiff. While the boy was busy with his drawing in the presence of the pope, Cardinal Maffeo Barberini happened to arrive, a most favorable circumstance for Gian Lorenzo. The pope had the cardinal immediately introduced, and knowing what a great lover of talent Barberini was, Paul commended Gian Lorenzo to the special protection of the cardinal, in whom the artist acknowledges the beginning and increase of his fortune. After having given him a gift of twelve gold medals, which were as many as the boy could grasp with his two hands, the pope made this prophetic pronouncement to him: let us hope this young lad is to become the Michelangelo of his century.

Making further steady progress each day, Gian Lorenzo was pointed out on the streets of Rome by all and infinitely embraced by all the princes and nobility. For Cardinal Scipione Borghese, he did portraits both of him and of the pope; for the cardinal, he also created his famous statue of Daphne (for the pedestal of which Cardinal Maffeo Barberini wrote that famous couplet) and that of David in the act of launching his sling, which he sculpted giving the face and body his own likeness. After Paul's death and the assumption of the

papacy by Gregory, the latter had Gian Lorenzo do several portraits of him both in marble and bronze, for which the pope honored him with the Cross[15] and granted him several lucrative pensions. Cardinal Maffeo Barberini next assumed the papacy. Knowing Gian Lorenzo to be capable of great things and having loved him tenderly from the moment the lad had been entrusted to his care by Paul V, this pope made much use of the artist throughout his long pontificate, in sculpture, painting, and architecture, as seen in the works he executed throughout this entire period. Since it was the pope's intention to have Gian Lorenzo paint the Benediction Loggia, the artist devoted himself to painting for the space of two years, producing during this period a great many canvases, some complete, some only sketched out. These are now held in the greatest esteem in the galleries of Rome. Thereafter, however, the pope decided instead to turn his attention to the famous work of the *Confessio* of the Holy Apostles Peter and Paul,[16] and Gian Lorenzo thus put painting aside. In the subsequent pontificates, he was kept ever busy in all the great projects undertaken in that period, the greatest of which are the Navona fountain, the *Confessio* of the Apostles,[17] the Portico of Saint Peter's, the Scala, and the Cathedra.[18] Alexander VII once said that if one were to remove from Saint Peter's everything that had been made by the Cavalier Bernini, that temple would be stripped bare.

There is no one who in the course of his life engaged in and produced greater works than he. His statues add up to a total of more than one hundred, while his works of architecture are beyond counting. He was singularly loved and esteemed by great princes, not only for his talent but also for the immense vitality of his genius, as well as for the skill and force that he displayed in conversation, being able immediately to hit the target of any discourse with a most ingenious liveliness. It was thanks to this skill that he enjoyed free access at dinnertime to Urban VIII, Alexander VII, and Clement IX, remaining each day for the hour of recreation that followed the meal and engaging his hosts with great familiarity and in erudite discussion. On such occasions, a source of true wonder to Alexander VII was the fact that, amid the company of learned persons whom he had chosen for this purpose, the Cavaliere, by dint of his own genius, had arrived at a point where the others had reached only after a great deal of study.

While he was living at Santa Maria Maggiore, he received the honor of being visited at his home by Urban VIII (following the example of Julius II) along with thirteen cardinals;[19] the papal master of ceremonies, Paolo Alla-leona, had wished to dissuade the pope from making this visit, but the pontiff scolded him saying that, when Paolo had approved the pope's going to his

nephews' house, what he had recommended was an act of childishness, but now that he, the pope, wanted to make a gesture that was glorious in itself and a stimulus to talent, he was trying to discourage him from it. The same honor was bestowed upon Gian Lorenzo twice by Alexander VII and once by Clement IX, who visited his house at S. Andrea delle Fratte, where on several occasions the Queen of Sweden also came calling, as well as all the great princes who traveled to Rome. His services were requested of Pope Alexander by Louis XIV in the year . . . [20] and the king's request was granted by the pope, since he had made it at the time of the conclusion of the peace treatises; the Duke of Créqui, having already taken his formal leave of the pope, was ordered by a courier sent to . . . to present himself there.[21] Gian Lorenzo was accompanied [on his journey to Paris] by His Majesty's official ministers and received immense honors from the state, being greeted by the magistrates [of the various towns en route] with public orations and welcomed several leagues [before reaching Paris] by the king's litter.[22] He interacted with the king with familiarity, winning, in return, both his esteem and monetary rewards commensurate with the generosity of so great a king. In Paris he did the king's portrait in marble and created the design and a *modello* of the Louvre. On his return [to Rome] he was given the same accompaniment.

It happened one day that Bernini went to Saint Peter's with his father, Carracci, and others, when at the church's exit Carracci turned toward the tribune and remarked: There will come some great big genius who will create in the middle of this church and at its far end two grand structures proportionate to its vast space. Gian Lorenzo was greatly stirred by this pronouncement and exclaimed to himself: Oh that I would be that person! This prophecy was later to be fulfilled.

He was so enamored of his profession[23] that at night in his dreams he would take his chalk box, portfolio, and paper and begin to draw in such a way that at times it was a source of astonishment to himself. One night, while he was doing a Saint Sebastian [*sic*] on his grill for Strozzi, not satisfied with his rendering of one of the legs, he lit a fire in order to burn his own leg and observe the effect that it had.[24]

He established the foundation of his family with great riches, one of his brothers was made a canon of Saint John Lateran by Urban VIII, and he now has a son who is a prelate employed in prestigious offices.[25] He currently is in the eighty-second year of his life, enjoying the best of health, having worked with marble until the age of eighty-one, which he terminated with a statue of the Savior, created as an act of personal piety.[26]

Appendix 2

The First Published Postmortem Tribute to Bernini: "Éloge du Cavalier Bernin," *Le Mercure Galant* (Jean Donneau de Visé), Paris, January 1681, pp. 76–85

This eulogy, full of unqualified praise for Bernini, is the first known published postmortem tribute to Bernini. It comes from Paris—as does the first published "biography" of the artist, that of Pierre Cureau de La Chambre—and from a source close to the French court. This is somewhat ironic, for Bernini's experience at the French court was, as is well known, less than pleasant.[1] A monthly periodical, the *Mercure Galant* was founded, edited, and, until shortly after the appearance of this piece, written solely by Jean Donneau de Visé (Vizé).[2] Hence we assume that this unsigned article also comes from his pen. It was published, as its masthead proclaims, with royal license, "au Palais" (on the premises of the Louvre) and dedicated to "Monseigneur Le Dauphin," the eldest son of Louis, "Louis the Dauphin" (1661–1711).

The *Mercure Galant* was widely popular at court and in the rest of courtly Europe, albeit disdained by some portions of the intellectual elite for its dilettante level of discourse.[3] It was a source of news (political, cultural, scientific, etc.) and gossip not only from the court and France but also from around the world. Its favored status at court was due, in large part no doubt, to an editorial policy that used every possible opportunity for the further glorification of France in general and of King Louis in particular—as indeed the concluding poem of this Bernini tribute exemplifies. Thus one can assume that its opinions were never fundamentally at variance with those of Louis XIV (who, in any event, exercised a stringent censorship of the press), including, presumably, in the present case, the highly favorable portrait and evaluation of Bernini.[4]

Idealizingly encomiastic and laconically synthetic as it is, the tribute shows itself sufficiently well informed about Bernini's life, character, and work. Its two major inaccuracies regard the number of paintings Bernini produced (he produced many, not few, if we are to believe Domenico and Baldinucci) and the extent of his personal involvement in the execution of his works (contrary to what is here claimed, Bernini did not always do the actual execution of sculpture designed by him). The *Mercure* obituary also mentions Bernini's writing of poetic verse: no such verse is extant, but it is possible that he included poetry of his own composition in some of his theatrical scripts. The February 16, 1662, entry of the diary of Pope Alexander VII indeed mentions that "this evening they [not identified] will perform music for us, with lyrics by Bernini," and, as is well known, lyrics set to music were then generally compositions in verse, whether written especially for that music by contemporary poets or appropriated from such famous poetic masters of the past as Petrarch or Tasso.[5]

Who, among the many people in Paris who knew Bernini well from direct contact, might have served as Donneau de Visé's informants on the topics here discussed? Our French editor does not specify. Perhaps it was largely or solely the same architect, Augustin-Charles Daviler (or d'Aviler, 1653–1701), who supplied the concluding sonnet and who had just recently returned from four years of study in Rome. Other possible sources of information were Bernini's Parisian friends and allies, Paul Fréart de Chantelou (1609–1694), the biographer Pierre Cureau de la Chambre (1640–1693), and any number of other French artists who had studied for substantial amounts of time in Rome, such as François Girardon (1628–1715), the latter having worked under Bernini during his second Roman *séjour* in the spring of 1669.[6]

Translation of the Text

This letter[7] from Rome calls to mind the death **[77]** of the Cavalier Bernini, which occurred in the same city on Thursday, November 28. I had promised you in the last issue to speak more amply of him and I shall here fulfill that promise.[8]

This great man was painter, architect, sculptor, engineer, and scenographer,[9] and possessed all of these different talents so equally that it would be difficult to say in which he excelled the most. Although he produced few canvases,[10] those that one can see by him would easily persuade the viewer that it was in painting **[78]** that he most occupied himself. His canvases possess beautiful coloring, are well understood, in chiaroscuro, and effortlessly

painted; they are what one could call, in the terminology of art, of a very grand manner.[11] The many monuments in his style that fill the city of Rome cause him to be regarded as one of the greatest architects of his century. It is surprising that the attention he gave to an art that requires the utmost concentration of spirit for its production did not at all prevent him **[79]** from almost always devoting himself to sculpture as well. He was not satisfied with simply creating models, as he could have done, to then give them to others to execute. He carved the works himself and so vigorously that it seemed as if the marble simply softened under his chisel. Moreover, there is nothing that remains of antiquity in which one can see the same bold, extraordinary workmanship as we see in his sculpture.

He was, furthermore, a great scenographer, as I mentioned earlier. Beyond the beauty of the amazing scenery **[80]** that he presented on stage, he also caused fire to break out and the Tiber to flow; he also made it hail and rain on stage. One can say to his further credit that it is almost impossible to invent anything in this field for which he has not shown the way.[12] He wrote very fine verse, was capable of agreeable conversation, possessed a lively, penetrating mind, and treated all in a most civil manner. His merit secured for him the title of Knight.

His fortunes began under Paul V and continued under all successive popes. Alexander VII **[81]** filled him with material rewards and made one of his sons a prelate. He would have made the same son a cardinal, they say, had the pope lived long enough. The honors received by this great man from every direction were well deserved. You are well aware of those accorded him in France at the time when the King summoned him here to consult with him on the design of the Louvre.

Never was genius so universal. It was a bounty and a torrent to which he simply abandoned himself, for he could never arrest its impetus. All of **[82]** his works, be they of painting, sculpture, or architecture, are of a quality that is marvelous, noble, grand, extraordinary, and yet effortless. One notices that he always distanced himself from what his predecessors created before him.[13] Since the likeness of extraordinary men is worthy of preservation, I send you one of him in a medallion, very true to life, engraved after the one done by Monsieur Chéron in 1674.[14] Cavalier Bernini was then seventy-six years old. You saw above that he died **[83]** at the age of eighty-two. You know what reputation M. Chéron enjoys. He is one of the more illustrious artists we have for things of this nature and most of his work has been for His Majesty. The explanation of the reverse of the medallion is easy to give: there you behold the various genres of art, with the words, *Singularis in singulis, in omnibus unicus*.[15]

Here is a sonnet in which this illustrious deceased personage is made to speak. M. Daviler is its author:[16] **[84]**

Of the sacred pontiffs their portraits I have formed,
Of their famous temple its splendor I have increased;
In their palaces I have joined art with grandeur,
And have acquired the advantages of their abundant esteem.

Marble and metal celebrate my works,
Prodigious fortune has filled my happiness to the brim,
And, over those envious of me, I have attained this honor,
For Rome has rendered homage to my merit.

But of all the many benefits I have received from the heavens **[85]**
The favor of LOUIS has been the most precious,
When I made of this Hero an Equestrian Colossus.[17]

And Europe will learn that, without fear of oblivion,
Leaving in their tomb my mortal remains,
In the shelter of his Name does my own rest secure.

Notes

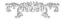

INTRODUCTION

1. Excerpts from Domenico's text were published in English by Bauer, 1976, 24–42. For the three facsimile editions of Domenico, see DLO/Pro, 61 n.57. For convenience, I refer to Domenico's text simply as *The Life of Gian Lorenzo Bernini;* for Baldinucci's biography, I use the title of its 1966/2006 English translation, *The Life of Bernini.* As with all the names of persons in Domenico's text, I use the most familiar, common form of the artist's name now in use, hence Gian Lorenzo Bernini, and not "Gio. [Giovanni] Lorenzo Bernino," as one usually finds in contemporary documentation. Family names were often treated as adjectives in early modern Italy; we also encounter the forms "Bernini" and "Bernina" (as in "Casa Bernina") in the documents.

The artist's first name is at times given in the primary sources simply as "Lorenzo" (such as in Jesuit Father General Oliva's official missive of April 23, 1665, to Jesuit superiors announcing the trip to France by "Laurentius Berninus" [see Chantelou, f.85, n.4]). The latter usage, I suspect, may reflect Bernini's own favoring of the name of his primary patron saint, Lawrence (and not Saint John): see Domenico, 15; and Chantelou, August 10, f.111, e.109. Hence I have not heeded the call by Fagiolo dell'Arco (2002, 50–51; Fagiolo/*IAP,* "Avvertenza," vii) for adoption of what he considers the more historically correct rendition of Bernini's first name as "Giovan Lorenzo."

I have found one (slightly later) exception to Fagiolo dell'Arco's statement that the form "Gian" is nowhere encountered in the sources: Lione Pascoli's *Vite de' pittori, scultori e l'architetti moderni* (1730–36) refers to him throughout as "Gianlorenzo." It may be of relevance to point out that the contemporary Giovanni ("Gio.") Paolo Oliva's name was indeed rendered in print as "Gian," as on the title pages and elsewhere in some of the volumes of his *Prediche dette nel Palazzo Apostolico,* Rome, 1659–74.

2. *Vita des Gio. Lorenzo Bernini* / Filippo Baldinucci. Mit Übersetzung und Kommentar von Alois Riegl, aus seinem Nachlasse hrsg. von Arthur Burda und Oskar Pollak (Vienna: A. Schroll, 1912); and Sergio Samek Ludovici, *Filippo Baldinucci. Vita di Gian Lorenzo Bernini. Con l'inedita Vita del Baldinucci scritta dal figlio Francesco Saverio* (Milan: Edizioni del Milione, 1948). The English translation was done by Catherine Enggass and published by Pennsylvania State University Press in 1966; it was reprinted, without revision, in 2006 with a new introduction by Maarten Delbeke, Evonne Levy, and Steven F. Ostrow.

3. Since this book is likely to be read by students and other nonspecialists, I include some elementary information and commentary that scholars might consider obvious or uninteresting. Readers can find further discussion of some of the same material covered by this Introduction (as well as additional related topics) in the 2006 volume of essays edited by Delbeke, Levy, and Ostrow, *Bernini's Biographies,* especially their thorough "Prolegomena" (hereafter "DLO/Pro"), indispensable to any study of the *vite* of Bernini by Domenico and Baldinucci. Also most useful is

their introduction to the 2006 reprint of the Enggass translation of Baldinucci (hereafter "DLO/Intro").

I might note that *Bernini's Biographies* was published in 2006, at which point I had completed all of my own research on Domenico, as well as the first draft of this Introduction and a second draft of my translation and its footnotes. (I attended the 2002 Rome conference on the same topic, organized by Delbeke, Levy, and Ostrow, in which *Bernini's Biographies* has its origins.) As is to be expected, though working independently, we (the authors of the "Prolegomena" and I) cite many of the same sources, focus on the same or similar aspects of the texts, and arrive at the same or similar conclusions. Wherever this is the case, I cite the corresponding passages in the "Prolegomena" (or in other essays in *Bernini's Biographies*).

In revising my Introduction after the appearance of *Bernini's Biographies,* I omitted discussion of certain topics supplied in sufficient fashion in the latter volume and simply refer the reader to the relevant passages. However, with respect to certain other topics treated in *Bernini's Biographies* and taken up in the present work, I offer here either further information or alternative interpretations, having consulted and evaluated the primary sources on my own. The same can be said indeed about almost all the other Bernini secondary sources cited here pertaining to Domenico and his text: wherever possible, I have returned to the relevant primary sources either to confirm or modify the descriptions and evaluations of earlier scholars, according to my own analysis of the topics in question.

4. Many of the topics and personages discussed in this Introduction are also encountered in Domenico's text and hence readers will find further information about them, with bibliography, in the relevant notes. Because of space limitations, I have had to be selective and laconically succinct in annotating Domenico's text: each line of Domenico's could warrant explanation and commentary, in light of the daunting body of research now available on Bernini and Baroque Rome.

5. Domenico, 2 (for discussion of the term *virtù* and its translations, see the Introduction, section 9). Domenico defines history in very similar terms in the (unpaginated) preface to his *Historia di tutte l'heresie* (discussed below): "And we shall be able to attain our present goal if we compose our account in such a way that the intellect is instructed in the knowledge of truth, which is the sole end of history and which alone is history" (E Noi giunger potremo al presente proposto, se ne ordinaremo i racconti in modo tale, che l'Intelletto rimanga ammaestrato nel conoscimento del Vero, ch'è l'unico fine dell'Historia, e ch'è solo l'Historia).

All citations of Domenico's *Life of Gian Lorenzo Bernini* are to the original 1713 pagination, which is supplied in the text of the translation in bold print and within square brackets. All other translations are my own, unless otherwise indicated. In citing Baldinucci's biography, I have used the Enggass translation, albeit at times revising it for greater clarity or correction of occasional inaccuracies.

6. Sohm, 2002, 449, summarizing one of the conclusions of Ernst Kris and Otto Kurz's *Legend, Myth, and Magic in the Image of the Artist.* For the early modern art biography as literary-historical genre, see Goldstein (and the subsequent discussion in Mendelsohn-Kramer-Goldstein; Rubin, esp. chap. 4; Soussloff, 1990; and Summerscale, 38–45; with specific reference to Bernini: Soussloff, 1982, 1987, and 1989; and DLO/Pro, 5–10, 32–39; see also the further bibliography on early modern biography supplied by DLO/Intro, xxxi–xxxii. For early modern historiography in Italy, see Bellini, 2002, 113–241; Bertelli; Bouwsma; Capucci; and Spini.

Domenico was not alone among early modern art biographers in protesting his strict adherence to historical accuracy while nonetheless transmitting data and anecdotes that are more fable than history: despite his well-publicized diligence in seeking out primary sources and credible witnesses (Rubin, 169–70), Vasari still published, e.g., a *vita* of Cimabue that is "entirely fictitious," for, in reality, "there was a complete lack of information about the life and career of that master" (Kris and Kurz, 30); for Vasari, see note 7.

7. For Bernini's remark about the Louis XIV bust, see Chantelou, July 29, f.96, e.89. I owe the analogy between biography and portrait sculpture to Sheila Barker. For Baroque biography and the panegyric, see Rubin, 168, specifically referring to the *Lives of the Most Eminent*

Painters, Sculptors and Architects by Giorgio Vasari (1511–1574). Despite the chronological gap separating the two biographers (Vasari and Domenico), much of what Rubin describes about the literary and historical sources, underlying theory, structure, and rhetorical style of Vasari's *Lives* is applicable to Domenico. Domenico's work, to a great extent, faithfully conforms to the conventions of its literary genre, as largely established by Vasari.

This Introduction focuses on the more significant of these features. Goldstein, 646–47, has compiled an inventory of biographical topoi found in Vasari's *Lives* representing common elements of the classic portrait of an artist. To varying degree and with some transmutation, all nine Vasarian topoi can be found in Domenico's *Life of Gian Lorenzo Bernini*, namely: 1. "There may be signs of the supernatural at his birth" (see Domenico, 1: no portents, but his birth was expressly ordained by Divine Providence); 2. "He has outstanding personal qualities" (Domenico, 3–4, assessment by the "Abbate di San Martino" and passim in the whole biography); 3. "He shows that he possesses a gift at an early age" (Domenico, chapter 1, entire); 4. "His education is, therefore, only a fine-tuning of that gift, recognized by his teacher, whom he early surpasses" (Domenico, 5); 5. "More important than what he learns from any other teacher are his own efforts, as he studies *disegno*, or the art of the ancients, mathematics, etc." (Domenico, 5, 12–15); 6. "His first works show that he is a mature artist" (Domenico, 9–10); 7. "Capable of harshness with lesser men, he is invariably generous to his friends" (Domenico, 112–14 for Bernini's love for his students; 177 for his readily roused ire); 8. "Indifferent to worldly goods, his mode of living is simple, bordering on the ascetic" (Domenico, 169–73; 177); 9. "He is saved by his art from harm, which is to say that he is preserved by the will of God to which he owes his art" (Domenico, 80–81, 84–87).

8. The absence of a separate inventory of Bernini's works of art (such as in Baldinucci) is telling in this respect, as are the extremely vague chronological indications that Domenico supplied regarding most commissions and events. Domenico also omits mention of several of Bernini's projects, such as, most conspicuously, the obelisk-bearing elephant monument to Divine Wisdom in the Piazza della Minerva (for which see note 33 below to Domenico, 108). By contrast, Domenico records for posterity works by his father that are either otherwise undocumented (such as the fountain for Villa Barberini ai Bastioni [Domenico, 59–60] or largely overlooked (such as the *cordonata*, or stepped ramp, at the front entrance to Saint Peter's Basilica [Domenico, 161]).

9. What Summerscale, 40, remarks about Malvasia applies to Domenico as well: in order to please his audience, Domenico, like Malvasia and other early modern art biographers, was obliged to include some of the more entertaining elements of "romance" in his text by means of "narrative gusto," comical anecdotes, and "various embellishments of a literary kind."

10. These annual census lists for the Bernini household have been published by Fagiolo/ *IAP*, 343–49, for the years 1643–81. For further detail of and commentary upon Domenico's life and publications, see DLO/Pro, 29–32.

11. The information about Domenico's birth and baptism comes from Carletta, 1898b, 1, who found the baptismal certificates of all of Bernini's children, except Maria Maddalena. Carletta does not give the sources of the documents he consulted (presumably in the relevant Roman parishes) but reports that most of the children were baptized in San Marcello al Corso. Two of the eleven Bernini children died in childhood: the first Paolo (b. 1644, deceased by 1646) and Francesca (b. 1654; d. 1657 or 1658), as we gather from the annual Easter census, Fagiolo/*IAP*, 343–45.

Domenico's date of birth is also given in the official 1672 catalogue of the Jesuit Roman Province, Domus Probationis, p. 33, no. 39 (ARSI, Provincia Romana 62, Cataloghi Triennali 1669–72). See Martinelli, 1996, 251–52, for the elder Domenico's last will and an *avviso* concerning his death (occurring October 29, 1656); and Fraschetti, 422–23, for Bernini's successive bouts of fever, lasting from September 1655 to April 1656, as reported by the Roman agent of the Duke of Modena; see also Petrucci, 1997, 176, for another *avviso* regarding the same illness. See Domenico, 51–53 and commentary, for more information about Caterina and her children.

12. For the extant portrait of Pietro Filippo, executed in 1693 by Domenico De Angelis (Milan, Koelliker Collection), see Petrucci, 2006, 15, fig. 1; see Domenico, 52, 111, 163, and 164, for more about this prelate-brother. For "the fullest account of [Pietro Filippo's] life and literary activities to date," see DLO/Pro, 23–26, to which must be added the transcription of the *avviso* of his death (on May 24, 1698, in Albano) and elaborate funeral in Santa Maria Maggiore published by Antonazzi, 47 n.33. To the list given of Pietro Filippo's ecclesiastical offices given on DLO/Pro, 24, must be added that of "Segretario dei Confini," as per Alexander VII's *Diary* (April 4 and 6, 1666 [Morello, 1981, 339]; for the "Congregazione dei Confini," see Del Re, 370–71. Some modern scholars—probably influenced by the Florentine Baldinucci—refer to Pietro as "Piero," employing the Tuscan version of that name (Baldinucci calls him "Pier Filippo" in every case).

As Domenico points out (42, 52, 111, 163, 164), Pietro Filippo's advancement within the ecclesiastical hierarchy (and that of other family members) came, in part, as reward for his father's activity on behalf of the papacy. But, as our author does not mention, Bernini also actively lobbied the popes on behalf of his sons' careers: regarding that of Pietro Filippo, see, e.g., Alexander VII's *Diary* under July 25, 1658, March 16 and April 22, 1659, January 30 and February 3, 1660, January 22, 1665 (Morello, 1981, 325, 326, 328, 334, 338). See also Chantelou, September 7, f.166, e.180, for Bernini's observation that princes, busy and distracted as they are, need to be actively lobbied about the granting of benefices, pointing to the example of his attempt at obtaining a canonry of Saint Peter's for his son.

13. Giuseppe Lancisi, canon of Santa Maria in Trastevere, in the unpaginated preface ("A chi legge") to the volume edited by him.

14. Fraschetti, 106, citing "Protocollo 44, sez. 45, atti del notaio Mazzeschi, Archivio notarile capitolino," Rome. As for the Gesù project, on August 21, 1672, Jesuit General Oliva signed the contract with artist Gaulli (Baciccio) for the decoration of the church's nave and transept vaults, dome and pendentives. Having played a decisive role in the selection of his protégé Gaulli for this commission and personally guaranteeing the success of the project, Bernini was also directly responsible for "the broader aspects of the design and . . . on occasion made the *modelli* or sketches from which Gaulli worked" (Enggass, 1957, 304; see also Enggass, 1964, 52–53; more recently, Fagiolo dell'Arco, 2002, 68–70; and Debenedetti). For the relationship between Gaulli and Bernini in general, see also Petrucci, 2006, 280–93; and A. Angelini, 2007, 206–8.

15. ARSI, Provincia Romana 173, fol. 169v. In fact, beginning with 1672, Domenico no longer appears in the annual Easter family census (Fagiolo/*IAP*, 347).

16. Martinelli, 1996, 252–53. Caterina's appellation, "Father Domenico" (Padre Domenico), would have been merely a nickname, since, as yet not ordained a priest, Domenico had no claim to that title.

17. For the complete text of Bernini's will, see BALQ, 60–72; 68 for the possibility of marriage or children in Domenico's future ("con conditione che detto Domenico pigli moglie e, se Dio vorrà, faccia figli"). However, the will also leaves open the possibility of Domenico's entering clerical life: "che entri in prelatura," BALQ, 67. The notary's introduction (November 28, 1680) to the publication of Bernini's will (BALQ, 58, "Consignatio et publicatio testamenti . . .") refers to Domenico likewise with a layman's title as "illustrissimus Dominus Dominicus Stephanus." According to the notary, Domenico, by the way, was absent from Rome at that time (BALQ, 58, "et ab Urbe absentis"). For discussion of the will, see Fraschetti, 425–30; Borsi, 34–36; and Fagiolo/*IAP*, 9–10, stating that the will was drawn up ten days before Bernini's death. The will itself, as published by BALQ, however, does not bear a date. The related notarial documents in BALQ likewise do not specify when the will was drawn up: one of the latter documents, transferring some of Bernini's ecclesiastical pensions to his son, Francesco, is dated November 18, 1680 (BALQ, 53).

18. The 1674 Jesuit catalogue is ARSI, Provincia Romana 82. There are no copies of the 1673 catalogue in the Jesuit archives and hence I could not confirm the fact of Domenico's departure in 1673. To make sure, however, that his omission from the 1674 catalogue was not a typographical error, I also consulted the 1675 catalogue: his name is likewise absent therein.

19. BALQ, 67: "Manifesto però a tutti li miei figli maschi che li'ntentione [sic] et espressa mia volontà è che stiano tutti quattro uniti d'habitatione, tavola, et altro spendendo ognuno la parte sua."

20. See the *Stati delle anime* census for that year published in Fagiolo/*IAP,* 349: along with brothers Pietro, Paolo, and Francesco, we find also listed "Sig.r Giuseppe Bernini, f.llo [i.e, *fratello*] 24." Despite the erroneous baptismal name here reported, this brother, "Gioseppe," reported as being twenty-four years old, can only be Domenico: the age is correct and there was no other male sibling in the family (Giuseppe happened to be Francesco's middle name). The fact that he is listed as "Signore" would indicate his lay status, as in his father's will of the previous year.

21. Fagiolo/*IAP,* 383; see also Fagiolo/*IAP,* 289, where Fagiolo dell'Arco mentions the fact of Cosimo's bequest to "abate Domenico, the Cavaliere's last son," without commenting on his clerical title.

22. Shortly after Domenico's birth, Pope Alexander VII redefined the criteria for admission into the *prelatura* with his constitution of June 13, 1659, *Inter coeteras:* in addition to being at least twenty-five years old and having an annual income of 1,500 *scudi,* one had to be the legitimate son of respectable parents and enjoy a stainless moral reputation. Moreover, of those wishing to work specifically in the tribunals, there was the further requirement of five years of university legal education or the possession of a doctorate in both canon and civil laws (*Enciclopedia cattolica* [Città del Vaticano, 1952], 9:1942, s.v. "Prelato"; see also Pastor, 31:127, with some confusion by the German scholar as to the content of Alexander's decree). Presumably the young Domenico was pursuing the requisite studies during his years away from the family home.

23. The document, regarding the newborn, Maria Caterina Tezio, was uncovered by Alfredo Marchionne Gunter and is briefly described by him in Fagiolo dell'Arco, 2002, 218.

24. Thus, we have no acknowledgment from Domenico himself of his years as a Jesuit. What might have motivated such silence? Was it too brief an experience to be recorded? Embarrassment over a failed vocation? As for Domenico's wife, the 1731 Bernini household inventory gives her name as Anna Teresa (Martinelli, 1996, 268, c.61r).

25. The mention of his "fresca età" occurs in his unpaginated preface to the reader. We might point out that the ecclesiastical censor of this work was his own cousin, Oratorian Father Francesco Marchese (1623–97), who had assisted Bernini during his final agony (Domenico, chap. 23) and was a figure of some notoriety in the Roman ecclesiastical world: see note 12 below to Domenico, 173.

26. See *DBI,* 9:365, for this editorial history. For Domenico's title of *Conte,* see Martinelli, 1996, 268 (c.61r) and 269 (c.63v); for that of his son, 265 (c.54v) and 268 (c.60v and c.61v).

27. *DBI,* 9:365.

28. *DBI,* 9:365.

29. "Costumano gl'Istorici per conciliarsi credenza da' Lettori protestar' sul' bel principio d'essere affatto alieni da ogni partialità verso quei soggetti, e quelle materie, di cui intraprendono à scrivere. Io all'incontro mi dichiaro tanto interessato nell'historia presente, che potrebbe forse trasportarmi qualche eccesso d'adulatione." In the next sentence he identifies the object of his adulation: "gli adorati Vicari di Cristo," the Roman pontiffs.

30. "la pratica del nostro operare, non havendo Noi sin'hora per lo spazio già trascorso di undici lustri presa giammai la penna in mano, che per santificarla in racconti di Ecclesiastici avvenimenti, ò strepitosi per guerre avvanzate contro Turchi, ò laboriosi per argomenti sudati contro Heretici, ò honestamente gradevoli per descrizioni fatte di abbellimenti religiosi, e profani, della Città di Roma, che non men vanta la sacra Primazìa del Pontificato Romano, che l'augusta magnificenza del Principato Romano" (unpaginated preface ["L'Autore a Chi legge"] to the *Vita del venerabile D. Giuseppe Maria Tomasi*).

31. *Historie di tutte l'heresie,* 4:615. Either ignorant of the true facts of the case or willfully misrepresenting them in order to convey a more august picture of ecclesiastical power, Domenico misreports the details about Galileo's imprisonment. The scientist spent no time in prison at any point either before or after his trial: see Shea and Artigas, 192–97; for Domenico's

role as the originator here of "one of the minor myths about Galileo's trial" (the fact of his five-year imprisonment), see Finocchiaro, 111. The *Acta Eruditorum,* an annual scholarly journal published in Leipzig during the eighteenth century, in reviewing the first volume of Domenico's history of heresy, points out (1708, 495) the book's religious bias, noting that "the author defends the hypotheses of the Church of Rome throughout" the work and is "extremely liberal in conferring the label of heretic" upon his historical subjects.

32. In the preface to his *Vita del Tomasi,* Domenico makes reference to the earlier published *Life of Gian Lorenzo Bernini,* expressing the hope that "dedicated to the honor of our father, [it] will be, for the sake of pious affection, either praised or at least excused" (dedicato all'honor di nostro Padre, sarà per affetto di pietà ò lodato ò almeno scusato). Noteworthy in this reference is the absence of any hint of defensiveness with respect to the Baldinucci biography.

33. Mascardi, 51–53; see 52 for the first guideline ("Sappia primieramente . . ."); see also 53, "pongono occasione di maraviglia insieme e d'imitazione." Mascardi's brief section on biographies (which he calls *vite,* lives) was inspired above all by Plutarch (as he says on p. 52) and is placed at the end of the Trattato Primo, capitolo 3, regarding the various divisions of the genre of history: "Effemeridi, Annali, Cronache, Commentari, Vite." For Mascardi and his *De arte historica,* see Bellini, 2002, 113–241. For bibliography on early modern biography and historiography, see note 6 above.

DLO/Pro, 34, make the same point: "Concerning the hagiographic aspect of the Bernini *vite,* it is important to recognize that hagiography and other forms of life writing share common foundations. The sacred biography claims the same classical sources as the artist's life and both genres employed similar schemata, rhetorical conventions, and anecdotes. As in virtually all other forms of life writing, one of the primary goals of hagiography was to praise the virtues of its subject, to present the subject as an exemplum."

34. Rubin, 162.

35. This list of hagiographic motifs derives from my own study of the primary sources (except for item c, which I owe to Sheila Barker). Again, fruitful comparison can be made with the popular *vite* of Saints Francis of Assisi, Ignatius Loyola, and Bernardino of Siena, whose cult enjoyed resurgent popularity in seventeenth-century Rome (for which see Mormando, 1999, 39–40). For further discussion of hagiography and Domenico, see DLO/Pro, 34–37.

36. Domenico never speaks of a conversion on Bernini's part or adverts to a difference in religiosity or moral behavior between the young and old Bernini at any point in the narrative. However, despite Domenico's silence on the spiritual or psychological meaning and effect of the terrible illness that struck Bernini at the age of "nearly thirty-seven" (Domenico, 47), coming between the diplomatically tailored reference to his tumultuous affair with Costanza (Domenico, 27) and discussion of his decision to finally end his resistance to taking a wife (Domenico, 50), I am certain that contemporary readers, steeped as they were in the conventions of the literature of saints' lives, would have easily recognized it as a significant, eye-opening, and soul-stirring event (and thus, in effect, a conversion experience) and spontaneously made the connection between the two events—illness and marriage.

As we shall see later in section 8, "Bernini's Religion," Baldinucci (i.134, e.68), instead does explicitly mention some sort of moral turning point on Bernini's part, coinciding with his 1639 marriage, even though he does not call it a conversion and downplays the degree of premarital misbehavior on the artist's part as simply "youthful romantic attachments." In Bernini's case, let us note, those "youthful romantic attachments" lasted until the ripe age of forty-one, by which time, according to early modern reckoning, a man was considered to have long reached complete adult maturity.

37. For Bernabò and his *stamperia,* see DLO/Pro, 31. D'Onofrio, 1966, 205 (see also DLO/ Pro, 20–22) points out the reference made by Domenico to his own *Life of Gian Lorenzo Bernini* in *Historie di tutte l'heresie,* 4:261, which refers the reader to chapter 15 of that biography (presumably to p. 111) concerning the costs of the construction and decoration of Saint Peter's Basilica. As D'Onofrio justly remarks, this would indicate not only that his biography was completed by 1708 (the date of the "Imprimatur" of that fourth heresy volume), but also that the author

expected readers to have access to it. Even if in manuscript form, it must have been in circulation as a more or less public document, as was frequently the case with unpublished early modern texts.

38. Rotondò, in his entry on Domenico Bernini in the *DBI*, 9:364–65, reports that the first Roman/Bernabò edition of the *Historia di tutte l'heresie* was incomplete, having been interrupted in 1709, and that the first complete edition in four volumes did not appear until 1711, that is, with the Venice edition printed by Paolo Baglioni; yet the extant Roman/Bernabò edition of 1705–9 is indeed complete, with all four volumes.

39. See Montanari, 1998b, 401–5, 416–25, for his discussion of this topic; see also the summary discussion in DLO/Pro, 18–23.

40. The abridged life of Bernini was finished by 1692 and published posthumously in 1728 in his *Notizie dei professori del disegno* (edition consulted: the Florence 1974 facsimile reprint of the Florence 1846 edition), 4:279–300, the prefatory pages here in question are 279–80. Francesco Saverio's biography of Filippo Baldinucci was published by Samek Ludovici, in the same 1948 volume as his edition of the Baldinucci biography of Bernini, 31–63, of which the relevant pages are 49–51.

41. Goldberg, 108, surmises that this prelate was Monsignor Pietro Filippo Bernini, whereas Montanari, 1998b, 421 n.107, conjectures that it was "probably" (assai verisimilmente) Cardinal Decio Azzolino, Christina's right-hand man and dear friend. However, Montanari, 401–3, and as we shall see later in detail, believes that the primary overseer of the Baldinucci biography project was the same Mons. Pietro Filippo. See Goldberg, 107–8, for his further discussion of the origins of the Baldinucci Bernini biography and his 1681 trip to Rome, bearing in mind, however, that the scholar did not have the benefit of the subsequently discovered documentation cited by Montanari, 1998b.

42. Montanari, 1998b, 421–22, points out that several documents attest to the fact that Baldinucci was in Rome as of April 13, most noteworthy among them, a letter from Bellori to Florentine *erudito* Antonio Magliabechi. Baldinucci's residence in Rome lasted six weeks (as reported by Goldberg, 108).

43. For "the many drawings" by Bernini in Leopoldo's collection, see Domenico, 28. The earliest known documentation of Baldinucci's involvement in the project is his December 10, 1680, letter to Pietro Filippo, extending condolences for the artist's death and requesting from the family further material for his biography in progress; he also mentions that the initial intention was to publish the volume while Bernini was still alive (Montanari, 1998b, 416–17). For Baldinucci's professional career and credentials as art connoisseur and art critic, see DLO/Pro, 26–28; and DLO/Intro, xiv–xviii.

Montanari, 1998b, 418, believes that the choice of Baldinucci as official Bernini biographer was made in part because of the artist's "ardent and continuous desire to be considered Florentine and to connect his name to Buonarroti, and Baldinucci, who was becoming the official historian of a Florence that to his eyes was still Vasarian, would have given him the best guarantee of presenting him as 'the Michelangelo of his century.'" Del Pesco accepts Montanari's conjecture (Chantelou, Italian ed., 2007, 200 n.30); for this point, see also DLO/Pro, 28; and DLO/Intro, xviii.

44. See Domenico, 43–44 and 167–68 (and commentary), and Baldinucci, i.133–34, e.67–68, as well as the long, detailed technical report appended by Baldinucci to his narrative (i.155–75, e.89–108). As Baldinucci acknowledges (i.158, e.91), the latter report derives from that prepared at the request of Innocent XI by Bernini's architectural right-hand man, Mattia de' Rossi; it is, in reality, almost a verbatim reproduction as D'Onofrio discovered (1966a, 204). Hence, the narrating "I" of this entire final section is likely Mattia, not Baldinucci, as in, for example: "And I myself have gone up there many times with the drawings and plans in hand, and, in the presence of some of the most prominent architects of Rome, have verified everything with my own eyes" (i.167, e.100; 1996/2006 English translation corrected). For this report, see also Menichella, 1985, 26 and 74; and in the more recent and most thorough investigation of the April 1680 charges against Bernini, see Marder, 2008, 431–44.

45. Fraschetti's well-documented, monumental biography (still indispensable, especially for the many primary sources transcribed usually in full) was occasioned by the 1898 anniversary year of Bernini's birth, during which an elaborate marble plaque was attached to the facade of the artist's home on the Via della Mercede with an Italian inscription proclaiming: "Here lived and died Gianlorenzo Bernini, the sovereign of art, before whom popes, princes, and populations reverently bowed" (the plaque is still in situ; see also Fraschetti, 432). For the short and tragic life of the brilliant Fraschetti (1875–1902), see Leonardi. However, even Fraschetti, to whom Bernini owes so much for the modern resurgence of his reputation, is at times openly disapproving, if not disdainful, of what he sees as the regrettably "baroque" excess of some of the artist's works. This is especially true of what he calls the older Bernini's *seconda maniera,* a supposed degeneration of his earlier, classically purer, "healthier" style, as exemplified by the *Santa Bibiana* statue (Fraschetti, 52). For disparaging remarks about Bernini, see Fraschetti, 52, 327, 380, 386–91, and 417.

46. The two quotations from Samek Ludovici come from his 1948 edition of the Baldinucci *vita* of Bernini: 195 (Domenico as plagiarist) and 18 (against the Panofsky thesis).

47. *Palatino: Rivista romana di cultura* 10 (1966): 201–8. The article is sometimes cited by its series title, "Note berniniane, 2."

48. For these three questions, see D'Onofrio, 1966a, 201–2 and 204. D'Onofrio, however, is incorrect on one detail: it was not Domenico who chose Lodovico Pico della Mirandola but publisher Rocco Bernabò, as is clearly stated on the title page of the volume. For Cardinal Lodovico, see note 93 below. A final curiosity-raising detail not identified by D'Onofrio is why, in his many references to Christina's great demonstrations of esteem for Bernini, Domenico never once mentions her putative patronage of Baldinucci's biography of his father. Silence about so eminent a royal honor seems strange indeed. This omission is further indication of the falsity of the "official version" of the origins of the 1682 biography.

49. D'Onofrio, 1966a, 204.

50. As Montanari, 1998b, 419, points out, D'Onofrio did not take note of the fact that the Florentine New Year began on the Feast of the Annunciation (March 25), and not on January 1. Hence Baldinucci's letter dated February 25, 1680, was actually written, as far as the world outside Florence was concerned, in 1681.

51. DLO/Pro, 11–12.

52. As both Montanari (1998b, 425) and Goldberg (116), point out, one further piece of evidence that Christina was not the patron of Baldinucci's biography is the lack of any record either of payments by the queen connected with the printing of the volume or of remuneration to its author. Christina would have assumed both of these financial responsibilities had she in fact commissioned the biography. We have the queen's letter (dated April 18, 1682) to Baldinucci, responding to his dedication of the biography to her, but it makes no mention of payment or reward; for the text of Christina's letter, see Montanari, 1998b, 424 (correcting the 1760 Archenholtz transcription, the latter reproduced by Samek Ludovici in Baldinucci, i.191 n.22).

53. For a summary of Montanari's research on this topic and his reconstruction of the original scenario by which the biographical project might have come to be, see also his 2006 essay, 73–78.

54. Montanari, 1998b, 402 for the *officina;* 403 for conjecture as to the dating of Christina and Baldinucci's involvement in the enterprise. Pietro Filippo could have possibly already met Baldinucci back in November 1665: according to Medici dispatches from Rome, Pietro Filippo went to Florence on November 21 to meet his father, who, returning from his Paris trip, arrived in the city on the following day and was feted for two days by the Medici court, of which Baldinucci, then bookkeeper to Leopoldo de' Medici, was a member (Montanari, 2001, 128, docs. 18–21).

55. For the Bernini *vite* as autobiographies, see Montanari, 2006, 78–84. The issue is raised in DLO/Pro, 37–38, referring the reader to the Montanari and Ostrow essays in the same volume. Ostrow, 2006, 132–36, however, rejects the suggestion: "What exists here [in Baldinucci and Domenico] are not autobiographical texts."

56. Montanari, 1998b, 419. Domenico would have been seventeen years old in 1674, at the commencement of the family's biography project, and thus, by that society's standards, mature and learned enough to participate in the enterprise. Even though I find Montanari's re-creation of the genesis of the biographies persuasive, it is nonetheless wise to heed the animadversion of DLO/Pro, 22: "The early production by Bernini's sons of a complete *vita*—made available to Baldinucci, and that later served as the basis for Domenico's book—is hypothetical. What we do have is evidence of intense activity by a growing cast—of writers, subjects, patrons—a few surviving manuscripts, and a set of hypotheses about the actual evolution of the texts."

Indeed, in Kathleen Morris's well-researched doctoral dissertation, "A Chronological and Comparative Study of Contemporary Sources on Gian Lorenzo Bernini" (University of Virginia, 2005)—a work not cited by DLO/Pro and which came to my attention only after completing the manuscript of this book—the author expresses deep disagreement with the Montanari theory about the genesis of the Baldinucci biography: see her discussion, "Which Came First: Baldinucci or Domenico?" 202–9. What Morris, 207, points out about Baldinucci's December 10, 1680, letter to Pietro Filippo asking for more information about Bernini's life—that it offers no explicit confirmation of his being under the direct employ of the Bernini family—is, admittedly, true of all the Baldinucci–Bernini correspondence cited by Montanari.

Morris furthermore challenges the thesis that Baldinucci made extensive use of a biography prepared by Domenico, for she does not believe that Domenico's text came into being at all as part of the family's campaign for the production of an authorized biography, as Montanari conjectured. The extensive verbatim overlap between the two biographies (that of Baldinucci and that of Domenico) is simply due, she says, to the fact that each biographer made use of the "same source material" (Morris, 210; much of that source material, she claims [199], is in the Bernini family notebooks at the Bibliothèque Nationale, Paris). But, in fact, the textual-linguistic overlap with that earlier extant source material, is in reality too limited to make the latter a compelling explanation. Exactly when or why Domenico wrote his biography, Morris is at a loss to say beyond speculating that it was written "to augment and personalize the literary account of the Florentine biographer" (Morris, 209).

Morris is correct in pointing out that nowhere in the extant documentation of the late 1670s or early 1680s is there any mention of Domenico in any context, much less the biographical one. Morris cites in particular the voluminous Roman "diary" or *Effemeridi*, of Carlo Cartari (1614–97), begun in 1642 and continually edited until 1691, which reveals the diarist's informed familiarity and direct interactions with the Bernini family but yields not one reference to Domenico (Morris, 206; for Carlo Cartari—not to be confused with Bernini's sculptor-disciple Giulio Cartari—see *DBI*, 20:783–86).

Despite the problems inherent in Montanari's theory about the genesis of the Bernini biographies, it is still, in my view, the most compelling explanation for the complex, fragmentary, and at times bewildering array of extant evidence relating to the issue. Certainly, at the least, the discrepancies and lacunae in the Baldinucci-spun "official story" of the origins of the 1682 *The Life of Bernini* must make us suspicious about the authenticity of the version(s) of the events supplied by Filippo and his son, Francesco Saverio.

57. Translation from Montanari, 2006, 104, citing Beltramme, 2005, 148–49. Note that the same January 1674 Cartari diary passage was found independently by Kathleen Morris (pp. 204–5) in her 2005 dissertation (see previous note). Unlike Montanari (2006, 104), Morris does not see it as providing any kind of further evidence that Filippo Baldinucci wrote his Bernini biography under the direct employ of the Bernini family.

58. For further discussion of this sketch, see appendix 1.

59. For La Chambre, see Montanari, 1998b, 400–401; Montanari, 1999, 103–4 and passim; Vanuxem; Kerviler, 462–76; Pellison-Fontanier and Olivet, 273–77; and Stanić, in Chantelou, f.16, n.3, and f.268, n.2.

60. For the Roman *avviso* as genre and historical source, see Infelise.

61. Stanić, in Chantelou, f.16, n.3; the *Mélanges* was first published in 1699–1700.

62. Montanari, 1999, 106.

63. See appendix 2 for further information on the journal, the Bernini eulogy, and its author.

64. See Montanari, 1999, 108–9, for Domenico's (and Baldinucci's) failure to make public note of La Chambre's tributes to Bernini. For the Frenchman's own statement of his intention, see the "Préface," 116–17 ("je diray hardiment le fort et le foible, le bon et le mauvais du cavalier Bernin. Je ne supprimeray point adroitement ce que ses ennemis et ses envieux luy ont repro-ché"). Montanari, 1998b, 332 n.10, assumes Domenico did read La Chambre's "Préface," given an error of poetic attribution in Domenico (136) that, says Montanari, could only have been copied from La Chambre.

65. Again, this is the assumption of Montanari, 1998b, 400, and 2006, 86.

66. Baldinucci, i.184–85, e.110–11.

67. See Montanari, 1999, 108–9, for the suggestion that La Chambre was Baldinucci's target here.

68. It was Montanari, 1998b, 385–98, who first identified this conjunction of adverse events in Bernini's life as the origins of the biography project. I accept Montanari's thesis but here describe some of the events and reactions to them in somewhat different terms.

69. This Roman *avviso* of August 2, 1670, can be found in any of the various studies on Ber-nini's ill-fated Santa Maria Maggiore tribune project, in addition to Rossi/*Avvisi* 18 (1940): 95. I here quote from the useful appendix of the primary sources relevant to this project in Roberto, 330; see 331, *avviso* dated August 23, 1670: "Bernini has fallen into a state of desperation for hav-ing had taken away from his hands the works [*fabrica*] at S. Maria Maggiore, replaced in that task by Cav.r Rinaldo [*sic*], his enemy [*suo nemico*]." For the tribune project, see Domenico, 161 and commentary.

70. Rossi/*Avvisi*, 18 (1940): 26, *avviso* from Vatican Library, Ms. Barb. Lat. 6404. As for the significance of the stoning of Bernini's home, what might strike us today simply as a passing nuisance was, instead, within the social code of honor of early modern Rome, well understood by its perpetrators, its victim, and all eyewitnesses as a ritualized act of revenge, intended to bring public shame upon the proprietor of the house. Usually accompanied by much loud insult-throwing and other boisterous shouting, this phenomenon (for which Elizabeth Cohen has coined the felicitous term "house scorning") was common in Bernini's Rome: see Cohen for an extensive study based on Roman criminal records of the time.

71. For the text of the anti-Constantine pamphlet, see Fraschetti, 321 n.1; for excerpts from *Il Costantino messo alla berlina* (Constantine brought to the pillory), a much later but closely related critique clearly based on this pamphlet, see Previtali (in Italian); and Bauer, 1976, 46–53 (in English); see Marder, 1997, 209, for the two works and their dating, and my commentary to Domenico, 106. See Rossi/*Avvisi*, 18 (1940): 58, for the *avviso*, dated March 28, 1671, with its reference to Bernini's "poco applaudito Costantino" containing "a heap of errors" (un cumulo degli errori); see also the earlier *avviso* dated December 13, 1670, reporting the widespread criti-cism that greeted the statue upon its unveiling.

72. The term "cabal" was used by Bernini himself in discussion with Chantelou about the opposition of the French architects to his presence in Paris (Chantelou, July 28, f.94, e.87).

73. For the *Louis XIV Equestrian*, see, above all, Wittkower, 1961 (512 for quotation in this paragraph); and Robert W. Berger for a necessary corrective of received wisdom on its destiny at Versailles. For further bibliography and discussion, see my commentary to Domenico, 147–53, esp. note 1 to p. 147.

74. For Bellori and the state of sculpture, see Soussloff, 1989, 598; for the same passage in Bellori, see Lingo, 42–43. Bellori goes on to say that had Duquesnoy not died young, he might have been the one to revive the art of sculpture. Strangely enough, in his *Life of Bernini* (i.154, e.88), Baldinucci makes positive reference to this very same biographical profile of Duquesnoy by Bellori: "Giovan Pietro Bellori has written of [Duquesnoy] in his usual erudite fashion in his book on modern painters, sculptors, and architects." One wonders how the Bernini family reacted to this observation. Was this a ploy by Baldinucci to further the pretense of editorial autonomy from the family? Later, however, as La Chambre announces in the revised edition

(1685) of his "Éloge," 126, Bellori, now under the employ of the very much pro-Bernini Christina of Sweden, was supposedly writing Bernini's biography.

There is no other documentation of such a planned biography by Bellori, unless this project somehow lurks behind his February 21, 1682, letter to a contact in Florence, asking for news about the status of Baldinucci's biography being published in the Tuscan capital (Montanari, 1998b, 424). Although nothing came of his supposed biography, this news item would indicate a change of heart on Bellori's part with respect to Bernini: see Montanari, 1998b, 418–19, and 2005b, 13, for this conjectured rapprochement between Bellori and Bernini.

75. Passeri, 242–43. Passeri dedicated his work to Louis XIV, yet another indication of the passing of cultural hegemony from Rome to Paris that would have saddened the last years of Bernini's life. For Passeri as anti-Bernini critic, see, for example, Sutherland Harris, 1987, 44.

76. Bernini's poor reputation among many of his contemporaries, on the very level of his moral-psychological character and professional behavior, would account for the insistence we find in both Domenico and Baldinucci's biographies of Bernini's greatness not only as an artist but also as a human being: see Domenico, 180, and commentary.

77. Martinelli, 1959 (reprinted in Martinelli, 1994, 247–55), with transcripts of all pertinent primary sources, remains the most complete account of the scandal. For the Albertoni chapel and the vicissitudes of Bernini's family life in the 1670s, see Beltramme, 2003 and 2005; see also my commentary below to Domenico, 164. Given the absence of any documentation of payment to Bernini by the Altieri in the extant Altieri archives, it would seem that Domenico, 164, is not telling the truth in reporting that his father "received remuneration for himself" for the Albertoni statue from Cardinal Nephew Paluzzo Altieri.

78. For Bernini's retreat at Sant'Andrea al Quirinale (where his son Domenico, then a Jesuit novice, would have still been in residence), see ARSI, Fondo Gesuitico 1024, "Nomina Exercitantium in Domo Probationis Romana ab an[no] 1650 usq[ue] ad 1693," luglio, 1673, n.68: "Caval. Bernino, per la morte di sua moglie siguita à di 12 di q[uesto mese] si ritirò con noi da quel giorno fino à 15 con un suo servitore."

79. For the near-fatal illness of Bernini's wife, Caterina Tezio, see Chantelou, September 12, f.175–76, e.191–92; September 14, f.180, e.197; September 20, f.194, e.215–16. (Caterina's grave illness is also mentioned in Cardinal Flavio Chigi's letter of August 4, 1665, to Bernini [original in BNP, Ms. italien 2083, pp. 25–26] and in an *avviso* dated August 8 in the Archivio Mediceo del Principato [vol. 4027a, fol. 556, doc. 8268] of the Medici Archive Project online database; my thanks to Sheila Barker for pointing out the latter document). Although not without editorial bias on the part of its author, the *Journal de voyage du Cavalier Bernin en France* (translated in English as *Diary of the Cavaliere Bernini's Visit to France*) is among the most valuable of the Bernini primary sources: it represents a detailed, almost daily account of Bernini's activities and conversations, public and private, during his entire Parisian visit, as reported by the man assigned by Colbert to serve as the artist's translator, companion, and personal attendant, Paul Fréart de Chantelou. It is of course not an exhaustive record of everything that Bernini did and said while in France, since Chantelou was not constantly in Bernini's company. For a good, succinct evaluation of this text, with some examples of textual comparison with the Baldinucci and Domenico biographies, see Ostrow, 2006, 121–32. For further comparison between Chantelou's and Domenico's accounts of Bernini's words and deeds, see my notes to Domenico's text, passim.

In addition to the recent French edition prepared by Stanić (incorporating new information from a second, reliable copy of the manuscript), Chantelou's *Journal* is also available in three translated editions, English, Italian, and German. In quoting Chantelou, I use the 1985 English edition (by Blunt, Corbett, and Bauer), revising that translation, when necessary, after consultation of the French text in Stanić's new edition. The German edition, edited by Pablo Schneider and Phillipp Zitzlsperger (Berlin: Akademie Verlag, 2006), represents a revised version of the translation published by Hans Rose in 1919; the Italian translation is by Daniela del Pesco, who also supplies extensive commentary (Naples: Electa, 2007).

80. For Caterina's will, dated September 30, 1673, see Martinelli, 1996, 252–53; and Fagiolo/*IAP*, 360–62 (363 for her death certificate); for Bernini's already discussed November

1680 will, again see BALQ, 53–74. For the conflict between husband and wife, see Fraschetti, 425–27; BALQ, 10–11; and Beltramme, 2003, 281–83.

81. Not mentioned by either Domenico or Baldinucci, the Colonna *Galleria* is a recent addition to the inventory of Bernini's work: see Strunck. Bibliography relating to the other Bernini works here mentioned will be supplied in the relevant notes to Domenico's text below.

82. DLO/Pro, 34. As the same authors point out at the beginning of their essay, the Domenico and Baldinucci biographies also represent "among the longest texts dedicated to a single artist of the early modern period."

83. This theme has received much attention in previous studies of Bernini's biographies; see my discussion in section 7 below.

84. DLO/Pro, 22: "We have no doubt that Domenico was fully aware of and responded to Baldinucci's book when revising his manuscript." This is a reasonable conjecture, but we cannot be sure that Domenico necessarily did so in systematic, thorough, and punctilious fashion. Morris, 198–233, offers a lengthy comparison between Baldinucci's and Domenico's biographies: however, coming within a dauntingly wide-sweeping survey of all known seventeenth- and eighteenth-century sources relating to Bernini, Morris's discussion remains within the realm of the readily apparent, generic similarities and differences and never engages the two texts in a direct, closely analytical confrontation between themselves and related extant documentation. For Morris's study, see also note 56 above.

85. See Montanari, 2006, 76–77, for reference to the "archetype" and for his reconstruction of the probable stages of the evolution of the two biographies. While acknowledging the complexities of the process of evolution of the two texts, Montanari believes that some identification of the separate, distinct contributions of Baldinucci and Domenico will still be possible by "systematically comparing the two publications with each other and with other material from the historiographical workshop set up by the Bernini family, as well as material belonging more generally to the early historiography of Bernini" (77; see also Montanari, 2005a, 200, for the same sentiment). While this might be possible for limited portions of the texts, having undertaken much of this same process of textual comparison for this edition, I do not share the same confidence.

86. DLO/Pro, 50.

87. That is, if we assume that not only did Baldinucci rework materials given to him by Domenico in the late 1670s or early 1680s, but also that Domenico, in revising his own original text for publication in 1711, consciously reacted to Baldinucci's published biography.

88. I have slightly revised the Enggass translation.

89. For further discussion of these and other, more subtle differences between the two biographies, see DLO/Pro, 32–59.

90. See Fehrenbach, 2005, passim, but esp. 7–9, for a discussion (in the context of contemporary scientific-philosophical lore) of the important theme of Bernini's *spiriti* that runs through Domenico's biography: "For Domenico, the life of the artist is composed of three dynamic elements: heart, flame and *spiriti*. But we must ask ourselves whether these elements are simply metaphors" (7); they are not, as Fehrenbach goes on to demonstrate.

91. Letter in appendix to Chantelou, f.291, e.344.

92. DLO/Pro, 39–49, "Themes of Bernini's Biographies," covers some of these same topics.

93. For Cardinal Lodovico Pico della Mirandola, see the scant information supplied by Guarnacci; Cardella; Pastor, vv. 33–35, *ad indicem;* and Caperna, 20 and 119 n.10. (The entry on Lodovico in Moroni's *Dizionario di erudizione storico-ecclesiastica* [45:211–12, s.v. "Mirandola, Lodovico Pio, Cardinale"] is taken verbatim from Cardella.) See also the entry on Cardinal Lodovico on the well-documented German university Web site, "Requiem," devoted to the Roman tombs of early modern popes and cardinals: http://www2.hu-berlin.de/requiem.

At the moment when Domenico's *Life of Gian Lorenzo Bernini* went to press, Lodovico was a newly minted cardinal: he had been elevated to the purple by Clement XI *in pectore* on May 18, 1712, a decision subsequently announced in consistory on the following September 26, with

formal consecration occurring on November 21 of the same year. Previously Lodovico had held a series of important offices in the papal curia, including, at the time of his elevation, that of Prefect of the Apostolic Palace. Lodovico was son of Duke Alessandro II of Mirandola (near present-day Modena in Emilia-Romagna) and Anna Beatrice d'Este. Bernabò in his dedication makes reference to the legendary fourth-century origins of the cardinal's illustrious family tracing back to the marriage between a German prince and Constantine the Great's granddaughter. However, of little help was the family's antiquity when French troops besieged Mirandola at the end of the seventeenth century. That successful siege sent the young Lodovico fleeing, first to Bologna and then to Rome, living in the most dire of straits for a period of time ("extrema angustia," says Guarnacci).

A subsequent trip to Vienna and appeal to the emperor gained for him the wherewithal to finish his education and begin an ecclesiastical career, doing so in Rome, where, soon after his arrival there, he was welcomed into the papal court by Pope Clement XI. Bernabò makes references to the vicissitudes of Lodovico's earlier life in his letter of dedication: this acquaintance with the facts of the prelate's personal life might suggest some degree of personal contact between the two men. Years after (1728) and purely coincidentally, Cardinal Lodovico became titular bishop of the Roman church of Santa Prassede, which houses one of Bernini's earliest works (the Santoni portrait bust). The cardinal's portrait is on display in that church on a column to the left of the sanctuary, where his heart is also buried (his tomb is instead in the Church of SS. Nome di Maria, near the Forum). The monastery of Santa Prassede, also coincidently, was (is?) proprietor of a Bernini painting (subject unknown), bequeathed in 1630 by its abbot, Orazio Morandi, who died in that year in prison, having been arrested for using astrology to predict the death of Urban VIII (Dooley, 177).

94. For "la fenice degl' ingegni," see note 101 below. Neither Bernabò nor Domenico mentions this coincidence. For Lodovico's career, I have consulted only published works, and not archival sources that may possibly be extant in Rome.

95. This grand, ornate type of exordium was conventional also for art biography, following the model of classical rhetoric; it is well exemplified by Vasari. See Rubin, 156–57; and my commentary below on Domenico, 1–2. Again, for the definition of *virtù*, see the Introduction, section 9.

96. For God (Providence, Heaven, etc.) and Bernini, see Domenico, 6, 11, and 28 (Urban's letter of exoneration of Bernini). For God as author of Bernini's success, see also Chantelou, June 25, f.63, e.40; July 30, f.98, e.91 ("God had come to his deliverance" in resolving a technical difficulty in the Louvre design); and September 7, f.167, e.180 ("the grace of God, to which he ascribes everything").

97. DLO/Pro, 41. See Lavin, 2005b, esp. 548–54, for a discussion of the sociological ramifications of the manner in which Bernini was remunerated for his work. Like true nobility, in accepting commissions (from only a select few individuals), Bernini did not work for a salary and did not charge fixed, predetermined fees. He was not "paid" for his efforts; instead he was instead "rewarded" (the verb Domenico usually uses) in the form of princely gifts (jewelry, luxury fabrics, silver and gold vessels), thus confirming his social identity as an artist of "aristocratic" status.

98. See my notes on the term *magnificentia,* as it appears below in "The Publisher to the Reader" in the original front matter, and on Domenico, 2.

99. For Algardi as Bernini's equal in the eyes of contemporaries, see Marder, 1992, 286. In a December 3, 1633, letter from Rome to the Duke of Modena, the poet and political agent Fulvio Testi reports that Duquesnoy is second only to Bernini as sculptor in the city of Rome: see Testi, 1:494–95. Although established later than that of Bernini, Cortona's reputation as painter and architect was, at its height, not far from that of Bernini, as attested to by the size of his studio, the number of disciples, and the quantity and prestige of commissions.

100. Chantelou, July 23, f.86, e.75.

101. Baldinucci, i.75, e.10, in contrast, quotes the pope as expressing more a hope than a prognostication, even though the Florentine biographer adds the qualification "prophetically" (vaticinando): "and turning to the Cardinal, [the Pope] said prophetically, 'We hope that this

youth will become the Michelangelo of his century.'" In this, the Baldinucci version conforms more faithfully to what we find in Pietro Filippo's *Vita Brevis* (see appendix 1). Domenico, 97, also makes use of the mouth of Sforza Pallavicino to establish Bernini's exalted status: he quotes the Jesuit cardinal as calling Bernini "la fenice degl' ingegni" (the phoenix of geniuses), by then a formulaic honorific with specific connotations, most famously applied to philosopher Giovanni Pico della Mirandola (1463−94), coincidentally, as earlier mentioned, ancestor of Cardinal Lodovico, to whom Domenico's book is dedicated. For Bernini and this epithet, see Delbeke, 2005; to Delbeke's list of Bernini's contemporaries to whom the label was applied, we can add Torinese literary theorist Emanuele Tesauro: see Amedeo di Castellamonte, *La Venaria Reale: Palazzo di piacere, e di caccia ideato dall'Altezza Reale di Carlo Emanuele II, Duca di Savoia* (1674), 8−9; for Tesauro, see the Introduction, section 9.

A description of the House of Savoy's magnificent hunting lodge complex outside Turin written by its architect, *La Venaria Reale* is cast in the form of a dialogue between Castellamonte and Bernini, who had indeed visited the site in late October 1665 on his way home from Paris (as explained in Castellamonte's *avvertenza* placed after the Dedication to the Duchess of Savoy).

102. For Bernini's "self-mythologizing," see D'Onofrio, 1967, 89. For Bernini and Michelangelo, see D'Onofrio, 172−87; Soussloff, 1989; DLO/Pro, 12, 52−53; Levy, 2006, 164−65, 170, 172−73; and Ostrow, 2006, 127−32. Ostrow, 127, cites Charles Perrault's *Memoirs*, confirming what we find in the Chantelou *Journal*, to the effect that Bernini "very often quoted Michelangelo, and was almost continually heard to say: 'si comme diceva il Michael Angelo Bonarotta.'" Among the early biographical sources, La Chambre's "Éloge" also disseminates the same message but in a more direct, explicit fashion than we find in Domenico: "Enfin on doit le considerer comme le Michel-Ange de nos jours," "Finally, we must consider him the Michelangelo of our times" (ed. Montanari, 1999, 126).

It is relevant here to point out the intermittent presence in Rome within the Barberini cultural circle of Michelangelo Buonarroti the Younger (1568−1647), grandnephew of the artist, who actively promoted the memory and mythological status of his eminent forebear and on occasion must have assuredly interacted with Bernini: see Cole, who studies five decades of newly discovered correspondence between the younger Michelangelo and the Barberini, including Maffeo.

103. DLO/Pro, 52, examples given on 52−53.

104. The similarities between Vasari's *vita* of Michelangelo and Domenico's *Life of Gian Lorenzo Bernini* are many. In each *vita* we find, to cite only some examples, the following claims about the artist (V = Vasari; D = Domenico; Vasari page numbers refer to the 1965 Penguin edition, trans. George Bull: see my Bibliography): the artist was sent into the world by God to serve as exemplar to mankind (V.325, 431; D.1−2); possessed a mastery of all three arts (V.325, 418; D.32−33); as young artist in training, was obsessed with the practice of drawing (V.326; D.12−13); as a youth, astounded his master with his first autonomous works, causing the master to realize that he could teach the boy nothing and that the boy's own native genius was sufficient inspiration and guide (V.39; D.5); had great ambition to succeed in his profession (V.330; D.5, 38); was so absorbed by his art that he was impervious to fatigue and other bodily discomfort (V.354; D.179); for the same reason, was reluctant to marry, remarking that his works of art were to be his children (V.428; D.51); had ungrateful former student who became an adversary (V.391; D.112); achieved difficult effects in his art with facility, seemingly effortlessly (V.18; D.6); surpassed the ancients in his art (V.418; D.149); was never satisfied with his works as executed since they were incapable of expressing his idea of artistic perfection as conceived in his imagination (V.418−19; D.180); could successfully use his instinctual "judgment of the eye" where traditional rules and precise measurements were insufficient or useless (V.419; D.40−41); preferred the solitude of his beloved art to the company of men (V.419; D.13, 179); enjoyed the esteem and friendship of many great eminent leaders and learned, talented men (V.419−20; D.98−99 but also passim); was a devout, practicing, orthodox Christian (V.423; D.169−73); was generous in almsgiving and secretly provided dowries for many poor unmarried girls (V.424; D.171−72); was of profound intellect, which manifested itself particularly in clever, humorous witticisms (V.425;

D.54, 96–97 and passim); with regard to the imitation of past masters, was of the belief that no artist who simply follows his predecessors can ever surpass them (V.427; D.5).

105. Domenico, 114; and Donato Giannotti, *Dialogi* (ed. Deoclecio Redig de Campos [Florence: Sansoni, 1939], 68d), cited by Saslow, 17. For Giannotti and his *Dialogi*, see Saslow, 20.

106. Vasari, 418. Vasari says of Michelangelo in more detailed fashion at the opening of this *vita* (325): "[The benign ruler of heaven] decided to send into the world an artist who would be skilled in each and every craft, whose work alone would teach us how to attain perfection in design (by correct drawing and by the use of contour and light and shadows, so as to obtain relief in painting) and how to use right judgment in sculpture and, in architecture, create buildings which would be comfortable and secure, healthy, pleasant to look at, well-proportioned and richly ornamented."

107. I first noticed the divergence between the two biographers' descriptions of Bernini's *composto* when beginning my translation of Domenico and comparing his version with that of Baldinucci; my understanding of the problem was subsequently deepened by the two excellent discussions of the issue by Montanari, 2005a, and Delbeke, 2006. Looking at the broader context in which these passages occur in their respective texts, both scholars bring many new insights to the question, although they arrive at partially divergent conclusions. According to Montanari, Baldinucci's passage on the *bel composto* refers specifically to Bernini's approach to architecture, while Domenico's discussion of the *composto*, derived from Baldinucci's, is to be dismissed simply as an inept, disfiguring restatement of an idea not of his creation and beyond his comprehension (Montanari, 2005, 209, for the latter point). Delbeke, instead, sees both biographers as making a statement about Bernini's mastery of all three arts, with each of them painting a different picture of how Bernini arrived at that achievement and of its implications (see Delbeke, 2006, 264, for a summary of his argument). I accept Montanari's argument (202) that Domenico's expression "fra' Primi" is not to be understood in a temporal sense: that is, Bernini is "among the foremost of artists," not (chronologically) "among the first artists," in achieving this *composto*.

108. Montanari, 2005a, 201. Montanari also observes that there is reason to doubt that either the term or the concept originated with Bernini himself, since both biographers present the issue as a matter of the "opinion" of others, not as the claim by the artist himself.

109. Enggass (Baldinucci, e.74) translates *attititudini* as "poses," whereas Delbeke (2006, 258) renders it as "attitudes." The English "poses" is normally used only with reference to human figures (or anthropomorphized nonhuman entities like animals) and would be the best translation if Baldinucci in this case were thus restricting the meaning of his term, *attitudini*. Baldinucci's *Vocabolario toscano dell'arte del disegno* defines *attitudine* with reference only to figures: it is "the act or action or gesture of a figure, that is, resting immobile, bending, rising up or otherwise moving about in any fashion, in order to express the emotions that one intends to depict" (L'atto, o l'azzione, o il gesto che fa la figura, cioè, di star ferma, chinarsi, alzarsi, o altrimenti muoversi in qualunque modo, per esprimere gli affetti, che si vogliono rappresentare), and wherever else the term appears in his *Vocabolario*, it seems likewise to be restricted to figures (online text at http://baldinucci.biblio.cribecu.sns.it/baldinucci/html/_s_index2.html).

If that is the case, however, the question then becomes: Why should the entire achievement of the *bel composto* rely solely on the rendering of human figures? Baldinucci presumably instead is referring to the configuration and placement of all constituitive elements of the works of art in question. Delbeke, 2006, does not discuss the meaning of the term or otherwise raise the issue, whereas Montanari, 2005a, 203, explicitly mentions that *attitudini* refers more widely to "the architectural and plastic elements" (elementi architettonici e plastici) of the "composite" work of art. Two illustrations of Baldinucci's generic description are Bernini's tombs of Urban VIII and Alexander VII, in which all elements, especially the figures, flow smoothly together, blending organically and harmoniously into one, well-integrated monument.

110. Baldinucci's mention at this point of mastery of only painting and sculpture as prerequisite to achieving this *composto* speaks in favor of Montanari's argument that the Florentine biographer in this passage is specifically describing Bernini's approach to architecture: see note 107 above.

111. Delbeke, 2006, 251–52.

112. Chantelou, October 9, f.239, e.274.

113. La Chambre, in his "Éloge" (Montanari, 1999, 126, emphasis added), also praises the "tender" quality of Bernini' sculpture: "Il n'a quitté le goût antique que pour donner à ces figures plus de mouvement et de vie, *plus de tendresse* et plus de verité." For further discussion of *tenerezza* in early modern art literature, see *Dizionario di arte* (see note 159 below), s.v. "Tenerezza."

114. Baldinucci, i.141, e.74, emphasis added. I have here substituted Enggass's "softness" with "tenderness." Later, Baldinucci (i.154, e.88) will claim that Duquesnoy "took the marvelous tenderness found in his work from Bernini" (Enggass translation revised, substituting "delicacy" with "tenderness" in rendering *tenerezza*). For further discussion of Bernini on *tenerezza* in architecture, see my commentary to the relevant passage on Domenico, 39.

115. Chantelou, June 25, f.64, e.41; see also October 2, f.217–18, e.246. For Michelangelo as an object of criticism (with further bibliography), see Soussloff, 1989, 583: "In [the] literature [on art in the sixteenth and seventeenth centuries] Michelangelo was either praised as a great artist or criticized as an example of what should be avoided." See also Cousinié, 285–87.

116. Chantelou, July 5, f.70, e.52: "il a loué extrêmement Annibal Carrache." The English edition of Chantelou renders the line as "he gave the highest praise to Annibale Carracci" and from what follows (Bernini's description of how Carracci appropriated the best qualities of all the greatest painters) that would seem to be his intent, that is, to accord Carracci absolute priority over all other painters, including Raphael and Poussin. Nonetheless, for caution's sake, especially in view of Bernini's classification of painters given by Domenico (29), mentioned below, in which Carracci ranks fourth, I would translate this Chantelou line more literally. For Bernini and Poussin, see note 118 below.

117. For San Lorenzo in Lucina as residence of the Bernini family and Carracci, see, respectively, Terzaghi and Andrews. Chantelou, June 16, f.59, e.35, for the supposed other encounter between Bernini and Annibale. For further discussion of Bernini's mythologizing of Annibale's role in his life, see Montanari, 2006, 100–101, and 2009, 100–101; and Ostrow, 2006, 125–32.

118. Strangely enough, nowhere to be found instead in either Domenico or Baldinucci is another eminent painter of the time, Nicolas Poussin, whom, according to Chantelou's *Journal,* Bernini repeatedly praised in the most superlative terms: for example, "Poussin, the greatest and most learned painter of all time" (Chantelou, October 10, f.246, e.282; see also July 25, f.88–90, e.80; September 8, f.167–68, e.181; and September 29, f.212, e.238). Did Bernini exaggerate his appreciation of Poussin's art in deference to his French host, Chantelou, a personal friend of the French artist and an avid collector of his canvases? Or did Chantelou, for his own ideological purposes, inflate Bernini's praise of Poussin, as suggested by Ostrow, 2006, 130–31 ("Chantelou, it seems, presented a Bernini who reinforced his own aesthetic beliefs").

Stanić raises the same suspicion: see his n.4 to Chantelou, f.56. Elsewhere in the *Journal* (July 29, f.95, e.89), Colbert in fact remarks to Chantelou that he "had heard it said that [Bernini] did not admire the works of M. Poussin, nor M. Poussin his." In truth, we know nothing about the rapport between Bernini and Poussin except for what is reported in Chantelou's *Journal,* including the fact of Bernini's supposed help in 1628 in securing for Poussin the prestigious commission for the *Martyrdom of Saint Erasmus* altarpiece in Saint Peter's, of which he boasts to Chantelou (September 8, f.167, e.181; for the altarpiece, see Rice, 1997, cat. 10, with the original documentation, none of which mentions any role by Bernini in securing the commission for Poussin, though Rice, like other scholars, accepts Bernini's word on the matter).

Note that the putative *Portrait of Poussin* by Bernini, which may have suggested some familiarity between the two men, has in the most recent reevaluations of Bernini's paintings been dismissed as a portrait of the French artist: see Petrucci, 2006, 334, cat. 23; and Montanari, 2007, cat. 10.

119. For the *avviso* and for Petrucci's interpretation, see Petrucci, 2006, 23; for yet another interpretation of this *avviso,* see Montanari, 2007, 85 n.132.

120. Domenico, 14, for Bernini's study of painting (i.e., drawing from past masters) as part of his training as sculptor; see also Baldinucci, i.74, e.9. Domenico, 37 (as does Baldinucci, i.81, e.15), later explains that Bernini then took up the study of painting again in earnest for two years

at the request of Pope Urban VIII, who intended to have him paint the Benediction Loggia at Saint Peter's. The project never came to fruition: Domenico blames Bernini's intervening illness for the failure, but it could very well be that in the end, even after his recovery, Bernini or Urban (or both) came to the realization that a project of this magnitude was beyond the capacity or interests of our artist. As Baldinucci, i.141, e.74, remarks, "although he felt a great inclination toward painting . . . his painting was merely diversion" (mero divertimento).

Confirming the fact that Bernini did not consider himself a painter is his remark about Poussin's *Saint Erasmus* altarpiece, "*If I were a painter,* that painting would be a great mortification to me" (Chantelou, July 25, f.89, e.80), quoted and discussed by Montanari, 2007, 65, emphasis added. Likewise, Bernini's friend Fulvio Testi quotes the artist in an August 17, 1637, letter to the Duke of Modena to the effect that "his profession is that of the chisel, not of the paintbrush" (Testi, 2:742–43).

121. For the *Saint Maurice* altarpiece, see Domenico, 26 (and commentary), and Baldinucci, i.130, e.64–65. The documents are clear in showing that Pellegrino alone received the official commission as well as the various payments for the work. For the still-unresolved question of the degree of Bernini's involvement in the creation of the work (design alone? design with close supervision of execution? design and some of the actual execution?), see *Bernini in Vaticano,* cat. 39; Rice, 1997, cat. 7; Petrucci, 2006, 152–57 and cat. 35; and Montanari, 2007, 61–66 and cat. 23.

122. Again, the *avviso* is to be found in Montanari, 1998b, 400.

123. Mérot, ed., 518.

124. Lyons, 145, 150, 151, for the quotations in this paragraph.

125. Lyons, 153–54, 156.

126. For the mutual admiration between Louis and Bernini, see especially Domenico, 134, assuming that it is not simply a case of courteous dissimulation, as Zarucchi claims, not without justification. Zarucchi (English translator of Charles Perrault's *Mémoires*) in fact argues persuasively in her 2006 essay, p. 32, that the reaction of Louis and Bernini to each other was solely one of diplomatically masked mutual disdain: "I will argue that . . . contemporary accounts suggest, rather, a mutual enmity between the two strong personalities of the sixty-six-year-old Bernini and the twenty-six-year-old Louis XIV."

127. For bibliography on Bernini and the theater, see note 27 to Domenico, 53.

128. For the connection between Bernini's stage performance and his work as sculptor-painter, see Montanari, 2003b. In Chantelou's *Journal,* Bernini speaks often and with obvious pride and pleasure about his plays; he summarizes plots and recites from memory extensive portions of his scripts, as well as discussing such details as the precise mechanics of effective theater construction and stage design: see the indexes to the French or English editions of the *Journal* for the relevant diary entries. According to Domenico, 130 (and confirmed by Chantelou, August 23, f.136–37; e.142–43), the theater was also a topic of conversation between Bernini and Louis XIV. For the sole extant script by Bernini, *The Impresario* (most likely written for the 1644 Carnival season [D'Onofrio, 1963, 28–29 for dating]), now available in several editions in both Italian and English, see note 27 to Domenico, 53.

129. Passeri, life of Guido Ubaldo Abbatini, 243: "Questo diletto era una catena, che tutti legava strettissimamente, perche a cagione di un mese di divertimento il Bernini li teneva tutto l'anno obbligati al lavoro, ed un anno collegava l'altro, sicchè fra il disegnare e il recitare era una perpetua insopportabile alternativa per la misera gioventù."

130. For these two reports, see Fraschetti, 261 nn.1 and 3. In the February 25, 1634, letter, Testi describes Bernini as "a close friend of mine" (mio amico particolare); in an earlier letter of January 29, 1633, boasting of the love between the two of them ("Questi si è innamorato di me et io di lui"), Testi mentions that Bernini has given him a gift of some of his drawings and has begun his portrait: see Testi, 1:432–33, no. 403; for the lost portrait of Testi by Bernini, see Petrucci, 2006, 429.

131. Without specifying title or date, Domenico, 56, mentions a later Bernini production at the Rospigliosi residence during the reign of Clement IX: this, as we know from other sources,

was the 1668 *La Comica del Cielo, ovvero La Baltassarra*, written years earlier by Giulio Rospigliosi (for this production, see Tamburini 1999–2000 and 2005). See Martinelli, 1959, 215, for a contemporary reference to a February 25, 1675, Bernini home performance (attended by Cardinal Nephew Paluzzo Altieri); and Fraschetti, 271–72, for documentation of Bernini's Carnival productions of both 1676 and 1677. Ademollo, 159, publishes *avvisi* reporting the February 1680 musical play *L'Onestà nelli Amori*, produced by the Bernini family, in which the aged Bernini may have had little or no direct part.

At some point, Bernini's prelate son, Monsignor Pietro Filippo, had initiated his career as playwright (having the honor of Queen Christina's patronage in this); it was he who wrote the libretto for this 1680 production, featuring music by Alessandro Scarlatti (see Montanari, 1998b, 406–7).

132. Domenico, 99, quotes to the same effect Cardinal Pietro Ottoboni, the future Pope Alexander VIII (1610–91, r. 1689–91), who used to call Bernini "an exceptional man, worthy of the company of great princes." For the figure of the courtier and his requisite talents, see the early modern Italian handbooks of courtly behavior by Baldassarre Castiglione, Giovanni Della Casa, Lorenzo Ducci, and Sebastiano Fausto da Longiano, all found in the personal library of Bernini's brother, Luigi (McPhee, 2000, items 86, 113, 146, 150).

The astute stratagem by which Bernini won over a hostile Pope Innocent is that of the Piazza Navona fountain *modello*, recounted by Domenico, 86–87, about which ploy one of Baldinucci's anonymous informants remarked: "[F]rom this one sees that [Bernini] was a more clever as a courtier than as sculptor and architect" (D'Onofrio, 1986, 406). Of course, the negative aspects of the courtier's life as discussed in contemporary treatises are also applicable to Bernini, such as the notion of the unpredictable but inevitable ebb and flow of *Fortuna* and the instability of princely approval, such as we hear from Domenico (80), discussing the difficult early years of the hostile Pamphilj pontificate.

Domenico's commentary on that chapter of his father's life conforms to what we read in the literature of the day: "*Fortuna* and the dangers of court intrigues had been privileged tropes of court treatises since the fifteenth century. Such tropes became even more common with the development of the increasingly large, rigidly hierarchical, and professional courts typical of the baroque period" (Biagioli, 324; for the life and psychology of the courtier in seventeenth-century Rome, see also Calcaterra).

133. Chantelou, June 6, f.46, e.15: "He is an excellent talker with a quite individual talent for expressing things with word, look, and gesture"; see also Mattia de' Rossi's June 5, 1665, letter describing Bernini's eloquence upon meeting Louis XIV for the first time: "The Cavaliere is accustomed to delivering speeches that are both very beautiful and well grounded, but that morning he was visibly inspired by God. Not a word came forth from his mouth that did not cause the King to marvel" (appendix to Chantelou, f.384–85).

134. See my further discussion of *ingegno* and Tesauro in the Introduction, section 9.

135. "The learned art of Bernini nourished itself of everything else but books; if anything, of images and fragments, of quotations that others could have prepared for him, such as the research on ancient porticos that we find among his papers or the description of Constantine and so forth. For him, 'man without letters,' with the authoritative mediation of his papal patrons, all was possible; other people read for him. He limited himself to read that which was not written in books, the miraculous nature of his materials, light, the marvels of his fantasy" (Borsi, in BALQ, 12).

Of his father's nonartistic schooling, Domenico, 2–3, says merely that the boy Bernini was "raised in the first rudiments of letters with good discipline by Pietro his father and Angelica Galante his mother." The admiring Chantelou observes in his *Journal* that "without having studied [Bernini] has nearly all the advantages with which learning can endow a man" (June 6, f.46, e.15), but note the qualification, "nearly."

136. These extant notes on grammar, the so-called Grammatichetta (BNP, Ms. italien 2082, fols. 17r–24v) are well known among Bernini scholars (e.g., see Bandera Bistoletti, 50, and Audisio, 39). Folio 17r bears the inscription: "Tutte l'emende sono di mano di Papa Alessandro Settimo" (All the annotations are in the hand of Pope Alexander VII). However, the exercises

are usually described as pertaining only to Latin grammar but, in fact, included among them are the complete conjugations of the three classes of Italian verbs (-are, -ere, -ire), which leads one to conclude that Bernini was reviewing his Italian grammar as well.

137. The February 1682 inventory of the books left by Luigi Bernini at his death, expertly edited by Sarah McPhee (2000), is a most valuable document that takes us closer to the intellectual-cultural milieu of his brother, Gian Lorenzo. However, that assemblage of books or any portion of it does not represent, I believe, the personal library of our artist. For example, we find none of the works for which Bernini supplied frontispieces—not even one copy of the many-times reprinted poetry of his mentor Maffeo Barberini (Urban VIII). We find nothing on the great artist with whom Bernini was all but obsessed, Michelangelo, who was the subject, as mentioned, of well-circulating biographies by Condivi and Vasari, and whose poetry had been published by his nephew in 1623, with a dedication to Maffeo Barberini (for which see Bellini, 2006, 296; and 2009, 187). According to Chantelou (August 10, f.112, e.111), the Frenchman's younger brother, Roland Fréart de Chambray, gave Bernini and son Paolo copies of his *Parallèle de l'architecture*, a major work of theory and history (for which see *Architectural Theory*, 239–47), but this too is missing from the 1682 inventory.

Likewise absent are all the devotional works praised by Bernini in Chantelou's *Journal*: see July 23, f.85, e.73 (the sermons of Gian Paolo Oliva for which Bernini also supplied a frontispiece) and August 23, f.134, e.138–39 (Thomas à Kempis's *Imitation of Christ* and Francis de Sales's *Introduction to the Devout Life*). The inventory in fact includes very few works of religious or devotional nature. On the contrary, it includes various secular works (like those of the "licentious" Marino, the scatological Boccaccio, and the theologically suspect Erasmus) that strike one as unlikely items in the personal library of the piously devout, orthodox Catholic that Bernini had become in his old age.

138. Another notorious case of heresy in seventeenth-century Rome was that of Miguel de Molinos, the prophet of Quietism, who arrived in Rome in 1663 and was probably known by Bernini, for they both frequented the court of Queen Christina. Although Molinos's condemnation and imprisonment by the Inquisition did not take place until after Bernini's death, his troubles were already brewing in the last decade of the artist's life.

For Domenico's disparaging account of Molinos's teachings and person, see his *Historia di tutte l'heresie*, 4:711–21; on p. 713, in speaking of Rome's initial blindness to Molinos's alleged hypocrisy, we might mention, Domenico uses a phrase, "Ma come che Roma alcuna volta travede bensì, ma non mai perde la vista," which appears in his *Life of Gian Lorenzo Bernini* (Domenico, 80) as a direct quote, with only slight variation, from his father.

139. Though documentation about its origins is lacking, the *Saint Lawrence* statue is now dated to ca. 1617, when Bernini was nineteen years old (*Nascita*, 62–77, with ample bibliography). For discussion of this episode in Domenico's narrative, see Levy, 2006, 172–73; and Damm, 2006. For the *Savior* (or *Salvator Mundi*) bust, see my commentary to Domenico, 167. See DLO/Pro, 13–16, for further discussion of the subject of the conflation of art and personal piety in Domenico's (and Baldinucci's) account of the artist's life and its consequences in modern interpretations of Bernini's oeuvre.

140. But see my discussion in note 36 above about the hagiographic topos of the life-changing near-mortal illness as it relates to Bernini. The most complete and most recent account of the Costanza affair, with much new research into the identity of the woman and her status in society, is McPhee, 2006.

141. Levy, 2006, 163.

142. The only work of art by Bernini to which Baldinucci attaches any personal devotional significance—but even here in a restrained manner—is the bust of the *Savior;* however, in so doing he was simply respecting a traditional commonplace of the genre of art biography, that is, the "idea that both religious conviction and artistic virtue are embodied in the artist's final work," as Soussloff, 1987, 118, points out. Taken in isolation by itself, Domenico's corresponding passage on the *Savior* bust is also rather understated, but inevitably that one description acquires a much stronger pietistic charge by virtue of the consistent tone of Domenico's narrative in its entirety.

143. Baldinucci's *Spiritual Diary* has been published more than once: the most recent edition was edited by Giuseppe Parigino (Florence: Le Lettere, 1995); for Baldinucci's piety, see also the already-cited biography by his son, Francesco Saverio, 58–63 (see note 40 above).

144. "Turning then to M. de Ménars, [Bernini] addressed a little exhortation to him, saying he was young and handsome and at that age one must take good care not to abandon oneself to pleasure; in his own case, God had put out a hand to save him, for, although he had a fiery temperament and a great inclination to pleasure in youth, he had not allowed himself to be carried away and had saved himself from it; like a man in midstream who does not know how to swim but is held up by gourds, he might sink sometimes to the bottom of the water but would, nonetheless, rise to the top again immediately" (Chantelou, July 23, f.85, e.72–73).

145. For Bernini's theater, see section 7 above. It is the character of Zanni, who in act I, scene 5 of Bernini's *Impresario* cautions his master, Gratiano the playwright: "Remember, they said the last time that [your play] was crude [*grosso*]." Both Fraschetti, 268, and D'Onofrio 1963, 99, quote the February 3, 1646, report of Duke of Modena's Roman agent, Francesco Mantovani, about the moral outrage provoked by Bernini's (untitled) Carnival satire at the residence of papal sister-in-law, Donna Olimpia Pamphilj: "riesce troppo libera e scandalosa, onde il Cardinale Carraffa et altri scrupolosi che c'intervennero, rimasero sommamente scandalizzati" ([the play] proved to be too free and scandalous, and indeed Cardinal Carafa [Pier Luigi Carafa (1581–1655)] and other scrupulous members of the audience were highly scandalized").

Albeit without reference to Bernini, Teodoro Ameyden's manuscript *Diario della città di Roma,* the entry for February 6, 1649 (fol. 209v, Biblioteca Casanatense copy), notes the same morally shocking quality of Donna Olimpia's theatrical productions: "La Sig.ra hà incominiciato le sue comedie, le quali riescono assai licenziose" (Madame has begun her comedies, which are proving to be rather licentious).

146. It is Domenico himself, 166–67, who tells us of Pope Innocent XI's order to cover up the nude statues. For the De Sylva Chapel and its recently restored (and uncovered) allegorical figures, see Negro, 2002.

147. Previtali, 58; Bauer, 1976, 53. See note 71 above for the pamphlet.

148. Karsten, 2007, 20. See Montanari, 2005c, 287, for a critique of those scholars who too readily interpret Bernini's art as a direct expression of his personal piety or theology.

149. Wittkower, 195–96. Domenico, 171, also mentions that "for forty years" Bernini attended the "Good Death" (*Bona Mors* or *Buona Morte*) devotions at the Church of the Gesù. In the Jesuit archives in Rome, I was unable to find seventeenth-century membership lists for the Congregation of the Good Death or any document linking Bernini to that group; however, Domenico does not claim that the artist was a formally inscribed member. See Maher, 268–82, for the congregation (instituted in October 1648; hence Domenico's "forty years" is a slight exaggeration).

Castellani's 1954 history of another pious congregation at the same church of the Gesù, that of the "Nobili" (Nobility) or the "Assunta" (its formal title is "Congregatione della gloriosissima Vergine Assonta"), lists Bernini as a member as of 1640 (Castellani, 273. Mullan's 1918 history of the same congregation makes no mention of Bernini, either as member or benefactor). Castellani cites no source for his information and one wonders about both the veracity of his claim and the state of extant documentation: Why, for example, is Bernini only one of five individuals explicitly listed by Castellani as members in the long period 1617–97 in an inventory claiming to list all known members from 1593 to 1954?

Although Bernini was not nobility, as *Cavaliere,* he was still eligible for membership, if the entrance criteria, repromulgated in 1629 (Castellani, 164, "siano nobili in quel grado, che si ricerca"), were taken seriously, as Maher, 251–52, says they were in the first half of the seventeenth century. The 1629 Rule (*Regole*) and Customs (*Consuetudini*) books of the congregation also mention nothing about almsgiving or of dowries to unwed poor girls (not even those given on its patronal Feast of the Assumption), of which Domenico, 171–72, makes much in his description of his father's favorite forms of charity.

It also seems strange that neither Domenico nor Baldinucci (nor any other source) makes note of his membership in what was an extremely prestigious sodality, known especially for its

sponsorship of the lavish Forty Hours devotional spectacles at the Gesù: see Mullan, 115–25, and Castellani, 189–90, for their sponsorship; for the Forty Hours devotion in general, see Weil, 1974a and 1992; and Fagiolo dell'Arco, 1997, *ad indicem;* see Maher, 248–59, for the most recent research on the history of the Congregation of the Nobles. It is pertinent to note, finally, that neither congregation (the Bona Mors and the Nobili) is mentioned in Bernini's last will and testament.

150. For the *Savior* bust and related bibliography, see my commentary to Domenico, 167.

151. Rubin, 151.

152. Among the discussions of the art-historical vocabulary of early modern Italy, I have found especially helpful those of Sohm and Summers.

153. Kenseth, 38. Benedetto Croce defined *ingegno* as the "facoltà inventiva in generale," the inventive (or creative) faculty in general (quoted by Montanari, 2004a, 309, noting that the word *genio* was soon to acquire the same meaning; see note 156 below for *genio*).

154. Tesauro, 82, for his definition of *ingegno* here quoted (emphasis added); the previously quoted phrase comes from the book's subtitle. For *ingegno* as a participation in divine power, see Kenseth, 38, citing Tesauro, 82–83 ("non senza qualche ragione gli Huomini ingegnosi fur chiamati *Divini* . . . Onde fra gli antiqui Filosofi, alcuni chiamarono l'Ingegno, *Particella della Mente Divina*"). Tesauro's extensive manual on metaphors and other forms of symbolic language, though mostly concerned with written language or spoken discourse, was also meant to apply to the visual arts (see, e.g., Tesauro, 86–87, 732). For Tesauro and *ingegno,* see also Fehrenbach, 2005, 9–10.

Though focusing on the Quattrocento, the discussion of *ingegno* (translated as "genius") in Kemp, 384–95, is useful, whereas Marzot's 1944 book, with its misleading title, pays little attention to the question of definition (for *ingegno* and *genio,* see 39–40) and offers no survey of actual usage. DLO/Pro, 43–44, discuss Bernini's *ingegno* briefly but leave the term untranslated and essentially undefined, whereas in her monograph on Vasari, Rubin translates *ingegno* simply and always as "talent" (see her index, s.v. *ingegno*).

The definition of *ingegno* found in Mirollo, albeit useful, is nonetheless conditioned by the author's specific objective, that is, a description of Baroque *poetic* theory and style, as is his translation of that term as "wit": "Ingegno: the wit, the fancy, the faculty of the soul which invents poetic materials, intuits or creates similitudes, apprehends beauty, and spawns witty metaphors and other conceits. The usage ranges from mere 'ingenuity' to something like the later 'genius.' . . . The English 'wit' is absolutely essential here; no other choice exists" (Mirollo, 117). Mirollo, however, also translates *arguzia* as "wit," though recognizing the resultant dilemma when the two words, *arguzia* and *ingegno,* appear side by side or in the same sentence, as happens in Baroque texts (Mirollo, 116).

Cherchi, 312, in discussing another influential work of Baroque literary theory, Matteo Peregrini's *I fonti dell'ingegno ridotti ad arte* (1650), translates *ingegno* as both "wit" and "ingenuity."

155. See in this regard the self-portrait etchings from two seventeenth-century artists, each depicting his own *genio: The Genius of Giovanni Benedetto Castiglione* (ca. 1648) and *The Genius of Salvator Rosa* (ca. 1661).

156. This change began in the eighteenth century and culminated in Romantic theory of the following century: see *Dizionario di arte* (see note 159 below), s.v. *Genio.* The same *Dizionario* (s.v. *Ingegno*) defines *ingegno* as the "inventive faculty, innate creative sense of an artist" and points out that its Latin root, *ingenium,* could also be translated as *genio.*

157. When referring to other entities, like plants, chemical substances, or the parts of the human mind, it instead meant "power," "property," or "faculty."

158. One exception is the title of chapter 11, which speaks of Bernini's "moderazione e virtù" (in the face of persecution), which I have translated as "temperance and valor." However, on page 80 of the same chapter, where Domenico speaks of Bernini's making use of his own *virtù* as consolation and a remedy for the current evils, I translate *virtù* as "talent" since, as we learn immediately thereafter, our author is specifically referring to his creation of the statue of *Truth Unveiled by Time.* Domenico also uses the word *talento* several times in his narrative (5, 41, 57,

and 96) but in each case he intends it as a less exalted-sounding synonym for *virtù,* even though some of his contemporaries might perhaps have made some distinction between the two terms.

159. No extensive discussion of the term exists in any previous study, as far as I can determine. My discussion here is based in large part upon my own encounter with the term in primary sources, as well as upon entries (all s.v. *virtuoso*) in the following reference works: *Dizionario della Lingua Italiana* (Tommaseo and Bellini, comp.); *Dizionario enciclopedico italiano; Oxford Companion to Western Art,* ed. H. Brigstocke (2001); *Dizionario di arte* (ed. Luigi Grassi and Mario Pepe [Turin: UTET, 1998]); and the unabridged *Oxford English Dictionary* (*OED*). For a useful discussion of "virtuosity" as defined by Castiglione, see Eamon, 222–25; see also Houghton, 51–58; and Summerscale, 130–31 n.101.

160. See the case (studied by Ostrow, 1998) of the now little-noticed Roman artist Paolo Sanquirico (ca. 1565–1630), a veritable "jack-of-all-trades," who, although mostly of mediocre talent, was nonetheless deemed a *virtuoso* by his biographer Giovanni Baglione and other contemporaries. The first use of the term *virtuoso* (according to the *OED*) in its much narrower contemporary meaning as referring to a musician or vocalist of extraordinary technical ability dates to after Domenico's lifetime.

When applied to women, the same label in Italy referred to accomplished females of a different type, as reported by a Dutch visitor to Rome in 1655: "There are some ladies in Rome who are called *virtuose,* who know how to sing, dance, play instruments and who converse reasonably well. One goes to them sometimes in company, as many as ten or twelve, and one can have a serious discussion or just a chat. When you want to go, you pay a *scudo* or two each . . . and leave . . . and if someone wants to stay the night, he will be satisfied" (cited by Storey, 250); however, not all of these *virtuose* necessarily extended their services to the realm of commercial sex.

161. The word *virtuoso* (or its plural form, *virtuosi*) as a noun designating a category of persons occurs in Domenico on pages 6, 7, 8, 13, 16, 24, 37, 46, 50, 51, 55, 65, 76, 97 (twice), 104, 105, 113, 126, 151, 155 (twice), and 156. In addition, we find it in publisher Bernabò's (unpaginated) letter of dedication, where he praises the cardinal's family for its cultural patronage, specifically, its "protezzione ai Virtuosi, e l'inclinazione alla Virtù." In the latter case, undoubtedly the term *Virtuosi* is being used in its broadest sense of "men of creative talent."

162. See the relevant entries in Morello, 1981.

ORIGINAL FRONT MATTER

1. For the dedicatee, Cardinal Lodovico Pico della Mirandola, see the Introduction, section 7. Bernabò's letter of dedication conforms to the conventions of its literary genre; see, for example, the advice of the contemporary handbook of administrative protocol and manners, Guarini's *Il segretario*: "Regarding the individual to whom one is composing the dedication, when the praise bestowed upon him is specific to his family, person, blood line, and virtue, it will be all the more appealing and more efficacious in favorably disposing his spirit to you" (Battista Guarini, *Il segretario,* [Venice, 1600], 132).

2. The emperor in question (whom Bernabò simply calls "Costanzo") is Constantius II, i.e., Flavius Julius Constantius (317–61 C.E.): in 337, upon the death of his father, Constantine, he acceded to the throne together with his two brothers, Constantine II and Constans. Euride has left no trace in the historical record outside of the legend here recounted, as far as I have been able to ascertain.

3. Bernabò has a bibliographical note in the margin: "Conte Loschi, *Comp. Hist.* verbo Duchi della Mirandola, mihi (presumably, "*in the edition consulted by me*"), pag. 569." The reference is to the genealogical history, the *Compendi historici* by Count Alfonso Loschi (dates unknown) of Vicenza, first published in Venice in 1652, with many subsequent editions. I consulted the 1668 edition, in which the entry "Dukes of Mirandola" is at pages 462–66. Loschi (462–63) includes the story of Constantius, Euride, and Manfred.

Manfred was a young German prince in service to the Roman emperor whose daughter falls madly in love with him, as he with her. Manfred and Euride are forced to flee the wrath of her disapproving father. After many years, various adventures, and the begetting of eight children, they receive pardon from her father (thanks to Manfred's military prowess on his behalf) and finally return to the emperor, who marvels at the account of their vicissitudes.

4. That is, Lodovico did not necessarily pursue fame and fortune in themselves and as a matter of ambition; they were simply bestowed on him as rewards of his own merit.

5. For misfortunes of Lodovico's life (as a young man he was deprived of his family wealth and property by the French who besieged Mirandola and lived in near poverty for some time thereafter), see the Introduction, note 93.

6. "Nella sua più florida età": for the significance of this expression in dating the writing of Domenico's biography, see the Introduction, section 4.

7. I have been unable to identify the author of these verses.

8. That is, through his apologetic historical writings, Domenico has fortified the defenses of the papacy and the Church. This—protecting and glorifying the image of the papacy (which expended enormous sums of money on his father in order to embellish Rome)—is one of the implicit goals of Domenico's biography: see the Introduction, section 3. Bernabò here uses an important term often employed in the Baroque vocabulary (including that of Domenico): "magnificence" (*magnificenza;* in Latin *magnificentia*), i.e., awe-inspiring material splendor of the highest order.

Since the mid-fifteenth century, with the beginnings of the long campaign on the part of the Renaissance popes for the material restoration of the imperial grandeur of the city of Rome—the *Renovatio Romae* (for which see Stinger)—external magnificence, on every front but especially in Saint Peter's Basilica, was one of the principal instruments whereby the papacy not only strengthened the faith and allegiance of the Catholic faithful, but also asserted the reality and legitimacy of its primacy as absolute ruler of the universal church. This only intensified in the Counter-Reformation, after the Council of Trent, and culminated during Bernini's lifetime in the Baroque papacy, especially the reigns of Urban VIII and Alexander VII, our artist's great patrons.

One of the most explicit, eloquent expressions of the goals of Roman "magnificence" is to be found in Giannozzo Manetti's *Life of Pope Nicholas V,* bk. 3, the "Testament of Nicholas V," in which the dying pontiff (r. 1447–55) justifies his grandiose building projects:

> The only people who understand that the authority of the Roman church is greatest and supreme are the ones who have learned its origins and its growth from their knowledge of reading. In reality, the masses of all the others, ignorant of and thoroughly lacking reading ability, might seem to hear often from educated and learned men the nature and extent of those matters and to assent to their truth and certitude; but still, unless they are moved by something extraordinary that they see, all that assent of theirs rests on weak and feeble foundations and will slip bit by bit in the course of time until it lapses to virtually nothing. But actually popular respect, founded on information provided by educated men, grows so much stronger and more solid day by day through great buildings. (Latin text with English translation in Smith and O'Connor, 472–75)

For "magnificence" in Baroque Rome, see also Preimesberger, 2008b; and Oberli, 203–9. For the related princely-patrician virtue of *magnificentia* (also translated as "magnificence"), equally esteemed in the Baroque mentality and hence invoked several times in our text, see my commentary on the term on Domenico, 2.

9. In Baroque rhetorical fashion, Domenico here plays with the paradox centering on the word "life": that is, life given in physical form (from father to son) and life given in metaphorical form (from son to father, in the form of literary immortality). For the paradox, see Levy, 2006, 159–61.

10. Gregory Nazianzen, "On His Sister, St. Gorgonia" (trans. L. McCauley), 101.

11. In fact, Domenico considerably abridges, simplifies, and, in so doing, distorts (when not outright falsifying) much of the history here recounted, as the commentary below will point out. He does so not only for practical editorial-narrative convenience but also to further his apologetic-hagiographic mission with respect to his father's memory.

12. "Let it be published." I have included the usually ignored *Imprimatur* page, as it is testimony to the history of the production of Domenico's text: it tells us, for example, that the last revision of the text was most likely finished by late 1711, since the *Censor Librorum* (Censor of Books) Guelfi rendered his judgment of it on January 16, 1712.

13. Domenico De Zaulis (1637–1722), author of *Observationes canonicae, civiles, criminales* (Rome, 1706; 2nd ed., 1723–24).

14. "A wise son [heeds] the instruction of his father," Proverbs 13:1.

15. Born in Borgo San Sepolcro, Tuscany, in 1659, Guelfi spent his Jesuit career teaching humanities and philosophy; he died in Rome in 1744 at the novitiate of Sant'Andrea al Quirinale, where he had resided for some thirty years (*Bibliothèque de la Compagnie de Jésus*, 3:1902).

16. Sellari's last name is more commonly rendered "Selleri." For this Dominican theologian (1654–1729), see the *Biographisch-Bibliographisches Kirchenlexikon*, 9:1368–70, s.v. "Selleri, Gregorio." The "Master of the Sacred Apostolic Palace" is the pope's official theologian; Selleri assumed that office on March 12, 1711.

CHAPTER I

1. Domenico's exordium, with its lofty claims expressed in grandiloquent prose, is in keeping with the conventions of early modern writing, which upon classical authority (Aristotle, Cicero, Quintilian) required literary works to begin with this type of curiosity-rousing rhetorical volley. It also harkens back to the example set by Giorgio Vasari in his *Lives of the Most Eminent Painters, Sculptors and Architects* (for the Vasarian exordium, see Rubin, 156–57). Though using different imagery, Baldinucci's exordium, i.71, e.6–7, nonetheless echoes that of Domenico, confirming the heavenly origin of Bernini's talent and his status as one of the most outstanding artists of any age, including antiquity.

2. I translate Domenico's *virtù* as "talent": see the Introduction, section 9, for the meaning of and translation challenges posed by this word.

3. For the spelling of Bernini's name, during his lifetime and today, see the Introduction, section 1, note 1. Note that in both premodern and modern Italian the word *Cavaliere* (Knight) loses its final vowel when followed by a personal name; the same is true of all titles ending in *-re* (*Signore, Monsignore, Dottore, Professore*, etc.).

4. Domenico here uses an important term, *magnificenza* (in Latin, *magnificentia*), one of the most recurrent words in the Baroque vocabulary relating to patrons and patronage. Commenting on inscriptions placed in Saint Peter's by Popes Paul V, Urban VIII, and Innocent X to commemorate their embellishment of the "magnificence" of the basilica, Preimesberger (2008b, 148) explains: "The contemporary notion of *magnificentia*, which had well-known origins in Aristotle . . . and was, by the seventeenth century, informed by a very long history, signifies the extraordinary expenditure of economic resources feasible only for persons of the highest social rank." That is to say, a patrician of any type—secular or ecclesiastical—proved himself worthy of that title precisely by doing what only he could do: spend exorbitant sums of money in lavish displays of public patronage (in the form of art, architecture, theater, festivals, banquets, and outright gifts to courtiers, clients, or the poor) to a degree beyond the capacity of any lesser mortal.

In the Baroque mind, *magnificentia* represented a virtue, one in which conspicuous consumption and extravagant display of wealth became indeed the inescapable duty of Christian aristocrats who contributed to the public good and solidified the allegiance of their grateful and wonder-struck subjects while proving their exalted ontological status. As such, this virtue was fully justified and defended by generations of the most respected theologians, beginning with

Thomas Aquinas, who "Christianized" Aristotle's pagan virtue of magnificence and who was followed in the fifteenth century by the Christian humanists of Renaissance Florence.

In the seventeenth century, the Christian articulation and defense of *magnificentia* was continued, e.g., in Roberto Bellarmino's *De officio principis* (1619) and by Emanuele Tesauro, both in his 1627 panegyric to Maurizio of Savoy, "La magnificentia sacra" (written while the author was still a Jesuit), and his classic manual of Baroque rhetoric, the *Cannocchiale aristotelico* (first edition 1654). For relevant extracts from the latter three texts, see Oberli, 31–33; for a succinct survey of the theory of *magnificentia* as virtue from antiquity onward, see Oberli, 21–39; to his bibliography must be added the studies by Guerzoni; Howard; Nelson and Zeckhauser, 67–84; and Preimesberger, 2008b.

For the allied phenomenon of *magnificentia* as awe-inspiring visual, material splendor (of buildings, cities, the personal appearance of grandees, etc.), see my commentary above in note 8 to the original front matter to publisher Rocco Bernabò's use of the term in his letter of dedication to Cardinal Pico della Mirandola. For other references in the text to this princely virtue par excellence, see, e.g., Domenico, 106 (Alexander VII), 132 and 143 (both Louis XIV).

5. Domenico's phrase, "almost everyone alive today" (quasi ogniun che vive), strikes us as somewhat strange if his "today" refers to the late date of the final redaction and publication (1711–13) of his text, and not its original composition "in the full flower of his youth" in the late 1670s or early 1680s (for this editorial history, see the Introduction, section 4). In any case, Domenico, a professional historian, here shows himself conscious of the issue of historical accuracy, even if he regularly strays from it in the narrative that follows: see the Introduction, section 1.

6. Baldinucci, i.73, e.8: "In truth he was born by divine plan, this child who, for Italy's good fortune, was to bring illumination to two centuries." As for Bernini's baptismal name, Chantelou's *Journal*, f. 111, e.109, notes on August 10, Feast of Saint Lawrence (Lorenzo, in Italian): "The Cavaliere said it was his name day as he was baptized Gian Lorenzo; his father had six daughters so that when he was born he wished his son to have both his father's and his grandfather's names." See also Domenico, 15, describing the early Saint Lawrence statue, done "out of devotion for the saint whose name he bore."

The names and dates of birth (to the extent known or approximated) of Pietro and Angelica's children born by spring 1609 derive principally from the annual Easter census of their family parish of San Lorenzo in Lucina in Rome of that year, published by Terzaghi, 105, doc. 1. The census does not give birth years, only ages, and not even that for the four oldest children: Agnese, Emiliana, Dorotea ("Torodea" in the census), and Eugenia. There is good reason to believe that the first-born Agnese (who died in 1609) was born in 1587 (Fagiolo dell'Arco, 2002, 199; Terzaghi, 102 n.8 for her death). The other three girls were all thirteen or more, since their relative placement on the census list indicates that they were all older than the next child, Giuditta, whose age is given as twelve (hence, born 1597). The census supplies the following other names and ages: Gio. Lorenzo, eleven (born 1598); Camilla, ten (born 1599); Beatrice, eight (born 1601); Francesco, five (born 1604); and Vincenzo, two (born 1607).

Three children were born after the 1609 census, Luigi, Ignazio, and Domenico. Judging from the order in which his sons are listed in Pietro's last will (Fagiolo dell'Arco, 2001, 351), one would assume that Ignazio was born in between Vincenzo (born 1607) and Luigi (born 1610); yet, according to an extant legal document (Fagiolo dell'Arco, 2002, 203–4, doc. 5), Ignazio in February 1626 was not yet sixteen years old and thus had to seek papal permission to take vows in the next month as a monk of Montecassino not having yet reached that required minimum age established by the Council of Trent. Hence, Ignazio must have been born in 1611 or later. Luigi's date of birth derives from his death certificate, which tells us that he died on December 22, 1681, at the age of seventy-one (Fagiolo dell'Arco, 2001, 371).

Fagiolo dell'Arco, 2002, 199, gives final son Domenico's date of birth as December 30, 1616, without naming his source, but presumably the parish records of San Martino ai Monti, where he was baptized; just before his death in October 1656, Domenico listed his age as "about forty years old" in his last will and testament (for which see Martinelli, 1996, 252–53).

Note that the list of Pietro and Angelica's daughters given by Fagiolo/*IAP,* 18, misses Agnese and Emiliana while mistakenly including the names of two nieces (Maria Angelica and Anna Maria, both nuns) of Angelica's, presumably as a result of misreading the latter's last will and testament (printed in Fagiolo/*IAP,* 353–57). In 1609, Pietro's mother, Camilla Boccapianola, was still alive and living with her son (Terzaghi, 101).

7. For Pietro, see the thorough 2005 monograph by Kessler, with ample bibliography; see also the probing discussion of his career in Dickerson, 303–24. For the portrait of Pietro in the Accademia di San Luca, Rome, believed to be a copy of a lost original by Gian Lorenzo, see Petrucci, 2006, 326–27, cat. 17; and Montanari, 2007, 134.

Born on May 6, 1562, in Sesto Fiorentino (Florence), Pietro was, at least in his early career, both painter and sculptor and, according to Baldinucci (i.73, e.8), was "of no ordinary acclaim." No paintings by him, however, seem to have survived. Although Domenico never specifically mentions the fact, Pietro likely taught Gian Lorenzo the principles of painting as well as of sculpture.

Pietro's friend and biographer, Giovanni Baglione (Baglione, "Vita di Pietro Bernini," 305), says that Pietro had few equals in his ability to carve marble, while his younger contemporary Giovanni Battista Passeri (b. 1610 or 1616, d. 1670) describes him as a "good, decent gentleman" and "of talent and good reputation" (Passeri, "Vita di Giuliano Finelli," 256). After youthful sojourns in Rome, Naples, and Calabria (with a brief return to Florence in 1595), he settled in Naples in 1596, to work on the grand embellishment of the Certosa (Charterhouse) of San Martino, which is where we first encounter him in Domenico's biography. For his 1587 marriage to Angelica in Naples, see note 8 below.

Once back in Rome in 1606, Pietro worked as sculptor variously for the Borghese (Cappella Paolina and the Villa Borghese), the Barberini (family chapel in Sant'Andrea della Valle), the Aldobrandini (their villa in Frascati), and, for the last several years of his life, as behind-the-scenes collaborator in his son's various projects (such as the Baldacchino). "Amidst many graces and much happiness" (Baglione, "Vita di Pietro Bernini," 305), Pietro died in Rome on August 29, 1629 (for his death certificate and his 1624 will and its 1628 codicil, see Fagiolo/*IAP,* 350–53).

In recent decades, thanks to the rediscovery of several of his works (showing a more versatile, more original, more refined talent than previously thought), as well as a more positive reevaluation of Mannerist art in general, Pietro is no longer dismissed by modern critics (as he was in 1969 by Hibbard-Jaffe, 169) as a "mediocre artist" who produced "monotonous, derivative works." Indeed, for Petrucci, he stands out as "one of the greatest exponents of Late Mannerist sculpture" (Petrucci, 2006, 32; also Zeri, 95). As Ostrow 2004, 357, observes, his two monumental reliefs for Santa Maria Maggiore, the *Assumption of the Virgin* and the *Coronation of Clement VII,* sought to challenge "all expectations of what a historical relief should be" (see also the discussion in Dickerson, 318–22).

During Gian Lorenzo's youth and early adulthood in Rome, father and son collaborated closely on several projects: it is now extremely difficult to distinguish with certainty their individual hands in the several jointly produced works from this early period. Over the years, the attribution of a few works has shifted constantly among critics between the two artists; for this vexing question, see Bacchi's general assessment in *Regista,* 65–76, as well as Lavin's discussions of Bernini's earliest works (Lavin, 1968a and 2004).

8. Little is known about Angelica, who married Pietro in Naples on January 17, 1587; from the matrimonial documents (Fagiolo dell'Arco, 2002, 199–200), we learn that she was only twelve years old at the time, marrying a man twice her age. She died in Rome on May 17, 1647 (Fagiolo/*IAP,* 353–57, for her death certificate and last will and testament). A portrait of Angelica, without name of artist (but presumably her son Gian Lorenzo) or date of execution, is listed in the 1681 inventory of Bernini's possessions left at his death (Martinelli, 1996, 256).

9. Pietro Filippo Bernini's *Vita Brevis* (appendix 1; hereafter cited as "Pietro Filippo") emphasizes the family's Florentine roots as well: "Pietro, born in Florence as had been all of his ancestors." The detail is not casual in Domenico's narrative, serving to reinforce the *imitatio Buonarroti* topos propagated by the text, that is, Bernini as "the Michelangelo of his century" (for

which see the Introduction, section 7; see also Domenico, 9). In a legal document drawn up at the end of his life (November 18, 1680), Bernini still calls himself "florentinus" (BALQ, 53).

Yet the Romans would not let Bernini forget his Neapolitan roots: in his *Roma ornata dall'architettura, pittura e scultura* (ca. 1661–63), Fioravante Martinelli (1599–1667) corrects the record: "Bernini [was] Florentine according to what Baglione writes, but the truth is that he was born in Naples" (D'Onofrio, 1969, 152). Another contemporary, the art biographer Passeri, makes a snide remark about "Bernini the Neapolitan, or, as he would have it, Florentine" (cited by Haskell, 1980, 34), whereas two well-known contemporary engravings both identify the artist as "Napoletano": the 1622 portrait of Bernini by Ottavio Leoni (*Regista*, cat. 2) and that of Piazza Navona by Louis Rouhier, *Obelisco Panfilio, Parte occidentale*, published ca. 1651 by Gio. Giacomo de Rossi (San Juan, 209, fig. 6.10). In any event, Bernini was made a Roman citizen on August 24, 1630 (Fagiolo dell'Arco, 2002, 215–16).

10. The "Royal Church" (Regia Chiesa) of San Martino is part of the large, sumptuous complex of the Carthusian monastery (Certosa) above Naples, now a museum. A fourteenth-century foundation under royal patronage, the monastery underwent a vast program of radical reconstruction and lavish embellishment during the late sixteenth and early seventeenth centuries, especially during the tenure of its ambitious prior, Don Severo Turbolo, with the involvement of renowned artists of the day such as the Cavalier d'Arpino and Lanfranco. Turbolo is presumably the anonymous "abbot of San Martino," mentioned shortly below: see Domenico, 3, and commentary (note 12 below).

11. A putto in Italian could variously be a baby, child, small angel, or cupid; Domenico uses the diminutive, *puttino*. Baldinucci, i.73, e.8, identifies this precocious work as the head of a *fanciullino*, a small child. This detail is also reported by Pietro Filippo, so presumably the information came from Bernini himself. No trace of this head remains and what we might have here is one of several examples of what D'Onofrio (1967, 89) calls Bernini's "self-mythologizing" when boasting of the precocity of his boyhood artistic accomplishments. Other examples are transmitted by Chantelou's *Journal*: e.g., October 6, f.228, e.260: "[Bernini] said that at six years he did a head in a bas-relief by his father; at seven another, which Paul V could hardly believe was by him." (This leads into the story of Bernini's first audience with the incredulous pope, who asks the boy to draw a head right then and there, for which see below Domenico, 8–9.)

Bernini was eight years old when he first arrived in Rome—we presume he is referring in his October 6 anecdote in Chantelou to a work in Rome since Pope Paul was able to examine it—and hence the chronology of the episode may not be correct. There is no documentation of the boy's contribution to either of his father's Roman monumental bas-reliefs, the prestigious commissions of the large *Assumption* and *Coronation of Clement VIII* marble reliefs in Santa Maria Maggiore, but see note 6 below to Domenico, 8, for Lavin's assertion that the young Bernini in fact executed the portraits of Pope Clement VIII in the two versions of Pietro's *Coronation* relief.

At the same time, however, documentation uncovered in the past forty years (see esp. Lavin, 1968a) has shown that the precocious chronology of Bernini's "self-mythologizing," while still inaccurate, turns out to be not as wildly exaggerated as one might otherwise suspect. For Bernini's earliest works, see D'Onofrio, 1967, 89–121; Lavin 1968a and 2004; Schlegel, 2001; Kessler, 2005 (with reconsidered attributions to Pietro), cat. A23 (Coppola bust), A32 (the Getty *Putto with Dragon*), C1 (Santoni bust); C2 (half figure of *John the Baptist*, priv. coll., Rome), as well as the relevant catalogue entries in *Nascita*.

12. The prelate in question is most likely Don Severo Turbolo (or Turboli), the great enterprising prior of the Certosa di San Martino, responsible for much of the monastery's lavish refurbishment in this period. Turbolo was *Priore* of the Certosa from 1583 to 1597 and then again from 1606 to 1607, serving the same role at the Certosa of Parma in between those two terms. His discernment of the young Gian Lorenzo's vocational aptitude must have taken place in 1606, after his return to San Martino and before the Bernini family's departure from Naples at the end of the same year. Turbolo's portrait in oil (giving his date of death as August 29, 1608) still hangs in the "Quarto del Priore" at the Certosa: for a reproduction, see Fittipaldi, fig. 98. He died in Rome and was buried in Santa Maria degli Angeli. For Turbolo, see Tufari, 142–43; and Kessler,

2005, 33−37 (passim), 57, and 59. It was a commonplace of early modern pedagogy that one of the most important first tasks of the preceptor was that of discerning the specific natural aptitude or congenital mental disposition (*ingenium*) of his pupil in order to identify the most profitable form of future work for the boy. The classical authority was Quintilian's *The Orator's Education*, bk. 1, chap. 3 (Amedeo Quondam, "La *Ratio* [*Studiorum*] e il classicismo," paper presented at the conference "The Jesuits and the Education of the Western World: 16th−17th Centuries," Georgetown University, Villa Le Balze, Florence, June 21, 2002).

13. *Ingegno:* see the Introduction, section 9, for a discussion of the term, which often eludes easy translation into English.

14. Domenico will again quote Alexander to this effect below on p. 97.

15. This same detail about Pietro's challenge is in Pietro Filippo and Baldinucci, i.75, e.10. Dickerson argues that Pietro also gave his son "the respect Gianlorenzo would show for modeling throughout his life" (Dickerson, 301−24, 303 for quotation), the extensive use of preparatory clay models representing, in that author's view, one of the sources of Bernini's distinctive sculptural style. Modeling in clay was not part of the conventional practice of Roman marble sculptors in the early seventeenth century. Among the successful sculptors in Rome distinguished for their modeling technique was Stefano Maderno (1575−1636), famous today for his statue of *Saint Cecilia* (1600, Santa Cecilia in Trastevere): "He may have influenced Gianlorenzo's modeling style, perhaps teaching the young Bernini how to model with his own exquisite finesse" for "at some point during his life Bernini learned to model in a style remarkably similar to Maderno's" (Dickerson, 333, 335).

Bernini would have had ample contact with Maderno between 1606 and 1625, since Maderno and Pietro worked together in Santa Maria Maggiore and remained close friends. Bernini himself (1624 and 1625) also hired Maderno as collaborator on the Baldacchino and Saint Elizabeth of Portugal canonization projects (Dickerson, 333−34). For the one explicit reference in the present text to Bernini's use of clay models, see Domenico, 133.

16. Recording examples of quick, incisive, clever wit (*arguzia* or *acutezza*) on Bernini's part is an important feature of Domenico's narrative, as in Baroque biography in general, inasmuch as wit was considered a prime manifestation of genius and much savored by seventeenth-century audiences. The display of wit, especially of the humorous kind, was, at the same time, a most valued form of social entertainment. It was also considered a necessary asset of the successful courtier; hence it is discussed at length in Castiglione's famous *Book of the Courtier* (bk. 2).

Another indispensable contemporary reference is the equally influential Baroque manual, Emanuele Tesauro's *Cannocchiale aristotelico* (first edition 1654), a thorough taxonomy of wit in all of its manifestations, most especially in the form of novel, often audacious, and, therefore, marvel-provoking metaphors called *concetti*, conceits (see Domenico, 170−71, for a theological conceit by Bernini, "Christ as the Cloak of Sinners"). Baldinucci, i.148−49, e.81−82, properly notes this verbal talent of Bernini's (a further manifestation, he says, of his *ingegno*) and gives several examples, two of them at the expense of poor Francesco Borromini.

17. Domenico would have us believe that this is an original, witty piece of artistic wisdom on the young Bernini's part. It is instead, as Evonne Levy points out, "a classical phrase from imitation theory," ancient in its origins but much associated with Michelangelo, thanks to Giorgio Vasari's *vita* of the artist (see Levy, 2006, 161 and n.7; for the relevant passage in Vasari's *Life of Michelangelo*, see Vasari, 1:426−27). It thus functions here as another subtle reinforcement of the *imitatio Buonarroti* theme of Domenico's biography, i.e., Bernini as the Michelangelo of his century. However, Bernini was not the only seventeenth-century artist to appropriate the phrase: "As is well known, Borromini admired Michelangelo and used the cult of Michelangelo to elevate the virtue of originality. He was fond of quoting a maxim of the master: '*chi segue altri, non li và mai inanzi.*' . . . In the decades after Michelangelo's death it became something of a slogan in the *botteghe* of many independent-minded artists and architects" (Connors, 2000b, 191).

For the text of the staged debate between Bernini and Barberini court *erudito* Lelio Guidiccioni on the subject of imitation and innovation in art, see D'Onofrio, 1996b (reprinted in Perrini, 173−94).

18. "Il suo solo ingegno." As Sohm, 64, observes, the binomial *arte/ingegno* (*ars/ingenium*) is one of the often-invoked, conventional polarities of early modern art theory: "*Ars* (or *techne, disciplina, doctrina, studium*) encompasses the theories, precepts, or models that can be transmitted and learned by an orator (but also a poet, architect, artist, etc.). . . . *Ingenium* (or *natura*) is an artist's individual talent, a natural gift that cannot be acquired through study but can be nurtured by study and a moral, healthy life." For further discussion of *ingegno,* see the Introduction, section 9.

Domenico here emphasizes Pietro's limitations as a teacher to his son, perhaps to stress the abyss between Pietro's old-fashioned Mannerism and Bernini's innovative Baroque style. Nonetheless, Pietro had a great facility for carving marble (praised by Baglione in his "Vita di Pietro Bernini") and a proven ability (especially in his monumental narrative reliefs with their "spectacular optical effects" and pictorial qualities) to produce sculpture that aspired to rival, if not surpass, the representational possibilities of painting. Hence he had much to offer his son, at least at the initial stages of the boy's training (Dickerson, 320 for the quotation in the preceding sentence; see also Ostrow, 2004).

19. "The greatest difficulty in art—which consists solely in perceiving the ease of nature": Domenico's original Italian is "quel più difficile dell'arte, che solo consiste nell'apprender il facile della natura," in which he contrasts two substantivized adjectives, *il difficile* and *il facile.* Domenico's expression, "il facile della nature," harkens back to a passage in Vasari, *Lives of the Artists* (1568), "Introduzzione alle tre arti del disegno," "Della Pittura," cap. XV, paragraph 4, likewise about the training of an artist: "Quando poi averà in disegnando simili cose fatto buona pratica et assicurata la mano, cominci a ritrarre cose naturali, et in esse faccia con ogni possibile opera e diligenza una buona e sicura pratica; perciò che le cose che vengono dal naturale sono veramente quelle che fanno onore a chi si è in quelle affaticato, avendo in sè, oltre a una certa grazia e vivezza, *di quel semplice, facile, e dolce che è proprio della natura,* e che dalle cose sue s'impara perfettamente, e non dalle cose dell'arte abbastanza già mai" (emphasis added; my thanks to Sheila Barker for calling my attention to this passage).

There is no corresponding passage in Baldinucci; the closest remark is on i.143, e.76–77: "Bernini wanted his students to love that which was most beautiful in nature. He said that the whole point of art consisted in knowing how to recognize and find it," a passage also found nearly verbatim in Domenico, 30. What Domenico wishes to say here is simply this: artists must imitate nature; but that which comes easily to nature (the production of a thing of beauty) comes only with difficulty to artists. This is, at bottom, a theological observation about the excellence of God's creative power and of the superiority of nature over all "artificial" human attempts at reproducing it. Domenico complicates this sentence by coupling the observation about the *difficile/facile* antithesis with reference to another separate and distinct antithesis, as if it were one logically and seamlessly connected thought. The second antithesis in question is also traditional and often invoked in art-historical discourse, and likewise built upon a "difficult /easy" contrast: the sign of a truly gifted artist is the ability to reproduce in art "difficult," challenging features (such as a profoundly foreshortened human figure) and perfect natural beauty. However, the latter must be done with *sprezzatura* (effortlessness, a term made famous by Castiglione's *Book of the Courtier*), that is, in such a way that the resultant work seems "easy," showing none of the intense technical effort that went into its creation. See Summers, 177–85, for the common contrastive binomial, *difficoltà/facilità:* "The ideal, in short, was to conceive ever greater things and to realize them without effort" (178). See also notes 20 and 21.

20. Here Domenico echoes an ancient theory of the imitation of nature that had been authoritatively articulated by the Roman antiquarian, critic, biographer, and theorist Giovanni Pietro Bellori (1613–96), according to which things in nature are never perfect in their entirety but may possess certain perfect parts. Hence the artist must judiciously select for study and imitation only those disparate fragments of perfect beauty that he finds scattered in nature. In so doing, he also develops within his imagination the "idea" of perfect beauty. Bellori first enunciated this "classicist" or "idealist" theory in his 1664 discourse to the Roman Accademia di San Luca, "L'idea del pittore, dello scultore, e dell'architetto," later published as preface to his

Le vite de' pittori, scultori et architetti moderni (1672). Bellori therein deplored realistic painters like Caravaggio and "Il Bamboccio" (Pieter van Laer) for following nature too faithfully and including in their canvases its ugly deformities and disproportions; but he also criticized (in his "Vita di Annibale Carracci") the Cavalier d'Arpino for not studying nature at all and working entirely from his fantasy.

Domenico will later report (14) that, according to his father, in addition to nature the study of the modern masters of painting—above all, Raphael—is another indispensable element of the young artist's education in ideal beauty. Lecturing at the Academy of Painting and Sculpture in Paris in 1665 (Chantelou, September 5, f.155, e.166–67), Bernini addresses the same issues, but points instead to ancient sculpture as the model of perfect beauty while expressing a decidedly less optimistic view of nature's value as a source for artists: he warns his audience that it "was fatal to put [young students] down to draw from nature at the beginning of their training, since nature is nearly always feeble and niggardly . . . [and] is devoid of both strength and beauty"; one needed to first "possess a knowledge of the beautiful," and this grasp of ideal beauty is attained only through intense study of ancient sculpture. But see Baldinucci, i.143, e.77, who quotes Bernini as having had a change of heart of sorts with regard to the possibility of finding "artistic" beauty in nature.

No comprehensive, systematic study of Bernini's art theory has yet been published; Barton's 1945 essay focuses only on the artist's remarks on the subject found in Chantelou's *Journal*. But the latter remarks alone do not sufficiently explain Bernini's particular approach to art, since, as Anthony Blunt points out in his introduction to the 1985 English translation of the *Journal* (Chantelou, e.xii), the principles that Bernini enunciated to the French students were "little more than the commonplaces of current art criticism." Though Domenico (or Baldinucci) does not spend much time on Bernini's theory of art, this does not mean that the artist did not ponder the issue in any substantial way from early on in life. As Preimesberger, 1985, 12, reminds us: "In 1621, Bernini became *Principe* of the Accademia di S. Luca. Whatever this honor might have meant for the status and the self-awareness of the barely twenty-three-year-old artist, it can be assumed it produced an increased interest in the theoretical foundations of his art, in tradition, in competition with tradition, and in innovation." In reality, Bernini was named *Principe* only much later, in 1630 (Pirotta; Lafranconi, 41–42), but by 1621 he was already a member of the academy and hence Preimesberger's point remains valid. See also note 20 below to Domenico, 42.

21. Domenico is invoking the well-known aesthetic principle first enunciated by the ancient Roman poet Horace, "Ars est celare artem" (The goal of true art is to hide art), and, by extension, the *difficultà/facilità* antithesis (see note 19 above). As Bernini remarks in a conversation in France about the remodeling of an elaborate, artificial waterfall at the château of Saint-Cloud, "art should be disguised with an appearance of naturalness" (Chantelou, August 2, f.103, e.99). Later, Domenico, 14, will quote his father as claiming that the two ancient torsos of *Hercules* and *Pasquino* "contained in themselves all that is most perfect in Nature without the affectation of art." See also the discussion of stage design in act 2, scene 4 of Bernini's comedy *The Impresario*.

22. This narrative scene (*historia*) is the colossal relief of the *Assumption* in Santa Maria Maggiore, originally intended for the external facade of the Pauline Chapel (*Cappella Paolina*), built and decorated by Pope Paul V Borghese. Domenico is probably guilty of a temporary lapsus in giving the chapel's location as Saint Peter's (a mistake not made by Baldinucci, i.73, e.8); there is a Pauline Chapel (named after Pope Paul III Farnese) at the Vatican, in the Palazzo Apostolico, not Saint Peter's Basilica. Pietro's relief, once finished in 1610, was instead installed inside Santa Maria Maggiore: the change in location was possibly because the "church authorities realized that they were dealing with a singular work of art, one that should not be wasted on a high-up spot" (Dickerson, 315). For the *Assumption* relief, see Kessler, 2005, 60–63 and cat. A21. According to Pietro's friend and biographer Giovanni Baglione, it was the Cavalier d'Arpino who recommended Pietro for this commission (Baglione, "Vita di Pietro Bernini," 305), which is quite possible, for the two men had both worked together at the Certosa di San Martino in Naples.

23. The permission of the Spanish Viceroy (who in 1603–10 was Juan Alonso Pimentel de Herrera, Count of Benavente, 1552–1621) was necessary since the monastery was under royal patronage. No date is here given for the family's departure from Naples, but the chapter title states that Bernini lived there until the age of ten (1608) and in the next chapter, p. 8, Domenico mentions that Bernini appeared in the "theater" of Rome for the first time at the same age of ten. Baldinucci and Pietro Filippo likewise supply no date. Instead, documentation strongly suggests that the family left Naples for Rome in late 1606, when Bernini was eight years old: the final payment for Pietro's Neapolitan work is dated August 22, 1606; on December 30 of that same year, he signed the contract for the Borghese *Assumption* relief, for which, shortly thereafter, on January 4, 1607, he was already receiving payment (Kessler, 2005, 434, docs. 71 and 72).

CHAPTER II

1. Domenico is defending Paul V against the criticism that he had squandered money on projects of mere aesthetic embellishment rather than on the more immediate and more urgent physical needs of the people. Urban VIII, Innocent X, and Alexander VII would be subject to the same criticism. To give some idea of the magnitude of the dramatic increase of papal spending under Paul V, just for the completion of the structure of Saint Peter's Basilica alone, that pontiff disbursed in the years 1605–20 "more than the total spent in the previous 100 years" (Dandelet, 47). For the *scudo*, see above my "Note on the Commentary, Sources, Translations, Abbreviations, and Currency."

2. The famous Scipione Borghese, whose memory survives above all, in the splendid Villa Borghese and its art collection (Galleria Borghese), was born (1576) as Scipione Caffarelli, son of Francesco Caffarelli and Pope Paul V's sister, Ortensia. Upon his uncle's ascent to the papal throne, he not only took his family name but also assumed the role of "Cardinal Nephew" (Nepote or Nipote), also called "Cardinal Padrone" (master cardinal), who functioned in effect as the pope's "prime minister" (for the role of Cardinal Nephew, see Rietbergen, 2006, 143–80).

Less interested in and less intellectually capable of papal administration (Coliva, 1998, 392–93), Scipione instead used his vast fortunes on art and on a sybaritic lifestyle, whose ill effects were to fill his last years with misery and bring him to an early death in 1633. To Scipione, however, Bernini owes the effective launching of his public career as autonomous master sculptor of universal acclaim, beginning with the *Aeneas and Anchises* group of 1618–19, immediately followed by what Hibbard calls "the miraculous series" of the *Rape of Proserpina (Pluto and Proserpina)*, the *David*, and the *Apollo and Daphne*, all done for Scipione (Hibbard, 1961, 101). For Scipione's life and art patronage, see, e.g., *DBI*, 12:620–24; *Grove Art Online*, s.v. "Borghese, Scipione"; D'Onofrio, 1967, 199–215; Reinhardt; Coliva, 1998, 389–420; Hill, 1998 and 2001; and Collins.

3. That is to say, the only difference between antiquity and the current times—so propitious to the arts thanks to the generous patronage of Paul V and Scipione Borghese—is their "age": the present age is young and antiquity is old. See Lione Pascoli's remark, "If the world survives another thousand of years or so, there will come a time when we will be the ancients and our descendants will be the moderns" (Pascoli, 522, Vita di G. B. Soria). Baldinucci, i.72, e.7, instead personalizes the comparison: it is Bernini himself, and not his collective times, who equals the artistic achievement of the ages past and who "in order to be considered the equal of the most illustrious and famous ancient masters and of the modern ones, [Bernini] perhaps lacked little else but age" (my translation). Again, the only difference between Bernini and the past masters, ancient and modern, was that of chronological age: he was "young" (only recently dead) and they were "old" (long since dead).

4. Bernini arrived in Rome most likely in late 1606 at the age of eight: see Domenico, 6, and commentary. See Levy, 2006, for a close, illuminating reading of this second chapter of Domenico's biography (beginning with Bernini's drawing for Paul V) as an example of the author's selective and carefully orchestrated *mimesis*, that is, the artful "imitation" or literary representation of his father's life and personality.

5. D'Onofrio, 1967, 94, remarks: "The reasons for such fame [already attached to the boy Bernini] are anything but clear in [Domenico], who, apart from that mysterious little putto head sculpted in Naples at the age of eight and a certain ability in drawing, has told us nothing specific [*about his actual production*]." In fact, Domenico (9) will shortly inform us that at the time of his first papal audience Bernini had already begun sculpting in Rome, his first work being a marble bust in the church of "Santa Potenziana" (but read: Santa Prassede). Domenico is vague about chronology, here leading us to believe that the first audiences with Scipione and Paul V occurred shortly after the family's arrival in Rome. Terzaghi, 102–3, finds this chronology plausible, reasoning that since the Bernini family was by 1609 living in the parish of San Lorenzo in Lucina, in close proximity to the Palazzo Borghese (then a busy workshop of artisans working on its large-scale renovation), Cardinal Scipione, Pope Paul's "talent scout," could easily have come to hear of this boy wonder in his very neighborhood. Instead, both Pietro Filippo and Baldinucci, i.74, e.9, suggest a longer lapse of time between arrival in Rome and papal summons and make no mention of the mediation of Scipione. According to them, it is the fame of the marble bust in Santa Potenziana/Prassede, provoking marvel in all of Rome, that caught the attention of the pope, who finally sends for the boy. The fact of this papal interview is documented in no other, independent primary source (but see note 6).

6. For this audience, see Pietro Filippo; and Baldinucci, i.74–75, e.9–10. Chantelou recounts the story of this first papal audience twice, each time with a different account of the events that led up to the incredulous pope's summons of the young prodigy: August 5, f.106, e.102: "The Cavaliere told him (*Colbert*) that he had done the *Daphne* at eighteen, and at the age of eight had done a *Head of Saint John,* which was presented to Paul V by his chamberlain. His Holiness could not believe that he had done it and asked if he would draw a head in his presence"; October 6, f.228, e.260: "He said that at six years he had done a head in a bas-relief by his father, and at seven another, which Paul V could hardly believe was by him; to satisfy his own mind, he asked him if he would draw a head for him." The *Head of Saint John* has not been traced, but see Huse for an attribution to young Bernini (ca. 1620) of a statue of *John the Baptist in the Wilderness,* now in the Bargello, Florence. Kessler, 2005 (cat. C2), has published an incomplete half-figure also of John the Baptist, ca. 1611–12, done together with his father and likely corresponding to a figure mentioned in Bernini's postmortem household inventory. As for Bernini's claim to have executed portrait heads in two of his father's reliefs, Lavin, 2004, 42–43, takes Bernini at his word (though adjusting his chronology) and identifies the two "heads" in question as the portraits of Pope Clement VIII contained in Pietro Bernini's two renditions of his monumental *Coronation of Clement VIII* for the Cappella Paolina, Santa Maria Maggiore: the now-missing first version of 1612 and the extant reprise, in situ, of 1614 (the years refer to payment dates). Pointing out that the portrait of Clement in Pietro's relief "is completely unlike those of the other figures," Lavin is adamant that the "portrait of Clement is thus certainly—not tentatively—by Gianlorenzo" (43). Ostrow, 2004, 358 n.99, rejects Lavin's conjecture. Instead, Pierguidi, 105, accepting Bernini's claim, rejects Lavin's identification of the two heads as those of Clement. It is highly unlikely, says the Italian scholar, that Pietro would have let his adolescent son execute the most important "head" in the work and if he had, Bernini would not have been shy about announcing the fact; instead, based on stylistic evidence, the "head" in question is more likely one of those immediately surrounding the pope in the relief.

7. That is, the astute young Bernini already knew—or had been properly coached—that it was forbidden to look the pope or any personage of exalted status directly in his face while that superior was gazing directly at him, just as the pope or any potentate would not have deigned to meet the direct glance of a person of inferior status. This matter of protocol might explain in part the "averted glance" pose of Bernini's later princely portrait busts such as the *Duke Francesco d'Este* and the *King Louis XIV.*

8. The pope's remark is also reported in the briefer accounts of the papal audience in both Pietro Filippo and Baldinucci, i.74, e.9.

9. Regarding this scene, as Levy, 2006, 165, points out, "Michelangelo's first sculpture was also a head—of a faun, produced for his fatherlike patron, Lorenzo the Magnificent. Once

the patron was furnished with this proof of talent, he saw to his early education," just as Pope Paul will do, giving this charge to Cardinal Maffeo Barberini. This is yet another of many subtle reinforcements of the *imitatio Buonarroti* topos within Domenico's text. Be that as it may, "At the inception of his career, Gianlorenzo specialized in two primary forms of sculpture, portrait busts (usually for wall memorials) and small figural groups representing infants interacting with animals" (Dickerson, 325).

10. On Domenico, 11–12, the pope repeats his prognostication. In Baldinucci, i.75, e.10, the pope's words in themselves seem more the expression of a cautiously expressed desire rather than a foretelling of an inevitable destiny: "and turning to the cardinal, [the pontiff] said prophesying, 'Let us hope that this young lad is to become the great Michelangelo of his century.'" Pietro Filippo repeats Baldinucci's version of the "prophesy-desire" nearly verbatim. On the subject of Michelangelo, we might here record the significant fact that in October 1618, Cardinal Maffeo Barberini (as he writes in a letter to his brother Carlo in Florence) was planning to have Gian Lorenzo bring to completion an unfinished (and unidentified) sculpture by Michelangelo: see Lavin 1968a, 236–37, suggesting that the Michelangelo work in question may have been the *Palestrina Pietà*, then owned by the Barberini but of doubtful attribution; and Pierguidi, 108, pointing to, instead, the *Rondanini Pietà*.

11. This "but" suggests that Bernini first made the gesture of refusing the pope's offer while showing his appreciation for that "honor."

12. Pietro Filippo reports the same detail of the boy's grasping for the twelve medals, whereas Baldinucci, i.75, e.10, has the pope giving them directly to him.

13. This "marble bust" is the first in a long series of portraits that Bernini was to produce in his lifetime, eventually excelling in this genre beyond all of his predecessors and contemporaries (with the possible exception of Algardi) and in the process transforming this form of art forever. Soon would come the most prestigious form of portrait commission in Rome, that of the reigning pope. "Already by his mid-twenties, [Bernini] had prepared the likeness of three sitting popes (Paul V, Gregory XV, and Urban VIII), and with these commissions, he quickly became the preeminent portraitist of the Roman aristocracy" (Dickerson, 337).

For Bernini and the art of the Baroque portrait, see Bacchi-Hess-Montagu, with an annotated checklist (283–96) of all the known portraits by Bernini, and *Marmi vivi* (342–52 for checklist); for Bernini's portrait busts from the period 1612–38, see Montanari, 2009. As for the specific work in question, Baldinucci, i.74, e.9 reports the same fact: "The first work to emerge from his chisel in Rome was a marble head located in the Church of S. Potenziana. Bernini at that point had only just completed his tenth year." The church is question, however, is Santa Prassede, as Pietro Filippo correctly reports. Domenico and Baldinucci's "Potenziana" might refer to "Pudenziana," a church in close proximity to the equally ancient but more famous church of Santa Prassede (the latter houses Pudenziana's relics and mosaics depicting the two Christian matrons together).

In his appended catalogue of Bernini's works, Baldinucci corrects his error: the first work listed under "Portrait Busts" is that of the "Majordomo of Sixtus V . . . [*located in*] S. Prassede." Pope Sixtus's majordomo was Bishop Giovan Battista Santoni, who died in 1592 and who is indeed the subject of this "first work" here cited by our three biographers. Although coming in the earliest phases of Bernini's activity in Rome, the *Santoni* bust has been dated between 1610–13, i.e., later than Domenico's chronology. For this bust, see, most recently, Kessler, 2005, cat. C1, judging it, however, a collaborative work of both father and son. Wittkower, cat. 2, had dated it to as late as 1616, while Lavin, 2004, 42, dates it resolutely to 1610, completely excluding the hand of Pietro, who was not known as a sculptor of portrait busts at any time in his career. Among those other anonymous "small statues" Domenico mentions as also belonging to this period is the marble group in the Galleria Borghese, *The Goat Amalthea Nursing the Infant Zeus*, dated by Lavin to early 1609 but certainly executed before 1615 (payment for its base dates to August 18, 1615). *The Goat Amalthea* is generally considered the earliest extant work entirely by Bernini himself (Lavin, 1968a, 229, and 2004, 44; *Nascita*, cat. 2; Coliva, 2002, 42–55; and Kessler, 2005, 76, 77, 95, 443–44, doc. 123; Pierguidi, 106, arguing for a date between late 1614 and August 1615).

Likewise very early in Bernini's career—though not mentioned by either Domenico or Baldinucci—is his portrait bust of Florentine surgeon Antonio Coppola, who died in 1612, the same year in which payment for the bust was made to Pietro Bernini. The bust is now in the museum of the church of San Giovanni dei Fiorentini, Rome: see Lavin, 1968a, 223–28, and 2004, 39–42; and, most recently, Montanari, 2005c, 273–74, 277, who confirms Lavin's identification of the young Bernini as sole creator of the bust; *Marmi vivi,* cat. 1. As Lavin, 1968a, 228, remarks, "One of the most important implications of the Coppola bust for our understanding of Bernini's development is that it confirms the early biographers' accounts of his precocious genius." However, Kessler, 2005 (cat. A23), assigns the Coppola bust entirely to father Pietro (as had several earlier critics, including Nava Cellini), whereas both Pierguidi, 106, and Bacchi-Hess-Montagu, cat. 1.2, consider it a collaborative work by Pietro and Gian Lorenzo.

Once considered among Bernini's earliest works—though the attribution is disputed—is the *Boy with the Dragon* (Getty Museum, Los Angeles), now more securely dated to ca. 1617 (for which see Lavin, 1968a, 229–32, and 2004, 44; Fogelman et al., cat. 21; and Kessler 2005, cat. A32, giving it entirely to Pietro). See note 46 below for another early and lesser-known work in the same Hellenistic-inspired genre, the *Boy on Dolphin,* once belonging to the Strozzi family, now in Berlin.

14. Annibale's pronouncement is not in Baldinucci or Pietro Filippo. Annibale Carracci, one of the most eminent and revered painters of his generation, serves a similar function in Domenico's biography as Michelangelo: he is yet another universally recognized master to whose name Bernini can attach his own and thus, by association, come to share in his fame as member of the same category of genius. Here, more specifically, he is a further, authoritative guarantor of Bernini's early status as prodigious artistic genius. According to Domenico (see also pp. 37–38) and to Bernini himself as reported by Chantelou (June 16, f.59, e.35), the young Bernini supposedly had on more than one occasion interacted directly with the great Annibale. However, one must treat some of the details of these reports with skepticism: see the Introduction, section 7, "Bernini and Annibale Carracci."

15. Domenico does not date this commission; yet, by placing it here in the narration and by referring to Bernini as the "little artist" (picciol'artefice, 11), he clearly wishes us to believe that the Scipione commission occurred not long after the first audience with Paul V, while his father was still in his youth. Pietro Filippo also gives the same impression by likewise placing the brief mention of this portrait commission right after the audience with Paul V. The commission, in reality, dates much later to 1632, by which time Bernini was a mature, thirty-four-year-old sculptor. Further, by then Paul V was long dead and hence could not have been shown the portrait of his nephew, as Domenico narrates. Baldinucci's chronology, i.76, e.11, is vague but nonetheless suggests a more reasonable later date. After having discussed the Montoya bust and mentioned the Bellarmino tomb monument, Baldinucci goes on to report that Paul V also wished his portrait by Bernini, after which, he says, the artist executed that of Scipione.

16. Very little is known about the circumstances that surrounded the commissioning of Bernini's portrait of Cardinal Scipione Borghese, described by Hibbard as "a milestone in the history of sculpture and one of the most beautiful portraits of all time" (Hibbard, 1961, 102). A dispatch dated June 8, 1633, from Rome to the d'Este Court in Modena, reports: "The Cavalier Bernini, upon commission from the Pope [Urban VIII], has done a portrait in marble of Cardinal Borghese who has in turn given him a gift of 500 *zecchini* and a diamond worth 150 *scudi*" (*Nascita,* 440, doc. 80; for the bust in general, see *Nascita,* cats. 29–30; Hill, 1998; Bacchi-Hess-Montagu, cat. 4.1, and *Marmi vivi,* cat. 25). There is no documentation either in the Barberini archive or elsewhere attesting to such a papal commission. Domenico instead says the commission came directly from the cardinal, while Baldinucci is vague on the point. I am inclined to believe that the d'Este court dispatch either simply errs on this detail or else means to say that, since Bernini was then in the exclusive service of the pope, the latter's permission was both needed and granted for the execution of this commission (for the latter explanation, see Hibbard, 1965, 89). In the Borghese archives there is extant an order signed by Scipione, dated December 23, 1632, authorizing payment of 500 *scudi* to Bernini for service rendered the cardinal, but with no specification

of the nature of that service (*Nascita,* 440, doc. 79). Hibbard's reasoning (1961, 102) that such a large sum could only have been for the portrait bust has largely been accepted.

Another, very fleeting mention of the Borghese portrait bust occurs in a contemporary document: Bernini's friend and d'Este agent Fulvio Testi mentions in a report of January 29, 1633, to the court of Modena that "a single bust" by Bernini of Cardinal Borghese cost 1,000 *scudi* (Fraschetti, 108). Finally, in a long letter, dated June 3, 1633, written to Bernini by another friend, poet Lelio Guidiccioni, we find further mention of the bust, described in detail and heartily praised for its lively, true-to-life depiction of the sitter (for the text of the letter, see Zitzlsperger, 179–83; 180–82 for the portrait). There survives as well a fine drawing of Scipione in profile by Bernini (Morgan Library, New York), most likely done in late 1632 (Sutherland Harris, 1977, cat. 28; Bacchi-Hess-Montagu, cat. 3.6).

Scipione was suffering from a severe case of gout, among other ailments, at the time of these Bernini portraits; he died in October 1633, shortly after their execution. In the 1681 inventory of Bernini's possessions there is listed, without attribution, a "portrait of Card. Borghese in terracotta with a gilt base": might this be Bernini's *modello* for his marble portrait? (for the inventory, see Martinelli, 1996, 254, c.502v; the same inventory [256, c.505r] also lists a portrait on canvas of Scipione by an unidentified artist, but presumably Bernini).

17. Domenico turns the discovery of this crack into an entire dramatic incident, involving not only Bernini but also his father, the marble polishers, and much hand-wringing emotion. Instead, Baldinucci's account (i.76–77, e.11–12) is not only different in the very facts of the incident, but is much shorter and more dispassionate: it is Bernini himself who discovers the crack and calmly produces a second version in secret and in just "fifteen nights." Then in Baldinucci follows the often-cited scene in which Bernini teases Scipione by first showing him the defective bust alone, allowing the cardinal's spirits to deflate at the sight of the marred portrait, whereupon they are again raised at the surprise unveiling of the second, more beautiful version.

18. *Pelo,* literally, a strand of hair. In reality, as close inspection of the bust shows, the defect in the marble was no mere "blemish" or "stain" (*macchia*) as Domenico describes it, but a major fissure originating deep within the interior of the block and visible in both the front (just above the eyebrows) and back of the head. Bernini was obliged to repair the damage by applying a type of putty and a safety clip in the back (covered over by a quite noticeable piece of marble tile): see the detailed technical report (with photographs) compiled at the time of the most recent conservation work in Coliva, 2002, 216–33. As Domenico, 135, will tell us, when doing the Louis XIV bust in Paris, Bernini instead took the precaution of preparing two blocks of marble for the portrait from the very start, lest one prove defective during the carving process.

19. This is the first appearance of an important leitmotif in Domenico's biography: Bernini's ingenious ability to convert a defect or handicap into an advantage: for other examples, see Domenico, 58–60, 61, 101, 110, 166. For this theme as it pertains to the Scipione portrait, see Levy, 2006, 165–71.

20. Baldinucci, i.77, e.12, instead and slightly more credibly, tells us that the second version took "fifteen nights" to complete. Neither biographer mentions that the second version, too, has a hairline crack, visible on the front, crossing between the lowest two buttons of the cardinal's *mozzetta* (see the technical report in Coliva, 2002, 227 and fig. 13). Note that in this same year, 1632, the indefatigable Bernini also worked on his colossal *Saint Longinus,* two marble busts of Pope Urban VIII, a bronze monument to Urban for the town of Velletri, and the restoration of antiquities for the Barberini, as well as the final stages of the Baldacchino and supervision of the ongoing embellishment project of the four piers in the crossing of Saint Peter's.

21. "Picciol'artefice." The adjective *picciolo* (i.e., *piccolo*) implies extreme youth, whereas at the time he did the Scipione Borghese busts Bernini was in fact all of thirty-four years old and quite established as a master sculptor.

22. Baldinucci, i.77, e.12, adds that a further result was that "from that day onward [Scipione] loved [Bernini] with a most tender love."

23. Thus, according to Domenico, Maffeo (1568–1644, Pope Urban VIII as of August 6, 1623) entered Bernini's life shortly after the completion of the Scipione bust, that work having

been executed, according to our author, while the artist was still *picciolo* (but see notes 15 and 21 above about the impossible chronology of Domenico's claim). Instead, both Pietro Filippo and Baldinucci (i.74–75, e.9–10) have the cardinal's fortuitous and auspicious arrival upon the scene and acceptance of the papal mentoring charge coincide with Bernini's first audience with Paul V, this audience, according to their vague chronology, occurring some years after the family's arrival in Rome, after the boy had reached his tenth birthday. Domenico makes no mention of Maffeo in relation to the first audience with Paul V, but here appropriates the same reference to the cardinal's arrival as both fortuitous and providential in describing this much later scene of the unveiling of the two Scipione busts.

Contrary to what these sources would have us believe, a close, ongoing relationship between Maffeo and Bernini could not have effectively begun until after the cardinal's definitive return to Rome from Spoleto in the summer of 1617, concluding a series of papal missions that had long kept him away from the papal capital. In 1617, the artist was nineteen years old and decidedly no longer a boy (D'Onofrio, 1967, 92 and 155). A cardinal since September 1606, Maffeo was named bishop of Spoleto in September 1608 but did not leave Rome to take up his episcopal residence until May 1610 (*EncPapi* 3:300–302); this leaves a two-year window of opportunity for such a relationship to develop, but there is no evidence, independent of Bernini and his family, that this indeed occurred. The first such independent evidence of a rapport between the Bernini and Barberini families is, instead, the mid-1614 commissioning of a statue of Saint John the Baptist (finished June 1615) from Pietro Bernini for the new Barberini family chapel in Sant'Andrea della Valle. As D'Onofrio, 1967, 155, points out, when Carlo Barberini first mentioned to his brother Maffeo the name of Pietro as possible sculptor of this Baptist statue (and only, let us note, as a last-minute substitute for the unexpectedly deceased Nicolas Cordier), Maffeo gave no sign of recognizing the name.

Hence the impossible chronology of Bernini's famous anecdote told to Chantelou (June 6, f.46–47, e.15–16) about Maffeo visiting the Bernini studio when our artist was only eight years old and producing works of prodigious quality. To the cardinal's warning, "Take care, signor Bernini, this child will surpass you and will certainly be greater than his master," Pietro is said to have replied: "That doesn't worry me. Your Eminence knows that in this game the one who loses wins." The first documentation specifically linking Gian Lorenzo and Cardinal Maffeo is the February 7, 1618, contract between Pietro and Maffeo commissioning four putti for the same Barberini chapel, the said putti to be done in collaboration with Pietro's son, Gian Lorenzo (D'Onofrio, 1967, 158; and Kessler, 2005, cat. C6). (This, by the way, represents the first appearance of Gian Lorenzo's name in any employment contract.) For the most recent and most thorough study of the Barberini Chapel in Sant'Andrea della Valle, see Schütze, 2007, 31–146.

24. That is, Divine Providence (invoked throughout Domenico's account as direct causal agent) knew that Maffeo was one day to become pope and so worked now, years earlier, to establish a close relationship between the future pope and the heaven-favored artist.

25. See also Domenico, 50, for another statement of Pope Urban's great love for Bernini. In the Chantelou diary, there are several pointed reminders of the close relationship between Urban and Bernini, as evidenced by the artist's frequent reference to his long-deceased patron: e.g., June 6, f.46–47, e.15: "[Bernini] was always eager to quote Pope Urban VIII, who loved him and valued his qualities from his earliest years"; and June 7, f.49, e.20: "[Bernini] continually quoted Urban VIII on every kind of subject, either to recall some trait of his character that was, he said, the most sensitive and responsive he had ever known, or to show on what intimate terms he had been with him."

26. Domenico's remark about Maffeo's "taking possession" of the boy is indeed quite strong in the original Italian, "appropriòsello tutto," literally, "he appropriated him entirely to himself."

27. As does Pietro Filippo, Baldinucci, i.73–74, e.8–9, describes this same three-year period of intense study of ancient sculpture (and modern masters, "above all Raphael and Michelangelo") immediately upon Bernini's arrival in Rome (and before the mention of the production of any sculpture by him in Rome), but reserves the recounting of Bernini's remarks

about the specific statues to the end of his biography (i.146, e.79–80). Domenico's placement of this detail here, after the audience with Paul V, suggests that such study was encouraged and made possible by the pope himself, who opened the Vatican art collection to the young boy.

28. Both Domenico here and Pietro Filippo give the impression that the Santa Maria Maggiore house was the first Roman home of the Bernini family, but a recently discovered parish census of 1609 shows them living in the Ripetta neighborhood within the parish of San Lorenzo in Lucina (Terzaghi, 101; Terzaghi mentions that the Bernini family does not appear on the 1607 census, which would suggest that they had still another earlier residence in Rome). Pietro acquired land for his house in the parish of Santa Prassede near Santa Maria Maggiore in October 1614 (Kessler, 442–43, doc. 119).

29. The *Apollo* is of course the *Apollo Belvedere,* one of the most famous and most copied of ancient statues, whose influence on Bernini is most visible in the figure of the same god in his Borghese group, *Apollo and Daphne.* Roman copy of a bronze Greek original, "both the provenance and date of the discovery of the statue remain uncertain. There is, however, good evidence that it had been . . . in the possession of Cardinal Giuliano della Rovere since the turn of the century" (Haskell and Penny, cat. 8, 148; Cardinal Giuliano became Pope Julius II, r. 1503–11). The statue is known to have been in the Vatican by 1509, and by 1511 in the Cortile del Belvedere, where Bernini later studied it.

The equally famous and influential statue known to Bernini and his contemporaries as that of Emperor Hadrian's young beloved, *Antinous,* is now considered instead to be a *Hermes,* another Roman copy of a lost Greek original. Although not all details are clear, the *Belvedere Antinous* was discovered in Rome sometime in the early 1540s, its purchase by Pope Paul III documented for February 27, 1543. Reports are divergent on the specific site of its discovery; shortly after its rediscovery it was likewise placed in the Cortile del Belvedere by Pope Paul III (Haskell and Penny, cat. 4). Neither statue is mentioned by Baldinucci. There is likewise no mention of the two in Bernini's conversation in Paris about the best examples of ancient sculpture, recorded by Chantelou, June 8, f.53, e.24–26. In that June conversation, the papal nuncio asks Bernini which was his favorite ancient statue and Bernini answers: "The *Pasquino,* first, and, second, the Belvedere *Torso*" (the *Hercules* mentioned by Domenico, 13). When Chantelou then asks of the *Laocoön,* Bernini "agreed that it was a wonderful work but said that the *Torso* was altogether grander." Elsewhere in Chantelou (August 23, f.134, e.140), Bernini mentions having measured the *Apollo* and the *Antinous* in order to resolve a problem with the dimensions of the head of an unidentified statue he had sculpted. Later in Paris, in his remarks to the Royal Academy of Painting and Sculpture (Chantelou, September 5, f.155, e.167), in cautioning the young students to acquire a knowledge of the beautiful by first studying ancient sculpture, Bernini "said that when he was very young he used to draw from the antique a great deal, and in the first figure he undertook, whenever in doubt over some question, he would go off to consult the *Antinous* as his oracle. Every day he noticed some further excellence in this statue." For Bernini and ancient art, see also Lavin, 1989; and Białostocki.

30. "di così ben regolata, e isquisita maniera."

31. See Baldinucci, i.146, e.79–80, where Bernini praises the famous statue for its "expression of emotion" and "the intelligence one observes in that leg, which appears stiffened, the poison having already penetrated it." Baldinucci also reports there that Bernini "used to say that the *Laocoön* and the *Pasquino* among the ancient works contained in themselves all the goodness of art, because one observed imitated therein all that was most perfect in nature, without the affectation of art. Bernini, however, said that the *Torso* and the *Pasquino* seemed to him more perfect stylistically than the *Laocoön,* but that the *Laocoön* was whole while the others were not" (see also note 29 above; for the *Torso,* see note 33 below).

32. My phrase "artists and other students of antiquity" translates Domenico's one word, *virtuosi.* Domenico's historical information concerning these statues is incorrect: for the *Antinous,* see note 29 above. The *Laocoön* was "discovered on 14 January 1506 on the property of Felice de' Freddi near S. Maria Maggiore, Rome. It was bought by Pope Julius II soon afterwards [and] taken to the Belvedere" (Haskell and Penny, cat. 52, 243; see also *Il Laocoonte dei Musei*

Vaticani, ed. Bejor, 2007). A finely executed marble copy of *Laocoön*'s head attributed to Bernini is in the Galleria Spada, Rome (Lavin, 2007, 91 and fig. 27); for Bernini's extant drawing after the *Laocoön,* see Lavin, 1981, 158–63 (entry by S. Ostrow).

33. The *Hercules* here in question is the *Belvedere Torso* (cited in note 31 above) as it is perhaps more commonly known; it is a fragment of a muscular male nude, showing his chest and upper legs in splendid torsion. Documentation records it in the collection of Cardinal Colonna between 1432 and 1435. It appears to have been purchased by the pope sometime in the early sixteenth century (but after 1506), while much of its early and enduring fame derives from the great admiration expressed for it by Michelangelo (Haskell and Penny, cat. 80, 311, 312). The precise subject of the *Torso* is not certain, but the presence of the feline skin on which it sits suggests that it is Hercules.

34. For the *Pasquino,* see note 31 above and note 35.

35. See Baldinucci, i.146, e.80, for the same *Pasquino* anecdote wherein Bernini's unnamed foreign interlocutor is identified as "someone from beyond the Alps." In Chantelou, June 8, f.53, e.24–25, Bernini tells the same story, in response to the question of the papal nuncio (see note 29 above), except that he identifies the other party as a cardinal. In the same Chantelou entry, Bernini further observes: "But, he [the offended cardinal] cannot have read what has been written about this work, that it is by Phidias or Praxiteles and portrays the figure of Alexander's servant supporting him, after he had received an arrow wound at the siege of Tyre. However the figure is so mutilated and ruined that the beauty which remains is recognized only by real connoisseurs." As Montanari, 1997, 58, points out, Bernini's friend Cardinal Sforza Pallavicino (for whom see Domenico, 96, 97, and 130) includes a brief version of the anecdote in his *Trattato della Provvidenza,* written ca. 1666–67. The badly damaged, fragmented statue, depicting one soldier holding the body of another (Menelaus and Patroclus?), is first documented in 1499–1500, its place and exact date of discovery unknown. In 1501, Cardinal Caraffa had it installed at one of the angles formed by the Piazza Navona, where it remains today (Haskell and Penny, cat. 72, 291). *Pasquino* is perhaps famous not only as an art object but also, beginning in the early sixteenth century, for its function as the public "voice" of the discontent of generations of Romans, who still today post their anonymous satiric criticisms—known as "pasquinades"—on the statue. For Bernini's esteem for the *Pasquino,* see also Lavin, 2007, 120.

36. Baldinucci, i.146, e.79, instead reports Bernini's same judgment about the *Pasquino* and *Laocoön,* not the *Torso,* as here. Baldinucci, i.146, e.80, adds: "[H]e said the difference between the *Pasquino* and the *Torso* is almost imperceptible and could not be perceived except by a great man [*uomo grande*], but that the *Pasquino* was indeed the better of the two." See Domenico, 5–6, for his earlier enunciation of the virtue of the highest form of art, that is, the imitation of what is most beautiful in nature, without the appearance of artifice.

37. Domenico passes in silence over the fact that Bernini apparently spent some time training in the studio of Cigoli (Lodovico Cardi, 1559–1613), another Florentine painter active in Rome and working, like Pietro, for the Borghese in the last years of his life. See Bernini's own anecdote in Chantelou, October 11, f.249, e.287: "Later, when [Bernini] was drawing from life at the academy, Cigoli, watching him remarked, 'You are a rogue, you don't draw what you see; this comes from Michelangelo.'" For Bernini and Cigoli, see Tuzi; Soussloff, 1982, 186 n.37; and Montanari, 2009, 81–83.

As far as other early, more direct, influences on the young Bernini, let us keep in mind not only his own father Pietro, who had also been active as a painter in his early career, but also Bernini's brother-in-law, Agostino Ciampelli (1565–1630), husband of his sister Agnese and likewise a Tuscan painter of status in Rome. Ciampelli did a series of frescoes in the Church of Santa Bibiana at the same time of its refurbishment by Bernini (see Domenico, 42–43) and was later involved in the Baldacchino design process, even before becoming *Soprastante* of the *Fabbrica* of Saint Peter's in 1629. See *Grove Art Online,* s.v. "Ciampelli, Agostino"; for Ciampelli as brother-in-law, see Terzaghi, 101. Note, however, that Agnese died in 1609; Ciampelli remarried sometime thereafter to a certain Camilla Latina, but was still referred to as Bernini's brother-in-law in later documents: see Lavin, 1968, 12 n.53 (unaware, however, of the earlier marriage to

Agnese). For a detailed description of the training of young painters in early seventeenth-century Rome, see Cavazzini, 49–80.

38. Domenico is right to acknowledge the special debt of Bernini's art to painting (twice specifying, however, that his father studied only the figures therein), but fails to identify another, even more significant aspect of that relationship and at the same time of the novelty and special achievement of Bernini's sculpture: its pictorial quality, that is, the successful naturalistic, seemingly effortless rendering in hard, cold, colorless marble of certain "difficult" visual (especially "coloristic") effects hitherto believed impossible in sculpture, such as that of warm, supple, living human flesh. In thus defying the traditional limits of the genre of sculpture in its representation of nature, Bernini demonstrates that the latter art, sculpture, is a worthy rival to or victor over painting in the traditional competition—the so-called *paragone*—between those two arts. See Domenico, 29–30 (and commentary) for Bernini's thoughts about the *paragone*, though he does not use the term; see also *Nascita*, 70–71; and Ostrow, 2004 and 2007. An excellent early example of this accomplishment is the statue that Domenico will describe shortly, the *Saint Lawrence*.

39. The many splendid frescoes in the various *Stanze* (Rooms) and *Logge* (Loggias) of the Vatican palace painted by Raphael Sanzio (1483–1520) beginning in 1510, under Julius II and Leo X, are of course among the most celebrated achievements of Italian High Renaissance art, as is Michelangelo's enormous *Last Judgment* (completed in 1541 under Pope Paul III) in the Sistine Chapel, also in the Papal Palace. (Strangely, no mention is made of Michelangelo's equally famous and beautiful frescoes on the ceiling of the same chapel.) The other work mentioned by name is *The Battle of the Milvian Bridge* by Giulio Romano (ca. 1499–1546), the closest and most accomplished of Raphael's disciples, who executed this epic scene (probably upon preliminary drawings by Raphael) during the years 1520–24, having secured the commission after the premature death of his master. Depicting the victory of Constantine the Great over Maxentius, with a swirling "cast of thousands," it is in the Sala di Costantino in the Vatican.

The works by Guido Reni in the Vatican cited here are the series of six frescoes executed in 1608 for Pope Paul V: three in the Sala delle Dame and three in the Sala delle Nozze Aldobrandini. For Bernini and Reni, see Schlegel, 1985. See Domenico, 29, for Raphael and Reni in Bernini's ranking of the greatest painters of modern times. Yet note, in his lecture to the students of the Royal Academy of Painting and Sculpture in Paris (Chantelou, September 5, f.155–56, e.166–68), Bernini advised that these students "should have access to copies of pictures by artists who painted in the grand manner . . . he was referring [specifies Chantelou] to Giorgione, Pordenone, Titian, and Paolo Veronese rather than to Raphael, although his knowledge of good proportion was better than any of them."

Interestingly, in the Bernini sources, Caravaggio is nowhere cited by name, except in Chantelou, September 29, f.212, e.239, which records Bernini's low opinion of Caravaggio's *Fortune Teller* (Louvre). For the conjectured influence of Caravaggio on Bernini, see Montanari, 2009, 77, 84, 88–89; for that of another contemporary artistic giant, Peter Paul Rubens, see Gregori.

40. Pietro Filippo adds here (just before the discussion of Bernini's statue of *Saint Lawrence*) the further detail that the young Bernini was so absorbed by the pursuit of his art that "at night in his dreams he would take his chalk box, portfolio, and paper and begin to draw in such a way that at times it was a source of astonishment to himself."

41. Briefly mentioning this work, Baldinucci, i.77–78, e.12, also places it in Bernini's fifteenth year. Pietro Filippo includes the anecdote in a much-reduced version, not specifying the year but implying that it was early in Bernini's career. Common consensus now dates the statue to 1617, when Bernini was nineteen years old. Chantelou, July 14, f.76, e.60, reports that in discussing "the subject of expression, the soul of painting," Bernini said that "he had discovered a method that had helped him; this was to put himself in the attitude that he intended to give to the figure he was representing, and then to have himself drawn by a capable artist." The principle inherent in Bernini's practice described by Chantelou is by no means original to our artist: "To experience for oneself the emotions that one proposes to depict is recommended by Aristotle (*Poetics*, 55, a 23–24) and by Horace (*Ars poetica*). The principle will also be adopted by the Carracci entourage" (Stanić in Chantelou, f.76, n.1). Bernini, however, takes the principle to an

extreme, thus enabling Domenico to make a flattering pietistic comparison between the young
artist and his martyred subject. For the *Saint Lawrence* statue (now at the Palazzo Pitti, Florence),
see Preimesberger, 1985, 1–7; *Nascita,* cat. 4; Coliva, 2002, 86–95; and Schütze, 2007, 194–209.
For a detailed analysis of this episode in Domenico, see Levy, 2006, 172–73; and Damm. Bernini
later would paint a now-lost canvas of *Saint Lawrence* "looking up to the heavens," known solely
from the 1692 inventory of Cardinal Flavio Chigi (Petrucci, 2006, 422, cat. 15).

Most likely also in 1617, Bernini produced another small marble work, *Saint Sebastian*
(Thyssen-Bornemisza Collection, Madrid), of similar size and sensual-devotional nature, but not
mentioned by Domenico (for which see Wittkower, cat. 4; *Nascita,* cat. 5; Coliva, 2002, 96–103;
and Schütze, 2007, 209–24). For a lost painting of Sebastian by Bernini listed in a 1649 inventory
of Cardinal Francesco Barberini, see Petrucci, 2006, 418, cat. 8. Also lost is yet another marble
statue of Sebastian, listed in Baldinucci's catalogue as being with the "Principessa di Rossano"
(Olimpia Aldobrandini, who married Camillo Pamphilj in 1647), for which see Testa, who
published in 2001 newly discovered documentation showing that in 1618, Pietro Aldobrandini
paid the young Bernini for the statue destined for the Palazzo Aldobrandini (now known as the
Palazzo Doria-Pamphilj). The latter document represents the first payment made directly to
Gian Lorenzo (now recognized as an independent adult) and not through his father.

42. For Saint Lawrence (Lorenzo) as Bernini's patron saint, see note 6 above to Domenico, 2.

43. Domenico's original word here is *lapis,* about which Heiko Damm explains: "In this
context [Domenico's biography], 'lapis' may denote the form of Bernini's drawing object rather
than its material. In his *Vocabolario* [*toscano dell'arte del disegno*], Baldinucci suggests black or red
chalk [see s.v. 'Amatita']. Actually Domenico (DB, 28) mentions his father's 'disegni in lapis'
referring to Bernini's coveted portrait drawings, carefully executed with different colored chalks,
as described by Baldinucci, *Vocabolario,* s.v. 'Mattita rossa, e nera, e suo uso.' Yet, in all likelihood,
the young Gianlorenzo used natural chalk ('pietra nera': black clay slate) or charcoal ('Carbone,
overo lapis nero') for his rapid studies. Both materials were readily available, in contrast to the still
rare graphite pencil ('Lapis piombino'), as well as the lead pencil, here out of the question because
of its hardness" (Damm, 243–44 n.14, with further bibliography). See also Montanari, 1998c,
46 n.4, who explains somewhat differently: "For the identification of the term *lapis* as referring
tout-court to red chalk, see, e.g., il *Vocabolario . . . di Baldinucci . . .* under s.v. 'lapis.'" For *lapis*
used by Domenico to denote the writing instrument, see Domenico, 98 and commentary.

44. The popular, exemplary story of the ancient (and most likely mythological) Roman
hero Gaius Mucius Scaevola, an episode from the early years of the republic, is recounted in
Livy's *History of Rome from Its Foundation* (2:12.1–13.5) and in *Roman Antiquities* by Dionysius of
Halicarnassus (5:27–30). While Rome is under siege by the Etruscan king Porsenna, Mucius, a
Roman youth of noble birth, enters the enemy camp under cover to slay the Etruscan leader;
instead, he mistakenly kills one of his secretaries. Captured and brought before Porsenna, Mucius
thrusts his right hand into a flame in order to demonstrate his courage and contempt for pain.
Impressed, Porsenna releases him and the young hero thereafter acquires the nickname Scaevola,
"Left-Hand."

A later, alternative, and, by Bernini's lifetime, equally current version of the *exemplum* has
Mucius placing his hand in the fire instead to punish himself for his mistake: this is the version
of the tale that Domenico invokes here. As Damm, 237–39, points out, the linking of the pagan
Scaevola and the early Christian martyr Lawrence has its origins in the Church Fathers and can
be found among early modern writers, such as Torquato Tasso. Another famous literary appari-
tion of the Scaevola–Lawrence pairing is in Dante's *Divine Comedy* (*Paradiso* 4:82–87).

45. That is, Cardinal Scipione Borghese, mentioned at the beginning of this chapter
(Domenico, 7), who thus honors Bernini with a personal visit to his home.

46. Both Baldinucci, i.77–78, e.12, and Pietro Filippo say outright that Bernini executed
the statue of Lawrence for Leone Strozzi. Guerrieri Borsoi, 197, rejects Domenico's version of
the statue's origins (i.e., as purely an act of personal piety), emphasizing that "it is a matter of
astonishment that a boy would consume the capital represented by this block of marble without
any assurance of recovering his expense through its sale, depicting a saint merely because he

bore his name." Born in Rome in 1555, Leone Strozzi was member of one of the leading noble families of Florence, who, as successful bankers, were "capable of rivaling in wealth, power and patronage the Medici" (Guerrieri Borsoi, 9). A banker, like his illustrious ancestors, Leone was also a collector of antiquities and modern painting and sculpture, having also lent military and diplomatic service to the Church under Pope Clement VIII Aldobrandini, with whom he enjoyed a close relationship (for Leone's career, see ibid., 11–13). He also enjoyed the friendship of the Barberini, another prominent component of the Tuscan community of Rome.

Leone died in Rome in 1632 and was buried in the Strozzi family chapel across from that of the Barberini in Sant'Andrea della Valle. As Fagiolo dell'Arco points out, Leone's interest in Bernini's *Saint Lawrence* is quite understandable: apart from the lure of its aesthetic qualities, the *Saint Lawrence* honored the patron saint of Strozzi's own banking profession and bore the name of his much beloved uncle, Cardinal Lorenzo Strozzi, who had raised the orphaned child (Fagiolo/*IAP*, 28–30). But perhaps Strozzi simply liked statues of heroic male nudes. The extensive suburban residence of the family, the Villa Strozzi (of which no trace remains today), was on the Viminal Hill near the Baths of Diocletian (for which see Guerrieri Borsoi, 69–82; and Marseglia). A marble *Saint Lawrence on the Grill* is attested in the villa's art collection as of 1632, but the inventory in question does not identify its creator, merely mentioning that it is a modern work (Guerrieri Borsoi, 197).

The same 1632 inventory also lists a small, anonymous marble statue, described as a "putto moderno che lo morde una serpe" (modern work of a small boy bitten by a serpent), which by common consensus is now identified with another early work by Bernini, the *Boy on Dolphin* (or *Boy Bitten by Dolphin*, Staatliche Museen, Berlin), for which see Guerrieri Borsoi, 200–201; *Nascita*, cat. 6, 96–101; and Schlegel, 2001, 47–49. The Villa Strozzi also contained several works by Pietro Bernini, as reported by Baglione in his 1642 *vita* of Pietro, but nowhere otherwise documented. Guerrieri Borsoi uncovered payments made in 1620 and 1622, from Strozzi to Pietro, the earlier payment being for a "group of satyrs" and the other not further specified; Leone also extended a loan of money to Pietro (Guerrieri Borsoi, 189; 188–97 for Pietro's works for Strozzi).

47. The "same aforementioned year" of Bernini's life is fifteen. Baldinucci, i.76, e.11, does not date the Montoya commission (or the anecdote), but says it comes "not much later" after Annibale's prophecy about the embellishment of Saint Peter's interior. Shortly thereafter in his chronology, in introducing the *Saint Lawrence* statue, the Florentine biographer specifies that Bernini was "still in his fifteenth year"; hence he would have us believe that our artist was still in his early teenage years when he executed the Montoya portrait. Instead, scholars now agree in dating the work to ca. 1622, a creation, thus, of Bernini the young adult (who was, in the same period, busy working on his Borghese mythological statues).

A Spanish prelate from Seville, Pedro de Foix Montoya (d. 1630), served as jurist in the papal tribunal (the *Segnatura*, of which Maffeo Barberini was at the time prefect) and was member of the very active, wealthy Spanish Arch-confraternity of the Resurrection, which produced the annual Easter Sunday pageantry in Rome. Montoya commissioned the bust for his tomb in San Giacomo degli Spagnoli in the Piazza Navona, the Spanish national church in Rome. (Note that Domenico mistakenly calls the prelate "Giacomo" instead of "Pedro"). At some point, however, the bust was transferred to another Roman church with Spanish connections, Santa Maria in Monserrato, where it remains today.

In Chantelou, August 17, f.123–24, e.125–26, Bernini relates another version of the anecdote, calling the work "one of the first portraits that he did." In the less dramatic Chantelou version, Montoya apparently is already among the spectators (and hence does not happen serendipitously to arrive in the midst of the discussion), and thus Cardinal Barberini's final "punch line" therein—"It seems to me that Mons. Montoya resembles his portrait"—lacks the wit of its counterpart in Domenico. (The 1985 English translation of Chantelou does not identify Barberini as the speaker of that line, as, instead, is clear in the 2001 French edition.) However, in Chantelou, Bernini supplies us with an interesting corollary to the story demonstrating the social power of a Bernini portrait: "This Spaniard paid him extremely well, but left his portrait in [Bernini's] studio for a long time without sending for it. [Bernini] was rather surprised and spoke

to several people about it, who explained to him that, as many cardinals and prelates saw the portrait in the studio, this did honor to Monsignor Montoya, for these same cardinals, ambassadors, and prelates stopped their carriages when they saw him in the street to talk to him about it, which pleased and flattered him, as before he had been remarkable in nothing."

For the Montoya bust, see Wittkower, cat. 13; and Preimesberger, 2006, 210–18. A putative studio copy of the portrait is now in London (*Effigies and Ecstasies*, cat. 21). Montoya had also earlier (probably 1619) commissioned from Bernini the two highly expressive marble heads of the *Anima salvata* (Saved Soul) and the *Anima dannata* (Damned Soul), now in the Spanish Embassy to the Holy See in the Piazza di Spagna, for which see *Nascita*, cats. 13 and 14; *Regista*, cat. 32a–b; and Lavin, 1993a.

48. After these early works for Montoya, Bernini, who apparently did not have much affection for the Spanish, produced very little for Spanish patrons. For Bernini's crucifix for King Philip IV, see Domenico, 64. In 1651, upon commission by the Spanish ambassador, Rodrigo de Mendoza, Bernini designed a fireworks display (another one of his talents) for public celebrations in Rome of the birth of the Infanta (Anna Margarita Teresa) of Spain (Fagiolo dell'Arco, 1997, 354–58). A few years later (1655), he also provided the design for the tomb of Spanish Cardinal Domenico Pimentel in Santa Maria sopra Minerva (Bernstock, 1987). His next two and final commissions from a Spanish patron came from the Marchese del Carpio (for whom see Domenico, 28), who in 1680 ordered two items from Bernini intended as gifts for the Spanish king, Charles II: a luxurious miniature replica of his Fountain of the Four Rivers and a small gilded bronze version of the Louis XIV equestrian statue redone as a portrait of King Charles (Montanari, 2003a; del Pesco, 2004). Bernini, who was in the last months of his life, of course merely supervised the execution of these commissions.

Of the few remaining objects in Bernini's repertory with a Spanish connection, none was commissioned by the Spanish court or by a Spanish patron. Bernini's design (ca. 1665) for the bronze memorial statue of Philip IV in the portico of Santa Maria Maggiore was commissioned by the basilica's canons and executed by his collaborator, Girolamo Lucenti (Ostrow, 1991; and Carriò-Invernizzi). There is also a 1661 report of two gifts planned by Niccolò Ludovisi, Prince of Piombino (then serving as Viceroy of Aragon) for Philip IV and Queen Marianna designed by Bernini, but this commission is otherwise undocumented and there is no trace today of the alleged gifts (see Garcia Cueto). For Bernini's attitude toward the Spanish, see the derogatory remarks made about them in Chantelou (e.g., June 8, f.51–52, e.23–24; October 19, f.275, e.318); see, as well, Perrault, 72, who describes Bernini as "openly contemptuous of [the Spanish]."

49. Baldinucci, i. 76, e.11, in similarly laconic fashion, also attributes both the Bellarmino portrait and the allegorical statue of *Religion* to Bernini. Bernini's half-bust of the cardinal and a large inscription are all that remain of the originally more elaborate tomb monument of Jesuit theologian and Counter-Reformation controversialist Saint Roberto Bellarmino (1542–1621; canonized 1930). The bust is still in the mother church of the Jesuit order, the Gesù (apse, left of altar), but the monument itself was disassembled in 1841, its other components dispersed and lost. The design of the tomb, whose original composition is known from an eighteenth-century drawing (Kessler, 2005, fig. 171), is dated to a later period than that reported by Domenico and Baldinucci, i.e., to ca. 1621, shortly after the cardinal's death, while the Bernini statues were executed even later, between 1622 and 1624. Pietro Bernini was responsible for the design of the sculptural elements of the tomb, carving a companion allegorical figure of *Wisdom*. However, the early sources are divergent in their attributions of the two statues between father and son, while also mentioning the contribution of Giuliano Finelli. For Bernini's Bellarmino portrait, see *Regista*, cat. 38; see Kessler, 2005, cat. D4, for Pietro's contribution to the tomb.

CHAPTER III

1. "According to his own inspiration": *a suo genio*. Enhancing the prestige of this commission, Domenico incorrectly states that it came from the pope himself and that the villa in question was the pope's residence. In reality, it was papal nephew Scipione Borghese who commissioned

the statues from Bernini for installment in his own suburban home, the Villa Borghese. However, not all four statues were original commissions from Scipione, and those that were did not come together in one group at the same time, as Domenico here claims. The *David* was begun as a commission from Cardinal Alessandro Peretti di Montalto (see note 9 below), whereas the *Aeneas and Anchises* may represent a work undertaken without commission and purchased by Scipione only after completion: see note 8 below.

2. "ritratto di tanto buon gusto."

3. The marble portrait here described—Bernini's first official commission from the Borghese family—is usually identified with the smaller-than-life-size "desktop" bust (33.6 cm in height) now in the Galleria Borghese: see *Nascita*, cat. 7, dating the bust to 1617–18; and Coliva, 2002, 104–15 (note that *Regista*, cat. 40, replicates verbatim *Nascita*, cat. 7). However, no documentation illuminating its origins survives and indeed, most recently, Bacchi warns that this small Galleria Borghese bust (which he dates, on stylistic grounds, to ca. 1622–23) "cannot be connected with any certainty" to the one here described by Domenico (Bacchi-Hess-Montagu, cat. 1.6, 103). Baldinucci, i.76, e.11, simply mentions, right before the Scipione portrait bust episode: "After that [i.e., the execution of the *Bellarmino* tomb figures], His Holiness, Pope Paul V, also wished to have his portrait made by Bernini." Extant documentation speaks also of another marble bust of Paul V by Bernini, commissioned in 1621 by Scipione after his uncle's death in January of that year (for which payment documents dated between June and September 1621 are extant). This later bust has disappeared but is likely to have been the one belonging to the Borghese family until its sale in 1893 to a Viennese collector and known only through a photograph. There is also extant a version in bronze cast by Sebastiano Sebastiani, of 1621–22, which likewise remained in the Borghese collection until the late nineteenth century and is now in the Statens Museum for Kunst, Copehagen. For the bronze portrait and the missing marble bust of 1621, see Bacchi-Hess-Montagu, cats. 1.3 and 1.6.

4. Note that in seventeenth-century Italian, as today, "villa" often refers to an entire estate comprising both its mansion and surrounding park, rather than the mansion alone.

5. Cardinal Scipione's suburban residence (the "Casino") is now a museum, the Galleria Borghese, and the surrounding estate now one of the city's public parks. Work on the estate began in 1607, with the residence itself constructed rather quickly between the summer of 1612 and May 1613. The Borghese family architect, Lombard Flaminio Ponzio (ca. 1560–1613), provided the initial design and began construction, which, at his death, was continued by Dutchman Jan van Santen or Zanten (b. Utrecht, ca. 1550; d. Rome, 1621), known more popularly in Italian sources as Giovanni Vasanzio or Vansanzio (Coliva, 1998, 396–97; *Grove Art Online*, s.v. "Ponzio, Flaminio" and "Vasanzio, Giovanni").

6. For the Borghese *Gladiator, Hermaphrodite,* and *Seneca,* see Haskell and Penny, respectively, cats. 43, 48, and 76; and more recently, Kalveram, cats. 94, 134, and 75. As for the Borghese *Venus and Cupid,* Domenico presumably refers to the Greek *Venere volgare,* for which see Kalveram, cat. 132. Together with many of the choicest antiquities of the collection, all four statues were sold to Napoleon Bonaparte in 1807 by his brother-in-law and husband of Pauline, Prince Camillo Borghese. The *Hermaphrodite* was indeed discovered during the reign of Paul V, in the garden of the convent of the Discalced Carmelites at Santa Maria della Vittoria. Bernini was paid in February and March 1620 for restoring the *Hermaphrodite* and sculpting its fanciful mattress (for the statue, see also *Nascita*, cat. 9; 124 for discovery; 130 for payment history). As for the cited "bas-relief" of *Alexander,* no notice of such a work is to be found in any description of the pre-1807 Borghese collection, including the exhaustive catalogues of Kalveram and Fabréga-Dubert. The 1610 Borghese inventory lists an "Alessandro Magno" but supplies no further detail (Kalveram, 152, no. 2, without commentary). There is a marble portrait of Alexander currently in the Galleria Borghese, but it was not identified as such until the eighteenth century by Antonio Nibby (Moreno, cat. 4.19.4; Moreno and Stefani, 93).

7. The correct order of execution of the four statues is *Aeneas and Anchises,* 1618–19; *Pluto and Proserpina,* 1621–22; *David,* 1623–24; and *Apollo and Daphne,* 1622–25. The execution of these statues marks the true beginning of Bernini's reputation as universally recognized independent master.

8. For this statue, see *Nascita,* cat. 8. Certain prominent early sources attributed the statue to Pietro Bernini alone, leaving the question of authorship (including a possible collaboration of both father and son) in debate for a long time. The question now seems to have been settled in Gian Lorenzo's favor, thanks to newly discovered documentation (see *Nascita,* 115; Coliva, 2002, 116–31; Kessler, 2005, E11; but see, most recently, Pierguidi, who wishes to reopen the debate). About the specific style of the *Aeneas and Anchises,* Baldinucci, i. 78, e.12, comments: "In it, although something of the manner of his father, Pietro, is discernible, one still can see, through the fine touches in the execution, a certain approach to the tender and the true toward which from then on his excellent taste led him." Baldinucci had traveled to Rome in the spring of 1681, as he says, in order to see Bernini's works for himself (see the Introduction, section 4). Reproposing D'Onofrio's 1967 conjecture based on the ambiguous nature of the earliest documentation, Pierguidi, 107–9, argues that Pietro and Gian Lorenzo sculpted the work together as a project of their own initiative, without commission, with the goal of enticing Scipione Borghese into purchasing it, as he indeed did.

9. Baldinucci, i.78, e.13, devotes a fair amount of text to the *David,* in which, he states, the artist "overwhelmingly surpassed himself." Baldinucci also points out that Bernini used his own likeness to sculpt its "beautiful face." Neither biographer mentions the now documented fact that the *David* was begun in March 1623 upon request, not from Scipione Borghese but from Cardinal Alessandro Peretti di Montalto. Upon the latter's death in June of the same year, Scipione assumed sponsorship of the commission. For the statue, see *Nascita,* cat. 18 (173 for the original Peretti di Montalto commission).

10. Baldinucci, i.78, e.13, is ecstatic in his praise for the *Apollo and Daphne,* confessing himself incapable of properly doing justice to it in words: "[It] surpasses anything imaginable" and, once finished, "all Rome rushed to view it as though it were a miracle." As Coliva observes, the statue "has been unanimously considered Bernini's masterpiece even by his most hostile critics" (*Nascita,* 261; for the most thorough study of the statue, see Hermann Fiore). Yet Domenico himself refrains from singling it out among the Borghese statues in quality and reception: all four statues, he will shortly say, defy description and provoked similar acclaim. See Chantelou, August 5, f.106, e.102, for Bernini's "self-mythologizing" boast to Colbert that he had sculpted this work at the age of eighteen (he instead began it at the age of twenty-four).

Elsewhere in Chantelou (August 23, f.136, e.142), Bernini comments on the great difficulty of rendering the lightness of human hair in this same work, having to struggle against the very nature of the marble. Neither Bernini nor his two biographers (Domenico and Baldinucci), however, acknowledge, with regard to this brilliant technical achievement, the significant contribution of Giuliano Finelli, a virtuoso marble-carver, who began as assistant to Pietro, then passed into his son's studio, which he was to later leave in anger. Domenico, 112, lists Finelli as one of Bernini's disciples, but without comment. For Finelli's embittered relationship with Bernini, see Montagu, 1989, 104–7. For Finelli's career in general, see Dombrowksi; for shorter notices, see Kessler, 2005, 89–91; and Bacchi, 1996, 805–7, and 2009; for photographs of his works in Rome, see also the copiously illustrated Ferrari and Papaldo, *ad indicem.*

11. "Tenderness" translates Domenico's *tenerezza,* a distinctive achievement of Bernini's sculpture, for which see the Introduction, section 7. See also Domenico, 39, where the same quality is identified as a desideratum of architecture as well. On p. 23, Domenico will mention the transfer of the statue of Pluto and Proserpina as a gift from one (former) Cardinal Nephew (Scipione Borghese) to another, then-reigning papal *nepote* (his bitter rival, Ludovico Ludovisi).

12. "oltre alla simetria di ciascuna di esse."

13. See Domenico, 179, for further description of Bernini's all-consuming love for his art. Baldinucci, i.142, e.76, reports another quotation from Bernini, not found in Domenico, about his great love for his art: "[G]oing to work was for him like going to a garden to delight himself." Using similar vocabulary (*deliziare, giardino*), this remark, however, echoes an observation that Domenico, 49, makes about the convalescent Bernini passing the time delightfully carving small works of marble: "come se convalescente andasse a deliziare in un qualche giardino."

14. Antonio Barberini Jr. (1608–1671), son of Urban's brother Carlo (1562–1630) and the youngest of the papal nephews, was made cardinal in August 1627, despite great "protest from

members of the college of cardinals over the pope's excessive nepotism and due to Antonio's youth and unsuitability for the job" (Wolfe, 2008, 113). Like (and at times in rivalry with) his brother Francesco, he took an active part in the family's extensive cultural patronage: "Universally described as spirited and vainglorious, Antonio had boldly declared early on that he intended to exceed the public fame and wealth of the *cardinali-nipoti* of the two previous papacies, Scipione Borghese and Ludovico Ludovisi" (ibid.). According to Domenico, 99, Antonio was especially close to Bernini. Cardinal-Protector of France during Urban's pontificate, in 1645 Antonio fled Rome for Paris (disguised as a *carbonario*) in the wake of Pope Innocent X's hostile maneuvers against the Barberini (Waddy, 1990, 250; Pastor, 30:52–53). He eventually found favor in the eyes of Louis XIV and played an important role in getting Bernini to Paris in 1665 (Chantelou, October 12, f.255, e.295; Domenico, 115). For Cardinal Antonio's character and cultural patronage, see Wolfe, 1998, 2007, 2008, and 2010; and Loskoutoff.

15. Bernini expresses the same regret in Baldinucci, i.77, e.12, where, however, his exclamation is provoked instead by seeing (the same number of years later and with the same companion) his two *Scipione Borghese* portrait busts. For an extensive, detailed analysis of Bernini's sculpting technique and tool kit by a professional sculptor of our day, see Peter Rockwell's *Marble Sleuth*, 169–96; see also Rockwell's technical *Commento* to many of the catalogue entries in Coliva, 2002 and his earlier essay, "Gli angeli di Ponte Sant'Angelo: Le tecniche dello scultore," in Cardilli Alloisi, 91–127.

16. As already noted, Baldinucci, i.78–79, e.13, makes the same remark about the futility of verbal description, but specifically with respect to the *Apollo and Daphne*. Domenico, 38–39, will make a similar objection regarding the Baldacchino—that the work simply defies description in words.

17. Baldinucci, i.78, e.13, reports the same details about Cardinal Maffeo's holding the mirror for Bernini "on several occasions" and the statue as a self-portrait. Pietro Filippo confirms the latter fact, adding "both in face and body." If Maffeo did indeed perform the mirror-holding service, it was necessarily before the beginning of the conclave on July 19, 1623, that ended on August 6 with his election to the papal throne, at which point the statue was still incomplete. Appropriately enough, Bernini expresses his own congenitally choleric temperament in David's face (Preimesberger, 1985, 2; for Bernini's fiery temperament, see Domenico, 177).

18. My thanks to David Gill of the Boston College Classics Department for his translation of the distich. See Baldinucci, i.79, e.14, for the fact of Maffeo's distich as moral remedy; see Preimesberger, 1985, 12–13, for the verse in the context of the contemporary poetic-moral polemic against *Petrarchismo* and *Marinismo*.

In Chantelou, June 12, f.57, e.30, Bernini informs his interlocutors that it was Cardinal François d'Escoubleau de Sourdis (1575–1628), the powerful archbishop of Bordeaux, who had expressed scruples over the sensuality of the *Daphne* and who thus prompted Cardinal Maffeo "to attempt a cure with a couple of verses. Whereupon he made an epigram from the fable of Apollo and Daphne." In fact, as we now know, Maffeo's distich predates the statue by several years (*Nascita*, 262; see Schütze, 2007, 193–247, for Maffeo's literary-religious influence on Bernini's Borghese statues as well as his smaller *Sebastian* and *Lawrence*).

Furthermore, it would appear that the sculpting of the *Apollo and Daphne* began only in early August 1622 (the invoice for the marble block is extant), by which time Escoubleau had already left Rome (by a matter of weeks) and hence could not have seen even a partially complete statue: see Bauer note to Chantelou, e.30. Be that as it may, though his name does not appear in Domenico's text, Escoubleau was well known to Bernini and his father. Bernini executed the French cardinal's marble portrait (Bordeaux, Musée d'Aquitaine) during Escoubleau's 1621–22 Roman visit, and in the same period father Pietro and son Gian Lorenzo sculpted for the prelate a marble *Annunciation* group for the church of San Bruno, Bordeaux (still in situ).

For Escoubleau's portrait (listed in Baldinucci's catalogue of Bernini's works as "Cardinal Serdi . . . Paris"), see Wittkower, cat. 14; Bacchi-Hess-Montagu, cat. 1.7, and *Marmi vivi*, cat. 5 (citing collaboration with Finelli). See Kessler, 2005, cat. C8, for the *Annuciation* group, of which Gian Lorenzo—with the collaboration of his father and Giuliano Finelli—seems to have been

responsible for the statue of the Virgin. Hess, however, gives both *Annunciation* statues to Pietro alone: Bacchi-Hess-Montagu, cat. 1.7, 108–9).

19. Baldinucci, i.79, e.13, says that Bernini "had not yet completed his eighteenth year."

20. Alessandro Ludovisi was born in Bologna in 1554 and died in Rome on July 8, 1623. Made cardinal by Paul V in 1616, he was elected pope (on the second day of conclave, as accurately reported by Domenico) on February 10, 1621, taking the name of Gregory XV in honor of his first "protector" and fellow Bolognese, Gregory XIII (*EncPapi* 3: 292–97).

21. Among the primary sources, Domenico is the only one to mention this early, and now-lost, portrait of Cardinal Ludovisi by Bernini. He does not specify the medium, whether paper, marble, or bronze. Alessandro became archbishop of Bologna in March 1612, when Bernini was just fourteen years old. If he did indeed do a portrait at this time, it may have been no more than a drawing, as M&MFagiolo, cat. 27, conjecture. Contemporary sources (Ludovisi inventories and Fioravante Martinelli) testify to the existence of a now-lost bust by Bernini of Gregory XV's father, Pompeo Ludovisi: see *Marmi vivi*, 351, checklist P4.

CHAPTER IV

1. Domenico does not mention that it was Bernini who created the statuary elements of Paul V's elaborate catafalque, the colossal centerpiece of a memorial service held one year after the pope's death in Santa Maria Maggiore (January 1622). This was the first of Bernini's several lavish ephemeral "machines" done over his lifetime. Adorned with no fewer than thirty-six statues in stucco and finished in just five weeks, it was a tour de force that increased Bernini's reputation as "artistic wizard" (Fagiolo/*IAP*, 45; see also Fagiolo dell'Arco, 1997, 235–40; and the contemporary description with engravings in *Breve Racconto della transportatione del Corpo di Papa Paolo V della Basilica di S. Pietro à quella di S. Maria Maggiore . . .* (Rome, 1623).

2. That is, Ludovisi, by extending such favor upon Bernini, had created in the artist a debt of gratitude that Bernini in some fashion was obliged to repay, not the least in the form of utter loyalty to his patron. Here Domenico invokes one of the most important elements of the psychosocial dynamics of the Baroque mentality, especially within the realm of court life, that of the "obligation": colloquially put, there was no such thing as a free lunch in Baroque Rome. Any gift given in any form demanded reciprocation—first and foremost in the form of abject loyalty to one's benefactor—at the risk of one's public reputation and, indeed, utter survival in society. As Galileo and his supporter within the court of Urban VIII, Giovanni Ciampoli, discovered, a court "favorite" could fall very easily and ruinously from the graces of a prince, no matter how affectionate and intimate the relationship had previously appeared between lord and subject (for the "Fall of the Favorite" phenomenon, see Biagioli, 323–29; my thanks to Eraldo Bellini for this citation). See Chantelou, October 18, f.269, e.312, for Bernini's cry that "the Pope could easily ruin him" (for disobeying papal orders by overstaying his permitted time in Paris). Hence Domenico, 180, in the penultimate line of his narrative, will underscore the remarkable fact of Bernini having successfully maintained the friendship of so many of the princes of Europe over the long span of his lifetime.

3. Baldinucci, i.80, e.14, also notes Bernini's knighthood in the papal Order of Christ, crediting Gregory's nephew, Cardinal Ludovico Ludovisi, with obtaining the honor for him. Ottavio Leoni's engraved portrait of Bernini of 1622 shows the new "Cavaliere" wearing the cross and gold chain of the order (for the Leoni portrait, see *Regista*, cats. 1 and 2). The knighthood, bestowed on June 30, 1621, came with a pension (see BALQ, 85; for the text of the nomination and photograph of Bernini's ceremonial sword found in the family crypt, see D'Onofrio, 1967, 283–84).

4. According to the diary of Florentine Francesco di Zanobi (November 18, 1622), his cousin Pietro Bernini told him that Gian Lorenzo had recently executed three busts of Gregory XV both in "marble and metal," for which the pope had conferred upon him the title of "Cavaliere di Cristo" (Bacchi-Hess-Montagu, cat. 1.4, citing Fraschetti, 32). For the several

extant Bernini portraits of Gregory XV, see Wittkower, cat. 12; and Bacchi-Hess-Montagu, Checklist A7a-e; for those in bronze see also Zitzlsperger, cat. 4. One of the portraits is the long-lost marble bust now in the Art Gallery of Ontario in Toronto (*Regista,* cat. 41; Zitzlsperger, cat. 3; but Bacchi-Hess-Montagu, cat. 1.4, 97, suggest that the Toronto bust may be a later one ordered in 1627 by his nephew Cardinal Ludovico for his home in Zagarolo). Of the portraits in bronze, as Wittkower (cat. 12) notes, "four almost identical" ones survive: Paris: Musée Jacquemart André (probably the one commissioned by Scipione Borghese, for which see also Montanari, 2002; and Bacchi-Hess-Montagu, cat. 1.4); Pittsburgh: Carnegie Museum of Art; Bologna: Museo Civico; and Rome: Galleria Doria Pamphilj.

5. Ludovico Ludovisi (b. Bologna, 1595; d. Bologna, November 1632). Like his papal uncle Gregory, Ludovico studied at the Jesuit Collegio Germanico, Rome, and, again like Pope Gregory, is buried in the Jesuit church of Sant'Ignazio, Rome. He was made cardinal on February 15, 1621. For the bitter animosity between Scipione and Cardinal Ludovisi, see Hill, 2001, 438. For Cardinal Ludovisi, see the informative pages in Rosa, 91—98, as well as the entry on him in the documented Web site, "Cardinals of the Catholic Church," by Salvador Miranda (Florida International University): http://www.fiu.edu/~mirandas/bios1621-i.htm#Ludovisi.

6. By "Villa Pinciana," Domenico means Villa Borghese, near the Porta Pinciana. The suburban Villa Ludovisi (located in the present-day Via Veneto area in the neighborhood still known as Quartiere Ludovisi) was indeed designed by Domenichino, the eminent painter of Bologna, appointed Papal Architect by the Bolognese pope, Gregory XV. Domenichino master-fully wove together into a delightful, well-integrated whole a patchwork of preexisting vineyards and residential estates that Cardinal Ludovisi had begun purchasing in the summer of 1621. However, it seems that Carlo Maderno had a determining hand in certain architectural compo-nents, especially that of the *palazzo grande* (for Maderno's role, see Hibbard, 1971, 211—12). Of this extensive villa (nearly 4,700 acres in the seventeenth century), no open parkland survives and only one of the original buildings, the "Casino dell'Aurora" (housing Guercino's famous fresco of Dawn, *Aurora*), today stands intact, residence of the Boncompagni-Ludovisi family. The estate was sold to developers in the early 1880s, amid much protest, in the period of the great urban expansion when Rome became capital of the newly unified Italian nation (see Schiavo, 1981; Amadio; Krems; and *Grove Art Online,* s.v. "Domenichino"). Bernini was later (1653—55) to design and begin construction of an ill-fated urban palazzo on Montecitorio for another member of the Ludovisi family (Prince Niccolò Ludovisi), for which see Domenico, 93 and commentary.

7. Baldinucci, i.80, e.14, reports the gift and the generous reward in much the same vocabulary, except that it was, he more accurately reports, the Cardinal Nephew, and not the pope, who bestowed the reward upon Bernini. This is yet another case in which Domenico identifies the pope as being the responsible agent in certain commissions and honors that Bernini accrued (as he did earlier in describing the commissioning of the four Borghese statues) in order to increase the aura of privilege surrounding his father's memory. For the political, self-protective nature of the gift of the statue on the part of a newly "disenfranchised nephew" (Scipione) to his successor-rival and open enemy (Ludovisi), see Hill, 2001, 438 n.37. Some hint of the competi-tion between the two men, Scipione and Ludovico, may be inferred from Domenico's qualifica-tion, "in imitation of the Villa Pinciana." The statue was transported to the Villa Ludovisi in late July 1623 (*Nascita,* 187), later returning to the Galleria Borghese, its present location, when Cardinal Ludovisi's art collection was acquired by the Italian state in 1908 (*Nascita,* 180).

8. I have not found confirmation of Domenico's surprising claim that Bernini had the singular privilege of being allowed to be at Gregory XV's bedside during his final days and at the moment of his death.

CHAPTER V

1. "L'istesso giorno della sua creazione": Domenico always uses the word *creazione* to refer to a pope's election (at the end of conclave), and not to his subsequent coronation (on

p. 34, he explicitly distinguishes between *creazione* and *coronazione*). However, since Urban left his conclave in a state of near-fatal illness, as Domenico will describe at the end of this chapter (33–36), it is highly unlikely that he would be have been able to grant an audience to Bernini. Nor is he likely to have done so on the extremely busy day of his coronation. We thus have yet another instance of Domenico's hyperbolic timing of events, whereby important personages, simply enthralled by Bernini or his designs, are so eager to see him or his plans that they summon the artist on the "very first day" or the "very next day" with respect to the particular episode in question (for other examples of this topos, see Domenico, 87, 127, and 131). Baldinucci, i.80, e.15, reports Urban's same often-quoted remark, but prefaces it with a slightly more cautious statement of chronology: "Scarcely had this great pontiff ascended the sacred throne . . ." Baldinucci also inserts at this point the observation that the "pope had conceived the lofty ambition that in his pontificate Rome would produce another Michelangelo."

2. Quite a degree of intimacy: helping to put the pope to bed! Pietro Filippo confirms the depth of affection by which Urban was bound to Bernini: he had "loved [Bernini] tenderly ever since Paul V had entrusted the boy to him." Pietro Filippo also mentions the fact of Bernini's privileged access to Urban (as well as Alexander VII and Clement IX) at dinnertime and during the postprandial "recreational" gatherings of *eruditi* and *virtuosi*.

3. Virtually no one, not even Bernini, "lived completely free of envy" in the Roman court. Certainly some of the calumny that Bernini faced over the bell-tower affair and the cracks in Saint Peter's cupola (described by Domenico, 62–63 and 167–68, respectively) was created in large measure by the jealousy of fellow "courtiers" in the Papal Palace.

4. Domenico will delay until the beginning of the next chapter (p. 37) the specification that, in giving this order to study painting and architecture, Urban had in mind the painting of the Benediction Loggia and the erection of "some grand structure" to fill the space under the cupola of Saint Peter's (the Baldacchino).

5. Domenico, 47–48, would have us believe that Urban's great dreams for Bernini the painter (specifically regarding the decoration of the Benediction Loggia) came to naught only because of the onset of Bernini's grave illness. Yet he does not explain why, once cured of his illness, the artist never took up the Loggia project. A likely reason might have been that, despite Bernini's undeniable gift as painter, he did not excel in all categories of that genre; as Montanari, 2007, 55–70, points out, his forte in painting seems not to have been large, multifigured narrative scenes (*istorie*), judging from the evidence of the extant *Saint Maurice* altarpiece (most likely done according to Bernini's design and supervision) and the *Pasce Oves Meas* marble relief in Saint Peter's, both of them rather mediocre compositions (for the two works, see Domenico, 26 and 61). Yet this is precisely the kind of decoration that the Benediction Loggia would have required. See, in this regard, Chantelou, June 7, f.50, e.20–21, for Bernini's complaint about princes who oblige their subjects to undertake projects for which their "talents and experiences" are not best fitted.

That complaint was made specifically with reference to Urban's ordering Bernini to construct new defense fortifications for Rome, but possibly it could apply also to this attempted foray into the realm of large-scale painting at the Loggia. For Bernini's known paintings—almost all of them, heads (including several self-portraits) or half-figures close-up, against an empty background—see the catalogues assembled by Petrucci, 2006; and Montanari, 2007 (the two critics disagree as to the number and precise identity of extant canvases that can be safely attributed to Bernini). Even the most generous reckoning (that of Petrucci) still amounts to no more than forty canvases.

6. This would appear to contradict what Domenico, 14, said earlier about the boy Bernini studying in the Vatican not only the works of Raphael but also Michelangelo, Giuliano Romano, and Guido Reni. True, in the earlier passage Domenico refers only to Bernini's study of the design and *espressiva* (modes of expression) of those specific masters inasmuch as useful also to sculpture, whereas here it is question of Bernini studying actual painting technique, i.e., *il colorito* (application of color), as he will soon specify. Nonetheless, it is difficult to imagine that in his early youth, Bernini never took paintbrush in hand, especially given the fact that his father had

been a painter as well. It is also difficult to imagine that, with respect to his architectural studies, the young Bernini paid no attention to the works of modern masters, especially those men (Michelangelo, Bramante, Ammanati, and Baldassarre Peruzzi) he later praised as "eccellenti Architetti" and "valent'huomini," according to Nicodemus Tessin's "Osservationi dal discorso del Sig.or Cav.ro [sic] Bernini" (Tessin, 158–59): see note 7.

7. Domenico gives the impression that as a painter Bernini was self-taught, but the young Bernini lived at close hand with painters (his father, brother-in-law Agostino Ciampelli, and Cigoli) and it is hard to imagine that none of these men contributed in any way to his painterly training. For the older Gian Lorenzo as master to young painters in training, one might mention recently discovered documentation regarding Bernini's little-known service as teacher (beginning in October 1624) at the Accademia di San Luca (Roccasecca, 141) and his own "Accademia del Disegno," convened from 1630 to at least 1642 in the Palazzo della Cancelleria, under the sponsorship of Cardinal Francesco Barberini (Montanari, 2007, 37–38).

As for Bernini's training in architecture, nothing specific is known except his own detailed study of ancient buildings (as mentioned by Domenico here and on 32). He appears to have had no formal training of any kind and no contemporary mentors in the profession. Presumably he also studied, in situ or via prints, the works of modern masters (such as Palladio, Peruzzi, Raphael, Bramante, Giacomo della Porta, Maderno, and, especially Michelangelo), as well as the important texts: Vitruvius, Alberti, Palladio, Serlio, Vignola, and Scamozzi. For Bernini's reference to Serlio's *Tutte l'opere d'architettura et prospettiva,* see Chantelou, September 19, f.188, e.208; for his citation of Alberti's *De re aedificatoria,* see Tessin, 160.

For Bernini's formation as an architect, see Thoenes; Bauer, 1996; Marder, 1998a, 19–21; McPhee, 2002, 40–43; and Antinori, 2004; for Bernini's theory of architecture, see Domenico, 32 and 39, and commentary. The "Osservazioni dal discorso del Sig.re Cav.ro [sic] Bernini," recorded in ca. 1673–74 by the Swedish architect Nicodemus Tessin the Younger (1654–1728), is another contemporary source for Bernini's thoughts on architectural theory and practice: see note 6 above. As Marder, 1998a, 20, reminds us: "Like his modern counterpart, the seventeenth-century architect's strength lay not in technical expertise, for which the masons and foremen were better qualified, but in matters of formal invention that depended on a knowledge of tradition in the particulars and of theory in broader compositional matters. . . . While [the various tasks incumbent upon the early modern architect] were specialized and challenging, they were not learned exclusively from apprenticeship in the building yards. . . . Indeed, the list of painters and sculptors who later became famous architects is long."

8. In Paris, Bernini remarked to the Venetian ambassador that "he should really have been a painter rather than a sculptor because he produced with a certain ease" (Chantelou, October 6, f.228, e.259). In contrast, see Baldinucci, i.140–41, e.74, who diminishes the status of painting in Bernini's life: "He knew from the beginning that his strong point was sculpture. Thus, although he felt a great inclination toward painting, he did not wish to devote himself to it altogether. We could say that his painting was merely diversion."

9. On p. 178, Domenico says instead that his father produced more than two hundred canvases, yet another inflation of numbers we find throughout this biography. Baldinucci, i.81, e.15–16, says little about Bernini's paintings: "During this period, without neglecting the study of architecture, he painted a great number of pictures both large and small which today display their splendid qualities in Rome's most celebrated galleries and in other worthy places. We will speak of these in detail elsewhere." That "elsewhere" is i.141, e.74, but the brief discussion there adds little to what Domenico tells us: it places the number of extant paintings at one hundred and fifty and again dismisses Bernini's painting activity as mere personal entertainment (see note 8 above). No paintings are included in Baldinucci's appended catalogue of Bernini's works. See also notes 10 and 11 below.

10. The only painting securely attributed to Bernini in the former Grand Duke's collection is the fine self-portrait of ca. 1630–35, acquired from the artist himself in 1674 through the mediation of Florentine painter Ciro Ferri and Paolo Falconieri, agent of Cardinal Leopoldo de' Medici (see Petrucci, 2006, 316–17, cat. 10; and Montanari, 2007, cat. 3). One of the

identifiable Barberini paintings is the *Saints Andrew and Thomas* (ca. 1626–27, National Gallery, London), representing the sole Bernini canvas whose attribution, approximate date, and provenance are known (see Petrucci, 2006, 340, cat. 29; and Montanari, 2007, cat. 17). There are no known paintings securely by Bernini in France (the autograph status of the early self-portrait in Montpellier is disputed: see Petrucci, 2006, 315, cat. 8; and Montanari, 2007, cat. 6).

11. Baldinucci, i.130, e.64–65, explicitly says that the *Saint Maurice* altarpiece (1638–40, Pinacoteca Vaticana) was "painted by Bernini and not by Carlo Pellegrini his disciple as everyone says," adding that "this work, when compared with the beautiful works of sculpture by the same artist, leads one to truly doubt whether it was in painting or the art of statuary that he made his name shine forth." All documentation relating to the commission and execution of the altarpiece speaks only of Pellegrini as its maker; but the insistence on Bernini's authorship by our two biographers (and other early sources) seems to suggest that he indeed played a significant role in the design and creation of the work. While the critical consensus would appear to be that Bernini certainly provided a design for and close supervision over Carlo Pellegrini, there is disagreement as to how much, if any, of this finished canvas comes from the master's own hand. See *Bernini in Vaticano*, cat. 39; Rice, 1997, cat. 7; Petrucci, 2006, 152–57, and 348–49, cat. 35; and Montanari, 2007, 61–66 and cat. 23.

12. The current location of the self-portrait formerly in Casa Bernini (if indeed surviving) is unknown. For the self-portrait in the Grand Duke's collection (as of 1674), see note 10 above. Bernini produced several self-portraits, on both paper and canvas, over the course of his lifetime: the earliest known one would seem to be the drawing, dated ca. 1612, in the Museo Horne, Florence (*Marmi vivi*, cat. 2), while the last is also a drawing, dated 1678–80, in the British Museum (Montanari, 1998b, 367 and fig. 34; Petrucci, 2006, 179 and fig. 187), only slightly preceded (according to Sutherland Harris's new dating) by the drawing in Windsor of ca. 1678 (Montanari, 2007, cat. 30; once believed to have been done during the artist's Parisian stay in 1665). For the self-portraits, see also Petrucci, 2006, 171–85 and cats. 1–13; Montanari, 2007, cats. 1–4; and Bacchi-Hess-Montagu, cat. 1.1 (oil on canvas, ca. 1623, Galleria Borghese); 3.1 (chalk drawing of ca. 1625 at the Ashmolean, though its status as self-portrait is debated); and cat. 3.13 (the late drawing at Windsor); and *Marmi vivi*, cat. 2. For portraits of Bernini by other artists, see note 30 below to Domenico, 177.

13. None of the three extant Bernini household inventories (1681, 1706, and 1731) mentions a painted portrait of Costanza by Bernini. The 1681 inventory lists one canvas—artist unspecified but presumably Bernini—bearing the double portrait of our artist and an unidentified woman, "una mezza Testa di Donna" (Martinelli, 1996, 255). The 1706 inventory again lists the two portraits (Bernini and a still-unidentified woman, "mezza testa di donna") but says that the canvas has been divided into two, i.e., the two portraits were separated since the last inventory (BALQ, 110). The separated portraits were still in Casa Bernini in 1731, according to the inventory drawn up in January of that year (Martinelli, 1996, 262).

It has been traditionally and very reasonably assumed that Costanza is the unnamed woman of this double portrait, but there is no documentary proof of this assumption and the canvas is now lost. Instead, the marble bust—listed in Baldinucci's catalogue of Bernini's works (i.177, e.113) as a portrait of "Costanza Piccolomini [in the] Gallery of the Grand Duke [of Tuscany]"—is extant and now in the Bargello, Florence. It is dated to 1636–38, corresponding to the approximate period of the amorous relationship between Bernini and Costanza. For the bust, see Montanari, 2007, cat. 14; Bacchi-Hess-Montagu, cat. 4.3; and *Marmi vivi*, cat. 29 (pointing out [p. 329] that by November 1646 the bust was in the granducal collection, having been given as a gift to Cardinal Giovanni Carlo de' Medici).

Domenico here applies to the Costanza portrait a witty remark of his father's (about being in love "with the original") used with both Queen Maria Teresa of France and Cardinal Sforza Pallavicino, as, respectively, Domenico, 136, and Baldinucci, i.148, e.81–82, tell us. As for "the original" Costanza, thanks to research by Sarah McPhee, we know something about the woman herself: born ca. 1614, she died in Rome in 1662, several years after her husband, leaving behind a young daughter, Olimpia Caterina (McPhee, 2006, 325, reports the surviving daughter's age at

seven, which, if correct, would mean that Costanza gave birth to her only—or only surviving—child at the late age of ca. forty-one, one year after her husband's death).

Bearing an aristocratic maiden name (Piccolomini), though not necessarily of high birth, Costanza, by the end of her life, had become a person of not insubstantial wealth and social status, as the contents of her house and her distinguished manner and place of burial (Santa Maria Maggiore) would strongly suggest (McPhee, 2006, 326–30). McPhee has found and published her last will and testament—in which she refers to herself as "Costanza, daughter of the late Leonardo Piccolomini of Viterbo, and once wife of the late Matteo Bonucello [sic] of Lucca"—as well as the postmortem inventory of her personal possessions (331–71, 332 for the quoted self-description).

Domenico does not mention what he surely knew—that Costanza not only was a married woman at the time of her affair with Bernini but also that her husband, Matteo Bonarelli (or Bonuccelli, Bonucello), was one of Bernini's own studio collaborators (for Matteo, see McPhee, 326–27, with discussion [n. 43] of the varying spelling of his last name; Matteo is mentioned by Domenico, 47). However, their marriage survived Costanza's infidelity, and indeed in his own will her husband (d. 1654) refers to her as "my most beloved wife" (McPhee, 2006, 325). The fragmentary nature of extant documentation still leaves various, vexing questions about Costanza's identity, social status, marriage, and love affair with Bernini and its aftermath. How could a supposedly "respectable" woman engage in a rather public extramarital affair not only with Bernini but with his brother Luigi as well and suffer no long-term consequences to her moral status in Roman society? Did her husband or other male family member make no honor-preserving response to either her egregious infidelity or Bernini's violent act of revenge? For Luigi's involvement and Bernini's revenge, see note 15 below.

14. The only mention of Costanza or her bust in Baldinucci's narrative is on i.86, e.21, as an appendage to the report of her husband's contribution to Bernini's *Matilda of Canossa* monument. The bust also appears in Baldinucci's appended catalogue of Bernini's works, where she is given her maiden name, Piccolomini. Later in the biography itself, naming no names, Baldinucci, i.134, e.68, concedes the fact of some youthful indiscretions on Bernini's part but denies any genuine impropriety: "[A]although it may be that up to his fortieth year, the age at which he married, Cavalier Bernini had some youthful romantic entanglements without, however, creating any impediment to his studies of the arts or prejudicing in any way that which the world calls prudence, we may truthfully say that his marriage not only put an end to this way of living, but that from that hour he began to behave more like a cleric than a layman." But see the Introduction, section 8, for discussion of this disingenuous claim on Baldinucci's part.

15. For the most complete account and analysis of the infamous Costanza affair, see McPhee, 2006. Briefly, in revenge for his lover Costanza's betrayal, with his own brother Luigi no less (whom he caught leaving her house one morning), Bernini sent a servant to slash her face. For this assault, Bernini was fined 3,000 *scudi* but later was absolved by the pope. These details come from an anonymous account among Filippo Baldinucci's manuscripts in Florence, which he omitted from his biography. Nicodemus Tessin the Younger's notebooks also mention the slashing of Costanza's face by Bernini. For these two documents, see McPhee, 2006, 320–21 and 325; see 321 for the text of Bernini's mother's undated letter to Cardinal Francesco Barberini pleading for his help in "taming" the wild Bernini, who has tried to murder his brother Luigi.

The undated letter does not mention the reason for the attempted homicide, but one assumes the reason is the Costanza-Luigi betrayal. Thomas and Elizabeth Cohen have pointed out that although the slashing of an unfaithful lover's face may seem monstrously violent to us today, Bernini was in fact playing out a not-uncommon form of revenge ritual (or *dispetto*) on the part of an offended male in Baroque culture (personal communication, October 7, 2007).

16. It might at first seem surprising that in the midst of a thoroughly hagiographic family biography, Domenico would draw attention to such a grave moral indiscretion (indeed, crime) on his father's part. However, in reality, the episode directly serves the purposes of the author's higher apologetic goal, as his subheading alerts us: "*Singular Display of Papal Esteem Toward the Cavaliere.*" See also the entry in Domenico's original index, under "Urbano VIII":

"Con singolare indulto l'assolve da un trascorso giovenile" (With a singular dispensation [Urban] absolves [Bernini] of a youthful lapse in behavior).

Clearly the episode is here to provide an opportunity for commemorating yet another form of supreme recognition of Bernini's worth and reputation from a contemporary of exalted status—the pope himself. There is not the least bit of contrition reported here on Bernini's part. Nor is any real moral blame imputed to him by his author-son, who minimizes the gravity of the crime, with a "boys will be boys" attitude (as most likely the pontiff did himself as well), even though "the boy" in this case was at least thirty-eight years old. See also Levy, 2006, 163, who observes that the episode in effect represents another example of what Domenico elsewhere emphasizes as one of his father's professional talents, that of turning defects and disadvantages into triumphant advantage.

17. Here and throughout the book, Domenico uses in generic fashion the word *lapis* (which I translate as "pencil") to describe the instrument with which Bernini created his drawings, although we know our artist used a variety of means, especially red and black chalk: see above Domenico, 15, note 43.

18. See Baldinucci, i.140 e.73–74. Baldinucci specifies as well the significant examples of Bernini drawings in the collection of Cardinal Leopoldo de' Medici, not mentioning that he himself was keeper of that collection and had in 1673 published his guide to master drawings, *Lista* (or *Listra*) *de' nomi de' pittori di mano de' quali si hanno disegno*. (As Montanari, 1998c, 33, points out, the Medici collection actually contained only fourteen drawings that could be securely attributed to Bernini.)

Acknowledging as well the "sending" of many drawings to France, Baldinucci further specifies (unlike Domenico) that the "Chigi family possesses many" and concludes with a general assessment of the quality of Bernini's drawings: in them "one notes a marvelous harmony of composition (*simmetria*), a great sense of majesty, and a boldness of touch that is really a miracle." Today, unfortunately, of the countless number of drawings the artist produced during his lifetime (be they academic studies, preparatory sketches for works in progress, or fully polished presentation pieces), only a mere fraction survives. (I have recently discovered a previously unknown and undocumented Bernini workshop presentation drawing for a tomb monument, which dates to ca. 1669 and was most likely intended for the recently deceased Tommaso Rospigliosi: the study of the new drawing is now being prepared for publication.)

The most complete catalogue remains Brauer and Wittkower (though much in need of updating); see also Sutherland Harris, 1977; Lavin, 1981; Blunt and Cooke (the catalogue of the Royal Collection at Windsor, another particularly rich deposit of Bernini drawings), as well as passim in the two recent catalogues of Bernini's paintings, Petrucci, 2006, and Montanari, 2007. See below Domenico, 161–62, for mention of a member of Bernini's household staff who maintained his own family for twenty years from the sale of the artist's drawings and *modelli* in his possession. For Bernini's own appreciation for master drawings, see Chantelou, July 6, f.71, e.54, where the artist confesses that "he derived the utmost enjoyment from seeing the first productions from the minds of great men; in them one saw the splendor of a pure, clear, and noble idea . . . ; the drawings of a great master were to a certain extent more satisfying than the works that he executed from them after great study and care."

19. For Domenico's *lapis* as "pencil," again see above cautionary note 43 to Domenico, 15. As Petrucci, 2006, 428, cat. 33, observes, the self-portrait here in question may be either that at Windsor Castle or that in the British Museum, both showing Bernini in advanced age. "One of the most important art collectors of the seventeenth century" (Anselmi, 2007, 192), the Spanish marquis also owned an untraced painting by Bernini (*Portrait of a Young Man with Drawing in Hand*), a *modello* of the Fountain of the Four Rivers in the Piazza Navona, two terra-cotta *mascheroni* (grotesque masks serving as architectural ornamentation), and the newly rediscovered small gilt bronze equestrian statue of Spanish King Charles II, based upon the *Louis XIV Equestrian*. Not all agree, however, as to the autograph status of the latter bronze. For all the preceding works, see Petrucci, 2006, 428, cat. 33; for the bronze, see also Montanari, 2003a. The very late self-portrait in question, however, has not been satisfactorily identified, if indeed it survives.

The extravagant Gaspar de Haro y Guzman, 7th Marqués del Carpio (1629–1687), Spanish Ambassador to Rome (1677–82) and enthusiastic patron of artists, was Spanish Viceroy of Naples from 1683 to his death. Since Domenico does not refer to him under his more august title of Viceroy, one presumes this section of the biography was written before his nomination to his Neapolitan post and never revised. For Don Gaspar (also known as the Marqués de Eliche, or Heliche or Liche), see Burke and Cherry, 1:462; Grove Art Online, s.v. "Carpio, Marquéses de"; and, especially, Marías (for his drawing collection); and Anselmi, 2007. Montanari (2003a, 411) sees at work here in Domenico's gift to Don Gaspar a conscious Bernini family effort to forge better ties with the Spanish crown after relations with the French court had gone sour. For Bernini's work for and attitude toward the Spanish, see note 48 above to Domenico, 16.

20. For Bernini's art of caricature, see Baldinucci, i.140, e.74, calling it "a particular product of his boldness" and specifying that the humorous portraits were done "without taking away their likeness or grandeur if the subjects were, as often happened, princes." Even though Bernini was not the originator of the caricature as an art form (that distinction belongs to Annibale Carracci), he certainly infused new life into it and helped popularize it as a genre unto itself. In Chantelou, August 19, f.127, e.129, annoyed by Louis XIV's courtiers who were disturbing his sketching, Bernini threatens, "I have a good mind to make a caricature of one of them." Discovering they do not understand the term, Chantelou is obliged to explain. Later in Chantelou, September 10, f.172, e.187, Bernini demonstrates, "with a couple of strokes," the caricature technique for the king. For Bernini's caricatures and social satire, see Sutherland Harris, 1975; and Lavin, 1990; on the history of the caricature, see also, more summarily, Stanić's and Bauer's notes to Chantelou, f.127 and e.129, respectively.

21. I here translate Domenico's invenzione as "genre," but elsewhere more literally as "invention," as is conventional in art-historical terminology in English. In early modern art discourse, "The word 'invention,' like 'disegno,' was used to signify two different capacities, or perhaps one should say two very different degrees of capacity. It could mean that mental faculty which enabled a great artist to conceive a new idea, a formula whose power emanated from both its aptness and its novelty; or it could mean little more than drawing, in our sense of the term, the way in which the conventional elements of a traditional formula were shifted and redisposed to create a new, but essentially uninventive image" (Montagu, 1989, 90). The term derives, like most of the technical vocabulary of early modern art theory, from the manuals of classical rhetoric, referring to, above all, the initial step in the process of composing a public oration or a work of art: as such "it conveys a sense of 'conception' or 'idea,' and is an esteemed procedure" (Kemp, 313). As an "esteemed procedure," see Vitruvius's definition of inventio as "the solving of intricate problems and the discovery of new principles by means of brilliancy and versatility" (quoted by Rubin, 259). However, it behooves us to note that Domenico, decidedly no art critic and no art historian, does not always necessarily use the word (or any of the vocabulary of art theory) with precise, subtle, theoretical connotations.

22. A major figure in the cultural life of late seventeenth- and early eighteenth-century Rome, Antonin Cloche, O.P. (not "La Cloche," as Domenico calls him), was born in Saint-Sever, France, in 1628 and died in Rome in 1720. Master General of the Dominican Order from 1686 until his death, he played an important role in the organization of Rome's Biblioteca Casanatense. A portrait by Carlo Maratti, later engraved by Étienne Gantrel, is extant. For Cloche, see Vicini Mastrangeli, 504–6. Villa San Pastore (since 1845, property of the Pontifical German College of Rome) is about thirty kilometers southwest of Rome, near Palestrina. In a letter of secondary dedication to Prince Niccolò Maria Pallavicino, "Lord of the Terra di Gallicano," in volume 4 of his Historie di tutte l'heresie, Domenico mentions that it was within Prince Niccolò's territory that he wrote his weighty tomes on heresy. Domenico does not specify further where he was living during his "long retreat" there, but presumably it was not in one of the prince's own residences, for he does not say so outright. The locale in question could have been the Dominican Villa Pastore, thus explaining Domenico's gift of his father's caricatures to Cloche as a token of thanks.

23. For the corresponding section in Baldinucci, see i.145, e.78–79, where the same painters are listed in the same ranking. Bernini's theory of painting and response to specific painters

is too large and complex a subject to attempt a summary here; see, most recently, the thorough introductions to Petrucci, 2006, and Montanari, 2007. Of the many references to painting in general and specific painters and their paintings in Chantelou's *Journal*, one in particular is here especially worthy of note, that of June 8, f.50–51, e.21–22, in which Bernini enunciates a further important principle for judging truly good paintings: "those paintings which are not constructed on correct principles nor based on a groundwork of drawing, which are distinguished only by lovely coloring or an unskilled charm, please only the eye and not the mind, which searching for satisfaction recoils with disgust from works not designed strictly according to good rules and imbued with intelligence and knowledge." Bernini then goes on to explain that this is why Michelangelo's paintings are of greater value than those of Barocci. As Bauer notes (n. 60 to Chantelou, e.22), the kernel of Bernini's principle goes back to Vitruvius, adding: "The irony is that in the 18th and 19th centuries Bernini came to play the role of Barocci in the same argument" about the inferiority of works of art whose appeal is judged to be merely surface by the prevailing aesthetic standards of the day. For other passages in Chantelou pertinent to Bernini's theory of painting, see the thorough index to the 2001 French edition of the *Journal*, s.v. "Bernin: Propos sur l'art," in addition to the entries under individual artists.

24. In Baldinucci, i.145, e.78–79, the aquatic image is slightly different: Raphael is "a bottomless vessel that collected waters from all the springs." In Chantelou, however, Bernini admits to some limitations to Raphael's art: for example, he is not a helpful model for student painters in learning the "grand manner" (September 5, f.156, e.167), and he did not explore the nature of color as had the Lombards (October 6, f.227, e.258). In any case, the description of Raphael's excellence as a result of his eclectic borrowing of the best from earlier masters is not original to Bernini: see Vasari, *Life of Raphael*, 318 (trans. Bull, Penguin, 1965 ed.): "From this painter [Fra Bartolommeo] Raphael took what suited his needs and inclination . . . and to this he added various methods chosen from the finest works of other painters to form from many different styles a single manner which he made entirely his own and which always was and always will be the object of tremendous admiration."

By the seventeenth century, the idea of a painter eclectically selecting and mixing individual traits from the styles of a host of past masters, thus "producing a perfect *misto* that accommodated the best quality of each individual artist," had become a common trope (see Loh for a discussion of this point, 484 for the quotation; see also Cropper, esp. chaps. 3 and 4). Bernini applies the same *misto* (blend) trope to Annibale Carracci, whose name had long been associated with such a process: see note 25.

25. The names of Correggio and Titian come up in appreciative fashion many times in Bernini's conversations as recorded by Chantelou, but never in the context of a global evaluation of their style. For the reference to Bernini in a 1680 Roman *avviso* as the "Titian of Our Times," see the Introduction, section 7. As for Carracci, in Chantelou, July 5, f. 70, e.52, Bernini "gave the highest praise to Annibale Carracci," doing so by means of another version of the eclectic "borrowing-from-the-best-masters" topos applied in Domenico to Raphael (see note 24 above): Annibale "had combined the grace and draftmanship of Raphael, the knowledge and anatomical science of Michelangelo, the nobility of Correggio and this master's manner of painting, the coloring of Titian, the fertile imagination of Giulio Romano and Andrea Mantegna. His manner was formed from the ten or twelve greatest painters as if by walking through a kitchen with a spoon he had dipped into each pot, adding from each a little to his own mixture." See Loh, 484, who quotes Bellori using a very similar description of Carracci by Francesco Albani (1578–1660); but Loh later (487) suggests that Bernini's own description of Carracci may have been taken from Malvasia's *vita* of Annibale. As Stanić reminds us in his note to this passage (Chantelou, f.70, n.2): "The eclecticism of Annibale Carracci was a commonplace of art discourse since the end of the sixteenth century"; see also Bauer's n.21 to Chantelou, e.52.

Noteworthy in Bernini's list of the greatest painters (and, in fact, in all of Domenico's text) is the absence of Nicolas Poussin. Praised to the skies by Bernini in Chantelou, Poussin's canvases in Paris sent Bernini into ecstasy. The latter displays of emotion may, however, have been diplomatic dissimulations for the benefit of his French companion, Chantelou, a personal friend to

Poussin and owner of many of his paintings. For Poussin and Bernini, see the Introduction, section 7, note 118. Hibbard, 1965, 171–72, instead, sees Bernini's praise of Poussin as completely sincere, explaining—unpersuasively—that Bernini "apparently was not very familiar with Poussin's works before coming to Paris." As for Michelangelo, in view of the various criticisms raised against his "hard" style by Bernini in Chantelou (see the Introduction, section 7 for discussion of *tenerezza*), it is not surprising to find his name absent from Bernini's short list of the greatest painters.

26. Regarding Guido Reni, Baldinucci, i.145, e.79, reports Bernini as saying more specifically that the Bolognese artist "had a style enriched by such fine concepts that his paintings delight not only skilled artists but also the uneducated." Reni (1575–1642) was in Rome at various times: from late 1601 to 1614; again in 1627 in a failed attempt to paint the Benediction Loggia; and then finally and briefly in 1632. In Chantelou's *Journal*, Bernini recounts various anecdotes involving Reni (see July 25, f.89, e.80, and October 13, f.256, e.296), giving the impression that the two men were on somewhat familiar terms with each other. Despite the vague, almost evasive tone with which Domenico seems to communicate his father's opinion of Guido, Bernini's judgments of Reni's canvases in Chantelou are usually extremely positive, if not indeed ecstatic: for example, on July 16, f.78, e.64–65, examining Reni's *Annunciation* altarpiece in the Carmelite Convent (now in the Louvre), Bernini praises it as "an object as beautiful as you could see anywhere, which alone was worth half Paris" (see also August 9, f. 110–11, e.108, and October 11, f.250, e.288).

27. This section addresses the long-standing debate on the *paragone,* or competition and comparison between painting and sculpture as rival means of representing reality. The issue is too complex to summarize and discuss here: see Ostrow, 2004 (regarding the art of Pietro Bernini) and 2007 (regarding Gian Lorenzo). The issue also comes up in Baldinucci more briefly (see i.145–46, e.79) and passim in Chantelou, beginning with June 6, f.48, e.17–18; see also October 6, f.228, e.259. In reading the passages devoted to Bernini's art theory in this chapter and elsewhere in this biography, again we must keep in mind that our author, Domenico, was no art theorist, nor art critic, nor art connoisseur. Hence we should not expect a complete, refined, or technically adept exposition of the subject. Domenico is simply repeating from memory disparate theoretical observations he presumably heard spoken by his father, without necessarily understanding their full significance or nuances, or using technically expert vocabulary.

28. "mendicati colori": Battaglia's historical *Grande Dizionario della lingua italiana* (10:70) gives as one subset (#6) of meanings for the adjective *mendicato* "privo di naturalezza e di spontaneità, artefatto, artificioso, innaturale, illusorio," citing a text from the Theatine preacher Paolo Aresi (1574–1644), "Un ben che si possiede per naturale è maggiore di quello che si possiede per arte, come la bellezza naturale, che quella che s'acquista con mendicati colori." Instead, Chantelou (August 24, f.139, e.146) quotes Bernini as saying that painting has "the advantage of *natural* coloring" (aidée de toutes les mêmes couleurs du *naturel* [emphasis added]).

29. The same analogy is also found in Baldinucci, i.146, e. 79; in Chantelou, June 6, f.47, e.16; and in the diary of the English sculptor Nicholas Stone Jr. (d. 1647), recounting his visit to Bernini's studio in Rome (N. Stone, 170–71). Stone's diary, by the way, also records Bernini's account of the creation of his *Thomas Baker* bust, for which see Domenico, 66–67 and commentary.

30. Bernini is obviously referring here to sculpture carved in stone, as opposed to that cast in bronze, the latter produced through a process that involves modeling in clay, not "subtraction" from stone. However, for clay modeling as preparatory to all of Bernini's sculpting, including in marble, see commentary to Domenico, 5 (Bernini's training under his father Pietro), citing the thesis of Claude Dickerson.

31. Baldinucci, i.143, e.76–77: "Bernini wanted his students to fall in love with that which was most beautiful in nature. He said that the whole point of art consisted in knowing how to recognize and find it." See Domenico, 5–6, and commentary for an earlier statement about the imitation of the beauty in nature.

32. The corresponding passage in Baldinucci is at i.144, e.77.

33. The corresponding passage in Baldinucci is at i.144–45, e.78. However, this would seem to contradict Bernini's belief that art is about imitating what is most beautiful, most perfect in nature. Resolution of this apparent contradiction may perhaps reside in the fact that Bernini does not call this form of painting (the "fine" depiction of "ugly" subjects) necessarily the highest or most desirable form of art. In any case, the observation—that repulsive things exquisitely painted bring pleasure—is, yet again, not original to Bernini: "It was already a commonplace in Italian art literature of the late sixteenth century that horrible things beautifully represented could generate pleasure," the authority for which idea was Aristotle's *Poetics* (Hipp, 200). See the discussion in Bellini, 2006, 288–89, who points out that the ugly-woman topos is also discussed by Bernini's friend and fellow Barberini courtier Agostino Mascardi.

34. Again, contrast this statement with that of Baldinucci, i.140–41, e.74, minimizing the status of painting in Bernini's life: "We could say that his painting was merely diversion."

35. Many episodes in Chantelou's *Journal* attest to Bernini's delight in looking at paintings and his obvious skill and experience in discussing questions of attribution and connoisseurship in general. However, contrary to what Domenico says in the next line, Bernini, while in Paris, had no hesitation in criticizing the works of other artists (and architects), especially the French ones, as duly noted by Chantelou.

36. Baldinucci, i.141–42, e.75, gives very much the same account, in which, however, the unnamed artist in question is described simply as "one of [the cardinal's] very favorite artists" and the cardinal himself as being "with little understanding of art." Yet again, while in France, as reported on many occasions in Chantelou, Bernini did not hesitate to openly criticize the work of other artists and architects, this being one of the factors undermining his rapport with his French hosts, especially Colbert. Of the many cupola frescoes created in Baroque Rome (for a complete summary catalogue, see Gloton, 169–89), I would conjecture that Domenico is referring here to Cigoli's *The Immaculate Virgin in Heaven with God the Father* (1610–12, Santa Maria Maggiore, Cappella Paolina), whose deficiencies immediately became the object of harsh criticism, generating a debate that became a "cause célèbre" (see Matteoli, 249; Contini, cat. 35; Ostrow, 1996, 209–10; and Tuzi, 22, for "cause célèbre"; see also D. Stone, 211, who publishes a letter from Cigoli to Galileo acknowledging the negative reaction to his cupola fresco).

Cigoli died in 1613, when Bernini was only fifteen, but there is nothing in Domenico's account here indicating that the artist in question was still alive at the time of Bernini's remark. The cardinal in this anecdote would therefore be Scipione Borghese, patron as well to Bernini. Bernini's unwillingness to criticize the cupola was likely a reflection as much of his fear of offending a powerful cardinal patron as it was of his professional courtesy toward a fellow artist (see Cropper, 2005, 5, quoting Antoine Coypel's recollection of the same fear on Bernini's part vis-à-vis Scipione in yet another case of negative artistic judgment). Scipione employed Cigoli in 1611–13 in his garden palace (now the Palazzo Pallavicini-Rospigliosi) on the Quirinal Hill, where he executed the fresco cycle of *Amor and Psyche* (Matteoli, 249). The cupola fresco in Santa Maria Maggiore represented a papal commission, but here Domenico does not say the cupola fresco itself was commissioned by the unnamed cardinal, only that the cardinal had had the artist in his employment. Despite the imperfect outcome of the fresco, both the Borghese pope and cardinal maintained their support of their artist Cigoli: see again D. Stone, who publishes a series of documents revealing Scipione's intense involvement in the advancement of Cigoli's reputation, specifically in the form of his nomination as Knight of Malta.

37. See Baldinucci, i.142, e.76, for the corresponding passage.

38. In Baldinucci (i.142, e.75–76), this claim by Bernini is followed by a quotation from Sforza Pallavicino: "What you say of your art I say of mine, that the fact that there are insoluble arguments against something is not a sign of the falsity of the hypothesis, although it raises doubts, but whether there are solid and convincing reasons that prove the conclusion. Yet the philosopher Zeno used such arguments as proofs, and to this day that which he left has not been demolished." For an analysis of Pallavicino's observation in the context of Baldinucci's *vita*, see Delbeke, 2004.

39. In this section, Domenico strings together, with no compelling logical connection between them, several of his father's pronouncements regarding architecture. The corresponding passage in Baldinucci, i.146–47, e.80, begins with a reference to Bernini's "splendid precepts" (i.e., plural) on architecture, but he discusses only one—that of turning disadvantages into advantages. For Bernini's education as architect, see Domenico, 26 (his study of ancient buildings), and commentary; for further theoretical pronouncements on architecture by Bernini, see also Domenico, 39 *(Material and Workmanship of the "Confessio")*, and commentary. There has been no comprehensive, systematic analysis of Bernini's various utterances on architecture scattered among the primary sources and it is beyond the scope of the present work to do so here. Let us note only that, besides Domenico and Baldinucci, four other important sources of Bernini's theory of architecture are: Chantelou's *Journal* (see, e.g., June 2, f.43, e.9; July 1, f.67, e.48; July 22, f.84, e.71; August 23, f.134, e.139–40; and September 7, f.165, e.178); Tessin's "Osservationi dal discorso del Sig.or Cav.ro [sic] Bernini"; and Bernini's two formal opinions (1652 and 1656) regarding the Duomo of Milan (published, with summary analysis, by Fagiolo dell'Arco, 2002, 185–91). For the influences of earlier architecture and architectural theory on Bernini-architect, see Askew; Boucher; Ray; Thoenes; Bauer, 1996; and Marder, 1999a and 2000a. For Bernini's architectural works themselves, see, among the comprehensive studies, Borsi; and Marder, 1998a. Further literature on Bernini's individual works is cited as we come to them in the narrative below.

40. Bernini seems to be saying that it is more fruitful to study the individual components and ornament of an ancient building (its majestic "parts") since its general, underlying structure (its "whole") has less to teach the student of architecture because it is deficient in the important quality of convenience of habitation. In his observations on the Duomo of Milan (see note 39), Bernini says the parts of a building are to be subordinated to the whole. On the question of architectural theory, see also Tessin, who quotes Bernini as saying that every building should inspire "stupore e maraviglia" (wonder and marvel). Tessin also records Bernini's self-defensive claim that sculptors and painters—who are experts in human anatomy—make the best architects since "architecture derives from the proportions of the human body" (Tessin, 158, 159).

41. Ironically, this is perhaps the principal criticism that Colbert consistently raised against all of Bernini's proposals for the new Louvre: in pursuit of magnificence of appearance, Bernini ignored or otherwise sacrificed the practical necessities and conveniences of the king and his household (such as protection from noise and safeguard against assassins). This grave deficiency also helped bring the project ultimately to failure. For Colbert's criticisms and Bernini's balking at having to deal with mundane details, see, e.g., Chantelou, June 19, f. 60–61, e.36–37; and July 30, f.99, e.93; see esp. August 19, f.126–27, e.128–29, for Colbert's detailed memorandum to Bernini "giving a full description of everything necessary for the comfortable accommodation of His Majesty" and his household. See also appendix 2 of Stanić's 2001 edition of Chantelou for the texts of Colbert's formal critiques of Bernini's three Louvre projects. For Bernini's Louvre project, see Domenico, chaps. 16, 17, and 18, passim.

42. See Domenico, 57, for another version of this statement of Bernini's and a list of case studies involving his fountains, beginning with that of the *Barcaccia* in the Piazza di Spagna. Other examples involve the Urban VIII coat-of-arms window in the Aracoeli; the door within the tomb of Alexander VII; and the window in the Cathedra Petri (Domenico, 60, 110, and 166, respectively). See Chantelou, October 9, f.239, e.274, for Bernini's related dictum, "Chi vuol veder quel che un uomo sa, bisogna metterlo in necessità" (If you want to see what a man knows, put him in a difficult position).

43. Troubled architectural genius Francesco Castelli, who assumed the name Borromini, was born near Lugano in 1599 into a family of architects, masons, and other artisans of the building trade. After an apprenticeship in Milan, he moved to Rome in 1619, where through Carlo Maderno (a relative of his mother's) he soon found work as a mason at Saint Peter's Basilica. He rose quickly through the ranks of his profession, thanks to both his extraordinary talent and his mentor Maderno, who (since 1603) had been Architect of Saint Peter's. His association with

Bernini began in 1624 as collaborator in the massive Baldacchino project, an experience that was to generate a lifetime of resentment against Bernini (see Domenico, 76, and commentary).

In Rome, he constructed a brilliant if at times controversial series of edifices of truly original inspiration, the most celebrated being the churches of San Carlino alle Quattro Fontane and Sant'Ivo alla Sapienza. His difficult and increasingly erratic personality eventually undermined his professional career in his later life, despite the support of the powerful prelate, Innocent X's architectural consultant, Virgilio Spada (for whom see commentary to Domenico, 79, regarding Innocent X's ill-intentioned "minister"). Eccentricity becoming psychosis, he died, tragically, a suicide in August 1667.

Domenico here, and even more explicitly on p. 112, identifies Borromini as a former student of Bernini's, an inaccurate label, since by the time Borromini began his association with the Bernini workshop on the Baldacchino project he was twenty-five years old, with an impressive architectural pedigree to his name, thanks to his family origins, years of formal training, and privileged work experience alongside Maderno, one of the leading architects of his generation. For Borromini's life and career (and conflict with Bernini), see Wittkower, 1975; Connors, 1980, 1998, and 2000a; Burbaum; Marder, 2000b; Raspe (for his last days and suicide); Morrissey (in a popular vein); Portoghesi, 2001; and, more summarily, *Grove Art Online*, s.v. "Borromini, Francesco."

44. For the corresponding passage about architectural heresy in Baldinucci, see i.148–49, e.82, where, however, Borromini's name is not mentioned and Bernini's interlocutor is identified as an "important prelate." In any case, the second party of this conversation may possibly have been Pope Alexander VII: according to a contemporary chronicler, the "Pontiff [Alexander VII] said that the style of the Cavalier Borromini was gothic, nor is this surprising, since he was born in Milan where the Duomo is gothic" (Portoghesi, 1968, 11, citing "the learned Monsignor Cartari, professor at the Sapienza," presumably curial lawyer and prolific diarist, Carlo Cartari, despite the ecclesiastical title inaccurately given him here).

The Baldinucci passage comes in a section devoted to Bernini's clever witticisms and is followed by another example of this verbal talent, likewise at the expense of the unnamed Borromini: "One time someone, I don't know who, said to [Bernini] that a certain person who had been his assistant was a very able architect. He replied, 'You are quite right, because he cuts corners (*perché egli è tagliacantone*).'" Bernini's witty remark is not only a wordplay on the literal meaning of the Italian *tagliacantone* (corner-cutter); it is also a reference to a stock character of the *commedia dell'arte,* the foolishly ambitious braggart (for the insult, see Bösel; Portoghesi, 2001, 40; see also Tommaseo-Bellini's *Dizionario della lingua italiana,* s.v. *"tagliacantone"*).

Later, in giving a list of Bernini's disciples (*discepoli*), Baldinucci, i.154–55, e. 88, returns to the topic of Borromini's supposed "Gothic" manner, repeating that "Cavalier Borromini spent many years in the workshop of our artist learning the art of architecture and became a rather proficient master; however, because of a desire for excessive innovation in the ornamentation of his buildings, he followed his own caprice and at times deviated so far from the rule that he approached the Gothic manner." (For Renaissance—and Baroque—disdain for the Gothic style, see Payne, *ad indicem.*) According to Montanari, 2005a, 206–7, this anecdote condemning Borromini's "Gothicism" is an attempt to counter any claims or suspicions that the source of that "Gothicism" had been Bernini. See Chantelou, October 20, f.281–82, e.326 (the only passage in Chantelou that comments on Borromini's art): "We discussed Borromini, a man of extravagant ideas, whose architectural designs ran counter to anything imaginable; a painter and a sculptor in their architecture took the human body as their standard of proportion; Borromini must have derived his rule from some chimera." For further discussion of Borromini and his relationship with Bernini, see Domenico, 76 and 112, and commentary.

45. This is Domenico's formulation of the famous concept of the *maraviglioso composto,* or *bel composto,* as Baldinucci, i.140, e.74, calls it. It is one of the most frequently invoked theoretical concepts in Bernini studies, especially with regard to his chapel of Saint Teresa in Santa Maria della Vittoria (the Cappella Cornaro). However, see the discussion in the Introduction, section 7, summarizing recent critical reassessments of the concept by Delbeke and Montanari. Both

scholars demonstrate in the end that the common understanding and employment of the term as found in virtually all previous Bernini studies, upon close analysis, simply do not correspond to the formulation in the original sources: Domenico and Baldinucci.

46. Baldinucci reports none of this amusing episode, inserted here by Domenico both for its sheer entertainment value and for the further aura of artistic "wizard" that it confers upon his father's image.

47. That is, the elaborate and lengthy funeral services and panoply of attendant rites that took place over the period of nine days of official mourning for the deceased pontiff, the so-called *Novendiali* (see Pastor, 28:10), not mentioned by Domenico.

48. Inasmuch as it was the first conclave held according to Gregory's new rules, "the 1623 conclave had an experimental quality to it" (Harper, 216). For Gregory's reform of the papal election process, aimed at reducing the influence of political powers (Spain and France), see *Enc-Papi*, 3:295. Domenico, however, glosses over the unseemly political fact that another element rendering the conclave bitterly contentious was the fierce rivalry between the two ex–Cardinal Nephews and *capofattioni* (faction leaders), Scipione Borghese and Ludovico Ludovisi. The 1623 conclave has been much analyzed: see the still-indispensable Pastor, 28:1–23; and, most recently, Harper, 216–22, citing further unpublished archival sources.

49. Gregory XV died on July 8, 1623. The subsequent conclave—not especially long for the early modern period—began on July 19 and ended on August 6, the day of Urban's election; his coronation was held on September 29. Cardinal Alessandro Damasceni Peretti di Montalto (b. 1571) died weeks before the beginning of the conclave on June 2, while Cardinal Cesare Gherardi (b. 1577) died on September 30 (hence after—not before—Urban's coronation). As Domenico reports, Cardinal Maffeo himself also fell ill, his illness dramatically worsening once he had been elected. According to Giacinto Gigli's contemporary *Diario romano,* Barberini himself "was convinced that he had been poisoned and accordingly all of the remedies administered to him were those for poisoning" (Gigli, 131). Domenico, instead, is careful here to give more natural causes, which apparently was indeed the case. (Paranoia among the power elite of early modern Rome was omnipresent as well as understandable, given the actual cases of poisoning recorded in the chronicles of the times.) The disease in question was probably malaria, which killed several of the cardinals in attendance and more than forty of their *conclavisti* (personal secretaries): for malaria and the conclave of 1623, see Rocco, 43–48.

It was for the extensive Roman villa (since destroyed) of this same Cardinal Peretti di Montalto (nephew of Pope Sixtus V) that Bernini created "his first monumental fountain design" (for the fountain, see Marder, 2004, 119 for the quotation; see also D'Onofrio, 1986, 343–52). Of the fountain, only Bernini's *Neptune and Triton* group (ca. 1622–23) is extant: sold to Joshua Reynolds in the late eighteenth century, it is now in the Victoria and Albert Museum, London. Domenico makes no mention of the fountain, nor of the marble portrait bust of the same cardinal sculpted by his father, though they are both included in Baldinucci's catalogue of Bernini's works. For the long-lost bust, dated 1622–23, now in Hamburg's Kunsthalle and only rediscovered in the 1980s, see Lavin, 1985; Bacchi-Hess-Montagu, cat. 1.9; and *Marmi vivi*, cat. 6. As already mentioned, Bernini's *David* (Galleria Borghese) originally began as a commission from Cardinal Peretti di Montalto.

50. This was so since the necessary two-thirds majority had already been attained. Other cardinals claimed instead that the fact of the missing ballot invalidated the entire election, thus throwing the conclave into confusion and fierce debate (see Pastor, 28:23, who also confirms Domenico's detail of the role of Odoardo Farnese in affirming the validity of the election).

51. This—Maffeo's election pursuant to his heroically virtuous insistence upon a recount of the votes—is one of the ten scenes included in the tapestry series commemorating the life of Pope Urban VIII, commissioned by his nephew Cardinal Francesco Barberini (1663–79, Vatican Museum, Galleria degli Arazzi); for the series, see Harper (215–52 for the election tapestry in question); and, summarily, Bertrand, 122–25, 142–43. The *accessus* is a second round of voting that immediately follows an inconclusive first ballot, in which "each cardinal . . . is allowed an additional vote in favor of a candidate other than the one for whom he had voted in the ballot;

such additional votes were added to those cast in the ballot in the hope of effecting a two-thirds majority" (*New Catholic Encyclopedia*, 2003, 1:57; s.v. *accessus*). Contrary to the impression that Domenico might leave us, "Maffeo Barberini's own set of daily vote tallies . . . confirms that until the very last moment he was, in track parlance, a 'dark horse'" (Harper, 217, citing Vatican Library, Ms. Barb. Lat. 4435).

52. Saint Michael's Feast is September 29. The choice of feast was not casual: Michael, co-patron of Rome, was, together with the Virgin Mary, the city's favorite protector against the plague and other epidemic diseases (see Rice, 1992, 428–29; and Mormando, 2005, 11–12).

CHAPTER VI

1. Both Baldinucci, i.81, e.15, and Pietro Filippo also report that Urban ordered Bernini to study painting, specifically intending him to decorate the Benediction Loggia of Saint Peter's Basilica, long since an unfulfilled goal for that visually prominent and ceremonially important site (from there newly elected popes give their first papal blessing to the crowds in the square). Pietro Filippo adds that Bernini abandoned his study of painting because the pope decided that he instead wanted him to begin work on what he (and both Domenico and Baldinucci) inaccurately calls "the *Confessio* of the Most Holy Apostles Peter and Paul," the Baldacchino. (See note 4 below for the definition of the architectural complex known as a *confessio*.) Domenico, 47–48, instead claims that the Loggia decoration project came to naught because of Bernini's grave illness, whereas Baldinucci is silent on the question.

2. Namely, the Courtyard (*Cortile*) of the Belvedere within the Papal Palace at the Vatican, housing some of finest pieces of ancient sculpture in the pope's collection, such as the *Apollo Belvedere*, the *Torso*, and the *Laocoön*, all previously mentioned by Domenico (p. 13) as a special focus of the young Bernini's study.

3. Pietro Filippo recounts the same prognostication and the same response, as does Baldinucci, i.75–76, e.10–11. Bernini fulfilled this alleged prophecy with his Baldacchino and Cathedra Petri (Chair of Saint Peter). If this encounter did indeed take place, it had to have occurred before July 1609, the date of Annibale's death. As already mentioned, there is cause for skepticism over Bernini's self-aggrandizing anecdotes about personal interactions with Annibale Carracci, since in early 1605 (before Bernini's arrival in Rome) the Bolognese artist had already retired from public life because of the severe physical and emotional illness that led to his death four years later. See the Introduction, section 7, "Bernini and Annibale Carracci," as well as Domenico, 10, and commentary (note 14).

4. Domenico's Italian word *Confessione* (*Confessio* in Latin) refers here to what today is called the baldachin or Baldacchino. In the chapter heading, he calls it more awkwardly the "*Work of the Four Metal Columns Called the* 'Confessio' of Saint Peter." The "*Confessio*" *of Saint Peter* more properly refers to the elaborately decorated chapel beneath the main altar that contains the body of Saint Peter, in whose design and construction Bernini played no role whatsoever (except perhaps for its balustrade, for which see Preimesberger, 2008a, 326, fig. 1; see also note 16 to appendix 1). The untranslatable Latin word *confessio* refers to a subterranean chamber located beneath an altar usually housing saintly relics; it is an architectural ensemble well represented in early modern Roman churches: see Ostrow, 2009. Baldinucci, i.81, e.16, is also at a loss to find an unambiguous one-word name for the structure in question, calling it "the great work of the four marvelous metal columns which hold up the baldachin together with its beautiful crowning element surmounted by the cross."

The two biographers' linguistic awkwardness is understandable, for Bernini's Baldacchino was at the time of its creation a new type of structure, completely *sui generis*. As Baldinucci (i.81, e.16) remarks, "What appears to the viewer is something completely new, something he had never dreamed of seeing." Bernini's Baldacchino fused into one novel whole three traditional types of "honorific coverings": "the architectural ciborium supported on columns, the processional baldachin carried on staves, and the canopy suspended from above. . . . It is as though

Bernini joined words from different languages to form a complete sentence" (Lavin, 1980, 20; see also 2005, 114–16). As Bauer, 1996, 147, furthermore points out: "A long series of full-scale models erected in the church by every pope since Clement VIII had plainly demonstrated the inadequacy of current ideas of architecture to meet the enormous challenges presented by the site of the tomb and the scale of the new Saint Peter's." For bibliography on the Baldacchino, see note 5.

5. Baldinucci, i.81, e.16, instead reports this monthly sum as 300 *scudi*. In 1657, the Bursar (*Economo*) of the Fabbrica reported that for his work on the "ciborium" (Baldacchino), Bernini was initially paid 200 *scudi* per month, later raised to 250 once the four columns were installed (Borsi, 348). For the Baldacchino, see Wittkower, cat. 21; Bauer, 1996; Kirwin; Marder, 1998a, 27–42; Connors, 2006; and Lavin, 2005, 116–30; in the latter study (122) and, more extensively in his 2008 essay, Lavin refutes claims that Borromini had had a role in the design of the structure: "Borromini was completely extraneous to the design process of the Baldacchino" (Lavin, 2008, 282).

Baldinucci, i.82, e.16–17, reports that, as soon as word of Bernini's design for the massive columns reached public notice, "inexperienced and stupid people started the same sort of whispering campaign against him that had been raised against the great Brunelleschi by the ignorant lowlife of Florence," namely, that the final product would be monstrous and overwhelm everything else in the vicinity. Fagiolo dell'Arco, 2002, 115, quotes in full the long, detailed personal account by Bernini (first published by Oskar Pollak in 1931) in which he summarizes all of his work—with the risks and dangers to his person—in the long process of creating the Baldacchino. However, as Jennifer Montagu has remarked about the latter document: "Bernini grossly exaggerates his participation in the making of the *Baldacchino*" (Fagiolo dell'Arco, 124 n.21)

6. Baldinucci, i.81–82, e.16, also excuses himself for not giving a detailed description of the work in similar terms, referring readers to the availability of engravings, enjoyed "even in distant lands."

7. It is difficult to agree with Domenico's assessment, "non tanto in sè riguardevole," for, even "in itself," the colossal yet graceful structure of richly decorated gilt bronze is indeed "noteworthy."

8. According to the premodern, Aristotelian understanding of optics, the so-called intromission theory, objects sent forth their likeness or "species" in the form of rays that are carried through the air and penetrate the eye of the beholder (P. Berger, 2007, 51).

9. Baldinucci, i.83, e.17: "Bernini used to say that it was by chance that his work came out so well, implying that under such a great dome and in such a vast space and among such massive piers, artistic skills alone could never arrive at suitable dimensions and proportions, although, on the contrary, the artist's genius and mind could envisage the appropriate dimensions without the help of any rules." Baldinucci here evokes the *giudizio dell'occhio* (judgment of the eye) topos, a principle that Domenico will shortly cite in reporting the conversation about the Baldacchino between Bernini and Sforza Pallavicino: see note 16 below.

Even though this was a truly epochal work, unprecedented in its genre, dimensions, and technical-aesthetic challenges, Bernini, in truth, left nothing "to chance." The extremely long, careful process of designing and executing the structure involved countless sketches and drawings of every detail and angle, perspectival studies (to test visually the relationship between structure and its surroundings), and the creation of three-dimensional trial models, "progressively larger in size up to full-scale and actually built and mounted in place" (see Kirwin, 125 and 157; Lavin 2005a, 121–23, 123 for the quotation; and *Petros Eni,* cat. II.25, for a contemporary drawing of the full-scale wooden model in situ). Hence Bernini's quip is more witty than true. For a "philosophical" reading of Bernini's remark, taken at face value, see Bauer, 1996, 148; see also Lavin, 2005a, 120–21.

For a description of the aesthetic-technical challenges Bernini overcame in the Baldacchino project, see also the anonymous report, assuredly produced by one of Bernini's intimates and included in the Bernini family papers (now at the Bibliothèque Nationale, Paris, Ms. italien 2084, fols. 130–31), along with Pietro Filippo's *Vita Brevis* (appendix 1 below): "Bernini, after

having with much modesty protested his lack of skill for a work of such importance, obeyed [the pope's orders], sparing himself no labor nor sleepless nights for months on end, creating designs and *modelli* in order to overcome the many difficulties that had been encountered by previous masters, of which the principal ones will be here explicated" (anonymous report, Audisio, 42 [col. 1]; for the whole report, see Audisio 42–43; see 28 n.1 for her conjecture about the origins of this report, composed most likely as part of the family's biography project. A most likely candidate for author of the report is Bernini's longtime principal architectural assistant, Mattia de' Rossi). See also the account (note 5 above) by Bernini himself, published in Fagiolo dell'Arco, 2002, 115. For contemporary criticism of Bernini's Baldacchino *modello*, see Bauer, 1996, 155.

10. Domenico's original Italian is "volendo con raro temperamento dimostrare di haverla più tosto per buona, che fatta," which has the distinction of being the most difficult line to translate in all of Domenico's often-convoluted, opaque Baroque prose. Note that *havere (avere* in modern Italian) means in this case *ritenere,* to judge, reckon, or consider. Bernini is admitting that the work came out well, but, in doing so, emphasizes the fact of its being good, not that of its being the work of his hand ("fatta [da lui]," done by him). Lavin, 2008, 287 n.22, instead translates (or rather, paraphrases on the basis of his debatable interpretation of the larger passage) this line as "the Cavaliere said in modesty that his work succeeded by chance, meaning that he achieved it intuitively, rather than deliberately." A special word of thanks to Eraldo Bellini for his help in deciphering this phrase.

11. This same teaching is reported in Baldinucci, i.145, e.78, but there it applies generically to all works of art, not just architecture. It is followed by a comparison with the process of rhetorical composition: "As an example, he cited the orator who first conceives, then orders, elaborates, and embellishes. He said that each of these operations demanded the whole man and that to do more than one thing at a time was impossible." The application of the language and goals of rhetoric to architecture was conventional, as it was for painting and sculpture: see Van Eck, 31–52.

In both Domenico and Baldinucci, for Bernini the final step of architectural creation entails the conferral of *grazia e tenerezza,* grace and tenderness, upon the edifice, though exactly how one achieves these qualities is not explained. It may seem somewhat unusual that Bernini should apply the term "tenderness" to a work of architecture (whereas in all other cases in Domenico it is applied to sculpture). But clearly Bernini wished even this branch of the arts of design to be endowed with that formal-material quality of "softness" and hence capable of stirring the emotions of the viewer.

As far as I as know, Bernini expresses this as an architectural desideratum nowhere else, and it is nowhere discussed in any of the secondary literature on Bernini's architecture. However, Bernini's enunciation about *grazia e tenerezza* is not original to him: it has its ultimate source in the aesthetic-affective vocabulary first introduced into architectural theoretical discourse by Sebastiano Serlio (1475–1553/55) and subsequently expanded, reinforced, and popularized by Vincenzo Scamozzi (1548–1616) in his *Idea dell'architettura universale* (1615). Consider, for example, Serlio's definition of good architecture (*architettura giudiciosa*) from bk. VII, chap. LI (Tenth Proposition, Discussion and Definition of Some Architectural Terms) of his *Tutte l'opere d'architettura et prospettiva,* as summarized by Payne (136): "good architecture is *soda* (solid), *semplice* (simple), *schietta* (plain), *dolce* (smooth, gradual), [and] *morbida* (soft, delicate: a surface, texture quality)," wherein Bernini's *tenerezza* can be found in Serlio's *dolce* and *morbida.* For further discussion, see Payne, 127–28 and 133–34; and Onians, 267; see also my Introduction, section 7, for a more general discussion of *tenerezza* in Bernini. As for Serlio on *grazia,* see the Glossary, s.v. *"gratia, disgratia* and *gratioso,"* to the 1996–2001 English edition of his *On Architecture* (ed. Hart and Hicks), 1:457. For Scamozzi's vocabulary elaborated from Serlio, see Payne, 231–32. My thanks to Sheila Barker for pointing me to Serlio.

12. The Pantheon, perhaps the best-preserved and most beloved of all of the ancient monuments in Rome; transformed into a Christian church in the early seventh century, it was formally known as Santa Maria ad Martyres. With pride, Domenico credits his father for being the one to suggest what our author considers the piously righteous spoliation of the Pantheon bronze, yet

another example of the early modern triumphal plunder of the remnants of antiquity on the part of the Catholic Church. But did the idea originate with Bernini? Louise Rice, whose 2008 essay is the most recent and most thorough investigation of the question of the fate of the Pantheon's ancient bronze, dismisses Domenico's claim, pointing out that it is found in no other source (Baldinucci included). Furthermore, as Rice documents, we now know that the actual amount of Pantheon bronze given to Bernini for the Baldacchino was not only minuscule (a mere 1.8 percent of the total removed from the monument), but all of it was returned to the Fabbrica unused and untouched.

Bernini found sufficient bronze from other sources, and he seems to have been extremely wary of using the Pantheon bronze because its precise chemical composition was a mystery and could prove dangerous when added to the volatile mix of other metals used to fuse the final product. Indeed, the first notices reporting the papal decision to strip the Pantheon of its bronze beams (beginning with an *avviso* of August 23, 1625, and including a December 1625 entry in Gigli's *Diario Romano*) make no mention whatsoever of the Baldacchino as the reason for the spoliation: the bronze, these first sources say unequivocally, was needed for the manufacture of armaments alone, for "throughout his pontificate, [Pope Urban] devoted himself with uncommon energy to enhancing his military preparedness" (Rice, 2008, 340 n.9 and 343 for the early reports; 344 for the quotation). So why, then, did Urban place a blatantly mendacious inscription (dated 1632) on the Pantheon prominently highlighting the Baldacchino and Saint Peter's tomb as the direct beneficiaries of this plundering of the Pantheon bronze, a claim that Domenico repeated (see note 13)?

As for the Pantheon itself, let us note that Bernini personally had an attitude of complete respect for that revered ancient monument, later opposing the disfiguring "renovations" desired by Pope Alexander VII. Moreover, despite the common myth, Bernini had no role whatsoever in the design or construction of the two bell towers (the infamous "asses' ears") added to the Pantheon by Urban VIII in the 1620s. For Bernini and the Pantheon, see also Marder, 1998a, 225–37.

13. The emperor in question is Constans II (son of Constantine III), who lived from 630 to 668 and reigned from 641 until his death. During his brief visit to Rome in 663, Constans did indeed strip buildings of their bronze and other materials, including the Pantheon's roof tiles, but, as Domenico correctly points out, left its portico bronze untouched (for further information on Constans and the Roman bronze, see Rice, 2008, 339 n.7). Domenico here repeats the claim propagated for all time in the marble plaque installed by Urban alongside the door of the Pantheon, surviving to this day: "Pope Urban VIII used the ancient remnants of the bronze truss for the Vatican columns and for machines of war, that a useless and all but forgotten adornment might become in the Vatican temple an embellishment for the apostolic tomb and in the fortress of Hadrian the instruments of public defense" (trans. Rice, 2008, 337).

By the time this inscription was installed, the pope was completely aware—as our author would have been as well, I suspect—that in fact none of the Pantheon bronze was used for the Baldacchino (see note 12 above); yet he nonetheless publicized this blatant lie. As Rice has amply demonstrated, the plaque represents an attempt—a successful one—by the Barberini propaganda machine to "spin a justificatory narrative" around the pope's decision to depredate the Pantheon for the manufacture of armaments, "one of [his papacy's] worst public relations blunders" (337). This decision provoked a tempest of protest from the Roman populace: by no means "all but forgotten" as the papal plaque claims, the Pantheon bronze was a very visible and valued feature of a much-beloved, venerable monument.

Urban's decision, done for an un-Christlike purpose (to make war), inspired the famous pasquinade "Quod non fecerunt barbari, fecerunt Barberini" (What the barbarians didn't do, the Barberini did; for its author, the Rev. Carlo Castelli, canon of S. Maria in Cosmedin, Protonotario Apostolico, and Roman agent of the Duke of Mantua, see Bossi, 57–65). In a clever damage-control maneuver, Urban decided, in the wake of the protest, to rewrite history and use the pretext of the Baldacchino to make his decision more palatable to the outraged Roman populace: that is, to claim that his primary motivation was pious, not military. In this Urban fully

succeeded, this piece of face-saving papal propaganda repeated for centuries by pious apologists like Domenico.

14. "e sopra di esso Baldacchino in un vago rilievo, che s'alza dal mezzo, la Croce." Domenico omits the fact that Bernini's original intention was to have a statue of the Risen Christ crown the ribbed superstructure rising above the canopy. However, this had to be abandoned because of its excessive weight. See Urban VIII's 1626 commemorative medal showing this earlier version of the Baldacchino in Marder, 1998a, 32, fig. 21.

15. Literary theorist, theologian, and church historian Sforza Pallavicino (1607–1667) is one of the leading figures of the cultural life of seventeenth-century Rome, a figure well known in the annals of Italian literature. (Note: his first name is not Pietro, it is Sforza; the "P." one finds on seventeenth-century title pages and in other sources is the abbreviation of his ecclesiastical title, "Pater" or "Padre.") Born of noble family, he studied at the Roman College and the Sapienza, becoming a doctor of theology in 1628 and a member of the Barberini literary court. However, in the troubled aftermath of Urban VIII's disastrous condemnation of Galileo, Pallavicino (ally of the pro-Galileo Giovanni Ciampoli and the suspect Lincei academicians) saw fit to remove himself from Rome for several years. Having returned to the city in 1636, he entered the Society of Jesus in the following year and later began teaching at the Collegio Romano, but he prudently refrained from publishing any of his writings until the death of the irascible Pope Urban.

Urban's successor, Innocent X, gave Pallavicino the mandate of responding to Paolo Sarpi's antipapal history of the Council of Trent, and Pallavicino did so, producing what is perhaps his most well-known work, the *Storia del Concilio di Trento* (1656–57). By the time of its publication, his longtime friend Fabio Chigi had ascended the papal throne as Alexander VII and the most florid period of Pallavicino's influence in Rome commenced, enhanced all the more by his nomination as cardinal in 1659. It was also then, it would seem, that his close relationship with Bernini had its effective beginnings. As Bellini, 2006, 292, reports: "The relationship between Bernini and Pallavicino during the years of Alexander VII [1655–67] has been documented . . . but we have no proof that such ties date back to the pontificates of Urban VIII and Innocent X." According to Pallavicino himself, Bernini "truly has very few friends whom he trusts as much as he does me" (Montanari, 1998b, 344, quoting a 1665 letter by the cardinal).

A late portrait of Pallavicino in red chalk by Bernini is in the Yale University Art Gallery (Montanari, 1997, 53, fig. 11). The cardinal was a loyal protector of Bernini's interests in Rome and with the French court, as well as mentor to his oldest son, Pietro Filippo. He is buried in Bernini's Church of Sant'Andrea al Quirinale. (Yet strangely enough, in his lengthy biography of Alexander VII, although citing by name other artists, Pallavicino never mentions Bernini, not even in describing and praising in detail the magnificent achievement of the Piazza San Pietro and its portico.)

Pallavicino's *Trattato dello stile e del dialogo* (1662) and his last work, the *Arte della perfezion cristiana* (1665), are important documents illuminating the intellectual-theological milieu of Bernini's later life, for which see Bellini, 2006, 292–307, who relates them to the Bernini biographies. For Pallavicino as a man of letters and philosopher more in general, see Bellini, 1999. For Bernini and Pallavicino, see also Montanari, 1997 (47 for Pallavicino as mentor to Pietro Filippo); Delbeke, 2000, 2004, and 2005; and Bellini, 2009, 183–88.

16. Pallavicino is here evoking the theme of the *giudizio dell'occhio,* a concept well known in early modern art discourse. The term refers to that innate sense of correct proportion that every artist must have but that only the very best truly possess in perfect measure. This "judgment of the eye" enables him to endow works of art with the most appropriate dimensions, drawn from his own intuition and purely visual judgment, especially in challenging, novel circumstances where traditional rules and measurements are simply of no help. For the *giudizio dell'occhio,* see Summers, 364–79; as Summers points out (368), "The importance of this principle probably grew as a direct result of concern with monumental public architecture and colossal sculpture" in the High Renaissance, representing, new, uncharted artistic territory, as encountered by Bernini in creating his Baldacchino. Hence Pallavicino, in confirming Bernini's possession of this innate

talent, is confirming his status as an artist of supreme expertise. And of equal importance, the cardinal is at the same time confirming Bernini's status as the Michelangelo of his century, for the *giudizio dell'occhio* was then "an idea always closely associated with Michelangelo" (Summers, 4).

On the contrary, Lavin, 2008, 285, claims that Bernini's "by chance" remark was instead "an ironic inversion of Michelangelo's famous dictum that the true artist must have the *giudizio dell'occhio* . . . if the artist's ingenuity and intelligence did not find the solution [to the problem of just measurement and proportion], it must be found by chance." Lavin, I believe, takes Bernini's witty quip too literally; see my note 9 above. It is no coincidence that this remark should come from the mouth of Pallavicino, for the cardinal not only was a universally respected arbiter of talent in his day, but also (as Montanari, 1998a, 149, points out) was "one of the most tenacious propagators of this comparison" between Bernini and Michelangelo (and between Popes Alexander VII and Julius II). For further discussion, see Montanari, 1997, 59, who observes: "This scene is to be located at the beginning of the Chigi pontificate when Gian Lorenzo had again returned to work in the apse of the basilica, installing there the Cathedra Petri; it was then that Andrea Sacchi dared to attack him face-to-face" in a dispute specifically on the question of the proper proportions of the structure. Domenico omits any reference to Sacchi's verbal assault but nonetheless implicitly responds to it here by inserting this authoritative defense of his father by the most eminent Cardinal Pallavicino.

17. Domenico is correct: the design process began sometime in 1624. The structure was inaugurated on June 29, 1633 (Feast of Saints Peter and Paul); for the inaugural festivities, see Fagliolo dell'Arco, 1997, 282.

18. On the occasion of the 1633 inauguration of the Baldacchino, Lelio Guidiccioni composed a long Latin poem, *the Ara Maxima Vaticana* (the Great Vatican Altar) celebrating, yes, the Baldacchino and Bernini, but, above and beyond all else, its patron, Pope Urban VIII. Domenico quotes from its introductory verses (see Guidiccioni for an unabridged English translation; see also Delbeke, 2008, 142−45). Poet and *erudito* Guidiccioni (Lucca, 1582−Rome, 1643) served in the court of Cardinal Scipione Borghese. At the cardinal's death, he passed into the service of Cardinal Antonio Barberini, who procured for him a canonry in Santa Maria Maggiore. He was, it would seem, on rather friendly terms with Bernini: for his June 1633 letter describing and praising Bernini's art, see Zitzlsperger, 179−83; and Dickerson, 381−82 (n. 1 for further bibliography). See also D'Onofrio, 1966b, for the text of his *Dialogo-recita* (a two-man dialogue performance involving Lelio and Bernini and dealing with themes of art, creativity, and innovation). See Fagiolo dell'Arco, 1997, 235−36, for his "sumptuous book" describing the January 1622 catafalque for Pope Paul V, to which, as already mentioned, Bernini contributed numerous statues in stucco. For Guidiccioni more generally, see also D'Onofrio, 1967, 377−80; and Newman.

19. Baldinucci reports the same response from the pope, who smiles, saying that "it will be appropriate to give the chain to he who offered such fine advice" (i.83, e.17). The pope's response was ironic, employing a play on words: "to give the chain" to the pope's consultant means to "throw him into prison" for suggesting such a ridiculously small reward, unbefitting the *magnificentia* of a pope and the miraculous achievement of the artist. (My thanks to Eraldo Bellini for this explanation.) For the royal virtue of *magnificentia*, see my commentary to that term on Domenico, 2.

20. Domenico's "usual provision" (*solita provisione*) presumably refers to the monthly sum of 250 *scudi* mentioned earlier on p. 38. Baldinucci, i.83, e.17, says the pope had the same amount of money "and certain pensions" given to Bernini. As for the conferral of the title of chief architect, this had already occurred in February 1629 and not upon the completion of the Baldacchino, as Domenico's placement of this detail here would imply. Domenico makes no mention of the "fierce attacks" against Bernini occasioned by this controversial papal appointment that greatly and justifiably offended much more experienced candidates for the job of Architect of Saint Peter's, especially Borromini (see Sutherland Harris, 1987, 46). See *Bernini in Vaticano*, 320, for Carlo Fontana's detailed list (Vatican Library, Vat. Lat. 8635, fols. 53v−56) of all remuneration received by Bernini for his "fifty-six years of service" (1624−80) to the Fabbrica of Saint Peter's:

the sum amounts to 176,570 *scudi,* not counting, Fontana notes, the "incalculable" financial reward accruing to Casa Bernini from all the various ecclesiastical offices ("Dignità Prelatizia") bestowed upon members of the family by the pontiffs. Fontana also reports therein that in the same period, for all the projects in which Bernini was involved at Saint Peter's, the Fabbrica spent a total of 1,086,000 *scudi.*

Also in 1629, another honorific title given to Bernini by means of a controversial Barberini fiat was that of "Principe" of the Accademia di San Luca: Bernini's tenure as "Principe" began January 1, 1630, having been imposed upon the academy by its cardinal-protector, Francesco Barberini, in circumvention of the usual electoral process (Lafranconi, 41–42). Although it is occasionally asserted that our artist became "Principe" of San Luca in 1621, Lafranconi, who is writing a history of the academy for the poorly documented period 1609–34, makes no mention of an earlier 1621 election; nor is there any in the documented "History of the Accademia di San Luca" Web site of the Center for Advanced Study in the Visual Arts, National Gallery of Art, Washington, D.C.: http://www.nga.gov/casva/accademia. Documented, instead, is Bernini's appointment in October 1624 as one of the teachers of the academy's Sunday art classes, these unpaid teachers bearing the title of *rettore* (Roccasecca, 141).

21. Pietro Filippo's *Vita Brevis,* after stating that Bernini "established his family with many riches," mentions that "one of his brothers was made a canon," presumably referring to Monsignor Vincenzo cited here. Little is known about these two Bernini brothers. Vincenzo died in November 1648 at the age of forty-three, according to his death certificate (for which see Fagiolo/*IAP,* 364; 363–64 for his last will and testament). Domenico died of plague in Rome in October 1656 (D'Onofrio, 1976, 252, citing the Carlo Cartari diary; for his will and contemporary report of his death, see Martinelli, 1996, 251–52).

During the same plague, Bernini, together with other eminent artists and architects, was sequestered by Alexander VII in the quarantined Quirinal Palace (Barker, 2006, 244). The 1681 Casa Bernini inventory lists a portrait by Bernini of this Domenico: see Petrucci, 2006, 324, cat. 15; and Montanari, 2007, cat. A14, for two different possible identifications among the extant Bernini canvases. Note that the ecclesiastical offices here conferred upon Vincenzo and Domenico would usually have been purchased by the person seeking them: presumably in this case they were not sold, but given gratis as rewards.

22. For Bernini's numerous portrait busts of Urban VIII (fourteen of them extant according to the latest census, though attributions are still debated), see Zitzlsperger, cats. 5–18; Bacchi-Hess-Montagu, cats. 2.5, 2.6, and 2.7, and their Checklist A16–A19 (287–89) and D1 (293); and *Marmi vivi,* cats. 10–13. On October 13, 1635, the Roman Senate decreed the commissioning of a statue in honor of the pope, this commission going to Bernini with a compensation of 2,000 *scudi.* The finished statue was unveiled on September 29, 1640, in the Sala dei Capitani, Palazzo dei Conservatori, Campidoglio; its execution, however, is "to a large extent studio work" (Wittkower, cat. 38).

Baldinucci, i.86, e.21, in reporting the same fact of the "very many portraits" of this pontiff, adds that he did several of "members of the Barberini family": for these family portrait busts, see Witttkower, cat. 24 (to which must be added that of Cardinal Francesco at the Palazzo Barberini [*Regista,* cat. 47]; see also Wittkower, cat. 27, for the 1630 memorial statue of papal brother, Carlo, of which Bernini executed the head).

For Bernini's busts of Camilla Barbadori Barberini (Urban's mother, d. 1609) and Francesco Barberini (Urban's uncle, d. 1600), see also Bacchi-Hess-Montagu, cats. 2.1 and 2.2. For his portrait of Antonio Barberini the Elder (Urban's great-uncle, d. 1559), see *Marmi vivi,* cat. 8. For the newly attributed portrait bust of Maria Duglioli Barberini, a collaborative work with Finelli (1620s, Louvre), see *Marmi vivi,* cat. 9. For the Bernini portraits of Urban on canvas, see Petrucci, 2006, 328–31, cats. 18–20; Montanari, 2007, cats. A11, S5, S8, and S9; and Bacchi-Hess-Montagu, cat. 2.4; and, again, *Marmi vivi,* cats. 10–13.

23. Baldinucci, i.85, e.19, for the corresponding passage. "Bibiana" is Vivian in English, but usually is not translated in the Bernini literature. Work began on the statue in August 1624

(Bernini's first payment for marble is dated August 10) and was completed by late July 1626, some of the carving having been done by Giuliano Finelli. For the Bibiana statue, the first in a long, glorious series of large-scale public religious sculptures by Bernini, see Wittkower, cat. 20; Marder, 1998a, 50–51; and Avery, 73–74; Tiberia, 1999, 13–18, especially regarding the statue's restoration (see also Tiberia, 2000, for the artwork within the church); and for the whole altar ensemble, see Ackermann, 2007, 32–36.

It is in the *Santa Bibiana* statue that we find the earliest discovered traces of pointing marks in a Bernini sculpture: "This suggests that Bernini may have relied on assistants to carve portions of this sculpture, in which case he would have undoubtedly provided them with a model for the purposes of transferring his design to the stone" (Dickerson, 383). For Bibiana's seventeenth-century cult and restoration of her church, see the indispensable, detailed contemporary account by Domenico Fedini.

The particularly "tender" visual effect created by this statue is in part due to the cream-colored patina that Bernini applied to the marble surface (for which see De' Giovanni-Centelles; and Tiberia, 1999, 16–17). Bernini also suffused the statue with natural light, coming from a hidden source, the first instance in his architectural practice of a technique that he used to great effect in several of his later chapels, including that of Saint Teresa in Santa Maria della Vittoria (Marder, 1998a, 51, 54). For Bernini's light, see Fehrenbach, 2005.

24. Strangely enough, neither Domenico nor Baldinucci (i.85, e.19) makes mention of the fact that it was Bernini to whom Urban gave the task of renovating this ancient church-shrine (dating to at least the fifth century, it is now sadly deprived of all traces of its original garden setting and utterly besieged by the surrounding Roma Termini railroad station). It represents his first architectural commission; his principal intervention was the construction of an entire new external facade, in addition to a new high altar with its statue of the martyr. Urban decided to refurbish the church in February 1624 for the jubilee year of 1625; shortly after the commencement of the labor, Bibiana's body was discovered (March 1624). Later that same year (July), Bernini received the architectural commission and presumably that of the statue as well. For an account of the church's origins and long history, see Vasco Rocca; and Fedini; for Bernini's architectural work there, see Marder, 1998a, 47–57.

25. Tuscan painter and architect Pietro da Cortona (1597–1669) later became a formidable rival to Bernini. Once his career in Rome was established, "Cortona's position in the Roman art world was second only to Bernini's" (Merz, 241). For the rivalry between Bernini and Cortona, see Sutherland Harris, 1987, 54–55; Marder, 1998b; and Merz, 142–43, 241–42. For the Bibiana frescoes, see Tiberia, 2000. Domenico omits mention of the fact that half of this same Bibiana fresco cycle was also done by the more senior Florentine painter, Agostino Ciampelli (1565–1630), who was Bernini's brother-in-law, married to his sister Agnese (d. 1609); see Terzaghi, 101; and my commentary to Domenico, 14.

Was there lingering resentment in the Bernini family over Ciampelli's belittling criticism of Bernini's Baldacchino design, whereby he dismissed the entire structure in insulting terms as a *chimera?* (Bauer, 1996, 155). Ciampelli at the time (1629) was *soprastante* (supervisor) of the works at Saint Peter's Basilica (see *Petros eni*, cat. II.25 by J. Connors). In calling the Baldacchino a *chimera*, Ciampelli was not merely dismissing it as a figment of Bernini's imagination, but denouncing it as a monstrous conglomeration of incongruent forms.

26. Total payments to Bernini for the statue were 600 *scudi* (Wittkower, cat. 20). To date, no documentation regarding additional payment or reward received by the artist has come to light.

27. Baldinucci, i.84, e.19, has only a brief summary paragraph about the piers and their respective statues and the artists responsible for them. The complex project, involving architecture, sculpture of colossal scale, and large amounts of decoration in various media, lasted from 1627 to 1640; see Lavin, 1968b, Preimesberger, 1993 and 2008a; and Dobler. Defensively, Domenico brings up at once the issue of the controversy over the cracks in Saint Peter's cupola, even though these charges, he claims, were to come only fifty years later. This is not completely true: see below in this note.

The cracks were attributed to Bernini's allegedly imprudent interventions in the piers that compromised the stability of the cupola and that, according to the alarmists of the day, threatened to bring down the cupola itself. (Note that this is a separate affair from the later described controversy over the cracks in the basilica's facade caused by Bernini's bell towers: for which see Domenico, 77–79.) As Domenico reports (here and on 167–68), the cupola controversy was indeed to play itself out in the last year of the artist's life (and beyond). But our biographer fails to mention that already in April 1636, troubling rumors had disseminated in the city about the alleged harm caused by Bernini's modification of the piers, which supposedly involved excavating new stairs, cutting the existing niches more deeply, inserting new ones above them, and carving out corridors within the masonry of the piers: see Marder, 2008, 428, for a concise summary of the charges, all of which, he says, were "either overstated or misrepresented the realities in the basilica."

According to an anonymous report drawn up at the time (1636) and distributed to the members of the Fabbrica of Saint Peter's, the danger was so great that the niches, stairwells, corridors, and chapels should be filled as quickly as possible, with the effect of undoing all of Bernini's artistic adornments and architectural modifications (McPhee, 2002, 43–44; Marder, 2008, 428). In a report to the Duke of Modena dated December 27, 1636, d'Este agent Francesco Mantovani informs his court that "already for quite some time" the newly appeared crack in Saint Peter's cupola has been a matter of public discussion, with the blame being directly ascribed to Bernini.

However, Mantovani also notes that "those in the know" attribute the alarmist anti-Bernini charges simply to envy. In a later missive (January 3, 1637), the same Mantovani reports that the "writings" circulating against Bernini over this issue "derive from" (derivano da) Ferrante Carli, who hates the artist so much that he would like to see him "exterminated" (esterminato). The erudite but infamously irascible, contentious lawyer and writer Carli (1578–1641) had been secretary to Scipione Borghese and was much involved in the world of the arts in Rome as a collector and dealer. For the texts of Mantovani reports, see Fraschetti, 70–71; for Carli (also known as Carlo), see *Grove Art Online*, s.v. "Carlo, Ferrrante"; Delcorno; Haskell, 1980, 123; and Marder, 2008, 428 n.7; for Mantovani, see Rice, 2008, 341 and n.13.

There is no mention in extant documentation of any subsequent formal investigations, charges, or exonerations in this period: this suggests that neither the pope nor the Fabbrica took the matter seriously in the 1630s. As for Bernini, for the Carnival season of 1637, a Roman *avviso* tells us, the artist intended to make the cupola affair the subject of his own satirical comedy, to show what little gravity he attached to the charges against him. Yet this public nonchalance was dissimulated, for the same *avviso* reports that Bernini had at the same time made contingency plans to flee to Naples should disaster strike (McPhee, 2002, 44; see also Fraschetti, 71, for Bernini's successful suppression of a planned 1638 satire against him by the students of the Collegio Capranica focusing on the same cupola controversy, as well as on his own personal character defects).

Although Bernini weathered these attacks of 1636–37 fairly well, "the issue of architectural competence . . . dogged him throughout his life" (Marder, 2008, 433). Indeed, as we learn from a long, impassioned digression on the physical condition of Saint Peter's in *L'ateista convinto dalle sole ragioni* (Venice, 1665), written by a prominent member of the circle of Cardinal Antonio Barberini (his "Vicario Generale" at the time), *Abbate* Filippo Maria Bonini, deep fears (clearly shared by the author) about the collapse of the cupola as a result of Bernini's alleged ineptitude were still circulating in the decades between the 1636 alarm and its formal renewal in 1680: see Bonini, 472–75. "Behold the evils that are caused by the recklessness of those who, with arrogant impudence, wish to insert their hands into the work of glorious men" (Bonini, 473).

28. What Domenico presents in the text that follows is indeed a straightforward description of Bernini's work on the piers, but, his just-announced refusal to rebut enemies notwithstanding, it serves in fact as a pointed response to the charges against his father. Domenico's detailed technical description, it would seem, derives from the long report written in exoneration of Bernini that Baldinucci appended to his Bernini *vita* (i.157–75; e.81–108), published along with engraved illustrations (depicting the features here described by Domenico).

Domenico, however, may have taken his text directly from Baldinucci's own source, i.e., the final account of the formal investigation undertaken by Bernini's longtime architectural associate, Mattia de' Rossi (with the assistance of Carlo Fontana and Giovanni Antonio de' Rossi), upon orders from Pope Innocent XI: see Domenico, 168, and commentary, for the latter 1680 papal investigation.

29. The upper niches in the four piers hold four of the most prized relics in Christendom, three of which purportedly relate to the Passion of Christ: they are, according to pious belief, the spear that lanced his side, a piece of the "true cross" upon which he was crucified, and "Veronica's Veil" (see note 30). The fourth relic, the head of the apostle-martyr Saint Andrew, was returned to its original resting place in Patras, Greece, in 1964.

One of the charges raised against Bernini in 1636 and again in 1680 involved these upper niches as well: that he had destabilized the piers by carving out entirely new niches above the preexisting ones below (in order to house the relics) and by excavating the interior of the piers in order to install stairs, giving access to the upper niches. Instead, the upper niches, although unadorned, had already existed (along with provisions for the addition of stairs to reach them), as shown in the original architectural plans, brought forward by Mattia de' Rossi and reproduced by Baldinucci (see discussion of this specific charge by Marder, 2008, 430). In fact, the decision to use the upper niches of the piers as reliquaries had been made long ago in 1606 by Paul V; the only "decisive change introduced by Bernini into the two-story organization of the piers under Paul V lay in devoting the lower niches to monumental figures of the saints, and the upper niches to representations of the relics themselves" (Lavin, 1968b, 28).

30. The much-venerated relic of the "Volto Santo" (Holy Face), also known as the Sacred Sudarium or Veronica's Veil, is, according to pious belief, the cloth used by "Saint Veronica" to wipe the bloody face of Jesus on the way to his crucifixion: in return for her kindness, Jesus left a clear imprint of his features on her veil.

31. The more precise Baldinucci, i.164, e.97, specifies that the height of the stairs was reduced from 9 to 7 *palmi*, by which means "the piers were somewhat strengthened." A *palmo romano* is equivalent to 22.34 cm, or about nine inches.

32. See Baldinucci's fig. 5, detail B, for an illustration of the new revetment. Unlike Baldinucci (i.162, e.95), who merely includes the new revetment in his summary list of Bernini's various alterations of the piers, Domenico here emphasizes this addition of a *grossa incrostatura*, a thick facing, as one of the pier-strengthening measures taken by his father. In reality, the added *incrostatura* was not as substantial as Domenico claims, and, in any case, even if it were, such a literally "superficial" feature could not effectively bolster the massive pier. Nonetheless, the fact of the new *incrostatura* is relevant to the charges raised against Bernini inasmuch as it draws attention to the fact that not only did Bernini not carve away from the surface of the niches, but he actually added to it.

33. In the grotto-chapel of Saint Veronica under the southwest pier, a fresco attributed to Bernini's disciple, Guido Ubaldo Abbatini, shows Bernini presenting his design for the reliquary niches to Urban VIII in 1631 (Lavin, 1968b, figs. 67 and 68; Fagiolo/*IAP*, 95, for the attribution).

34. For the other three statues in the piers, see Lavin, 1968b, 28–37. Regarding the commissioning of the statues for the piers, the already-mentioned (note 9 above) anonymous but intimately detailed technical description of the execution of three of Bernini's works (included in Bernini family manuscripts in the Bibliothèque Nationale, Paris, Ms. italien, 2084, cc. 130–31) claims that the pope and the Congregation of the Fabbrica of Saint Peter's had originally granted the commission of all four statues to Bernini alone, but, fearing the resentment of other sculptors, Bernini himself begged the congregation to divide the commission among other artists. For the passage, see Audisio, 43.

35. The magnificent *Longinus* was conceived and executed in the years 1628–38 (with interruptions between 1631 and 1635); see Preimesberger, 2001; Wittkower, cat. 28; and Avery, 101–4.

36. François Duquesnoy (1597–1643), one of the most eminent sculptors in Rome at the time, then considered as second in stature to Bernini alone. For the Flemish Duquesnoy, see

Domenico, 112 (and commentary with biographical data and bibliography), where he is not quite accurately listed as one of Bernini's *allievi* (students).

37. The Tuscan sculptor who trained under Pietro Tacca, Bolgi (1606–1656) entered Bernini's workshop shortly after his arrival from Florence in 1626, working on the Baldacchino (duly listed by Domenico, 112, as one of Bernini's students). His securing the prestigious *Saint Helena* commission in Saint Peter's at the age of twenty-four speaks well of Bolgi's professional status in Rome in 1629. Yet after laboring for ten years on the work, he left Rome in disgust over the poor reception accorded his colossus (see *Grove Art Online,* s.v. "Bolgi, Andrea"; and Bacchi, 1996, 786–87).

The same technical report composed in Casa Bernini now in Paris (note 9 above) speaks of Bernini's generous procurement of one of the pier commissions for one of his unnamed students, referring presumably to Bolgi. The student, however, exceeded his talent in executing the statue, and Bernini was "rather deceived" by the final product, despite much advice given and even "touching up" (*ritoccamenti*) of the statue by the master: "e perché tra questi [other sculptors given the commissions] vi era un suo allievo, parendoli saper assai più quando fusse fori della sua direttione, procurò ne havesse una, ma restò assai ingannato anch'il Bernino come poi si seppe; mosse a compassione più e più volte con li suoi avvisi e ritoccamenti lo rimesse in strada sicome fece con un altro suo honorevole" (Audisio, 43, 2nd col.). The other disappointing unnamed student mentioned here—the one described as bearing an honorific title (*honorevole*)—presumably is Borromini, who had also been knighted by the pope and called "Cavaliere."

38. For this statue, see Preimesberger, 1993; for Mochi (1580–1654), see *Grove Art Online,* s.v. "Mochi, Francesco"; Bacchi, 1996, 824–26; and most recently, Favero (78–84 for the *Veronica*). The only one of the four statues for which Domenico provides an aesthetic judgment—a positive one—is Mochi's *Saint Veronica* (similarly in Baldinucci, i.84, e.19, who calls it a "beautiful labor" [*bella fatica*]). This is ironic given the fact that of all the four statues, Mochi's work suffered the most attack upon its unveiling and that relations between Mochi and Bernini from that moment on were quite bitter.

Domenico, 112, will later accuse Mochi of "ingratitude" toward his former master (for their relationship, see Montagu, 1989, 30–31, 35, and 2008, 56–58; and Sutherland Harris, 1987, 50). In this regard, the June 22, 1658, entry (Morello 1981, 325) in Pope Alexander's personal diary is telling: the pope there reports advice offered to him to the effect that the task of transporting certain of Mochi's statues from Saint Peter's to the Porta del Popolo should not be given to Bernini, for, it is feared, they are likely to suffer an "accident" in the process—an "accident" deliberately caused by Bernini?

39. For the project, see Wittkower, cat. 33 (noting that extant documents "make possible a very detailed reconstruction of the monument"); and Scott, 1985. The commission was granted in late 1633; the unveiling took place in March 1637, although the monument was not completely finished until early 1644. Domenico's distribution of the labor on the monument is largely correct: see Wittkower, cat. 33, for a more complete description and for Bernini's own personal statement of his share of the labor, probably "somewhat overstated," according to the same Wittkower. However, the documents Wittkower cites make no mention of Luigi's role in the execution of the statue of the countess, only those of Bernini, Niccolò Sale, and two other stonemasons (for Sale, see Domenico, 112).

Baldinucci's short paragraph on the *Matilda* monument (i.86, e.20) reports the same information and same attributions, adding that Bonarelli was "another of Bernini's pupils and husband of that Costanza whose portrait . . . made by Bernini, is seen in the Royal Gallery of the Most Serene Grand Duke [of Tuscany]." (For Bonarelli, see below note 41, as well as note 13 to Domenico, 27.) Like Domenico, Baldinucci (here and again on i.152, e.86) also claims that Bernini did only the head of the statue of Matilda, the remainder being the work of Luigi. Finally, as does Domenico, Baldinucci (i.86, e.20) also insists: "It is quite true, however, that in all these works, besides the model and design, Bernini always did some retouching with his own hand."

40. Little is known of the life and work of Stefano Speranza, documented in Rome from 1629 to 1636. According to the short biography by contemporary Giovanni Baglione, he was

Roman born and died at a young age. Previous to his service as Bernini's studio assistant, he had worked in the workshop of Bolognese artist Francesco Albani. From 1629 to 1632, he received payments for his contributions to Bernini's *Saint Longinus* statue and thereafter executed small details on various other sculptural projects for Bernini until 1636; after that date, there is no further notice of the artist. For Speranza, see Bacchi, 1996, 844.

41. Although Domenico does not mention the fact, Matteo Bonarelli (1599–1654) was husband of Bernini's erstwhile lover, whose portrait bust was described earlier in our text (see Domenico, 27; his date of birth comes from McPhee, 2006, 325, reporting that he was fifty-five at the time of his death). His last name is also at times rendered "Bonuccelli" or "Bonucello" (as in Costanza's will and testament; for which see McPhee, 2006, 331). Born in Lucca, he was by 1636 a member of Bernini's studio (the Costanza-Bernini affair is dated ca. 1636–38), contributing to the execution of the relief in the niche above the *Saint Longinus* statue.

In addition to his various works for Bernini, Bonarelli is especially known for his design of twelve lions in gilded bronze for Philip IV of Spain, a commission procured for him by Velázquez, who also ordered from him a bronze copy (now in the Prado, Madrid) of the Borghese *Hermaphrodite*. Matteo was employed in repairing and reproducing antiquities for the Spanish king and Pamphilj family. He has also made history as the original owner of Poussin's celebrated canvas *The Plague at Ashdod*, later sold to Richelieu by his widow (McPhee, 2006, 329). For his life and career, see Bacchi, 1996, 787, with further bibliography; McPhee, 2006, 325, 329, and 331; and for his work with antiquities for the Pamphilj and other patrons, see Palma Venetucci, *ad indicem*.

CHAPTER VII

1. This would thus place us in ca. 1635, but here, as elsewhere, Domenico's dating may be inaccurate. He may also be exaggerating the gravity of the illness for dramatic effect, for neither Baldinucci nor any other primary source mentions a life-threatening sickness of Bernini in this period. English sculptor Nicholas Stone II (1618–1647) notes in his diary that at the time of his visit with Bernini in Rome on October 22, 1638, the artist was "not very well" and was in bed, but this may not be the same illness (diary quoted in Lightbrown, 1981, 459–60). In any case, this illness provides an opportunity to demonstrate the great esteem and love for Bernini on the part of the pope, the court, and the city of Rome (see also note 2). As mentioned in the Introduction, section 3, the fact of a life-threatening illness preceding a major moral turning point in one's life (in this case, Bernini's "settling down" into stable, respectable marriage, ending the wayward ways of his prolonged bachelorhood) would have been readily recognized by contemporary readers as a commonplace of the literature of the lives of the saints (hagiography), a genre that exerted much influence on Domenico's narrative. In Bernini's real life, the illness may not have been the immediate prelude to his marriage as in this biography, but this is the sequence of events as deliberately constructed by Domenico, presumably drawn from his father's own self-representation.

2. See Domenico, 26 and 37. Domenico would have us believe that Bernini turned to the Loggia decoration project after the completion of the Baldacchino, but there is no documentation indicating that Bernini even began preparing for the project in the form of preliminary drawings. The fact of Bernini's illness may be used here as an excuse to cover up his father's inability or unwillingness to execute the kind of major narrative statue cycle in fresco required by the Loggia but alien to the artist's natural inclinations or talent in the realm of painting. According to Pietro Filippo's *Vita Brevis* (appendix 1 below), it was instead the more important Baldacchino project that made the pope take Bernini away from painting; Baldinucci gives no reason for the abandonment of the Loggia project.

3. Domenico, 179, mentions again Bernini's intense, corporally punishing dedication to his work. In Paris, having been praised for the ease with which he worked, Bernini responded quoting Michelangelo, "Nelle mie opere caco sangue," "I shit blood when I work" (Chantelou, September 20, f.195, e.216). Domenico's terms, *spirito* and, on the next page, *spiriti* (spirits, that

is, life forces), refer to contemporary scientific understanding of the composition and function-ing of the human soul and body and their interconnection, involving the elements of light, fire, and heat, to which Domenico makes occasional reference in his biography. Most important, Bernini's fundamental temperament is defined as choleric or fiery (Domenico, 177). For the *spiriti* and Bernini's temperament, see Fehrenbach, 2005.

4. Baldinucci, i.139, e.73, also reports this fact of Bernini's total, exhausting, and ecstatic absorption in his work (with the same specification that "it seemed as if he wanted his spirit to come out from his eyes in order to give life to his stone"), but in a completely different context, i.e., at the end of his *vita*, in discussing Bernini's habits and character in general. For the sig-nificance of this intertextual phenomenon (that of very similar language occurring in different contexts in the two biographies), see the Introduction, section 6.

5. Urban's most famous personal physician was art connoisseur and theorist Giulio Man-cini, but he died in 1630. The published sources are vague about the identity of Urban's physi-cians in any given year—there may have been more than one simultaneously—but according to Amabile (2:266, n. A to doc. 327), Silvestro Collicola served in that role from 1632 onward, succeeding (if not serving at the same time with) the historically more important Pietro Servio (d. 1648); see also the lists in Marini's *Degli archiatri pontifici* (I:xlii) and Moroni's *Dizionario di erudizione storico-ecclesiastica* (44:136, s.v. "Medico"). My thanks to Sheila Barker for sharing with me her bibliography on this topic.

6. Francesco's title is here *Sopra Intendente* (more commonly written *Soprintendente*) *Generale dello Stato Ecclesiastico,* the usual appointment for the papal nephew chosen to be Cardi-nal Padrone (master cardinal), somewhat equivalent to that of a papal viceroy or prime minister with wide-ranging powers, but exercised effectively only in the case of weaker popes. For the office of *Soprintendente,* see *The Papacy,* 2:1032–33, s.v. "Nepotism"; for the role of the Cardinal Padrone, see Rietbergen, 2006, 148–50, from his essay, "The 'Days and Works' of Francesco, Cardinal Barberini, or How to be a Powerful Cardinal-*Padrone.*" Oldest of the three sons of Carlo Barberini, the erudite and cultured Francesco (1597–1679) was the most active and most powerful of Urban's nephews. Named cardinal in October 1623, he was responsible for much of the family's art patronage in all realms from architecture to tapestry (for Barberini art patron-age, see, e.g., the many essays in Mochi Onori-Schütze-Solinas). However, as Wolfe, 2000, 79, points out: "In contrast to his uncle [Pope Urban], Cardinal Francesco . . . was not a patron of Bernini's, having entrusted to him, as far as we know, only one important architectural commis-sion, the remodeling of the choir of the basilica of San Lorenzo in Damaso (1638–1640)."

On the topic of Bernini's rapport with Urban's Cardinal Nephews, Baldinucci, i.94, e.28–29, comments: "The trust and love shown by Urban was equaled by his nephews, Francesco and par-ticularly Antonio." Fraschetti, 158, publishes an obsequious March 1647 letter from Bernini to Cardinal Francesco, then exiled in Paris, in which the artist confirms his "fedelissima devotione" to the cardinal and his family. Yet in the preceding Carnival season (1646), the same Bernini had satirized the banished Barberini in his annual comedy, to the disgust of certain members of the audience for such a shocking lack of loyalty (see Fraschetti, 268–70, for contemporary accounts of the play, also printed in D'Onofrio, 1963, 99–100).

7. For Cardinal Antonio the Younger, see Domenico, 19, and commentary. Domenico does not mention the third papal nephew and brother to Francesco and Antonio: Taddeo (1603–47) was the sole layman among the male siblings, who joined the Barberini clan to that of the ancient Roman aristocratic family, the Colonna, by marrying Anna Colonna in 1627. Though Prince of Palestrina, Prefect of Rome, Castellano of Castel Sant'Angelo, General of the Papal Armies, and Governor of the Borgo, he nonetheless played a secondary role in the life of the Barberini court with regard to its cultural-artistic patronage, and hence is of lesser relevance to the biography of Gian Lorenzo.

8. Regarding the cautious reserve that Bernini maintained in the presence of his princely patrons, the advice of Battista Guarini's *Il Segretario,* a contemporary handbook of administrative procedures and courtly protocol, is pertinent:

The wise man will indeed let his prince assume an attitude of familiarity with him, not being able to do otherwise; however, he, the servant, in turn, must never behave in like fashion toward his prince. Patricians [*i grandi*] are like lions, who can never be so tamed that they forget they are lions. And since they are ever mindful of their greatness even while dreaming in their sleep, as well as when they relax or play, the shrewd servant must never abandon his demeanor of respectful subaltern. If he is indeed compelled at times to accept the favor of interacting with them a bit more familiarly, this must be done with a necessary quantity of reserve and judgment. (Venice, 1600, 88)

9. Antonio Barberini the Elder (1569–1646) was youngest brother to Urban VIII and Carlo. Born and raised in Florence, he entered the Capuchin order (a reform branch of the Franciscan family) in 1592. Unwillingly, he obeyed his papal brother's summons to Rome in 1623, but once there continued to live his rather simple, relatively unworldly life. Named cardinal in October 1624, he is often called after his titular church, Sant'Onofrio. Somewhat surprisingly, Domenico does not mention anywhere the other and oldest of Urban's brothers, Carlo (b. Florence, 1562), the only one to marry and produce heirs (the papal nephews Francesco, Antonio, and Taddeo). Commander of the papal armies (*Generale di Santa Chiesa*), he died on a mission in Bologna on February 25, 1630. In his memory, Bernini produced an ephemeral funeral catafalque, a permanent memorial plaque in the Aracoeli church (upper counterfacade), and, together with Algardi, a life-size statue (of which Bernini carved the head) in the Campidoglio. For these three projects, see Fagiolo dell'Arco, 1997, 275–77; Wittkower, cats. 26 and 27; and Lavin, 1981, 72–77 (entry by N. Courtright); and Lavin, 1983.

10. Though Domenico's hyperbolic description of this wonder drug might lead one to suspect a narcotic, Sheila Barker, who has extensively researched the field of seventeenth-century Italian medicine, comments: "The pope's doctor would not have administered a narcotic to a long-languishing, weak patient. Narcotics were generally reserved for treating extreme pain, as they are now, and were recognized to be extremely dangerous as they could produce death in a weak person. Being feverish and throttled by seizures, he was likely prescribed a drug to restore his vitality, usually meaning one that strengthens the heart, spirit and nerves. He was probably administered a julep of precious stones or an *elixir vitae,* which are mentioned specifically as the drugs that the papal physician used to keep Urban VIII alive in his last days" (personal communication, December 15, 2008).

For the two drugs in question, *giulebbe gemmato* and *elixir vitae,* see Giuseppe Donzelli's widely consulted and continuously republished medical encyclopedia, *Teatro farmaceutico, dogmatico, espagirico,* Parte Terza (respectively, 42–43 and 86–87 in the Naples 1675 edition). Both drugs were given in very small doses; the former, containing pulverized precious and semiprecious gems, was extremely expensive and hence would have been quite a munificent gift. For the two drugs mentioned as given to the aged Urban VIII, see the anonymous *avviso* from Rome, Archivio di Stato, Florence, Mediceo del Principato 4027a, unnumbered folio, undated (but probably 1644), document no. 19596 in the *Documentary Sources for the Arts and Humanities* database of the Medici Archive Project (www.medici.org).

11. This passage echoes Baldinucci's report (i.142, e.76) about Bernini's great love for his work, quoting the artist as saying that "going to work was for him like going to a garden to delight himself." As for the small marble sculptures in question, no identifications have thus far been made or are likely possible in the future unless new documentation comes to light. Wittkower, cat. 41, conjectures that the completely undocumented *Medusa* bust (Capitoline Museum, Rome) may be one of the marbles from this period of convalescence. It is easy to imagine how such a figure might give expression to Bernini's distress during his protracted illness, especially given the chronic migraines that also afflicted Bernini until the age of forty (Domenico, 177). However, does this over-life-size bust qualify as "small," as per Domenico's specification here? For the *Medusa* as, instead, a portrait of the faithless Costanza Bonarelli, see Avery, 91–92; for the bust as a "kind of ironic, metaphorical self-portrait," which "embodies the noble victory of virtue over vice," see Lavin, 2007, 129.

12. Baldinucci, i.94–95, e.28, reports the same visit (which provoked "the marvel and applause of all Rome"), although he does not date or otherwise connect it to any illness or other specific episode in Bernini's life. Pietro Filippo, in reporting this papal visit to the Bernini house, remarks that Bernini received "such an honor, extended in emulation of Julius II." The latter is a reference to Pope Julius's visit to Michelangelo's house, thus reinforcing the Michelangelo-Bernini parallel that both the artist and his first biographers publicized, but that here Domenico refrains from making explicit.

13. The long-lived Paolo de Branca Alaleone (in Domenico, "Allaleona") was papal master of ceremonies from 1582 until his retirement in 1638, a crucially important office during an age in which not only religious worship but also the sociopolitical dynamics of daily life revolved around and depended upon elaborate, formal, public ceremony. Born in Rome ca. 1551, he died in January 1643, leaving behind a meticulously detailed diary of all the rites and rituals of the papal court of which he was a part. For his biography, see Caetani; and Wassilowsky and Wolf, 25–30. In Baldinucci, i.93–94, e.28, Urban's rebuke of Alaleone is stronger, beginning with the rebuke "You really are an ignoramus." Pietro Filippo's *Vita Brevis* (see appendix 1 below) also includes this anecdote involving a disapproving Alaleone and a scolding Urban.

14. Its placement within Domenico's narrative would indicate that this otherwise undocumented visit occurred in 1635 or 1636, by which time the unmarried Bernini was living in his home at Santa Marta, directly behind Saint Peter's Basilica (he is documented at Santa Marta by November 1634, having moved there with his mother sometime after his father's death in August 1629: see Masetti Zannini for an episode of fire there). Yet Pietro Filippo's *Vita Brevis* says the visit took place at Bernini's home at Santa Maria Maggiore, which would date the visit (and the illness that occasioned it) to between August 1629 and November 1634.

The artist did not move to his still-standing *palazzo* at Via della Mercede, #11 (near Sant'Andrea delle Fratte) until the winter of 1642 (Fagiolo/*IAP*, 108; 112–14 for description of Via della Mercede house; Bernini also owned but rented out #12). Hence, contrary to what has been said or implied in the Bernini literature (e.g., Samek Ludovici, n.68 to Baldinucci, i.94), the early eighteenth-century lunette mural on the *primo piano* of the Via della Mercede house commemorating this visit by Urban VIII is meant to depict the Santa Maria Maggiore or the Santa Marta house, not that in Via della Mercede (see Petrucci, 2006, 406, fig. 20, for the most legible reproduction of the mural).

The Via della Mercede was in the same neighborhood in which "artists resident in Rome were mainly clustered," Bernini being the only artist in Rome, beside Pietro da Cortona, to possess such a large house unto himself at that time (Merz, 159, 162). As for the pope's sudden decision here to visit Bernini "that very same day," the latter timing seems highly implausible in view of the enormous logistical challenges entailed in organizing a papal excursion outside the Vatican accompanied by such a large number of cardinals and high-ranking courtiers.

15. "mà una non sò quale particolare propensione verso di lui, ch'ei stimava affetto, mà in sostanza era in Urbano stima della sua Virtù": Domenico seems to be saying that Urban's attraction toward Bernini had something (philosophically as it were) deeper than mere personal affection, even though evidence indicates that the latter was, to be sure, there as well. See Baldinucci, i.93, e.27–28, for the corresponding passage. Earlier, Baldinucci, i.85, e.20, had reported that the pope "desired to make him, so to speak, immortal." For Urban's "affezzione" and "parzialissima propensione" toward Bernini, see also Domenico, 11.

16. Baldinucci, i.85, e.20, reports that the pope wanted Bernini to marry "not so much that some child and heir to his virtue be left to Rome, but in order that he might have someone to look after him so that he might have more time and peace for his art." Bernini's first reaction to the pope's suggestion of marriage, according to Baldinucci, was "repugnance." Baldinucci further reports: "During the course of the year of 1639, among the fine offers made to him, he chose [blank space here for missing name], daughter of Paolo Tezio, secretary of the congregation of the Most Holy Annunciation, a man of great worth and goodness" (for Paolo, see note 17). Later Baldinucci (i.134, e.68) will claim that once married, Bernini lived more like a vowed religious than a layman (see the Introduction, section 8, for a discussion of this claim).

Thanks to several contemporary documents (a dispatch dated May 28, 1639, from the Duke of Modena's agent in Rome, Francesco Guallengo; an unpublished note in the Baldinucci manuscripts; the legal agreements between Bernini and the Tezio family; and the matrimonial records in the bride's parish of S. Tommaso in Parione), we know a good amount of detail surrounding Bernini's selection of a bride, their financial agreements (Bernini refused Paolo's dowry offer and instead secretly paid his father-in-law 15,000 *scudi*), and the wedding itself. Pope Urban would appear to have had no role in the choice of the bride, whereas it was a certain unnamed "Oratorian Father" who had reportedly pointed Bernini in the direction of the Tezio daughters: see Russo, 53–54, conjecturing that the priest in question might have been Orazio Giustiniani (1580–1649, made cardinal 1645), then "Primo Custode" of the Vatican Library and consultant of the Sant'Uffizio, who in fact acted as Bernini's legal delegate at the drawing up of the notarial document relating to the marriage.

The quiet, private wedding ceremony took place in S. Tommaso on May 15, 1639, with the parish pastor, Monsignor Gaudenzio Polo officiating. Strangely enough, Bernini was granted extraordinary ecclesiastical exemption from the obligatory advance publication of the marriage banns and examination of the witnesses. Did Bernini fear hostile testimony coming forward at this point perhaps to delay or block the marriage? For the related documents and discussion, see Fraschetti, 104–5 (Modena report and parish record); Russo, 53–54; D'Onofrio, 1967, 137–38 (Baldinucci ms. note); and Fagiolo/*IAP*, 108–9 and 357–60 for texts of the legal agreements. For Orazio Giustiniani, see also *DBI* 57:354–56.

17. Note that Bernini's future bride—the silent, seemingly passive woman here in question who probably had no say in the choice of her spouse—is still not yet given a name by her son Domenico. We know little about her, Caterina Tezio, beyond what Domenico tells us. Born October 27, 1617 (hence nineteen years after Gian Lorenzo), she, it would seem, dutifully performed her assuredly difficult role as wife to the fiery Bernini and as mother to their numerous children until her death in July 1673. The only discordant note in their marriage that we know of is the conflict between husband and wife over the terms of the inheritance of their daughters (for which conflict see Fraschetti, 425–27; and Beltramme, 2005, 155–56; see also Beltramme, 2003, for other insights into Caterina's psyche as a Roman housewife). However, while in Paris in 1665, Bernini complained of sorely missing his wife and children (Chantelou, July 23, f.86, e.75) and upon receiving word of Caterina's near-fatal illness publicly burst into tears and was in a state of depression until news of her recovery arrived (Chantelou, September 12, f.175–76, e.191–92; September 14, f.180, e.197; September 20, f.194, 215–16).

As for Caterina's father, Paolo, originally of Biella (Piedmont), was by then a Roman citizen, a jurist, and procurator for the d'Este court in Rome, hence a man of some distinction and means. Likewise was his wife, Eugenia Valeri, whose family had burial rights in S. Tommaso in Parione, in Via di Parione, near the Oratorian Church of Santa Maria in Vallicella or Chiesa Nuova. For the Tezio family, see Fraschetti, 104; and Russo, 53–54, although the latter understates their economic status. Caterina's mother, Eugenia, died just hours after the baptism of her grandson, Francesco Giuseppe, on October 9, 1654 (Carletta, 1898b, 1).

18. A feature of Roman government since antiquity, the *Senatus Consultum* (plural *Consulta*), meaning literally "advice of the Senate," was a decree or recommendation of the Senate having the effect of law. Domenico records the names of the Senate leaders at the time and the two scribes since these data would be necessary in tracing the document within the archives.

19. Clement XI (Giovanni Francesco Albani) reigned 1700–1721.

20. Two of the eleven Bernini children died in childhood: the first Paolo (1644–1646) and Francesca Giuditta (1653–1658). The surviving nine, most of whom left very little mark on the historical record, are: Pietro Filippo (1640–1698); Angelica (1646–?); Agnese Celeste (1647–?), Paolo Valentino (1648–1728); Cecilia or Angela Cecilia (1649–?), Dorotea (1650–?), Maria Maddalena (1652–?), Francesco Giuseppe (1654–?), and Domenico Stefano or Stefano Domenico (1657–1723). For the Bernini children and their birthdates, see Fraschetti, 105–6 (taking his information from Carletta, 1898b, who uncovered their birth certificates), and the annual Easter census lists published by Fagiolo/*IAP*, 343–49; for Paolo Valentino's date of death,

see Martinelli, 1996, 272, note g, cited there without a source; for Pietro Filippo's death, see Antonazzi, 47 n.33.

21. Baldinucci, i.94, e.29, calls him (Tuscan style) "Pier Filippo," fulsomely praising his "most affable nature" and "great talent for heroic verse." Domenico will have occasion to mention this brother several other times in his account, especially for the distinguished ecclesiastical offices and benefices gained for him by their father. Called by Domenico and in the family documents simply as "Monsignore," Pietro Filippo is the presumed author of the early biographical sketch of his father, which is here (appendix 1) translated into English for the first time. For the most complete account of Pietro Filippo's life to date, see DLO/Pro, 23–26, to which must be added the transcription of the *avviso* about his death (on May 24, 1698, in Albano) and elaborate funeral in Santa Maria Maggiore published by Antonazzi, 47 n.33. For a reproduction of his portrait on canvas executed in 1693 by Domenico De Angelis (Koelliker Collection, Milan), see Petrucci, 2006, 15.

22. The failed sculptor Paolo (1648–1728) was mocked in a 1684 *avviso* for attempting to marry above his station, he who was "born from dung" (nato de stercore). Nonetheless, he succeeded in marrying into the distinguished Roman family of the Maccarani. According to Fagiolo/*IAP*, 275 (without source), Paolo was elected to the Accademia di San Luca in 1673, though at some point he abandoned the sculptor's profession completely, with little to his professional credit (see also Domenico, 124, and commentary). Although no further luminaries, artistic or otherwise, ever issued forth from the Bernini line, Pope Benedict XIV conferred noble status upon the family in 1746 (Fraschetti, 106). The 1910–14 edition (revised by Carlo Augusto Bertini) of Teodoro Ameyden's *La Storia delle famiglie romane* (p. 212), pronounced the family extinct, the last direct male heir, Prospero Bernini, having died in 1858. However, the family line continued through Prospero's adopted daughter, Concetta Caterina Galletti (d. 1866): see Forti (a Bernini descendant), 196; D'Onofrio, 1986, 418 n.31. See Briganti for the 1964 auction of many of the original possessions of Casa Bernini.

23. What Domenico says about his own life here is deceivingly oversimplified: see the Introduction, section 2, for a summary of all that is known and can be reasonably conjectured about our author's biography. We learn from the 1731 Bernini household inventory that Domenico's wife was named Anna Teresa (Martinelli, 1996, 268, c.61r); the same source refers to his son, Giovanni Lorenzo (265, c.54v and 268, c.60v and c.61v), and his daughter, Angela (269, c 64r); the second of Domenico's two daughters was Caterina, here mentioned on this same page.

24. In 1711: see the Introduction, section 3, for the origins of Domenico's *Life of Gian Lorenzo Bernini*. Given the date of the book's formal "Imprimatur" (January 1712), it was most likely in 1711 that Domenico submitted his completed manuscript to the ecclesiastical censors for approval, a necessary step before publication.

25. These two siblings, nuns in the noncloistered convent attached to SS. Rufina and Seconda in Trastevere, Rome, will appear again in Domenico, 160, during Clement IX's visit to the Bernini home. See also Chantelou, September 7, f.166, e.179, for a sentimental detail regarding one of these daughters: "Paolo [Bernini] said that his father intended to return to this country [France] after making the trip to Rome; there was only one thing that worried him, that one of his daughters, whom he loved dearly, was a nun in a convent where, however, no vows were taken; he did not wish to leave her behind, but perhaps the Pope would not permit him to bring her with him."

26. The *Segnature* (Signatures)—the *Segnatura della Grazia* and *Segnatura della Giustizia*—were two of the three tribunals of the Roman curia (the third is the *Sacra Rota,* a history of which Domenico published in 1717): see Del Re, 227–34.

27. For Domenico's misleading chronology here, see note 28. As Baldinucci, i.150, e.83, declares, "entire books" could be written about Bernini's theater—especially now after decades of new research on the topic. Bernini's plays (virtually all of them produced, it would seem, as annual Carnival entertainments) represented a lifelong, essential part of his artistic production, to which he devoted much time and energy. The theater was clearly a vital, if not indispensable, means of self-expression for him, on both an artistic and psychosocial level.

A good portion of the primary-source documentation regarding Bernini's theater has been published by D'Onofrio, 1963 (in appendix), to which, however, must be added other important contemporary texts published by Saviotti; Bruno; and Montanari, 2004a, as well as the various related passages in Chantelou's *Journal*. Indispensable, of course, is the (incomplete and untitled) script of Bernini's sole surviving comedy (probably 1644), given the modern title *The Impresario* (which Italian scholars, following D'Onofrio, call *Fontana di Trevi*). The text has by now been published, with extensive commentary, in several editions, by D'Onofrio (Italian, 1963), Ciavolella (Italian, 1992), and Beecher-Ciavolella (bilingual, 1985, and English, 1994), including most recently (2007) a "dramaturgically restored" version in Italian (completed on the basis of analogous early modern Italian theater) by Perrini, who retitles it *Truth Uncovered by Time*.

In addition to the commentary accompanying these editions, among the most useful studies of Bernini's theater and its most immediate historical context are M&MFagiolo, 179–95 (and pertinent catalogue entries); Lavin, 1964 and 1980, 146–57; Fahrner and Kleb (though some of the later contemporary references they cite, in reality, refer to Pietro Filippo's productions, for which see Montanari, 1998b, 406–7; and DLO/Pro, 24–25); Beecher; Cope; F. Angelini; Tamburini, 1999–2000 and 2005; Carandini; Montanari, 2003b (for the thesis that theatrical performance served Bernini and his students as a training vehicle for the development of their skills in depicting the *affetti* in sculpture and painting), 2004a, and 2007, 36–51 (revisit of his 2003b study of the rapport between Bernini's paintings, theater, and training of young artists); and Bruno. See also the pages relating to Bernini in studies of Barberini-sponsored theater and music, esp. Murata; and Hammond, 1994.

Note that Domenico and Baldinucci both cite Bernini's plays by specific titles; however, none of the other rather substantial contemporary primary sources, including Bernini's own self-references in Chantelou and the manuscript of *The Impresario*, ever mentions titles. There is no secure indication that the comedies in fact were given formal titles. And further, what Domenico and Baldinucci refer to as separate "plays" are instead in some cases simply single acts or episodes within a play, usually memorable for some outstanding special stage effect. As is documented in the reports of contemporary spectators, Bernini used the same repertory of effects or episodes in more than one play or within the same play: e.g., a single Bernini production one year contained both the "Flooding of the Tiber" and the "Two Theaters" scenes (see D'Onofrio, 1963, 96–99, reprinting the February 13, 1638, letter of the Duke of Modena's Roman agent, Massimiliano Montecuccoli).

28. Contrary to what Domenico says or leads one to believe, Bernini's theatrical productions began as early as 1632, and not in ca. 1635, supposedly coinciding with his convalescence: see the Introduction, section 7, for this dating. Spanning many decades of his adulthood, most of his productions were performed in his own home, although some were created for the Barberini and the Pamphilj (Donna Olimpia) and staged in their residences.

We do not know from independent sources who or what first prodded Bernini into writing and staging his comedies; he may have simply decided to emulate the Roman social tradition of offering Carnival entertainment to the public. In both Domenico and Baldinucci, Cardinal Antonio Barberini plays an important but different role as key mover: according to Domenico, the convalescent Bernini first writes his plays as a pastime and then shows the scripts to the encouraging Antonio, whereas Baldinucci, i.94, e.29 (with no indication of chronology or mention of convalescence), simply states that Bernini "composed and produced" his "fine edifying plays" at Antonio's "urging and expense." Baldinucci reports in the same paragraph that there were other plays performed in Rome—not of Bernini's creation—that utilized stage machinery that Bernini invented, and ends by promising to take up the subject later in his narrative. He keeps that promise on i.149–51, e.83–85, with more detailed notice of specific plays and their contents, but essentially as we find them in Domenico.

Baldinucci's second discussion begins with the general statement "It is not surprising at all that a man of Bernini's excellence in the three arts [painting, sculpture, architecture], whose common source is drawing, also possessed in high measure the fine gift of composing excellent

and most ingenious theatrical productions since it derives from the same genius and is the fruit of the same vitality and spirit." Baldinucci also there specifies that Bernini's busiest playwriting period was "during the time of Urban VIII and Innocent X." Many important details about and insights into Bernini's theater can also be culled from Chantelou, but the relative citations are too numerous to discuss or even summarize here (see the indexes to both the French and English editions). Let us simply note that Bernini, while in Paris, speaks often and with pride and enthusiasm of his plays (including four that Domenico does not mention), even reciting portions from memory.

29. *Prole*, his literary creations. Domenico earlier (p. 53) made a distinction between physical and literary "offspring" when talking about his children.

30. That "general statement" is the concluding line of this section (p. 57) about making the artificial or false (*finto*) seem real.

31. By stage sets (*le comparse*), Domenico seems to mean both the painted scenery and the machinery responsible for producing "marvelous" special effects like the rising or setting of the sun.

32. Baldinucci, i.149, e.83, also reports that the "ideas" with which Bernini enriched his plays led erudite spectators to believe that he had taken them from the ancient Roman playwrights, Terence (d. 159 B.C.) and Plautus (d. 184 B.C.), "authors never read by Bernini." (See the Introduction, section 7, about Bernini's reputation as *uomo senza lettere*, not well educated or interested in "book learning.") Italian Renaissance comedy modeled after Plautus and Terence was known as *commedia erudita*, but by Bernini's maturity this type of play had waned in popularity. We again have only one extant script by the artist—*The Impresario*—from which to evaluate his particular brand of theater, but that script is incomplete by at least 40 percent (according to Perrini, XXI) and not necessarily representative of Bernini's unscripted productions. To the extent that one can indeed place that original hybrid (*The Impresario*) in any specific category, it—and presumably the rest of Bernini's theatrical output—would seem to bear close affinity with the contemporary *commedia ridicolosa*.

A characteristic phenomenon of seventeenth-century Rome, the *ridicolosa* was a popular, eclectic, and informal genre of comedy: the scripts (subsequently published) were typically written by nonprofessional playwrights, who were nonetheless men of letters. They did so "as a mere pastime, in just a few days and with little effort; however, their authors dedicated themselves with much passion and amusement to the actual performance of the plays" (Santoni and Sagredo, 239–40), a description that fits Bernini's case very well. The *ridicolosa* incorporated elements from both the *commedia erudita* and the *commedia dell'arte* (the latter, by Bernini's adulthood, also in decline), such as stock characters, plots, and comic routines (*lazzi*), a humorously confusing mix of Italian dialects and foreign languages, and the satire of contemporary manners. Its satiric humor is intimately rooted in the chronicles of daily local life. For the *ridicolosa*, see Mariti; Cope; Slawinski, 138–39; and Santoni and Sagredo, 237–74 (with a catalogue of titles at the Casanatense Library, Rome).

Two of Bernini's learned contemporaries and members of his theatrical audience, poet-courtier Fulvio Testi (1593–1646) and *Abate* Zongo Hondedei (d. July 1674; also known as Giuseppe Ondedei, Mazarin's Italian agent and as of 1654 bishop of Fréjus, France), instead describe his farcically satiric plays as *all'antica*, in the ancient style, which Montanari, 2004a, 316–17, interprets as referring to Aristophanes. Florentine man of letters Giovanni Battista Doni (1594–1647) seems to do so as well, specifying that the plays were "much like the comedies of the Greeks." The same *erudito* Doni provides us with contemporary confirmation of the professional quality of Bernini's meticulously rehearsed theatrical productions: "[N]othing [in his play was] without purpose, nothing superfluous; indeed, everything was dynamic and to the point; the characters perfectly integrated into the plot, the action lively and true to life" (quoted by Montanari, 2004a, 303).

33. As far as both its supposedly "nonoffensive" satire and moral "decency" are concerned, Domenico is whitewashing the nature and tone of his father's work (as does Baldinucci, i.150, e.83). Bernini's theater, fully in the spirit of the Carnival season, was apparently at times quite

risqué, such as that which he produced for Donna Olimpia in February 1646, which scandalized some in the audience (see the report by the Duke of Modena's Roman agent, Francesco Mantovani, in D'Onofrio, 1963, 99–100; for the "licentious" quality of Donna Olimpia's theater, see also Teodoro Ameyden's manuscript *Diario della città di Roma*, Biblioteca Casanatense, Rome, fol. 209v, entry for February 6, 1649). In act 1, scene 5 of his extant script, *The Impresario*, Gratiano's servant, Zanni, warns his master, who is preparing a new production: "Remember, they said the last time that [your play] was crude (*grosso*)."

One wonders what Bernini's good Jesuit friend Gian Paolo Oliva—famous for his vehement preaching against the "immorality" of popular theater—thought of his productions. For Oliva's antitheatrical preaching, see Taviani, 241–59; and Oliva's *Prediche dette nel Palazzo apostolico* (3 vols., Rome, 1659–74), *ad indicem*, s.v. *comedia* or *comedie* (e.g., vol. 2, Predica LXXXII, "Della Concettione Immaculata," 190 and 192, "comedies and Carnivals must be forbidden to Christians"). For the great offense at times given by Bernini's satire, see also note 34. Bernini's Carnival production for Donna Olimpia was apparently an attempt to ingratiate himself with the Pamphilj in the aftermath of the bell-tower crisis: see Laurain-Portemer, 1969, 195 n.8, for Elpidio Benedetti's letter of March 12, 1646.

34. The pope in question is presumably Urban VIII. A February 5, 1633, report from Rome to the Duke of Modena, in describing the daring satire of Bernini's play of the season, mentions that "most believe that it all [Bernini's theatrical production] happens with the involvement and consent of His Holiness. This is confirmed by the fact that it has been learned with certainty that Pope Barberini and [Cardinal] Antonio enjoyed to no end what was recounted to them of the play's subject and of the circumstances surrounding it" (cited by D'Onofrio, 1963, 91).

Pontifically approved or not, Bernini's satire did at times give grave offense to its targets: the most notorious example is perhaps the case of Cardinal Gaspar Borja, humiliatingly mocked on stage in 1634. In 1646, the artist's veiled but nonetheless audacious satire was understood as mocking the pope and his nephew themselves (and the exiled Barberini as well), and "it was a miracle that Bernini did not end up in prison." See the dispatches from Rome to the court of Modena reprinted in D'Onofrio, 1963, 92 for Borja and 100 for the 1646 comedy; see also 105 for Salvator Rosa's veiled denunciation of the causticity of Bernini's theater. On Bernini's "art of social satire" expressed in his theater and his sketched caricatures, see Lavin, 1990 (a revisit of his earlier essays on the same topic).

35. Contemporary accounts confirm the fact that Bernini himself performed as actor (in addition to director and scenographer) in his plays, as did his brother Luigi and members of his workshop. The February 1638 report of Montecuccoli (agent of the Duke of Modena) notes: "[T]ruly one must say that [Bernini] knows how to produce such things, and not so much for the quality of the stage machinery as for the quality of the acting" (D'Onofrio, 1963, 96). Baldinucci, i.149–50, e. 83, tells us: "Sometimes it took an entire month for Bernini to act out all the parts himself in order to instruct the others and then to adapt the part for each individual."

In his *vita* of Bernini's disciple, Guido Ubaldo Abbatini, however, art biographer Passeri snidely remarks that the master in fact kept his poor oppressed students "in chains" throughout the year just to prepare for the annual Carnival productions (Passeri, 243). For Passeri as anti-Bernini critic, see Sutherland Harris, 1987, 44.

36. As Lavin, 1980, 150, points out, "None of the [theatrical special effects] Bernini used was actually invented by him." This includes the use of hydraulics (as in Bernini's "Tiber flood" scene) and pyrotechnic devices (as in the conflagration scene in Bernini's *Fair*), both practiced earlier by contemporaries. Bernini would have found precise instructions for creating such marvel-rousing theatrical machinery in the well-known illustrated manual of architect and engineer Nicola Sabbatini (ca. 1575–1654), *Practica di fabricar scene, e machine ne' teatri,* first published in 1637; see Hewitt for an unabridged English translation.

Sabbatini's manual reveals the surprisingly sophisticated level of special-effects technology that had been reached by that point in theater history. Sabbatini, in turn, "was not the inventor of the devices which he describes. . . . The machines in the *Practica* were well known and had

long been used" (Hewitt, 37). A copy of Sabbatini's handbook is inventoried in Luigi Bernini's personal library (McPhee, 2000, 444, cat. 35). This is not to say that Bernini's genius, as in all of his works of art deriving from earlier models, did not transform the machinery into something marvelously more effective and uniquely his.

37. Baldinucci, i.150, e.83, also describes this "famous comedy of the *Flooding of the Tiber.*" According to Montecuccoli, the flood scene was part of Bernini's 1638 play performed in the Barberini theater, which also concluded with the "Two Theaters" episode: see D'Onofrio, 1963, 96–99, for the text of the correspondent's long, detailed, act-by-act description, mentioning that the satire was prudently more impersonal than in past years.

38. Baldinucci, i.151, e.84, tells us that *The Fair (La Fiera)* was "produced for Cardinal Antonio Barberini during the reign of Urban VIII," and that its fame "will live forever," for "[t]here was everything in it that one is accustomed to seeing on such occasions." However, Baldinucci refers to this as a separate play from the one containing the famous conflagration scene, which he had already described earlier (i.150, e.84). No other contemporary document refers to a Bernini production by the name of *La Fiera* for Casa Barberini. For the 1639 reprise of Giulio Rospigliosi's *Chi soffre speri* (Let he who suffers have hope) in the Barberini theater, Bernini did produce a well-documented intermezzo (*intermedio*) entitled *La Fiera di Farfa,* featuring a tableau of the popular market at the famous Abbey of Farfa (for which see Hammond, 1985, and 1994, 236–39; and Fratellini). This, however, is not the play that Domenico evokes here; he makes no mention of the *Fiera di Farfa.*

Hammond states that the *Fiera di Farfa* represents "the only documented case of [Bernini's] participation in a Barberini opera during the pontificate of Urban VIII" (Hammond, 1994, 237). But see Lavin, 1980, 148, for a second example of Bernini's indirect connection with the scenery used in another Barberini production, the 1641 *L'innocenza difesa;* see also note 2 below to Domenico, 155, for Bernini's collaboration on a post-Urban, 1656 Barberini drama mentioned in the Medici archives. As for the simulated conflagration, one eyewitness account describes such a scene within a play by Bernini, namely, a February 14, 1635, letter of Cardinal Francesco Barberini (cited in Bruno, 69 n.6). During Bernini's visit to Paris in 1665, Abbé Francesco Butti mentions that he was in the audience during the performance of this play and was one of the first to flee in fear (Chantelou, October 5, f.225; e.256, with Bernini supplying further details about the stunt). Strangely enough, though, in his two short descriptions of the same Bernini 1635 production, *Abate* Zongo Hondedei makes no mention whatsoever of the fire scene; instead he speaks of the "two academies" of painting and sculpture as the main focus of that plot (see Saviotti, 72–73 for the texts; Hondedei's letters are dated February 14 and 24, 1635).

39. Baldinucci, i.150, e.84, instead confesses: "There was such terror among the spectators that it was necessary to reveal the trick to keep them from fleeing," with no mention of the death caused by Bernini's somewhat irresponsible, if not sadistic, stunt. Lavin, 1989, 28–30, suggests (halfheartedly) that Bernini's trick may have been his application of Aristotelian homeopathic catharsis, but he himself later admits (35) that "there is not the slightest evidence that Bernini adhered to the pathological interpretation of Catharsis, or even that he read Aristotle. I rather doubt it, in fact, since he was not of a very scholarly turn of mind."

40. See Baldinucci, i.151, e. 84, for the corresponding passage. Bernini himself describes the scene while in Paris: see Chantelou, July 26, f.91, e.82–83. Again this—a variation of the generic theatrical topos of "the play within a play"—is not original to Bernini, having been staged by the artist's older contemporary and dean of Italian professional theater, Giovanni Battista Andreini (d. 1654): see his *Le due Comedie in Comedia* (first printed edition, Venice, 1623). Bernini used versions of this device in his 1637 play known as *The Two Coviellos (I Due Coviielli)* and in his untitled play of 1638, together with his "Tiber Flood" scene (for contemporary accounts, see D'Onofrio, 1963, 94–96 and 97–98).

Domenico's mention here of a later reprise for the Rospigliosi refers to Bernini's 1668 production of *La Comica del Cielo, ovvero La Baltassarra,* written by Giulio Rospigliosi, then reigning as Pope Clement IX (see Tamburini, 1999–2000, for this production; 117–21 for this special effect; for the same play, see also Tamburini, 2005). Even with the assistance of all extant

descriptions, as Tamburini observes, it is not entirely clear how Bernini achieved this effect of double reality in specific spatial-material terms. Bernini's extant *Impresario,* in which main character Gratiano must come up with a play to please the prince, also makes use of a variation of the double-reality, "play within a play" theme.

41. Baldinucci, i.151, e.84, claims that Bernini "was the first to invent the wonderful machine of the sunrise," followed by mention of King Louis's request and Bernini's witty reply. But, as Lavin, 1964, 571 n.15, observes, this particular trick of solar technology "belonged in a tradition of sunrises and sunsets that goes back at least to Serlio" in the sixteenth century. In any case, Bernini's sassy response to the French king was not entirely diplomatic and presages the artist's self-defeating behavior in France in 1665. (See, on a related note, Laurain-Portemer, 1987, 115: Bernini writes to Cardinal Mazarin of his "secret" for machinery creating the effect of night and day, "il segreto di una illuminazione ideata per una macchina, per simulare il giorno e la notte.")

No other source mentions a Bernini play by the name of *The Marina,* but the marvel-inspiring solar effect is recorded in the letter of Francesco Barberini (Bruno, 69 n.6) describing Bernini's production of 1635; in the latter play, however, the sun was setting, not rising, doing so slowly over the waters of the sea and making use, no doubt, of the same machinery. There is also an extant drawing of such a scene attributed to Bernini or his circle: the setting (or rising) sun over a body of water (Brauer and Wittkower, 33–34, pl. 15; F. Angelini et al., 1997, 120, cat. 226; and A. Angelini, 1998, 300). Bernini also employed his special sunset effect as the concluding scene in his *Fiera di Farfa* intermezzo, as we know from a Roman *avviso* dated March 5, 1639 (published by Ademollo, 29–30, but not included among the documents reproduced in the appendix to D'Onofrio, 1963).

42. The play is perhaps more commonly known as the *Palazzo Incantato di Atlante* (The enchanted palace of Atlantis), based on an episode from Ludovico Arisosto's best-selling epic poem, *Orlando Furioso.* The script of the play was by Giulio Rospigliosi with Luigi Rossi providing the music. This well-documented opera of 1642 was yet another extravagant production of Casa Barberini, but Bernini's name appears nowhere in the documentation (see Hammond, 1994, 243–53).

It seems strange that both Domenico and Baldinucci (i.151, e.84) would confidently and in unqualified terms attribute the scenery and special effects to Bernini. Indeed, Baldinucci, i.151, e.84, says that this play and *The Marina,* produced with new *invenzioni,* "astonished their age." Instead, it is known with certainty that Barberini court painter Andrea Sacchi was responsible for the stage scenery and machinery. So why would our two biographers state otherwise? This, of course, would not be the only case of their (and Bernini's) arrogating credit to our artist for the work of another. However, usually in the latter cases, Bernini indeed had some actual, legitimate, if limited, connection with the project in question, such as Pellegrini's *Saint Maurice* altarpiece (Domenico, 26).

Regarding the *Palazzo Incantato di Atlante,* it is known (through a detailed letter from eyewitness Ottaviano Castelli in Rome to Mazarin in Paris) that the play's premier on February 22 was a disaster, in large part because of the malfunctioning of the machinery: "with respect to the machines, it went so badly that His Eminence [Antonio Barberini] became fearfully enraged, threatening prison and similar things," to the open amusement of his brother and rival, Cardinal Francesco (Hammond, 1994, 248; see also Bruno, 86). Since the cardinal's reputation and much of his financial investment were at risk, might Bernini have perhaps been called in to salvage the situation for future performances, thus giving Domenico and Baldinucci grounds for crediting our artist with its success?

43. It has been conjectured that Bernini's unwritten play about the faulty workings of the stage machinery (also briefly mentioned by Baldinucci, i.151, e.84–85) might be the extant *Impresario.* However, in the latter text, although the question of machinery—its quality and effect—is a central theme (see esp. Act 2, Scene 4), that of its malfunctioning is not. No machinery malfunctions in the play. In any case, Bernini may have derived his inspiration for such a play from the disastrous experience of the premier performance of *Il Palazzo di Astolfo,* which he is likely to have witnessed at the Barberini theater (see note 42 above).

44. What Domenico gives here in italics as the title of another, unstaged play, *Modo di regalar le Dame in Comedia*, Baldinucci, i.151, e.85, instead describes as its goal, "per regalar le dame in commedia." The verb *regalare* in seventeenth-century (and modern) Italian usually means "to give a gift [to someone]" or "to give [something] as a gift." However, in early modern Italian, it could also have the sense of "to regale"—to entertain, delight, gratify, or amuse. Fraschetti, 266, claims that in this play, *Modo di regalar le Dame in Comedia*, "flowers and confetti were gallantly offered to the most genteel ladies of the Roman aristocracy," but he does not identify the source of this detail; it is not in Carletta's article, "Bernini a teatro" (*Don Chisciotte di Roma*, 6 n.305, 1898, 1–2), which Fraschetti had earlier cited in n.1 on the same page (giving the incorrect issue number: it is 305, not 355). See M&MFagiolo, cat. 168, who claim that this play is to be identified with the one discussed in Chantelou on October 2 (f. 218, e. 247), *Chi sprezza, vuol' comprar* (Who decries, wishes to buy, a proverb), a play about the courting of women, which neither Domenico nor Baldinucci mentions. M&MFagiolo also claim without justification that the verb *regalar* in both Domenico and Baldinucci is "evidently a typographical error" for *regolar* (to regulate, govern, correct).

It is perhaps relevant to note that our same contemporary eyewitness, Zongo Hondedei, mentions that Bernini's troupe (if I have correctly deciphered his slightly confusing letter) improvised a theatrical entertainment in 1635 at a dinner organized by Cardinal Antonio Barberini, at which his sister-in-law Donna Anna Colonna Barberini and twenty-five other patrician ladies were guests (Saviotti, 73): Did this experience give Bernini his idea for a future play by which to "regale the ladies"?

45. "In far parer vero ciò, che in sostanza era finto." Baldinucci, i.151, e.85, reports this remark of Bernini's, but he does so instead as the artist-playwright's express reason for why he "disapproved of horses or other real creatures appearing on stage, saying that art consists in everything being simulated although seeming to be real." In fact, as Samek Ludovici points out (n. 145, Baldinucci, i. 276), Bernini himself was guilty of the same thing: he used live horses in his *Two Theaters* play and a live ox on stage in 1634 to mock Cardinal Borja (D'Onofrio, 1963, 92). On the same subject of deceptive artistic simulation, in *The Impresario*, Act 2, Scene 4, Gratiano—presumably Bernini's alter ego—declares, in discussing his clever machine for clouds: "Ingenuity and design constitute the magic art by whose means you deceive the eye and make your audience gaze in wonder" (Bernini, *Impresario,* trans. Beecher-Ciavolella, 1995, 53).

What was true of Bernini's theater is true of his other works of art, as Montanari points out, identifying the goal common to his entire oeuvre: "to push to the limits of possibility the traditional extent of imitation in order to reach a completely new and revolutionary degree of involvement on the part of the spectator, who is the sole, true, most consciously intended protagonist of Bernini's sculpture, architecture, and comedies" (Montanari, 2004a, 318).

CHAPTER VIII

1. On p. 32, Domenico had already quoted Bernini's similar dictum about the challenges of architecture.

2. See Baldinucci, i.83–84, e.17–19, for the *Barcaccia,* aptly translated as "old tub" by Hibbard and Jaffe, 160. As for the chronology of the project, the fountain "presumably was planned in 1627 or possibly slightly earlier; the design was finally settled, at the latest, in mid-1628"; actual construction was complete by mid-1629 (Hibbard and Jaffe, 167; see also Kessler, 2005, 405–9, cat. E12). Scholarly debate over the attribution of this fountain—was it by Pietro Bernini or Gian Lorenzo?—has now been concluded in favor of the son (see Kessler for a concise summary). The earlier doubt had derived not only from discordant attributions in the primary sources (e.g., Baglione, 1642, gave it to Pietro) but also from the fact that as "Architetto dell'Acqua Vergine" (from September 1623 to his death in August 1629), Pietro was *ex officio* in charge of the fountain project and hence his name, and not Gian Lorenzo's, appears on all extant documentation, which extends from January 1628 to June 1629 (for the texts, see Kessler,

456–59; see D'Onofrio, 1986, 353, for Pietro as overseer of the Acqua Vergine). As to iconography, as Hibbard and Jaffe, 163, remind us, "Ship fountains can be traced back to antiquity." But D'Onofrio, 1986, 363, claims that the *Barcaccia* is modeled after a common type of work boat (not military ship) commonly seen in the nearby Porto di Ripetta. See also note 5 below.

3. The Acqua Vergine, "Virgin Water" (named after a legendary young maiden at its source), was one of the few ancient Roman aqueducts still functioning in early modern times. Since the beginning of the grand papal program for the *restauratio Romae* (the restoration of the glory of Rome) in the sixteenth century, repair of aqueducts and expansion of their water distribution represented one of the priorities of the pontiffs. For the socio-hydraulic history and analysis of these early modern aqueduct projects, see Rinne, 2005, who notes (198) that the entire Acqua Vergine system—and not just the Piazza di Spagna—suffered from chronic low water pressure since, dependent solely on gravity for its water distribution, it served an area of Rome that was both extremely flat and wide. See also Rinne's interactive Web site on Roman aqueducts: http://www.iath.virginia.edu/rome/. Like his father, Bernini was also named by Urban VIII to important water-related posts: in October 1623 to superintendent of the fountains (*bottini*) of the Acqua Felice, and in late 1625 to "Commissioner or Inspector of the conduits of the fountains in Piazza Navona" (D'Onofrio, 1986, 353).

4. But this is what early modern Roman fountain designers had already been doing since the previous century: "Each fountain was designed around the distinct, inherent possibilities of the water at a specific location. Whether it shot in a lofty jet, fell in a rushing cascade, bubbled from a low nozzle, or slipped slowly over a stone lip, it did so because the symbiosis between gravity and topography had been exploited by the design" (Rinne, 1999, 76).

5. The papal distich is in Latin in the original text. Baldinucci, i.84, e.19, quotes Bernini to the effect that the "good architect" will always endow his fountains with a *concetto* (conceit)— some distinctive and noble poetic theme or historical allusion. But did Bernini himself originally design the *Barcaccia* with a conceit and did that conceit coincide with the one announced here by Pope Urban's distich? The verses in question had in fact been written about ten years earlier by then Cardinal Maffeo Barberini for a different and nobler (truly military) ship fountain, the *Galera Vaticana* (D'Onofrio, 1986, 367). Maffeo's verses were often put to secondary, postpublication use as they are here and as we saw in the case of the *Apollo and Daphne* statue (Domenico, 20). Perhaps, however, they attempt in this case "to endow the fountain with some complex symbolic allusion that in reality it did not possess" (D'Onofrio, 1967, 364–66). For contemporary verse (including that of Leone Allacci) in response to and praise of the *Barcaccia* as the ship of the Church, see Pietro La Sena, *Cleombrotus* (Rome, 1637), 74–78. Ironically, the fountain celebrated as symbol of the Catholic Church appears to be sinking (D'Onofrio, 1986, 358). Further irony derives from the fact that the poet-pope here in question was the very one responsible for inflicting upon the Roman people one of their most costly military disasters of the century, the War of Castro, waged on behalf of Barberini dynastic ambitions.

6. These lines are likewise in Latin in the original text. See Baldinucci, i.84, e.18–19, for a more censorious attack on this anonymous "indiscreet poet" who dared mock the pope. Yet the anonymous poet was correct in his charge, that the verses preceded the fountain and not vice versa (see note 5). If the anonymous verses were so offensive, why do both Baldinucci and Domenico publicize and indeed immortalize them in their published biographies? Was the papal respondent's wit simply too clever and too entertaining to ignore?

7. That is, the church of Santa Maria in Domnica (Domenico mistakenly writes "Domenica"; other contemporaries render it, likewise erroneously, "Dominica"). Both the church and its ship fountain (created in the early sixteenth century, incorporating a copy of an ancient Roman naval sculpture) still survive on that hill, now the site of one of Rome's public parks, the Villa Celimontana, created from the remnants of the once-vast Mattei family estate. However, nothing remains of Bernini's fountain of the eagle atop Mount Olympus (also mentioned by Baldinucci, i.147, e.81) and preserved in at least one contemporary engraving. Duke Girolamo Mattei commissioned for his villa a series of fountains and other embellishments for the 1650 Jubilee Year; Bernini's Eagle Fountain may have been part of that project. Bernini may have

also created yet another fountain, featuring Triton, for the same Mattei villa, but its existence is known only through a citation in one early source and hence doubtful. For all of the preceding, see D'Onofrio, 1986, 391, and figs. 347–48; for the iconography of the thematic gardens of Villa Mattei as earlier devised under Duke Ciriaco Mattei (d. 1614), see MacDougal.

8. The eagle was the animal associated with Zeus, king of the Greek gods, whose abode was Mount Olympus.

9. Baldinucci, i.147, e.80–81, also records the existence of this otherwise undocumented and long-missing fountain, correctly pointing out (as Domenico does not) that "this is a concept that had been used earlier by another artist for a fountain for the Most Serene Grand Duke of Tuscany." Baldinucci is referring to the sculpture by Giambologna on Tribolo's fountain at Villa Petraia, Florence. For both fountains, see Wiles, 103, and her entire chap. 9, "Bernini's Debt to Florentine Fountains." See Dickerson, 331–32, for a refutation of the claim of Giambologna's influence on Bernini's style: "Gianlorenzo never showed a real fondness toward Giambologna at any point in his life").

The now-disappeared Barberini estate in question, also called Villa Barberini al Gianicolo, was located above the Porta di Santo Spirito, on the northeastern slope of the Janiculum called Monte Santo Spirito, which had been fortified with bastions during the Renaissance. What remains of it—some open green space and one building—is now the international Jesuit head-quarters, their Curia Generalizia. For the most exhaustive study of the villa to date, see Bentz (I thank Professor Bentz for sending me a copy of her unpublished paper); see also Battaglia.

All scholarly attempts at uncovering traces of Bernini's *Woman Drying Her Hair* fountain sculpture have thus far been in vain. Wiles, 103, without citing her source or further detail, reports that it was sold and sent to England in the eighteenth century. Domenico here gives the impression that the property belonged to Cardinal Antonio; instead, its legal owner was his nephew Carlo (1630–1704), Prefect of Rome, who in 1653 (the year he was named cardi-nal) undertook completion of work at the villa, which his father Taddeo had purchased some-time between 1634 and 1644. The latter dates come from Bentz; Taddeo died in exile in Paris in 1647; see also D'Onofrio, 1986, 394, for the origins of the commission. However, according to extant documentation (cited by Bentz), Cardinal Antonio was often in residence at the villa. Coincidentally, not long after the publication of this biography, Domenico was to come to know this villa even better: our author's name appears on an official survey and appraisal of the prop-erty dated 1718 (Battaglia, 411; Battaglia reports that his search of the Barberini archives found complete silence surrounding the Bernini fountain on their property).

10. The verses are in Latin in the original. Domenico does not name Urban as their author, just as the one who ordered them inscribed on the fountain. But see Hibbard and Jaffe, 165 n.23: Urban included a poem on this same fountain, entitled "In apem fontis melliti qui est in Vaticano," in the first edition of his poetry published after the completion of this fountain (i.e, the Vienna 1427 edition, which I have not been able to consult), and thus "the implication is unavoidable that the poem was written especially for the occasion." Baldinucci makes no men-tion of this fountain, the origins of which are still debated.

Although extant documentation shows that Borromini, and only Borromini, was paid for his carving work ("lavori d'intaglio") on the fountain in April 1626, there are some scholars (most notably D'Onofrio and Fagiolo dell'Arco) who argue for Bernini as inventor of the clever design: see D'Onofrio, 1986, 354, for text of the 1626 payment and Bernini's authorship; and Fagiolo/*IAP*, 105. The fountain, reserved for the pope's personal use, features five, not three, bees. It is not to be confused with Bernini's other "Fountain of the Bees," also done for the Barberini (in 1644), now located at the foot of the Via Veneto in a largely reconstructed state: see D'Onofrio, 1986, 385–89.

11. For this work (counterfacade, S. Maria in Aracoeli), see Wittkower, cat. 37. The monu-ment (an inscribed scroll held aloft by two Fames, surmounted by the papal tiara) was decreed by the Roman Senate on February 11, 1634, to mark the annexation of the city of Urbino into the Papal States as well as Urban's benefactions to the city of Rome. The inscription bears the date 1634, but work was not completed until 1636. Bernini's small fee (100 *scudi*) would indicate that

his own contribution to the monument, beyond that of providing the design, was modest. On the same counterfacade is Bernini's earlier memorial (1630) to Urban's brother, the late Carlo Barberini, general of the papal army.

12. Not the Circus, but rather the Temple of Flora: see Platner-Ashby's *Topographical Dictionary of Ancient Rome*, s.v. "Flora, Templum." This is all that Domenico says about Bernini's work (1629–ca. 1634) at Palazzo Barberini "alle Quattro Fontane," on the northern slope of the Quirinal Hill, then just on the edge of the suburban area. For the palazzo's design and construction, see Hibbard, 1971, 83–84 and 222–27; Waddy, 1976 and 1990, 173–271; Fiore; Magnanimi; Marder, 1998a, 59–63; Borsi, cat. 12; Cherubini in *Regista/Restauri*, 19–26 (recent facade restoration); Burbaum, 84–108; Antinori, 2003; and Frommel, 2004.

Baldinucci, i.85, e.20, is even more laconic on the subject, but, like Domenico and other early sources, states without qualification that Bernini was responsible for its design. Yet in his appended catalogue of Bernini's works of architecture, Baldinucci limits Bernini's design contribution to the palazzo's "facade, stairway and hall *(facciata, scala e sala)*." Indeed, as Antinori, 2003, 145, points out, telltale signs of Bernini's hand are to be discerned in certain features of the western facade, the oval staircase, and the oval *sala* on the garden side of the *piano nobile;* see also Frommel, 2004, 100–102, for similar conjecture. However, none of Bernini's contributions can be identified with certainty, and, in fact, the authorship of the architecturally complex and unique design of the Palazzo Barberini remains an enigma. Carlo Maderno was official architect of the project (with Borromini and Bernini assisting) until his death in January 1629, at which time most of the design was complete but construction itself had not yet begun. As Hibbard (1971, 83) conjectures, when Bernini took over as architect in February 1629, "together with Borromini he must have revised myriad details."

Though his design for the residence was rejected as too costly, Pietro da Cortona also contributed smaller architectural elements, in addition to his magnificent fresco on the ceiling of the *salone*, the *Triumph of Divine Providence*, 1632–39 (for Cortona's architectural contributions, see Merz, 17–29). The Barberini themselves of course would have had much decisive input. Cardinal Francesco's biography of his brother Taddeo claims, "The entire fabric was the work of [Taddeo's] mind" (Marder, 1998a, 61). Ideas from the several nonprofessional advisers initially consulted by the family might also have made their way into the final product as well.

As for Bernini, even before Maderno's death, the young artist, having the ear of Urban VIII, could have had a real voice in determining the palazzo's design: "Bernini's influence would explain why Borromini was willing to revise a guidebook written by an enemy of Bernini's [Fioravante Martinelli's *Roma ornata*] to read 'the Palazzo Barberini was designed by many, but especially by Cavalier Bernini.' . . . It would also explain why the palace, Madernesque in so many details and even in so many larger ways, still seems to be the product of a mind and era later than Maderno's" (Hibbard, 1971, 84). Yet in contrast, in 1657 Pope Innocent X's architectural adviser, Virgilio Spada claimed: "[Cardinal Francesco] Barberini told me a few days ago that the Palazzo Barberini . . . was in large part the design of Borromini, and Borromini himself told me the same thing, which at first I did not believe, but in the end I did believe" (Lavin, 2008, 289–90). According to Marder, "A thorough analysis of the fabric and its history indicates that Bernini had little responsibility for most crucial decisions" (Marder, 1998a, 59). As Waddy, 1976, 183, rightfully concludes: "The Palazzo Barberini is not a unity, the inevitable outcome of a single persistent thought; nor is it properly a synthesis. It is a number of things, coexisting, the product of the efforts of many persons."

13. Emphasizing that Bernini worked on this fountain with his own hands ("con suo scarpello"), Baldinucci, i.84, e.19, cites it as an example of Bernini's precept that fountains should always be endowed with "some true meaning or allusion to something noble, be it truth or fiction," i.e., a poetic or historical conceit. The fountain was begun in 1642, in honor of the twentieth anniversary of Pope Urban's reign. The motif of Triton blowing into a shell recalls Bernini's 1622 fountain sculpture *Neptune and Triton* (now in the Victoria and Albert Museum, London) for the now-disappeared Villa Peretti Montalto. For this splendid Barberini fountain (now pathetically stranded in the middle of a large, sterile, noisy traffic island), see D'Onofrio,

1986, 371–84. Domenico passes in silence over some of his father's other fountain projects (such as the Villa Peretti Montalto fountain and his aborted work in the 1640s on the Trevi fountain): see D'Onofrio, 1986, passim, for a complete list and discussion.

14. For this important motif (Bernini as "always true to himself") in both Domenico's and Baldinucci's biographies, see Lyons, 2006.

15. Domenico calls the relief by its Latin name, *Pasce oves meas*. The project was executed over the long period of 1633–46, with little actual labor by Bernini himself and with a major interruption between 1634 and 1639: see Wittkower, cat. 34; and Bauer, 2000. Yet another visual assertion of papal authority, it is considered among Bernini's least successful creations (as by, e.g., Fraschetti, 326; Wittkower, cat. 34; and Montanari, 2007, 66). In Baldinucci, the corresponding and similarly brief mention of the *Feed My Sheep* relief and the Propaganda Fide reconstruction (see note 14 below) is at i.85–86, e.20, where he also and simply notes that Bernini made the design as well for the bell tower of Saint Peter's, deferring until several pages later (i.95–100, e.29–34) his detailed discussion of the latter ill-fated project and the controversy surrounding it.

16. Domenico presents this project, executed in 1644 (for which see Antonazzi, 39–47; and Marder, 1998a, 63–67), as yet another example of a design in which his father turns a handicap into an asset. The site in question is the northern facade of the Palazzo Ferratini, the much-remodeled sixteenth-century building representing the original nucleus of the young Collegio di Propaganda Fide, founded in 1622. Bernini's simple, almost drab facade survived intact (as it does today) the expansion of the Collegio that Borromini carried out over the years 1647–66 (most of the work on the "Nuovo Collegio" was executed in the 1660s). The same, unfortunately, cannot be said of Bernini's Chapel of the Three Magi (1634) within the same complex, not mentioned anywhere by Domenico but described by a Roman *avviso* in December 1634 as "marvelous and beautiful," thanks to the unusual oval shape that Bernini gave to it (Antonazzi, 27; see also 28, figs. 22 and 23, for the interior and exterior designs of the chapel).

Bernini's chapel was demolished in the fall of 1660 (Antonazzi, 67) in order to make way for a larger chapel of Borromini's design. The demolition, however, had already been decided in late 1652 with the formal adoption, following Pope Innocent's approval, of Borromini's second proposal for the new college. Borromini's first proposal had envisioned saving Bernini's chapel, but that became logistically impossible in view of the architectural *desiderata* (including a larger worship space) expressed by the cardinals of the Sacra Congregazione de Propaganda Fide. Hence one must not see the demolition as an act of spite or revenge upon Bernini by his rival, Borromini, even if the latter may have indeed derived some malicious satisfaction in the process. Also perhaps deriving malicious satisfaction from the demolition was another conspicuous Bernini opponent, Domenican friar and architect Giuseppe Paglia, who served as *misuratore* for the Borromini project from 1658 onward (Antonazzi, 60–62). For Borromini's "Nuovo Collegio" at Propaganda Fide, see also Stalla; for the Propaganda project, especially in the context of the Borromini-Bernini rivalry, see Burbaum, 231–61.

17. The last bays at either extremity of the facade of Saint Peter's that appear to be part of the original facade in fact represent later separate additions (1612–13) by Carlo Maderno during the reign of Paul V as bases for two bell towers (see Hibbard, 1971, 160–63, 170–80). The upper portions of the towers were never constructed during that pontificate; hence Bernini was now (presumably 1636) ordered to "finish" the structures. For the chronology of the project, see note 21 below. Bernini's ambitious plans were also ultimately to come to naught and no further attempts were made to build the desired towers. The relatively modest-sized, low-rise clocks that one sees today atop the bays were added in the late eighteenth century by Giuseppe Valadier.

McPhee's 2002 monograph is now the most thorough study of the long, complex, controversial case of Bernini's luckless towers. McPhee's research further exonerates Bernini for the bell-tower fiasco: blame goes in large part to the excesses of Pope Urban VIII, who pressured the artist "to produce an increasingly ambitious design," one that was too heavy for the foundations below (McPhee, 140). In his narrative, Domenico summarizes the whole affair in just a few short pages that are more misleading than illuminating. The same is true for Baldinucci's account, i.95–100, e.29–34, which combines into one continuous narrative all phases of the long, drawn-out case

(creation of the tower, subsequent appearance of the cracks, ensuing uproar and intrigue against Bernini, official investigations, and demolition of the work). Domenico, instead, delays to chapter 11 (discussion of the Innocent X pontificate) his description of the anti-Bernini intrigue and eventual demolition, thus giving the false impression that all was smooth and rosy during the reign of the good (i.e., Bernini-loving) Pope Urban.

For a convenient summary of the difference between the known facts of the case and the presentations by Domenico and Baldinucci, see McPhee, 2002, 172–75 and 175–77, respectively. To exonerate Bernini completely, both biographers are careful in pointing out the extreme caution Bernini took in designing the towers, in securing permission from both pope and Fabbrica, and in seeking out the expert and favorable judgment of the two veteran master masons before executing his plans.

18. The *Fabbrica* (or in Latin, *Fabrica,* "Works") was the congregation of cardinals that oversaw construction, maintenance, and embellishment projects in Saint Peter's Basilica; for its composition and functioning, see Rice, 1997, 7–12; and McPhee, 2002, 121–35. As McPhee, 173, remarks, Domenico's oversimplified "account glides over the considerable evolution of the design, the ever-increasing height of the structure, and the aesthetic problems that presented themselves upon its completion. His version presents a seamless picture of a single tower: conceived, approved, and built." Here as elsewhere in his biography (e.g., the Paris trip of 1665), Domenico's simplifications serve not only to shorten a complicated narrative for the reader's convenience but also, and more important, to enhance his father's image. Upon closer inspection, the course of events is never as flatteringly and entirely pro-Bernini as Domenico represents them.

19. Baldinucci (i.96, e.30–31) gives a much more detailed description of the tower's design with heights specified for each story. He also mentions (i.96, e.31) that "the wooden model" of the tower is "still in the office of the Fabbrica." Instead, as McPhee, 2002, 44–45, observes, because of the constantly evolving nature of Bernini's plans and the insufficient extant evidence, uncertainty reigns on the question: "Much scholarly debate has focused on the original aspect of this tower and the changes that occurred during its construction."

20. Baldinucci (i.95, e.30) gives the same names, likewise omitting Pietro Paolo's surname: it is Drei. Nothing is known of Colarmeno; for the better-documented Drei, see McPhee, 2008 (a detailed account of Drei's career). However, according to Baldinucci, it was the pope who called in these two experts, whereas Domenico gives the impression that the initiative came from Bernini. What neither biographer mentions is the fact that in February 1637, before construction began, an anonymous technical report was circulated that severely criticized Bernini's planned tower for both its enormous expense and, more important, its imprudent size, warning that the existing foundations (built by Maderno) could not possibly tolerate such additional weight. This report, obviously drawn up by someone with professional expertise—Borromini is its suspected author—may have provoked the special consultation on the foundations by Drei and Colarmeno. It was, in any case, ultimately dismissed and the decision to proceed was taken—a decision (and Domenico is correct in this) taken by all responsible parties involved, not just Bernini. For the 1637 report and decision to proceed, see McPhee, 2002, 50–52.

21. The first tower built was on the south side of the facade, which is on one's right, according to Domenico's reckoning, if standing on the church steps looking away from the basilica. For the extant stone plaque commemorating its erection by Bernini "painter, sculptor and architect," see Fagiolo-Portoghesi, 62, fig. 2. Domenico is correct about the insertion of the temporary wooden finial, but does not mention that it represented a later response to criticism of Bernini's initial design (McPhee, 2002, 69). As for the chronology of the project, we do not know precisely when the pope first gave his orders to the artist, but the "earliest secure notice of the tower planned by Bernini" is a November 1636 payment order for architect-woodworker Giovanni Battista Soria, who produced a *modello* according to Bernini's specifications. In May 1637, the travertine marble began to arrive; the completed tower was unveiled on June 29, 1641, the Feast of Saints Peter and Paul (McPhee, 2002, 46, 52, 73; for the stages and details of construction, see 56–71).

22. This is simply not true. Even before its official unveiling (June 29, 1641), Bernini's tower design became the subject of attack, especially for its crowning element (see note 21). As for reaction to the completed tower (completed, that is, with the exception of its finial in stone), we have this report from Giacinto Gigli's *Diario Romano:* "A few days [after the ceremonial unveiling and inaugural festivities] a third of the said bell tower was dismantled because it was unsatisfactory, and the Cav. Bernini, who was responsible for it, having been reprimanded by the pope, fell ill and was in great danger of death" (Gigli, 341; see also McPhee, 2002, 74; the attic story was removed at this point: McPhee, 175). Furthermore, on September 28 of the same year, we have the first report of cracks in the facade caused by the new bell tower, allegedly threatening a major collapse of the structure. According to a Roman *avviso* of that date, the pope severely reproached Bernini for refusing to heed the advice of others—as if the decisions thus far made had been simply the artist's alone! (McPhee, 2002, 75). Hence Bernini's bell-tower troubles did not begin only after 1644 (subsequent to the coming to power of the anti-Barberini and anti-Bernini Pamphilj pontiff), as Domenico would have us believe.

23. Strangely enough, despite the anxiety-raising appearance of the facade cracks supposedly provoked by the south tower and the lingering doubts about and criticism of Bernini's design based on aesthetic factors, work proceeded on the second (north) tower with the full consent of the Fabbrica. Work on this second tower did indeed stop abruptly in July 1642 (with only its first story built). But as McPhee (2002, 76–81) persuasively argues, the reason for halting construction had nothing to do with architectural concerns; rather, it was a shortage of funds as a result of the costly War of Castro then being recklessly waged by Urban VIII. Domenico will pick up the bell-tower story again on p. 77.

CHAPTER IX

1. The bronze crucifix for the King of Spain, intended for the Pantheon des Reyes of the Escorial (inaugurated March 1654) and now in the sacristy of the Colegio at the Escorial, is dated ca. 1653–54, thus produced later than the chronology Domenico here implies, though no documentation pertaining to the commission has yet come to light (Wittkower, cat. 57; Petrucci, 2006, 202; and Morello et al., cat. 20, 88). The suggestion by Fraschetti, 216, based on Gigli, 560–61 (and repeated by M&MFagiolo, cat. 150), that this might correspond to a wedding gift ("a corpus of the Crucified Christ within a most richly constructed case") given by Pope Innocent X in the summer of 1649 to Maria Anna of Austria, Philip's fifteen-year-old bride, is implausible. Similarly undocumented is Petrucci's claim (2006, 202) that the Escorial cross represented a papal gift supervised by Secretary of State Cardinal Fabio Chigi.

More correctly, Baldinucci, i.108, e.42, first mentions the crucifix (executed "at the request of the King of Spain") among the works of the end of Innocent X's pontificate of which a replica is later (i.148, e.81) reported: "The Cavalier . . . made a similar one for himself. While he was in France, he ordered his family to present his crucifix to Cardinal Pallavicino." The crucifix given to Pallavicino is mentioned in the Jesuit's will (Montanari, 1997, 50) and is now identified with that at the Salander O'Reilly Galleries (Petrucci, 2006, 202).

Neither biographer mentions the crucifix ordered from Bernini by Cardinal Antonio Barberini, as a gift to Louis XIV, ca. 1655, likely a replica as well of the one for Philip (present whereabouts also unknown): see Bandera Bistoletti, 43 (Antonio's letter of March 10, 1656); Petrucci, 2006, 202; and Morello et al., cat. 20, 88 (see the same entry for a newly discovered Bernini crucifix in Germany). For Bernini's other works for Spanish patrons, see note 48 to Domenico, 16.

2. Bernini's celebrated *Francesco d'Este* bust (commissioned August 1650; finished October 1651) is well documented (see the appendix of primary sources prepared by Mancini in Lavin, 1998a). The artist and sitter never met; the bust was executed on the basis of just two profiles painted by Justus Suttermans. The duke's brother, Cardinal Rinaldo d'Este, supervised the project from Rome.

Although a Bernini friend and admirer (see Domenico, 99 and 162), Rinaldo initially gave equal consideration to Algardi as prospective sculptor. For the bust, which established the idealizing Baroque portrait type of the absolute ruler, see Lavin, 1998a and 2005b (the latter article especially concerns Bernini's financial "reward" from the duke and its sociological implications); and Jarrard, 2003, 157–66.

The duke's commissioning of his portrait from Bernini was just one facet of Francesco's ambitious and successful campaign for the aggrandizement of his image and that of his family (exiled to Modena in 1598 after papal annexation of their ancestral homeland, Ferrara) through grand projects of art and architecture; in 1659, Bernini was approached by the d'Este family for an equestrian statue of Francesco I; for the latter and Bernini's involvement with d'Este art projects, see Marder, 1999b; and Jarrard, 2003.

3. The *doppia* (plural, *doppie*) was a gold coin weighing 6.781 grams, twice the weight of a Roman gold *scudo* and hence its name ("double"). The *unghero* (more commonly spelled *ongaro*) was a gold coin fashioned in imitation of the Hungarian florin (hence its name in Italian), issued by various principalities of Italy, including Modena (see Martinori, s.v. *ongaro*).

Baldinucci, i.106, e.40, reports that Bernini received "in so many silver pieces an honorarium worth three thousand *scudi*," this figure confirmed by extant documentation (Mancini appendix, 55, in Lavin, 1998a). The Florentine Cosimo Scarlatti (d. July 1686) was Bernini's maggiordomo since at least 1643: see the Bernini household Easter census in Fagiolo/*IAP*, 343–49; for Scarlatti's last will and testament, 382–84.

4. For this commission, see Baldinucci, i.88–89, e.23–24, who specifies that Bernini first secured the pope's permission before executing the English king's portrait. The portrait was executed at a time when the papacy still hoped for the conversion to Catholicism of King Charles (1600–1649, r. 1625–49) and, with him, the English nation, given the propitious circumstance of the king's marriage to a Catholic, Henrietta Maria, daughter of Henry IV of France, who was also goddaughter to Pope Urban VIII (see note 11 below). Lightbrown, however, maintains that "there is not the slightest evidence that either [Urban VIII] or his nephew [Cardinal Francesco Barberini] thought [the bust] would seriously influence the King's political and religious policy" (Lightbrown, 1981, 451).

The history of the bust, destroyed in the January 4, 1698, fire that consumed Whitehall (Brotton, 352), is fairly well documented, the first mention of the commission being a letter of June 13, 1635 from Gregorio Panzani, Barberini agent in London, reporting the king's delight in the pope's granting of permission for the bust; "there is every reason to believe that it was Henrietta Maria who made the formal request to the Papal court" (Lightbrown, 1981, 441). The design of Bernini's original is known through various forms of evidence: an early eighteenth-century marble copy in Windsor Castle, a late seventeenth-century engraving attributed to Van der Voerst (Lightbrown, 1981, figs. 1 and 3, respectively), as well as recently published plaster casts and drawings (for which see *Effigies and Ecstasies,* cat. 26). Lightbrown, 1981, remains the most thorough discussion of the bust commission.

5. Namely, when the time comes to send Bernini remuneration for the portrait.

6. As Lightbrown, 1981, 442, reasons, the correct date of this letter "was certainly" 1635 (the year in which Van Dyck painted his triple portrait of the king, used as Bernini's model), not 1639 as Domenico here reports, nor 1636 as corrected by Fraschetti, 110. However, according to Lightbrown, "The earliest date at which Bernini can have begun work on the bust would fall in the last weeks of April 1636."

7. Baldinucci, i.88, e.23, who does not reproduce Charles's letter, says of the Van Dyck portrait: "I saw this painting less than two months ago in the house of Bernini's two sons." Willed at Bernini's death to his brother Luigi (BALQ, 62), the painted portrait is now in the Royal Collection, Windsor Castle: see Bacchi-Hess-Montagu, cat. 6.2.

8. That is, Bonifazio Olivieri, one of Bernini's studio assistants, who shared the transportation responsibility and perilous journey with Thomas Chambers ("Tommaso Camerario"), a Scotsman in the entourage of Sir William Hamilton, who served as Henrietta Maria's agent in Rome (for a detailed account of the bust's journey to England, see Lightbrown, 1968; see also

Lightbrown, 1981, 445-46). As Lightbrown, 1968, 117, notes, "The long and detailed instructions which [Cardinal Francesco] Barberini drew up for Chambers still survive," as does some of the correspondence between the same cardinal and the two couriers, written en route. The bust arrived safely at its destination on Sunday, July 26, 1637.

9. Domenico's anecdote of the king's spontaneous reaction is simply not true. While indeed both Charles and his wife were extremely pleased with the bust, there is no record of their precise words upon viewing it for the first time. Furthermore, the gift of the ring was not decided until much later: "Contemporary correspondence shows that matters [pertaining to Bernini's remuneration] proceeded very differently and much more deliberately, and above all, that the king in no way concerned himself with the question of payment" (Lightbrown, 1981, 446-47).

10. Baldinucci, i.88, e.23, gives that same value of the ring, sent after much delay to a by-then impatient and importunate Bernini. This figure is also reported in a dispatch from Rome to the court of Modena. However, English sources place its value at 4,000 scudi. See Lightbrown, 1981, 448-49 for the ring and Bernini's anger at the delay in payment.

11. Henrietta Maria, or Henriette-Marie (1609-1669), youngest daughter of King Henry IV of France and Maria de' Medici, married Charles in 1625. After the king's execution in 1649, she traveled between France and England, returning permanently to the French court in June 1665. Strangely enough, although Bernini's stay in France coincided with the queen's residence there, Chantelou's Journal never mentions an encounter between the two. See Chantelou, f.392, letter by Mattia de' Rossi of July 24, 1665: "We were then dismissed by His Majesty, who mounted his coach in order to go and receive the Queen Mother of England, who was en route to Saint-Germain, where she is residing in this moment." Her daughter, Henrietta Anne, married Philippe, the Duke of Orléans, brother of Louis XIV, both of whom Bernini met on several occasions during his stay at the French court.

12. Baldinucci, i.89, e.23-24, publishes the same letter with minor variations; the most important difference is that of the date, June 26, 1639, which is indeed the one we find in the extant original: BNP, Ms. italien 2082, fol. 37r-v. However, Lightbrown, 1981, 453, published what he also describes as the original, extant in the Royal Library and once pasted, he says, on the back of Van Dyck's portrait of the king. Was there a second autograph original?

13. Whoever translated Henrietta's original letter into Italian misread the name of this gentleman: as we read in the extant original (see note 12), it should be "Conneo," i.e., George Conn (or Con), also known in Italian as Giorgio Conneo (Coneo) and, in Latin, Conaeus. Of Scottish birth, Conn went to Rome in 1623 to join the household of Cardinal Montalto, having previously studied at the University of Bologna and served as tutor to the son of the Duke of Mirandola. By 1626, he was a member of the Barberini court, meriting inclusion in Leone Allacci's portrait of the Barberini courtiers, the Apes Urbanae (Rome, 1633, 125-27). In July 1636, he replaced Gregorio Panzani as papal agent in London and as such was under constant surveillance as a spy. His masculine charm and "well-spoken, gentlemanly manner gave him great appeal with women," including the queen, and won several notable conversions to Catholicism (D. Barnes, 51; see also Smuts, 29, for his success with Henrietta and her female courtiers). Born sometime early in the century, Conn died young in Rome on January 10, 1640 (last will and testament are extant), just a short while after his return from England, at which time he brought this letter to Bernini. A funerary monument in his honor (with portrait bust by Lorenzo Ottoni), commissioned by Cardinal Francesco Barberini, is in S. Lorenzo in Damaso, where Conn had a canonry (Ferrari and Papaldo, 182). For his life, see Oxford Dictionary of National Biography, s.v. "Conn"; C. Hibbard, passim; Albion, passim; Bone, 99; and the informative pages in Solinas, 1992, 256-60 (257 n.100, for his will), as well as Solinas, 2007, 209-10.

14. Charles's last years, beginning in 1642, were marked by civil war, culminating in his overthrow and eventual beheading on January 30, 1649. However, Henrietta Maria would have gotten her Bernini bust had she not procrastinated so much in having the necessary oil portraits done by Van Dyck, three of which were executed and are extant. For these canvases (and the queen's procrastination), see S. Barnes, cat. IV.125, 126, and 127; see cat. IV.123 for another Van

Dyck portrait of the queen, which she gave to Francesco Barberini in 1639; see also Raatschen, 142–44, for the Van Dyck portraits for Bernini. Although she did not get her Bernini portrait, Henrietta Maria did own a (now lost) reliquary of Saint Helena designed by Bernini (*Effigies and Ecstasies*, 29). Domenico includes a detailed discussion of King Charles's last years and execution in his *Historie di tutte l'heresie*, 4:634–36.

15. Domenico's "Lord Coniik" (which seems like a bungled amalgam of "Conn" and "Dyck," as in "Van Dyck") is instead Thomas Baker (1606–1658) of Whittingham Hall, Suffolk. Baker was "an ordinary country gentleman" and "young man of no particular achievement," but obviously was of substantial financial means and "guilty of an audacious act of overweening vanity in commissioning a bust of himself" (Lightbrown, 1981, 464–65). Baldinucci, i.89, e.24, simply identifies the Englishman in question as "a very noble and rich cavalier of London" who "decided to go to Rome" specifically to have his portrait done by Bernini. Baker's sister was Maid of Honor to Queen Henrietta Maria and this connection may have given some credence to the unconfirmed story that the English engraver and antiquary George Vertue (1684–1756) told in 1713, that it was her brother Thomas who accompanied the Van Dyck portrait of King Charles to Rome.

In fact, Baker seems to have already been touring the Continent since the summer of 1634, continuing to do so for several years thereafter; on the other hand, a return visit home in the autumn of 1625 (during which he could have picked up the finished portrait of the king) cannot be excluded (Lightbrown, 1981, 456–58 for his travels; 463 for the Vertue claim; *Marmi vivi*, cat. 27, 318, for Montanari's belief that Baker indeed served as courier for the Charles I bust). As for his stay in Rome, all we have is record of a visit to the English College there on November 16, 1636, by a "Mr. Baker, gentleman of distinction" and (according to Bellori) of Thomas's purchase of a "life-size naked Cupid" from François Duquesnoy, mostly likely in 1641 or early 1642 (Lightbrown, 1981, 456 and 458).

Now at the Victoria and Albert Museum, London, Bernini's bust of Baker is dated ca. 1637–39. For the bust and further biographical data on Baker, see Lightbrown, 1981, 453–68; see also *Effigies and Ecstasies*, cat. 27; Bacchi-Hess-Montagu, cat. 6.1; *Marmi vivi*, cat. 27 (dating it to spring 1637–summer 1638); and note 16.

16. The Spanish *dobla* may have then been worth three *scudi* (Wittkower, 1953, 19 n.5), thus explaining the 6,000 *scudi* figure given by Baldinucci (i.89, e.24). Chantelou, Oct 6, f.228, e.259, reports the story of the Baker bust told by Bernini himself: Bernini "said that he had done several portrait busts, among others one of an Englishman who had seen the bust of the King of England. . . . He wanted one of himself so much that he would not leave him alone until he had agreed to do it and had promised him any sum provided that no one should hear about it. In the end the Englishman had given him ____ *écus*" (the amount in the manuscript is illegible: see Stanić's n.1 to Chantelou, f.228).

Another, much earlier version of the story told by Bernini is recorded in detailed fashion by the young English sculptor Nicholas Stone Jr., who visited Bernini in his Roman studio in 1638: Bernini told Stone that he was persuaded to do the bust not because of the promised reward, but of the opportunity of showing the English how much better he could do a portrait when working from a real-life sitter, rather than merely a portrait in oil, as in the case of Charles I. However, Bernini was forced to abandon the bust (at the terra-cotta *modello* stage) before its completion, since the pope "would have no other picture sent into England from his hand but his Majesty" (Lightbrown, 1981, 460, quoting Stone).

Stone further quotes Bernini as claiming that he had "defaced the modell in divers places." Thus, "it is surmised that the sculptor either repaired the terra-cotta or created another and then executed the marble, leaving much of the work to an assistant in order to elude reprisal. Most scholars believe that this assistant was Andrea Bolgi (1605–1656), the only 'man of consequence' in Bernini's studio at the time" (Bacchi-Hess-Montagu, cat. 6.1). Of the Baker bust ("one of the first examples of a bust whose only function is as a work of art rather than as a celebratory or commemorative image of an important, powerful, or lauded figure"), furthermore, "there is general agreement that Bernini was responsible for the head and, perhaps, the lace" (Bacchi-Hess-Montagu, cat. 6.1).

17. See Baldinucci, i.89–91, e.24–26, also identifying the intermediary as Cardinal Antonio (who in addition to being a close friend to Bernini also served as Cardinal-Protector of France). However, Mazarin played an important role in the commission from the beginning, eager (according to Laurain-Portemer, 1987) to emulate Rome in exploiting art for the aggrandizement of France's political image and power. The initial idea (dating to summer 1640) apparently was to have Bernini execute a full-length statue, but it is conjectured that the idea was vetoed by Pope Urban and Cardinal Antonio: a "mere" prime minister, and a foreign one at that, did not merit a statue of those dimensions (Hendler, 61; Laurain-Portemer, 1987, 117).

Goldfarb, cat. 110, 261, quotes Mazarin's Roman agent Elpidio Benedetti (for whom see Domenico, 71) as reporting that it was Bernini who preferred to begin with simply a bust before proceeding to a large statue, but that may have been a diplomatic lie. Bernini began the bust in September 1640, finishing it in January 1641; it reached Paris on August 21, 1641. Bernini and Richelieu are likely to have met in Rome in the spring of 1638, when Richelieu came to the city to receive his cardinal's hat (Mirot, 167; Fraschetti, 111).

Neither Domenico nor Baldinucci identifies the model Bernini used in executing the bust. It is a matter of debate whether he had used the extant portraits in oil by Philippe de Champaigne (National Gallery, London) from which Francesco Mochi later executed his full-length statue of Richelieu. For the bust (now in the Louvre), see Goldfarb, cat. 110; *Regista,* cat. 53; Gaborit (who resolved any lingering doubts as to the autograph status of the Louvre bust); Hendler; and Bacchi-Hess-Montagu, cat. 6.4. For the unresolved question of the Philippe de Champaigne portraits and Bernini, see Goldfarb, cats. 110, 111, and 112; and Bacchi-Hess-Montagu, cat. 6.3.

18. The bust was also accompanied by Bernini's assistant, Niccolò Sale (Goldfarb, cat. 110, 261). For the Frenchman Sale, see Domenico, 112, and commentary. Richelieu (b. 1585) was fifty-seven at the time of his death in December 1642. Hence Domenico's chronology is correct, whereas the 1642 date given to Bernini's letter is not (see note 21 below).

19. The formulaic salutations used in seventeenth-century Italian letters conformed to a strict hierarchical protocol dependent upon the social rank of the recipient; see Stevens, 6–7. The title *Padrone,* "Master" (which in other contexts can also mean "Patron"), is an honorific used for both lay and ecclesiastic correspondents (my thanks to Eraldo Bellini for this observation).

20. That is, for any shortcomings the work might have because Bernini could not execute the bust from life.

21. The year should be corrected to 1641, since we know that on August 21, 1641, Mazarin wrote to Cardinal Antonio announcing the arrival of the bust (Laurain-Portemer, 1987, 118).

22. Again, as usual, Domenico gives a detailed description of the munificent reward bestowed upon his father, as indicative of the exalted status and "virtue" of both the donor and the recipient (see the Introduction, section 7). Although there is no record of Richelieu's reaction to the bust, Mazarin confided with dismay to his brother (in a letter of September 3, 1641) that, even though the "excellence of the bust truly surpasses all that could have been expected," it did not resemble the minister at all. However, Mazarin blamed the painted models and not the artist, predicting that not all in the French court would like it. Nonetheless, on December 18, 1641, Mazarin wrote Bernini a most flattering letter reporting the "admiration" that his Richelieu portrait had provoked in Paris and mentioning the fact that better portraits in oil would be executed (by Van Dyck) from which the artist could work on a second marble portrait. Presumably the latter reference is to the full-length statue ordered next from Bernini, a revival of the original plan.

Sometime thereafter, Bernini produced a terra-cotta *modello* of a new Richelieu portrait (extant in Casa Bernini at the time of his death, as per the January 1681 household inventory), which is thought to have served as a model for two bronze busts, both extant, one in Potsdam and the other in Victoria, Australia (Wittkower, cat. 42).

23. The Italian cardinal whom Domenico calls Giulio Mazzarini and Mazzarino is today conventionally known by his French name, Jules Mazarin (1602–1661). His friendship with Bernini dated at least to 1632 (see note 28 below). Born and raised in Italy, Mazarin became prime minister of France after Richelieu's death in 1642 and successfully continued his predecessor's

mission of establishing French hegemony in Europe. Before his definitive move to Paris in January 1640 (as a naturalized citizen), Mazarin had led the pro-French faction within the Barberini papal court, gaining much favor with Louis XIII and Richelieu, who secured a cardinal's hat for him in December 1641.

24. As mentioned in note 17 above, the full-length statue of Richelieu was never executed, at least not by Bernini. This was most likely due to Barberini opposition rather than the minister's death, although the reason may also have been French dissatisfaction with the quality of Bernini's bust. Francesco Mochi did sculpt such a full-length portrait, extant but decapitated and otherwise badly mutilated (Goldfarb, cat. 112). While in Paris in 1665, Bernini will once again deal with Cardinal Richelieu, or rather, his memory: the Duchess d'Aiguillon, Richelieu's niece and universal heir, sought (and ultimately ignored) Bernini's advice for the design of the cardinal's tomb at the Sorbonne (Chantelou, October 8, f.238, e.272; yet Bernini had already sent the duchess a tomb design in 1657: see Chantelou, f.238, n.4).

25. See Baldinucci, i.92, e.26–27, who, however, erroneously dates Louis XIII's invitation to Bernini to the year 1644, whereas the king died in May 1643. The eldest child of Henry IV and Marie de' Medici, Louis (b. 1601) reigned from 1610 until his death. According to Bernini himself (Chantelou, July 22, f.83, e.70), "when he [Bernini] was quite young, the comte de Béthune [French ambassador to Rome, Philippe de Béthune, Comte de Selles and Charost (1561–1649)] had tried hard to persuade him to come to France and offered him as inducement a great salary and rewards from the king; he had weighed the advantages and resolved on coming, but Urban VIII, then only Cardinal Barberini, had made him change his mind." However, Béthune—one of Caravaggio's protectors—was in Rome only in the periods 1601–5 and 1624–30. By 1624, Maffeo was already pope; hence Bernini's memory is slightly faulty here. See Barbiche and de Dainville-Barbiche, 495–96, for the dates of Béthune's tenure in Rome.

26. In the seventeenth-century Roman vocabulary, the word "heretics" referred to the Protestants, but here it refers more specifically to the Huguenots.

27. For Mazarin's various attempts to bring Bernini to Paris in the period 1644–60 (as part of his overall cultural-political campaign for the establishment of French hegemony), see Laurain-Portemer, 1987 (121, 124, and 131 for specific dates). For Mazarin as art patron more generally, see Haskell, 1980, 180–87. One of the Mazarin commissions that Bernini refused was the design of his new residence, the Palais Mazarin, where, ironically, the artist himself would be housed in 1665 while working at the court of Louis XIV: see note 28.

28. Like Bernini, Mazarin had also been a member of the Barberini circle during his Roman period of 1632–34, and thus, we presume, the two knew each other fairly well (Laurain-Portemer, 1987, 114). How Bernini really felt about the cardinal might perhaps be deduced from a remark the artist made during his 1665 Parisian stay, four years after Mazarin's death: the Cavaliere "repeated some reflections which he said often occurred to him in the Palais Mazarin— how little it profits a man to have built great palaces, possessed vast wealth and high favors; it might have been better for the Cardinal had he thought about having good quarters where he is now. Father ____, a Dominican and a papal preacher said . . . those who were Christians and refused to give up their sinful ways should be put in the madhouse" (Chantelou, August 18, f.126, e.128; Bernini was at the time residing in the Palais Mazarin itself, for which see note 22 below to Domenico, 128).

29. Baldinucci, i.92–93, e.27, also prints this letter, but without a date. In what would appear to be the extant original (BNP, Ms. italien 2083, p. 87), the last five lines of the letter are underlined for emphasis; as the underlining is written with the same ink and same amount of pressure as the rest of the letter, one assumes that it was not added later by another hand. Yet the letter in the BNP (beginning "Haverebbe V.S. offeso" and ending "ogni vera felicità") is dated July 18, 1645, not August 27, 1644, as Domenico diligently reports twice on this page. In any event, as is evident in this letter and as Laurain-Portemer, 1987, 121 n.39, points out (but accepting the August 1644 date): "Contrary to what Domenico claims, it was Bernini himself who made the first move since Mazarin's letter . . . was in fact written in response to one sent by the artist."

In 1644–65, Bernini was apparently contemplating a safe haven for himself in France, given the widespread incandescent anger against his parton, Urban (d. July 29, 1644), generated during the last ruinous years of his reign (Laurain-Portemer, 1987, 121–22). Baldinucci, i.92, e.27, gives the same pious reason for Bernini's decision not to move to France, i.e., gratitude for Urban's memory. The letters of commission, *brevetti,* that Mazarin mentions in this letter concerned Bernini's royal pension and his position as architect to the king (Laurain-Portemer, 1987, 121). See Laurain-Portemer, 1969, 193, for a never-executed project conceived by Cardinal Antonio Barberini in the summer of 1658 to have Bernini sculpt Mazarin's portrait (as well as that of the king) on the basis of painted portraits to be done by Pierre Mignard. Mazarin agreed to the proposal, promising to send the canvases as soon as possible.

30. The abbé Elpidio Benedetti (ca. 1610–90) served as agent to both Mazarin and Colbert in Rome, acting as ubiquitous intermediary for the French court on nearly all important projects involving art and architecture, such as Bernini's design for the new Louvre (see, e.g., Colbert's letter printed by Domenico, 117). For Benedetti, see *DBI,* 8:250–51.

CHAPTER X

1. As usual, Domenico's chronology is extremely vague. However, by placing this (otherwise undocumented) conversation here, just before mention of Urban's death, Domenico leads us to believe that it took place not long before the pope's demise. In fact, Urban had planned his tomb with Bernini years earlier, namely, by late 1627. Its execution took twenty years to complete, occurring in two phases, 1628–31 and 1639–47. Domenico's claim on p. 74 that construction began in March 1644 is untrue. Baldinucci, i.86–88, e.21–22, more appropriately places discussion of Urban's tomb earlier in his narrative: between the notice of the Matilda of Canossa monument and the Charles I bust, offering a detailed, aesthetically sensitive description of the work. For the tomb, see Wittkower, cat. 30; Avery, 119–26; Fehl; and Lavin, 2005a, 131–35.

2. Urban's tomb is in the apse of the basilica, on the right side (to one looking from the nave) and opposite Guglielmo della Porta's tomb of Paul III (executed 1551–75), which had been moved there from the southwest cupola pier. Bernini clearly designed his Urban monument as a sufficiently "matching partner" to the earlier tomb (Lavin, 2005a, 130–31).

3. I have not been able to trace the authors of these encomiastic citations. However, Domenico may have consulted the list of "authors who have made mention of Signor Cavalier Bernino" assembled by Carlo Cartari in 1674, at the request of Pietro Filippo Bernini, presumably for the purposes of the planned biography of his father. The list is extant, among the Bernini papers in Paris (BNP, Ms. italien 2084, fols. 108r–112v): see Montanari, 1998a, 129 n.5, and 1998b, 402.

4. Urban's tomb was unveiled on February 28, 1647. Innocent's remark is not recorded by any other source, Baldinucci included. However, a letter dated March 2, 1647, by the Barberini agent in Rome, Cardinal Angelo Giori, to Francesco Barberini in Paris quotes the pope as saying about the newly unveiled tomb, "It is beautiful, it has come out beautiful" (Feliciangeli, 28). Born in 1587, the son of a Roman tailor, Giovanni Giacomo Panciroli (also Pancirolo, Panzirolo, and Panziroli) was made cardinal in July 1643. He is considered the first papal secretary of state (appointed September 1644) in the modern sense of the term, since Innocent X was unable to rely on his nephew to fulfill the diplomatic-political duties that had hitherto been the responsibility of the Cardinal Nephew (Cardinal Padrone). Panciroli remained in office until his death in 1651.

5. According to Baldinucci, i.87, e.22, the verses were written by Cardinal Angelo Rapaccioli (d. 1657), not Panciroli. For the question of their authorship, see Montanari, 1998a, 133 n.13; for Rapaccioli as poet, see Montanari, 1998b, 402. Rapaccioli also wrote a Latin panegyric on Bernini's Baldacchino, extant among the Bernini family papers in the Bibliothèque Nationale, Paris (BNP, Ms. italien 2084, fols. 96r–99v).

6. Baldinucci, i.88, e.22, reports the anecdote in more concise fashion. We have confirmation of the episode in the letter of March 2, 1647, by Cardinal Angelo Giori. Giori was present

at the unveiling, since Urban had given him the task of supervising the tomb project (Wittkower, cat. 30) and had functioned as Roman agent of the Barberini during their exile in France. Strangely enough, however, Giori does not identify Bernini as the quick-witted respondent to the anti-Barberini quip about the scattered bees. The cardinal only describes this defender of Barberini honor as "another of our clients (*creature*) who was standing nearby" (Feliciangeli, 29). Giori does mention Bernini's name in the very next paragraph of his letter (about a different matter completely), making no connection between the artist and the just-described episode. Did Bernini or his heirs thus appropriate to our artist a witticism uttered in fact by another contemporary? Yet in his annual Carnival production of the previous year (1646), Bernini did not show himself to be so respectful of his former patrons, satirizing the "dispersed Barberini" to the disgust of some in the audience at the artist's shocking ingratitude: see the report from Francesco Mantovani, agent in Rome of the Duke of Modena, in D'Onofrio, 1963, 99–100.

7. Domenico makes it appear as if the Barberini left Rome of their own free choice. Instead, in rather ignominious fashion, they were obliged to escape to Paris in order to avoid investigation and prosecution by Innocent for financial corruption during Urban's reign.

8. Domenico, here and at the beginning of chapter 11, whitewashes the facts in his characterization of Urban's unpopularity at the time of his death, that is, he exonerates the pope from any responsibility for the great antipathy provoked among the people for the havoc he wrought, financially and otherwise, upon Rome, the Papal States, and indeed Christendom, especially through his nepotistic practices, his mishandling of the Thirty Years' War, and the War of Castro, which cost the papal treasury 5 million *scudi* (Nussdorfer, 226, for the Castro war costs).

For the generally acknowledged "disastrous finale" to Urban's pontificate, see *EncPapi* 3:314–17; see also Nussdorfer, 245–46, for the unprecedented virulent explosion of postmortem condemnation of Urban, denounced as "the new Nero." For the political and spiritual paradoxes of Urban's reign, see Hook. Also, at the beginning of chapter 11, Domenico will be evasive as to the causes of Innocent X's antipathy for the Barberini, as if it were simply a matter of personal, unjustified pique. For Domenico as staunch papal apologist in all of his published works, see my Introduction, section 3.

CHAPTER XI

1. Again, a whitewashing by Domenico of Urban's record: see note 8 in chapter 10.

2. Domenico now returns to the case of the bell towers begun in chapter 8 (see pp. 62–64 above and commentary), which ended with the completion of the first bell tower to universal applause and with work on the second supposedly halted only because of the death of Urban VIII. For the corresponding pages in Baldinucci of this second part of the affair, see i.97–100, e.31–34. As McPhee, 2002, 95, observes, Domenico's account of the case is "thick with conspiracy: a hostile pope, a villainous minister, and an envious architect all plot to undermine the Barberini favorite"; instead, "the archives tell a less dramatic story."

As mentioned in the Introduction, section 3, a popular motif of traditional hagiographic literature (of great influence upon Domenico) is the fierce persecution suffered by the saints, patiently and meekly endured, which tests and confirms their heroic, canonizable virtue. We might mention here that even though his uncle the pope may have shunned Bernini, his nephew Camillo Pamphilj did not: in 1645, he brought the artist, incognito, for a professional consultation at the Villa Pamphilj on the Janiculum, then under construction by Algardi (Barberini, 2001a, 73).

3. The "storm" (*tempesta*) that kept not only the Roman court but also "all of Italy" in agitation was Pope Innocent's active hostility toward the Barberini and their clients and supporters, which sent the Barberini themselves fleeing to France to escape legal prosecution. Baldinucci's introduction to this chapter of Bernini's life (i.97, e.31) runs thus: "When Innocent X was elevated to that supreme office, a vast field of intrigue opened up against Bernini with little regard for the memory of Urban VIII. People whom Pope Innocent X trusted and who, though he

thought them very experienced, were on the contrary little informed concerning these arts were made use of."

One of these anonymous trusted but supposedly incompetent advisers will be cited by Domenico, 79, as responsible for the decision to completely demolish Bernini's bell tower; the personage in question is presumably Father Virgilio Spada. The most influential and (*pace* Domenico) most knowledgeable of Innocent's advisers in matters of architecture, Virgilio Spada (1596–1662) came from an old, distinguished, and wealthy family of Romagna, where his father, Paolo (1541–1631), served as papal treasurer for the region. In the second half of the sixteenth century, Paolo moved his family to Rome, where two of his sons, Bernardino (1594–1661, cardinal as of 1626) and Virgilio, eventually made names and further ecclesiastical fortunes for themselves. (Palazzo Spada, purchased by Bernardino in 1632, is now a public museum.) Superior general of the Oratorian order as of 1638, Virgilio also held the important office of private almoner (*Elemosiniere Segreto*) to the pope. For Virgilio's biography, see *Grove Art Online*, s.v. "Spada: (1) Virgilio Spada"; for further details of his career as architectural adviser to Innocent X, especially as relevant to the bell-tower case, see McPhee, 2002, 85–87.

In 1634, upon commission from Virgilio Spada, Bernini designed the architectural setting for a work of sculpture to be placed on the main altar of San Paolo Maggiore in Bologna (the sculpture in question, *The Beheading of Saint Paul*, had been separately commissioned, without Bernini's knowledge, from his rival Algardi). Also in that year, Bernini submitted a design for the new facade of the same church, but it was rejected. For both works, see Marder, 1998a, 67–70.

4. For the latest and a carefully documented consideration of Borromini's role in the bell-tower affair, see McPhee, 2002, passim. Borromini's criticisms of the bell tower, let us note, were not all mere gratuitous defamation, as Domenico would have us believe. Here our author depicts Borromini (described as one of Bernini's "students" also on pp. 32 and 112) as finally exacting his revenge for a long-standing grudge, in addition to finally obtaining the glorious professional status that he believed rightfully his and usurped by Bernini. It is difficult to assess adequately with accuracy and confidence the nature and dynamics of the much-publicized rivalry between Bernini and Borromini (most recently and most popularly analyzed by novelist-journalist Jake Morrissey). As the Roman agent of the Duke of Savoy reported in October 1661, the two men "do not get along, directly opposing each other in every matter" (Baudi di Vesme, 125, for the full report).

Although that rivalry spanned several decades of their lives, extant documentation is scant, fragmentary, and rife with unverifiable claims by partisan representatives on either side (such as Passeri and his claim of Bernini's secret deal with Agostino Radi to cheat Borromini of money in the late 1620s). Even simple facts such as Bernini's 1632 reported recommendation of Borromini for the Sant'Ivo alla Sapienza church commission can be and have been interpreted in either a conspiratorial or benign manner, depending on the eye of the interpreting beholder.

Certainly it is inaccurate to paint Borromini in all phases of this long-standing conflict simply as the villain tormenting a blameless Bernini, as does Domenico. It is also true that, as far as professional influence and inspiration between the two artists are concerned, it was a two-way street. The origins of Borromini's not entirely unreasonable resentment are usually seen in the 1629 appointment of the completely inexperienced but pontifically favored young Bernini as successor to Borromini's revered master and relative, Carlo Maderno, in the prestigious office of Architect of Saint Peter's and in Bernini's appropriating to himself all the credit for collaborative work at Saint Peter's. See the description of Borromini's antipathy toward Bernini contained in the biographical account drawn up for Filippo Baldinucci by Borromini's nephew, Bernardo Castelli, who quotes his uncle-architect as saying, "It does not displease me that [Bernini] took the money [that should have gone to Borromini for his work at Saint Peter's], but it displeases me that he enjoys the honor of my labors" (Burbaum, 279; 277–82 for Castelli's entire account).

Baldinucci collected this testimony but omitted it from the published edition of his *vita* of Borromini. That thereafter, in response to Bernini's domination of the Roman art scene, Borromini should be resentful is no surprise: he was but one of many similarly disenfranchised and angry artists in Bernini-dominated Rome. A particular notorious case of Borromini's

disenfranchisement by Bernini the clever strategist is the Piazza Navona fountain commission, for which see Domenico, 85. For the complicated rapport between Bernini and Borromini, see also Portoghesi, 2001; Burbaum; Connors, 1989, 83–84; Fagiolo/*IAP,* passim; and Marder, 2000b.

5. In contrast to Domenico's large-scale indictment of Borromini, Baldinucci, when describing the opposition against Bernini during the bell-tower affair, does not mention Borromini by name until the very end of his account, doing so in just one short, strong, but not vehement statement (i.100, e. 34). Earlier in his account of the bell-tower case (i.97, e.32), Baldinucci pointedly avoids citing Borromini by name, albeit clearly referring to him: "One of the first ill effects of these lies was that the Pope was persuaded to use another person to build his family palace as well as the churches of Saint John Lateran and S. Agnese in Piazza Navona."

6. That is, Borromini later fell out of papal favor. However, it was not simply because of his opposition to Bernini, as Domenico would have us believe: Borromini's own erratic, difficult personality became increasingly a professional obstacle as time went on, ending in what would appear to be a complete nervous breakdown and eventual suicide.

7. Domenico is accurate in saying that the cracks appeared shortly after the building of the first tower. However, by treating the topic here under the Pamphilj pontificate and after a long hiatus in his narrative—and not earlier, and chronologically more correctly, under the reign of Urban VIII—he misleads the reader into believing that no problems arose while Urban was still alive: see p. 63 above and commentary. Though in this chapter Domenico makes reference to only one tower, let us keep in mind that construction of the second tower had also begun under Urban, halted only after the completion of its substantial first story.

8. Baldinucci, i.96–97, e.31, instead attributes his version of this alarmist speech to unnamed "opponents of Bernini" (contrari del Bernino) and not to Borromini. His version also omits mention of Urban's name, referring instead to "those popes" who give all the work in Rome to just one man. Finally, Baldinucci also makes it clear that this complaint was raised while Urban was still alive, whereas Domenico's placement of it here makes it seem as if it were spoken later, i.e., during Innocent's pontificate.

9. Baldinucci, i.97, e. 32, recounts the same meeting between Bernini and Innocent, about which McPhee, 2002, 97–98, comments: "There is no corroborating record of this encounter, and it is likely to have been embroidered by time and personal interest." Contrary to the impression given by Domenico, it was not Innocent's anti-Barberini, pro-Borromini sentiments that caused him to investigate Bernini's tower: desiring to ready Saint Peter's basilica for the 1650 Jubilee, Innocent was obliged to attend to the question of the various cracks (on the facade and the Benediction Loggia ceiling), determine their cause, and apply a solution. By late 1644, a special committee was assembled for this purpose, a detailed technical report having been drawn up by papal architectural adviser Virgilio Spada. In the course of the following year (and slightly beyond), the Congregation of the Fabbrica met five times to examine the case (McPhee, 2002, 95).

10. Instead, Bernini's reaction in reality was not so serene: we have already quoted Gigli's diary regarding the grave illness into which Bernini fell immediately following the negative reaction to his bell tower in June 1641 (see p. 63, note 22, above). Fraschetti, 163, quotes Giovanni Gaetano Bottari, in *Dialoghi sopra le tre arti del disegno* (1754), as reporting that in a fit of anger Bernini even "went so far as to slap the face of the treasurer of Saint Peter's in public" for having mocked him and his tower. The latter report is probably apocryphal (see Morris, 80 n.205, for an investigation into this claim). Nonetheless, in truth it is no more unbelievable than Domenico's claim about his father's absolute calm in the face of the crisis, a crisis that effectively threatened to destroy his entire professional reputation and financial security, as well as do massive physical damage to the most sacred basilica of Christendom.

11. Domenico here mistakenly gives Maderno's first name as Paolo.

12. All of this explanation repeats Domenico's earlier description of the planning of the tower construction on p. 63. The "Congregation" is that of the Fabbrica of Saint Peter's. In the next line of this self-defense before the pope, Bernini emphasizes that the cracks were caused not by his perfectly-in-plumb tower, but by the settling of the *nuova fabbrica,* i.e., the nave added decades earlier by Carlo Maderno under Pope Paul V.

13. Baldinucci, i.97–98, e.32, has Bernini defending himself in the same terms and making the same recommendation for the two soundings, to which the pope agrees. Instead, as McPhee, 2002, 174, notes, "We know that at least the second sounding was made at Borromini's insistence and was ordered by the pope."

14. That is, the construction (*nuova fabbrica*) of the new nave by Carlo Maderno (Architect of Saint Peter's, 1603–29), begun in 1609 and consecrated in 1626 (Hibbard, 1971, 163–65). It was not Bernini who delivered the results to the congregation, but Virgilio Spada (McPhee, 2002, 104, also noting on 119 that we have no corroborating record of what Bernini said at any of the bell-tower investigative meetings that he attended).

15. Baldinucci's summary of the experts' reassuring, pro-Bernini conclusion (i.98–99, e.33) contains more technical detail and more focus on Maderno's responsibility. Baldinucci (i.96–97, e.32) also makes more explicit the critics' charge that Bernini's tower, incorrectly designed, had not remained "in plumb," thus causing the disaster-threatening cracks. In fact, the solicited professional opinions regarding causes and solutions were quite mixed and at times contradictory, although the important one, that of Virgilio Spada, was essentially favorable to Bernini, albeit not to the degree that Domenico reports here. Spada's advice was to let the natural and nonthreatening settling of the building play itself out without further intervention and then later repair any cracked elements as needed. As for a more immediate response, he recommended, one could diminish the weight of the tower by replacing the upper tier with a lighter version.

Nonetheless, the engineering reports having been delivered, the pope ordered a consultation and competition among architects soliciting both their evaluation of Bernini's tower and their design for a revised bell tower: eight were submitted, including Bernini's own revised plans, but none from Borromini. In the end, the architect consultants agreed on Bernini's own revised plans as the best alternative, which called for "the removal of the attic and separating facade and towers" (McPhee, 2002, 113, 121, 140, 144, 164 [for the quotation], 165).

16. The only meeting of the five ad hoc sessions of the Fabbrica at which both pope and Borromini were present was that of June 8, 1645. Note that Borromini had personally inspected Maderno's foundations during one of the soundings and made detailed notes and drawings; hence he did not speak without firsthand knowledge of the facts (McPhee, 2002, 100–103, 113).

17. Baldinucci, i.99, e.33, likewise says that Innocent was convinced by the explanation of the experts and had concluded that it was necessary only to lighten the bell tower by removing the attic story and to reinforce the foundation. He adds: "And here, take note, my reader, that all that I here am relating I have taken from authentic records kept in the archive of the Fabbrica." In fact, on February 20, 1646, at the penultimate meeting (of those dedicated to the tower question) of the Fabbrica, at which all the results of the consultation and competition were deliberated, "the opinions of the cardinals and architects as to whether the towers should be saved and refounded or demolished were so divided that no resolution was taken." However, indications are that the pope seemed to favor Martino Longhi's persuasive counsel, which was pro-Bernini inasmuch as it recognized that Maderno's foundations were seriously defective and advised saving the original towers by refounding, not demolishing, them (McPhee, 2002, 142 [for the quotation] and 161).

Just days later, however, on February 23, 1646, the pope made an unexpected, dramatic decision, representing a seemingly sudden, radical shift of mind-set: a terse statement from Innocent was read before the congregation of the Fabbrica in which the pope ordered the total dismantling of the towers, with new ones to be built according to another, unidentified design. This February 23 order raises many unanswered and now unanswerable questions. Unfortunately, after so much time, energy, and travail, strangely and abruptly "the official story of the bell towers ends here [on February 23, 1646]: no further mention of new towers appears among the records of the Congregation" (McPhee, 2002, 165).

18. This is the feudal *borgo* San Martino al Cimino, purchased by the pope in 1645 and used as a summer residence principally by Donna Olimpia (who died there of plague in 1657); for the property, see Bentivoglio. Domenico's assertion about the ill-intentioned minister changing the

pope's mind specifically during a trip to San Martino is impossible: as McPhee, 2002, 175, notes, "Innocent made two trips to S. Martino during his lifetime: one in 1653, the other in 1654. There is no evidence for a trip in 1646 [when the final dismantling decision was made]. Further, according to the minutes of the Congregation meetings in 1646, the pope was leaning toward Martino Longhi's solution for saving Bernini's tower on 20 February and two days later ordered the demolition. A trip to S. Martino, involving the pope and his entourage, could not have taken place in so short a time."

19. Baldinucci, i.99, e.34, gives the same story about Innocent's journey to San Martino as the opportunity that Bernini's enemies used, including "a certain person semiskilled in art," to persuade the pope to demolish the entire bell tower. Domenico and Baldinucci here can only be referring to Virgilio Spada, Innocent's trusted adviser on so many important architectural programs, including that of the renovation of the Lateran basilica (McPhee, 2002, 96). Summarizing her investigation of the supposed anti-Bernini prejudice on the part of Spada (and Pope Innocent), McPhee emphasizes that all the evidence, especially Bernini's request addressed to Spada and his brother for help in the tower crisis, "belie[s] the long-standing assumption that Virgilio Spada was a malign conspirator allied with Francesco Borromini. The pope appears not as the hostile enemy of the Cavaliere but as an engaged and deliberative judge eager to spare the tower." In fact, although a supporter of Borromini, "Virgilio penned a detailed and deliberate defense of Bernini, refuting Borromini's incendiary warnings." And again: "At every point during the course of the competition Spada supported Bernini" (McPhee, 2002, 120, 181). Yet, in here blaming Spada, Domenico was apparently being faithful to his father's own perceptions of reality, for in 1658 Bernini complained to an unnamed third party that Spada had continually opposed (*attraversato*) him since the reign of Innocent X, and was responsible for the decision to demolish the bell towers.

Spada responded to these complaints in a calmly reasoned, detailed letter to that same anonymous party, archived under the title "Sopra doglianze fatte dal Cavalier Bernini." The latter text can be found in both del Pesco, 1988, 67–69; and McPhee, 2002, 261–62, doc. 42 (and 181–82 for discussion). In both cases, the transcription is abridged, del Pesco offering more of the original text. The recipient of Spada's letter could not have been Pope Alexander VII (as per del Pesco, 1988, 67), since the pontiff would never have been addressed as "Vostra Signoria Illustrissima," as is the recipient of this letter.

20. On the contrary: the dismantling of the completed south tower and the partially built north tower took place slowly over the course of some ten months from the date of the papal order of February 23, 1646, to January 1647 (McPhee, 2002, 167). Bernini, however, did not sit back passively: according to a report dated May 26, 1646, by Francesco Mantovani, the Duke of Modena's agent in Rome, to prevent the dismantling Bernini attempted to bribe the pope's sister-in-law, Donna Olimpia, and nephew, Camillo, with gifts, of, respectively, one thousand doubloons and the diamond ring worth 6,000 *scudi* that had been given the artist by King Charles I of England (Fraschetti, 167 n.1). According to the same Modenese source, Bernini was also held financially responsible for the loss of the towers (April 28, 1646, report, Fraschetti, 166 n.6).

Another contemporary source, the Carlo Cartari diary, specifies that 30,000 *scudi* worth of bond investments (*luoghi de' monti*) were seized from Bernini in compensation to the papal treasury (D'Onofrio, 1986, 402). But it is not certain that the seizure was permanent. Carlo Fontana reports in his 1694 *Tempio Vaticano* that Bernini's bell towers cost over 100,000 *scudi* to build and about 12,000 to dismantle, with some of the reusable elements later incorporated into the construction of the "twin" churches in Piazza del Popolo, S. Maria di Montesanto, and S. Maria di Miracoli (Fontana, bk. 6, chap. 2, 434 [original pagination]). For reuse of the marble in other Roman construction projects, see Borsi, 347.

21. Baldinucci, i.100, e.34, also reports Innocent's later regret over the tower demolition and the bad advice from "a certain minister with little artistic competence" regarding two other unnamed decisions that he counseled. Since Spada was a long-term protector of Borromini, it would not be surprising if the other two "bad decisions" also involved Borromini, whose

erratic behavior constantly caused grave problems to both him and his employers, including the Pamphilj.

22. Baldinucci, i.92, e.27, notes that "negotiations resumed" between Mazarin and Bernini regarding the artist's transfer to Paris "after July 1644, when Urban died." Bernini may have been remembering these early troubled years of Innocent's pontificate when later in Paris he remarked, referring presumably to himself, "that at this period there was one man in Rome (whom he did not name) to whose knowledge the public always gave its due, whatever might be said or done against him, which goes to show that in Rome even if an individual might be unfair, the public was not" (Chantelou, July 22, f.84, e.71).

By the way, Domenico borrows this same expression of his father's about Roman "eyesight" in his own *Historia di tutte l'heresie,* 4:713: in describing the city of Rome's reception of the Quietist master Miguel de Molinos, he comments that the city was at first fooled by the Spanish "impostor" but eventually came to see the light, for "Rome may sometimes see in distorted fashion but never loses its sight completely" (Roma alcuna volta travede bensì, ma non mai perde la vista).

23. Baldinucci, i.100, e.34–35, at this point in his account and as prelude to the discussion of the Cornaro chapel, goes into a similar and even longer philosophical reflection about "the wisest" of men who keep their equanimity in the face of adversity, as did Bernini. In the midst of this storm, he displayed an "absolute command of his emotions. Thus he lived tranquilly and carried his work on with great diligence. During this very period he brought forth for Rome to see the most beautiful works he had ever done." Domenico's reference to "four years" of papal disfavor toward his father presumably corresponds to the period between Innocent's ascent to the throne in 1644 and the 1648 implementation of Bernini's design for the Navona fountain. But let us recall that already in 1645, Innocent had commissioned Bernini to complete the decoration of the nave of Saint Peter's, a massive project (for which see Domenico, 93, and commentary), which would indicate that pope's antipathy for the artist was not as absolute as here represented.

The pope could have immediately stripped Bernini of his position as Architect of Saint Peter's, but he made no such attempt. In any case, Domenico's account of Bernini's vicissitudes within the papal court must also be seen through the conventional lens of contemporary literature describing the life of the courtier: "*Fortuna* and the dangers of court intrigues had been privileged tropes of court treatises since the fifteenth century. Such tropes became even more common with the development of the increasingly large, rigidly hierarchical, and professional courts typical of the baroque period" (Biagioli, 324).

Domenico would have us believe that opposition to Bernini was mostly limited to this "short time" of a mere four years. Instead, after reviewing the substantial amount of documented anti-Bernini opposition by the artist's contemporaries throughout the span of his professional lifetime, Sutherland Harris rightly concludes otherwise: "Bernini's career was, therefore, far from being simply one of progressive advancement in an atmosphere of continual and enthusiastic adulation, interrupted only by a brief loss of favor immediately after the death of Urban VIII" (Sutherland Harris, 1987, 44).

24. For the incomplete *Truth Unveiled by Time,* dated 1646–52 (now in the Galleria Borghese), see *Nascita,* cat. 31; Hermann Fiore in *Regista/Restauri,* 27–35; Coliva, 2002, 234–47; and De Marchi. Baldinucci's brief account is at i.106–7, e.40–41, noting, not entirely incorrectly, that the statue was done "at about the same time" as the bust of Duke Francesco d'Este. The first documented reference to the statue is a July 6, 1647, letter to Cardinal Mazarin from Bernini's close friend Paolo Giordano II Orsini, the Duke of Bracciano (1591–1656), reporting that Bernini had "dedicated his spirit to doing for his own study and pleasure a work that I believe will be one of the most beautiful and marvelous in the world" (excerpted in *Nascita,* cat. 31, 295).

Domenico may be correct in his claim that Bernini began the statue soon after the demolition of his bell towers at Saint Peter's (but recall that the demolition, ordered on February 23, 1646, took ten full months to complete). Although at his death the artist indeed ordered that the statue of *Truth* remain in Casa Bernini in perpetuity as a moral reminder to his heirs (as Domenico mentions and as is stated in Bernini's will [BALQ, 71–72]), that was not always his

intention: as the 1647 Orsini letter indicates, Bernini was willing to sell the statue to Mazarin, who, in the end, refused it since Bernini would not agree to move to Paris. For Mazarin and Bernini's statue of *Truth,* see Laurain-Portemer, 1969; and 1987, 124–31. For Orsini and Bernini's several portraits of him (in marble and bronze, all dating to 1623–24), see Benocci; and Dickerson, 338–40.

25. Since the figure of Time was never sculpted, Domenico presumably is repeating from memory his father's description of it or had access to extant drawings of the complete group. Chantelou, August 23, f. 136, e.142, contains a description of the figure of Time from Bernini himself, who still in 1665 spoke of the project as one he intended to finish:

> M. de Créqui mentioned the statue of *Truth* which is in the Cavaliere's house in Rome: it is the perfection of beauty. The Cavaliere said he had done this statue for his house, but that the figure of Time, which carries and points to the figure of Truth[,] was not finished: his idea is [note the present tense of the verb] to represent Time bearing Truth aloft, and to show by the same means the effects of time which in the end ruins or consumes everything; for in the model he had made columns, obelisks, and tombs which appear to be overturned and destroyed by Time, though they were nevertheless the things that support him in the air; without them he could not remain there, "although he has wings," he added with a smile. He said it was a saying current in Rome that Truth was only to be found in Bernini's house.

In the same conversation, Bernini described to Louis XIV, with obvious autobiographical intent, "a piece from one of his plays where a character is reciting the tale of his misfortunes and speaks of the unjust persecution of which he is the victim. In order to console him, one of his friends begs him to take courage, saying that the reign of calumny will not endure forever, and that Time will at last reveal the Truth: to which the unhappy creature replied, 'It is true that Time reveals Truth but he doesn't reveal it in time.'"

26. Domenico here uses the intensive plural, "molti Sommi Pontefici," even though he will record visits to Casa Bernini by just two popes, Alexander VII and Clement IX. Further, as we know from documentation, their primary reason for visiting the home was not necessarily to see the statue of Truth, as here claimed (see Domenico, 104–6, and commentary for the papal visits).

27. One has the sense that, in insisting on the superlative public response to his father's statue of *Truth,* Domenico "doth protest too much," for the work has not been counted among the most artistically noteworthy of his father's creations by anyone's reckoning.

28. The marginal subheading in Domenico's text is mistaken: Baldinucci's poem is about the unused block of marble intended for the never-executed figure of Time, not the completed statue of Truth. Baldinucci, i.106–7, e.40–41, introduces his own poem thus: "The author of the present book saw this marble block in recent months and immediately, almost as if he wished to sympathize with its misfortune, wrote the following verses and in fun left them with the previously mentioned Monsignor Pier Filippo Bernini. In the poem he imagines that the marble speaks."

29. Domenico exaggerates: although Baldinucci's family was old and prominent among Florentine clans, it was not noble in the strict sense of the term.

30. Domenico incorrectly has "volto a *me* stesso" whereas Baldinucci (the author of the poem), i.107, e.41, has "volto a *se* stesso," which makes more sense: in the speech that follows, the poet imagines Bernini, about to begin his work, talking to himself in the second-person singular. This interior monologue within the poem (which I have made more evident with the addition of open and closed quotation marks) begins with "Accustomed" and ends with "intact" (respectively, *Dunque* and *intiera* in the original Italian). Then, after the poet's monologue, the block of stone speaks again.

31. Domenico's original text has the past tense here ("ti fù d'uopo," was it necessary), which I have amended to the present tense, as per Baldinucci's version, "ti fie [i.e., sia] d'uopo," is it necessary.

32. It is not possible to render in English the poem's concluding play on words: in addition to its literal meaning, "to remain as stone," the expression "restare di sasso" also means "to stand aghast."

33. Bernini received this commission in late January 1647. The chapel was inaugurated in 1651 (just one month before the inauguration of the Fountain of the Four Rivers in the Piazza Navona) but not fully completed until the summer of 1652: see Napoleone, whose research enables us now to document in specific detail the various stages of and collaborators in the construction. Of the entire design and contents of the chapel, Domenico comments on only the sculptural group of *Teresa in Ecstasy*. In addition to that statue, Baldinucci, i.101, e.35, also attributes to Bernini's hand the figure of "the last Cardinal Cornaro," Federico, who commissioned this sepulchral monument to himself and his family.

Long considered in Bernini scholarship as the supreme example of Bernini's integration of all the arts into one harmonious *bel composto* (beautiful whole or composite), the chapel is, surprisingly, not cited as such by either Domenico or Baldinucci. Yet both biographers discuss Bernini's *composto* elsewhere in their biographies: see my Introduction, section 7, for the recent revisionist interpretation of Bernini's *bel composto*. For the Cornaro chapel, see Lavin, 1980; Wittkower, cat. 48; Preimesberger, 1986; Barcham, 1993 and 2004; Carloni in *Regista/Restauri*, 37–46; and Napoleone.

34. Federico Cornaro (1579–1653) came from one of Venice's wealthiest and most powerful families; his father, Giovanni, had been doge of the republic from 1624 to 1629. Urban VIII made Federico cardinal in 1626 and patriarch of Venice in 1631, and as patriarch Federico promoted reform of the local church. However, in 1644, Federico resigned from his patriarchate (the first to do so in Venetian history) and, perhaps with papal aspirations of his own, moved to Rome, where he worked to promote Venetian political interests. In Rome, Domenico's hagiographic description notwithstanding, "he led a life of great luxury, as indicated also from his private expenditures, recorded in payments registered at the Banco di Santo Spirito" (Napoleone, 174; see also Barcham, 1993, 821–22).

The Carmelites of Santa Maria della Vittoria ceded the chapel (in reality, the left arm of the church's transept) to Cornaro on January 22, 1647. The construction of this small chapel cost Cornaro the "staggering" amount of 12,089 *scudi*, one fifth of the construction costs of the whole of Bernini's sumptuous church of Sant'Andrea al Quirinale (Barcham, 1993, 822). Federico, however, did not get much opportunity to enjoy the fruits of his expenditures: he died shortly after its completion.

35. In Baldinucci's account (i.101, e.35), instead, Bernini declares that the *Saint Teresa* statue was "the most beautiful work ever to have come from his hand." According to Baldinucci (i.109, e.43), it was of the Scala Regia that Bernini remarked, "This was the least bad work he had ever done." Bernini was fond of this self-deprecating turn of phrase: in Chantelou, October 5, f. 224, e.254, in taking final leave of Louis XIV, Bernini says "he had worked on [the king's portrait bust] with so much love that it was the least bad portrait he had done."

36. Baldinucci, i.101, e.35, transcribes the same poem, a product, he adds, of Monsignor Pietro Filippo's "most acute genius," a bit of flattery for the man who had probably paid him to write the biography. For other contemporary poetry dedicated to Bernini's Cornaro Chapel, see Montanari, 2003c, 184–89 and his appendix.

CHAPTER XII

1. Once again, Domenico puts on rose-colored glasses when describing papal behavior. However masked with smiles and embraces, Innocent's decision to reconcile with the Barberini had everything to do with pragmatic politics, including direct pressure (military and otherwise) from the French, who were protecting the Barberini (see Rodén, 2000, 43–46; and the detailed account of the conflict between Innocent and Mazarin in the older but still-indispensable Coville).

Later in Innocent's reign, in order to extend the safety net for the Pamphilj family that would be necessary after the pope's demise, Donna Olimpia arranged for the marriage of her granddaughter, Olimpia Giustiniani, to Maffeo Barberini, son of Anna Colonna and the late Taddeo. They wed in June 1653, but this was no "bond of love" as the poor twelve-year-old Olimpia literally had to be dragged, kicking and screaming, into that union (Herman, 322–27).

2. Yet again Domenico iterates his theme of Bernini as "always true to himself" (for which see Domenico, 61, and commentary). Baldinucci, i.101, e.36, explains the recovery of Bernini's status in the papal court as a result not of Innocent's reconciliation with the Barberini but rather of Bernini's sheer worth (*virtù*) as both man and artist.

3. Reflecting contemporary belief, Domenico's history is incorrect: the obelisk in question was first erected by Emperor Domitian in A.D. 80 in the stadium (not circus) named after him in the Campo Marzio, the present-day Piazza Navona (then also known as the Foro Agonale, the "Forum of the Competitions, or Contests"). In A.D. 309 Emperor Maxentius transferred it to the new circus constructed in honor of his son, Romulus, alongside the Via Appia, near, as Domenico correctly states, the "Valle di Egeria" and the Tomb of Cecilia Metella. The obelisk collapsed in the sixth century, breaking into five pieces. However, Caracalla's name is not entirely extraneous here: until 1825 (when archeologist Antonio Nibby discovered Domitian's original commemorative plaque), the Via Appia circus was indeed named after the third-century Caracalla due to a statue of that emperor found nearby. For the history of the obelisk, see D'Onofrio, 1992, 288–96.

Domenico is incorrect on another point: Emperor Tiberius did construct the Praetorian Barracks in Rome but in an entirely different suburban location (near the present-day Biblioteca Nazionale Centrale on the Viale Castro Pretorio).

4. Oxhead: *Capo di Bove*. The frieze crowning the ancient tomb of Cecilia Metella (erected ca. 50 B.C.) is a marble relief of festoons interspersed with bucranes (the skulls of oxen).

5. The pope's decision was made in April 1647, but the obelisk relocation seems not to have begun until much later, in July 1648 (according to payment documents). It is uncertain precisely when the pope officially approved Bernini's design. Innocent X's July 10, 1648, chirograph, which is always cited in the Bernini literature as his act of approval of the design, is, in reality and primarily, a work order directed to Monsignor Luca Torregiani assigning him as supervisor of the obelisk-fountain project and asking him to proceed with its execution. Among the various details included in the order (about transporting and erecting the obelisk and securing funds for the project through a new property tax), the chirograph mentions, with no special emphasis, that the fountain is to be executed according to Bernini's design (for text of the chirograph, see D'Onofrio, 1986, 424 n.36; see also my notes 8, 11, and 12 below).

The obelisk was finally erected in situ in August 1649, with payments to Bernini's collaborators for work on the fountain beginning in December of that same year (D'Onofrio, 1986, 422 and 424; Wittkower, cat. 30, 269). Domenico, who mentions none of the preceding, also does not mention that the pope's designs for the obelisk were part of a grand scheme aimed at the upgrading of the neighborhood immediately surrounding the Palazzo Pamphilj (the urban power base of his family), "one of the most sweeping and extravagant Baroque transformations of an urban site" (Wittkower, cat. 50, 269).

At the same time, by upgrading the central Navona fountain and making it (and not the Trevi Fountain) the principal display fountain for the Acqua Vergine, Innocent was also communicating a symbolic message about the diminished status of the Barberini, in whose "territory" the Trevi Fountain was located (Marder, 2000b, 140–41). For the Palazzo Pamphilj and the family's dynastic ambitions as pursued through art and architecture, see Leone.

6. Despite what Domenico says here, all indications appear to be that, until the fountain project was somewhat abruptly and inexplicably given to Bernini, the pope was in support of Borromini's design. Note that, although Bernini had been appointed by Urban VIII to the office of superintendent of the Navona water conduits (D'Onofrio, 1986, 541), on April 11, 1645, Innocent instead gave to Borromini the task of extending the Acqua Vergine water pipes into that piazza for the benefit of the new central fountain planned for the site. Hence it is not

surprising that the pope also would have given preference to Borromini in the commission for the fountain itself (D'Onofrio, 1986, 404).

In a gloss to an unpublished guide to Rome, *Roma ornata dall'architettura, pittura e scultura* (ca. 1661–63), compiled by his friend Fioravante Martinelli (1599–1667), Borromini, in his own handwriting, makes the following claims: "Innocent X with a personal order [*chirografo*] gave the middle fountain commission to the Cav. Borromini, who had brought the water there and who had come up with the idea of placing there the obelisk and to adorn it with a pedestal with shells in which four narrative scenes in bas relief were sculpted and with the four most famous rivers of the world and with other ornamentation from Father Virgilio Spada; but said commission was given to the Cav. Bernini at the insistence of Signora Donna Olimpia Pamphilj and on the basis of his own design [the fountain] was reworked in the form presently seen" (D'Onofrio, 1986, 406–7; see also D'Onofrio, 1969, 282; extant drawings show that Borromini indeed first conceived the idea of using the four great rivers of the world in the fountain's design).

Another contemporary but anonymous testimony (extant among the Baldinucci manuscript resources gathered but not included in his Bernini biography) reports instead that among all the designs submitted in this competition, Algardi's found most favor (D'Onofrio, 1986, 406). In completely ignoring Donna Olimpia's prominent role in the securing of this commission (see note 7), Domenico and Baldinucci perhaps wish to distance Bernini's name from the infamous memory of the pope's notorious sister-in-law.

7. See Baldinucci, i.101–2, e.36, for a more summary statement about Prince Niccolò and his friendship with Bernini. Niccolò (1613–1664) was the younger brother of Ludovico Ludovisi (d. 1632), Cardinal Nephew of Pope Gregory XV, both of whom (cardinal and pope) had shown appreciation for Bernini's talent, as Domenico (21–23) earlier recorded. The major difference in Baldinucci's account is that he does not hide the fact that Bernini knew that Niccolò's request was specifically intended to insert the excluded artist into the competition, as Bernini well knew; in other words, he does not disingenuously claim, as Domenico, that Bernini believed that Niccolò asked him for the *modello* purely for his private pleasure.

It is hard to believe that the shrewd Bernini would have unquestioningly accepted the prince's mendacious claim and not suspected that the prince had ulterior (albeit benign) motives for this request. In any case, as D'Onofrio, 1986, 411, points out, backed by "such a powerful protector" as Prince Niccolò, it is not surprising that Bernini was able to gain the pope's attention for his fountain design. But was Prince Niccolò truly the key intermediary here?

According to two other contemporary accounts (the Anonymous Baldinucci Informant cited in note 6 above and an undated report from Francesco Mantovani, Roman agent of the Duke of Modena), the real reason for Bernini's success in securing this commission lay in the fact that he was able to enthrall the pope's powerful sister-in-law, Donna Olimpia, with a *modello* of the fountain design made of silver, whereas those of his competitors were simply of mundane terra-cotta (see note 6 also for Borromini's implication of Donna Olimpia in the granting of the commission).

Although noting the fact that at the time the pope was disaffected with Borromini for troubles relating to the Lateran basilica restoration project, the Anonymous Baldinucci Informant remarks sarcastically, "From this [stratagem] one sees that [Bernini] was more clever as courtier than as sculptor and architect." While Mantovani's dispatch admits that Bernini's design was done "with outstanding and marvelous artifice," it too accuses Bernini of "being astute and crafty to the highest degree" in devising this "more clever stratagem." Neither source excludes the possibility of the scenario that Domenico describes, that of a deliberately orchestrated postprandial encounter by the pope with Bernini's *modello*.

There are no traces today, however, of the reported silver *modello* by Bernini. See D'Onofrio, 1986, 406 and 411–12 for, respectively, the Anonymous Baldinucci Informant and the undated Mantovani report (but note that D'Onofrio's April 1647 dating of the Mantovani report is completely unsubstantiated). For "Borromini and Bernini at Piazza Navona," see Marder, 2000b, who also conjectures the crucial role of learned Jesuit Egyptologist Athanasius Kircher in helping to secure the commission for Bernini; see Fehrenbach, 2008, 100–101; and Rowland, 2000, 89,

and 2005, 154–56, for more on the collaboration between Bernini and Kircher in the fountain design.

8. The prince's marriage at that point could not have been so "fresh": it was at least three years earlier, on December 21, 1644 (even before the rediscovery of the obelisk in question), that Niccolò wed Costanza Pamphilj (1627–65), daughter of Pamphilio Pamphilj and Donna Olimpia Maidalchini. As D'Onofrio, 1986, 411, conjectures, Domenico might instead be referring to the wedding of Donna Olimpia's son, Camillo Pamphilj, with Olimpia Aldobrandini (also known as the Principessa di Rossano), which took place on February 10, 1647, and thus more recently with respect to the events here described.

9. The story of the commission of the Fountain of the Four Rivers in the Piazza Navona is among the most detailed of those recounted by Domenico. For the project, see Wittkower, cat. 50; *Regista*, cats. 108–17; Preimesberger, 1974; D'Onofrio, 1986, 395–439; Sutherland Harris, 1990; Burbaum, 178–204 (esp. for the Borromini-Bernini rivalry); Petrucci, 2004; and Fagiolo-Portoghesi, 200–213. For a thorough study of the fountain's rich symbolism and cultural-political-religious context, see Fehrenbach, 2008.

10. The term *modello* usually refers to a well-articulated three-dimensional model of a work of architecture in advanced stages of planning, often prepared for examination by a patron before execution of the actual work. For extant *modelli* of the fountain, see D'Onofrio, 1986, 418 n.31 (questioning the attribution to Bernini); Fagiolo/*IAP*, 319; Fagiolo dell'Arco, 2002, 109–12; and Fagiolo-Portoghesi, 202, fig. 2.

11. The Feast of the Annunciation is March 25. There is an undated seventeenth-century painting in the Museo di Roma showing Innocent's immense cavalcade arriving at the Church of the Minerva for the feast (see color reproduction in *EncPapi* 3:323). However, according to the obsessively meticulous diary of Fulvio Servanzi, papal master of ceremonies, Innocent did not dine at the Palazzo Pamphilj on that day in 1647. According to the same diary, the pontiff did attend a formal "state" dinner at the family's residence on April 23, 1647, following a lavish procession of pope, courtiers, and ambassadors, remaining there until "22 hours" (two hours before sunset). Yet as Servanzi records, the pope also dined—privately this time—with his relatives in the Palazzo Pamphilj on March 6, 1648.

Since the first documented evidence indicating Innocent's choice in favor of Bernini's design is, in effect, the already mentioned papal chirograph of July 10, 1648 (ordering Monsignor Torregiani to begin execution of the obelisk-fountain project), this more casual March 1648 dinner could have been the occasion here described by Domenico, if indeed this detail of his account has any basis in reality. See D'Onofrio, 1986, 411, for all the preceding data (D'Onofrio, however, inexplicably dismisses the March 1648 dinner as a possible occasion for the stratagem).

Also arguing for the March 1648 date is the fact that the initial and necessarily lengthy competition among artists (excluding Bernini) for the fountain's design presumably did not begin until after Pope Innocent had personally examined the obelisk in situ in April 1647 and decided to bring it to the Piazza Navona. Fagiolo dell'Arco (Fagiolo/*IAP*, 183 and 319) conjectures, basing his conclusion upon circumstantial evidence, that Innocent's first encounter with Bernini to discuss the fountain design took place in December 1647.

12. In Baldinucci, i.101–2, e.36, the prelate in attendance is simply identified as "the Cardinal," and not specified as the "Cardinal Nephew." If this staged encounter with Bernini's *modello* did indeed take place in March or April and the "Cardinal Nephew" was indeed witness to it, then it must have been in the year 1648 because the office of "Cardinal Nephew" was vacant in the previous year, 1647, between January 21 (when papal nephew Camillo resigned his office and clerical state, just before marrying Olimpia Aldobrandini) and October 7 (when the pope created Francesco Maidalchini a cardinal). Francesco Maidalchini, nephew of Donna Olimpia, served as "Cardinal Nephew" until September 19, 1650, when he was deposed in favor of Innocent's adopted "nephew," Camillo Astalli (*EncPapi*, 3:325).

13. Baldinucci, i.101–2, e.36–37, presents the same account of how Innocent came to choose Bernini's model, with the pope sent in ecstasy over it for a "half hour and more" before finally bursting forth with a similar exclamation about the prince's strategy and the irresistibility

of Bernini's designs. All of this, Baldinucci continues, was followed "soon thereafter" with the pope summoning the artist to apologize for his neglect of him, amid "a thousand demonstrations of esteem and love."

14. Another instance of what I call Domenico's "very same day" topos, used to emphasize the irresistible, energizing effect that his father and his designs had on his exalted patrons: see above Domenico, 24, and commentary, regarding "the very first day" of Urban's pontificate.

15. Again, Domenico's claim is not to be given credence: the ever-vigilant Bernini was too able and too experienced a creature of the court to be caught off guard in this way, living and working in an environment in which professional (if not actual physical) survival depended on remaining current on all news and rumor.

16. Baldinucci, i.102–3, reports the same remark by Innocent. Note that the Enggass English translation (e.37) erroneously attributes the statement instead to the general public ("It was often said that Bernini . . .").

17. That is, Innocent's decision to favor Bernini. Note that the pope is the "prince" of the Papal State (the "Patrimony of Saint Peter"), its supreme, sole, absolute monarch.

18. Baldinucci, i.103–4, e.37–38, presents a very similar though differently ordered description of the fountain. It is also lengthier and more encomiastic (the fountain is praised as "among the most marvelous inventions of Bernini"), while supplying more technical detail about dimensions and materials. One small divergence in detail is Baldinucci's explanation that the attribute of the River Ganges, the tree branch in its hand, represents "the immensity of its waters."

Baldinucci identifies and underscores the truly marvelous technical achievement of the fountain—the fact that so great a mass of stone appears to hover over a void. He also explains that, although the mass appears to be made of a single piece of rock, it is instead composed of many artfully placed pieces each interconnecting so as to hold each other firmly in place. These same two technical notes, instead, Domenico inserts into a conversation between Innocent and Bernini in the next episode that follows, an account of the papal inspection of the still-unveiled fountain. Finally, the South American animal that Domenico calls a *tatou* is generally taken to be an armadillo.

19. Regarding the details that came from Bernini's own hand, Baldinucci (i.104, e.38) is in agreement with Domenico, except for the specification that the artist was responsible for only half, not all, of the horse. (Wittkower, cat. 50, 269, cites a March 17, 1657, document of the Fabbrica of Saint Peter's that "explicitly stated that Bernini executed 'with his own hands the horse and other things'" in the fountain.) Baldinucci's description, like that of Domenico, ends with the same list of the other sculptors involved in the carving and their specific contributions, with the same final qualification that Bernini gave "many strokes with his own hand" to the figures of the Rio de la Plata and the Nile.

20. I have maintained Domenico's idiosyncratic rendering or misidentification of these sculptors' names, men who appear in documentation relating to other Bernini projects. They are, for the Nile, "Antonio Fangelli" (Jacopo Antonio Fancelli of Rome, 1606–1674); the Ganges, "Monsù Adamo" (Claude Poussin of Lorrain, active in Rome 1643–54), mistaken here (as often elsewhere) perhaps for Adam-Claude Brefort, also of Lorrain (active in Rome 1633–ca. 1673); the Danube, "Andrea Lombardo" (Antonio Raggi of Ticino, 1628–1686); and the Rio de la Plata, Francesco Baratta, correct name but more specifically Francesco Baratta *Senior* of Massa (d. 1666). Of these men, Domenico mentions only Raggi and Fancelli elsewhere (Raggi on 106, for carving the Alexander VII statue and Fancelli on 112 in the list of Bernini's disciples).

For the careers of these four collaborators, see, in addition to the studies of the Navona fountain, the thorough but succinct entries (with ample bibliography) in Bacchi, 1996; for a photographic guide to their extant work in Rome, see Ferrari and Papaldo, *ad indicem*. A further collaborator on the project was the painter Guido Ubaldo Abbatini, who applied color to the rocks, palm trees, and plants (Morris, 99); all signs of this polychromatic detail have long since disappeared.

21. See Baldinucci, i.104–5, e.38–39, for the pope's inspection and Bernini's playful surprise, essentially the same account. A visit to the fountain by Innocent is recorded by the papal

master of ceremonies and by Gigli's *Diario Romano* on June 8, 1651 (four days before its official unveiling). It is probably on this date that the episode Domenico recounts here took place (D'Onofrio, 1986, 427, 430; Gigli notes that the pope remained in visit "for more than a half hour"). Carlo Cartari's diary also records the June 8 papal visit, specifying that it took place at the "twenty-second hour," that is, two hours before sundown (Morris, 96).

See the contemporary painting, attributed to Filippo Gagliardi, in the Museo di Roma (inv. MR 35459) depicting a visit by Innocent to the completed fountain (reproduced in Fagiolo-Portoghesi, 201). The painting shows no signs of construction still in progress, (no fencing or equipment surrounding the fountain), and hence may not depict the June 8, 1651, visit unless the painter decided to "clean up" the scene.

22. Once again, the appearance of a favored leitmotif in Domenico's biography, Bernini "who is always true to himself": see Domenico, 61, and commentary.

23. For contemporary poetry in praise of the fountain, see Montanari, 2003c, 177–82.

24. This anecdote about the fears surrounding the obelisk's collapse and the Cavaliere's "remedy" is not in Baldinucci. Neither the general public nor the seemingly nonchalant Bernini could have been here unmindful of the fact that just a few years earlier another work of the Cavaliere's, the infamous bell tower of Saint Peter's, had been the cause of grave anxiety over a possible disastrous collapse. Indeed, Morris, 214, conjectures that Domenico inserted this anecdote—found nowhere else in the Bernini documentation—in order to confirm and emphasize his father's competence as architect and engineer in the wake of the serious doubt raised by the earlier vitriolic polemic over his failed bell towers for Saint Peter's.

The stormy weather here in question may correspond to one of the two violent *tempeste* reported for August 9 and 26, 1653 in Gigli's *Diario Romano*, 687 and 688. In any case, the fact that the obelisk remained standing and undamaged in the wake of the strong, fifteen-minute earthquake that struck Rome on July 23, 1654 (Gigli, 709–10), would have put to rest any remaining doubts about the stability of the structure.

25. See Baldinucci, i.105–6, e.39–40, for the corresponding summary of other Bernini works done during the Pamphilj pontificate. Baldinucci does not list the portraits of Innocent in his narrative but rather in his appended catalogue of Bernini work: one in "Casa Panfilia," another "For Casa Bernina." Domenico, instead, speaks more vaguely of "several busts." Two marble busts, very similar but not identical and both now securely attributed to Bernini are in the Doria-Pamphilj Gallery: dated within the same short period of time, the one with the large horizontal fissure in the area of the chin and neck is considered the earlier of the two (ca. 1647), while the other is dated by some scholars to later in the same year, but by others to as late as ca. 1650.

It is surmised that, as in the case of the Scipione Borghese portraits, Bernini was obliged to sculpt the second bust precisely because of the appearance of the unsightly crack on the first. This first, defective bust, kept in "Casa Bernina," was bequeathed by the artist to Cardinal Decio Azzolino (see Domenico, 176), ending up in its present location in the eighteenth century. There are other contemporary portraits of Innocent, executed in other materials, in the Doria-Pamphilj Gallery and elsewhere, some of which have in the past been attributed to Bernini. It is known (from Bellori), however, that Algardi as well did portraits of Pope Innocent X (for which see Bacchi-Hess-Montagu, cat. 5.10). For the two Doria Pamphilj busts, see *Regista*, cat. 54; for the same two, plus all the others in the Doria-Pamphilj, see Wittkower, cat. 51; see also Barbiellini Amidei; Zitzlsperger, cat. 19; and Bacchi-Hess-Montagu, cat. 5.10, 236–37, and Checklist A30. Alas, not even Bernini's supreme artistry could disguise the fact that poor Innocent was not, by any stretch of the imagination, what you would call a handsome man.

26. See below pp. 106–7 (and commentary) for Domenico's later account of the *Constantine* commission, mentioned only perfunctorily by Baldinucci (i.105, e.39 [initial commission] and i.110, e.44 [completion]). Innocent commissioned Bernini to do the statue of Constantine sometime in 1654: according to the diary of Cardinal Fabio Chigi, on September 5, 1654, Bernini had shown him a design for the monument that was to be placed within Saint Peter's basilica opposite that of Countess Matilda. Although Bernini was paid the large sum of 900 *scudi* through August 1657, work was never completed, the statue being left merely *abbozzato* (blocked out).

After remaining in suspension for several years, the colossal statue was eventually brought to completion sometime between November 1667 and July 1668, hence not during the reign of Alexander VII, as Domenico here says, but after. Its formal unveiling took place in November 1670, during the pontificate of Clement X. See Wittkower, cat. 73; Marder, 1992 (specifically for a detailed study of the initial Pamphilj phase of the Constantine project); and Marder, 1997, 165–79, for a succinct but thorough survey of the long process of the statue's design and execution.

27. Baldinucci, i.105–6, e.39, reports the same commission for the decoration of the nave of Saint Peter's, noting that the area in question was then referred to as "Paul V's Addition" (for Maderno's nave, see Hibbard, 1971, 71–72, 163–65, 180–83). Baldinucci also offers the same detail about the origin of the name *pietra cottonella* (see note 28). The decoration of the nave was a project dear to Pope Innocent, who wanted to finish the still-unadorned portion of the basilica in time for the 1650 Jubilee. The commission came to Bernini as early as October 1645, at the same time that investigations were proceeding into the bell-tower problem. This timing indicates, as mentioned (note 23 to p. 80 above), that Innocent's attitude toward Bernini, if not entirely positive, was not unremittingly hostile either. Domenico, however, does not point out the fact that this commission predated the supposed grand reconciliation between the hostile pope and the victimized artist.

Although the commission went to Bernini (still officially Architect of Saint Peter's at this time and until his death), Virgilio Spada also had much input into the project. The almost forty artists employed therein were, furthermore, given a fair amount of freedom in their work. Domenico devotes only one sentence to this commission, which in reality was of gigantic proportions: it entailed not only the paving of the enormous expanse of the nave floor and the revetment of its pilasters and the walls of six huge chapels, but also the creation of 56 medallion-portraits of the popes, 192 large angels, 104 over-life-size doves, and six pairs of equally over-life-size allegorical figures in the spandrels above the chapel arches. For the nave project, see Tratz, 1991; and, more summarily, Wittkower, cat. 47; Borsi, cat. 30; Lavin, 2005, 142–44; for Spada's praise of Bernini's supervision of the project, see Montagu, 1985, 27.

28. Domenico is correct about the origins of Cottanello "marble" (in reality a form of limestone). Bernini used this stone, also quarried in antiquity, to great effect in Saint Peter's and Sant'Andrea al Quirinale. It can also be seen in Sant'Agnese in Agone. "Rich complexity and visual warmth are words that come to mind when describing [this] sheared and veined red-and-white marble" (Heiken et al., 171).

29. Baldinucci, i.106, e.40, likewise specifies that Bernini just made the *modello* of the "altar" of Santa Francesca Romana. It is more correctly termed the *Confessio*, the latter Latin word designating an underground tomb shrine beneath an altar housing the body or relic of the saint (for the *confessio*, see above note 4 to Domenico, 38). The saint's remains were rediscovered in the church of Santa Maria Nova in the Forum (also known as the church of Santa Francesca Romana) on April 2, 1638, but were not transferred to the new crypt until May 1649.

The commission was given to Bernini by its patroness, Suor Agata Pamphilj, sister to Innocent X. Construction preparation presumably began as early as 1641, before Innocent's election (Lavin, 1980, 185), since the decision to build the new shrine to the saint was made at the time of her body's rediscovery and initial designs must have been conceived not long thereafter. Execution was by Giovanni Maria Fracchi, a Bernini collaborator on other projects (such as the new apse designed by Bernini for San Lorenzo in Damaso, not mentioned by Domenico).

The bronze figures of Saint Francesca and her companion angel were seized by Napoleonic troops in ca. 1798 and, it would seem, subsequently destroyed. The original appearance of Bernini's design is known from a later engraving; the present reconstruction dates to 1866–69. For the Francesca Romana *Confessio*, see Wittkower, cat. 45; Lavin, 1980, 58–62; 185–87; and Borsi, cat. 29; see Fagiolo-Portoghesi, 132, for the terra-cotta *modello* of the saint's face by Bernini.

30. Both Domenico and Baldinucci, i.106, e.40, reduce to a single, inaccurate line the rather complicated history of the fountain in question, that on the southern end of Piazza Navona, facing Palazzo Pamphilj (on one side) and the church of San Giacomo degli Spagnoli

(on the other; now called Nostra Signora del Sacro Cuore). They both also incorrectly claim that the statue in question was carved by Bernini himself: documentation proves instead that the execution was entirely the work of Giovanni Antonio Mari. (The figure in question, identified as a Triton in contemporary documents, is actually a *Moro,* Moor.)

Soon after the inauguration of the central fountain (the Four Rivers), Innocent decided to upgrade the two subsidiary ones, though a shortage of funds quickly became a problem; indeed, the fountain on the opposite (northern) end of the piazza remained without sculpture until the nineteenth century. Bernini's first design of 1652 for the south fountain, featuring a large central shell, was deemed too small once installed and hence the shell was removed (it is now at the Villa Doria Pamphilj on the Janiculum). A full-length replacement statue was ordered by the pope on May 2, 1653, that is, the present *Moro,* designed by Bernini but carved by Mari, who was paid in installments from August 1653 to July 1655. Shortly after becoming pope, Alexander VII paid Bernini 300 *scudi* for his work on the same fountain. For the commission, see Wittkower, cat. 55; Borsi, cat. 36; D'Onofrio, 1986, 440–48; and the various essays in Butterfield.

31. Baldinucci, i.108, e.42, instead discusses the Palazzo Ludovisi commission once he has already switched the focus of his narrative from Innocent X to Alexander VII, placing this building project in approximately the same period when Bernini was doing the *Daniel* and *Habakkuk* statues for the Chigi Chapel in Santa Maria del Popolo. Prince Niccolò purchased the Palazzo dei Capponi on Montecitorio in 1653, and shortly thereafter, in April of the same year, work on its remodeling and enlargement began, according to Bernini's design (of which the artist presented a *modello* in silver to his patron's wife, Costanza Pamphilj, daughter of Donna Olimpia Maidalchini).

Work on the palace, however, came to a halt as a result of the eruption of hostilities between Innocent and Niccolò, which sent the latter fleeing the city (he died in Cagliari in 1664). No further construction was carried out on the building until, as Domenico correctly states, the pontificate of Innocent XII (r. 1691–1700), who wished to house there certain offices of the papal curia. Carlo Fontana finished the building, maintaining some of the original features of Bernini's design. It is now the home of the Italian Chamber of Deputies. See Borsi, cat. 35; *Regista,* cat. 72; and Marder, 1998a, 153–55.

For the 1665 rumor about King Louis XIV's desire to purchase the Palazzo Ludovisi, supposedly at Bernini's recommendation, see Montanari, 2001, 111 and doc. 10.

32. At this point in his narrative, Baldinucci, i.106–7, e.40–41, discusses the *Francesco d'Este* bust and the *Truth Unveiled by Time* statue, already discussed by Domenico (pp. 80–83). Immediately thereafter (i.107–8, e.41–42) comes the account of the renewed friendship between Bernini and Mons. Fabio Chigi, without mention of Chigi's new role as secretary of state or Domenico's preface about how "fortune" had secretly worked to dispose events favorably in Bernini's regard, bringing Chigi to the papal throne.

33. Domenico, 73, identifies Panciroli as author of poetry in honor of Bernini's tomb of Urban VIII and on p. 77 mentions (correctly) the cardinal's crucial help in getting Innocent elected pope. However, at the time of his death, Panciroli was in fact bitterly estranged from Innocent, and news of the unloved cardinal-secretary's death was met by an outpouring of expression of "universal hatred" for the deceased, according to the diary of Cardinal Domenico Cecchini (d. 1656): see Fumi, 319.

34. Both Domenico and Baldinucci specifically locate the first encounter between Chigi and Bernini in Cardinal Astalli Pamphilj's antechamber in the Palazzo Apostolico. Chigi arrived in Rome in late November 1651 (D'Onofrio, 1976, 14). However, whereas for Baldinucci this first meeting marked the renewal of an "old friendship" ("venne fatto di stringer vieppiù l'antica amicizia"), Domenico leads us clearly to understand that it was, more precisely, the effective beginning of their friendship. In fact, though both men had been part of the Barberini circle during Urban's pontificate, there is no documented trace of a friendship between the two men, if only because of the transience of Chigi's residence in Rome in those years.

Born and raised in Siena of an illustrious but no longer affluent family, Fabio arrived in Rome in 1626, where he immediately entered the Barberini court. Only three years later, he left Rome

to take office as papal vice-legate in Ferrara; he was in Rome again in 1634 but departed the following year for Malta, where he was appointed Inquisitor and Apostolic Visitor. From Malta, he went to Cologne in 1639 as papal nunzio representing the Church at the Westphalian peace negotiations, with only a brief stop in Rome. For the preceding and other details of Chigi's early career, see Fosi, 2000a and 2000b. After his definitive return to Rome to serve as secretary of state, he was named cardinal (February 19, 1652) and elected pope on April 7, 1655, reigning until his death on May 5, 1667 (*EncPapi*, 3: 336–48).

As for documented contact between Chigi and Bernini during the early Roman years (1626–29), all we have at the present time are personal notes by Chigi listing various works of art on display in Rome, those of Bernini included among them, but without any indications of a friendship between the two men (A. Angelini, 1998, 39, 42). For Chigi's biography and cultural interests, see also Angelini-Butzek-Sani.

35. *Sopraintendente* (more commonly *Soprintendente*) *Generale dello Stato Ecclesiastico:* for this title, see Domenico, 48, and commentary. With the expansion of the office of secretary of state (under Innocent X and Panciroli) and the lessening of reliance on papal relatives, the *Soprintendente* (the role usually given to the Cardinal Nephew) lost much of its power.

Adopted by Pope Innocent, Camillo Astalli (1619–1663), brother of the husband of Caterina Maidalchini (niece to Donna Olimpia), replaced the ineffectual Cardinal Francesco Maidalchini (1621–1700) as Cardinal Nephew in September 1650. Francesco, in turn, had replaced in the same role Camillo Pamphilj (son of Donna Olimpia and thus the true blood nephew to Innocent) in October 1647, several months after Camillo had abandoned his cardinal's hat in order to wed the Princess of Rossano, Olimpia Aldobrandini (married February 1647). The completely inexperienced Cardinal Astalli Pamphilj, equally as ineffectual in his role as his predecessors, was eventually (February 1654) forced to leave Rome in disgrace.

36. Chigi had not been in Rome since 1635, having gone from Malta to Germany with no sign of any substantial stay in Rome en route; hence the two men had truly not seen each other in decades. Again, they seem also to have had no effective acquaintance during Chigi's very brief Roman periods in the late 1620s and in 1634: see note 34 above (for more on the relationship between Bernini and Chigi, see Domenico, 95, and commentary). Be that as it may, what we have here is the first example of what I call the "instant recognition" topos in Domenico's narrative, in which one illustrious personage instantly recognizes another of the same exalted stature whom he has never seen before (or, as here, not seen for a long time) in person simply on the basis of the unmistakable greatness exuding from his very being. For other examples, see Domenico, 103 (Christina recognizes Bernini) and 127 (Bernini recognizes Louis XIV).

The topos, however, is not original to Domenico: see, e.g., Comanini's dialogue on art theory, *The Figino* (1591): "A shared fate brought both Martinengo and Guazzo to Figino's residence at the same time on the same day. Known to each other by reputation though not by sight, the two gentlemen met at the door" (Comanini, 5). Compare as well *abate* Elpidio Benedetti's description of the first encounter between Mazarin and the same Fabio Chigi: Benedetti, 124.

CHAPTER XIII

1. Alexander was elected on April 7, 1655; his coronation took place on April 18. Baldinucci, i.108, e.42, makes the same claim in similar language ("The sun had not yet set on the day that was Cardinal Chigi's first in the office of Supreme Pontiff when he sent for Cavalier Bernini"). The same had earlier been claimed with respect to the newly elected Urban VIII (see Domenico, 24, and note 1 on that page). Here as before, the truth of the assertion is highly unlikely, given the well-filled papal schedule on such a day of momentous consequence. Furthermore, as Morello, 1992, 191, observes: "Most probably the episode in question in Baldinucci and Domenico stretches the truth a bit, since in the first pages of the Diary [of Alexander VIII], precisely in the months that extend from Chigi's election to the papacy through the end of 1655, Bernini's name appears very few times."

In fact, according to Morello's own transcription of all the Bernini-related passages in that diary, the artist is mentioned only once, on November 9, in all of 1655, merely for having recommended someone for a position. His regular appearances in the diary begin on January 22, 1656 (Morello, 1981, 322). However, during part of this period, from at least late September 1655 through late April 1656, Bernini was fighting a protracted case of *febbri terzane doppie* (double tertian fevers), presumably malaria (Fraschetti, 422–23, citing the dispatches of the Roman agent of the Duke of Modena). For Bernini and Alexander, see also Angelini, 1998, 21–125, passim; and Morello, 2008.

In the same passage (i.108, e.42), Baldinucci specifies that the newly elected Alexander summoned Bernini that first day to "incite him to embark upon great things in order to assist him in carrying out the ambitious plans that he had conceived for the greater embellishment of God's temple, the glorification of the papacy, and the decoration of Rome." A similar line appears in Domenico, 99, but, instead, at the conclusion of the long initial section of this chapter recounting the high esteem for Bernini on the part of various personages of the Chigi court (which Baldinucci, instead, treats much later, that is, at the end of his chronological narrative, at i.151–52, e.85–86).

2. The *Camera* is the Camera Apostolica, the papal treasury. Baldinucci, i.108, e.42, too, notes the unprecedented nature of this honor bestowed by Alexander, but specifies that the pontiff "named Bernini his own personal architect *and* of the Camera ("dichiarò suo proprio architetto *e* della camera," emphasis added). In reviewing some of Bernini's architectural job titles, Quinterio, 364, notes, without chronology, that the artist appears in the Vatican documentation—but "only sporadically"—in the role of *Architetto Camerale,* "whose function, related solely to civil construction projects of the State, was that of calibrating building calculations, first measured by the Auditor (*Revisore*) della Camera Apostolica, on which this office directly depended." Is this the same role here in question? Further clarification and study are needed of Bernini's role in these various types of architectural service to the pope and papal curia.

3. Baldinucci, i.108, e.42, quotes Alexander to the same effect and in the same context of Bernini's inclusion in the company of the "learned persons" customarily gathered by Alexander for his postprandial recreation. For lists of the specific persons at such gatherings, see Alexander's personal diary, Morello, 1981, passim. Alexander's statement about Bernini is also included in Pietro Filippo's *Vita Brevis* (appendix 1 below).

4. For analysis of this fly episode (not included in Baldinucci), see Delbeke, 2000; Montanari 1997, 57–58; and Bellini, 2006, 301–7 and 2009, 188–201. The anecdote originally appeared in the much earlier *Arte della perfezione cristiana* (1665) by Sforza Pallavicino (for whom see Domenico, 40, and commentary). In appropriating the anecdote from its source, Domenico (presumably on the basis of his father's reminiscences) makes two significant changes: first, he makes Bernini the originator of the ingenious remark, whereas in reality it came from Pallavicino himself; and, second, in identifying the works of art that provoked the less-than-favorable comparison with the fly, Domenico substitutes "various painted and drawn portraits" by *other* artists for what was, instead, in Pallavicino's original text his father's own sculpted portrait of the pope. See Domenico, 108, for the "many, many portraits" of Alexander that Bernini executed.

5. *Lapis* in the original Italian, for which see note 10 below. For *lapis* as the artist's drawing medium, see note 43 above to Domenico, 15.

6. Domenico already quoted Alexander to this effect on p. 4 above, in discussing the discernment of the young Bernini's career path.

7. The honorific label "phoenix of geniuses" was first and most famously applied to Renaissance philosopher Giovanni Pico della Mirandola (d. 1494), ancestor of Cardinal Ludovico to whom this biography is dedicated. However, one finds it applied to various personages in Italian history (such as to literary theorist Emanuele Tesauro in Castellamonte's 1674 *Venaria Reale,* 8–9): see the Introduction, section 7, for the epithet. Delbeke, 2005, 245, explains the mythological allusion: "According to the most widespread version of the phoenix's tale, the miraculous bird regenerates from its own ashes, three days after its nest, built from Arabic spices, is set ablaze by the sun." See the rest of Delbeke's article for his thesis that in making this pronouncement, Pallavicino "imposes a precise interpretative perspective on the artist's work" (247).

As Fehrenbach, 2005, 4, points out, the Bernini-as-phoenix epithet and Pallavicino's earlier reference to being *infiammato* (literally "inflamed," but translated above as "impassioned") by Bernini also reinforce the recurring image of Bernini as the classic "choleric" (fiery) personality (see Domenico, 177).

As for Pallavicino's habit of burning incense in his residence, that was most likely a preventive measure against disease, especially the bubonic plague. Contemporary medicine held that "corrupt air" was a major cause of disease (the "miasma theory") and hence one could disinfect the air with smoke and certain aromas (Mormando, 2005, 16, with further bibliography). Recall that the bubonic plague hit Rome in June 1656, the pandemic lasting until the following summer: see D'Onofrio, 1976, 223–58; and Barker, 2006.

8. For the significance of this recurrent label in Domenico—it is used more than ten times in his biography—see DLO/Pro, 47. Baldinucci, i.151, e.85, has Pallavicino defining Bernini as instead "the greatest man" (il maggior uomo); the Florentine biographer himself refers to Bernini as a "grand'uomo" on i.120, e.54. Pallavicino's praise of Bernini as a "great man" (Grand'Huomo) will be echoed in the very last line (p. 180) of Domenico's book; for the expression, see also note 8 below to Domenico, 141; and 178 for further words of praise for Bernini by Pallavicino. On the same theme, see Chantelou, October 20, f.281, e.325: in a discussion about Mazarin, "The Cavaliere remarked that Cardinal Pallavicino had identified two great spirits (*deux grands esprits*) of his day, Cardinal Mazarin being one of them; he did not want to name the other. The Nuncio said that he suspected that it was the Cavaliere. He [Bernini] denied it rather weakly."

9. Baldinucci, i.151, e.85, attributes to Pallavicino the comparison with the greatest "theologians, orators and captains," which Domenico, instead, appropriates here, without citing its source, as if it were his own original observation.

10. Some of the personal notes written in pencil (*lapis*) by Alexander to Bernini have survived and are among the Bernini papers in the Bibliothèque Nationale, Paris (Morello, 1992, 205). The pope's use of pencil is in this case to be seen as a flattering display of familiarity, not a sign of the lesser value attributed to the correspondence by the pope. Contrary to earlier appearances of the word (pp. 15, 27, 28, and 96), Domenico here italicizes *lapis* in both instances: this is likely because use of the term to denote the writing instrument (the still rather rare graphite or lead pencil)—and not the artist's drawing medium—was new at the time. (My thanks to Eraldo Bellini for the preceding two observations.) For Domenico's generic use of the term *lapis* with respect to Bernini's drawings done in black or red chalk, see note 43 above to Domenico, 15.

11. Baldinucci, i.151–52, e.85–86, also covers this topic but with greater brevity. In his list, Baldinucci does not include Ottoboni (not knowing that the latter would one day be pope) or Azzolino. Azzolino is, however, mentioned later (i.137, e.71) as one "who had been a most cordial protector" and thus recipient of a Bernini postmortem bequest. Baldinucci does include two other names, Cardinal Angelo Rapaccioli (d. 1657; also mentioned, i.87, e.22, as the author of poetry in praise of Bernini's tomb of Urban VIII) and Cardinal Flavio Chigi (1631–1693). Rapaccioli is nowhere mentioned by Domenico. For papal nephew and great patron of the arts, Flavio Chigi, see Domenico, 108, and commentary.

12. Born in 1618 in Modena, Rinaldo was the son of Duke Alfonso III and Isabella of Savoy; he was also brother to Duke Francesco I, whose portrait bust Bernini executed in 1650–51, with Rinaldo serving as intermediary; see Domenico, 64, and commentary. In his youth, Rinaldo abandoned a military career to follow a more promising ecclesiastical path and moved to Rome. In 1641, at the age of only twenty-three, he was created cardinal deacon and continued thereafter to climb the ranks of power within the Roman prelature. Rinaldo owed much of his wealth and influence to his role as loyal, assertive cardinal-protector of French interests in Rome, for which Paris rewarded him generously. He died in September 1672. See Domenico, 162, for Rinaldo's extravagant remuneration to Bernini for a minimal amount of work at the cardinal's famed villa at Tivoli in 1661.

At the same villa, Bernini designed in the 1660s the Fontana del Bicchierone (Big Cup), a giant artificial cascade. Though in earlier years they may have interacted in Barberini circles, the

first documentation of a direct connection between Rinaldo and Bernini dates to 1650 during negotiations for the ducal portrait bust. In 1653, Bernini provided Rinaldo with a design for a never-executed monumental staircase for the Barberini "Casa Grande ai Giubbonari" then being leased by the cardinal. Our artist probably also contributed to the design prepared by his trusted architectural assistant Mattia de' Rossi for the remodeling of Rinaldo's later Roman residence, the Palazzo Sannesi. Jarrard, 2002, 396, states that the various commissions from Rinaldo to Bernini "substantiate the impression that Rinaldo d'Este was one of Bernini's few lasting patrons outside papal circles." Yet in terms of actual executed works, Rinaldo's commissions were not significant in either number or size. For Bernini and Rinaldo and the commissions, see Jarrard, 2002, and her 2003 monograph, passim.

13. For Cardinal Antonio, see Domenico, 19, and commentary.

14. Azzolino was born of minor nobility in the northeastern Italian town of Fermo in 1623. Moving to Rome as a young man, he had the good fortune of securing (through Francesco Barberini) the position of secretary to Giovanni Giacomo Panciroli (future papal secretary of state), through whom he made the acquaintance of Giovanni Battista Pamphilj (the future Pope Innocent X). With the progressive rise in fortune of Panciroli and Pamphilj came also his own. He was named cardinal in 1654, eventually becoming secretary of state under Clement IX. A man of refined culture and an able diplomat, he was assigned by Alexander VII to act as adviser to Christina of Sweden after her installation in Rome. This was a difficult task that he performed adroitly despite the gossip and near-scandal generated by his deep friendship with the emotionally volatile queen, who was quite smitten by her charming cardinal-protector.

Within the College of Cardinals, he was a member of the so-called *squadrone volante* (flying squadron, for which see Signorotto), which opposed the influence of political powers (France and Spain) in papal elections and helped elect both Alexander VII and Clement IX. Sole heir to Christina's estate, he survived her only by a matter of weeks, dying in June 1689. For Azzolino, see Montanari, 1997; and Rodén, 2000; see also Chantelou, f.85, n.5, where Stanić cites excerpts from an unpublished 1665 letter from Bernini in Paris to Azzolino, discussing the artist's work at the French court. A protector of Bernini's reputation in Rome, Azzolino will make two more appearances in Domenico: on 174 as attending to the artist in his final illness; and on 176 as recipient of a Bernini bequest.

15. Pietro Ottoboni became pope on October 6, 1689, at the age of seventy-nine, thanks especially to pressure from the French court; his pontificate was brief, ending in 1691. Born in 1610 of an old, distinguished Venetian family, he had moved to Rome by 1630, finding favor with the Barberini and thus beginning his ascent up the ecclesiastical ladder. Named cardinal in 1652, he came close to election as pope in 1667. He exercised much authority during the reign of Innocent XI as secretary to the Congregation of the Holy Office (i.e., the Inquisition).

Ottoboni's name, to my knowledge, occurs nowhere else in the Bernini sources as participant in the life of the artist, though the two would have certainly encountered each other regularly in the ecclesiastical halls of power. He is quoted here more for the cachet of his status as future pope, rather than as intimate friend to Bernini. After Christina of Sweden's death, Ottoboni acquired from her estate the monumental allegorical mirror (depicting the figure of Time, who lifts a veil covering the glass) designed for the queen by Bernini (for which see *Regista*, 404, cat. 158; and Zirpolo, who identifies the theme as that of "Truth Revealed by Time," connecting it to Christina's temporary disgrace that followed her brutal execution of her courtier Monaldeschi).

16. According to the memoirs of Charles Perrault, who, as assistant to Colbert, had much occasion to interact (at times unpleasantly so) with Bernini in Paris in 1665, Bernini "had a lively, sparkling wit and a great talent for making himself shine in company; he was a good speaker, with a full stock of sayings, parables, anecdotes, and witticisms which he used in most of his remarks, not deigning to give a simple answer to a question" (Perrault, 62).

17. For Alexander's many architectural and city planning projects, which transformed the landscape of Rome as no pope before or since, see Krautheimer, 1985; and Habel, 2002. As

Morello, 1992, 207, reminds us, the rapport between Alexander and Bernini was one of close "creative collaboration" in which the pope (who had studied architecture in his youth) was at all times an active, expert participant with original ideas of his own.

18. Baldinucci, i. 109, e.43, dedicates only a few brief lines to the colonnade and the other projects of the Chigi pontificate, excusing his brevity with a protestation of the impossibility of doing justice to the "magnificence and originality" of these "sumptuous works." What is now usually called in English the "colonnade" is referred to as *il portico* or *i portici* in the original documents (Domenico and Baldinucci included). On a literary note, as Eraldo Bellini (2006, 275; and 2009, 159) points out, Domenico's "new order" remark here is a citation from Torquato Tasso's epic poem, *Gerusalemme liberata* (13:73), so appropriate to the epic nature of these Chigi undertakings.

19. The documentation pertaining to the conception and design of the colonnade, which involved not only the pope and Bernini but also Virgilio Spada and papal librarian-scholar Lucas Holstenius, shows that the group clearly strove to emulate, if not surpass, the magnificence of the ancients in creating the new Piazza San Pietro. Of particular inspiration was the legendary triumphal portico of ancient Greece at Chalcis (Marder, 1998b, 146–48; Habel, 261, 282–85; see also Borsi, 348–49, for the text of Holstenius's memorandum, "Dei Portici Antichi," for which see also del Pesco, 1988, 11–38).

For a detailed, documented chronology of the Piazza San Pietro project, see del Pesco, 1988, 40–96. Among the key dates of the project are: July 31, 1656, the Fabbrica confers the commission upon Bernini; the following month (August 20), Bernini presents his first sketches, initiating what was to be a long process of design development. On August 28, 1657, the foundation stone and commemorative medals are ceremonially installed, even with the design still in a state of flux; construction begins in early 1658, coming to an end only in 1667. Bernini discusses his colonnade design in Chantelou, July 15, f.76–77, e.61–62, pointing out that one of its main goals was to correct the long-lamented defect of Maderno's facade, the fact that it was too low for its width. For Bernini and Piazza San Pietro, see Kitao; Borsi, cat. 45; del Pesco, 1988; Marder, 1998a, 126–49; Rietbergen, 1983; Martinelli, 1987; Habel, 257–85; and Lavin, 2005, 144–55.

20. For the statues atop the colonnade, all executed (and to a large extent designed) by Bernini collaborators, see Martinelli, 1987 (33 and 47–48 for summary lists with attributions and locations).

21. Domenico's information (repeated again on p. 161) is correct: the south corridor of the colonnade (to one's left when facing the basilica) was completed shortly after Alexander's death in May 1667 and the election of the new pope, Clement IX, who placed his coat of arms there.

22. Baldinucci, i.109, e.43, instead gives this monthly figure as 260 *scudi*. Neither biographer is correct; as is clear in extant documentation, on August 6, 1657, the Fabbrica decided that Bernini's remuneration for both the Cathedra and colonnade projects at the same time, assigning him, for the colonnade work, 60 *scudi* per month for five years and, for the Cathedra, 200 *scudi* per month for forty months, in addition to his usual monthly sum from the Fabbrica (del Pesco, 1988, 54; see also 40 and 56). As for the expense of the colonnade itself, Rietbergen estimates the total cost of the entire project conservatively at 1 million *scudi*, representing "nearly half of the annual revenue of the Church in this period."

23. About the exceedingly complex and challenging Scala Regia (Royal Staircase) project, Marder, 1997, 130, reports: "Oddly enough we have no indication as to when the new staircase was commissioned or approved. And unlike all other components of the piazza or the basilica, there is no recorded discussion of the design among members of the Reverenda Fabbrica di S. Pietro." However, the design process must have come to maturation by late 1662 or early 1663, for construction began in spring 1663 and appears to have been largely finished by 1667, except for whitewashing and painting, which continued until November 1668. For all facets of this project, see the exhaustive Marder, 1997.

Baldinucci, i.109, e.43, makes brief mention of the Scala Regia in the same paragraph as his description of the colonnade, noting the marvel and difficulty of the engineering involved in this work, as well as the beauty of the final product with its "most beautiful perspective of stairways,

columns, architraves, cornices and vaulting." He also repeats Bernini's remark that he would never have believed an account of this project had it been written about someone else's work. (However, what Baldinucci quotes Bernini saying about the Scala Regia as "the least bad work" he ever did is reported by Domenico, 83, as applied by the artist, instead, to his *Saint Teresa* statue.)

Domenico and Baldinucci do not exaggerate the complex, even perilous technical challenges that Bernini successfully overcame, to the amazement of his contemporaries, both expert and lay. He transformed the formerly dark, narrow, undistinguished staircase of daunting height into a grand, noble, functional, and well-lit monument (conveniently divided into two separate, more manageable flights of steps with a landing in between). Among the major challenges was the fact that the staircase's very structure was intricately connected with the supporting walls of the huge rooms above it (the Sistine and Pauline Chapels, and the Sala Regia), some of which were in a dangerous state of disrepair: see Marder, 1997, 150−57, citing the detailed eyewitness account by Carlo Fontana from his 1694 *Tempio Vaticano* (4:13).

24. Indeed, the vast expense of the project provoked public criticism (such as the August 1656 *memoriale* of Cardinal Giovanni Battista Maria Pallotta) against such extravagance in calamitous times, both economically and otherwise (the plague was still raging in Rome). In its August 19, 1656, memorandum announcing the colonnade project, the Fabbrica surprisingly declares that it was being undertaken solely "pro subventione pauperum aliorum indigentium familiarium Urbis," "in order to assist the poor and other indigent residents of the city." This assistance to the poor (as elsewhere made explicit) would come in the form of the many new jobs that the project would create.

The same point is also, and equally self-defensively, raised at the very beginning of a later memorandum in the Chigi archives, responding to criticism of the colonnade project on all fronts. The memorandum in question (Vatican Library, cod. Chigi H II 22, fols. 107r−109v) was first published in its entirety by del Pesco in 1988 as the work of an anonymous author but clearly belonging to the *parte berniniana* (Bernini faction). Montanari, 1997, 48, subsequently identified its author as Bernini's son, Monsignor Pietro Filippo, on the basis of Pope Alexander's handwritten additions (at the beginning and end of the text) indicating that the memorandum had come from "Monsignor Bernino."

Tentatively dated by Montanari to 1662, the manuscript also bears numerous corrections by Sforza Pallavicino; inevitably it gives voice to many of Bernini's own direct observations, if not extensive verbatim dictation. See del Pesco, 1988, 42−43 (for the Fabbrica's 1656 decree and Pallotta's criticism); 62−65 (for Pietro Filippo's memorandum); and 43−45 for the text of yet another anonymous memorandum (Vatican Library, cod. Chigi H II 22, fols. 102−3), dated to shortly after August 1656, also defending the portico expenditures, which, as it says, would "keep employed so great a number of poor artists, who amidst the present calamities, cannot find work."

25. "The *Scala Regia,* the ceremonial entrance to the Vatican Palace, formed an integral part of Bernini's planning of the Square of St. Peter's" (Wittkower, cat. 68, 285). For Bernini's work in the Sala Regia (Royal Hall), used for the reception of dignitaries, see Domenico, 108. The Sala Regia connects the Sistine Chapel to "the chapel of Paul III" (Pauline Chapel, Cappella Paolina), the latter chapel being famous for its two frescoes by Michelangelo, *The Conversion of Saul* and *The Martyrdom of Peter.*

26. To cause the irregularly shaped stairway to appear of equal width along its entire length, Bernini, in other words, created a visually successful and aesthetically pleasing optical illusion, one of the most celebrated in an age that abounded and delighted in the clever "deceptions" of its art and architecture. In the illusionistic play of his columns in the Scala Regia, Bernini may have been inspired by Borromini's earlier trompe-l'oeil colonnade, the famous *Galleria prospettica* (1653) on the ground floor of the Palazzo Spada, designed in conjunction with mathematician and perspective expert Giovanni Maria Bitonto: see Marder, 1998a, 70, who also cites the influence of Bitonto's illusionistic tabernacle on the main altar in San Paolo Maggiore, Bologna, a project—that of the main altar—to which Bernini had contributed architectural elements.

CHAPTER XIV

1. Christina Wasa (1626–1689) was the only child of Gustavus Adolphus (1594–1632), King of Sweden, who, as one of the most successful military leaders of the Protestant forces during the Thirty Years' War, wrought massive devastation upon the continent and represented the fiercest nemesis of the Catholic Church. Succeeding her father as ruler of Sweden, Christina signed the Treaties of Westphalia, which ended the long, disastrous warfare, but at grave and permanent damage to the political and economic status of the papacy and the Catholic religion. Hence her conversion, as Domenico remarks, represented for Rome a great triumph over its "northern" (Protestant) enemies.

Domenico's qualification, "now rich in her own person alone," would have reminded his original audience of the financial straits that plagued the queen for many years after her abdication and conversion. Concluding a long process of negotiation and preparation, Christina entered Rome officially "incognito" on Monday evening, December 20, 1655, through the newly reopened Porta Pertusa behind Saint Peter's, at which time she had her first meeting (lasting half an hour) with Pope Alexander. Although Christina's arrival at the Palazzo Apostolico was classified as a "private" event, it was nonetheless witnessed by a host of privileged spectators, Bernini apparently among them (see note 5 below). The queen's official grand entrance (through the freshly remodeled Porta del Popolo) took place on Thursday, December 23, and is described in intimate detail by several contemporary chroniclers (see D'Onofrio, 1976, 11–105 for a thorough, well-documented account; and 20, 24, and 25 for the December 20 arrival).

Christina spent most of the rest of her life in Rome, often an embarrassment to the papacy for her unorthodox, capricious behavior, fueled by her rather freethinking religious and social views and her unstable psyche. Baldinucci, i.110, e.44, uses the same phrase as Domenico to describe the resplendent Christina, "ammantata di nuova e bella luce," continuing with words of praise for her patronage of artists in general and in particular of Bernini, whose fame had already reached her in Sweden. For Christina's life and politics, see Stolpe; Åkerman; Rodén; and Buckley; for a detailed account of her conversion and journey to Rome, see the already-cited D'Onofrio, 1976, 11–105 (including a long excerpt from the Carlo Cartari diary); for her entrance, see also in summary fashion, Fagiolo dell'Arco, 1997, 376–79; for Christina and Bernini, see Montanari, 1998b. Domenico includes a long, detailed discussion of Christina—her conversion, "rare qualities," life in Rome, and death—in his *Historie di tutte l'heresie*, 4:636–41.

2. Alexander was well known in "northern lands" because of his tenure as papal legate to the peace-treaty negotiations in Westphalia. The contemporary *Diario Romano* by Gigli echoes Domenico's words about Chigi's good personal reputation among the "heretics" (D'Onofrio, 1976, 19). There was a lapse of four years between Christina's first decision to convert (August 1651) and her arrival in Rome (December 1655). She formally abdicated her throne in June 1654. As papal secretary of state, Alexander oversaw all the delicate negotiations involved in the queen's conversion and later, as pope, took direct, personal care in orchestrating Christina's triumphal journey to Rome, spending the "astronomical sum" of 100,000 *scudi* (D'Onofrio, 1976, 20, for both the chronology and cost).

We have it upon the informed authority of Cardinal Sforza Pallavicino that among the principal causes of Christina's delay in moving to Rome was the fact of Donna Olimpia's imperious presence in the city: there was no room for a second "prima donna" in Rome (D'Onofrio, 1976, 44, 48). After Alexander's election, Olimpia understood that it was best that she quickly leave town; as already mentioned, she died in 1657 of the plague at the Pamphilj estate in San Martino al Cimino (Viterbo).

3. "Onde diede tempo la fama di disporre il Pontefice a riceverla, non altrimenti."

4. At the Vatican, Christina was housed, by extraordinary concession from the pope—women were not allowed to sleep in the papal precincts—in the Torre de' Venti (Tower of the Winds), for which see D'Onofrio, 1976, 26, 28, and 34. For Bernini's architectural and decorative work in readying her apartments there, see Montanari, 1998b, 333, quoting a detailed report

from the Medici agent in Rome. Nothing remains, by way of drawings or actual remnants, of the coach Bernini designed for Christina: for a detailed contemporary description and small engraving, see Fagiolo dell'Arco, 1997, 377 and 378; and Montanari, 1998b, 335.

The chronicle describing the coach, *Historia della sacra real maestà di Christina Alessandra . . .* , by Galeazzo Gualdo Priorato (published in 1656 by the *Camera Apostolica*, i.e., at papal expense) also reports the conversation between Christina and Bernini on Tuesday, December 21, the morning after her incognito arrival in Rome. During that conversation, upon hearing Count Raimondo Montecuccoli tell the queen that Bernini had designed the papal gift-coach, which she was at that moment inspecting, our artist modestly quipped: "If you see anything defective in it, it came from me." To this, Christina, with equal wit, quickly retorted: "Then in that case there is nothing at all from you in this coach" (Montanari, 1998b, 333).

Another contemporary source, the diary of Neri Corsini, supplies further details about that December 21 conversation, which was followed by a tour of the art in the Papal Palace with Bernini as her guide (Montanari, 1998b, 333). Neither source identifies the December 21 meeting as the first encounter between the queen and the artist: see note 5. In preparation for Christina's entry into Rome, Bernini also remodeled and embellished the Porta del Popolo: Domenico, 107–8, mentions this project but does not associate it with Christina. As we know from Nicodemus Tessin's notes on his visit to Palazzo Riario (the queen's ultimate, permanent residence in Rome, now known as the Palazzo Corsini) and the postmortem inventory of her possessions, Christina owned several works of art by Bernini: see Domenico, 176 (his bequest to the queen of the *Savior* bust), and commentary.

5. This is another example of what I call the "instant recognition" topos in Domenico, for which see 94, and commentary. The episode is not in Baldinucci: specifying neither date nor venue, Baldinucci, i.111, e.45, simply mentions that Bernini was fortunate to be present, together with "the others of the papal household," at that "most solemn ceremony with which he and all of Rome greeted Her Majesty." Domenico follows this topos with a second one, much used by our author, that of the "that very same day" phenomenon (here, more specifically, "that very same evening"), for which see Domenico, 24, and commentary.

Since, as mentioned in note 4, on the morning of Tuesday, December 21, Bernini gave Christina a personal tour of the papal art collection (after which occasion there would obviously no longer be any possibility of the queen's having to identify the artist in a crowd merely on the basis of her intuition), this "instant recognition" incident must have taken place on Monday, December 20, when, as pointed out in note 1 above, Christina entered the city "secretly" through the Porta Pertusa and proceeded immediately to the Palazzo Apostolico for her first "informal" meeting with Pope Alexander, this brief meeting taking place well into the evening, two hours after sunset (Gigli, 751; Cartari diary in D'Onofrio, 1976, 72).

Christina could indeed have spotted Bernini in the crowd of spectators lining the route to the papal audience room on that occasion. However, it seems a bit unusual that so late in the day, after long travels and lengthy, tiresome ceremonial duties, the queen would also then be receiving guests, Bernini among them, "that very same evening."

6. The two cardinals in question were appointed by the pope to formally receive Christina on Monday, December 20, at her resting station twenty kilometers north of Rome (at Olgiata on the Via Cassia) and then escort her the rest of the way to the Palazzo Apostolico. They were not chosen casually: Giovanni Carlo de' Medici (1611–1663), brother of Grand Duke Ferdinando II of Tuscany, was of the Spanish faction—Spain had lent support to the queen during her abdication and conversion process—while Friedrich (1616–1682), son of Landgrave Ludwig V von Hessen-Darmstadt, was, like Christina, a "trophy" convert from Lutheranism (in 1636), in addition to being a relative of hers (D'Onofrio, 1976, 24 n.12). Domenico's original text mistakenly gives Cardinal de' Medici's name as "Giovanni *Giacomo*."

7. In his subheading, Domenico says Christina visited Casa Bernini "many times." Later he specifies that the first, undated visit here described was followed by three others (not otherwise documented). A diplomatic dispatch from Rome in the archives of the House of Savoy

dates the first visit to February 20, 1656, mentioning the queen's particular praise for his statue of *Truth* and its *morbidezza,* literally, softness (Montanari, 1998b, 350–51). However, Domenico is incorrect in associating this visit with Bernini's statue of *Constantine,* since the artist had not even begun working in earnest on that statue until 1662.

As Montanari, 353 (correcting Marder, 1997, 171), conjectures, the *Constantine* reference must relate to a subsequent visit by the queen, perhaps sometime soon after her reentry (June 20, 1662) from a long absence from Rome, assuming that Domenico's placement of the queen's visit in close proximity to that of Pope Alexander has some basis in historical truth (the pope's visit took place on June 19, the day before Christina's return). See also notes 11 and 15 below. Baldinucci (i.143, e.76 and i.152, e.85) also refers to multiple visits by Christina to Bernini's home but specifies neither the number nor the dates of such visits.

Curiously, in all his references to Christina's great demonstrations of esteem for Bernini, Domenico never once mentions her supposed patronage of Baldinucci's biography of the artist, another indication of the falsity of the "official version" of the origins of that biography (for which see the Introduction, section 4).

8. "che era proprio di quella virtù, che tale appresso il Mondo lo rendeva."

9. Baldinucci, i.143, e.76, more laconically reports the same anecdote of the artist's coarse work clothes being touched by queen, omitting, however, the final part about Bernini's talent having rendered him famous in the world. Wittkower and Wittkower, 271, commenting on the anecdote, point out: "This story may well be true although it sounds like a variation of the familiar *topos* invented in praise of the dignity of the artistic profession, best illustrated by the famous anecdote according to which Charles V picked up Titian's brush." In the same category is Malvasia's story about Guercino and the same Christina (in which the queen deigns to touch the artist's hand): see Montanari, 1998b, 353–54 (339 for the Malvasia source), who situates this topos within the context of the rising social status of the artist.

10. This is one of several appearances of the epithet *Grand'Huomo* in Domenico's narrative, the same words with which he will end the biography: see Domenico, 97 and 180, and commentary. However, this same remark, nearly verbatim, is attributed by Baldinucci (i.127, e.61) instead to Alexander VII, also at the conclusion of mention of the pope's visits to Casa Bernini.

11. Baldinucci simply makes quick mention of Alexander's two visits to Bernini's house (i.127, e.61) and later includes the pope in the list (i.152, e.85) of those illustrious personages who over the years had honored the artist with personal visits to his home. From Alexander's diary, we know that the first visit took place on June 19, 1662 (Morello, 1981, 333). Domenico mentions that he was six years old at the time of this visit, which would correspond to the year 1663 (he was born on August 3, 1657); hence, if his memory is correct, this anecdote about his flustered response to Alexander's interrogation may instead date to the second papal visit in June 1663 (see note 15 below). Furthermore, although, as Domenico claims, the papal visit may have indeed occurred in close proximity to one by Christina, this could not have been the case in 1662, since, as mentioned in note 7 above, the queen was absent from Rome for several months before Alexander's securely dated June 1662 visit.

12. Domenico, 50, quotes Pope Urban to the same effect, explaining that the papal visit renders homage not only to Bernini himself but to all artists as well.

13. "Checco" is the diminutive for Francesco, the name of Domenico's older brother.

14. The virtue of *magnificentia* (magnificence) is one of the prerequisites of the Baroque prince, ecclesiastical or secular: see my commentary on the term on Domenico, 2. Giacomo Filippo Nini (1629–1680), of Sienese patrician family, had been in Alexander's service since the ex-nuncio's return from Cologne; he received the cardinal's hat in 1666.

15. According to Alexander's diary, this second visit took place on June 5, 1663 (Morello, 1981, 335), being just one of the stops the pontiff made in the course of a day-long outing in Rome. In Chantelou, September 10, f. 172, e.187, responding to King Louis's question as to whether Alexander VII had come to Bernini's house while the artist was executing the pope's portrait, Bernini's assistant, Giulio Cartari, replied that "His Holiness had come ten times," an unlikely and, in any case, undocumented claim.

As for the three statues mentioned (and in Baldinucci, i.110, e.44), all commissioned for the cathedral of Siena, we know that the *Jerome* and *Magdalene,* begun in late 1661, were shipped to their destination at the end of June 1663 (hence shortly after the pope's visit), whereas the finished, full-figure seated statue of the pope left Rome in July of that year. Both Domenico and Baldinucci are correct in specifying that Bernini did only the *modello* for the pope's statue; Antonio Raggi did the actual carving, being paid for his work between November 1661 and July 1663. For the *Jerome* and *Magdalene* statues, see Wittkower, cat. 63; Lavin, 1981, 228–39 (entry by P. Gordon); Angelini, 1998, 165–72; and Angelini-Butzek-Sani, 409–22 (with data and bibliography on the entire chapel project). For the marble statue of Alexander VII, whose erection had been decreed by the government of Siena in summer of 1660, see Wittkower, cat. 64; M&MFagiolo, cat. 181; and Angelini, 1998, 177–78.

In the same Chigi Chapel (of the "Madonna del Voto") in the Duomo of Siena are statues of *Saint Catherine of Siena* and *Saint Bernardino of Siena,* executed in 1662, upon designs by Bernini, respectively, by Ercole Ferrata and Antonio Raggi (Angelini, 1998, 173).

16. The sculptor and stuccoist Antonio Raggi (called "Antonio Lombardo" by Domenico) was born in Lugano in 1624 and died in Rome in 1686; he arrived in the papal city in 1645, joining the workshop of Alessandro Algardi. A master in his own right, he was one of the great army of artists that Bernini recruited in 1647 to finish the decoration of the nave of Saint Peter's (for which see Domenico, 93) and went on to become one of Bernini's most trusted and most active collaborators in works of both stucco and marble, executing many of his master's designs and *modelli* (see *Grove Art Online,* s.v. "Raggi, Antonio").

In addition to many impressive works in stucco (such as in Sant'Andrea al Quirinale), Raggi—to cite only some of his best-known works for Bernini—carved the statue of the Danube River in the Fountain of the Four Rivers in the Piazza Navona (as Domenico, 89, notes, mistakenly calling him *Andrea* Lombardo); he also carved the statue of the *Virgin Mary and Child Jesus,* on Bernini's design, commissioned by Cardinal Antonio Barberini and sent to the Discalced Carmelite church of Saint-Joseph-des-Carmes, rue de Vaugirard, Paris, where it arrived in August 1663 and is still in situ (Wittkower, cat. 53). Earlier (1649), Raggi executed the larger-than-life-size group of *Jesus and Mary Magdalene,* known as the *Noli me tangere* (also still in situ), for the altar of the Bernini-designed Cappella Alaleona in the church of SS. Domenico and Sisto (see Wittkower, cat. 52).

17. Domenico does not mention his father's collaboration in the architectural design of the Chigi Chapel in the cathedral of Siena, dedicated in August 1662, though not fully finished until later. The architect was Benedetto Giovannelli of Siena, but its patron, Pope Alexander, was also quite actively engaged in the project. According to Morello, 1992, 196–97, Alexander's personal diary would indicate that Bernini was more directly involved in the remodeling and embellishment of the chapel than previously believed. For the chapel project and Bernini's designs for its various components (such as the bronze gate), see Acidini Luchinat; Angelini, 1998, 155–73; and Marder, 1998a, 289–92. Bernini was also involved in the design of the lantern for the cupola of the cathedral of Siena (Acidini Luchinat, 401).

18. Domenico, 93, earlier mentioned this commission by Innocent X and now keeps his promise of a more detailed description (see commentary to Domenico, 93, for further data and bibliography). Interestingly enough, as noted above, Baldinucci only perfunctorily mentions the initial commission (i.105, e.39) and installation of the colossal statue (i.110, e.44), with no further comment. Does he not want to draw too much attention to a work that had been met with severe criticism in Rome from the moment of its unveiling? See the denigratory contemporary critique (ca. 1670–74), "Del Costantino del Cav.re Bernini," published by Fraschetti, 321–22 n.1.

Extracts from the later *Il Costantino messo alla berlina* (Constantine brought to the pillory), a more extensive and better-known attack on the statue and its maker (based on the previously mentioned earlier pamphlet), have been published by Previtali in Italian and by Bauer, 1976, 46–53, in English. Even though it addresses Bernini as if he were still alive and refers to the statue as a recent arrival on the Roman scene, it dates to after 1725: see Marder, 1997, 209, for these two pamphlets, and 208–12 more generally for the "Critical Fortunes of Bernini's *Constantine.*"

Another unfortunate association of the statue is as the site of Luigi Bernini's sodomitic crime (for which see Martinelli, 1959 [reprinted in Martinelli, 1994, 247–55], still the most complete account of all known facts of the case). Domenico, instead, here sings the praises of the statue and, later (pp. 153–54), of Luigi Bernini. In any event, when visiting Bernini's home on this occasion, Alexander could not have viewed the *Constantine* statue in its completed state, for it was not finished until late summer 1668, well after the pope's death in May 1667. In an *avviso* in the archive of the Vatican Secretariat of State, the same reason—to examine the completed statue of *Constantine*—is instead given for the July 28, 1668, visit to Bernini's studio by Alexander's successor, Clement IX (Roberto, appendix I, 307). For Clement's visit, see Domenico, 159–60, and commentary. Domenico makes no mention of the *Constantine* with respect to Clement's visit.

19. According to Chantelou (October 6, f.228, e.260), Bernini too boasted of the immense size of the block of marble, but spoke in terms of its cost, not weight: "Then [Bernini] told us about the Constantine that he had been commissioned to do for Saint Peter's; the marble alone would cost 3,700 crowns (*écus*), and it would only be in bas-relief." According to the agent who shipped the marble block, its weight was "over thirty cartloads" (Wittkower, cat. 73). The "cartload" (*carrata* or *carrettata*) was then "the standard measurement for marble, being the weight that could be drawn in a cart by a pair of oxen," the latter, in turn, representing "the normal source of energy for transporting both unworked and finished statues. . . . By the end of the sixteenth century it was a little over a ton" (Montagu, 1989, 28). However, since the weight of the *carrettata* varied over time and place and depended "on the size and strength of the carts used by the transporters" (Marder, 1997, 285 n.19), it is, in the end, a highly approximate unit of measure.

Although thus far no evidence has come to light of Bernini's having used more than one piece of marble in creating his *Constantine*, doubts linger as to whether the report of the shipment of marble weighing more than thirty cartloads actually refers to a single block (Marder, 1997, 285 n.19 and 287 n.40). I have searched in vain for a complete set of the precise measurements of the finished *Constantine*, but given what we do know of its approximate size—Montanari (2004b, cat. 23) gives its height as ca. 3.8 meters, while Wittkower (cat. 73) indicates that its width is somewhat over 3 meters—the original uncut block must have conservatively been ca. 21 cubic meters in volume (conjecturing a distribution of 4 m x 3.5 m x 1.5 m).

Knowing the density of Carrara marble (2,710 kg or 5,962 lbs [ca. 3 tons] per cubic meter), we can translate this volume into a weight of ca. 63 tons, which is considerably greater than the weight Domenico and the shipping agents reported—if their *carrettata* indeed represented only slightly over one ton in weight, as Montagu reports. (My thanks to geophysicist Dr. Denis Reidy for his assistance with the preceding calculations.)

20. "In this sign you shall conquer." The cross and motto are included in Bernini's decorative scheme for the larger setting of the *Constantine* statue: see Marder, 1997, pl. 12. Bernini's statue is often called the *Conversion of Constantine*. As Domenico here states and as Bernini himself described in a December 30, 1669, letter to Colbert, the emperor is "represented in the act of admiring the Vision of the Cross appearing to him" (cited by Marder, 1997, 166).

21. As Domenico says, the decision to place the *Constantine* statue at the foot of the Scala Regia (and not in Saint Peter's proper, as initially planned) was made during Alexander's pontificate. Precisely when that change in site was decided is not known: it most likely occurred between April 1662 and July 1664 (Marder, 1997, 174). Alexander, however, did not live to see the statue's unveiling, nor did his immediate successor, Clement IX; *Constantine* was only unveiled during the pontificate of Clement X in 1670. In the end, all payments to Bernini for the commission amounted to the princely sum of 7,000 *scudi:* "This large sum indicates that the execution must have been essentially his" (Wittkower, cat. 73).

22. For rapid mention of all of these "secondary" Chigi works in Baldinucci, see i.110, e.44. However, in more correct chronological fashion, he earlier (i.108, e.42) had already cited Bernini's restoration of the Chigi Chapel in Santa Maria del Popolo, once Fabio Chigi became cardinal (February 19, 1652).

23. Was Bernini thinking of Alexander when in Paris he complained to Chantelou (June 7, f.50, e.21) that "very often when a prince finds a servant whom he likes and who has his

confidence, he entrusts him with every kind of responsibility and thinks nothing properly done unless he does it"? Alexander's diary (see Morello, 1981, passim) lists numerous other smaller decorative and architectural tasks given to Bernini (who in turn would have assigned them to his workshop assistants for execution upon his instructions and at least partial designs).

24. Plans for the restoration and further embellishment of the chapel began shortly after Fabio Chigi's 1652 elevation to the cardinalate by Innocent X. These included the installation of a new marble inlaid floor and oval bas-relief portraits of Chigi ancestors Agostino and Sigismondo on preexisting pyramid monuments. Both the floor and the portraits were of Bernini's design. See Wittkower, cat. 58; Borsi, cat. 39; Angelini, 1998, 135–40; *Regista,* cat. 73; and Fabjan in *Regista/Restauri,* 47–56.

25. On June 26, 1657, Bernini was paid 1,000 *scudi* for the already installed *Daniel* (Wittkower, cat. 58), which, according to Angelini (1998, 140), had been finished by August 1656. Marble for *Habakkuk and the Angel* was delivered in October 1656; the statue was installed in the chapel in November 1661. For the two works, see also *Regista,* cats. 74–78; and Fabjan.

26. The large-scale renovation, aesthetic updating, and embellishment of the rest of the church (including its facade) were all of Bernini's design and under his supervision, but much freedom was given to his collaborators, who were largely masters in their own right, such as Antonio Raggi, Ercole Ferrata, and Giovanni Antonio Mari. See Angelini, 1998, 144–52; *Regista,* cats. 79–81; Marder, 1998a, 283–87; and esp. Ackermann, 1996.

27. The subject of Domenico's sentence is Pope Alexander, but we are of course meant to understand that the new design of the city gate also came from Bernini, as already mentioned in the commentary to Domenico's discussion (p. 103) of Queen Christina's December 1655 entry into Rome. For Bernini's redesign of the gate, see D'Onofrio, 1976, 51–57 (esp. for its inscription); Borsi, cat. 42; Habel, 75–80; and Antinori, 2008. The Porta del Popolo was later modified in the years 1877–79; for the gate as Bernini originally designed it, see Antinori, 2008, figs. 4 and 15 for, respectively, a pre-1877 photograph and a contemporary drawing (ca. 1658) by architect Felice Della Greca. The Church of Santa Maria del Popolo stands literally next to this city gate at which the ancient Roman road, the Via Flaminia, reaches what is now the beginning of the historic center of Rome and becomes the Via del Corso, leading straight to the Piazza Venezia.

28. In a grammatically somewhat illogical sentence, Domenico grossly exaggerates Bernini's role in this "most noble perspective." To begin with, the artist had nothing to do with creating the "vistas" or "the division" of "the three grand streets," which had been the product of papal urban renewal in the early sixteenth century. Further, in addition to the city gate there, Bernini's contribution to the remodeling of the Piazza del Popolo—an important component of Alexander VII's grand vision for the embellishment of Rome—is limited to the architectural enhancement of the two "wedges" of land facing the square, within the "trident" of converging streets in question (Via del Babuino, Via del Corso, and Via di Ripetta).

In February 1657, Bernini was given the initial task of identifying the abutting property owners as one of the first steps in the process (Habel, 2002, 78). Ultimately it was decided to construct on the wedges two identical (or nearly identical) churches. The history of the design and construction of these two churches (Santa Maria dei Miracoli and Santa Maria in Montesanto) is long and complicated: the two-church commission was first given to Carlo Rainaldi, not Bernini, although what was ultimately built incorporates important design revisions from Bernini (especially on the exterior of Santa Maria in Montesanto), as well as from Carlo Fontana, who later took over the commission from Rainaldi (for Rainaldi's detailed 1661 presentation drawing of the piazza and churches, see, most recently, Angelini-Butzek-Sani, cat. 199).

The most complete study of the twin-church project remains Hager, 1967–68; among the subsequent and more synthetic studies and discussions, see Krautheimer, 114–25; Marder, 1998a, 150–53 (assigning much influence to Bernini on the ultimate design of the churches); Borsi, cat. 74; Varriano, 142–43; Habel, 2002, 78–95; Wiedmann, 197–202; Curzietti, 2006; Fagiolo-Portoghesi, 248–53; and Antinori, 2008.

29. In the small hill town housing the papal summer villa, Alexander had Bernini design and build the entirely new church of San Tommaso da Villanova. The project began in April 1658; consecration of the finished edifice took place in May 1661. Strangely enough, Domenico

identifies the project using the name of the older church on the site dedicated to local patron saint, Nicholas (Nicola), which had been completely razed to erect Alexander's church. Even though at the project's initiation, the planned new church was indeed still called San Nicola (as we find on the 1658 foundation medal [Marder, 1998a, 217–18]), this was soon changed pursuant to the November 1658 canonization of the Spanish saint Thomas of Villanova (see Fagiolo dell'Arco, 1997, 394–99, for Bernini's contribution to the canonization ephemera). As Fagiolo/ IAP, 219, points out, the name change was political in nature, i.e., to gratify the Spanish.

Is Domenico, decades later, here making his own political statement in ignoring the Spanish name? Or is he simply confusing the Castelgandolfo church with another Chigi-sponsored church project in which Bernini (as has been recently discovered) was also involved (1665–66), the small church of San Nicola in Ariccia, the Chigi fiefdom just a short distance away (for the latter church, see L'Ariccia del Bernini, 36–37; for Ariccia, see note 30 below). For the church of San Tommaso da Villanova, see Borsi, cat. 50; Fagiolo dell'Arco, 2001; and Marder, 1998a, 211–23.

As for the remodeling and embellishment of the papal residence itself at Castelgandolfo, Bernini redesigned the facade (some of his preparatory drawings survive) and added a galleria (no longer extant in its original state) to the building, which had been constructed in 1629 by Urban VIII. Alexander's inscription on the facade dates the renovations to 1660. Bernini's work on this Papal Palace has been little studied, but see Fraschetti, 292; M&M Fagiolo, cat. 186; and Marder, 1998a, 212.

30. The hill town of Ariccia, a short distance from Castelgandolfo, was sold by the Savelli family to the Chigi in 1661, and in the following year the family began its massive program of embellishing their new fiefdom, yet another symbol of their renewed social status. The church here in question is Bernini's Pantheon-inspired Santa Maria dell'Assunta (Saint Mary of the Assumption), designed and constructed in the years 1662–65.

As part of the same complex, Bernini also designed the enlarged ducal palace facing the church, executed between 1664 and 1672; it is now a museum. Unfortunately, the aesthetic unity of the complex is destroyed by the Via Appia Nuova, which now runs right through the square, the Piazza di Corte. In the same town, Bernini also contributed to the design of the church of San Nicola (see note 29) and, just outside town, remodeled the Santuario della Madonna di Galloro, 1660–63 (for which see Borsi, cat. 52; and Marder, 1998a, 241–43).

The "Prince Chigi" here cited is Agostino (1634–1705), son of Alexander's brother, Augusto. Agostino, who married heiress Maria Virginia Borghese (niece of Paul V and daughter of Olimpia Aldobrandini Borghese Pamphilj), assumed the title of Duke of Ariccia after the death of his uncle, Don Mario Chigi: see L'Ariccia del Bernini, 18–19. For Bernini's church of the Assunta, see Borsi, cat. 55; and Marder, 1998a, 239–59; for the history of the Chigi fiefdom and the works of art and architecture (by Bernini or otherwise) contained therein, see again L'Ariccia del Bernini, passim.

31. After making the Palazzo del Quirinale his preferred domicile and venue for papal court business—a controversial decision indeed (Marder, 1998a, 212; Habel, 2002, 12)—Alexander needed to increase its size to accommodate his household. He did so by creating the so-called Manica Lunga (Long Sleeve), that drearily monotonous hulk of a dormitory wing (subsequently lengthened even further) along what when then called the Via Pia (now the Via del Quirinale). The task, spanning the years 1656–59, was given to Bernini, who also later produced designs for the piazza in front of the principal entrance that were never carried out.

Earlier, unmentioned by Domenico, Bernini had in the late 1630s redesigned the main portal and facade of the palace (Habel, 2002, 34; Effigies and Ecstasies, cats. 82–83). Barker, 2006, 246, also points out the little-known fact of Bernini's supervision of the construction of the "Gallery of Alexander VII" within the palace. For the Palazzo del Quirinale and Bernini, see Wasserman (with focus on the Quirinale's sixteenth-century transformation into the Papal Palace); Borsi, cat. 43; and Habel, 2002, 11–62, passim.

32. Papal nephew Cardinal Flavio Chigi (1631–1693) was the most prominent member of the papal court during the pontificate of his uncle, Alexander VII. A most engaged patron of the arts in his own right and much given to epicurean and venereal pleasures, Flavio represented his

uncle in important diplomatic tasks, domestic and foreign; most noteworthy was the expiatory mission to Louis XIV's court in 1664 pursuant to the infamous Duke de Créqui affair (for which see Domenico, 116). He also oversaw many of the papal architectural-urban planning projects, including that of his uncle's tomb in Saint Peter's (for which see Domenico, 154). Hence, inter-action between the cardinal and Bernini was continuous and intense: see Angelini, 1998, passim; for the Bernini clay *modelli* in Cardinal Flavio's collection, see Raggio.

In December 1661, Chigi purchased a Colonna property in Rome in the Piazza Santissimi Apostoli for use as his personal residence and Bernini was commissioned to redesign the palace; construction terminated in 1666 (see Domenico, 139, for Flavio's letter to Bernini commenting on Luigi Bernini's overseeing the project during Gian Lorenzo's visit to Paris). For the Palazzo Chigi (now Chigi Odescalchi) in SS. Apostoli, see Borsi, cat. 58; Marder, 1998a, 155–56; and Habel, 2002, 199–216. For an uncensored and unflattering portrait of the private life and less-than-exemplary character of Cardinal Flavio drawn from the reports of the Genovese agent in Rome, see Neri, 663–64.

As for the remodeling of the two public spaces in the Palazzo Apostolico, the Sala Regia and the Sala Ducale, in combining the two rooms into one large papal audience hall, Bernini once again "made a virtue of necessity," as Wittkower, cat. 277, remarks: since the wall between the two halls could not be completely removed, Bernini placed there "the suggestive motif of the large curtain which seems to have just been raised by zealous putti." The actual execution in stucco was carried out by Antonio Raggi between October 1656 and January 1657; see also Borsi, cat. 59; and Marder, 1998a, 124–26.

33. For Bernini's design and construction (1658–63) of the Arsenal (destroyed in World War II) in the papal port city of Civitavecchia, see Busiri Vici; Fagiolo dell'Arco and Di Macco; and Borsi, cat. 51. As mentioned (note 23 above), Alexander's personal diary makes laconic mention of other, otherwise unknown projects assigned to Bernini by the pope: for example, the April 7, 1658, entry states: "Bernini is bringing . . . the display [*mostra*] of the Acqua Vergine fountain [*botte*] in Trinità de' Monti" (Morello, 1981, 324).

Of the works by his father executed during the Chigi pontificate but passed over in silence by Domenico (and Baldinucci), the most glaring omission is the charming monument to Divine Wisdom in the Piazza della Minerva featuring a recently rediscovered Egyptian obelisk car-ried by an elephant, dating to 1666–67. According to D'Onofrio, 1992, 313, this omission is a sign of Bernini's own distancing himself from a not entirely successful project vitiated by the unwanted design interventions of the hostile Dominican architect from Sicily, Giuseppe Paglia (ca. 1616–1683). Paglia supervised the construction of the monument and hence the design itself had in the past been wrongly attributed to him. For Paglia's career, see Forte.

For the Minerva monument, see also Heckscher; Wittkower, cat. 71; *Effigies and Ecstasies*, cat. 107; and Curzietti, 2007, who, on the basis of new documentation, reconfirms Bernini as creator of the design. Marder, 2008, 431–33, identifies the same anti-Bernini Paglia as fomenter of the defamatory rumors of April 1680 about the cracks in Saint Peter's cupola (for which see Domenico, 167–68).

34. Domenico literally says that his father did "molti, e molti Ritratti" of the pope. In his appended catalogue of Bernini's works, Baldinucci, i.177, e.113, lists only three (materials not specified): two in "Casa Chigi" and one in "Casa Bernini." For the many extant portraits (in various media) of Alexander and the complicated question of their provenance and attributions, see Wittkower, cat. 65; *Regista*, cat. 56; *L'Ariccia del Bernini*, cats. 12 and 13; Fagiolo dell'Arco, 2002, 59; Bacchi-Hess-Montagu, cat. 6.6 and Checklist D5-8, 293–94. For Bernini's drawing of Alexander in profile (Leipzig), see Angelini et al., 2000, 175, cat. 101.

35. The first stone of Sant'Andrea al Quirinale (just down the block from rival Borromini's San Carlino) was laid by Cardinal Odescalchi (the future Pope Innocent XI) on November 3, 1658. It was consecrated on November 11, 1670; by 1672, all work was completed except the decoration of the side chapels; this final labor was only concluded in the early eighteenth century (Borsi, 354). It is "the unquestionable jewel of Bernini's church architecture" (Marder, 1998a, 187). It was an extremely expensive church to build (56,030 *scudi* spent from inception to 1672),

but Bernini refused all payment for his labors, apart from an initial sum of 500 *scudi* (Connors, 1982, 21 for Bernini's refusal, 37 for the cost). Its formal patron was Prince Camillo Pamphilj, nephew of Innocent X and son of Olimpia Maidalchini, but from the very start Pope Alexander took personal, active, and continual interest in the church, located across the narrow street from his primary place of residence and business, the Palazzo del Quirinale.

Together with Sforza Pallavicino, Gian Paolo Oliva, celebrity preacher of Rome (including the papal court), head of the Jesuit order as of 1661, and later friend and spiritual adviser to Bernini, played an important role in the project from the start (Marder, 1998a, 196), including that of authoritative defender within his order of a much more ornate style of Jesuit church decoration than hitherto seen in their houses of worship (Haskell, 1972, 56–60; Connors, 1982, 21). Hence the first effective interactions between Bernini and Oliva probably date to the beginning of the Sant'Andrea project in 1658, even though, independent of that project, the two would also have met on various occasions in the papal antechambers both in Rome and Castelgandolfo, as we surmise from Pope Alexander's diary (see Morello, 1981, e.g., 326, 327, 329 under, respectively, March 16, 1659; September 14, 1659; and April 29, 1660). For Bernini and Oliva, see also below Domenico, 122, and commentary. For the Sant'Andrea church project, see Borsi, cat. 49; Connors, 1982; Frommel, 1983–84; Smyth-Pinney; and Marder, 1990 and 1998a, 187–209.

36. This sentiment, reported by Baldinucci, i.141, e.75, is expressed even more emphatically on the last page of Domenico's biography (180), and several times in Chantelou's *Journal* (e.g., July 23, f.86, e.75; September 25, f. 201, e.224; and October 9, f.239, e.274). As Stanić (n.1 to Chantelou, f.202) notes, this state of chronic dissatisfaction was considered by Leon Battista Alberti (*De re aedificatoria,* 9:10) as a moral quality proper to the excellent architect, while Vasari cites it as a trait of great artists like Leonardo and Michelangelo. Domenico's encounter with his father in the church is likely to have occurred while the boy was in residence at Sant'Andrea as a Jesuit novice (1671–73), by which time the interior of the church was largely complete. At the death of his wife in July 1673, Bernini spent a few days in retreat at Sant'Andrea. See the Introduction, section 2, for Domenico's brief career as a Jesuit, and section 5, note 78, for the artist's 1673 retreat. Baldinucci says nothing about Bernini's predilection for Sant'Andrea.

37. "Oh quanto mi vergogno di haver operato così male": for a summary discussion of the various scholarly interpretations of this surprising remark, see Fehrenbach, 2008, 196–201. Among the scholarly interpretations is that of Marder, 2000b, 145, who suggests that perhaps Bernini was in reality expressing remorse not for the quality of his workmanship on the fountain, but for the devious manner in which he had taken the commission away from his rival. In this case, one would have to translate the verb *operare* as "behave." This would represent an extremely rare expression of compunction on the part of the fundamentally narcissistic Bernini.

CHAPTER XV

1. Baldinucci, i.109–10, e.43–44, discusses the Cathedra immediately after his description of the colonnade and the Scala Regia but before the paragraph devoted to Christina of Sweden. Baldinucci also recalls Annibale's prophecy and cites the Cathedra as an example of Bernini's "unsurpassable patience," inasmuch as the artist, after creating and installing (in 1660) the full-scale *modelli* for the four colossal statues of the Church Fathers, was obliged to redo his work after discovering that the statues were too small for the site.

Domenico, 154, briefly returns to the Cathedra, mentioning its completion and unveiling after the artist's return from Paris. Alexander gave the formal commission to Bernini in January 1657; the solemn inauguration of the Cathedra took place in January 1666, though some finishing touches remained to be done. For the Cathedra, see, most recently, Ackermann, 2007, 179–206, and Schütze, 2008; as well as Battaglia, 1943, still indispensable for the original sources and detailed, documented chronology; for more succinct accounts, see Wittkower, cat. 61; Borsi, cat. 47; Lavin, 1981, 174–93, esp. regarding related extant drawings (entry by S. Ostrow); Tratz,

1988, 427–43; Sutherland Harris, 2001; and Lavin, 2005a, 155–59; see Moffitt for a historical footnote to the project.

2. Although it is true that Bernini worked with remarkable rapidity and simultaneously on multiple projects during the Chigi pontificate, Domenico exaggerates in claiming completion of all the previously mentioned works in just six years.

3. That is to say, there was not much to admire in the original chair in terms of its aesthetic qualities. Domenico says nothing about the grave doubts about the authenticity of the chair as the throne of Saint Peter raised by new scholarship at the time. For the history of the wood-and-ivory chair, now clearly established as of Carolingian manufacture, see *Petros eni,* cat. VI.5; and Schütze, 2008, 405–7 and fig. 3.

In conformity with the express desire of the pope, the Fabbrica of Saint Peter's decreed the relocation of the chair from the Baptismal Chapel (first chapel on the left upon entering the basilica, as Domenico correctly states) to the apse in March 1656 (Borsi, cat. 47). Domenico also does not mention the fact that during the pontificate of Urban VIII, Bernini had redesigned both the relic's wooden encasement and a good portion of the Baptismal Chapel, in which the chair was displayed for pious devotion twice a year. For the extant encasement executed in 1636 by Giovanni Battista Soria, see *Bernini in Vaticano,* cat. 264; Roser, 269–73 and fig. 10; and Schütze, 2008, 409–12 and fig. 9.

Though nothing remains of his interventions in the remodeled chapel, Bernini's first design (1630–37, with execution mostly by Luigi Bernini) is known in detail, thanks to a sketch by Domenico Castelli; it clearly anticipates several of the salient features of his later Cathedra Petri as created in the apse of the basilica: see Rice, 1997, cat. 3b; Roser, 269–71 and fig. 9; Schütze, 2008, 409–10 and fig. 7. There is extant (Morgan Library, New York) a large drawing, dated 1626–29, of the full-scale wooden model of the Baldacchino in place above the main altar, behind which one clearly sees the outline of Bernini's early design for the Cathedra, with the chair held aloft by the Church Fathers against a sunburst "gloria" of Paradise. If the evidence of this drawing is to be trusted, one can only conclude that already during the reign of Urban VIII, Bernini (and the pope) had begun to think about placing the chair-relic in the apse and to conceive of its setting essentially as it was later to come to fruition under Alexander VII: see *Petros eni,* cat. II.25 (by J. Connors). The drawing in question is attributed to Agostino Ciampelli, Bernini's brother-in-law, who collaborated on the Baldacchino project.

4. "come che è più difficile l'essere sopraggiunto da somiglianti pensieri, che il metterli in esecuzione."

5. Domenico again exaggerates: extant documentation makes it clear that Bernini was paid a *provisione* of 200 (not 250) *scudi* per month for forty months, for a total of 8,000 *scudi* for all of his work on the Cathedra. Even though the project took longer than forty months to complete, Bernini was not paid anything beyond that preestablished time limit: see Battaglia, 231, doc. 506, and 159 for discussion of his remuneration for the Cathedra project.

6. More misinformation from our author: between the Fabbrica's acceptance of Bernini's first design for the Cathedra (March 1657) and the public inauguration of the not fully completed structure (January 1666), nine years had elapsed.

7. In praising the pope's accomplishments, Domenico may here also be consciously defending Alexander ("il papa di grande edificazione," as he was sarcastically nicknamed) against the criticisms of financial recklessness leveled against him. "Of matters financial and economic Alexander appears to have been both innocent and heedless. The situation in the Papal States and in Rome in particular inherited by him and increasingly deteriorating under him could hardly have been worse. . . . Unemployment, always high, had become chronic. By 1661 the state debt . . . had reached 39 million *scudi.* At the time of his death it was estimated to have reached the 50 million mark (Krautheimer, 13; see also *EncPapi* 3:343). As Neri, 684, reports on the basis of diplomatic correspondence, the Roman populace shed few tears at the passing of *Papa* Chigi: "Alexander VII's death was not mourned, rather, judging from contemporary documentation, it was desired by the Roman people."

8. Pietro Filippo's *Vita Brevis*, in turn, has Alexander remarking of Bernini: "If one were to remove from Saint Peter's everything that had come from the Cavalier Bernini, that temple would positively be stripped bare." D'Onofrio, 1966, 205, cites Domenico's reference to his still-unpublished *Life of Gian Lorenzo Bernini* within his already published *Historie di tutte l'heresie*, 4:261: discussing expenditures relating to Saint Peter's recounted by Bernini, Domenico refers the reader to chapter 15 of his biography of his father (then still in manuscript), about the cost of the basilica's embellishment (this financial detail is mentioned in response to Lutheran charges that alms collected for the basilica were in fact directed elsewhere). Carlo Fontana's 1694 *Tempio Vaticano*, 4:2:432, estimates the cost of rebuilding and decorating the basilica, from the time of Julius II onward, at 46,800,490 *scudi*.

9. Domenico's use of the term *allievi*, students, is rather loose, since some of the men listed began their work with Bernini already as adults and were well trained and experienced in their profession. In the case of Mochi, the term "student" does not apply by any stretch of the imagination, since he had already reached the status of acknowledged master in his own right before his involvement with Bernini. In his corresponding list, Baldinucci, i.152–55, e. 86–89, instead uses the term *discepoli*, but the situation remains the same: in order to aggrandize the scope of Bernini's direct influence on his contemporaries, both biographers include in the fold of "students" and "disciples" several independent figures who had merely and temporarily collaborated with Bernini on some projects.

It is beyond the scope of this commentary to furnish even summary accounts of the careers of all of these men, who in any case can be found in the standard art history reference works such as *Grove Art Online;* see also the biographical appendix to *Regista*, 463–77, in addition, of course, to references embedded within studies devoted to the various Bernini works to which they contributed. For Bernini's collaborators and his relationships with them, see also Montagu, 1985 and 1989; Sutherland Harris, 1987; and Tratz, 1988, 397–421. For the sculptors mentioned here, see the succinct but thorough entries with bibliography in Bacchi, 1996; for a photographic guide to their extant works in Rome, see also the copiously illustrated Ferrari and Papaldo, *ad indicem*. For Bernini's architectural assistants, see Quinterio.

Note that Baldinucci, i.152–54, e. 86–87, begins his discussion of Bernini's *discepoli* with a long paragraph on the artist's brother, Luigi, whom Domenico instead discusses later (chap. 20, 153–54) in an entirely separate context. To Domenico's list of students, Baldinucci, i.155, e.89, appends two further names, Francesco Baratta and Antonio Raggi, as examples of those who, while not having done their training with Bernini, achieved greater perfection in their art thanks to their collaboration with him.

10. Although omitted by Domenico, among Bernini's disciples is a succession of painters who, working under the master's close guidance and at times according to his designs, produced canvases and frescoes that were integral components of Bernini's larger multimedia works such as churches and chapels: Carlo Pellegrini (1605–1649); Guido Ubaldo Abbatini (1600–1656); Frenchman Guillaume Courtois (Guglielmo Cortese, "Il Borgognone," 1628–1679); Ludovico Gimignani (1643–1697); and Giovanni Battista Gaulli, "Il Baciccio" (1639–1709). For these men as *pittori berniniani*, see Petrucci, 2006, 146–57 (Pellegrini); 261–63 (Abbatini); 263, 268–72 (Courtois); 272, 276–80 (Gimignani); and 280–93 (Gaulli).

Baldinucci, i.152, e.86, states that Bernini had "many disciples in the art of *painting,* sculpture and architecture" (emphasis added), but he mentions no painters by name in subsequent discussion. See, again, Montanari, 2007, 37–38, for recently discovered documentation regarding the already mentioned "Accademia del Disegno" conducted by Bernini from 1630 to at least 1642 in the Palazzo della Cancelleria under the sponsorship of Cardinal Francesco Barberini.

11. For Borromini, see Domenico, 32, and commentary; for de' Rossi and Contini, see separate notes below. Of the three architects, it is Fontana (1638–1714) who proved most eminent in his field, and indeed is counted among leading architects of late seventeenth- and early eighteenth-century Rome. Although Bernini's influence on him was not insignificant during the ten years of their association, by the time Fontana began his collaboration with the master in

1664, he, a mature adult, had already completed his architectural training under Giovanni Maria Bolino and Pietro da Cortona, and had thus developed his own distinct style.

Like others before him, Fontana too left the Bernini workshop in disgust over the subservient professional life he was forced to lead under Bernini's command. Nonetheless, in his well-informed and thorough history of the construction of the new Saint Peter's Basilica, *Tempio Vaticano* (1694), Fontana exonerates Bernini of any blame for the failure of the bell towers and confirms Domenico's description of the extreme challenges that Bernini successfully overcame in the Scala Regia project. Fontana later inherited the position of "Architect of Saint Peter's" upon the death of Mattia de' Rossi, who, in turn, had inherited it from his master, Bernini. Fontana still awaits a modern, comprehensive monographic study; for a summary of his career, see *Grove Art Online*, s.v. "Fontana (v): (1) Carlo Fontana"; for the tensions between Fontana and Bernini, see Jarrard, 2002, 410.

12. Called "Francesco Caneoy Fiammengo" by Domenico, the Flemish Duquesnoy (1597–1643), together with Bernini and the Bolognese Alessandro Algardi (1598–1654), formed the triumvirate of leading sculptors in Rome during the first half of the seventeenth century. He trained under his father in Brussels, but moved to Rome in 1618, working independently, it would seem, for several years before beginning his involvement with Bernini in 1625. Hence he brought to the Bernini workshop considerable training, skills and professional experience, and was not simply Bernini's "student."

In 1625, Bernini hired Duquesnoy to contribute three ephemeral statues for the canonization apparatus for Saint Elizabeth of Portugal (Lorizzo, 355–56). Duquesnoy was later one of Bernini's assistants on the Baldacchino, making clay models for the project. His colossal statue of Saint Andrew in Saint Peter's was created as part of the decoration of the basilica's four piers, a project Bernini directed (for which see Domenico, 43–46, and commentary). Baldinucci, i.154, e.88, claims that the Flemish artist took from Bernini "that marvelous quality of tenderness [*tenerezza*]" found in his work. For Duquesnoy, see Boudon-Machuel; and Lingo; for Passeri's claims of Bernini's ill treatment of Duquesnoy, see Sutherland Harris, 1987, 44–45.

13. The extremely talented Finelli (ca. 1602–1653), responsible for some of the virtuoso carving on Bernini's *Apollo and Daphne* group, had previously been assistant to Pietro Bernini, according to Passeri and Fioravante Martinelli. He ended up leaving the Bernini workshop in anger: see Montagu, 1989, 104–7. For further bibliography on Finelli, see the commentary to Domenico, 18, above (discussion of the Borghese statues of the 1620s).

14. Baldinucci, i.155, e.88, omits Cartari's last name and of him simply says: "The already mentioned Giulio Cesare, who accompanied [Bernini] to Paris, served and assisted him until the end of his life" (see i.117, e.59, for that earlier mention). Cartari (ca. 1641–1699) is here and in every instance in Domenico's biography called "Cartarè," which might lead one to suspect that it was the Italianized form of a French surname; however, in his recently discovered last will and testament, he identifies himself as "the son of the late Pietro, a Roman" (Fagiolo dell'Arco, 2002, 220).

For his life, in addition to the Bacchi and Ferrari-Papaldo volumes, see Alfredo Marchionne Gunter's appendix in Fagiolo dell'Arco, 2002, 218–27, publishing various documents from the end of his life (death notice, extracts from his will, inventory of possessions) and establishing his exact date of death. The faithful, long-serving Cartari, who had the privilege of accompanying Bernini to Paris and assisting him in the sculpting of the Louis XIV marble bust, joined Bernini's workshop ca. 1660, quickly gaining the complete respect and confidence of his master. Until recently, he was believed to have worked simply and completely within Bernini's shadow.

Weil's characterization is typical of past scholarly judgment about Cartari as a mere almost-anonymous extension of Bernini's carving hand: "Cartari never became more than a skilled craftsman . . . and is not known to have produced a single work that was not designed and executed under Bernini's supervision" (Weil, 1974b, 81). But see now Curzietti, 2008, who publishes new documentation regarding his independent authorship of two fine memorial busts in the Poli Chapel, San Crisogono, Rome (1679–81) and reminds us of other recent discoveries (especially dating to his post-Bernini years).

Curzietti thus presents a new, more positive assessment of Cartari's career, his original, distinctive talent, and autonomous identity as an artist. (Curzietti in the same work [p. 44] attributes for the first time to Cartari the excellent terra-cotta portrait bust of Bernini in the Hermitage, Saint Petersburg, believed to have been part of a never-realized project for Bernini's own funeral monument). In Paris, Cartari, in his spare time and on his own, had designed and carved a head of Saint John the Baptist, which the king considered so beautiful that he could not believe it had been done by the young sculptor (Chantelou, September 30, f.215, e.242).

15. Domenico's discussion of Sale is a near verbatim reproduction of that of Baldinucci (i.155, e.88–89), both biographers dedicating to the pathos-marked life of the sculptor an amount of space disproportionate to his professional importance. Active in Rome from 1630 to 1650 and all but undocumented outside the few Bernini sources mentioning him, Sale produced relatively minor work of mostly a decorative nature for various Bernini projects such as the Cappella Raimondi. In 1641, Sale, together with Giacomo Balsimello, accompanied Bernini's bust of Cardinal Richelieu to Paris. The entry on Sale in Bacchi, 1996, represents the fullest treatment of his brief career.

16. For the Bernini-designed Cappella Raimondi (1640–47) and Sale's contribution to it, see Lavin, 1980, 22–49, 188–92; Wittkower, cat. 46; Borsi, cat. 21; and Marder, 1998a, 106–10.

17. About Mochi (1580–1654), Baldinucci (i.154, e.87–88) remarks in similar diplomatic understatement: "It is said, however, that he later preserved little memory of the benefit received from the Master." For Mochi, see Domenico, 46, and commentary. For Borromini, see Domenico, 32, and commentary.

18. Baldinucci, i.154, e.87, is more effusive in his praise for Mattia (1637–95), who, let us note, was still alive at the time of his writing: he is "Bernini's most beloved disciple," who "over the space of twenty five years worked right alongside his master and continually served him until his death with filial love." Furthermore, "his attractive personality, vivacious spirit, knowledge, and other excellent traits are of such a quality in themselves and are so well known in Rome that the mere mention of his name suffices to draw forth every greatest praise."

Mattia began his long association with Bernini in 1659 with the San Tommaso da Villanova project at Castelgandolfo (Menichella, 62). Accompanying Bernini to Paris—Mattia's extant letters to Rome during that trip are precious documentation of that chapter of Bernini's life—he worked closely with his master on the design of the new Louvre. He was at Bernini's bedside during his last days (Domenico, 175). However, his relationship with Bernini was not without its turbulence, some of it provoked, as usual, by Bernini's insistence on taking the credit for all work issuing from his workshop: see Jarrard, 2002, 410–12.

At Bernini's death, Mattia inherited his master's prestigious office as Architect of Saint Peter's. Yet for all of his talent, contemporary status, and independent works, he remains known today simply as Bernini's right-hand man in matters of architecture (but see Marder, 1998a, 24–25 for a more positive assessment). For Mattia's life and career, see, above all, Menichella's 1985 monograph; for his letters from Paris to Rome in 1665 in French translation, see appendix 4 to the 2001 French edition of Chantelou, 383–97; for excerpts in Italian, see Mirot, passim.

19. Domenico's text says "si rese molto affezzionato il Cavaliere," but there clearly should be the articulated preposition al (and not the definite article il) before "Cavaliere." For the same claim by Michelangelo about his irresistible attraction to men of talent, see the Introduction, section 7.

20. Domenico's hyperbolic statement about the great bond of love between Bernini and Contini is in contrast to Baldinucci's text, in which Contini is simply another name in the list of disciples (i.155, e.88). It is relevant to note that Contini (1642–1723) was still alive at the time of Domenico's final editing of his text (1711). According to Baldinucci (i.154, e.87), it was Mattia who was Bernini's most beloved (più diletto) disciple. Contini was trained by his father, Francesco, but his formation in the Bernini studio was decisive for the development of his style. One of his earliest projects with Bernini was the catafalque for Alexander VII (1667). He went on to do several others for deceased popes and other distinguished Roman personages (such as Cardinal Antonio Barberini, d. August 1671): see Fagiolo dell'Arco, 1997, ad indicem.

CHAPTER XVI

1. This period of Bernini's life—his four-month employment at the court of Louis XIV and its aftermath—represents the largest "episode" of Domenico's narration, occupying four and a half chapters. The summons to Paris was considered, in the eyes of contemporaries, the highest recognition accorded the artist during his lifetime and thus the greatest proof of his "sublime" status, inasmuch as Louis (1638–1715) was in 1665 (the year of the Paris trip) well on his way to becoming the most powerful monarch in Europe, as all on the continent understood. (The long-lived Louis was still reigning at the time of the publication of Domenico's biography in 1713.) The Paris trip also represents an extremely large segment of Baldinucci's narrative (i.111–25, e.45–59), placed immediately after another "episode" involving royal recognition of Bernini, that of Queen Christina.

Yet, ironically, Bernini's trip was a failure on at least two major fronts: first, his design for the new wing of the Louvre—the primary purpose of the journey to Paris—was ultimately discarded, despite much feedback and repeated revision; and, second, thanks to Bernini's unremittingly rude, narcissistic behavior toward the French and his openly expressed disdain for their art and architecture, our artist by and large alienated his Parisian hosts, handicapping any diplomatic aspirations that the court of Rome may have nurtured for his trip in this regard. Furthermore, in the aftermath of the journey, after a long and troubled gestation, Bernini's colossal equestrian statue of Louis XIV, upon reaching its destination, was met with complete royal rejection—indeed, the king's first impulse was to want it destroyed (see commentary to Domenico, 153). See note 2 for primary sources and bibliography relating to Bernini's journey to Paris.

2. Domenico here repeats what he said on pp. 2 and 64 about the international competition over Bernini. In this case, however, the "joust" (giostra) was simply between the desiring Louis XIV and the resisting Pope Alexander, since no other "major potentate" of Europe had summoned Bernini to his court in this period. Although questions remain, this episode of Bernini's life is rather well documented by extant, published, primary sources of all types. At the same time, however, let us not deceive ourselves, despite these rich and at times personally intimate resources, we may never fully know the true sentiments of most of the players involved in this affair, since all of them, from king to valet, in Paris as in Rome, hid between a well-guarded public mask of courtly dissimulation in their fierce struggle for power and sheer survival—even physical—in the small, well-circumscribed hothouse environment of the court.

Among the primary sources, pride of place goes to the detailed *Journal* kept by Paul Fréart de Chantelou (1609–1694), appointed by the king to assist Bernini in the interactions and necessities of the artist's daily life in Paris (see my Introduction, note 79; Domenico never mentions Chantelou by name, but alludes to him on p. 145). The *Journal* is now available in four annotated editions and translations: French, English, Italian, and German. The most authoritative version is Milovan Stanić's 2001 French edition, enriched by many other newly published primary sources.

Though lengthy and written with a tone of seeming objectivity, Chantelou's *Journal* is not of course a complete account of all the artist's doings and utterances in Paris (since Chantelou was not with Bernini at all times of every day), nor does its author always rise above his own subjective views. In addition to the numerous individual scholarly studies (cited below) relating to Bernini's specific works in or for France (such as the Louis XIV portrait bust) or to some aspect of his interaction with the French court, the most important studies of a more general nature are those of Gould; Schiavo, 1957; and above all Mirot, who reproduces many of the primary sources, some extracted from the monumental editions of the official papers of Minister Colbert and of Louis's administration, published by Clément and Depping.

3. The civil uprisings mentioned in the previous sentence are the two insurrections of the so-called *Fronde* (that of the parliament and that of the nobility), waged against Mazarin and the crown from 1648 to 1653. Domenico would like us to believe that it was Louis XIV's idea to renew the attempt at getting Bernini to Paris in the 1660s. In fact, the prime mover, as early as 1662, was Cardinal Antonio Barberini, then living in Paris. (Cardinal Antonio had taken refuge in Paris subsequent to his 1645 escape from the anti-Barberini climate of Rome, but he was able

to return to Rome with the full blessings of Innocent X in July 1653. He returned to Paris in 1662 as extraordinary papal nuncio to present Pope Alexander's gift for the newly born son of Louis XIV [Wolfe, 2008, 124]. He was in Paris for the entire time of Bernini's own visit there in 1665. For more of Antonio's biography, see Domenico, 19, and commentary.)

For Antonio's role in the negotiation to get Bernini to Paris, see Chantelou, October 12, f.255, e.295; and Pope Alexander's diary, April 28, 1663: "è da noi il Pollini, che il Cav. Bernino non vuol ire in Francia *chiamato dal C*[ardinal] *Antonio*" (Morello, 1981, 335, emphasis added). See also Mirot, 168–70, who reproduces an exchange of letters between Bernini and Antonio: exasperated by Bernini's evasiveness regarding his willingness to travel to Paris, the cardinal begins his letter, "I don't know what game it is that we are playing; Your Excellency [Bernini] holds his cards up so high, that one can learn nothing; hence, impelled by impatience, I am revealing my own cards." Antonio's letter is dated October 27, 1662; Bernini's reply, November 19, 1662 (for Bernini's personal copy of his reply, see BNP, Ms. italien 2083, p. 315). For Cardinal Antonio's "Art Diplomacy for the French Crown at the Papal Court," see Wolfe, 2008.

4. Just as Domenico reports, the origins of what became a major diplomatic-military "showdown" between France and the papacy was indeed an armed street brawl between the pope's Corsican guards and those of French ambassador Créqui (Créquy) on August 20, 1662, which ended with the papal guards firing upon the ambassador's residence, attacking his wife's coach, and killing one of their pages. Deliberately exploited by France, then flexing its muscles in order to assert its hegemony over the other European powers, this "Corsican Guard Incident" gave Louis an excuse to seize the papal city of Avignon and march his armies toward the Papal States, on the (entirely false) charges that Alexander had provoked the August 20 incident and was refusing reparation for this supposedly egregious diplomatic insult.

The incident has been described in detail many times: see, e.g., Gérin, 1894, 1:283–346; Pastor, 30:94–113; Schiavo, 1957, 23–31; and Karsten, 2006; for a contemporary French account of the events, see the 1707 *Histoire des démeslez de la cour de France avec la cour de Rome au sujet de l'àffaire des Corses* by Abbé Régnier-Desmarais (pseudonym of François Séraphin, private secretary to Créqui). Ambassador Charles de Blanchefort, duc de Créqui (1623–1687), had only arrived in Rome earlier that same year (1662), reestablishing diplomatic relations with the papacy after several years of rupture (he later resumed his ambassadorship to Rome on May 31, 1664).

Baldinucci makes no mention of this diplomatic crisis in describing the events leading to Bernini's departure for Paris. He does mention briefly (i.115, e.49) that Créqui, about to leave Rome at the end of his tenure as ambassador, presented Louis's letters of petition for Bernini's services to the pope and the artist himself, as Domenico also mentions later in this chapter.

5. Domenico entirely whitewashes Louis's behavior in this manipulation of events for nationalistic self-aggrandizement, making the French king appear simply the misled, ill-informed victim of a malevolent Duke of Créqui, instead of the shrewd, conscious strategist that he was: "Documentary evidence in the Paris Archives shows that neither the King nor his advised believed for one moment the truth of their allegations against Alexander VII and his Government" (Pastor, 31:108). Earlier, in 1661–62, rattling its sword, the French monarchy had exploited another bloody skirmish in London provoked by disagreement over the right of precedence involving the carriages of the Spanish and French ambassadors in parade. France won that showdown as well, issuing a commemorative medal to vaunt that ceremonial but politically charged international victory (for the London affair, see Roosen, 463).

6. The peace treaty was signed in Pisa on February 12, 1664, mediated by Grand Duke Ferdinand of Tuscany (for the text, see *Traité de Pise entre nostre très-saint Père le Pape Alexandre VII et très-haut, très-excellent et très-puissant Prince Louis XIV,* Paris, 1664; for commentary, see, e.g., Gérin, 1880; Pastor, 31:106–7; and D'Onofrio, 1992, 319–20). The impotent Pope Alexander was forced by Louis to accept a series of stringent and, above all, humiliating terms. The latter included construction in the heart of Rome of what the Italians called the "pyramid of shame" commemorating the affair: for its origins, design, and contemporary engravings, see Erben (its design and execution were the responsibility of papal architects, but Erben, 436–37, excludes Bernini's involvement in

the project, although Mattia de' Rossi may have had some role). A triumphal commemorative medal publicizing the pyramid, by Jean Mauger, was issued in 1664 by the French court. The pyramid was demolished in June 1668, four years after its erection, pursuant to Clement IX's concessions to Louis regarding the right of nomination of certain bishops and abbots (Pastor, 31:417–18).

I have thus far found no confirmation of the claim of a secret papal concession at Pisa allowing the "loan" of Bernini to the French court. The pope's official—and patently reluctant—permission did not come until over a year later, April 23, 1665 (see below, Domenico, 123 and note 25). Furthermore, the entirely tentative tenor of the extant correspondence between Paris and Rome in the months preceding Bernini's departure—some of which is reprinted by Domenico in this chapter—would seem to indicate that there was genuine doubt as to the outcome of negotiations with the artist and the papal court. Had the pope agreed in February 1664 in such dramatically decisive political circumstances to lend out "his" Bernini, the artist would have had little or no choice in the matter. Instead, the doubt was great enough for the French court to put pressure on eminent personages in Rome like Sforza Pallavicino and Gian Paolo Oliva to persuade Bernini to accept Louis's offer (see notes 20 and 22 below).

Likewise arguing against Domenico's claim is the competition among Roman architects for new Louvre designs initiated by the French court in April 1664, Bernini being only one of four architects asked to submit plans (see Perrault, 55–57, for the king's unsent letter to Poussin in Rome, claiming that the competition was completely open in nature). However, as Morris, 135, rightly points out, the existence among Bernini's personal papers in the BNP of a translated copy of the August 30, 1662, letter from Louis XIV to Alexander VII regarding the king's reaction to the Créqui affair would suggest that "the diplomatic incident involved Bernini in some way," for otherwise "it is difficult to imagine why the artist would have a copy of this letter."

7. As personal representative of the pope, Cardinal Chigi arrived in Paris in July 1664 to extend formal apologies to Louis XIV, as obliged by the Treaty of Pisa (see Pastor, 31:111–13). For an account of the Chigi mission by members of the papal convoy, see Schiavo, 1957, 25–26; from the French side, there is also an official *mémoire* drawn up by the same Chantelou who was to be Bernini's Parisian guide in the following year. For the *mémoire*, see Stanić, 1997, 110–12; see also Campbell, cats. 44 and 45, for the commemorative tapestry (part of the *History of King Louis XIV* series), based on a design by Charles Le Brun, depicting Chigi's audience with the French king. Of Domenico's claim about "oral confirmation" from Chigi of the loan of Bernini to the French court, I have thus far found no mention in the documentation accessible to me; the 1957 study by Schiavo of the Vatican documents pertaining to Bernini's journey to France makes no mention of the fact in its discussion of the Chigi legation to Paris.

8. Domenico's representation of the scope of the project is not entirely accurate. Construction of the "new Louvre" (the present Cour Carrée, "Square Court") had already been initiated and slowly advanced by Louis XIV's predecessors. What remained to be done—and what Bernini was asked to design—was the important fourth and final wing of that four-sided building, whose facade (facing east) was to be the principal entrance to the royal palace, even though the earlier portions might be subject to transformation in the process (see Chantelou, f.33, fig. 8, "Schematic Plan of the Louvre and Environs at the Time of Bernini's Visit").

Among the many studies of Bernini's Louvre project, see Mirot, passim; Gould, passim; del Pesco, 1984; and Marder, 1998a, 261–78; for a recently discovered additional design by Bernini for the Louvre, see Hall; for an almost day-by-day account of the design process, see the Chantelou *Journal* and the commentaries supplied with the various modern editions of that text. Mazarin's protégé, Jean-Baptiste Colbert (1619–1683) was the most influential of Louis XIV's ministers; upon becoming Superintendent of Buildings in January 1664 (and in 1665 Minister of Finance) he made the completion of the Louvre one of his priorities, and hence supported the summoning of Bernini to Paris. He, however, was to be one of Bernini's principal *bêtes noires* in Paris and afterward: see Domenico, 138 ("some jealous Minister"), and commentary.

Note that Domenico errs in referring to Colbert as the "Marquis de Colbert." Colbert is his family name; he never assumed an aristocratic title.

9. The letter is in Baldinucci, i.111–12, e.45–46; for the French, see Clément, 5:245. The original, dated March 9, 1664, is extant: BNP, Ms. italien 2083, pp. 339–40. The letter was delivered to Bernini on April 20, 1664, by Colbert's Roman agent, Elpidio Benedetti (Mirot, 171). Domenico, however, does not mention that similar invitations were delivered in the same period to three other Roman architects (Carlo Rainaldi, Pietro da Cortona, and an otherwise unknown Candiani) soliciting proposals for the new Louvre. Although Bernini was of course the most favored candidate, the architects were in competition with one another, a fact of which Bernini was not aware until October 1664 and of which he then complained (Mirot, 170–76 and 183 n.4; Gould, 10–12 and 15; and Perrault, 54–58, who tells us that at first Colbert thought of using as intermediary the painter Nicolas Poussin, "Ordinary Painter to the King," longtime resident in Rome).

On a philological note, let me here point out, without further comment, that the texts of this and all subsequent letters as reproduced by both Domenico and Baldinucci bear small differences in vocabulary between them: e.g., in Colbert's March 1664 letter, for the original "palais," Domenico has "palazzo," whereas Baldinucci has "edifizio"; Domenico opens with "Signor Cavaliere," which in Baldinucci is simply "Monsieur." The differences in question are distinct from the partial modernization of orthography and punctuation made by Baldinucci's 1948 editor, Sergio Samek Ludovici (for which see his note to Baldinucci, i.66). Further, the letters are not printed in the same sequence by the two biographers.

10. For the *abate* Elpidio Benedetti, see Domenico, 71 (Mazarin's letter), and commentary.

11. Bernini's properly obsequious and falsely modest letter of acceptance, dated May 4, 1664, is extant and has been published by Depping, 4:535–36. According to Alexander's diary, on Sunday, June 15, 1664, the pope met with Bernini, who brought with him his designs for the Louvre (Morello, 1981, 337). There is no specific mention in the papal diary of Bernini's having requested or received permission to work on these plans for Paris.

12. Baldinucci, i.112, e.46, instead assigns a smaller value of 3,000 *scudi* to the diamond-framed portrait of the king. He also mentions the same fear that "one could attribute the value of the gift merely to the royal and singular liberality of that crowned head," hence the reason for reproducing the letters from Colbert and the king. Contrary to Domenico's claim, the jeweled portrait gift—as Benedetti reports in his June 24, 1664, letter to Colbert—was given to Bernini earlier that same month upon the artist's submission of the design to the *abate*, hence well *before*—and not *after*—the king had received the design and expressed his opinion of it: for the letter, see Mirot, 178–80.

According to the 1706 inventory of the Bernini household possessions, Bernini's son Paolo had the stones removed from this now-lost gift from Louis XIV and made into a piece of jewelry for his wife, Laura Maccarani (BALQ, 52, 115). A similar gift sent by Louis XIV to art biographer Carlo Cesare Malvasia (who in 1678 dedicated to the French king his *Felsina Pittrice*) can be found in the Collezioni Comunali d'Arte, Palazzo d'Accursio, Bologna (Summerscale, 30–31 n.106).

13. Baldinucci, i.114–15, e.48–49, for the letter, with a few, minor differences (see note 9 above); the original (dated, as here, October 3, 1664, from Vincennes) is extant: BNP, Ms. italien 2083, p. 343 (see 303 for Bernini's Italian translation). Colbert begins this letter with an apologetic tone, for his response came after long months of anxiety-raising silence on the part of the French court regarding Bernini's submission (sent in June), apart from the minister's simple acknowledgment of receipt dated July 25, 1664.

14. Domenico himself passes over in silence—as if the matter were without consequence—the reference in Colbert's letter to future feedback about the plans to be communicated in person by Cardinal Flavio Chigi upon the latter's return to Rome. In fact, Bernini's plans were met with a great deal of criticism from Colbert, who summarized it in a long, detailed memorandum. The extant official critique, *Observations sur les plans et élévations de la façade du Louvre envoyés de Rome par le cavalier Bernin,* announces in its first line the three most important requisite features of the planned building: magnificence, convenience, and, above all, security.

However, on the latter two counts, Bernini's design was—and in the future will continue to be—found wanting (for the text of the *Observations,* see Clément, 5:246–50; the report is also excerpted by Mirot, 180–82; see Clément, 5:251–58, for a further set of instructions also dated 1664, *Mémoire au Cavalier Bernin. Observations à faire sur les appartemens nécessaires dans le nouveau bastiment du Louvre*). The critique was delivered to Colbert's agent in Rome, Elpidio Benedetti, in September 1664, but the fearful Benedetti did not want to be the one to have to communicate this bad news to the choleric Bernini. Hence the task was delegated to a more authoritative and familiar personage, Flavio Chigi (Mirot, 182–83).

Upon receiving the French feedback from Chigi in November (see Benedetti's letter of November 25, 1664, in Depping, 4:539–40), Bernini, as predicted, exploded in anger, as we know from a December 2, 1664, letter to Colbert from Ambassador Créqui in Rome (Depping, 4:548–49). Créqui's letter also mentions Bernini's early and abiding conviction that the French architects would never permit a foreigner to design the royal edifice. Nonetheless, Bernini was placated and persuaded to do a revised second design. He will do a total of five different designs—including the newly discovered one published by Hall in 2007—before the project was terminated.

Domenico, 129, mentions only a second design, rendered necessary, he claims, simply by Bernini's own changed conception of the building upon seeing the actual site in Paris. Not surprisingly, Domenico omits mention of the critique of Bernini's first plan, which, our author further claims, had been applauded without reservation and rewarded by the king.

15. Domenico's breezy summary of the events subsequent to Flavio Chigi's return to Rome in October 1664 (Mirot, 183; Pastor, 31:113) represents both a gross simplification of a longer, more tortuous process and some sheer misinformation. The official permission by the pope did not come until several months later in April 1665 (Domenico prints the papal "brief" on p. 123). Until shortly before that point, such permission was not guaranteed, nor was Bernini's own willingness to travel to Paris—hence all the pressure exerted on the artist and his friends to dispose him to the journey, as Domenico, 122, reports.

16. See Baldinucci, i.113–14, e.47, for the same letter. Fraschetti, 339 n.1, gives the original French text (from the Vatican archive copy), also published by Clément, 5:506. Domenico places Louis's letter to Alexander first in this April 1665 series of missives from Paris to Rome, whereas, in reality, his letter is dated one week *later* than the one sent to Bernini—a glaring fact to which Domenico would not have been insensitive for its diplomatic ramifications. The delayed dating of these letters was likely meant as yet another deliberate affront to the pope by Louis. Louis's letter is further noteworthy for its condescension in refusing to utter a direct word of thanks to the pope (despite the king's claim in the next letter to Flavio Chigi) and the irony of its description of the French kings as the "most zealous" supporters of the papacy in all of Christendom.

17. Baldinucci, i.114; e.48. Fraschetti, 339 n.2, gives the original French text copied from the Vatican archives; see also the slightly abridged version in Mirot, 195–96.

18. "As a matter of etiquette, the kings of France called all dukes and cardinals 'mon cousin'" (Bernier, 125); according to Coville, 35, this was in fact a custom of all Catholic monarchs, Christina of Sweden among them (see her letter to Mazarin in Stolpe, 241–42). In 1630, the official diplomatic status of cardinals had been greatly enhanced by a decree of Urban VIII that placed them at a rank just below that of secular monarchs, replacing their former title, *Illustrissimi,* with the more exalted one, *Eminentissimi* (Rodén, 2000, 68; Visceglia; and the contemporary report in Gigli's *Diario Romano,* 193).

19. Reproduced also in Baldinucci, i.113, e.46–47; and Fraschetti, 339 n.3; see Clément, 5:505–6, for the text in French. The original letter is extant: BNP, Ms. italien 2083, p. 350.

20. This is the counter-signature of the Marquis Hugues de Lionne (1611–1671), who was Louis's secretary of state for foreign affairs from 1663 until his death. While in Paris, Bernini was asked for designs for the remodeling of the marquis's Parisian mansion (demolished in the early nineteenth century), which he indeed provided: see, e.g., Chantelou, August 17, f.124, e.126.

Until recently, it was believed that Bernini's Hôtel de Lionne plans had been insultingly ignored, as were several other smaller private commissions in Paris. But thanks to recent archival

discoveries, we now know that the artist's proposals were indeed carried out: see Bandera Bis-toletti, 51–56; and Chantelou, f.124, n.2 (by Stanić). De Lionne was on friendly terms with Bernini's Jesuit confidant, Sforza Pallavicino, and wrote to the cardinal on April 11, 1665, asking for his assistance in convincing the Cavaliere to go to Paris (Montanari, 1997, 46, with further information supplied by the same author, 1998b, 344 n.59).

21. Baldinucci, i.116, e.49–50, also mentions Oliva's role in the collective effort to cajole Bernini into accepting the king's invitation. The Florentine biographer describes Father Oliva as Bernini's *amicissimo* and praises the Jesuit as "the honor of that most noble religious order no less than the glory of this century." However, Baldinucci also lets us know that Oliva was no disinterested interlocutor; the priest was already quite predisposed to being of service to the French king, since he was acutely mindful of the political interests of the Jesuit order in France. Baldinucci cites Oliva as advising the artist that it would be "good to obey [this command] even at the cost of his [Bernini's] life," a detail Domenico does not mention but which Oliva himself reports in his letter to Minister de Lionne, reprinted by Domenico, 141–42. In Paris, Bernini makes a point of publicly acknowledging Oliva's crucial role in getting him to Paris so as to fur-ther ingratiate the Jesuit general with the French king: see Domenico, 141–43, and commentary.

Born in Genoa of patrician family, Gian Paolo Oliva (1600–1681) became Vicar-General in 1661 and Superior General in 1664 of the Jesuit Order, having already (since 1629) made a great name for himself as preacher in Rome, including the papal court from 1651 to 1675 (ca. 300 of his sermons are in print). As general of the order, he distinguished himself through his able steering of the ship of the Society of Jesus amid the stormy political and theological waters of late seventeenth-century Europe and in the process earned the personal esteem of King Louis XIV, as we read in Oliva's entirely encomiastic obituary in the *Journal des Sçavans* (later *Savants*), Monday, February 16, 1682, 43: "Le Roy l'honoroit de son amitié, et avoit une estime singulière pour sa personne" (The king honored him with his friendship and had singular esteem for his person).

That claim is confirmed by a letter from the Paris court from Jesuit Father Jean Adam (1608–1684), who had the privilege of having "a very long conversation" with Louis XIV dur-ing which the king expressed his deep esteem for Oliva's "singular virtue," "stupendous political skill," and "extraordinary authority gained among princes": see ARSI, Vitae, 158, fol. 246, "Ex epistola Reverendi Patris Ioannis Adam . . ." A persuasive proponent of a more ornate approach to the grand-scale decoration of Jesuit churches, Oliva singlehandedly "set all the Jesuit churches in Rome on an entirely new course" (Haskell, 1972, 56).

Oliva was involved in incisive ways in several important artistic projects of the Society in Rome, most notably the building of Sant'Andrea al Quirinale (Marder, 1998a, 196) and the decoration of the ceiling and cupola of the Jesuit mother church, the Gesù, executed in 1672–83 (Enggass, 1964, 31–74, 135–40, and 176–79). Though Bernini's effective, sustained connection to the Jesuits dated back at least to 1648, when he began his participation in the Jesuit "Good Death" devotions at the Gesù (Domenico, 171, and commentary), the artist may have first begun his personal acquaintance with Oliva himself through interaction on the later Sant'Andrea church project undertaken in 1658 (but see above Domenico, 108, note 35).

Note that Domenico's qualification here, "as was his custom," would indicate a relationship that by spring 1665 was rather well established. Earlier, in 1664, Bernini had supplied a drawing of *Saint John the Baptist Preaching* to serve as frontispiece to the second volume of Oliva's pub-lished sermons for the papal court, the *Prediche dette nel Palazzo Apostolico* (mentioned by Oliva in his letter to Bernini in Domenico, 142). Oliva's sermons contain several references to Bernini's works in Saint Peter's and elsewhere, without naming the artist, however. A comprehensive account of Oliva's life is wanting, but see Patrignani, 4:189–91; *Bibliothèque de la Compagnie de Jésus*, s.v. "Oliva, Jean Paul"; Fois, 1992 and 2001; and *Diccionario Histórico de la Compañía de Jesús*, 2:1633–42; for Oliva and Bernini, see Kuhn; Haskell, 154–67; Montanari, 1998b, 312, 315, 318, 319, and 322; and Fagiolo dell'Arco, 2002, 174–77.

22. Oliva's published correspondence includes one, undated letter to Cardinal Antonio in Paris (Oliva, 1703, 1:49, no. 38). In it, the Jesuit mentions having received several letters from the cardinal and refers vaguely to the task at hand of "exploring the mind of the Cavalier Bernini,"

presumably with regard to the artist's willingness to travel to the French court. As usual in his official correspondence, knowing that there was no such thing as a completely private letter in those times, Oliva is both extremely reticent to divulge any substantial details of the matter in question and evasive in his response, grandiloquently lengthy as the latter may be.

23. On April 23, 1665, Oliva sent an official memorandum to all the superiors of the Society of Jesus announcing the departure of "Laurentius Berninus" for Paris and giving instructions as to what should be done in case of the Cavaliere's sudden death there: see Stanić's n.4 to Chantelou, July 23, f.85 (the original copy of Oliva's missive given to Bernini is extant: BNP, Ms. italien 2084, fol. 95r). It was most likely Bernini himself (fearful of dying abroad without sufficient and immediate spiritual suffrage for his departed soul) who requested this favor from Oliva.

24. This meeting between Bernini and the pope took place on the morning of April 21, as we learn from a letter to French foreign minister Hugues de Lionne from Cardinal Sforza Pallavicino. The postscript of the letter reads: "It has just happened that, having spoken to the pope this morning of this matter, [I learned that] His Holiness has said to the Cavaliere: 'We beg you with great insistence to satisfy the King's request'" (Montanari, 1997, 46). Hence Domenico makes it appear that the pope had not insisted with or given his permission to Bernini until Bernini himself came forward to say that he agreed to go to Paris, whereas Pallavicino's postscript makes it appear that Bernini's acquiescence was determined instead by a direct, firm request from the pope.

Though vague on this question of immediate causality, Pope Alexander's diary (Morello, 1981, 338) also laconically records the meeting on the same day and specifies that the absence was to be for five months ("col Cav. Bernino, che vada in Parigi per cinque mesi solamente"); in the papal letter to Louis, the period granted instead is three. In the end, Bernini was at the French court for four and a half months, arriving in Paris in early June and departing mid-October. Baldinucci (i.116, e.50) does not report Bernini's visit to the pope to receive permission, nor the pope's begrudgingly terse send-off wishes, but he does reprint the papal brief to Louis. As Jarrard, 2003, 208, remarks, the pope's relinquishment to Louis of his prized possession, Bernini, "formalized the acknowledgement of France's emergence as the leading European power."

25. The pope's brief (in Latin) is also printed by Baldinucci, i.116; e.50; see also Mirot, 196. To speak of his "love" of Louis and his "willingness" to lend Bernini to him of course could only have been, in truth, a painful, reluctant act of diplomatic dissimulation on the pope's part.

Note that Domenico gives the wrong date for Alexander's brief: it should be April 23, as we find in Baldinucci and the French archival copy published by Mirot, 196.

CHAPTER XVII

1. Domenico's date is incorrect; the correct date of departure, not known with complete certainty, is most probably April 25, as we find in Baldinucci, i.117, e.50 (Gould, 1). Baldinucci mentions the same distress (with Domenico's same words, "pena e timore") of the city of Rome at the thought of losing Bernini forever. In his trip to Paris, Bernini chose not to travel in the entourage of Ambassador Créqui, as the king's letter had suggested (Domenico, 121), preferring the land route to the water route taken by the French diplomat (see the letters from Minister de Lionne and Nuncio Roberti in Chantelou, f.15 and f.381–82; and the Medici dispatch dated April 25, 1665, in Montanari, 2001, 124–25, doc. 4). Though we know very little of what he did and saw in most of the localities through which he passed, Bernini traveled to Paris via Viterbo, Bolsena, Siena, Florence, Bologna, Milan, and Turin; then over the Alps by way of the Mont Cenis Pass to Chambéry (then part of the Duchy of Savoy, not France), before arriving at the first town in France, Pont-de-Beauvoisin, eventually followed by Lyon, the party's first major stop in French territory (Mirot, 198–201; see 203–5 for the subsequent Lyon-Paris route).

A report from the Duke of Modena's Roman agent informs us that Bernini had to omit a stop in Modena supposedly to avoid further delay (Fraschetti, 340 n.2): Morris, 135–36,

however, makes the persuasive suggestion that such a surprising omission (given Bernini's past history with the d'Este family, as sculptor of Francesco I's bust and as a close friend to Cardinal Rinaldo d'Este), may have been imposed on Bernini by Pope Alexander, displeased by the profit derived by the d'Este family from the Créqui incident (recall that Cardinal Rinaldo was the well-rewarded protector of French interests in Rome).

2. The Florentine Cosimo Scarlatti (1604–1686) was a member of the Bernini household at least from 1643 onward, if not earlier, according to the annual Easter census lists published in Fagiolo/*IAP*, 343–49 (at times described therein as "Cosimo fiorentino"). Cosimo died in Rome on July 22, 1686, asking in his will to be buried in the Bernini family tomb in Santa Maria Maggiore. Domenico was named his universal heir (Fagiolo/*IAP*, 382–84, for his will and death certificate, which gives his age as eighty-two).

One of the three other unnamed members of Bernini's household accompanying the artist to Paris was apparently a certain "Barbaret": upon departure from the French court in October, among the larger gifts given by Louis XIV to Bernini's principal assistants was the sum of nine hundred *livres* presented to the artist's interpreter, identified in the French documentation simply as "Barbaret," perhaps Barbaretto in Italian (Perrault, 76 n.66, citing the *Comptes des Bâtiments du Roi*).

As for the young Paolo Bernini (b. 1648), Bernini probably took him on the journey to further his nascent career as a sculptor. In Paris, Paolo carved (as a gift for the Queen of France) a marble relief of the *Christ Child Playing with a Nail*, now in the Louvre. Yet in his *Journal*, Chantelou reports seeing Bernini-father giving "touches" to his son's statue on so many occasions that the work must be considered as much his as Paolo's (see, e.g., Chantelou, July 28, August 1, and September 6 and 27; September 20 for the queen as intended recipient). No other extant work can be attributed with certainty to Paolo (Bacchi, 784). Paolo later abandoned sculpture apparently to dedicate himself to the life of a gentleman of leisure, made possible by the sizable inheritance from his father (see the prediction to this effect by a 1668 Roman *avviso*, published in Weil, 1974b, 133).

3. In his letter of April 10, 1665, nuncio Carlo Roberti mentions that the king will send to Bernini an advance sum of 20,000 *écus* for the expense of the journey (letter in Chantelou, f.381–82); the figure given in the royal accounting books is 30,000 *livres,* plus 900 for exchange and 386.5 for tax (Wittkower, 1961, 517). In the end, Bernini's stay in France was to cost Louis over 100,000 *livres* (Wittkower, 1961, 517 n.3).

4. Baldinucci the Florentine omits any mention of Bernini's stop in rival Siena. Mattia de' Rossi's letter to Pietro Filippo Bernini from Siena, dated May 1, is extant (published by Mirot, 198–99 n.1), followed by another letter from him from Bologna, dated May 5 (Mirot, 199–98 n.2). Domenico says that Don Mario "happened to be in Siena," but that may not have been by choice but by constraint, having been temporarily exiled from Rome as one of the terms imposed upon Alexander by Louis XIV in the Treaty of Pisa (Pastor 31:106; Don Mario was commander of the papal garrison at the time of the Corsican Guard attack on the French ambassador's soldiers and hence the French request for his punishment by exile).

For Bernini's two brief visits to Florence (en route to and from Paris), see the Medici correspondence published in Montanari, 2001. The latter documentation suggests that Bernini's sightseeing in Florence took place not during his first visit (probably May 2 and 3) but rather his second (November 22–23). Two of his first cousins were still living there: see Montanari, 2001, 114–15 and 116 n.69; see 121–23 for Bernini's November 25–26 visit to Siena, during which he asked to see all the extant work of the Sienese painter Ventura Salimbeni.

5. Not surprisingly, Baldinucci, i.117–18, e.51, devotes more space than Domenico to Bernini's stay in Florence, the biographer's hometown, claiming that Grand Duke Ferdinand II (1610–1670) distinguished himself above and beyond all other princes in the honors accorded Bernini en route to Paris. He also gives more information regarding what Bernini saw by way of art and architecture and about the Marchese Riccardi (d. 1675), who had been Medici ambassador to Rome (1645–58). As Ferdinand's *maggiordomo maggiore*, Riccardi occupied "possibly the highest and most prestigious position at court," as well as serving on "the very select State council" (Sparti, 161). See also note 6.

6. That is, the Palazzo Medici-Riccardi on the present-day Via Cavour, sold in 1659 by Grand Duke Ferdinand to the same Marchese Gabriello Riccardi (see note 5). Now a museum, in 1665, when Bernini visited the palace, it did not yet contain the family's collection of antiquities (which Bernini examined in the old Riccardi residence on Via Gualfonda, as Baldinucci informs us) and had still not undergone its transformation into the splendid late Baroque patrician residence that we see today (see the museum's Web site: http://www.palazzo-medici.it/eng/home.htm).

In a letter of February 4, 1679, the distinguished *erudito* and Medici agent Lorenzo Magalotti states quite confidently that Bernini contributed to the design of the remodeled Palazzo Medici-Riccardi. If true, most likely that contribution came only in the form of rather informal consultations during Bernini's brief stops in Florence en route to or from Paris in 1665. No payments to Bernini from Riccardi or correspondence between the two parties have been uncovered amid the well-studied documentation relating to the renovation of the palazzo (Sparti, 162–63). Among the extant correspondence from the Bernini family archives is a short letter (BNP, Ms. italien 2082, fol. 66r) from Riccardi to Bernini dated December 27, 1665, communicating further expression of his and the grand duke's esteem, affection, and support (published by Montanari, 2001, 129–30, doc. 26 [but for his "2083," read "2082"]).

Also extant there (BNP, Ms. italien 2082, fol. 70r, published by Borsi, 359, from the Medici archive copy) is a letter from Ferdinand's son and successor, Grand Duke Cosimo III, dated August 11, 1671, acknowledging receipt of Bernini's design ("of which every line shows your exquisite intelligence and the nobility of your ideas") for the altar of the "church of the Cavalieri," namely, Santo Stefano de' Cavalieri in Pisa (for which project see Fraschetti, 114; M&MFagiolo, cat. no. 239; and Wittkower, 269).

7. Baldinucci, i.118, e.52, also reports Bernini's humorous remark about the traveling elephant. Bernini would have had at least two opportunities of seeing live elephants for himself in Rome when pachyderms visited the city in May 1630 and July 1655 (Gigli, 191 and 747).

8. Duke Carlo Emanuele II (1634–1675) had begun his effective reign of Savoy in 1663 with the death of his mother, the regent. He was nephew of Cardinal Maurizio (1593–1657), who lived in Rome for several years (1621, 1623–1627, and 1635–38), where he was a prominent patron of the arts and would have had occasion to interact with Bernini (for Maurizio, see Oberli). Through his mother (Christine Marie, daughter of Henri IV and Marie de' Medici), Carlo Emanuele was cousin to King Louis XIV. He is infamous for his brutal 1655 massacre of Protestants in the Savoy domain.

On his return trip from Paris in October, stopping again in Turin, Bernini toured Carlo Emanuele's recently completed hunting lodge outside the city, the "Venaria Reale," as its architect, Amedeo di Castellamonte, tells us in his published guide (1674) to the vast estate (see my Introduction, note 101). Earlier, in October and November 1661, with Pope Alexander's special permission and lively interest, Bernini was involved in the design of the House of Savoy's residence at Mirafiori, as we learn from the diplomatic correspondence; the same correspondence tells of a 1666 painting commission to Bernini from the duke, never apparently executed, however (Cavallari-Murat, 347, citing primary sources published by Baudi di Vesme, 1:125–27). Under commission from Cardinal Giacomo Rospigliosi, nephew of Clement IX, Bernini later (1669) provided the design for two silver reliquary urns sent as gifts to the same Carlo Emanuele II (see Roberto, 295–99).

9. "Tanto appresso i virtuosi Principi rimane in pregio la Virtù."

10. Pont-de-Beauvoisin (*département* Isère, *region* Rhône-Alpes) was then the first town in French territory encountered by those arriving from Italy via the Mont Cenis Pass. Baldinucci, i.118, e.52, also mentions this first ceremonial reception on the part of the French.

11. Regarding Bernini's reception at Lyon, Baldinucci, i.118, e.52, merely says, "He was not yet three miles from Lyon when he was met by all of the painters, sculptors and engineers of the city, some on horseback, others in coach." Bernini and party arrived in Lyon on May 22 and left the next day, according to Mattia de' Rossi's letter written on May 23 from that city (Mirot, 202–3 n.2).

As the city's archbishop remarked of the artist's reception there, "This is a completely extraordinary honor, one that the city of Lyon reserves only for princes of the blood" (Chantelou, prologue, f.41, e.4; see Mirot, 200–203 for further details: e.g., the king sent his *maître d'hôtel* to Lyon to wait on Bernini; ice was even fetched from Roanne to make sure that Bernini's drinks would always be cool). See Bandera Bistoletti, 57–60, for two works in Lyon (an extant hospital bell tower and a destroyed church tabernacle) whose designs are connected to Bernini, as well as for a bronze version of his *Louis XIV* portrait commissioned from Bernini by the city fathers and mentioned in the artist's own correspondence (possibly corresponding to the bust currently at the National Gallery of Art, Washington, D.C.).

12. Bernini had been made a *Cavaliere di Cristo* by Gregory XV: see Domenico, 22. Here Bernini makes use of the same masquerade ruse that was so popular in contemporary comic theater and that he himself had included in one of his plays, *The Two Coviellos:* life imitates art! (Fagiolo/*IAP*, 297). "The city's nobility and other men of distinction" translates Domenico's "*Nobiltà e Virtuosi di quella Città.*"

13. Baldinucci, i.118, e.52, also reports the detail about Bernini's almsgiving, though not specifically with respect to Lyon.

14. Baldinucci reports neither the letter nor the remark in any form. I have not been able to trace the original of this letter or identify the person to whom it was sent. In any event, Bernini laments in similar terms to Chantelou after the reception of great praise from members of the court: "I have one great enemy in Paris, but a great one . . . the idea they have of me" (Chantelou, June 29, f.65, e.44). Perrault's *Memoirs,* 73, quotes Bernini to the same effect.

15. Three sources describe Bernini's arrival and first days in Paris: the opening pages of Chantelou's *Journal,* papal nuncio Roberti's report of June 5 to Flavio Chigi (Schiavo, 31–32), and Mattia de' Rossi's letter of the same date to Pietro Filippo Bernini in Rome (complete Italian text of the latter in Mirot, 205–7 n.3; French translation in Chantelou, appendix, f.383–85). Domenico is incorrect in the details conveyed in these two sentences: the first official encounter outside Paris between Bernini and the king's representative, Chantelou, occurred at Juvisy, some fifteen kilometers south of the capital, on June 2.

Bernini then rode for three miles in Chantelou's coach (borrowed from Colbert's brother) until they were met by nuncio Roberti, the Abbé Butti (for whom see Domenico, 140, and commentary) and other members of the court. In the early afternoon on the same day, they arrived in Paris, where Bernini and party were lodged in the (now disappeared) Hôtel de Frontenac within the Louvre precincts (see Chantelou, June 2, f.42–44, e.8–10, lacking certain details; and the previously mentioned and more complete Mattia de' Rossi letter of June 5, 1665). Domenico may have consulted Mattia's letter in the family archive when compiling his biography, but he does not follow it in all details; see the following notes.

16. Mattia's letter of June 5, 1665 (see note 15), says that Colbert arrived to greet Bernini later on the same day of his arrival, once the artist was settled in his lodgings at the Louvre. In Chantelou, instead, the first mention of a visit by Colbert is after dinnertime on the next day, June 3 (f.44, e.11). Baldinucci, i.118, e.52, reports the same fact of Colbert's visit on the same day of Bernini's arrival, greeting him on behalf of Louis, who "was awaiting him at Saint-Germain with impatience."

According to Chantelou, when Colbert came calling, he found Bernini still in bed after his postprandial repose and refused to let the artist get out of bed. As Bauer notes: "In an age when elaborate displays of courtesy were the counterpart of jealously guarded claims to precedence, Colbert's refusal to allow Bernini to leave his bed was a pretty piece of deference" (Chantelou, e.11, n.25). On the morning of the next day, June 4, Colbert accompanied Bernini (with Paolo and Mattia) for the artist's first audience with the king, who was then at the royal chateau of Saint-Germain-en-Laye, about nineteen kilometers west of Paris, his principal residence in these years (see Chantelou, June 4, f.44–45, e.12; Mattia de' Rossi, letter of June 5, printed in Mirot, 206 n.3 and in Chantelou, f.384–85).

17. This amusing detail about the king's impatience, not found in Chantelou, is instead recounted by Mattia de' Rossi in his June 5 letter to Rome (see note 16): "The King, anxious

to see the Signor Cavaliere, appeared from behind a door and looked at the Cavaliere, laughed (*rise*), and then withdrew inside again." What made the king laugh? We wonder.

18. Neither Chantelou (June 4, f.45, e.12) nor Mattia de' Rossi (June 5 letter; see note 16 above) mentions the presence of Turenne (Henri de La Tour d'Auvergne [1611–1675], vicomte de Turenne, Maréchal-Général of the Camps and Armies of the King) at this audience. The "maréchal" in question was instead probably Antoine de Gramont (1604–1678), identified by name by both sources. Mattia—calling him "il mariscial di Cremona"—says that Gramont served as interpreter between Louis and Bernini on this occasion. Domenico might have here substituted Turenne's name since he was (and is) by far the more illustrious of the two French officials. Considered one of the greatest military commanders of the seventeenth century, Turenne is one of the few national heroes buried in Napoleon's company at Les Invalides, Paris.

19. Baldinucci, i.119, e.52, simply says: "No longer being able to stand the delay, the great monarch appeared at the door." Neither Chantelou's diary nor Mattia de' Rossi's letter (see note 16 above) describing this first encounter mentions this detail of Bernini's immediate recognition of the king. In fact, even before leaving Rome, Bernini well knew what the king looked like: Domenico has forgotten that he already told us (p. 118 above) that in June 1664, as a reward for his first Louvre design, Bernini had received a jeweled-encrusted portrait of Louis.

If that were not enough, our artist had undoubtedly had other occasions to familiarize himself with the king's features from images readily available, to be sure, in Rome in various forms (paintings, engravings, and medallions). There must have been many portraits of the king on display in Rome in 1662 during the city's massive celebrations of the birth of Louis's heir, of which Bernini was responsible for the colossal ephemeral decorations at Trinità dei Monti (for the 1662 celebrations, see Fagiolo dell'Arco, 1997, 407–12). Hence the anecdote is almost certainly untrue, representing, instead, yet another appearance of our author's "instant recognition of greatness" topos, for which see Domenico, 94, and commentary. See also Chantelou, September 28, f.209, e.235: "The Cavaliere said that the words of the Cardinal Legate [Flavio Chigi, who had been at Louis's court in the previous year] were true, [namely, that] one would recognize the King among a hundred noblemen without ever having seen him, for his bearing and his face were so filled with majesty and assurance."

20. Baldinucci, i.119, e.53: "For the most part the monarch spoke of the great regard he had for Bernini's talent and his desire to make public acknowledgement of it." Mattia de' Rossi's June 5 letter tells us that, after Bernini's grandiloquent introductory discourse, the king, in a state of admiration, turned to the court and said, "Well, then, now I indeed know that this is the man I had imagined" (Mirot, 206 n.3; Chantelou, appendix, f.385).

Describing Louis's demeanor toward Bernini in a later letter to Rome (September 11, in Chantelou, appendix, f.395), Mattia claims that the king spoke to and jested with Bernini in a very familiar manner "as if he were his best friend," and, to the astonishment of all, even asked Bernini's pardon for having to miss appointments, something unheard of in a king's interaction with an inferior. Yet the shrewd king harbored no illusions about Bernini: in his dispatch dated June 19, 1665, the Duke of Modena's agent at Louis's court and royal theatrical architect, Carlo Vigarani (1637–1713), says the king told him that he did not want Bernini invited to the upcoming festival at Versailles "because he [the king] had understood [Bernini], after just a half-hour of conversation with him, to be a man predisposed to finding nothing well done in France" (Fraschetti, 343 n.1).

21. Both Baldinucci (i.119, e.53) and Chantelou (June 4, f.45, e.13) are also careful to note Bernini's privileged placement at this initial royal banquet, where seating was strictly determined by social status.

22. As already noted, Bernini's first Parisian residence was the Hôtel de Frontenac, later demolished in the Louvre expansion (see n.1 to Chantelou, June 2, f.44). As Mattia's letter of August 7 mentions, the mansion was located within the Cour Carrée of the Louvre complex (Chantelou, appendix, f.393). Bernini spent two months there before switching residences in early August.

While it is true that the move to the Palais Mazarin afforded Bernini more privacy in his work—see Chantelou's August 6 memo to Colbert (Chantelou, f.401–2)—that was not the

principal reason for the move. Nor was the move a matter of the artist's choosing: Colbert asked Bernini and entourage to move to accommodate other needs of the royal court (see Mattia's letter of August 7, in Chantelou, appendix, f.393). As Stanić (n. 4 to Chantelou, f.107) reminds us: "One must not confuse the various 'Hôtels Mazarin' with the cardinal's residence [here in question] which Chantelou sometimes calls 'hôtel' but which bore the name 'Palais Mazarin' from its origins." In the early 1640s, when constructing the residence, Mazarin had attempted unsuccessfully to commission its design from Bernini. Then fronting on the Rue des Petits Champs, the Palais was just northwest of the Palais Royal, beyond the densely inhabited urban area; what remains of it is now incorporated within the complex of the Bibliothèque Nationale (Rue Richelieu site). See the remainder of Stanić's note for further information and bibliography about the Palais Mazarin, as well as Ballon, 186–87 n.76.

CHAPTER XVIII

1. See Domenico, 118, and commentary, for the first design. However, Domenico neglects to mention that the first design had been rejected and was soon followed by a second one even before Bernini's departure for Paris (Louis's letter reproduced on p. 119 makes reference to these two designs). As already noted (note 14 to Domenico, 119), Bernini was to create a total of five different designs for the Louvre. Here as elsewhere, Domenico's omissions serve not only to simplify an otherwise complicated narrative, but also to eliminate details that shine a less glorious light upon his father.

According to a Medici dispatch of June 1665, Louis supposedly also asked Bernini to survey the area around Paris for an appropriate site for yet another royal edifice to be designed by Bernini (Montanari, 2001, doc. 8, 125–26), a detail not mentioned in Chantelou.

2. This sentence is in italics in the original, indicating that it is a direct quotation— presumably from King Louis, although Domenico does not state this explicitly. In any case, in describing the king's enthusiastic reaction to Bernini's revised Louvre plans on June 20, Chantelou (f.61, e.37) simply notes: "The whole [plan] pleased His Majesty so much that he told the Cavaliere how very glad he was that he had begged the Pope to allow him to come." Later in the same entry (f.61, e.38), Chantelou quotes the king as having said that "now his mind was at rest [about the Louvre], having entrusted this task to the ablest man in Europe."

3. This is, in substance, true: according to Chantelou, June 20, f.61, e.38, Bernini first showed the king only his design for the elevation of the facade. Approving of what he saw, Louis then "asked him to make a design for the facade facing the service courtyard."

4. The three masters were Pietro Sassi, Giacomo Patriarco, and Bernardino (or Bellardino) Rossi, summoned in late June: see Chantelou, July 19, e.66, n.67.

5. Baldinucci, i.119, e.52, reports this same quotation from Bernini earlier in his account, while describing the artist's first arrival in the king's antechamber, without mention of Pallavicino's remark.

6. This is a literal translation of Domenico's Italian. What he means is simply that all this initial praise could one day turn into blame—which indeed happened.

7. This presumably refers to Colbert. See Domenico, 138, for another, similar reference to "some jealous minister" in the French court.

8. "quanto più si compativa il suo desiderio coll'occupazioni di quello."

9. According to Chantelou (f.134–37, e.139–44), on August 23, after waiting for the king to finish having his foot bled, Bernini had a long conservation with Louis about various topics, including the theater. However, Chantelou there mentions nothing about Versailles or the difference between French and Italian women. See also Chantelou, September 13, f.179, e.195: at the conclusion of his first (and only) visit to Versailles—then just a much more modest, private retreat for the king—Bernini happens to encounter the king on the grounds and compliments him simply on the beauty of his "beautiful and elegant" estate.

10. Baldinucci, i.148, e.82, includes Bernini's witty praise of Versailles and his humorously evasive remark comparing French and Italian women in his brief catalogue of Bernini's witticisms placed toward the end of his *Vita,* after the chronological narrative has come to an end.

11. Philippe, duc d'Orléans (1640–1701), often called simply "Monsieur" in Chantelou and other contemporary French sources. Although Chantelou does not record the duke's presence on this occasion, he may indeed have been there. In any case, Bernini would have had several opportunities of meeting and interacting with the duke and his wife (Henrietta Anne, 1644–1670, daughter of King Charles I and Queen Henrietta Maria of England). The duke commissioned from Bernini a design for a rustic waterfall for his residence at Saint-Cloud, a feature that the artist himself had spontaneously suggested upon visiting the estate (see, e.g., Chantelou, July 26, f.93, e.84; and August 18, f.125, e.127). The project came to naught, as did several of Bernini's other smaller design proposals solicited from him from members of the court.

12. Louis's mother was Anne of Austria (1601–1666), daughter of Philip III of Spain, who had served as regent in the years 1643–51, much under the influence of Cardinal Mazarin. As Chantelou reports, she was sickly and bedridden when Bernini met her for the first time on June 4; she died several months later in January 1666. Anne built the church of Val-de-Grâce as an ex-voto after the birth of her first and long-awaited son, Louis. Bernini first visited the stately Baroque church on June 13, studying its features carefully, in the company of its architect, Gabriel Le Duc (d. 1704).

13. For a summary of the disputed question of the authorship of the design of the main altar of the church, with its Bernini-esque baldachin, see Chantelou, e.32 n.102, with bibliography (to which add Borsi, cat. 61; Bauer, 1987; and Ackermann, 2007, 220–27). It is now certain that Bernini had no direct part in the design in the altar as built (finished in 1669). According to Chantelou, on June 25, the Queen Mother sent two, not one, of her high-ranking representatives to Bernini to solicit a design from him: Jacques Tubeuf (Superintendent of Finances) and Étienne de Bartillat (Treasurer). According to Chantelou (f.63, e.41), Bernini did not refuse the request outright: being reassured by the two delegates that it was indeed the Queen Mother's desire, and not merely that of the nuns of the monastery, he replied that "in that case he would consider it."

14. Domenico is not entirely clear: what "same sentiments" did Bernini repeat to the queen? Those he expressed the day before to her representatives? Or those Anne expressed just now to him? Presumably the latter, in order not to offend the queen with a face-to-face refusal. In any case, Domenico is incorrect about chronology: although Chantelou (or any other source) makes no mention of this audience with the Queen Mother, the earliest it could have taken place was three days later (June 28)—not Domenico's favorite adverbial exaggeration, the "very next day"—when next Bernini traveled to Saint-Germain to sketch the king for his portrait.

15. In reality, the Queen Mother was not altogether pleased with the design: see Chantelou, July 8, f.72, e.55. In the end, as already mentioned, Bernini's design was ignored. In his letter of July 10, Mattia de' Rossi gives a detailed description of Bernini's proposed design, of which no drawings survive (Chantelou, appendix, f.389).

16. For *magnificentia* (magnificence) as a prerequisite virtue of the Baroque prince, secular or ecclesiastical, see my commentary on the term on Domenico, 2. As for Domenico's chronology, it once again is incorrect: according to Chantelou (June 20, f.61, e.38), Louis made the formal request of Bernini for his portrait bust on June 20, five days before the Queen Mother's representatives had requested a design for the Val-de-Grâce altar.

However, our biographer is correct about the king's deferential tone in making the request, as we learn from Mattia de' Rossi's June 26 letter ("con grandissima modestia"). Mattia also confirms June 20 as the date of the request (Mirot, 217, n.1; Chantelou, appendix, f.387). However, as Gould, 41–42, points out, the fact that Bernini brought his sculptural assistant Cartari with him "leaves very little doubt that the matter [of his doing the king's portrait bust] had been raised in Rome long before [the making of the formal request]." As the artist himself says, Bernini had

heard rumors about the king's desire for a bust—and one of his wife—ever since arriving in Paris, and at one point expresses great annoyance to Chantelou that no explicit order had yet come from Louis (Chantelou, June 11, f.55, e.28).

According to Mattia's June 5 letter, the subject was raised by Louis's brother, the Duke of Orléans, during their first encounter on June 4 (Mirot, 207, n.3; Chantelou, appendix, f.385). In any event, in Louis's mind, let us note, Bernini's portrait was not intended to enjoy any exclusivity as the official representation of the king at this stage of his life: French sculptor Jean Warin was also commissioned to do a marble bust of Louis XIV while Bernini was in Paris: see Chantelou, October 8, f.238, e.273, and Mattia de' Rossi's letter of October 1, 1666, describing the unveiling of the Warin portrait, which occasioned some anti-Bernini chatter (Mirot, 268, n.1; and Chantelou, appendix, f.396−97).

17. This statement is probably not true: Chantelou makes no mention of such a visit on any day in June, one that, if had indeed occurred, the French diarist, one should think, would have assuredly been recorded. The earliest mention of the subject by Colbert occurs on July 5, and only as a brief, informal aside. According to the artist's son Paolo, Colbert's urging of Bernini to remain in France occurred on August 30: Chantelou records this detail from Paolo in his September 7 entry, following an account of the Frenchman's own long conversation with Bernini on the specific benefits of remaining in the king's service in Paris, including the social advancement of his children.

Interestingly, in his brief mention of the blandishments offered to Bernini to persuade him to stay, that of being able to have his son joined in matrimony to "a noblewoman with a rich dowry" is specifically highlighted by Baldinucci, i.123, e.57 (note that the 1996/2006 English translation of this passage is erroneous). Certainly, as tensions between Bernini and his French hosts, especially Colbert, increased over the course of the subsequent weeks, interest in keeping the artist in Paris seems to have waned. It is significant that, during Bernini's formal parting conversations with the king and Colbert, no mention at all is made by Louis or his minister about the artist's returning to France (see Chantelou, October 19 and 20).

18. Bernini did indeed begin work on the bust immediately, having his first sitting with the king on June 23 (Chantelou, June 23, f.63, e.40). Chantelou's *Journal* is of course the most important primary source for the history of the step-by-step execution of the Louis XIV bust, for which nothing remains by way of preparatory sketches, on paper or in clay. As for the role of the three-dimensional preparatory models in clay, note that Domenico here speaks of *molti in creta,* while Chantelou, June 24, f.63, e.41, mentions that Bernini "worked the whole day at the model [*modèle*] of the bust" after just one session with the king; see also Mattia's July 10 letter mentioning the same detail of the clay model (*il modello abozzato*), reprinted in both Mirot, 219 n.1, and Chantelou, appendix, f.389.

However, as Wittkower (1951, 8) reminds us, Bernini "did not make—as was the general custom—a large model of the size of the bust, to which he could refer when working on the marble." Among the many studies of the bust, see Mirot, 215−46, passim; Wittkower, 1951; Gould, 41−87, passim; Lavin, 1993b and 1999; and Preimesberger, 2006, 201−10; see Tratz, 1988, 474−78, for a succinct but thorough, step-by-step chronology of the execution of the bust (466−71 for discussion); and for a terse chronology of the bust's entire history, see Wittkower, cat. 70. For Bernini's clay models pertaining to other sculptures, many of which still survive, see Lavin, 1978b; Raggio; Gaskell, 1999; the two essays by Barberini and Hemingway-Sigal in Coliva, 2002, 277−84, 285−89; *Earth and Fire,* cats. 43−48; and Barberini, 2001b, 49−56.

One might note (as per Lavin, 1981, 4) that in Bernini's sculpting practice "terra-cotta models . . . played a crucial role—far greater than in the work of any previous sculptor." German painter-writer Joachim von Sandrart (1606−1688), e.g., reports that Bernini showed him no fewer than twenty-two *modelli* for the *Longinus* statue (Coliva, 2002, 285). To date, more than fifty terra-cotta models have been attributed to Bernini, of which about thirty are firm in their attributions (Dickerson, 4 and n.1 for bibliography). As mentioned in the commentary to Domenico, 5, regarding Bernini's early artistic training, Dickerson argues that one crucial, distinctive factor in determining Bernini's remarkable sculptural style was his early introduction

to the benefits of clay modeling, introduced to the latter practice (then foreign to the working methods of Roman sculptors) most likely by his Florentine father, with perhaps further training under Stefano Maderno: see Dickerson, 301–80.

19. In his letter of July 31 from Paris to Rome, Mattia de' Rossi comments on the problem with the French marble: "The marble (chosen for the bust), which is friable [*cotto*], does not allows the Cavaliere to carve the hair in the way that he would like, obliging him to bring it (the hair) more forward" (unpublished letter quoted by Stanić, Chantelou, July 31, f.100, n.2). Chantelou (August 4, f.104, e.99) reports the same concern: "[Bernini] told me he was very worried by the marble, which he called *marmo cotto,* which was so friable that he was forced to work with a trepan lest it broke under the chisel." About the difficulty of finding suitable marble, see also Mattia's letters of July 10 and 17, 1665 (Mirot, 227 n.2 and 229 n.1; also in Chantelou, appendix, f.390 and 391).

20. In the course of his discussion of Bernini's theory of art, Baldinucci, i.144, e.77–78, describes Bernini's working method in portraiture, including the fact of sketching his subjects while they were in motion and ignoring initial sketches during the actual execution.

21. "In oltre fù suo costantissimo proposito in somiglianti materie, far prima molti disegni, e molti della figura, ch'egli dovea rappresentare."

22. Chantelou, July 29, f.96, e.89: "The Cavaliere replied that . . . until now he had worked entirely from his imagination, looking only rarely at his drawings; he had searched chiefly within, he said, tapping his forehead, where there existed the idea of His Majesty; had he done otherwise his work would have been a copy instead of an original." Much has been made of the fact that, in his portrait of Louis, Bernini intended to convey (as he himself says in this same speech to Chantelou) not only his likeness but also the idealized "qualities of a hero." This, however, did not prevent Bernini from inserting on the bust a few homely unshaven hairs just below the king's mouth, as Louis noticed and commented on: see Chantelou, September 11, f.174, e.189–90 ("The Cavaliere added that a freshly shaven appearance lasts only two or three hours, so that for the greater part of the time there is hair on the face; one must endeavor to represent people as they are generally").

23. Baldinucci, i.144, e.78, reports the same praise by Bernini for Louis's *ingegno* and its ability to apprehend beauty, as does Chantelou, August 2, f.101, e.96 (referring to the king's "esprit"). Bernini is constantly praising the king's intelligence in the Chantelou *Journal:* see, e.g., September 9, f.171, e.185; and September 28, f.210, e.235. In matters of art and architecture, Bernini goes so far as to declare the king "the most learned man in the country" (Chantelou, August 12, f.116, e.116). One might of course object: How could Bernini do otherwise, in dealing with a divine-right, absolute ruler with a monstrous ego in whose court he was an utterly dependent guest? Moreover, that Bernini had true reservations about Louis's intellectual development is evident in the artist's lament that in his youth Louis had been given by Mazarin "no opportunities for learning" and now does not surround himself with learned men whose knowledge and experience he could absorb (Chantelou, August 2, f.101, e.96; September 6, f.159, e.171).

24. As Bauer points out, in the end, seventeen "sittings"—not the twenty Bernini predicted upon accepting the commission—were necessary: five in order to draw the king, twelve to work on the marble (Chantelou, June 20, e.38, n.116).

25. This same anecdote is in Baldinucci, i.119, e.53, but not in Chantelou or any other source.

26. Baldinucci, i.199–20, e.53, repeats the same anecdote. The fact of Bernini's trend-setting royal hairstyle is confirmed by no other primary source, even though Mattia de' Rossi's June 26 letter mentions the detail of Bernini's requesting a comb and adjusting the king's hair "with his own hands according to his own way" (Mirot, 218 n.1; also in Chantelou, appendix, f.388). Behind the anecdote, however, lies a polemic, whose memory our two biographers are perhaps trying to dissipate by replacing it with what is possibly a humorous untruth. Bernini's bust was in fact criticized for showing the king's forehead fully exposed, an exposure that Chantelou defended by explaining that "the forehead was one of the principal parts of the head and from

the point of view of physiognomy [the art of detecting qualities of mind and character through physical features] the most important, that it therefore should be visible; moreover the King had a forehead of great beauty and it should not be covered up" (Chantelou, July 22, f.82, e.69).

Despite Chantelou's reasoned defense of this detail, the artist nonetheless, soon thereafter, carved a single, flat curl in the center of the forehead (Chantelou, July 29, f.95, e.88), with less than attractive visual results: "The cutting of this curl, of course, meant that the upper part of the forehead receded into a slightly deeper level of the stone, so that now the bumps [over the eyes, already overemphasized] stand out even more prominently" (Wittkower, 1951, 13). The accomplished portrait sculptor Jean Warin, viewing the bust after the addition of the forehead curl, also found fault with Bernini for having taken too much off the king's forehead (Chantelou, August 19, f.128, e.131).

27. Having learned from bitter experience in doing the *Scipione Borghese* bust in the 1630s, Bernini worked simultaneously on more than one block of marble, lest some crack or other unsightly blemish come to light in the carving process. As Chantelou records, Bernini began blocking out the marble portrait on July 6. Supplementing and clarifying Domenico's simplified account, Bauer (Chantelou, July 6, e.53, n.22) summarizes Bernini's experiences at this stage: "Bernini tried out all three of the blocks he had selected (above, June 21), but, as he had feared, none turned out to be of truly portrait quality (Mirot, 226, n.2). He therefore chose the two best pieces (Schiavo, p. 33) and began to rough-out both, with the aid of his young assistant, Giulio Cartari (Dom. Bernini, pp. 135–36). One of these blocks contained a hidden vein that surfaced in the eye of the portrait, and the other required cautious handling because it was tender and friable (Fraschetti, p. 345, n.1 and below, August 4)."

28. On October 5, Louis came to formally inspect the completed portrait. In responding to the king's praise, Bernini burst into tears and withdrew from the room (Chantelou, October 5, f.224, e.254). Two decades later, the bust was moved from the Louvre to Versailles, where it remains today. Its allegorical pedestal was never executed (Wittkower, 1951, 19). There is no indication in the extant documentation that Louis was anything but completely pleased with the portrait bust (unlike Bernini's later *Louis XIV Equestrian* statue, discussed below). See Vanuxem, 162–63 and 167 n.32, for displays of the king's genuine enthusiasm for the later reinstallation of the bust at Versailles and for the embellishment of its pedestal (1684–85).

29. Marie-Thérèse of Austria (1638–1683), daughter of Philip IV of Spain.

30. See Domenico, 27, who himself uses the same turn of phrase (being "in love with the original") with respect to Bernini's two lively portraits of his father's once-beloved mistress, Costanza. In his catalogue of Bernini's witticisms, Baldinucci, i.148, e.81–82, instead quotes Bernini as repeating the remark to Cardinal Pallavicino in response to the crucifix the artist gave him ("I will say to Your Eminence what I said in France to Her Majesty the Queen"). Chantelou does not record the remark to the queen.

31. Baldinucci, i.120, e. 53–54, reproduces the poem right after the "hairstyle à la Bernini" remark, saying it was the work of "un bell'ingegno" (he does not give the poetic response that follows in Domenico). We find the poem in Chantelou as well (September 19, f. 189, e.209), who identifies its author as the Abbé Butti (or Buti), an Italian member of Louis's court; hence the poem did not come from Rome as Domenico here claims (for Butti, see Domenico, 140, and commentary). It is also included in Cureau de La Chambre's *Éloge du Cavalier Bernin* (Montanari, 1999, 124). Also contrary to what Domenico says here, the poem's subject is not the Louis XIV bust, but its pedestal (never executed and not otherwise mentioned in this biography), which was to contain a clever literary conceit. As Stanić points out (Chantelou, f.189, n.2), the poem and its response are included in a manuscript anthology of verse celebrating the Louis XIV bust in the Bibliothèque Nationale, Paris (Mélanges de Colbert).

32. This response is not by Bernini: as Chantelou explicitly reports (September 26, f.203, e.226), the poem was written by a French man of letters, the Abbé Amable de Bourzeïs (1606–1672).

33. There is no confirmation of this claim in Chantelou or any other contemporary source: it is unlikely that Louis himself would stoop to such abject begging.

34. Chantelou confirms the fact of Bernini's papal dispensation from the Sabbath laws (August 24, f.139, e.146).

35. This presumably is Colbert, although others in the court, like Charles Perrault (First Clerk of Buildings) and Charles Le Brun (official painter to the king), also had reason to fear being supplanted by Bernini, if the king's great esteem and love for the Italian artist were indeed of such sincerity and depth as Domenico would here have us believe. The increasing hostility between Colbert and Bernini is well documented in Chantelou's *Journal,* as is the shrewd Louis's own realistic assessment of the less-than-lovable and esteemable Bernini, despite the public displays of mutual admiration on the part of both artist and king.

36. Bernini may have heard this also directly from Chantelou: August 10, f.113, e.111–12: "On my return home I (*Chantelou*) learned from Mme. de Chantelou, who had come from M. Renard's, that he had told her that there was a cabal of architects intriguing against the Cavaliere and among a large gathering of the profession, only the younger Anguier had taken his part." Bernini himself understood this even before he left Rome, i.e., that the French would oppose any foreigner given the Louvre commission: see the already-cited December 2, 1664, letter to Colbert by Ambassador Créqui in Rome, quoting Bernini to this effect (Depping, 4:548–49). Of course, with his constant criticism of the French and their culture, as recorded throughout Chantelou's *Journal,* the arrogant and undiplomatic Bernini did nothing to win over the opposition and did much to offend even those who were initially predisposed to welcoming his arrival, such as Colbert (see, e.g., Chantelou, July 29, f.95, e.88–89, recording Colbert's pleasure over hearing that Bernini had *finally* "praised something in France").

37. The papal nuncio was Carlo Roberti de Vittorij (see Domenico, 127, and commentary). Chantelou's *Journal* confirms Domenico's claim about frequent visits by the two prelates.

38. Baldinucci, i.124, e.58, also reproduces this letter, with its same separately cited "conclusion," to illustrate how the pope and his nephew, Cardinal Flavio Chigi, lost no opportunity in soliciting Bernini's speedy return home. Describing it as one of two letters Bernini received in Paris from Cardinal Chigi, Baldinucci dates this one to August 4, 1665. In fact, what we have here is a falsification of the documentation, for the two passages in question are in reality extracts from two entirely separate letters from Chigi to Bernini, whose originals are extant: the first, longer passage comes from Chigi's letter dated July 21 (for original, see BNP, Ms. italien 2083, pp. 161–62), while its supposed "conclusion" represents the opening lines of Chigi's letter of August 4 (original in BNP, Ms. italien 2083, pp. 25–26). For the August 4 letter, see note 40 below.

In reproducing the July 21 letter, Domenico and Baldinucci omit several lines (coming after "the Segnatura") regarding the cardinal's eagerness eventually to chat at length with Bernini about what he has found in France by way of art and architecture and his greetings to Abbé Buti. The question is: Who was first responsible for falsifying the status of these two letters, Domenico or Baldinucci? Given the state of the extant originals—to which both biographers presumably had access—there is simply no way one could have mistaken the second letter as the mere conclusion to the first. Let us also note for the record that there are two further extant letters from Cardinal Chigi written to Bernini while he was in Paris: one dated June 29 (original in BNP, Ms. italien 2083, p. 153, beginning "Non mi maraviglio degli onori che si fanno a V.S.") and another dated August 17 (original in BNP, Ms. italien 2082, fol. 96r–v, beginnning, "Fra le cose inaspettate che à me siano mai giunte è stata la lettera di V.S. de' 22 del passato"). As its first line states, Chigi's August 17 letter was written in response to Bernini's letter of July 22, which is extant and has been published by Gould, 71–72. See Chantelou, July 23, f.85, e.74, for Bernini's mention of the fact that "in the last few days he had written to Cardinal Chigi" (in fact, it was just the day before).

39. "Monsignore" is Bernini's eldest prelate-son, Pietro Filippo, who was working in the *Segnature* (plural, as in the original of the letter in the BNP), the papal tribunal divided into the *Segnatura di Grazia* and the *Segnatura di Giustizia* (for which see Del Re, 227–34). As he did with Cardinal Sforza Pallavicino (Montanari, 1997, 50), Bernini must have repeatedly entreated Cardinal Chigi to protect and advance his son's interests within the papal court during his absence,

for all but one (that of August 4) of the four letters that Chigi sent to Bernini in Paris (see note 38) mention "Monsignore" and the progress of his career. In his own narrative, Domenico, 111, makes note of his brother's promotion to the upper levels of the ecclesiastical echelons (la prelatura) and elsewhere mentions his career advancements (pp. 52 and 163), but does not specify the Segnatura.

The latter is true for Baldinucci's biography, as well as Pope Alexander's diary. The papal diary, however, lists other promotions given to Pietro Filippo: e.g., January 30, 1660; January 9, 1663; and April 4, 1666, for which see Morello, 1981, respectively, 328, 334, and 339. As we surmise from remarks of his in Paris (Chantelou, September 7, f.164, e.176), Bernini may have nurtured the hope that his son might one day become pope. For further information about Pietro Filippo, see note 12 to the Introduction.

40. As mentioned in note 38 above, this is in fact the opening of an entirely separate letter, dated August 4, written to Bernini in Paris by Cardinal Chigi. In the remainder of his rather long letter, the cardinal mentions the recent near-mortal illness of the artist's wife and her recovery, sends his greetings to King Louis, reports on his own health, inquires whether Bernini has seen any of "those portraits in wax" in Paris, sympathizes with him on the challenges of designing an altar for the church of the Val-de-Grâce ("since the architecture of that church is so contrary to what we are used to seeing in Rome"), and comments on the progress of construction of his own palazzo in Rome.

CHAPTER XIX

1. See Chantelou, October 17, f.263–65, e.305–7, for a detailed description of the ceremonial laying of the foundation stone and commemorative medal. For the medal, created by Jean Warin (1606–1672), see *Effigies and Ecstasies*, cat. 93. Some scholars have viewed this ceremony as a sham: by this date, alternative plans for the new Louvre had already been solicited from French architects, leading one to conclude that Louis and Colbert had already made up their minds to set aside Bernini's plan in favor of a French solution (see Chantelou, July 30, f.96, e.90; and Stanić's chronology under 1665 and 1667 in Chantelou, f.36). However, speaking against this "sham" theory is the fact that Mattia was obliged with great insistence by Colbert to return to Paris and, over the course of one year, to work on completing Bernini's plan in all its minute detail and producing a formal, highly articulated—and expensive—model in wood and stucco: in his letter to Bernini dated January 23, 1666, Colbert speaks of "having emphatically begged Monsieur not to lose time in sending us Signor Mathia" (après avous avoir conjuré instamment Monsieur de ne point perdre temps a nous renvoyer le Signor Mathia [BNP, Ms. italien 2083, pp. 243–44; see also note 6 below]).

Bernini, as well, continued laboring on the Louvre project: an extant letter from Chantelou, dated January 1666, comments with pleasure on Bernini's work in progress of the two Hercules *colossi* destined for the new Louvre as per his design (Mirot, 265–66; see Schiavo, 1957, 41, for the Abbé Butti's poem in honor of those same Hercules statues. For Butti, see note 2).

2. According to Chantelou, October 19, f.274, e.317, Buti—or Butti, as more often in the sources—was indeed present at this final audience (for which see note 3). Butti here makes his only one, late appearance in Domenico's account of his father's Parisian sojourn, but, as confidant of both Cardinal Antonio Barberini and King Louis XIV, the *abbé* played an important role (mostly behind the scenes) in this chapter of Bernini's life, as we see from his frequent appearances in Chantelou's *Journal* from start to finish.

Before moving to Paris, the Italian-born Francesco Butti (1604–1682) was protégé of and secretary to Antonio Barberini. He preceded the cardinal to the French capital when the Barberini decided a self-imposed exile from Rome was in their best interests in the aftermath of the 1644 election of the hostile Pamphilj pope, Innocent X. At the French court, he obtained the good graces of Mazarin, who used him as intermediary in various affairs, a role that continued under Mazarin's successor, Colbert, if to a lesser degree. (Mirot, 168, characterizes Butti

as having the "allure" of a secret political agent, while Gould, 28, sees him, too innocently, as a "genial busybody.") Granted French citizenship in 1654, Butti is a well-known figure in the history of music, as librettist of noteworthy musical plays and as a decisive contributor to the introduction of Italian opera in France. For his biography, see *DBI*, 15:603–6; Mirot, 168; Chantelou, June 4, f.44, n.5; e.12, n.26; Gould, 28; and the entries, *s.v.* "Butti, Francesco," in the *New Grove Dictionary of Music* and *New Grove Dictionary of Opera*.

3. Chantelou, October 19, f.274, e.317, describes the last audience between Louis and Bernini: he mentions that the "King leant over to answer [Bernini] while he was still bowing and spoke to him apparently most graciously, showing every sign of regard for him," but he does not record the king as making the remark about his deep love for Bernini, which Domenico here attributes to him. Instead, according to Chantelou, f.224, e.254, it was earlier, on October 5, during his official inspection of the finished portrait bust, that Louis expressed his affection for (and to) the artist: responding to the emotionally stirred Bernini, the king "behaved in the most kindly way in the world, and told the abbé Buti, who was near, to tell the Cavaliere that, if he had only understood his language, he would be able to communicate his feelings to him and say many things that should make him very happy and would reveal how warmly he returned the Cavaliere's affection." Domenico does not mention, of course, that just one day before his final audience with the king, in a fit of absolute rage against the French court and, in particular, Colbert, Bernini had threatened to leave Paris without saying a word to anybody, not even the king (Chantelou, October 18, f.268–69, e.311).

4. This is a rare instance in which Domenico's chronology is correct: the distribution of the gifts did occur sometime later on the same day as the final audience with the king (Chantelou, October 19, f.276; e.320).

5. In addition to Baldinucci, i.124–25, e.59, three other sources—Chantelou, October 19, f.276, e.320; Perrault, 75–76; and the *Comptes des Bâtiments du Roi*—record the gifts given to Bernini and entourage in the form of outright cash and promised annual pensions. It would be tedious here to list and compare the differing amounts reported (in confusingly different coinage) by each source. Presumably the most reliable are those of the royal bookkeeper in the *Comptes des Bâtiments du Roi*. The latter ledgers reveal that Bernini was paid 33,000 *livres* (= 11,000 *écus*, = 3,300 *pistoles*, = 3,000 *louis d'or*). See Chantelou, introduction, f.38, for the preceding currency conversion and the contextualizing observation that "[a] modest family could live decently with 25 *livres* per month" at the time. For the *Comptes* figure, see Perrault, 76 n.66; and Chantelou, October 19, e.320, n.231.

Suffice it to say that the amounts involved were extremely generous, and hence proof, in contemporary eyes, of Bernini's exalted worldly status and Louis's virtuous *magnificentia* (magnificence). As already mentioned, the king, in the end, spent over 100,000 *livres* on Bernini's stay in France (Wittkower, 1961, 517 n.3). For the French calumny spread about Bernini's supposed dissatisfaction with Louis's remuneration, see Domenico, 145–46. For subsequent tensions over Bernini's irregularly received French pension, see Wittkower, 1961, 497–502.

6. Mattia returned to Paris at the end of May 1666, remaining there one year; he arrived back in Rome on July 18, 1667 (Menichella, 68). The fact that Colbert was anxious to have Mattia return (see note 1 above) and, when he did return, asked him to give the many finishing details to Bernini's plan as well as construct a (time-consuming and costly) wood-and-stucco model of Bernini's Louvre design (Mirot, 266–67; Menichella, 67–68) would indicate that the decision to reject Bernini's plan was not made until, at the earliest, the spring of 1667, when Mattia left Paris a second time. On March 11 of that year, Colbert is on record as still declaring that the work on the Louvre was going to be carried out according to Bernini's design (Gould, 116). However, the following month, the Parisian agent of the Duke of Modena reported rumors of the imminent rejection of Bernini's design (Fraschetti, 358 n.2).

Several months later, in a letter dated July 15, 1667 (extant original: BNP, Ms. italien 2083, pp. 243–44), Colbert formally communicated to Bernini the king's decision not to adopt his plans, citing, as primary reasons, the great expense and long duration of the construction, which would now prove prohibitive, given yet another imminent war (Mirot, 273; Gould, 117).

According to Perrault, 79, at the end of his second Parisian stay, Mattia agreed with Colbert's criticism of Bernini's Louvre plan, saying "I [Mattia] pointed it out to him [Bernini] many times, but he always answered me by saying that it was not my place to think about it, and that he had brought me only to draw and to carry out his ideas."

We do not know what Bernini's reaction was to the news of the cancellation; it could not have been serene, to say the least. However, it is unlikely that the pious Bernini contemplated suicide because of the rejection, as public rumor subsequently claimed (we know of the rumor from a letter of September 1667 by Christina of Sweden in which she explicitly refutes it [Fraschetti, 276]).

7. We know few details about Bernini's return journey; we know that they reached Lyon on October 30, for Mattia wrote to Pietro Filippo to report the fact (extant letter, BNP, Ms. italien 2083, p. 131). On the journey home, Bernini was accompanied by the young *abbé* Pierre Cureau de La Chambre (1641–1693), to whom he was first introduced by Chantelou on October 18. Having had the opportunity of interacting with Bernini a fair amount during his subsequent year of residence in Rome (Chantelou, introduction, f.16, n.3; Vanuxem, 160 n.17), La Chambre published in February 1681 a fulsome postmortem tribute, the "Éloge de M. le cavalier Bernin."

This "Éloge" has been described (by Montanari, 1999, 106) as the first "biography" of the artist, though its primary purpose is not to set forth the facts of Bernini's life and career. Indeed (at least in its original version), it offers just a little more biographical data than we find in the very first such published tribute, that of the *Mercure Galante* of January 1681 (for which see appendix 2 below). La Chambre later composed what can be considered a kind of prospectus for an intended full-length biography (that never got written), the "Préface pour servir à l'histoire de la vie et des ouvrages du Cavalier Bernin." The "Préface" was published in 1685 together with a revised, expanded edition of the "Éloge." For the complete texts and discussion of La Chambre's two works, see Montanari, 1999; see also my Introduction, section 4.

8. With the same preface about confirming the authenticity of his claims by means of contemporary documentation, Baldinucci, i.120–21, e.54–55, prints the same letter. He also includes a line—removed by Domenico—in which the Jesuit promises a second letter of thanks to de Lionne. Unlike Domenico, Baldinucci also prints Oliva's second, promised letter to de Lionne on i.121–22, e.55–56. The two letters can be found in the published edition of the Jesuit's correspondence: Oliva, 1703, no. 577 (2:10–12) and no. 579 (2:13–14), both undated. Domenico's omission of the second letter to de Lionne is reasonable since the letter regards only Oliva and not Bernini, who is simply mentioned in its first sentence: "The Cavalier Bernini writes to his son Monsignor Pietro that he is astounded by the esteem in which Your Excellency holds me (Oliva) and by the love which you (de Lionne) have condescended to bestow upon me."

Domenico's version of Oliva's first letter to de Lionne differs from that reproduced by Baldinucci, which, however, reflects accurately the text as found in the published edition of the Jesuit's letters. Among the differences of vocabulary, Domenico has, for example, *Cavaliere* for Baldinucci's *architetto* and *codesto gentiluomo; in questa Corte di Roma* for *qui;* the more emphatic *gloria* for the simple *riputazione;* and, most noteworthy of all, *quel grand'Huomo,* for the original *un tanto uomo,* thus inserting into Oliva's letter a favorite and pointed formulation of his own, the same one with which he concludes the biography (Domenico, 180; for the phrase and its significance, see DLO/Pro, 47; see also Domenico, 97).

9. Bernini made a point of acknowledging Oliva's role in his very first conversation with Chantelou upon arrival in Paris; according to Bernini, Oliva had counseled him: "If an angel appeared from heaven telling him that he would die during his journey, he would still advise him to go" (Chantelou, June 2, f.43–44, e.10). As an obvious promotional gesture for his friend Oliva, Bernini repeats the same story later during his Parisian stay (Chantelou, July 23, f.85, e.73–74), adding that he had informed the king of Oliva's decisive role in getting him to Paris. The king responded that he would have de Lionne send a letter of thanks to the Jesuit.

10. Certainly on the personal level, Bernini's reputation in France did diminish as a result of his Parisian sojourn: with his constant, unrepressed criticism of practically all things French, he

did not ingratiate himself with his hosts at the court. "Despite his great success as a papal court-ier, Bernini could not bring himself to do obeisance for the sake of French self-esteem" (Hib-bard, 1965, 171). The French may have continued to consider him a great artist (see Vanuxem for this thesis and the entirely encomiastic January 1681 *Mercure Galante* obituary [appendix 2 below]), but it would have been difficult to think warmly of him as a person, given his conde-scending, narcissistic behavior while among them. In contrast, as far as the Italians were con-cerned, as Morris, 137, rightly points out, there is no indication at all in extant documentation that the artist's failure in Paris "reflected negatively on Bernini in his native country."

11. Mont Cenis (Monte Cenisio, or Moncenisio, in Italian) was then one of the principal alpine passes between Italy and France. Those crossing between the two countries today can instead use the Fréjus Tunnel, which goes through the heart of the mountain.

12. This letter was likely written in response to the one that Bernini mentioned he had sent to Oliva in late July (Chantelou, July 23, f.85, e.74, referring to his letters to Rome written "in the last few days"). There are extant among the Bernini papers in Paris two signed copies of Oliva's letter: BNP, Ms. italien 2083, pp. 39–40 and 157–58. Domenico abridges the text, which Baldinucci, i.122–23, e.56–57, publishes in its entirety. It can also be found in the published Oliva correspondence: Oliva, 1703, 2:18–19, no. 582).

13. The drawing in question, *Saint John the Baptist Preaching* (of which a preparatory sketch is now in Leipzig), was for the frontispiece to the second volume of Oliva's *Prediche dette nel Palazzo Vaticano,* published in 1664, for which see *Bernini in Vaticano,* cat. 71; Lavin, 1981, cats. 65–77; *Regista,* cat. 178; and Sutherland Harris, 1977, cats. 81 and 82. Bernini later provided another frontispiece, the *Multiplication of the Loaves,* for Oliva's *In selecta Scripturae loca Ethicae Commentationes* (1677), for which see *Bernini in Vaticano,* cat. 75; Sutherland Harris, 1977, cat. 97 (misidentifying the Oliva volume in question); and *Regista,* cat. 188. In Paris, in a pious exhorta-tion to Colbert's young, handsome brother-in-law, M. de Ménars, Bernini recommends Oliva's sermons, "in which he would find many excellent things which would help him along the path of virtue and would instruct him in the Italian tongue" (Chantelou, July 23, f.85, e.73).

14. The consummate Baroque diplomat, Oliva is being disingenuous: a public figure of his stature and experience would have known well that there were no secrets in Rome, that busy "theater" of international gossip and intrigue.

15. That is to say, the Louvre will surpass in fame the residences of all the ancient Roman emperors, causing them to be forgotten. The letter is also in Baldinucci, i.122–23, e.57, with a concluding line (omitted by Domenico) about Monsignor Pietro Filippo's exemplary comport-ment in Rome. Unlike Domenico's edited and abridged version, as already mentioned, the text of this letter in Baldinucci respects the original as found in Oliva's published letters (Oliva, 1703, 2:18–19, no. 582).

16. Bernini entered Rome on December 3, as we know from Alexander's diary entry under that date (Morello, 1981, 339). We have no confirmation from other sources of the circumstances under which Bernini was received once within the vicinity of Rome. According to Medici dis-patches from Rome, Bernini's eldest son, Pietro Filippo, had gone to Florence on November 21 to meet his father, who arrived in the city on the following day (Montanari, 2001, 128, docs. 18, 19, and 20).

17. Alexander's diary has no entry for December 4. Instead, two days later, on Sunday, December 6, it lists Bernini (with no comment) as among the pope's postprandial visitors (Morello, 1981, 339). However, we know from a letter of the pope's brother, Mario Chigi, that Bernini did visit with the pope on December 4 (Montanari, 2001, 123 and doc. 25).

18. Baldinucci, i.125–26, e.59–60, instead prefaces the letter by saying that, upon Bernini's return, Oliva was so happy for the success of the artist's Paris sojourn that he, who had played a role in getting Bernini to Paris, could not help expressing his satisfaction by means of this let-ter. In reality, I suspect, Bernini had personally asked Oliva to send this letter in order to help quell the damaging rumors about Bernini's ingratitude toward and ill speaking of the king (see Domenico, 145). Louis XIV (1638–1715) was still alive in the years that Domenico published his biography, hence another reason for emphasizing this particular point. The letter is among those

published by the Jesuit (Oliva, 1703, 2:86–88, no. 645, undated), here shorn of the last few lines that contain no reference to Bernini.

19. "L'ha precipitato in una prodigiosa ingratitudine": I translate the text literally in order to maintain Oliva's deliberately shocking but nonetheless facetious rhetorical paradox involving the words "gratitude" and "ingratitude." In the phrase "despoiled him of both his birth and dominion," Oliva is referring to Bernini's remark to Louis during his penultimate audience in which the artist declared Louis great, not because of the accident of his birth or the fact of his royal office, but because of his own innate spirit (Chantelou, October 5, f.224, e.254). Thus, Oliva begins by claiming, with mock horror, that Bernini had committed an act of monstrous ingratitude by dismissing his patron's sublime birth and office, but then immediately reverses himself, making it clear that Bernini in fact had done something more honorable and more flattering by recognizing that Louis's greatness instead resided in and shone forth from his own person and comportment. (My thanks to Sheila Barker for the preceding observation.)

20. Baldinucci makes no mention of this subject (the malicious gossip). The murmurings about Bernini's supposed ingratitude began immediately after his departure: on October 22, Colbert remarked to Chantelou that Bernini "had not appeared to be very grateful [touché]" for the king's gifts, an opinion that other members of the court expressed, including Louis's brother, who said that the king indeed believed the rumor. Hence Chantelou was advised by other members of the court to write to Bernini, "telling him to send word to M. de Lionne to undeceive the king" (Chantelou, October 22, f.283, e.328).

Chantelou—almost certainly the anonymous "good friend in Paris" that Domenico cites here—wrote to Bernini at least twice and includes copies of these letters (dated October 27 and 30) in his *Journal* (f.284–85, e.329–30). Of Bernini's own letters to Chantelou printed in the Frenchman's *Journal*, only one (written from Lyon on October 30) seems to respond (and then only obliquely) to the report of the gossip. However, the October 30 letter does not match the one that Domenico prints here, except in the cool tone of nonchalance that Bernini assumes (Chantelou, f.285, e.330). Note that the Oct. 30 date is conjectured.

Hence either the artist wrote more than one letter to Chantelou about the slander campaign (the other having disappeared); or Domenico is not really quoting an actual letter but perhaps repeating the older Bernini's later personal recollection of what he had written years earlier to Chantelou. In any case, Bernini may have called this storm down upon his own head: according to Colbert, "The Cavaliere told the Nuncio [that he was dissatisfied with the royal gifts], and the abbé Butti had not denied it." Butti, in turn, told Chantelou that the rumor "was started by the wrong interpretation put on [Bernini's] speech to M. Colbert" (Chantelou, November 8, f.289, e. 332; November 30, f.290, e.333).

21. Another rumor, repeated at the king's supper table by the Maréchal de Gramont, was that Bernini had given an insultingly meager gratuity to the concierge who served his place of residence in Paris: Chantelou, October 22, f.283, e.327. A Medici dispatch from Paris of October 23, 1665, also mentions Bernini's shamefully small gratuities (Montanari, 2001, 127, doc. 14).

22. Assuredly informed about Bernini's parting gifts from King Louis, Pope Alexander may also have been told of the artist's remark regarding the disparity in the rates of his compensation between Paris and Rome, as we might conclude from the laconic entry of the papal diary on December 23, 1665: "M. Febei ci parla del Cav. Bern(in)o e sue altre [provisioni], la Fr(anci) a insinora l'ha d(at)i 30 m(ila) d(ucat)i, che in R(om)a al contrario" (Monsignor Febei [papal master of ceremonies] speaks to us about the Cav. Bernini and his other compensation; France has thus far given him 30 thousand ducats, in contrast to [what he has received] in Rome).

23. See Domenico, 80–81, for Bernini's statue of *Truth Revealed by Time*, executed in the wake of public excoriation for the damage to Saint Peter's, supposedly caused by his bell tower, a charge of which he was later exonerated. The ironic reference in the previous sentence to gold, frankincense, and myrrh is of course to the gifts of the three magi (astrologers transformed into "kings" by Christian piety) to the infant Jesus as reported in the New Testament.

24. Baldinucci, i.126, e.60–61, dedicates only a few lines to the *Louis XIV Equestrian* statue, perhaps out of prudence, since at the time of his writing the fate of the controversial statue

was a matter of great uncertainty and preoccupation for the Bernini heirs. Although finished by 1677, it was ignored by the French court until late 1684, when it was finally sent for by Colbert's successor, Louvois. Baldinucci gives a quick explanation of its poetic conceit but does not mention the infamous smile on Louis's face. He also states that the statue was destined for Paris, even though there was more than one report emanating from Rome to the effect that it was to stay in Rome and be placed in front of the French-controlled church of Trinità dei Monti (Wittkower, 1961, docs. 21 and 33).

Indeed, a design by Bernini dating to 1660 for a monumental staircase for Trinità dei Monti prominently features a colossal statue of Louis XIV Equestrian. The design was solicited (and reworked) by the French agent Elpidio Benedetti, who was subsequently mistaken for its *inventor* (Marder, 1980). The artistically and politically ambitious plan, however, went nowhere, only to be resurrected by Benedetti (again unsuccessfully) in 1668 after the conclusion of the reign of the anti-French Alexander VII. Domenico makes no reference to Benedetti's Trinità dei Monti project; he leads us to understand that from the start the *Louis XIV Equestrian* was destined for Paris.

25. See Audisio, 40, for Bernini's letters to Louis XIV and Colbert, written immediately upon his return to Rome in December 1665 (in the opening of the letter to Colbert, read "December" for the erroneous "October"). A letter dated January 1, 1666, from Colbert responds to Bernini, thanking the artist—a person, he says, "of consummate judgment and extremely refined and delicate taste"—for discoursing so worthily and so widely "in all the courts of Italy" (i.e., en route back to Rome) on the "great qualities of the King his master" (text in Chantelou, appendix, f.405, n.1).

26. As usual, in his account of the origins and execution of the *Louis XIV Equestrian* project, Domenico simplifies and distorts what is a long, complicated, and tormented history. Again, he does so not only for narrative convenience but also, and, more important, for the purposes of whitewashing a chapter in Bernini's life in which the artist did not comport himself, for whatever reason, in the single-minded, exemplary fashion here described by our author.

To the extent that they can be known, the facts of the case—with detailed, documented chronology—have been set forth in Wittkower's thorough 1961 study. The documentation shows that Domenico is wrong, or at best misleading, on (at least) four counts: 1. As there is no real proof (see below in this note) of a formal equestrian monument commission from the French court during Bernini's residence in Paris (and for at least two years thereafter), there was most likely no binding promise by Bernini to do the statue. (Why would the artist commit to spending an enormous amount of money and years of labor to a work of monumental proportions without certainty about its being accepted and compensated?); 2. Unfettered by a formal commission or even binding promise, Bernini did not begin actual work on the statue until several years after his return from Paris: the first mention of the project by Colbert comes only in a letter of December 2, 1667 (in which he formally asks the artist to undertake the project), while marble for the statue was purchased only in late 1668; 3. Not only did Bernini delay beginning the statue even after the purchase of the marble, but he also worked on it decidedly without enthusiasm and had to be constantly prodded forward by Colbert and his delegates in Rome; 4. Although Bernini designed the monument, only Louis's head was carved entirely by the artist, a good portion of the rest of the execution being left to the students of the French Academy in Rome, as both the sculptor and Colbert had agreed would be the case.

Regarding the origins of the project, there are only two vague, fleeting references to the possibility of an equestrian statue by Bernini in Chantelou's *Journal* (August 13, f.118, e.117; and October 12, f.255, e.294) and none in the official French government documentation, until the December 2, 1667, letter from Colbert to Bernini. This silence seems strange in the case of so enormous an enterprise, enormous in terms of expense, time, and an old man's energy. Even stranger is the fact, as Wittkower points out, that "in spite of promises and requests, [Bernini] never sent a drawing of the monument to Paris . . . and even after his death Colbert was still without an exact record of it" (Wittkower, 1961, 513).

As for the artist's lack of enthusiasm, Wittkower further reminds us: "Bernini hesitated a long time—in fact over two-and-a-half years, from December 1667 to the second half of

1670—about whether he should embark on [this] gigantic enterprise" (Wittkower, 1961, 499); see also below note 3 to Domenico, 148. An *avviso* of May 31, 1670, reports that his French pensions have been suspended "for not having fulfilled his promise to the Most Christian King [Louis XIV] made at the time that he was at that court to execute an equestrian statue of His Majesty," but in reality neither Chantelou's diary nor French court documentation mentions the attachment of any strings to that royal pension, despite Colbert's later claim (March 1667) that Bernini was being paid the pension in order to lend a guiding hand to the French Academy in Rome (Wittkower, 1961, 519, doc. 9 and 522, doc. 29).

27. The October 30, 1665, letter from Chantelou to Bernini, which warns him of the slander campaign in Paris, clearly states that the king had not only heard the rumor, but believed it as well (Chantelou, f.285, e.330). It is unlikely that Domenico did not know this, despite the uncertainty he feigns here. Further, there is no evidence of any direct communication from Louis to Bernini after their final audience on October 19, 1665. Moreover, until May 16, 1670, there is clear evidence that "the king was completely uninformed" about Bernini's further artistic undertakings on his behalf (Wittkower, 1961, 522, doc. 28 and commentary).

28. "Singular in each, unique in all," that is, not only is Bernini's talent outstanding in each of the arts of design, but he is also unique in possessing a simultaneous mastery of all of them together. The medal's reverse shows anthropomorphic representations of Sculpture, Architecture, Painting, and Mathematics, and, on its obverse, a finely wrought portrait of Bernini in profile. The medal bears the name of its maker ("F. Chéron"), the year of execution (1674), and the age of the sitter (seventy-six). Baldinucci, i.126–27, e.61, describes the medal right after he mentions the *Louis XIV Equestrian* statue, saying that it was ordered by the king "in order to give further signs of his appreciation and esteem for our artist."

Chéron's medal would appear to be an indication of "the high reputation the artist still had at the Paris court in that year" (Wittkower, 1961, 528), but it is completely undocumented in the primary sources outside of Domenico and Baldinucci. Hence we can know nothing of the true intentions of the French court in deciding to issue it. All we know of the medal's history is what Domenico and Baldinucci tell us and what can be conjectured from the physical evidence of the medal itself. We assume that neither Baldinucci nor Domenico would have dared claim royal patronage of the medal while Louis was still alive (he died in 1715) had it not been true. For the medal, see *Regista*, cat. 13; and *Effigies and Ecstasies*, cat. 6, which points out that "Chéron's portrait appears to depend on no known prototype, so it may be assumed that Bernini sat to the medallist, or to a commissioned draughtsman for this purpose."

Unmentioned by Domenico or Baldinucci is a second medal by Chéron in honor of Bernini, with a profile of the artist and two Latin inscriptions; the medal is undated and undocumented, but Montanari (*Regista*, cat. 12; and 1998b, 420–21 and fig. 71) argues for identifying this medal with the one reportedly ordered by the Bernini heirs shortly after his death (another hypothesis, also discussed by Montanari, dates the medal instead to 1655). As for the maker of these two Bernini tributes in bronze, the talented French medalist Charles Jean-François Chéron (1635–1698), after being taught by his father, went to Rome in 1655, where he received further training in medal engraving under Gasparo Mola, with some study apparently in Bernini's studio as well. Bernini's October 1674 letter of recommendation written to Colbert on behalf of Chéron on the eve of the latter's return to France is extant (text in *Regista*, cat. 13).

In Rome, Chéron also produced large portrait medals of Clement IX (1669), Clement X (1671), and Christina of Sweden (ca. 1674). He returned to France in 1675, summoned by Louis to work on the medallic history of his reign. For the artist's life, see *Grove Art Online*, s.v. "Chéron: (1) Charles-Jean-François Chéron"; for the much-practiced art of the commemorative medal in Baroque Rome, see Montagu, 1996, 73–91 (passim for Bernini's involvement with that genre); for the Roman portrait medal and medallion in our period, see Ostrow, 2008, 65–67; for Bernini and the Roman Baroque medal, see also Michelini Tocci; and Balbi De Caro.

29. It is strange that Domenico would devote so many pages—stretching across two separate chapters—to a statue that its recipient considered an utter failure. By 1711 (the time of his final revision of the biography), he surely knew of its rejection by Louis and its refashioning by

François Girardon (in 1688) into a *Marcus Curtius Riding into the Fiery Abyss*. It is also unlikely that his better-informed readers would have been ignorant of the statue's less-than-glorious fate at Versailles. D'Onofrio believes that these pages on the *Louis XIV Equestrian* were simply written prior to the reports of its poor reception in France and never subsequently revised by the author. In contrast, and more plausibly, Morris, 221 n.599, sees this prolonged discussion of the statue as an attempt by Domenico, well aware of the shabby welcome it had received in Paris, to counteract the bad publicity circulating about the statue.

CHAPTER XX

1. I have translated Domenico's awkwardly phrased and potentially confusing line literally: he makes the bold claim that Bernini's *Louis XIV Equestrian* surpasses even those of its type produced by the ancient Greeks and Romans ("those most fortunate times" are classical antiquity). Of this type of sculpture—equestrian portraits of rulers—the most famous in early modern Italy, and indeed the only one extant from antiquity, was that of Emperor Marcus Aurelius on the Capitoline Hill, long believed, through the Middle Ages, to be Constantine the Great.

Domenico's claim echoes that of Giovanni Paolo Oliva, who in a long letter, dated November 27, 1673, to King Louis's confessor, Jean Ferrier, describes the (yet unfinished) statue in enthusiastic detail and compares it most favorably to the works of the ancients (text in Fraschetti, 360–61 n.2. One wonders whether Oliva sent the letter at Bernini's request to engender favorable publicity at the French court. A copy of Oliva's letter is among his extant papers: BNP, Ms. italien 2083, pp. 21–23).

As for Bernini's desire of "ennobling the final chapter of his life" by means of this statue, Domenico, 167, will make a similar claim about the artist's intentions in sculpting his bust of the *Savior;* see also note 2. For the supposed royal order, see Domenico, 146, and commentary. For the *Louis XIV Equestrian,* see, above all, Wittkower, 1961; but also Gould, 122–34; R. Berger; *Nascita,* 310–29; Lavin, 1999; and Fagiolo dell'Arco, 2002, 120–23.

2. Domenico, 107, makes a similar observation about the marble block used for the *Constantine* statue. Colbert told Bernini to model the *Louis XIV Equestrian* upon his *Constantine,* "changing something in the pose of the figure and horse in order that one will not be able to claim that it is a copy" (Wittkower, 1961, 521, doc. 23). The marble for Louis's statue cost 20,166 *livres* (Wittkower, 521, doc. 20).

3. Domenico's estimation is approximately true, if we assume, following Wittkower (1961, 499, 511), that Bernini finally committed to doing the statue in the second half of 1670 and brought it to full completion in 1677; see also note 26 above to Domenico, 146, for the statue's chronology. Domenico's claim about the extraordinary energy level of the aged Bernini is also true. At the most intense period of the statue's execution, that is, "between the summer of 1671 and the autumn of 1673 Bernini as a rule spent six to seven hours daily working the marble, and this was in addition to other work on which he was engaged in these years—an astonishing feat for a man in his seventies" (Wittkower, 1961, 511). Again, Domenico's claim that this statue contained all of his father's life force (tutti i suoi spiriti) and "the liveliest portion of his art" (il più vivo dell'arte) will later find an echo in his description of the *Bust of the Savior* (Domenico, 167).

4. Which twelve years? Presumably those between the delivery of the marble block in 1668 (Wittkower, 1961, 521 n.28) and Bernini's death in 1680. For the postmortem inventory of Bernini's studio, "where he worked on the statue of the King of France" (as the document specifies), see Tratz, 1988, 426.

5. This remark about the rule of silence in Bernini's studio is digressive, even though Domenico means for it to serve as an introduction to his anecdote about the disapproving visitor. It also appears in Baldinucci, i.139, e.73, but in a completely different context—in the last portion of his *vita* describing Bernini's feverish and totally absorbed state of mind while working. See the Introduction, section 6, for what this means in terms of the complicated intertextual

relationship between the two biographies. We know from both Chantelou (e.g., August 21, f.131, e.135) and the diary of Carlo Cartari (Weil, 1974b, 133, November 19, 1668 entry) that Bernini did not object to having spectators while he worked.

6. Bernini's witty response contains a clever play on words: the original Italian ("pare che diano fastidio li peli") alludes to the proverbial expression "cercare il pelo nell'uovo," to split hairs, to be overly critical. (My thanks to Eraldo Bellini for this observation.)

7. Baldinucci, i.141, e.74–75, reports and replies to this same criticism about Bernini's drapery but in regard to all of his sculpture in general, with no reference to either the *Louis XIV Equestrian* or antiquity. Further, Baldinucci prefaces the passage with a statement not found in Domenico about the "marvelous tenderness" (*tenerezza*) Bernini imparted to his sculpture, from which subsequently, the biographer claims, "many great men who worked in Rome in his time learned."

Cureau de La Chambre's *Éloge* of Bernini also praises the artist's great facility for carving marble, surpassing even the ancients (Montanari, 1999, 124–25). For the criticism of the drapery of the *Louis XIV Equestrian,* see Fehrenbach, 2005, 6–7. For an analysis of Bernini's carving technique by a professional sculptor, see Rockwell, 169–96, and his technical remarks on individual works, passim, in Coliva, 2002. Note that the Italian word *pasta* did not mean the dry food product (which is, even today, more properly *pastasciutta*) but, rather, "dough."

8. "There is a good deal of collateral evidence to prove that Domenico reproduced here the gist of a real conversation. The most telling piece of evidence is, of course, the work itself" (Wittkower, 1961, 503 n.17). We do not know the identity of Bernini's French interlocutor on this occasion, but the fact that Domenico includes such a long, detailed explanation of his father's intended but apparently misunderstood *concetto* is grounds for believing that the biographer was responding to widespread criticism. Yet none of the contemporary reports from Paris or Rome in 1685 relaying the news of the king's dissatisfaction with the statue specifically mentions the smile or indeed any other single feature (e.g., its Baroque exuberance) as cause of the royal displeasure. It was, the latter reports say, simply found to be "così mal fatta e meschina" (so badly done and shabby), "si mal faits" (so badly done, referring in the plural to both the horse and its rider), "così difettosa e mal fatta" (so defective and badly done), and "si vilaine" (so hideous or revolting). The latter quotations come, respectively, from an anonymous Italian *avviso* from Paris, the *Journal* of the Marquis de Dangeau, a letter of Giovanni Battista Lauri (assistant to papal nunzio Ranuzzi in Paris), and an official letter by minister Louvois (for the first two, see Wittkower, 1961, 530, docs. 80 and 81; for Lauri's text, Robert W. Berger, 237–38; for Louvois's letter, see note 14 below).

The controversial and presumably damning smile was not part of Bernini's original conception of the king's demeanor: it is, e.g., not in the fine, highly finished clay *modello* now in the Galleria Borghese (for which see *Nascita*, cat. 32) and is not mentioned in Father Oliva's description of the statue in his November 1673 letter (see note 1 above). The smile is presumed to have been added after Louis's early victories in his war against the Dutch republic: in Cardinal d'Estrées's letter from Rome of July 13, 1672, to Colbert, the French prelate refers to the appropriateness now—pursuant to the military success over the Dutch—of adding further ornaments and trophies of victory to Bernini's statue of the king (Wittkower, 1961, 524, doc. 43).

As for French reaction to the smile, Wittkower comments: "The *Roi Soleil* sculptured smiling for eternity! From the point of view of French court etiquette no worse assault upon seemliness and decorum could be imagined, and the King's negative reaction was a foregone conclusion" (505). For discussion of Bernini's *concetto,* the poetic symbolism of the statue, in addition to Wittkower, 502–5, see Lavin, 1993, 170–71.

9. Again, one has the impression that, regarding the artistic quality of and critical response to Bernini's equestrian statue, Domenico "doth protest too much": for no other work of Bernini's does our author dedicate so much space to the singing of its praises and reporting of its success with contemporaries (at least among the Romans). All of this, one suspects, represents an attempt at covering up and compensating for its failure in the eyes of the most important person, its subject and patron, King Louis. To my knowledge, no one has published or studied these

reported tributes by the Roman orators and poets (see note 10). For Mattia de' Rossi's design for its pedestal, sent to Paris in 1685, see Menichella, 24; and Rossi/*Avvisi*, 20 (1942): 215.

10. That is to say, this anthology of poetry in praise of Bernini's statue remained only in manuscript form. The latter collection, if extant, has not been traced. I did not find it among the Bernini family papers in the Bibliothèque Nationale, Paris (Ms. italien 2082, 2083, and 2084). It is not to be identified with the manuscript anthology of verse elsewhere in the Bibliothèque Nationale, glorifying, according to Stanić, the relations between Louis XIV and Bernini, and intended for publication (Chantelou, f.170, n.5). It is also not to be identified with Carlo Cartari's manuscript compilation of authors mentioning Bernini, collected at the behest of Monsignor Pietro Filippo, most likely for the purposes of the family's biographical project (for which see Montanari, 1998b, 402–3). Montanari, 1998a and 2003, has studied some of the contemporary poetry in praise of Bernini's works, but none of those has the *Louis XIV Equestrian* as its subject. However, Montanari, 1998a, 164 n.103, does provide a list of the few known compositions in honor of the *Louis XIV Equestrian*.

11. Presumably the poem was written ca. 1677, the date of the completion of the statue, when Domenico was twenty years old. As the prodigious quantity of Latin verse produced by seventeenth-century Romans demonstrates, the ability to write poetry formed part of the basic schooling of every liberally educated man in this period. Domenico's poem, overlooked by scholars, "is not lacking in interesting themes useful for the interpretation of the statue and comes from a source, more than 'authorized,' practically from the artist himself" (Montanari, 1998a, 164 n.103). The original is in Latin and in dactylic hexameter (not reproduced in the translation). Its title contains a play on words between *eques* (knight) and "equestrian," which has not been captured in the English. My sincere thanks go to David Gill of the Boston College Classics Department for his generosity in providing this translation.

12. That is, the Dutch on whom Louis waged war, 1672–79.

13. The "Gnoscian maiden" is Ariadne of Crete. There was a constellation called "Ariadne's crown"; Louis is apparently to don this crown upon arrival in the heavens. (My thanks to David Gill for this note.)

14. Domenico is correct about the silence of the French court with respect to the statue between its completion and December 1683, when it was finally sent for by Colbert's successor, Louvois (François-Michel Le Tellier, Marquis de Louvois, 1639–91). On September 16, 1681, the Bernini brothers wrote a letter to King Louis—apparently in vain—seeking clarification about the destiny of the statue (Wittkower, 1961, 529, docs. 69 and 70).

Newly published French documentation—the critical edition of minister Louvois's correspondence—adds further important data about the summoning of the statue and its journey to Paris, e.g., the full text of Louvois's letter to Paolo Bernini, dated December 12, 1683, in which, responding to Paolo's letter of November 1 of the same year, finally and formally announces the king's decision to send for the statue: see Sarmant and Masson, 1:82, no. 227; for various reports of the statue's subsequent passage from harbor to harbor, see Sarmant and Masson, vols. 1 and 2, Index, s.v. "Bernin: *Statue équestre de Louis XIV*." See the same collection (2:438, no. 2007) for the full text of Louvois's letter of October 1, 1685, summarizing the king's reaction to the work: "The equestrian statue of the king by the Cavalier Bernini is so hideous (*si vilaine*) that there is no chance that once the king sees it, he will allow it to remain in its current state"; the letter also mentions sending sculptor François Girardon to Versailles "to examine what can be done to fix (*racomoder*) it."

Although diplomatically feigning ignorance as to the reason for the pre-1683 French silence, Domenico, in likewise diplomatic fashion, lets us know that the obstacle was Colbert—the "ill-intentioned minister" he mentioned earlier—by directly juxtaposing mention of Colbert's death (September 6, 1683) and the arrival of the request for the statue from Paris. According to Wittkower (1961, 512–14), Louvois's interest in Bernini's statue reflected his hatred of Colbert and, by association, any Colbert-sponsored art projects: one of the latter included a rival *Louis Equestrian* statue by Charles LeBrun, which Louvois cancelled in favor of Bernini's.

Also playing a role in the delay, surmises Wittkower, may have been the machinations of Elpidio Benedetti, who wished to see the statue remain in Rome and used in the pro-French monument that he envisioned at Trinità dei Monti. See also Burke, 191–97, for Louvois's "statue campaign of 1685–86," which had the minister populating all of France with monumental representations (especially equestrian) of the king and which presumably would have inclined him even more in favor of making use of Bernini's completed work. However, according to Gardes, the "fever" to fill the country with specifically equestrian portraits of Louis XIV had already begun in 1665 and continued for almost three decades (Gardes, 87–88; 136–37 for his chart of all the *Louis Equestrian* projects—executed or otherwise—for the years 1665–94).

15. Thanks to extensive surviving documentation, we know many of the step-by-step details of the statue's journey from Bernini's studio (July 1684) to its temporary stop in Paris (March 1685) to its transfer to Versailles (September 1685) and its fourth and final reinstallation there at the Swiss fountain, the *Pièce d'Eau des Suisses* (June 1702): see Fraschetti, 361–64; Wittkower, 1961, 529–31; Robert W. Berger; and the more recently published documentation in Sarmant and Masson (see note 14).

Three military ships were necessary for the statue's transportation, for there were reports that both the Genovese and the Spanish (offering a reward of 30,000 *scudi*) were separately plotting to "kidnap" the statue in order to humiliate the French king: see, for the Genovese, Fraschetti, 361 n.2; and for the Spanish, Montanari, 2003a, 412 (the latter article also discusses the immediate fortune of the *Louis Equestrian* statue in general).

16. Note that Domenico does not claim that the king considered the statue an object of admiration, for, in fact, Louis and presumably most at the French court decidedly did not: see note 8 above. Robert Berger has argued that, contrary to what is still often claimed in the Bernini literature about its immediate banishment to a place of obscurity at Versailles, documentation shows that the statue instead "occupied a place of distinction and easy visibility in the gardens of Versailles from 1686 to 1702," at the Neptune Basin (R. Berger, 233).

At the same time, however, documentation makes it extremely clear that from his very first glance at it, the king so disliked the statue that he contemplated having it destroyed. In the end he decided to have it reworked by sculptor François Girardon (who had known Bernini during his long stay in Rome) into a *Marcus Curtius Riding into the Fiery Abyss*. Ironically, this transformation was later to save the statue from the antiroyalist destruction of the French Revolution. Also by ironic coincidence, *Marcus Curtius* had been the same subject that Bernini's father, Pietro, had chosen decades earlier (1616–17) in transforming for Scipione Borghese a sculptural fragment from antiquity, still at the Galleria Borghese (for which see *Regista*, 320; and Kessler, cat. A29.) The final irony of the destiny of this statue was its selection (in the form of a copy in lead) by architect I. M. Pei as the crowning (and sole) sculptural ornament to Pei's much acclaimed remodeling (1985–89) of the main entrance to the Louvre Museum (for which see Hoog).

17. The name of Luigi Bernini (1610–December 22, 1681), sculptor and engineer, appears in numerous documents relating to the career of his brother. (The name of another sculptor brother, Francesco [1604–1627], also appears in the documentation, but only briefly, having assisted Bernini with the 1625 canonization apparatus for Saint Elizabeth of Portugal: see Lorizzo, 355 n.11, noting his appearance as well in another document as restorer of ancient sculpture; for Francesco's dates, see Terzaghi, 101 and n.6.)

Luigi provided a degree of expertise in mechanics, physics, and hydraulics lacking in Gian Lorenzo and without which our artist may never have achieved the success that he did. "[A]s the technical expert in matters of architecture, he worked alongside his brother Gianlorenzo in most of the projects carried out by the latter. As a sculptor he seems to have been no more than the mere executor of his brother's designs and models" (Bacchi, 1996, 784). Mostly a silent figure in the documentation, Luigi is, unfortunately, also known for the crime of sodomy he perpetrated in 1670 (for which see the Introduction, section 5), which caused his brother no end of grief, just as Luigi had earlier done by his love affair with Gian Lorenzo's own mistress, Costanza Bonarelli, in the late 1630s (for which see Domenico, 27, and commentary).

Though still in the dark about much of Luigi's life, training, and career, thanks to recent archival discoveries, we are now in possession of his last will and testament (Fagiolo/*IAP*, 368–71); death certificate, supplying us as well with his exact age (op. cit., 371); and the postmortem inventory of his personal possessions, including his library (372–82). For an expert identification of his book collection, see McPhee, 2000, but see also my Introduction, note 137, for caution in identifying this library with that of Bernini himself.

According to the 1681 inventory of the Bernini household possessions (Martinelli, 1996, 255, c.504r), there were two painted portraits (artist unidentified, but presumably Gian Lorenzo) of Luigi in the family collection: Petrucci, 2006, 334–35, cat. 24, argues that one of them is currently in the Koelliker Collection, Milan, a canvas that instead Montanari, 2007, cat. R14, rejects both as autograph work by Bernini and as a portrait of Luigi (whose physical appearance is unknown). For Luigi, see also *DBI*, 9:375–76; Fraschetti, 103; Bacchi, 1996, 784 (with ample bibliography); Ferrari-Papaldo (*ad indicem*); and *Grove Art Online*, s.v. "Bernini, Luigi."

18. Luigi was twelve years younger than Bernini (see note 17). As Lavin, 2008, 293, points out, "Luigi was also nearly as precocious as his brother, whom he was assisting as early as 1626; from 1630 he is documented as a major participant in the work at St. Peter's." Lavin (294 and figs. 19 and 20) identifies Luigi as the sitter in Bernini's drawing of a youth in the Royal Library at Windsor (#RL5543), as well as the young man seen next to Bernini in the fresco on the vault of the southwest grotto chapel under Saint Peter's depicting Bernini's presentation of his Four Piers design to Urban VIII.

Baldinucci, i.152–54, e.86, discusses Luigi in the more subordinate context of Bernini's *discepoli* (albeit occupying among them "first place"), whereas Domenico here accords him a more dignified status of his own, separate from the collective discussion of Bernini's "students" on pp. 111–14. However, Baldinucci's description of Luigi and his talent is lengthier, more detailed, and more effusive in its praise—perhaps necessarily so, since the memory of the 1670 sodomitic scandal that Luigi created was likely still fresh in readers' minds (see note 17).

Calling Luigi a "good sculptor, better architect, and excellent mathematician," Baldinucci recounts that Luigi devoted himself for a period of time to sculpture, listing his specific works of sculpture (omitted by Domenico except for a brief mention on p. 47 of his work on the *Matilda of Canossa* statue). Luigi, continues Baldinucci, "then devoted himself to civil architecture, mathematics and mechanical engineering, and especially to the calculation of the forces and measurement of enclosed bodies of water," citing his vital collaboration on the erection of the Piazza Navona obelisk and the Scala Regia. Baldinucci then informs us that, although Luigi (as Superintendent of the Works of the Apostolic Palaces) worked as a subordinate to Bernini (who was official Architect of Saint Peter's), the latter very often let Luigi work by himself without interference, "being certain that his brother would not err" (i.153, e.86). Finally, Baldinucci, i.154, e.87, mentions that Luigi is still alive and well at sixty-nine years of age, even though by the time Baldinucci's biography was finally published, he had in fact died (on December 22, 1681).

19. Baldinucci, i.153–54, e.86–87, also mentions Luigi's inventions, supplying a bit more technical description and background detail: the tall mobile tower for cleaning and other maintenance jobs in the basilica (in use at Saint Peter's until the early twentieth century), the organ mover, the industrial-size scale, and the heavy-duty hauling machine used for transporting the massive stones of the colonnade. Note that Domenico ineptly conflates the latter two inventions into one; for the same two inventions by Luigi, see Marconi, 2004, 174–79 (scale) and 219 (hauling machine). Baldinucci says the tower was ninety *palmi* in height, whereas Domenico (characteristically) increases that to one hundred.

For an engraving and early twentieth-century photograph of Luigi's portable tower, see Scott, 1993, figs. 30 and 32. It was Luigi's duty, by the way, to keep the Baldacchino clean ("deputato a tener netto il Baldacchino della Confessione"), a salaried office later given to Mattia de' Rossi in May 1680 (Menichella, 73).

20. For Bernini's design of the Chigi Palace at Piazza SS. Apostoli, see Domenico, 108, and commentary.

21. For the earlier discussion of the Cathedra, see Domenico, 109–11. It was unveiled on January 17, 1666. For a detailed contemporary description of the unveiling ceremony with Pope Alexander in attendance, see Battaglia, 1943, 229–31, doc. 505.

22. Domenico is incorrect: Alexander started discussions with Bernini about the tomb early in his papacy, in August 1656. This initial planning went nowhere because of the pope's other priorities, not because of his death (Bernstock, 1988, 171). However, even prior to his election to the papacy, indeed from his youth, Alexander suffered poor health (Bernstock, 170; EncPapi, 3:343) and was quite mindful of death: he even kept a coffin and a marble skull, ordered from Bernini, in his bedroom from the start of his pontificate (M&MFagiolo, cat. 209; and Bernstock, 1988, 171 n.16). Domenico returns to the topic of Alexander's tomb on p. 166, describing its completion.

Baldinucci, i.130–32, e.65–66, devotes one long passage, with detailed description, to the papal tomb, where, he says, "Bernini's genius shines forth with its customary vitality." Baldinucci also informs us that Bernini's design was approved before the pope's death by both Alexander and his nephew, Flavio, adding that the artist also "modeled [the tomb] with his own hands." Yet Bernini did little or nothing of the actual execution (perhaps giving only final touches to the pope's portrait). He was paid 1,000 scudi on October 7, 1672, for the design and small-scale model (Wittkower, cat. 77).

No mention is made by either biographer of the ill-starred later plan (design and initial execution in 1667–70) by successor Clement IX to place Alexander's tomb, along with his own, in a new, enlarged, and much embellished tribune of Santa Maria Maggiore (for the latter controversial and failed project, see D'Onofrio, 1973, 29–54; Marder, 1998a, 311–14; Anselmi, 2001, 32 for the 1667 commencement date; and Roberto, 260–87). After going through a series of design changes (drawings are extant) and other vicissitudes (above all, the Santa Maria Maggiore phase), construction of Alexander's tomb was finally begun in 1672 and ended in early 1678. For the tomb's history and design, see Wittkower, cat. 77; Bernstock, 1988; Angelini, 1998b, 185–97; Koortborjian; and Zollikofer, 1994.

23. Alexander died on May 22, 1667. Bernini designed the catafalque in his honor in Saint Peter's: see Fagiolo dell'Arco, 1997, 447–48; and 2002, 160, 165–66, for contemporary descriptions.

24. That is, the pope gave his nephew, Cardinal Flavio Chigi, responsibility of overseeing the project through to its completion. For Cardinal Flavio, see Domenico, 108, and commentary.

CHAPTER XXI

1. Baldinucci, i.127, e.61–62, likewise cites the new pope's "not little friendship" with Bernini dating to the Barberini years, as well as his gifts as poet-playwright. Born in Pistoia, the Tuscan Giulio Rospigliosi (1600–1669) first arrived in Rome in 1614, sent there to study with the Jesuits at the Collegio Romano. After subsequent university study in Pisa, he returned to Rome, beginning an ecclesiastical career and progressive ascent up the totem pole of the church hierarchy that culminated in his election to the papacy in 1667. His talent for poetry was genuine: "The poetic work of Rospigliosi, expressed mostly in the production of musical dramas, assumed a determining role in the evolution of Roman musical theater" (EncPapi, 3:356). However, his reign as pope was brief, beginning June 20, 1667, and ending with his death on December 9, 1669. For Clement's life and career, see EncPapi 3:348–60; D'Affitto and Romei; and D'Affitto.

For Bernini's works for Clement IX, see Sebastiano Roberto's exhaustive 2004 monograph (which includes an essay by Marcello Fagiolo). For Rospigliosi's theater, see Hammond, 1994, passim; and Romei. See also Romei's documented Web site, Banca Dati Giulio Rospigliosi: http://www.nuovorinascimento.org/rosp-2000/home.htm.

2. Both Domenico and Baldinucci lead us to believe that Bernini and Rospigliosi collaborated on several dramas for the Barberini, yet until now the only documented case of

collaboration by the two men on a Barberini theatrical production was the *Fiera di Farfa* inter-mezzo for the play *Chi soffre speri* (Let he who suffers, have hope) in its 1639 reprise (Hammond, 1994, 237; see 235–43 for that production).

Most recently, however, Sheila Barker has discovered a 1656 Medici *avviso* from Rome that speaks of Bernini's scenery design for the play *Dal male il bene* (Good out of evil), commissioned by Cardinal Francesco Barberini in honor of Christina of Sweden and adapted by Giulio Rospigliosi from a Spanish source, apparently Calderón de la Barca (the *avviso* and related research will be published in Barker's book-in-progress, *Bernini in the News: Gian Lorenzo Bernini and Roman Avvisi in the Medici Granducal Archive*).

Although there is no reason to doubt Domenico's claim here about the deep friendship and esteem between Bernini and Giulio Rospigliosi—given their overlapping interests and activities as members of the Barberini circle—as research now stands, the only documentation illustrating that relationship until 1667 are the sparse facts relating to the 1639 and 1656 Barberini produc-tions. No letters or other written communication between the two men have thus far been found, and likewise no other *avvisi* or diary entries attesting to the nature or frequency of their direct interaction.

3. In briefer terms, Baldinucci, i.128–29, e.62–63, reports the same facts of Bernini's inclusion at the pope's table, usually as the sole guest. Baldinucci also recounts there the anecdote of Bernini's humbly requesting the pope's word of "consolation" before leaving his presence. As for the fact of Clement and Bernini dining alone, contemporaries would have understood this as an extraordinary sign of friendship and an even more extraordinary privileged access to power: to have the ear of an absolute sovereign all to oneself!

4. It is ironic that Clement would be "pitying" (compassionando) Bernini's "advanced age," since the pope himself was only two years younger than Bernini and in a much poorer state of health.

5. Like all the "direct" speech quoted in Domenico's text (and always placed in italics by our author), this reply is given in third person in the original; in this case, I have converted it to the first person, in addition to adding the quotation marks.

6. We are expected to believe the fact of yet another and equally improbable "first day" interview with the new pope, as in the case of Urban VIII and Alexander VII (see Domenico, 24 and 95). In the course of that "first-day" interview, according to Baldinucci, i.127, e.62, Clement also "gave rather lively demonstrations of his love" for Bernini.

As for the requested fountain work that resulted in Bernini's clever invention (also in Baldinucci, i.127–28, e.64), it seems improbable that a reasonable man like Clement would have expected such a complicated job of hydraulic engineering, architecture, and sculpture to be accomplished in one day. Neither biographer informs us of the identity of the poor servant(s) who had to stand there turning the wheel of Bernini's invention for however long it took the pope to fall asleep! In any case, in concocting the latter device, the artist undoubtedly made recourse to the standard, well-developed techniques of theatrical sound-effect machinery.

7. Similarly Baldinucci, i.145, e.78, speaks of Bernini's creative application and consci-entiousness equally in the design of a lamp as of a "very noble edifice." It is true that Bernini's inventive talent extended even to such small decorative objects, as illustrated in the case of the lace collar on the *Louis XIV* marble bust: regarding the latter, as Chantelou reports to the admir-ing king, "The Cavaliere had not followed the design of the [actual lace collar] left with him but had invented a lovely sequence of flowers and foliage from his imagination" (Chantelou, September 30, f.214, e.241). See Domenico, 103, for Bernini's design of the coach given as a gift to Queen Christina by the pope.

For Bernini's extensive design work in the realm of the decorative arts (with the talented Johann Paul Schor of Innsbruck [1615–74] as his frequent collaborator), see Gonzalez-Palacios, 1970; *Regista*, cats. 124a–b, 142a, 143a–b–c, 151, 158, 159e, 160, and 162, and, in the same volume, the essay by Gonzalez-Palacios, 185–230; *Effigies & Ecstasies*, cats. 148 and 150, and in the same volume, the essay by Clifford, 37–44, passim; and Fagiolo dell'Arco, 2002, 147–56.

8. The bridge in question was in ancient times called the *Pons Aelius* (dedicated A.D. 134), named after Emperor Hadrian (Publius Aelius Hadrianus), who built it to serve as a sumptuously embellished passageway to his tomb, the Mausoleum of Hadrian, now known as the Castel Sant'Angelo. During the reign of Pope Gregory the Great (r. 590–604), both the bridge and mausoleum were renamed after Saint Michael the Archangel, who, according to pious legend, appeared above the tomb to signal the cessation of a deadly pestilence that had struck the city.

In the seventeenth century, it was only one of two functioning bridges over the Tiber River in Rome proper (the other being the Ponte Sisto) and the only major bridge crossing the river in the most densely populated portion of the city, hence its great importance for circulation of traffic and military defense. For devout Christians (especially pilgrims), it was also endowed with religious significance not only because of its historic connections with Saint Michael but also, and more important, because of its role as privileged entrance to the sacred precincts of Saint Peter's (for the latter role, see Lavin, 2005a, 182–209).

9. This well-documented project began early in Clement's reign: the first purchase of marble for it occurred in September 1667, just two months after the new pope's election. However, dying in December 1669, the pope did not live to see its full completion (that occurred in spring 1672, under his successor, Clement X). Before his death, Clement was at least able to admire the bridge with five of its ten angels installed in September 1669 (Weil, 1974b, 34). The remodeling and embellishment of the bridge represented a more complicated project than either Domenico or Baldinucci indicates.

As architect of the project, Bernini had responsibility, not only for the design of the bridge and its angelic ornamentation, but also for the many other architectural-engineering tasks implicated in the multifaceted restoration (for which see Weil, 1974b, 28, 35, and 40). For the project, in addition to Weil's 1974 monograph, see also D'Onofrio, 1981, 81–97; *Regista*, 93–104; Minozzi in *Regista/Restauri*, 77–83; Lavin, 2005a, 182–209; and Roberto, 137–53.

10. Baldinucci, i.147–48, e.81, reports a similar remark in his very brief account of this commission, inserted in the midst of a discussion of Bernini's theories and notable sayings at the end of the chronological portion of his *vita*. Baldinucci also mentions that Bernini conceived of his angelic ornamentation "in order to allude to the ancient name of the bridge," a connection that Domenico did not explicitly make.

As for Bernini's personal delight in the sight of water—a soothing balm to his fiery nature—we have this famous scene from Chantelou, July 31, f.100, e.94: "Our evening drive was rather short; he wanted to go on the Pont-Rouge [the bridge over the Seine at the Tuileries] and stopped the coach on it for a good quarter of an hour, looking first from one side of the bridge, and then the other. After a while, he turned to me and said, 'It is a beautiful view; I am a great friend of water; it does good for my temperament.'"

11. There are ten angels in total. The "superscription of the cross" is the scroll bearing the Latin abbreviation "INRI" (Jesus of Nazareth King of the Jews), which, according to the New Testament, was nailed by the Romans to Jesus' cross. Contrary to Domenico's claim, and like most of his sculpture in the last several decades of his life, neither statue was entirely by Bernini's hands. On August 17, 1668, Bernini and Paolo were each paid 700 *scudi* for their two statues (Weil, 1974b, 32).

In his diary entry for September 26, 1668, Carlo Cartari reports being told (by Pietro Filippo Bernini's secretary) that father and son were each working on a separate angel, whereas later, on January 3, 1669, when visiting the Bernini studio, Cartari witnessed Bernini and his son working on the *Angel Carrying the Crown of Thorns,* while another assistant was working on the *Angel Carrying the Superscription* (Weil, 1974b, 33). Yet why is there no mention at all of Paolo Bernini by Domenico or Baldinucci in their accounts of the Ponte Sant'Angelo?

Perhaps the two biographers knew what connoisseurs, on the basis of the visual evidence, have come to conclude today, that Paolo's actual role in the execution of "his" angel (carrying the crown of thorns) was in fact negligible or nonexistent: "Despite the repeated mention of the name of Paolo Bernini in the Cartari diary and the papal chirograph . . . with respect to the execution of one of the two angels, scholars today, it would seem, are in agreement about the

impossibility of discerning any trace of [Paolo's] intervention in the extraordinary workmanship of the two angelic figures" (Minozzi, in Coliva, 2002, 251).

For the restoration of the bridge's angels in the 1980s, see Cardilli Alloisi, whose edited volume also includes much on the history and decoration of the bridge, with an extensive appendix of primary sources.

12. Domenico's simplified account of the events in question is erroneous on several counts. Our author makes it appear that, in a case of cause-and-effect, the primary reason for the pope's visit was to order Bernini to remove—or, not to place—his statues on the bridge. Baldinucci, i.129, e.63, makes no such claim, stating, simply and more accurately, that "that pontiff as well, in emulation of his predecessors, wished to go in person to the artist's home in order to see his works of art."

Clement IX's visit to Bernini's home—the only one of his short reign—is recorded in a document in the archives of the Vatican Secretariat of State, according to which, on Sunday, July 28, 1668, in the course of a long day of visiting various churches and other sites (including the bridge), Clement also stopped "at the studio of the Cav. Bernini in order to see the statue that he had done of the great Emperor Constantine that is to be placed facing the portico of the basilica" (Roberto, appendix I, 307).

Note that there is no mention of the statues of the angels as motivation for this papal visit. Note also that Domenico (p. 106), instead, had claimed, and erroneously so, that this goal—to view the recently completed statue of *Constantine*—was the reason for Alexander VII's second visit to Bernini's home (whereas, as noted, the *Constantine* statue had been far from completion at the time of Alexander's visit). In fact, neither of the two Bernini angels in question was finished at the time of Clement's July 1668 visit: on January 3, 1669, Bernini told Cartari that the two statues were about two months away from being ready for installation (Weil, 1974b, 33). For Domenico's further inaccuracies regarding these angel statues, see note 13.

13. This anecdote is also related by Baldinucci, i.129–30, e.64, with the same jocular (but otherwise undocumented) response from the pope and same comment about the marvel of an old man carving "three statues larger than life in the space of no more than two years." Here, too, Domenico and Baldinucci are wrong on more than one count. Contrary to what our two biographers claim, documentation (the Carlo Cartari diary) shows that, even before the two Bernini angels were completed, the pope had already begun (by February 15, 1669) to consider sending them to his hometown of Pistoia (where he was aggrandizing the family name through the usual acts of architectural patronage); the actual decision to do so was made in late June or early July of that same year (Weil, 1974b, 33).

While it is true that Clement did order two copies made of the Pistoia-bound angels, he did not live to see them executed, nor was the execution of either copy done by Bernini, despite the claims to this effect by both Domenico and Baldinucci (in his appended catalogue of Bernini's works): in 1670 and 1671, Paolo Naldini and Giulio Cartari were each paid a total of 700 *scudi* for sculpting the two copies, the same amount that Bernini and Paolo were given for the originals, which would indicate their responsibility for the complete execution (Weil, 1974b, 34; D'Onofrio, 1981, 87, while noting its inferior quality, argues, unpersuasively, that Bernini himself did the copy of the *Angel with the Superscription,* using Giulio Cartari merely as a "cover").

The two originals, by the way, never left Rome: they remained in storage until March 1729, when Prospero Bernini (son of Bernini's son, Paolo Valentino) donated them to the family parish church of Sant'Andrea delle Fratte, where they remain today (Weil, 1974b, 33). For the two angel statues by Bernini, see also Tratz, 1988, 443–53; Negro, 1999, in *Regista/Restauri,* 67–75; and Coliva, 2002, 248–61.

14. This would indeed be "cause of sheer amazement" if it were true, but it is not, as pointed out in note 13.

15. For the text of the inscription, placed on the bridge by Clement X in 1672 and commemorating his predecessor's modesty in this regard, see Weil, 1974b, 35. Clement IX's pontifical motto was, appropriately enough, *Aliis non sibi clemens* (Benevolent to all except himself (*The Papacy: An Encyclopedia,* 1:349).

16. Baldinucci, i.129, e.63, reports this same episode.

17. The two daughters are Agnese and Cecilia, as mentioned above (Domenico, 53). The absence of the rule of cloister meant that the women were able to leave their monastery on occasion.

18. Domenico's adjective, "little" (piccola), is intended here as a term of endearment, not size, because Bernini, in fact, had nine children, as our author well knew!

19. Namely, the "arm" to the left of the basilica, if one is facing its facade, finished only in 1667. The "Holy Office" was the Inquisition. See above, Domenico, 99–100, and commentary, for the earlier mention of the colonnade (or portico, as Domenico prefers to call it) and the chronology of its construction, as established by del Pesco, 1988.

20. A *cordonata* is a ramp with shallow steps. The most famous one in Rome is that designed by Michelangelo leading up to the Capitoline Hill. Bernini's much smaller and easy-to-miss *cordonata* in Saint Peter's Square (more specifically in the so-called Piazza Retta) is fan-shaped. It is identified as a separate feature unto itself in Fontana's *Tempio Vaticano*, 381 (fold-out map), "Pianta del Tempio Vaticano e Portici, n.11, "Padiglione che ascende alla Piazza pensile." Baldinucci, i.129, e.63, also notes this eminently convenient contribution by Bernini calling it a "scala a bastoni," *bastone* (sing.) here having the technical architectural meaning of torus: ring or convex molding.

21. This failed project, dating to the very last months of Clement's papacy, is not mentioned by Baldinucci, perhaps because it was still a painful subject for both the Bernini family (angered and humiliated by the vitriolic anti-Bernini invective it generated) and the Roman public (angered at the wasted expense and destruction of ancient mosaics that it caused, even before it was aborted). Domenico, for his part, reports it here in all alacrity, as if oblivious to any of the bad blood attached to its memory. Yet he is unlikely to have been truly oblivious to the horrendous public-relations consequences of this episode, for his brother Pietro Filippo had been at that time, and for many years thereafter, canon of that same basilica, which also contained the Bernini family tomb.

The aborted project involved the enlargement and embellishment of the apse of Santa Maria Maggiore in order to house the tomb monuments of both Clement IX and his predecessor-benefactor, Alexander VII (see Domenico, 154, and commentary). See BNP, Ms. italien 2084, fols. 152r–155v, for two sets of formal responses, among Bernini's personal papers, to the various objections raised against his ambitious apse design.

After Clement's death, the project continued for a short while until public opposition (including that of the Rospigliosi heirs) became too great, leading to Bernini's humiliating dismissal from the job in May 1670. He was replaced by the younger Carlo Rainaldi, who designed the more modest sheathing of the ancient apse one sees today. This episode represented yet another of the heartbreaking failures that marked Bernini's professional and personal life in the early 1670s and probably led to the family's apologetic biography project: see the Introduction, section 5, esp. note 69.

Bernini's defeat in this commission also occasioned the artist's drawing of the *Blood of Christ* (*Sangue di Cristo*) composition, meant as an act of pious retaliation and personal professional vindication ("darà a vedere essere impareggiabile nella sua virtù"), according to a contemporary *avviso*. The drawing will later be discussed by Domenico (170), in more hagiographic terms, as part of the artist's preparation for death. For the connection between the drawing and the failure of the basilica apse project, see D'Onofrio, 1973, 51–53 (53 for the quoted *avviso*, also in Anselmi, 2001, 70, under August 1670).

Another document, a letter by the d'Este agent in Rome accompanying Bernini's gift of the engraved drawing to the Duke of Modena, simply says that the composition was created for the utility of all viewers and "to the glory of the offering that is made to the Eternal Father of the most precious blood of Christ" (published by Imparato, 142–43; but see Jarrard, 2002, 416, specifying the correct year, 1670, and nature of the gift, i.e., it was not an autograph copy of the drawing). For the apse project, see also D'Onofrio, 1973, 29–54; Anselmi, 2001; Marder, 1998a, 311–14; Roberto, 260–87; and Zollikofer, 1998.

22. Among the few extant presentation drawings by Bernini depicting saints or other devotional scenes, only one has been identified as having probably been a gift to Clement IX, that of the *Holy Family*, now in the collection of the Rospigliosi heirs at the Galleria Rospigliosi-Pallavicini (see Sutherland Harris, 1977, cat. 85).

In Paris, Bernini made a few such pious drawings to present as gifts, including *The Penitent Saint Jerome*, given to Colbert on October 19 (Louvre; Sutherland Harris, 1977, cat. 83), and the *Holy Family*, given to Mme. de Chantelou on October 20 (private collection; see Chantelou, f.279 and f.454, fig. 46; and Dreyer). Chantelou also reports that Bernini "told me that each year in Rome he made three drawings, one for the Pope, one for the Queen of Sweden, and one for Cardinal Chigi, and presented them on the same day" (Chantelou, September 30, f.213, e.240).

23. For Bernini's drawings, see also Domenico, 27–28, and commentary. The individual here in question has not been identified, although he may be one of the Bernini household servants listed in the annual family census from 1643–81 (Fagiolo/*IAP*, 343–49). Lavin (1980, 3) puts forth the tentative suggestion that the core of the extremely large collection of drawings (spanning decades of Bernini's life) now in Leipzig may be traceable to this Bernini employee, since the nature of the Leipzig collection leads one to suspect that it came from the Bernini studio as a group.

It might be relevant to note that one of the few Bernini drawings with some indication of provenance is the academic study (*academia*), *A Male Nude from Behind*, in the Royal Collection at Windsor Castle, which bears an inscription from French sculptor, Michel Maille (active in Rome from 1678–1700 as "Michele Maglia"): "Purchased from Cesare Madona on April 7, 1682." Whitaker and Clayton (cat. 136, p. 368), who have most recently published the drawing, conjecture, "The 'Cesare Madon[n]a' from whom he bought the sheet may conceivably have been the widow of Giovanni Cesari, a sometime assistant of Bernini," but do not tell us where in the primary sources they found Giovanni Cesari, a name unknown to me.

24. For Rinaldo and his special friendship with Bernini, see Domenico, 99, and commentary. What Rinaldo (shrewd cardinal-protector of the French crown in Rome) actually accomplished, outside the realm of mere pragmatic politics, to merit Domenico's label of "that sublime genius," is unclear. See Baldinucci, i.152, e.85, for the same record of Rinaldo's esteem for Bernini, as well as the gift ring "with five diamonds worth 400 *scudi*" and the basin of equal value.

Baldinucci specifies that Bernini's "slight amount of work" consisted of "checking whether the design for a certain fountain in his famous garden at Tivoli had been correctly executed by means of a small touch of his hand upon certain stucco ornamentation." Bernini's letter of June 15, 1661, to Rinaldo confirms this inspection and adjustment work of his at the Villa d'Este (text in Fraschetti, 229 n.1).

Neither biographer mentions Bernini's more substantial—though poorly documented—work on the fountain of the *Bicchierone* and the Water Organ, at the same d'Este property and in this same period, 1660–61 (for which see Wittkower, cat. 80; and Jarrard, 2003, 184). Bernini's drawings, dating to 1652, furthermore, are extant for small fountains for the Este family for the ducal summer palace at Sassuolo, south of Modena (see Wittkower, cat. 80; and Jarrard, 2003, 184). In the late 1660s, Bernini was also engaged by Rinaldo to help redesign the Palazzo Sannesi (behind the Pantheon; now Palazzo Maffei-Marescotti) as his permanent Roman residence (Jarrard, 2003, 177–84).

25. Baldinucci, i.130, e.64, briefly mentions Clement IX's death, but with no reference to the Duke of Beaufort's demise or the Candia defeat. For Domenico, author of a two-volume history of the papal military campaigns against the Turks (see the Introduction, section 3), this episode would understandably command more attention. See note 26.

26. The colorful and not entirely savory ex-Frondeur François de Vendôme, Duke of Beaufort (1616–1669), was one of the illegitimate grandsons of King Henry IV of France and thus a cousin to Louis XIV. His august naval commission was the result of family connection rather than military expertise. Having arrived in Candia on June 19, 1669, he lost his life there shortly thereafter on June 25. Candia was the capital city of Crete, but the whole island was then also known as the "Kingdom of Candia." The Christian war with the Turks over Candia began

in 1645 and ended in 1669 with the Venetian surrender of the capital to the Ottomans, pursuant to the abject defeat here mentioned.

The "Duke of Bouillon" is Emmanuel Theódose (not Théodore) de la Tour d'Auvergne (1643–1715), and nephew to the same famous Maréchal de Turenne mentioned by Domenico, 127. Before his ascent to the cardinalate, his titles were, more correctly, the Abbé de Bouillon and the Duke of Albret. He owed his cardinal's hat, above all, to his uncle the Maréchal, who petitioned Louis XIV, who in turn petitioned the pope, who was all too happy to grant the request in view of France's cooperation in the Candia expedition. However, Bouillon was not formally elevated to the cardinalate until August 5, 1669, hence after the departure of the Beaufort expedition. He died as bishop of Ostia and was buried in Bernini's church of Sant'Andrea al Quirinale. For his life, see *Dictionnaire de biographie française* (1954) 6:1323–25; for the story of his elevation to the cardinalate, see Bérenger, 488–92; for a portrait at Versailles by Gaulli of the extremely juvenile-looking cardinal, see Petrucci, 2008, 1:75, fig. 107.

Contrary to Domenico's pious explanation, King Louis wanted the papal ensign—rather than the French flag—to fly over the French ships, not out of love of the cross or the papacy, but because of France's national interests, which depended on maintaining an amicable rapport with the Turks. As Pastor (31:93 and 424) observes: "Not only was the Most Christian King [Louis] a friend of the Turks, he was likewise eager to continue Mazarin's anti-papal policy. . . . The whole expedition [to Candia] was to be carried out in the name and under the banner of the Pope because Louis XIV was unwilling even now to break off diplomatic relations with the Porte [the Ottoman Empire]." Pastor, 31:424, describes the pope's gift as "a magnificent scarlet banner adorned with the image of the Crucified and the inspiring inscription: *Dissipentur omnes inimici eius:* Let all his enemies be scattered."

27. For the Beaufort catafalque of September 28, 1669 (executed with the collaboration of Johann Paul Schor), see Fagiolo dell'Arco, 1997, 475–78; and Roberto, 82–84. According to contemporary reports, Clement grieved the duke's death more profoundly and more publicly than that of his young nephew, Tommaso Rospigliosi, who died in early August of that same year (Roberto, 83).

28. "Monsignore" is Pietro Filippo Bernini, mentioned on previous occasions as the recipient of other ecclesiastical offices and benefices, as rewards for his father's efforts on behalf of the papacy. Suppressed in 1870 with the unification of Italy, the Sacra Consulta was one of the papal tribunals, having purview over nonecclesiastical court cases (see Del Re, 346–50).

29. Born in Rome, Emilio Altieri (1590–1676) served as "Maestro di Camera" (superintendent of the papal treasury) under Clement IX, who, just weeks before his death in December 1669, promoted the already elderly man to the cardinalate. The seventy-nine-year-old Altieri was elected pope (on April 29, 1670) as a compromise to terminate a deadlocked and painfully long conclave. Shortly after his election, Clement adopted as his legal nephew, Cardinal Paluzzo Paluzzi degli Albertoni (1623–1698; cardinal as of 1664), whose own nephew, Don Gaspare Albertoni, had married Clement X's niece, Laura Caterina Altieri. (Both Gaspare and his father, Angelo, also legally assumed the Altieri name, since the Altieri family was without male heirs.) Much of the actual governance during Clement's reign was done by Paluzzo (*EncPapi* 3:360–68; and the documented Web site: http://www.fiu.edu/~mirandas/cardinals.htm).

Domenico devotes only one page to this pontificate, giving no indication of the considerable tensions between his father and the pope and papal nephew, created in large part by Luigi Bernini's crime of sodomy (which occurred in December 1670). To secure Luigi's exoneration, Bernini was obliged to labor, free of charge, for the Altieri: in addition to the famous *Ludovica Albertoni* statue mentioned below, at no cost to the pope or his family, Bernini also designed a series of decorative statues (executed by his workshop) for the Palazzo Altieri (Piazza del Gesù), then under reconstruction.

For the courtyard of the same palazzo, as we learn from a contemporary *avviso di Roma* (October 11, 1670), Bernini was also apparently commissioned to do an equestrian statue of papal nephew Don Gaspare, but the work—a ludicrous act of gross egoism on the part of a mere "don"—never saw the light of day, even, it would seem, in the form of preparatory sketches

or *bozzetti* (for the *avviso,* see Martinelli, 1959, 207; see also Wittkower, cat. 81, 36a). Despite the lack of completely cordial relations with the papal family and contrary to earlier accounts of Bernini's career during the Altieri papacy, Altieri did not strip Bernini of his title of *Architetto della Camera Apostolica:* see Anselmi, 2001, 51. For Bernini's rapport with and works for the Altieri family, see Martinelli, 1959 (reprinted in Martinelli, 1994, 247–55), still the most complete discussion of this aspect of the artist's life, especially Luigi's crime.

30. Usually wont to whitewash the personalities and behaviors of the pontiffs even in the face of substantial documentation to the contrary, Domenico would here, however, appear to be accurate in his assessment of Clement X, described by contemporary Venetian diplomatic correspondence as "humble of heart, sincere, compassionate, charitable, and extremely lenient" (*EncPapi* 3:367). What has been described as "one of the finest examples" of the art of the portrait medallion in Seicento Rome is that of Clement X executed by Bernini, ca. 1670, and cast by Girolamo Lucenti (for which see Ostrow, 2008, 67, whence the quotation). Bernini also did at least three other portraits (busts in marble and bronze) of Clement X: see Domenico, 176, and commentary.

31. Baldinucci, i.130, e.64, puts a further positive spin on the Altieri's lukewarm attitude toward Bernini, saying that "the pope's most advanced age of 81 . . . gave Bernini the opportunity of resting his mind a bit from the incessant labors spanning a period more than 70 years." At issue in the lack of significant artistic or architectural accomplishments during the Altieri pontificate was the poor state of the papal treasury after years of exorbitant building projects, especially by Alexander VII. As already mentioned (note 29 above), the working relationship between Bernini and the pope and papal nephew Cardinal Paluzzo was not free of tension.

32. Regarding the new mixed-marble pavement of Saint Peter's, Domenico neglects to specify that the area in question is the atrium (also called the portico) of the basilica, as Baldinucci (i.130, e.64) correctly reports and where today within the pavement itself we still see Altieri's coat of arms; Fraschetti, 394 n.1, publishes a Fabbrica payment order related to this Bernini commission dated November 1671.

The new altar with its Bramante-inspired tabernacle (cf. the *Tempietto* of San Pietro in Montorio) in the chapel of the Most Blessed Sacrament was, in truth, a project with a long history: in 1629, as one component of the renovation of the entire chapel, Urban VIII had already commissioned Bernini to design the altar and soon thereafter the artist began his design work in earnest, only to be interrupted a few months later by more pressing matters.

Under Alexander VII, Bernini returned to the design of the altar but had to abandon it once again for the sake of more important projects. In 1672, under Clement X, Bernini was able to return to this long-delayed project and bring it to completion. The chapel was unveiled on December 24, 1674. For the Blessed Sacrament altar, see Wittkower, cat. 78; Lavin, 1981, 316–35; the three essays by Casale, Carta, and Falaschi in Martinelli, 1996; Marder, 1998a, 299–303; Beck; Ackermann, 2007, 207–19; and Jobst. In the chronologically corresponding section in Baldinucci (i.130, e.64), mention is also made of Bernini's (disputed) authorship of the *Saint Maurice* altarpiece once in this chapel (1638–40, now Pinacoteca Vaticana), which Domenico instead places in his earlier discussion of Bernini's paintings: see Domenico, 26, and commentary.

According to Hager, 1978, Bernini may have had some direct role at the design stage of yet another Altieri commission (specifically from Principe Angelo Altieri Albertoni), the church of San Bonaventura in Monterano near Lake Bracciano, though the documents speak only of his assistant, Mattia de' Rossi, as project architect.

33. This commission, attributed by Domenico to the cardinal's "devotion," is instead described by Baldinucci (i.130, e.64) as motivated simply by the cardinal's desire to "avail himself as much as possible of Bernini's work." The long-standing chapel, where Ludovica Albertoni was buried in 1533, had over the years become a popular center of devotion among Roman housewives and matrons (including Bernini's wife, Caterina Tezio) inasmuch as it focused on the cult of several female saints, Ann (mother of the Blessed Virgin Mary), Francesca Romana, and the never-canonized Ludovica (b. 1473): see Beltramme, 1998 and 2003. For further bibliography

on the chapel, see note 34. After the beatification of his great-great grandmother Ludovica on January 28, 1671, Cardinal Paluzzo rededicated the chapel entirely to her name (although Gaulli's altarpiece there is dedicated to Saint Ann and the Virgin Mary). Note that, in the eyes of the Church, Ludovica was, and is, only a "blessed" (*beata*), not a saint.

34. Recently discovered documentation has clarified the chronology of Bernini's *Ludovica Albertoni* commission, apparently granted to Bernini much later than until now has been presumed. Marble for the statue was purchased on February 7, 1674, which means that Bernini probably received the commission in late 1673. The artist completed the statue in just over six months, for it was already installed by August 31, 1674.

Cardinal Paluzzo may have been formally the patron of this commission but only the name of his brother, Angelo Altieri Albertoni, appears in the extant financial accounts (for Angelo, see note 29 above). For all of the preceding, see the two essays by Ulivi and Di Napoli Rampolla in *Regista/Restauri*, respectively 85–95, 97–110 (see also Di Napoli Rampolla in *Regista,* 97–110, and in Coliva, 2002, 263–68). For Bernini's statue and remodeling of the entire chapel, as well as the earlier history of the chapel, see also Wittkower, cat. 76; Hibbard, 1987; Lavin, 1981, 302–9 (entry by S. Ostrow); Perlove; Careri, 51–86; and Marder, 1998a, 296–99.

An *avviso* dated February 17, 1674, reports that Bernini received this commission in preference to other artists because he offered to do the work free of charge in order to have his brother Luigi recalled from exile after his crime of sodomy of December 1670 (Martinelli, 1959, 313). Note that, even though this chapel—with its careful integration of sculpture, painting, architecture, stucco decoration, and theatrical lighting—is often cited as another example of the artist's *bel composto,* Domenico (like Baldinucci) does not invoke the latter concept and simply focuses here on the one statue of the dying woman.

35. "Monsignore" is, again, Bernini's eldest son, Pietro Filippo, often referred to simply by his ecclesiastical title in the family sources. The "Congregazione delle acque e strade" (its full name) had responsibility over the roads, bridges, and aqueducts of the Papal State (Del Re, 341–43). For some of Pietro Filippo's activities as secretary of this congregation, see Segarra Lagunes, 380. In reporting Bernini's securing of this particular salaried sinecure for his son, the Roman agent of the Duke of Modena sarcastically compares the artist to Moses striking his rod against the rock and causing water to flow forth, the rock being Bernini's marble and the water being this job with the papal water department (Fraschetti, 396–97, the document is undated).

With regard to remuneration to Bernini himself, Domenico tells another face-saving lie: there is no payment or reward in any form documented for Bernini's work on the Albertoni chapel. This fact argues in favor of the contemporary claim that the artist worked free of charge in order to mollify Paluzzo's hard stance against his exiled brother, Luigi, and gain the latter's exoneration. The latter effort was successful, it seems, in 1675, the Jubilee Year, which traditionally was celebrated with the granting of special pardons and indulgences.

CHAPTER XXII

1. Born in Como, Odescalchi (1611–1689) was elected pope on September 21, 1679, after an unusually long and divided conclave that had already eliminated some twenty candidates. Taking his name from his benefactor, Innocent X Pamphilj, he is indeed known, as Domenico here relates, for his efforts in bringing order to the papal treasury, eliminating nepotism, and financing (with subventions of millions of *scudi*) military campaigns against the advancing Ottoman Empire (Polish king John III Sobieski's 1683 victory against the Turks at Vienna was the highlight of these campaigns).

A man of stringent morals and austere character, he severely restricted theater production in Rome, thus earning the odium of Christina of Sweden and probably as well of the theater-loving Bernini, who depicted the pope in a most unflattering caricature in which the pontiff is made to look like a repulsive, desiccated bug (Lavin, 1981, cat. 99, and 40–46). The process for Innocent's canonization began shortly after his death but got nowhere until 1956, when Pope

Pius XII, a man of not-dissimilar character and physical appearance, finally beatified his predecessor (*EncPapi*, 3:368–89).

2. Baldinucci, i.152, e.85–86, makes the same observation about Innocent's supposed (and otherwise undocumented) esteem for Bernini, albeit in a different context—in his catalogue of high-ranking admirers of Bernini. Yet Innocent XI displayed little interest in art, architecture, and the urban development or adornment of Rome, except for the completion of the Palazzo di Montecitorio, which was to house the papal tribunals (*EncPapi* 3:375; for Montecitorio, see note 31 to Domenico, 93).

3. "Early in 1678 the tomb was practically finished" (Wittkower, cat. 77); see Domenico, 154, and commentary, for the tomb project and related bibliography. Despite what Domenico's next sentence would have us believe, Bernini did very little of the actual execution. The handicapping, preexisting door incorporated into the design as an integral feature is yet another example of Bernini's talent for turning material necessity into artistic virtue, one of the recurrent themes of Domenico's narrative. Baldinucci, i.130–32, e.65–66, gives essentially the same detailed description, including mention of the "modesty dress" ordered by the pope (see note 4).

4. The "modesty dress" was cast in bronze by Girolamo Lucenti at the end of 1678, based upon a *modello* by Filippo Carcani. The other female figure, that of Charity, was originally intended, it seems, to have bare breasts as well (Wittkower, cat. 77). Domenico's claim about the great difficulty that Bernini experienced by that papal order seems a bit exaggerated, but is meant to emphasize his father's skill in overcoming challenging design obstacles.

Since Innocent XI was still alive at the time of his writing, Baldinucci's discussion of the papally imposed "modesty dress" (i.131–32, e.66) is even more flatteringly defensive of the pope, as well as of the artist: "However, Bernini considered this [addition of the modesty dress] very well worth the trouble since by means of such a provision and such an example, he caused the sanctity of so great a pontiff to shine forth for centuries to come."

5. Baldinucci, i.132, e.66, also dates the bust of the *Savior* (*Salvator Mundi*) to 1678 ("Bernini was already in the eightieth year of his life"). Pietro Filippo's *Vita Brevis*—last updated when the artist was still alive and eighty-two years old—dates it instead to 1679 ("havendo operato di marmo sino all'anno 81, quale terminò con un Salvatore per sua devozione"): see my discussion of this chronology below in appendix 1, note 26. Though not mentioned in his will (published in BALQ, 58–73), Bernini did indeed bequeath this half-length and over-life-size bust to Queen Christina. After her death in 1689 and that of her universal heir, Azzolino, just months later, it passed into the collection of the papal family, the Odescalchi. It is documented there until January 16, 1773 (Morello-Petrucci-Strinati, cat. 50, 178), after which all traces are lost.

As for the identity of the bust among extant versions, in the past forty years three works have surfaced that have claimed the serious attention of Bernini scholars as candidates for the title of autograph original. These three *Savior* busts, corresponding in size and composition to the biographers' description and the one extant Bernini drawing (for which see *Regista*, cat. 227), are in the Chrysler Museum in Norfolk, Virginia; the Cathedral of Sées in Normandy; and the convent annexed to the basilica of San Sebastiano fuori le mura, Rome (the most recently discovered of the three).

Although once championed as autograph by Petrucci and Fagiolo dell'Arco (see *Regista,* cat. 228, and Fagiolo dell'Arco, 2002, 38), the Sées version is now generally believed to be a French copy of the same period, perhaps the one ordered by Chantelou himself. The leading contender for the autograph original—assuming that Bernini did not carve a replica himself—is that in San Sebastiano, Rome.

There seems to be a certain air of defensiveness in Domenico's praise of the execution of the *Savior* bust, admitting, as he does later on this same page, that "the weakness of [Bernini's] pulse did not match the liveliness of his conception." Furthermore, Bernini's assertion that practice of design effectively compensates for physical feebleness is not entirely persuasive, especially since he himself, after examining some late pictures by Poussin, had remarked to Chantelou (August 10, f.112, e.111), "There comes a time when one should cease work; for there is a falling off in everyone in old age."

Regarding the bust (all versions), the most recent summary discussion and evaluation is that by Petrucci in Morello-Petrucci-Strinati, cat. 50; see also Martinelli, 1996, 194–97; *Regista,* cat. 228; Lavin, 1972, 171–84; 1978a; 1998b; 2000; and 2003, 112–19; Malgouyres; Fagiolo/*IAP,* 327; and Petrucci, 2003.

6. Pietro Filippo, even more explicitly, says that the *Savior* bust was done "per sua devozione," as an act of personal devotion (see note 5). However, according to Baldinucci, i.132, e.66, the artist's motivation in creating this work is not only different but also not particularly devout: although Baldinucci acknowledges that Bernini "had already for some time turned his thoughts intensely to the achievement of his eternal repose rather than to the increase of his worldly glory," the fundamental reason given for the execution of the bust was the fact that the artist "felt a strong urge in his heart to offer—before closing his eyes on this light—some sign of gratitude to Her Majesty, the great Queen of Sweden who had been his most outstanding protectress."

Baldinucci also informs us that this work was Bernini's favorite, his *beniamino.* In the abridged account of his *Life of Bernini,* published in his later collection of artists lives, *Notizie dei Professori del disegno da Cimabue in qua* (Florence, 1846 ed., 4:294), Baldinucci mentions being shown the *Savior* bust with great pride and ceremony by Christina herself when the Florentine visited the queen in her Roman palace.

As for the origins of the bust, Lavin, 2000, argues persuasively—on the basis of its large scale, specific iconography, and the tall, elaborate pedestal that Bernini designed for it—that the artist may have originally intended the bust for public display in a hospice planned by Innocent XI in the Lateran palace, the refurbishment of which the pope assigned to Bernini in 1676 (this short-lived plan came to naught).

7. Domenico (147 and 148) speaks in similar terms of the *Louis XIV Equestrian* statue: that it was done to ennoble the final chapter of Bernini's life and that it enclosed within it all the accomplishments of his art. Domenico here repeats yet another topos of art biography: as Sousloff, 1987, 118, points out, "The idea that both religious conviction and artistic virtue are embodied in the artist's final work is a commonplace." As such, it likewise serves to further link Bernini and Michelangelo, for both Condivi and Vasari made use of the topos in describing Michelangelo's unfinished Florentine *Pietà.*

8. Domenico's word here is *disegno,* which can mean both design and drawing. Here it seems more appropriate to translate it simply as "design"—referring only to the mental conception, and not actual physical act, which the infirmities of old age could undermine. The word I translate here as "tenderness" is *tenerezza.* See the Introduction, section 7, for these two terms, challenging to any translator.

9. See Domenico, 43–45, for his earlier discussion of the embellishment of the four piers, mentioning that fifty years later false charges were to be raised against Bernini for damage caused to the cupola by his interventions on the piers. In fact, as discussed in the commentary to those pages, the charges of Bernini's perilous destabilization of the cupola had already been clearly voiced in that same period, in 1636, apparently, however, without invoking an official reaction from the Fabbrica or the pope. Yet as we also saw, grave fears about the imminent collapse of the cupola due to Bernini's interventions simply did not disappear between 1636 and 1680, as we learn, for example, from Filippo Bonini's *L'ateista convinto dalle sole ragioni* (Venice, 1665, pp. 472–75).

As for Baldinucci, his biography likewise makes no mention of these 1636 charges and raises the issue only when discussing the last year of the artist's life (i.133–34, e.67–68), referring the reader to the detailed, illustrated account of the affair and point-by-point technical-historical refutation of the charges, appended to the end of his biography (i.155–75, e.89–108). Baldinucci's report claims that the fear-mongering rumor began in April 1680 (i.156, e.89), which was indeed the case, for a Roman *avviso* dated April 13 of that year announces the fact and content of the rumor, warning that the collapse of the cupola was imminent (Marder, 2008, 431, citing also a similar *avviso* of June 1; Marder's essay is entirely devoted to the final 1680 chapter of this affair, summarizing all known facts and clarifying with precision the charges and their refutation).

Baldinucci's report, the biographer says, is based not on his own observation, but on the "noble efforts, studies and observations of the famous Mattia de' Rossi" (the latter, as mentioned, was one of the architects whom the pope asked to investigate the cupola charges and indeed the narrative "I" of these final pages of Baldinucci is in fact probably Mattia, whose report was transcribed nearly verbatim by the biographer: see note 13 below). Baldinucci's account is much more intense and dramatic than Domenico's in its characterization of the nature of the crisis—sent by Heaven, the biographer says, to test Bernini's spirit—and much more vociferous in its denunciation of the perpetrators of the rumor. The great ferocity of Baldinucci's defense is understandable since he was writing while the controversy was still playing itself out, whereas by 1711—the date of the final revision of Domenico's biography—the issue had long since been put to rest. See also note 11 below.

10. That is, the movement of the cupola, whose natural process of settling had caused the cracks, as Domenico already explained, 43–44.

11. For Mattia, see Domenico, 112–13, and commentary. Carlo Fontana (1638–1714) was one of the leading architects in Rome in the late seventeenth and early eighteenth centuries, achieving this status soon after Bernini's death. In 1694, he published a lengthy detailed, well-illustrated description of the construction and embellishment of the new Saint Peter's Basilica, *Tempio Vaticano*, as a follow-up to the cupola investigation that Pope Innocent XI requested of him, as Fontana says in the introduction, Libro 1, Capitolo 1, Proemiale. He also mentions that the 1680 alarm about the supposedly ruinous condition of the cupola was delivered to the pope in writing.

While of far less exalted status, Giovanni Antonio de' Rossi (1616–1595) was also a respected figure in his profession. Among his more notable works are the Palazzo Altieri (Piazza del Gesù) and the Palazzo d'Aste (Piazza Venezia). However, the fact that, on the one hand, Giovanni Antonio was uncle to Mattia de' Rossi, and, on the other, that Mattia was a longtime right-hand man to Bernini would make one suspect that this 1680 investigative commission was "stacked" from the beginning in the artist's favor.

Menichella, 1985, 26, argues instead that Mattia's appointment is a reflection of the professional esteem and authority that he enjoyed in Rome as architect, independent of Bernini, despite the long collaboration between the two. In any case, the substantial body of unimpeachable historical and technical evidence—visual and textual—adduced by Mattia and the other two investigators indeed exonerates Bernini of all blame, as does Fontana's *Tempio Vaticano*.

12. According to Carlo Fontana's *Tempio Vaticano*, the papal charge to organize this group of architects was given not to Monsignor Giannuzzi (the name found also in Baldinucci, i.158, e.91), but to Monsignor Gio. Carlo Vespignani, the "Economo Generale" of the Fabbrica of Saint Peter's (Fontana, 1). As to the identity of the villain in this case, he would appear to be Giuseppe Paglia (ca. 1616–1683), a Sicilian Dominican friar who was also a professional architect. In the mid-1660s, Paglia had clashed with Bernini over the design of the Piazza Minerva monument to Divine Wisdom (the elephant bearing the obelisk) and in 1680, as Marder (2008, 431–33) conjectures, was probably plotting to undermine Bernini's status in order to bolster his own career, then in severe decline.

In September 1680, the pope asked Paglia (who worked for the Camera Apostolica as *misuratore*) to conduct his own, separate investigation of the cupola and then meet with Mattia and company, which he did on November 12. The latter special committee in turn produced a final, binding judgment for the pope, entirely exonerating Bernini. For Paglia and the Minerva monument, see my commentary to Domenico, 108 (the passage on sundry works by Bernini for Pope Alexander).

13. The pages in Baldinucci, i.155–75, e.89–108. Baldinucci himself acknowledges (i.158, e.91) that he borrowed from Mattia's report but, as D'Onofrio (1966, 205, emphasis in original) points out that this final portion of Baldinucci's text in reality "is *an almost identical copy* of de' Rossi's manuscript sent to [Baldinucci] in Florence (a manuscript which I had the good luck of rediscovering)." Domenico's explicit reference to Baldinucci's *vita*, by the way, would indicate

that our author feared no comparison between his biography and that of Baldinucci, despite the large amount of verbatim overlap between the two.

14. Namely, the supposedly alarming state of near collapse, only imagined at Saint Peter's, was instead a real threat in the case of the Cancelleria (the Chancery). The Cancelleria, built in the late fifteenth century, was for many years during Bernini's lifetime the home of Cardinal Francesco Barberini (d. December 10, 1679). No study exists of Bernini's work on the Cancelleria, and no related documents have come to light, except for the May 15, 1680, chirograph by Pope Innocent XI ordering Monsignor Ginetti to have the necessary repairs done on the building (Schiavo, 1964, 11 n.2). See Rossi/*Avvisi*, 19 (1941): 492, for an *avviso* dated April 13, 1680, describing the imminent danger of collapse of a part of the Cancelleria and blaming the late Cardinal Francesco Barberini for having ignored the grave problem.

For Bernini's work of the late 1630s–early 1640s on the apse of the church of San Lorenzo in Damaso within the same Cancelleria, see Schiavo, 1964, 99–100, as well as *Bernini in Vaticano*, cat. 93; and Borsi, cat. 22.

Bernini's involvement in the Cancelleria repair project presumably dates to the summer and most probably also the fall of 1680. Equally silent as to the date of the commission, Baldinucci's account (i.134, e.68) of Bernini's Cancelleria experience is essentially the same as Domenico's, although with a heightened description of the alarming state of the palace's disrepair and the challenges it presented to Bernini ("every day new difficulties of the gravest sort were discovered"). Baldinucci also makes more explicit the fact that Bernini actually finished the repair job successfully, to great applause from the city of Rome, and only afterward fell sick. This story of the challenging but successfully executed Cancelleria repair work serves "to further defend Bernini against claims that he was technically incompetent or sloppy. Thus, the Pope calls on this aged artist, rather than one of the many younger professionals, to solve what is seen as a critical technical problem" (Morris, 222).

CHAPTER XXIII

1. After mentioning the debilitating Cancelleria task, and without even a paragraph break within his text, Baldinucci, i.134, e.68, moves rather abruptly to an account of Bernini's morally virtuous life, personal religious precepts, and edifying death, coinciding with the contents of Domenico's chapter 23, but with far less detail. Significantly, if not also somewhat strangely, Baldinucci's account begins with an insistent disclaimer, which (as I conjecture in the Introduction, section 8) may well have been necessitated by lingering rumors about the true nature of Bernini's personal mores, as exemplified by his comportment in the Costanza affair. The disclaimer insists that, on the one hand, despite the youthful emotional entanglements Bernini may have once had, such behavior was never to the detriment of his art and to the exercise of the virtue of prudence(!), and, on the other, that once he married at age forty, he lived the life more of a vowed religious than a layman, having put his former ways behind him completely.

2. Baldinucci, i.136, e.70, reports the same "small change" remark, but given in response to the questioning of his confessor, "as Bernini was nearing his last breath." As Lavin, 1972, 166, points out: "Many of the most striking aspects of Bernini's death are elucidated in the writings of Father Marchese," Bernini's priest-nephew (for whom see note 12 below), who wrote several volumes of popular spirituality and devotion. Most relevant here are his two books published in 1670, *Unica speranza del peccatore che consiste nel sangue del N.S. Giesù Cristo* (The sole hope of the sinner that resides in the blood of Our Lord Jesus Christ) and *Ultimo colpo al cuore del peccatore* (Last blow at the heart of the sinner); see also his posthumous book on preparation for a good Christian death, *Preparamento a ben morire* (1697).

In emphasizing his father's serene trust in divine mercy, Domenico may also be telling us indirectly that his father was no Jansenist: that he did not ascribe to the rigorist theology of Jansenism, which taught that salvation came only as a result of extreme effort and was not freely granted to a sinful humankind by a severe, angry, exacting God. The controversy over Jansenism

and the troubling but fundamental issues it raised (regarding salvation, grace, and free will) travailed the Church for a good portion of both Gian Lorenzo and Domenico Bernini's lifetimes, despite repeated papal condemnation.

Of this long (and, indeed, as of 1713 still unconcluded) chapter of doctrinal history Domenico writes at length in volume 4 of his *Historia di tutte l'heresie*, as pertinent to every pontificate of recent times beginning with that of Urban VIII (the controversy first erupted in the early 1640s) and through that of the then-reigning Clement XI (see esp. *Historia*, 4:617–32 and 681). Thus we can be sure that, as he wrote these lines, Domenico was mindful of their theological implications vis-à-vis current polemics. See also note 8 below for his mention of Bernini's frequent communion.

3. Domenico does not say it explicitly (as does Baldinucci, i.135, e.69), but the drawing in question, known as the *Sangue di Cristo* (Blood of Christ), was of course done by Bernini himself. Though the composition is mentioned in the two biographies only in the context of Bernini's approaching death, neither biographer actually claims that Bernini did the drawing or commissioned its reproduction specifically during the last days of his life.

In fact, the drawing in question must date to 1669 or early 1670, since the engraving of it by François Spierre (who also engraved Bernini's drawings for the Oliva volumes) was done in time to be included in Marchese's already-cited volume of 1670, *Unica speranza del peccatore*. What some believe to be the autograph original is in the Teylers Museum, Haarlem for which see, e.g., Morello-Petrucci-Strinati, fig. 37b). Imparato, 142–43, published a letter, which he tentatively dated to 1671, mentioning an autograph copy of the drawing sent to the Duke of Modena; but Jarrard, 2002, 416, describes the gift in question instead as an engraved copy of the *Sangue di Cristo* composition sent in the summer of 1670, as we learn from a letter from Modena by Cardinal Rinaldo d'Este dated August 17, 1670, referring to "the sheet with Christ on the Cross printed on silk."

The allegorical composition was inspired by a vision of the Florentine nun-mystic, Maria Maddalena de' Pazzi (1566–1607), who was canonized in April 1669, for which occasion Bernini designed a commemorative medal. For Maria Maddalena and Bernini's composition, see Lavin, 1972, 167–70; and 2000, 105–12; for the medal, see Sutherland Harris, 1977, cat. 79; for Bernini and the canonization ephemera, see Fagiolo dell'Arco, 1997, 470–74.

The dating of the composition gives credence to the already-quoted report by a contemporary Roman *avviso* to the effect that, having been dismissed from the Santa Maria Maggiore apse renovation job and replaced by Carlo Rainaldi, the humiliated Bernini was going to prove to the world his "incomparable virtue" with the execution of an awe-inspiring image of Christ, which he planned to have engraved (see Domenico, 161, for the Santa Maria Maggiore project, and my commentary for this 1670 *avviso*).

As for painted versions of the compositions, three extant contemporary canvases are known: two by Bernini's close collaborator, Guglielmo Cortese, "Il Borgognone" (Rome, Museo di Roma; and Genoa, priv. coll.) and the third by an anonymous painter from the Bernini circle, once thought the work of Ludovico Gimignani, another of Bernini's painter-collaborators (Ariccia, Palazzo Chigi, Fagiolo Coll.). The Museo di Roma canvas came from the Bernini heirs, the Forti family of Rome. But it is the Genovese version, dated ca. 1670, that is believed (by Petrucci) to be the one commissioned by Bernini from Cortese, one of his favorite painters.

For the drawing, engraving, and paintings, see the most recent, thorough discussion by Petrucci in Morello-Petrucci-Strinati, cats. 37–40, with ample bibliography (to which must be added Martinelli, 1996, 191–92). Note that the 1966/2006 Enggass translation of Baldinucci's *vita* (p. 69) mistakenly says that Bernini himself "also painted this pious concept on a great canvas," whereas the original Italian text (i.135) instead (employing the "fare causativo" grammatical construction) reads, "fecesi anche dipingere in una gran tela" (he had the canvas painted by someone else).

4. Here Bernini turns a fundamental tenet of Christian doctrine—salvation through Jesus Christ—into a Baroque conceit through the clever vehicle of a common visual metaphor. Some explication of Christian doctrine is needed here as background to Domenico's exposition in this

passage: God the Father, angry for millennia over the disobedience of Adam and Eve (the "Fall"), condemned to hell all of their progeny (with a few exceptions) until the coming of the Messiah, his son, Jesus (the "Incarnation"). Jesus finally placated the wrath of God the Father by the blood sacrifice of his death on the cross (the "Redemption"). Moreover, Jesus' sacrifice, "his blood," serves this expiatory-protective function for all repented sins committed even after his crucifix-ion (included Bernini's), for the sins of mankind continue to provoke "divine vengeance," as Bernini and his contemporaries believed.

5. In this academic analogy, who, we wonder, is the professorial thesis examiner, and who is the student examinee? In any case, the point is that Bernini, a mere layman, had a sophisti-cated grasp of the finer points of theology. See, however, the Introduction, section 8, "Bernini's Religion," which cautions about reading too much into this passage: in the theocratic, carefully censored environment of Counter-Reformation Rome, Bernini was not, and could not, engage in any sort of innovative theological speculation, lest he provoke the suspicions of the Inquisi-tion, from whose scrutiny no one was exempt.

As for the kind of practical, popular spirituality that Bernini seemed to admire, apart from (we presume) the already-cited works of his nephew Francesco Marchese, Bernini read, carefully and devotedly, the much loved *Imitation of Christ* (early fifteenth century) by Thomas à Kempis, and another spiritual best seller, the more recent *Introduction to the Devout Life* (1609) by François de Sales, who had been canonized by Alexander VII just days before Bernini left for Paris. For Bernini's praise of these two works, see Chantelou, August 23, f.134, e.138–39.

6. Having indicated earlier that Bernini was no Jansenist (see note 2 above), Domenico may also be implicitly signaling that his father was, at the same time, no Quietist, that is, he did not ascribe to the passive, contemplative theology of Quietism, another popular and controver-sial contemporary spirituality with many adherents in Rome in the late seventeenth century.

Representing the opposite end of the theological spectrum from the rigorist, "active" theol-ogy of Jansenism, the more easygoing Quietist movement was founded by the Spanish priest Miguel de Molinos (1628–1696), who arrived in Rome in 1663 and soon found much favor as spiritual director, especially among the upper echelons of society. Quietism preached the utter annihilation of the will and the futility of active personal effort (even in the form of the tradi-tional "works of mercy" and other pious "concrete action") in order to attain mystical union with God. Of the movement and its founder, Domenico writes at length, and in greatly dispar-aging terms, in his *Historia di tutte l'heresie*, 4:711–21. Molinos, described in Domenico's *Historia* (4:711) as that "great hypocrite, notorious impostor, and most cunning heresiarch," was eventu-ally (1687) brought down by the Inquisition, with Bernini's nephew, the Francesco Marchese, playing an active role in his persecution and condemnation (Lavin, 1972, 165).

Since Christina of Sweden, Bernini's friend and nominal patroness of Baldinucci's biography of the artist, was also a devotee and protector of Molinos, Domenico may have feared that his father would be considered "guilty by association" and hence may be attempting here to prove otherwise—that his father was no follower of Quietist principles.

7. Baldinucci, i.135, e.69, also reports Bernini's forty-year participation in the Jesuit devo-tions at the Church of the Gesù. Although neither biographer states it outright, we presume they are claiming that Bernini was a duly inscribed, dues-paying member of the "Congregation of the Happy Death" (*Bona Mors* in Latin, or *Buona Morte* in Italian). Yet in the Jesuit archives (ARSI), I could not find any documentation of Bernini's formal enrollment in this sodality. In any case, the congregation was founded in 1648, hence Bernini's participation would have been less than forty years in duration. Furthermore, his hectic schedule, including trips outside Rome (Castelgandolfo, Ariccia, Tivoli) also made weekly participation impossible.

For the most thorough and most recent discussion of the *Bona Mors* sodality, based on new archival discoveries, see Maher, 33–37, 268–82. On the topic of Bernini and the Jesuits, note that there is no evidence whatsoever that Bernini ever did the Ignatian *Spiritual Exercises* or belonged to that other well-known pious congregation at the same church of the Gesù, that of the *Nobili* (Nobility): see the Introduction, section 8, esp. note 149.

8. Baldinucci, i.135, e.69, instead is more specific in his claim that Bernini "twice a week nourished himself on the Eucharistic sacrament." The Carlo Cartari diary, under the date November 19, 1668, mentions that Bernini, aged seventy, attended Mass daily at Sant'Andrea delle Fratte, near his home (Morris, 245). The subject of the frequency of communion was yet another controversial question agitating the Catholic Church during Bernini's lifetime. How often could one worthily receive the consecrated host? Yearly? monthly? weekly? daily? Was the Eucharist to be used as a frequent "remedy" for one's sinful tendencies or instead as a rare "reward" for good behavior? Would God be offended if one were to presume to partake of the Eucharist on too frequent a basis?

An issue dating back to the previous century, frequency of reception of the Eucharist was further polemicized in the seventeenth century by both the Jansenist and Quietist controversies. By the 1670s, the debate had intensified to such a point that in February 1679 (the year before Bernini's death), Pope Innocent XI was obliged to pronounce himself on the issue in the form of an official bull, *Cum aures sanctissimi* (which ends up simply leaving the matter to the discretion of local confessors and pastors). See Domenico's discussion of the polemic, giving the full text of the 1679 papal bull, in his *Historia di tutte l'heresie,* 4:703 – 5. Hence, on this issue as well, it is highly likely that Domenico was mindful of the polemical implications of this detail of his father's religious praxis (which, like his attitude toward divine mercy, would place Bernini in the more "liberal," anti-Jansenist, but non-Quietist, camp).

As for Eucharistic adoration mentioned in the next line, one should note the especially magnificent ephemeral display of the "Forty Hours" (*Quarantore*) Eucharistic devotion held at the same church of the Gesù in February 1640 on the occasion of the centenary celebration of the Society of Jesus. The display was the responsibility of Bernini's disciple, Niccolò Menghini (1610–1655), but Bernini is believed to have had some hand in its design: see Fagiolo dell'Arco, 1997, 314–16; see also 270 for Bernini's own *Quarantore* display of 1628 in the Pauline Chapel at the Vatican, and 320 for another *Quarantore* at San Lorenzo in Damaso in 1641. For an extant drawing by Bernini depicting a *Quarantore* design, tentatively dated 1668, see Tonkovich; and Fagiolo dell'Arco, 2002, 164 and fig. 167.

9. Domenico exaggerates once again: in reality, Bernini's last will and testament makes provision for only one annual dowry (of 25 *scudi*) for such a girl, "una povera zitella honesta e da bene" (BALQ, 61). Bernini seems to have had particular concern for the fate of impoverished maidens, for his will also contains the provision that, in case of extinction of the Bernini family line, the "Archiconfraternita della santissima Annunziata della chiesa della Minerva di Roma" is to become his universal heir (BALQ, 66–67, 70).

The most conspicuous public service of this old, prestigious confraternity was the annual distribution of dowries on March 25, Feast of the Annunciation (Bernini's will, instead and as Domenico correctly states, provides for the conferral of Bernini's dowry on the Feast of the Assumption, August 15 [BALQ, 61]). The March ceremony, at Santa Maria sopra Minerva, was an extremely solemn public occasion, with much pomp and circumstance, involving the partici-pation of the pope himself (who personally distributed the dowries) and an enormous retinue of cardinals, nobility, and military escorts. For a detailed description of the event, see Gigli, 39 n.32; see also the summary historical information and bibliography supplied by Hibbard, 1971, 188; and D'Amelia, 307 and n.5. Hence Bernini had chosen as his beneficiary an extremely "high profile," elite institution of charity.

10. That is, God wants to see one's faith expressed in concrete charitable action, not merely in obsequious words of devotion. In a society in which the majority of the population was poor and in which people (including the Church) simply accepted as an unchangeable fact of the natural order the established economic polity responsible for this massive rate of poverty, alms-giving was considered one of the preeminent "corporal works of mercy" and most commendable manifestations of the theological virtue of *caritas* (love). However, one might also be tempted to suspect that Domenico was also responding to the many years of criticism hurled at Bernini over the vast sums of money that he accumulated during his long, financially successful career.

11. It is virtually a universal trait of conventional hagiography (the literature of the lives of the saints) to include a detailed description of the saints' preparation for death and of their death itself, the manner of their passing being revelatory of the moral quality of their soul on earth and future destiny in eternity.

As even the rather unorthodox Christina of Sweden, in completely orthodox fashion, explains in one of her "Maxims": "Our true worth and our blessedness depend wholly on the last moment of our life: all the rest vanishes like smoke that disperses and is scattered by the wind. But in this last terrible or happy moment, God lets us know what we were and shall remain for all eternity, before the whole universe and in God's own sight" (quoted by Stolpe, 276).

A remark Bernini made in Paris to Chantelou is also relevant to the artist's pious beliefs about the act of dying: Bernini "said [to Chantelou] that he thought my brother (Roland Fréart de Chambray) so good and saint-like in character that should he (Bernini) die in France, he would beg him (Roland) to be present at his death" (Chantelou, August 16, f.122, e.123).

12. Baldinucci, i.134−35, e.68, confirms the role of Bernini's nephew at this point in his life, spelling his last name, however, "Marchesi," as does Bernini in his will: see BALQ, 62 and 72. I have already mentioned (note 2 above) Marchese's several popular works of practical spirituality and his efforts in eradicating the "heresy" of Quietism. Priest of Saint Filippo Neri's Roman Oratory, Marchese was born in 1623 and died in 1697.

As the biographical profile written by a fellow Oratorian reports: "Learned and virtuous, he entered the congregation in '43, soon distinguishing himself for his exemplary behavior and zeal, as well as for the seriousness of his studies. He dedicated himself to writing works of piety and was the initiator in Rome of devotion to the Immaculate Heart of Mary." Later in life (after Bernini's death), he went on to become Superior General of the Oratorians, governing, we are told, with great virtue and wisdom (Gasbarri, 177−78, for the preceding quotation and biographical data).

13. Death is a test (cimento) even for devout believers who had lived their entire lives in utter probity, because, according to the popular (and then fully orthodox Catholic) belief, at the moment of death the devil made his last attempt to win over the soul of the dying person through a strenuous series of temptations.

This belief is best expressed in the Barberini musical drama Il Sant'Alessio, with script by Giulio Ropsigliosi (the future Pope Clement IX), in which (act 2, scene 8) the Devil prepares for his assault on the dying Alessio: "Already with fixed intent, Alexis is preparing his heart for death; in this last combat, then, let not my daring plan fall short in cunning or force, for a soul, up to its very last moment, remains exposed to danger. Ah, if only, in the tearing of the bodily veil, in that irreparable instant on which depends an eternity of torment, on which depends an eternity of happiness, I could steal him eternally from Heaven, him, for whom I have so longed, o how brilliant a victory, o how great a triumph!" (translated by Brian Trowell, pp. 90−91, in the libretto supplied with the CD audio recording of Il Sant'Alessio [1634 ed.] by "Les Arts Florissants," directed by William Christie, Paris: Erato Disques, 1996).

Bernini's mother, Angelica Galante (d. May 1647), in her last will and testament, echoes the same belief: "I supplicate all the saints to assist me in the hour of my death and defend me from the snares of the Demon" (Fagiolo/IAP, 354). See, even more graphically, Oratorian preacher Stefano Pepe's Le battaglie de gli agonizzanti (Genoa, 1651; Venice, 1652), describing in more than three hundred pages the "demonic temptations in the hour of one's final agony."

14. Bernini's stroke came just three days after the papal committee charged with investigating the accusations against him regarding the cracks in Saint Peter's cupola delivered its final report to the pope completely exonerating him of all blame. Roman diarist and Bernini family friend Carlo Cartari tells us that the artist suffered the stroke on Friday, November 15, whereas the papal committee had filed its report on December 12 (see Marder, 2008, 432 for the December 12 date and 434 for the suggested connection between Bernini's exoneration and his stroke; for the Cartari diary entry, see Lavin, 1972, 157 n.1).

15. See Baldinucci, i.136, e.70, for the same witty remark about his paralyzed right arm (but reporting that his whole right side was also paralyzed). As Fraschetti, 423, remarks, "Not even on the edge of the grave" did Bernini's wit cease to sparkle!

16. The complex, enigmatic, and protean Christina will probably always elude all attempts to define her views in neat, simple categories. However, despite the queen's popular reputation as a cynical libertine and psychologically unstable personality, there are signs that in her last years she had indeed formed for herself a genuine personal faith built upon a mature, authentic, even mystical spirituality, though, to be sure, one that did not necessarily coincide in all elements with official Roman Catholic orthodoxy. Informing the Cardinal secretary of state, Alderano Cybo, of Christina's death on April 19, 1689, Cardinal Azzolino claims—how could he do otherwise?— that the queen "died with the disposition and sentiments of a saint and as a true, faithful daughter of God and of the Catholic Church."

Before dying, Christina had received the last sacraments and had asked a blessing from Pope Innocent, as well as his pardon for all the unpleasantness between them. "So Bernini's request for prayers on his deathbed is not in the least ridiculous [as Fraschetti, 423, mockingly proclaimed it to be]. He meant it quite seriously and knew what he was doing. Like so many of Christina's closer friends, he was convinced that her religious experience was valid and that she possessed great, if not unique, understanding in these matters" (Stolpe, 274).

For Christina's religion, see Stolpe, 293–331; Børresen; Åkerman; and Buckley, 310–12. Baldinucci, i.135, e.69, reports the same request made of Azzolino by Bernini, though not as a direct quotation as here in Domenico and without Christina's reply. See Montanari, 1998b, 412–13, for the letters exchanged between Pietro Filippo and Azzolino during Bernini's *agonia*, confirming Domenico's claim here about the cardinal's personal solicitude during the artist's final days.

17. Baldinucci, i.136, e.70.

18. Another example of Bernini's wit still functioning *in extremis*. For de' Rossi, Cartari, and Contini, three of Bernini's closest disciples, see Domenico, 112–14, and commentary. Baldinucci, i.136, e.70, also mentions Mattia and Contini's presence at their master's deathbed, but not that of Cartari.

19. Baldinucci, i.137, e.70, specifies that his death occurred at around midnight ("circa alla mezza notte"). This is confirmed by the notary's statement at the time of the opening of Bernini's will (BALQ, 58): the artist's death, he notes, occurred "hora 6 circiter," about the sixth hour after sunset. For the reckoning of time in early modern Italy (based on a division of the day into twenty-four hours beginning at sunset), see Colzi.

20. Martinelli, 1959, 225–26 (also in Rossi/*Avvisi*, 19 [1941]: 491), quotes two contemporary Roman *avvisi*—malicious in tone but not necessarily devoid of truth—claiming that Bernini's final bequests were politically motivated ("fatti politicamente"), which, of course, they were, as were all gifts in the ever self-interested world of the Roman court. Certainly in making them, Bernini hoped to secure the recipients' continuing protection of his family.

More specifically, however, one of the *avvisi* makes the claim that the bequests were for the benefit of "others" (plural) of Bernini's family (his brother Luigi?) who "had strayed onto the path of evil" (acciò che protegga gl'altri che si sono incamminati per la mala vita). No less ominously, the other *avviso* states that the gifts were made in order to purchase the silence of those in authority in light of a possible audit of Bernini's books ("siano stati fatti politicamente, e con consideratione, quasi che fosse necessaria o la bombace per chiudere le orecchie, opure una mano per chiudere la bocca, acciò con il tempo non escano voci disonanti per una dubitata revisione de conti").

21. Baldinucci, i.137, e.71, instead says that the painting (a "large" one of "Christ") was by Bernini's own hand, but there is no documentation of such a painting by Bernini himself. An *avviso* dated November 30, 1680, claims that Bernini left the pope the gift of "one of the most beautiful paintings that had adorned his rooms" specifically in exchange for the indulgences sent to Bernini by Innocent before the artist's death (see Rossi/*Avvisi*, 19 [1941]: 491).

For a discussion of Bernini's bequests, particularly the debate-provoking detail of the painting, see Lavin 1973, 162, and 2000, 246 n.35; Montanari, 1998b, 414–16; Petrucci, 2001, 79–80; and Brejon de Lavergnée. None of the bequests that Domenico lists here are included in the artist's formal published will (text in BALQ, 58–73).

22. Christina of Sweden. For the bust, see Domenico, 167. Christina's most recent biographer, Buckley, 317, claims: "It was a great irony, too [that Bernini gave the Savior bust to the queen], for Christina disliked this sculpture almost as much as she had disliked the pope [Innocent XI]." Unfortunately, Buckley does not cite the source of this information.

According to Nicodemus Tessin's notes on his visit to the queen in the Palazzo Riario and the postmortem inventory of her possessions, Christina by the end of her life owned several works by Bernini, all of which are either untraced or cannot be identified with certainty: two paintings, a marble bust of a female figure, several drawings (some representing annual gifts from Bernini, as per Chantelou, September 30, f.213, e.240), and—the single documented commission from the queen to Bernini—a monumental mirror depicting the winged figure of Time seen lifting the drapery that hangs over the reflective glass. For the Bernini works in Christina's collection, see Montanari, 1998b, 367–69; for the mirror (disappeared after 1740) and its still-debated allegorical message, see *Regista*, cat. 158; Montanari, 1998b, 372–75; and Zirpolo.

23. Baldinucci, i.137, e.71, is slightly more specific: Cardinal Altieri was given "the marble head with bust, portrait of Clement X." According to Montanari, 1998b, 416, the gift represented a further gesture of thanks for the pardon extended to Luigi Bernini. The identity of the specific bust bequeathed to Cardinal Altieri, if extant, is a matter of debate and, given the current status of documentation, impossible to resolve; indeed, "the question of Bernini's portraits of Clement X is a complicated one" (Bacchi in Bacchi-Hess-Montagu, cat. 6.12, 279).

Baldinucci lists a portrait of Clement X in his appended catalogue of Bernini's works but gives no location. There is a half-figure statue of the pope in marble, formerly in the library of the Palazzo Altieri (now in the Galleria of Palazzo Barberini), not completely finished, but securely attributed to Bernini. The documents speak also of two other busts of Clement X by Bernini: one in marble (and now lost) for the refectory of the confraternity of Trinità dei Pellegrini and another of unspecified medium for Cardinal Paluzzo Altieri for his chambers at Palazzo Altieri (see Wittkower, cat. 78a; *Regista*, cat. 60; Bacchi-Hess-Montagu, cat. 6.12).

The latter bust for the Cardinal Nephew may have been in bronze, not marble, for the later Swedish visitor Nicodemus Tessin mentions that he saw such a bronze portrait of Clement by Bernini in the Palazzo Altieri, in addition to the marble one in the library. This may be the one now at the Minneapolis Institute of Arts, although the attribution of the Minneapolis bronze is still questioned (see *Regista*, cat. 59; and Fagiolo dell'Arco, 2002, 59, both supporting the attribution to Bernini). For further discussion of Bernini's portraits of Clement X and related drawings, see also Lavin, 1981, 294–301; and Villa, who also discusses, on the basis of new documentation, the question of the bequeathed bust.

24. Baldinucci, i.137, e.71, also says that Azzolino received a portrait bust in marble of Innocent X from the artist's own collection. See Domenico, 93, and commentary, for the bust— most likely the earlier, defective one of Bernini's two executed papal portraits in marble, both now in the Galleria Doria-Pamphilj.

25. Baldinucci, i.137, e.71, also describes the gift to Cardinal Rospigliosi as a painting of his own hand, having run out of works in marble to give him. However, there is no indication in extant documentation of the identity of the painting. For the statue of *Truth* (indeed left in trust to his family as per the artist's formal will [BALQ, 72]), see Domenico, 80.

26. Domenico simply uses the generic word, "*componimenti*," but Baldinucci, i.138, e.71, is more specific: "The minds and the pens of the literati exhausted themselves in composing tributes, sonnets, songs, and other most spirited, erudite verse in Latin and the vernacular that were presented in public in his praise."

Unfortunately, none of these postmortem "compositions" has been identified or published. I found no trace of them among the Bernini family papers in Paris (BNP, Ms. italien 2082, 2083, and 2084); that collection, strangely enough, contains only three letters of condolence to the family upon Bernini's death (Ms. italien 2082, fols. 102r, 104r, 106r). It is also strange that, as far as we know, there was no major public oration given at the time—none, as far as we know, was published as a text unto itself—as was customary in the case of funerals and memorial services of distinguished personages, such as Michelangelo. Was the anti-Bernini sentiment in Rome too strong to warrant such a tribute?

27. There is no official documentation confirming the monetary value of Bernini's estate at the time of his death. The Carlo Cartari diary mentions the rumor that Bernini's "estate adds up to six hundred thousand *scudi* or more," while another anonymous Roman *avviso* says that it is "above three hundred thousand *scudi*" (for both, see Lavin, 1972, 157 n.1). For the January 1681 inventory of Bernini's possessions, see Martinelli, 1996, 253–60.

As for Christina's remark, as mentioned, according to contemporary belief, the true greatness of a prince (secular or ecclesiastical) is proven by the *magnificentia* with which he treats his dependents, e.g., through the material rewards he extends to them (see commentary on the term, *magnificentia,* on Domenico, 2). Given the queen's well-known antipathy toward Innocent XI, her remark is likely to have been meant as a bit of sarcasm aimed specifically at the pope.

Baldinucci, i.137, e.71, also reports the queen's same remark, adding that she "gave extraordinary signs [of mourning for Bernini's death], it seeming to her that the world had lost in him the single birth that had produced the talent of our century."

28. Baldinucci, i.137, e.71, reports the same details of the elaborate church ceremony, "which corresponded to the dignity of the deceased and the resources and love of his children, who ordered a most noble funeral for him with generous distribution of candles and alms." Baldinucci also confirms the fact of the delay of the burial because of the crowds of people in attendance.

In his will, Bernini says only this about funeral services: "I leave up to my aforementioned heirs the [details of my] funeral; however[,] I remind them that, for the poor souls of the deceased, suffrages in the form of Masses and prayer are more necessary that the external appearances of funeral ceremonies" (BALQ, 60). Other contemporary confirmation of the details of Bernini's funeral is extremely sparse, coming in the form of a laconic report from the sacristan of Santa Maria Maggiore, a few lines in the Carlo Cartari diary, and a brief anonymous *avviso* (for which see Fraschetti, 424; and Lavin, 1972, 157 n.1). These sources speak of a solemn, "superb" funeral in the basilica illuminated with sixty torches and decorated in "noble fashion," with a choir providing music during the service, after which candles and bread were distributed to the poor.

Nothing is said about those who attended the funeral from the ranks of the Roman elite, or about the preacher who may have delivered a sermon-eulogy on this occasion. The archivist of Santa Maria Maggiore and I searched in vain the basilica's archives for any documentation relating to Bernini's funeral: it seems strange that so supposedly grand a liturgical service for so eminent a personage would leave so meager a trace in the historical record, again, quite a contrast with the postmortem honors accorded Michelangelo.

As for the detail of the distribution of candles (*cera* or *cere*) and alms at the funeral, this was customary in Rome at the time, serving as another proof of the family's *magnificentia,* as well as having the practical effect of ensuring large, appreciative crowds at one's funeral (McGuiness, 82).

29. The Bernini family crypt, granted to Pietro in the early part of the century, is today marked by a nondescript marble slab on the pavement of the basilica, to the right of the sanctuary, adjacent to the sanctuary balustrade. The coat of arms and inscription presently seen— "Nobilis familia Bernini hic resurrectionem expectat" (The noble Bernini family here awaits the resurrection)—date to after 1746, when Pope Benedict XIV conferred the status of nobility upon the Bernini family. Excavations of the ill-kept interior of the crypt in 1931 (for which see Artioli and Carpineta) uncovered no traces of Bernini's remains, except for a fragment of his Cavaliere's sword, now in the basilica's Archivio Capitolare (D'Onofrio, 1967, 144 and fig. 69 [tombstone]; 284 and fig. 135 [sword]; *Bernini in Vaticano,* cat. 329 [sword]).

It is both strange and ironic that the artist who conceived so many elaborate tomb monuments was to have none for himself, although there is an extant drawing for such a monument by Bernini collaborator, Ludovico Gimignani, ca. 1670 (Rome, Istituto Nazionale per la Grafica, Fondo Corsini): see *Regista,* cat. 229; and Montanari, 1998b, 390, fig. 49. Montanari hypothesizes that the terra-cotta portrait bust of an older Bernini in Saint Petersburg may relate to this never-executed funeral monument: see Montanari, 1998b, 399 and fig. 51 (calling it a self-portrait); and *Regista,* cat. 230 (by Sergej Androsov, who instead attributes it to the Bernini workshop). Most recently, Curzietti, 2008, 44, has attributed it to Bernini's disciple, Giulio Cartari.

30. Baldinucci (who never met Bernini in person) also describes Bernini's physical appearance, immediately after reporting his burial: i.138, e.72. Several other written descriptions of Bernini's physical appearance have come down to us, mostly dating from the later years of the artist's life. They are all provided by contemporaries who had interacted rather extensively with him, and hence are all quite similar.

The most extensive is that of Chantelou, from 1665:

> Bernini is a man of medium height but well proportioned and rather thin. His temperament is all fire. His face resembles an eagle's, particularly the eyes. He has thick eyebrows and a lofty forehead, slightly sunk in the middle and raised over the eyes. He is rather bald but what hair he has is white and frizzy. . . . He is very vigorous for his age and walks as firmly as if he were only thirty or forty. I consider his character to be one of the finest formed by nature, for without having studied he has nearly all the advantages with which learning can endow a man. Further he has a good memory, a quick and lively imagination, and his judgment seems perspicacious and sound. He is an excellent talker with quite an individual talent for expressing things with word, look, and gesture, so as to make them as pleasing as the brushes of the greatest painters can do. This is no doubt the reason why his comedies have been so successful. (Chantelou, June 6, f.46, e.14–15)

See also the descriptions of Perrault, 62 (more positive than expected from a man who thoroughly disliked Bernini), and Cureau de La Chambre (in Montanari, 1999, 125). Fehrenbach, 2005, 1, makes the important observation that, as contemporaries would have immediately recognized, Domenico's description of Bernini—as that of Chantelou—represents "the classic features of a choleric, or fiery temperament," referring to the conventional psycho-biological classification of all human beings into four major physical-mental types as defined by the classical theory of the four humors. For the latter theory, see the influential works on physiognomy by humanist-scientist, Giambattista della Porta (1535–1615), especially his much-reprinted and reedited *De humana physiognomia* (first edition 1586), explicating the widely accepted belief (first articulated by Aristotle) of the intimate correspondence between human physical (esp. facial) features and psychological-moral traits.

As for Bernini, in addition to written descriptions, there are also many self-portraits and portraits of the artist executed *dal vivo* by other contemporaries—in oil, marble, bronze (Chéron's two medals), or on paper (drawings and engravings)—that span his lifetime. For Bernini's self-portrait, see note 12 above to Domenico, 27. As for Bernini portraits done by other artists, the earliest known one is the drawing by Ottavio Leoni, ca. 1622 (subsequently engraved), and the last, a painting by Gaulli (undated but after 1665) and engraved by Arnold van Westerhout specifically for use as the frontispiece for the Baldinucci biography: see *Regista,* cats. 1–16; *Effigies and Ecstasies,* cats. 1–8; Petrucci, 2006, 175–85, and 394, cat. 3; Montanari, 2007, cats. 1–7, 25, 30. For a portrait of Bernini within a fresco by Abbatini depicting the presentation of the four-piers design to Pope Urban, see Lavin, 1968b, figs. 67 and 68; and Montanari, 2007, 79, fig. 83.

For the marble portrait of Bernini sent to Cureau de La Chambre and seen in the frontispiece to his "Éloge de M. le Cavalier Bernin" (1685), see Bacchi, 2009, 21–22 (now at the Philadelphia Museum of Art; the museum's Web site attributes this workshop bust to Bernardo Fioriti and dates it to ca. 1660).

31. Regarding Bernini's eyes and their "look," Baldinucci, i.138, e.72, instead says, more irenically, that the artist "had a lively, animated [*spiritoso e vivace*] eye with a strong gaze." In his later years, Bernini, by the way, needed eyeglasses: see Chantelou, July 25, f.89, e.79; August 2, f.103, e.99; and August 14, f.119, e.119.

32. On Bernini's eating habits, Baldinucci, i.138, e.72, reports: "His moderate eating habits helped maintain his good health. Ordinarily he allowed nothing to be prepared for him except a small dish of meat and a great quantity of fruit." Chantelou, August 1, f.101, e.96, adds: "[Bernini] said that he disliked eating anywhere but at home, in case he ate too much and felt ill and also because of the waste of time involved in sitting down to an elaborate meal."

In Baldinucci, Bernini's remark about his love of fruit is described jokingly as the "original sin" of those born in Naples (cf. Chantelou, October 20, f.279, e.323, where Bernini immediately eats up Madame de Chantelou's parting gift of sweets, right then and there, upon its presentation to him!).

Given his constant, nervous, high-strung level of activity, it is understandable that Bernini would crave the fast-energy source of sugar supplied by the fruit. More relevant, contemporary medicine also recommended fruit as the ideal food for cholerics such as Bernini: see, e.g., the much consulted and reprinted Baldassar Pisanelli (fl. 1559–83), *Trattato della natura de' cibi et del bere,* passim under the various, specific fruits discussed (my thanks to Sheila Barker for this citation).

33. Baldinucci, i.138, e.72, describes Bernini's health, at least in his earlier life, more negatively: "This same heated nature held him in a state of poor health until the age of forty, not being able, without harm, to tolerate the rays of the sun, not even their reflection, and thus often suffered from migraine. With the advancing years, however, this excessive heat diminishing, he guided himself to a state of perfect health."

As for his migraines, given the prevailing scientific notions about physiognomy, these headaches were fully understandable, if not inevitable: Bernini, as mentioned, is consistently portrayed as a "choleric" or fiery temperament; his headaches disappeared once his inner *spiriti* cooled as a result of the natural aging process, as Baldinucci pointed out (and for which see Fehrenbach, 2005, 1 and 11). The cessation of his headaches also seems to have coincided more or less with his marriage, though our biographers do not mention the fact.

34. In Baldinucci, i.138, e.72, this explanation is given to "those who used to criticize him" for his fiery temperament. For three clamorous, documented examples of the artist's wrath, see commentary to Domenico, 27 (revenge exacted against his mistress, Costanza Bonarelli; his attempted assassination of his brother Luigi) and Chantelou, October 6, f.229–30, e.261–62 (his explosive response to Charles Perrault's criticism). As for Bernini's frequently hypercritical judgment of others and their work, see Colbert's remark to Chantelou (July 15, f.77, e.62): "Yes, this is true [that Bernini is a very talented man] but I wish he would spare others a little."

CHAPTER XXIV

1. There is still no single, exhaustive catalogue of Bernini's sculpture and works of architecture. Of his paintings, none is possible, given the dispersal into oblivion of much of his production. By way of published catalogues, for the sculpture, see Wittkower; for the architecture, see Borsi; for painting, Petrucci, 2006; and Montanari, 2007. For all of Bernini's works identified as of 1967, see the cat. entries in M&M Fagiolo, now, of course, in need of much updating. Earlier (p. 26), Domenico had put the number of his father's canvases at, instead, more than one hundred fifty, "not counting those about which we have no information." Baldinucci, i.141, e.74, also says that number is "more than one hundred fifty," not including "the paintings by his hand that are on public view." Pietro Filippo numbers Bernini's statues at "one hundred and more," while his works of architecture are "innumerable" and his paintings, "very many."

2. This is one hyperbolic claim (repeated by Baldinucci, i.138, e.72) that, instead, would appear to be true, given what we know of Bernini's incessant activity throughout his adult life. Baldinucci, i.138–39, e.72, comments on Bernini's level of activity: "When not diverted by architectural projects, Bernini normally spent up to seven straight hours without resting when working in marble: a sustained effort that his young assistants could not maintain."

3. For Sforza Pallavicino, see Domenico, 40; for his further praise of Bernini, see Domenico, 97.

4. See Baldinucci, i.139, e.73, for Bernini's acknowledgment of the special assistance of Saint Peter. As for other celestial help given to the artist, commenting in Paris on the favorable reception of his Louvre design by King Louis, Bernini remarked that "God was the author of his success; before he had begun work he had entrusted himself to Him and every day since had

prayed that that grace might be vouchsafed him to succeed" (Chantelou, June 25, f.63, e.40; unfortunately, in the long run, God changed his mind about the destiny of Bernini's Louvre design). For Bernini's frequent reference to divine providence, see the Introduction, note 96.

5. The same passage is in Baldinucci, i.139, e.72. See also Domenico, 14 and 18, for Bernini's deep love for his art.

6. Baldinucci, i.139, e.72–73, reports this same need for the cautionary presence of an assistant at Bernini's side, but reports it as a fact pertaining to all of Bernini's life, not just his old age: even the young Bernini would get so absorbed by his work that he would forget his physical surroundings and hence the fears for his safety while working on scaffolding.

The phrase translated here as "causing an irreparable collapse" is, in the original Italian, "con irreparabile caduta," literally, "with an irreparable fall." In the absence of mention here by Domenico of specifically working high above the ground on scaffolding, the Italian word *caduta* seems out of place and leads me to suspect that Domenico has lifted this thought from Baldinucci's text, forgetting to revise the vocabulary (*caduta*/fall), which in Baldinucci refers to an actual physical fall, not a generic "collapse" of health. See also Domenico, 48, for the same topic of the intense, exhausting pace of Bernini's work habits.

7. See Domenico, 109, for an earlier statement of Bernini's chronic dissatisfaction with his own work.

8. For the same thought, see Baldinucci, i.142, e.76. See also Chantelou, September 11, f.175, e.191, where Bernini proclaims that truly learned men are by nature humble because they realize how little they know.

9. Another clever conceit on Bernini's part: adding zero to any number increases its magnitude tenfold, e.g., $1 + 0 = 10$.

10. In these final three words, printed in capital letters, "UN GRAND'HUOMO," Domenico sums up the ultimate goal of his biography—to demonstrate that his father was not merely an excellent artist, but indeed a great man in general (DLO/Pro, 47). For his often-used term *grand'huomo*, see Domenico, 97, and commentary. See also Domenico's insertion of the expression into Father Oliva's letter to the Marquis de Lionne (note 8 to Domenico, 141, above).

Baldinucci's biography concludes with no such lofty rhetorical clincher, although he earlier (just before his discussion of Bernini's disciples) echoed this sentiment in quoting Sforza Pallavicino: "I will close this section with Cardinal Pallavicino's familiar remark that Cavalier Bernini was not only the best sculptor and architect of his century but, to put it simply, the greatest man as well" (i.151, e.85).

This emphatic vindication of the goodness and greatness of Bernini the man (and not just the artist) most likely aims in part to counteract his rather poor reputation among many of his contemporaries precisely on the level of moral-psychological character and professional comportment, a reputation famously summed up by Passeri's characterization of Bernini as "that dragon of the Hesperides" (for which see the Introduction, p. 31 and note 75).

APPENDIX I

1. For Pietro Filippo as playwright, see Montanari, 1998b, 406–7; for his biography, see notes 20 and 21 to Domenico, 52. The *vita* was written as one long block of uninterrupted text, which for ease of reading I have divided into separate paragraphs. Likewise for ease of reading, my translation polishes away some of the awkward coarseness of the original.

2. For the manuscript's handwriting, see Montanari, 1998b, 402, and note 20 below.

3. Audisio, 41–42; I have omitted most of her notes on the physical condition of the manuscript. For the 1844 transcription, see Mazio, 340–44. Morris, 200–202, in discussing the present sketch, raises doubts as to whether the brief discussions of a certain anonymous manuscript life of Bernini by Fraschetti, 3, and Bossi, 15 n.1, refer to this same *Vita Brevis* by Pietro Filippo, even though the short extracts from that anonymous *vita* published by Fraschetti and Bossi correspond to those in the present *vita*. (Bossi, a canon of Saint Peter's Basilica, mentions

that the ms. *vita* in question once belonged to Bernini's son, Monsignor Bernini, and had been offered for sale to him [Bossi] by an unknown party, who had acquired it from a certain late Monsignor Carini [Fraschetti, 3; Morris, 201].)

The basis of Morris's doubts is Bossi's statement that, in researching Bernini's life, he preferred the anonymous ms. *vita* over Domenico's published biography of 1713 because he found the former "more reliable" (più esatto): Bossi's preference would seem strange, Morris, 201–2, reasons, if he were indeed referring to Pietro Filippo's short, fragmentary *Vita Brevis,* which "seems unlikely to be compared to a complete text." Hence, as Morris, 202, concludes, "the possibility of the existence of another manuscript biography, not yet discovered, cannot be dismissed."

4. See notes to the text below regarding the *Saint Lawrence* and the bust in Santa Prassede.

5. Immediately preceding *The Vita Brevis* in the same collection of Bernini family papers in the Bibliothèque Nationale, Paris (Ms. italien 2084, fols. 130–31), is another anonymous but intimately detailed account, more technical in nature, about three of Bernini's projects at Saint Peter's (the Baldacchino; the embellishment of the four piers, and the bell towers). Audisio (42) has transcribed this account as well, noting that this previously unpublished report was probably also composed for the sake of the biography-in-progress, as was *The Vita Brevis.* However, its author is not the same person(s) who compiled *The Vita Brevis:* not only is the handwriting different from either of the two hands evident in *The Vita Brevis,* but this text also, and more important, displays a distinct technical expertise that is missing in the present biographical sketch. The purpose of the account seems to be that of underscoring the technical and aesthetic challenges that Bernini encountered, and hence of defending Bernini against his critics while glorifying him for his successful resolution of the difficulties. Unfortunately, the report is far less detailed in its coverage of the four-piers project and the bell towers than it is on the first topic of the Baldacchino. Bernini's architectural right-hand man, Mattia de' Rossi, is a likely candidate for the account's author.

6. The correct year is 1598.

7. "esercitando diversi negotii": in light of what he says in the next line, our author presumably means that Pietro in his early years worked in more than one genre of art, and not just marble sculpture, as we know was indeed the case: see Kessler, 17–19. (Fraschetti, 3, however, takes the word *negotii* literally, meaning "businesses," and says that "it seems that Pietro worked principally as a merchant [*commerciante*].")

As for the qualification, "according to the custom of his town," the prologue to Vasari's *Life of Michelangelo* is perhaps relevant: in praising the artist as having supreme talent in all the forms of art, Vasari suggests that this versatility comes naturally to the Tuscans, "for the Tuscans have devoted to all the various branches of art more labor and study than all the other Italian peoples." Pietro (1562–1629) was first in Naples from 1584 to 1594; then again (after an interlude in Florence) from 1596 until his definitive transfer to Rome in 1606. See Kessler, 2005, for the most complete and most recent account of Pietro's biography and artistic production.

8. The text says literally that "he went to Naples to get married" (andò ad accasarsi in Napoli), as if marriage, and not employment, was the principal reason for the relocation to Naples.

9. His age is left blank in the manuscript, but it was most probably at age eight (1606): see Domenico, 6, and commentary.

10. "una vivacità grandissima d'ingegno e genio grandissimo in apprendere il disegno e la scoltura": see the Introduction, section 9, for discussion of the terms *ingegno, disegno,* and *genio.*

11. For this precocious work, see Domenico, 3, and commentary.

12. "più con il suo buon gusto."

13. This awkward "etc." is in the original text. The bust in question is that of Giovanni Battista Santoni, which is indeed in the Church of Santa Prassede. Domenico, 9–10, instead reports that, at the age of ten, the boy had done "a marble head" located in the church of "Santa Potenziana," whereas Baldinucci (i.74, e.9) says the boy "had then scarcely completed his tenth year" when he carved a bust in marble for the same misidentified church of S. Potenziana.

14. Audisio marks this word as a *lettura incerta,* a conjectured deciphering of the illegible manuscript.

15. The Cross of the Order of Christ, which gave him the title of knight, "Cavaliere": see Domenico, 22, and commentary.

16. In the seventeenth century, the necropolis under the main altar of Saint Peter's was believed to contain a portion of the remains of Saint Paul's body as well; for an erudite contemporary discussion of the question, see Filippo Buonanni's *Numismata summorum pontificum templi Vaticani fabricam indicantia* (Rome, 1696), chap. 24, 137–61; see also Kirwin, 14. However, what Pietro Filippo here improperly calls, in Italian, the "Confessione" is actually the Baldacchino, the gilt bronze structure serving as canopy, frame, and adornment for the main altar of Saint Peter's. More correctly, a *Confessione* or, in Latin, *Confessio,* is a subterranean shrine under the altar bearing saints' relics; in English, such a structure is conventionally referred to by its Latin name: see note 4 above to Domenico, 38.

The Baldacchino was a new, hybrid structure invented by Bernini that left his contemporaries at a loss for a proper label by which to identify it: see Domenico, 37, and commentary. Domenico, 48, does not identify the Baldacchino project as the reason for Bernini's turning away from painting; it was rather a grave illness, he claims.

17. The same "*Confessio* of Peter and Paul" (namely, the Baldacchino) mentioned in the previous sentence.

18. The Scala Regia and the Cathedra Petri, the monument in the apse of the basilica encasing what was then believed to be the original throne used by Saint Peter.

19. An explicit reference to the *imitatio Buonarroti* theme of the early Bernini sources, for which see the Introduction, section 7. For this papal visit, see note 14 to Domenico, 50.

20. The year (here omitted in the text) of the actual formal request to the pope was 1665; for Louis's letter, dated April 18, see Domenico, 119–20. As Audisio's n.61 informs us, from the start of this sentence to the conclusion of the *Vita,* there is a change of handwriting, the new hand being recognizable as that of Monsignor Pietro Filippo.

21. Domenico, 121, tells us that, still in Rome but having concluded his tenure as French ambassador and taken formal leave of the pope, Ambassador Créqui was obliged, upon receipt of the special-delivery orders from Paris, to officially re-present himself to the papal court to deliver Louis's letters of request to the pope and Cardinal Chigi, as well as to Bernini himself. For the Treaty of Pisa, signed in February 1664, between Louis XIV and Alexander VII, see Domenico, 117, and commentary.

22. I have filled in the missing portions of this confusingly laconic sentence based on what Domenico, 125–27, relates of the journey.

23. "Era talmente inamorato della sua professione." Instead of "professione," Audisio reads "perfettione" (perfection). I checked the manuscript and though the word in question is difficult to decipher, I read it as "professione," as we also find in the 1844 Mazio transcription, 344, and which here would seem to fit the context better. In any case, the point is clear: Bernini lived for his art, day and night, awake and asleep.

24. The text, "un S. Bastiano" (a Saint Sebastian), is mistaken: the statue in question is instead *Saint Lawrence,* for which see Domenico, 15–16, and commentary. Domenico also reports there that the statue was initially done as an act of personal piety and only afterward sold to Strozzi. Baldinucci, in contrast, simply states that it was made for Strozzi.

25. The Lateran canon in question is Monsignor Vincenzo, the artist's brother (Domenico, 42), while the prelate-son is Pietro Filippo himself (Domenico, 52, 111, 163, and 164). Note that I have rejoined here (as does Mazio, 344) what are obviously two halves of the same sentence but are physically separated in the original manuscript because the pages in question are bound incorrectly in the library's manuscript. Instead, Audisio simply transcribes the text as it physically appears in the incorrectly bound manuscript.

26. Both Domenico, 167, and Baldinucci, i.132, e.66, tell us that Bernini set to work on the *Savior* bust (also known by its Latin title, the *Salvator Mundi*) in his eightieth year (1678). They do not necessarily contradict what Pietro Filippo reports here, since one could interpret

the monsignor's statement to mean that Bernini *finished* the bust in his eighty-first year (1679), having begun it in the previous year (1678). Neither Domenico nor Baldinucci states that the bust was both begun and completed in 1678.

APPENDIX 2

1. For the text and discussion of Cureau de La Chambre's *Éloge de M. le Cavalier Bernin*, see Montanari, 1999, as well as the Introduction, section 4, above.

2. For Donneau de Visé (1638–1710) and the *Mercure* (founded in 1672), see Vincent; Sgard; Niderst; Klaits, 67–72; Bellanger et al., 1:137–42. According to Sgard, 322 and 323, until December 15, 1681, Donneau de Visé wrote the periodical by himself and thereafter with Thomas Corneille and occasional other collaborators. In 1724, it was renamed the *Mercure de France*.

3. "Composed in the style of an intimate letter to a fashionable lady, the *Mercure* became a great success. While sensitive literati decried Visé's style as, in La Bruyère's phrase, 'a step below zero,' its wide influence made it an important arbiter of taste for two generations. It helped set the uniform standards of thought and behavior which provided a cultural cement for the diverse leisured groups of urban French society" (Klaits, 67). Christina of Sweden was among its readers (Bignami Odier and Morelli, 78).

4. This would thus lend support to the argument that Bernini's difficulties with the French court were not due to the king's antipathy, but that of Colbert and the "cabal" of French architects who succeeded in bringing Bernini's Louvre project to its demise. Domenico says as much, who speaks of an unnamed "jealous minister" at the court and points out, without comment, that the end of the silence from the French court with respect to the long-terminated statue of Louis XIV Equestrian coincided with the death of Colbert and the coming to power of his successor, Louvois (see Domenico, 138 and 153, and commentary). Mirot, 278, however, argues that it was Louis XIV (not Colbert) who lost interest in Bernini. Alternatively, one could argue that whatever the nature of Louis XIV's true feelings toward Bernini, since the king had invested large sums of money in the artist, it was entirely in the court's best interests to contribute to the dissemination of a favorable image of Bernini.

5. For the diary entry, see Morello, 1981, 332: "La sera ci fanno musica con le parole del Bernino." Earlier in his diary (February 27, 1658; Morello, 1981, 324), Alexander notes that Don Mario Chigi that evening was going to the home of Bernini, whose children were to perform an operetta: might Bernini have supplied lyrics for this musical performance as well?

6. For Girardon's 1669 stay in Rome, see the related letters printed by Clément, 5:280, 281, 521. At Versailles, Girardon would later have the dubious honor of transforming Bernini's *Louis XIV Equestrian* statue into a *Marcus Curtius*. I have not investigated whether there is documentation suggesting that Donneau de Visé indeed interacted with the men mentioned here, but in all likelihood he did, as they were all connected in various ways to Louis's court.

7. The letter in question is an anonymous report preceding this *Éloge* in the same issue: sent from Rome, it features news from the papal capital and concludes with a poem in which a personification of Ancient Rome speaks of ceding its glory to France. The original was printed without paragraph divisions; for greater ease of reading, I have divided the texts in smaller blocks.

8. The *Mercure Galant* had briefly reported the death of "two illustrious men" (Bernini and Jesuit Father Athanasius Kircher) in its December 1680 issue (pp. 220–21); in the same issue, it delivered a tribute to Kircher, but postponed its tribute to Bernini to the next issue, with the promise of an accompanying portrait-medal: "Nous avons aussi perdu deux Hommes illustres, mais dans un âge fort avancé. L'un est le Pere Kirkher [sic] Jesuite, Professeur de Mathematique et si estimé, par le grand nombre d'excellens Ouvrages qu'il a donnez au Public . . . et le Chevalier Bernin, qui l'a suivi, en avoit quatre-vingts quatre. Je vous parlerai amplement de ce dernier dans ma Lettre du mois prochain, et vous en donnerai une Medaille." The mistaken age of eighty-four given for Bernini at the time of his death is corrected in the present January 1681 text.

9. "Macchiniste": for which see Domenico, 56–57, and commentary. As for Bernini the "engineer" (Ingénieur), many of his accomplishments in this realm came thanks to the talent of his more expert engineer collaborators, above all his brother Luigi (for whom see Domenico, 153–54, and commentary; and Baldinucci, i.152–54, e.86).

10. In an April 2, 1674, letter to Cardinal Leopold de' Medici encouraging the purchase of Bernini's self-portrait of the 1630s (now in the Uffizi), his agent in Rome, Paolo Falconieri, writes, "I wouldn't want this [canvas] to escape us, because, in addition to its being extremely beautiful, Your Highness knows that this man has painted almost nothing" (quoted in Petrucci, 2006, 317, cat. 10). Bernini, as we know, painted almost exclusively for his own private pleasure and purposes, so much so that Falconieri and Donneau de Visé were most likely not alone in thinking Bernini's painting production negligible; see Domenico, 26 and 178, and commentary.

11. "Ils ont le coloris beau, sont bien entendus, de clair, obscur, facilment peints, & ce qu'on peut appeller en termes de l'Art, d'une tres grande maniere." The words "sont bien entendus, de clair, obscur," despite the commas, might represent a single thought unit, in which case the meaning would be "they demonstrate a proficiency in chiaroscuro." (My thanks to Pamela Jones and Sheila Barker for discussing this passage with me.)

For the quality of being "well understood," see, e.g., Perrault's *Memoirs*, 63, which criticizes Bernini's bust of *Louis XIV*, saying that the king's sash in that portrait "is not properly understood," i.e., its purpose for being there and the way in which it is draped are not clear: "Since it wraps about the edge of the King's arm, it can only be a sash which was draped over the bust itself, and not the sash which was on the King's body when the bust was made, because the sash did not cover up his arm in such a way."

12. "qu'il est presque impossible de rien inventer dont il n'ait donné les ouvertures."

13. "On remarque qu'il s'est toûjours éloigné de ce que les autres ont fait avant luy."

14. The author is here referring to the special insert included in this issue with a reproduction of the commemorative medal in question. No documentation thus far has come to light regarding the origins of this medal, known as a royal commission only through the Baldinucci and Domenico biographies (*Regista*, 302, no. 13). For François Chéron and the medal, see Domenico, 147, and commentary.

15. "Singular in each [art], unique in [his possession of] all of them," referring of course to Bernini's command of all the arts of design, mathematics being essential to the artist as well.

16. Augustin-Charles Daviler, or d'Aviler (1653–1701), won appointment as royal pensionary to the French Academy in Rome in September 1674. However, en route from Marseille to Genoa, his ship was seized by Algerian pirates and he spent the next sixteen months a prisoner in Tunis. Freed from captivity, d'Aviler immediately went to Rome, arriving there in March 1676 and remaining until late 1679. Later in life, after his return to France, d'Aviler was eventually to make a reputation for himself as an architect in Montpellier and throughout Languedoc, as official "Architecte de la Province."

Giving his name to a decorative element for doors and windows known as the "Daviler arch," he was author of the best-selling manual *Cours complet d'architecture*. For his life and career, see Verdier, as well as *Architectural Theory*, 264–73; and *Grove Art Online*, s.v. "Aviler, Augustin-Charles d'." See Clément, 5:392–93, for Colbert's March 1679 letter to Charles Errard, director of the French Academy in Rome, citing d'Aviler's service to the crown in supplying drawings of "the most beautiful palaces and churches" in the city, with a proposal that he also report on its fountains and water supply.

17. It is surprising that the poet would focus attention on the *Louis XIV Equestrian* statue and in such a celebratory tone, since its fate at the time still lay in limbo, the statue having been ignominiously ignored by Louis and Colbert since its completion in 1677. Are we therefore to presume that its public reputation in Paris was not yet sullied, however Colbert or Louis may have felt privately about the statue? Yet surely those at or near the French court, Donneau de Visé and d'Aviler among them, would have known something of the travailed history and present ambiguous status of the colossus.

Bibliography

Acidini Luchinat, Cristina. "Alessandro VII, il Bernini e la Cappella del Voto nel Duomo di Siena." In *Gian Lorenzo Bernini architetto e l'architettura europea del Sei–Settecento,* ed. Gianfranco Spagnesi and Marcello Fagiolo, 389–410. Rome: Istituto della Enciclopedia Italiana, 1983–84.

Ackermann, Felix. "Berninis Umgestaltung des Innenraumes von S. Maria del Popolo unter Alexander VII. (1655–1659)." *Römisches Jahrbuch der Bibliotheca Hertziana* 31 (1996): 369–426.

———. *Die Altäre des Gian Lorenzo Bernini: Das barocke Altarensemble im Spannungsfeld zwischen Tradition und Innovation.* Petersberg: Imhof, 2007.

Ademollo, Alessandro. *I teatri di Roma nel secolo decimosettimo.* Bologna: Forni, 1969 (facsimile reprint of 1888 ed.).

Ago, Renata. *Economia barocca. Mercato e istituzioni nella Roma del Seicento.* Rome: Donzelli, 1998.

Åkerman, Susanna. "Kristina Wasa, Queen of Sweden." In *Modern Women Philosophers, 1600–1900: A History of Women Philosophers,* vol. 3, ed. Mary Ellen Waithe, 21–40. Dordrecht: Kluwer Academic Publishers, 1991.

Albion, Gordon. *Charles I and the Court of Rome.* London: Burns Oates and Washbourne, 1935.

Amadio, A. A. "La villa Ludovisi e la collezione di sculture." In *La collezione Boncompagni Ludovisi. Algardi, Bernini e la fortuna dell'antico,* ed. Antonio Giuliano, 9–17. Venice: Marsilio, 1992.

Ameyden, Teodoro. *Diario della città e corte di Roma notato da Deone Hora Temi Dio.* Manuscript, Biblioteca Casanatense, Rome, Mss. 1831–1833.

———. *La storia delle famiglie romane.* Rev. ed. by Carlo Augusto Bertini. Rome: Rivista del Collegio Araldico, 1910–14.

Andrews, Keith. "Annibale Carracci's Last Residence in Rome." *Burlington Magazine* 116 (1974): 32–35.

Angelini, Alessandro. *Gian Lorenzo Bernini e i Chigi tra Rome e Siena.* Siena: Banca Monte dei Paschi di Siena, 1998.

———. "Bernini, la pittura e i pittori." In *Bernini pittore,* ed. Tomaso Montanari, 197–209. Cinisello Balsamo: Silvana Editoriale, 2007.

Angelini, Alessandro, Monika Butzek, and Bernardina Sani, eds. *Alessandro VII Chigi (1599–1667). Il papa senese di Roma moderna.* Siena: Maschietto e Musolino and Protagon Editori Toscani, 2000.

Angelini, Franca. "Gian Lorenzo Bernini e la sorpresa del vedere." In *Valore del falso. Errori, inganni, equivoci sulle scene europee in epoca barocca*, ed. Franca Angelini and Silvia Carandini, 143–57. Rome: Bulzoni, 1994.

Angelini, Franca, Silvia Carandini, et al., eds. *Roma splendidissima e magnifica. Luoghi di spettacolo a Roma dall'umanesimo ad oggi.* Milan: Electa, 1997.

Anselmi, Alessandra. "I progetti di Bernini e Rainaldi per l'abside di Santa Maria Maggiore." *Bollettino d'arte* 86, no. 117 (2001): 27–78.

———. "Gaspar de Haro y Guzmán VII Marchese del Carpio: 'Confieso que debo al arte la magestad con que hoy triumpho.'" *Roma moderna e contemporanea* 15 (2007): 187–253.

Antinori, Aloisio. "Roma: Palazzo Barberini alle Quattro Fontane." In *Storia dell'architettura italiana. Il Seicento,* ed. Aurora Scotti Tosini, 140–45. Milan: Electa, 2003.

———. "Sulla prima formazione di Bernini architetto: Michelangiolismo e palladianesimo a Roma da Paolo V a Urbano VIII." In *Bernini dai Borghese ai Barberini. La cultura a Roma intorno agli Anni Venti,* ed. Olivier Bonfait and Anna Coliva, 2–11. Rome: De Luca, 2004.

———. "La città santa e la città degli uomini. Piazza del Popolo." In *La magnificenza e l'utile. Progetto urbano e monarchia papale nella Roma del Seicento,* 103–32. Rome: Gangemi, 2008.

Antonazzi, Giovanni. *Il Palazzo di Propaganda.* Rome: De Luca, 1979.

Architectural Theory: From the Renaissance to the Present. Cologne: Taschen, 2003.

L'Ariccia del Bernini. Rome: De Luca, 1998.

Artioli, Romolo, and Benedetto Carpineta. "La ricerca della tomba di Gian Lorenzo Bernini." In *Atti del III Congresso Nazionale di Studi Romani,* 2:321–24. Bologna: Capelli, 1935.

Askew, Pamela. "The Relation of Bernini's Architecture to the Architecture of the High Renaissance and of Michelangelo." *Marsyas* 5 (1947–49): 39–68.

Audisio, Felicita. "Lettere e testi teatrali di Bernini: Una postilla linguistica." In *Barocco romano e barocco italiano. Il teatro, l'effimero, l'allegoria,* ed. Marcello Fagiolo and Maria Luisa Madonna, 26–44. Rome: Gangemi, 1985.

Avery, Charles. *Bernini: Genius of the Baroque.* Boston: Little, Brown, 1997.

Bacchi, Andrea, ed. *Scultura del '600 a Roma.* Milan: Longanesi, 1996.

Bacchi, Andrea, Catherine Hess, and Jennifer Montagu. *Bernini and the Birth of Baroque Portrait Sculpture.* Los Angeles: J. Paul Getty Museum; Ottawa: National Gallery of Canada, 2008.

Bacchi, Andrea, and Stefano Pierguidi. *Bernini e gli allievi: Giuliano Finelli, Andrea Bolgi, Francesco Mochi, François Duquesnoy, Ercole Ferrata, Antonio Raggi, Giuseppe Mazzuoli.* Florence: Il Sole 24 Ore and E-ducation.it, 2008.

Baglione, Giovanni. *Le vite de' pittori scultori et architetti (1642).* 3 vols. Vatican City: Biblioteca Apostolica Vaticana, 1995.

Balbi De Caro, Silvana. "Gianlorenzo Bernini and the Roman Baroque Medal." *Medaglia* 7 (1974): 7–26.

Baldinucci, Filippo. *Vita di Gian Lorenzo Bernini.* Ed. Sergio Samek Ludovici. Milan: Edizioni del Milione, 1948.

———. *The Life of Bernini.* Trans. Catherine Enggass. University Park: Pennsylvania State University Press, 1966; reprinted 2006, with introduction by Maarten Delbeke, Evonne Levy, and Steven F. Ostrow.

———. *Diario spirituale.* Ed. Giuseppe Parigino. Florence: Le Lettere, 1995.

Baldinucci, Francesco Saverio. *Vita del Baldinucci scritta dal figlio Francesco Saverio*. In Filippo Baldinucci, *Vita di Gian Lorenzo Bernini*, ed. Sergio Samek Ludovici, 31–63. Milan: Edizioni del Milione, 1948.

Bandera Bistoletti, Sandrina. "Lettura di testi berniniani. Qualche scoperta e nuove osservazioni. Dal *Journal* di Chantelou e dai documenti della Bibliothèque Nationale di Parigi." *Paragone/Arte* 36, no. 429 (1985): 43–76.

Barbiche, Bernard, and Ségolène de Dainville-Barbiche. *Sully: L'homme et ses fidèles*. Paris: Fayard, 1997.

Barberini, Maria Giulia. "Algardi e Villa Pamphilj." In *Villa Doria Pamphilj: Storia della Collezione*, ed. Beatrice Palma Venetucci, 69–73. Rome: De Luca, 2001a.

———. "Base or Noble Material? Clay Sculpture in Seventeenth- and Eighteenth-Century Italy." In *Earth and Fire: Italian Terracotta Sculpture from Donatello to Canova*, ed. Bruce Boucher, 49–56. New Haven: Yale University Press, 2001b.

Barbiellini Amidei, Rosanna. "Figure e ritratti di Innocenzo X." In *Innocenzo X Pamphilj. Arte e potere a Roma nell'età barocca*, ed. Alessandro Zuccari and Stefania Macioce, 163–76. Rome: Logart, 1990.

Barcham, William. "Some New Documents on Federico Cornaro's Two Chapels in Rome." *Burlington Magazine* 135 (1993): 821–22.

———. "Verwandtschafts- und Selbstrepräsentation in der Cornaro Kapelle, Rom." In *Tod und Verklärung: Grabmalskultur in der Frühen Neuzeit*, ed. Arne Karsten and Philipp Zitzlsperger, 205–18. Cologne: Böhlau, 2004.

Barker, Sheila. "Art, Architecture, and the Roman Plague of 1656–57." *Roma moderna e contemporanea* 14 (2006): 243–62.

Barnes, Diana. "The *Secretary of Ladies* and Feminine Friendship at the Court of Henrietta Maria." In *Henrietta Maria: Piety, Politics, and Patronage*, ed. Erin Griffey, 39–56. London: Ashgate, 2008.

Barnes, Susan J., et al., eds. *Van Dyck: A Complete Catalogue of the Paintings*. New Haven: Yale University Press for the Paul Mellon Centre for Studies in British Art, 2004.

Barton, Eleanor Dodge. "The Problem of Bernini's Theories of Art." *Marsyas* 4 (1945–47): 81–111.

Battaglia, Roberto. "Il Palazzo di Nerone e la Villa Barberini al Gianicolo." *Roma* 20 (1942): 401–17.

———. *La cattedra berniniana di San Pietro*. Rome: Reale Istituto di Studi Romani, 1943.

Baudi di Vesme, Alessandro. *Schede Vesme. L'arte in Piemonte dal XVI al XVIII secolo*. 4 vols. Turin: Società Piemontese di Archeologia e Belle Arti, 1963–82.

Bauer, George C., ed. *Bernini in Perspective*. Englewood Cliffs, N.J.: Prentice-Hall, 1976.

———. "Bernini's Altar for the Val-de-Grâce." In *Light on the Eternal City: Observations and Discoveries in the Art and Architecture of Rome*, ed. Hellmut Hager and Susan Scott Munshower, 176–87. University Park: Pennsylvania State University Press, 1987.

———. "Bernini and the Baldacchino: On Becoming an Architect in the Seventeenth Century." *Architectura: Zeitschrift für Geschichte der Baukunst* 26 (1996): 144–65.

———. "Bernini's *Pasce oves meas* and the Entrance Wall of St. Peter's." *Zeitschrift für Kunstgeschichte* 63 (2000): 15–25.

Beck, Melissa. "The Evolution of a Baroque Chapel: Pietro da Cortona's *Divine Wisdom*, Urban VIII, and Bernini's Adoration of the Sacrament." *Apollo* 150 (1999): 35–45.

Beecher, Donald. "Gianlorenzo Bernini's 'The Impresario': The Artist as the Supreme Trickster." *University of Toronto Quarterly* 53, no. 3 (1984): 236–47.

Beecher, Donald, and Massimo Ciavolella. "A Comedy by Bernini." In *Gianlorenzo Bernini: New Aspects of His Art and Thought,* ed. Irving Lavin, 63–114. University Park: Pennsylvania State University Press and College Art Association, 1985.

Bejor, Giorgio, ed. *Il Laocoonte dei Musei Vaticani: 500 anni della scoperta.* Milan: Cisalpino, Istituto Editoriale Universitario, 2007.

Bellanger, Claude, Jacques Godechot, Pierre Guiral, and Fernand Terrou, eds. *Histoire générale de la presse française.* Vol. 1, *Des origines à 1814.* Paris: Presses Universitaires de France, 1969.

Bellini, Eraldo. "Scrittura letteraria e scrittura filosofica in Sforza Pallavicino." In *Il vero e il falso dei poeti. Tasso, Tesauro, Pallavicino, Muratori,* ed. Claudio Scarpati and Eraldo Bellini, 116–21. Milan: Vita e Pensiero, 1999.

———. "From Mascardi to Pallavicino: The Biographies of Bernini and Seventeenth-Century Roman Culture." In *Bernini's Biographies: Critical Essays,* ed. Maarten Delbeke, Evonne Levy, and Steven F. Ostrow, 275–313. University Park: Pennsylvania State University Press, 2006.

———. "Le biografie di Bernini e la cultura romana del Seicento." In *Stili di pensiero nel Seicento italiano. Galileo, i Lincei, i Barberini,* 159–201. Pisa: Edizioni ETS, 2009.

Beltramme, Marcello. "G.L. Bernini a San Franceco a Ripa. Una rilettura per una nuova proposta tematica." *Studi romani* 46 (1998): 29–59.

———. "Tracce per una biografia morale dell'ultimo Bernini: La famiglia, i beni, la sopravvivenza del nome." *Studi romani* 51 (2003): 280–300.

———. "Un nuovo documento sull'officina biografica di Gian Lorenzo Bernini." *Studi romani* 53 (2005): 146–60.

Benedetti, Elpidio. *Raccolta di diverse memorie per scrivere la vita del Cardinale Giulio Mazarini, Romano, primo Ministro di Stato nel regno di Francia.* Lyon, n.d. (but ca. 1653).

Benocci, Carla. *Paolo Giordano II Orsini nei ritratti di Bernini, Boselli, Leoni e Kornmann.* Rome: De Luca, 2006.

Bentivoglio, Enzo. "'Non oppidem, sed urbem.' Il principato pamphiliano di S. Martino al Cimino." In *Imago pietatis 1650. I Pamphilj a San Martino al Cimino,* ed. Sivigliano Alloisi, 47–60. Rome: Palombi, 1987.

Bentz, Katherine M. "The Villa Barberini ai Bastioni: Papal Politics and Family Power in the Urban Landscape of Early Modern Rome." Paper presented at the College Art Association Annual Conference. Boston, February 2006.

Bérenger, Jean. *Turenne.* Paris: Fayard, 1987.

Berger, Pamela. "Mice, Arrows, and Tumors: Medieval Plague Iconography North of the Alps." In *Piety and Plague: From Byzantium to the Baroque,* ed. Franco Mormando and Thomas Worcester, 23–63. Kirksville: Truman State University Press, 2007.

Berger, Robert W. "Bernini's *Louis XIV Equestrian*: A Closer Examination of Its Fortunes at Versailles." *Art Bulletin* 63 (1981): 232–48.

Bernier, Olivier. *Louis XIV: A Royal Life.* New York: Doubleday, 1987.

Bernini, Domenico. *Memorie historiche di ciò, che hanno operato li sommi pontefici nelle guerre contro i Turchi dal primo passaggio di questi in Europa fino all'anno 1684.* Rome, 1685.

———. *Vita del ven. padre fr. Giuseppe da Copertino de' minori conventuali.* Rome, 1722.

———. *Historie di tutte l'heresie.* 4 vols. Rome, 1705–9.

Bernini, Gian Lorenzo. *Fontana di Trevi: Commedia inedita*. Ed. Cesare D'Onofrio. Rome: Staderini Editore, 1963.

——. *L'impresario*. Ed. Massimo Ciavolella. Rome: Salerno, 1992.

——. *The Impresario*. Trans. Don Beecher and Massimo Ciavolella. 2nd ed. Carleton Renaissance Plays in Translation. Ottawa: Dovehouse Editions, 1995. (For the bilingual edition edited by the same two scholars, see Beecher and Ciavolella, 1985.)

——. *La Verità discoperta dal Tempo: "Comedia ridiculosa."* Restauro drammaturgico in due tempi di Alberto Perrini. Soveria Mannelli: Rubbettino, 2007.

Bernini in Vaticano. Rome: De Luca, 1981.

Bernini scultore. La nascita del barocco in Casa Borghese. Ed. Anna Coliva and Sebastian Schütze. Rome: De Luca, 1998.

Bernstock, Judith. "Bernini's Tomb of Alexander VII." *Saggi e memorie di storia dell'arte* 16 (1988): 167–90; 363–73.

Bertrand, Pascal-François. *Les tapisseries des Barberini et la décoration d'intérieur dans la Rome baroque*. Turnhout: Brepols, 2005.

Biagioli, Mario. *Galileo Courtier: The Practice of Science in the Culture of Absolutism*. Chicago: University of Chicago Press, 1993.

Bialostocki, Jan. "Gian Lorenzo Bernini e l'antico." In *Gian Lorenzo Bernini e le arti visive*, ed. Marcello Fagiolo, 59–72. Rome: Istituto della Enciclopedia Italiana, 1987.

Bibliothèque de la Compagnie de Jésus. Ed. Augustin de Backer, Aloys de Backer, and Carlos Sommervogel. 12 vols. Louvain: Editions de la Bibliothèque S.J., Collège Philosophique et Théologique, 1960.

Bignami Odier, Jeanne, and Giovanni Morello, eds. *Istoria degli intrighi galanti della Regina Cristina di Svezia (Anonimo del '600)*. Rome: Palombi, 1979.

Birindelli, Massimo. *Piazza San Pietro*. Bari: Laterza, 1981.

Bober, Phyllis Pray, and Ruth Rubinstein. *Renaissance Artists and Antique Sculpture: A Handbook of Sources*. London: Harvey Miller and Oxford University Press, 1986.

Bone, Quentin. *Henrietta Maria, Queen of the Cavaliers*. Urbana: University of Illinois Press, 1972.

Bonfait, Olivier, and Anna Coliva, eds. *Bernini dai Borghese ai Barberini. La cultura a Roma intorno agli anni venti*. Rome: De Luca, 2004.

Bonini, Filippo Maria. *L'ateista convinto dalle sole ragioni*. Venice: Nicolò Pezzano, 1665.

Børresen, Kari Elisabeth. "La religion de Christine de Suède." In *Cristina di Svezia e Roma*, ed. Börje Magnusson, 9–20. Stockholm: Swedish Institute in Rome, 1999.

Borsi, Franco. *Bernini architetto*. With appendix of catalogue entries by Francesco Quinterio. Milan: Electa, 2000 (originally published in 1980).

Borsi, Franco, Cristina Acidini Luchinat, and Francesco Quinterio, eds. *Gian Lorenzo Bernini. Il testamento. La casa. La raccolta dei beni*. Florence: Alinea Editrice, 1981.

Bösel, Richard. "Borromini: Tagliacantone. Architektonische Gestaltungsprinzipien eines 'Eck-' Aufschneiders." *Römische historische Mitteilungen* 43 (2001): 545–60.

Bossi, Gaetano. *La pasquinata, "Quod non fecerunt barbari, fecerunt Barberini." Ricerche storiche*. Rome: Libreria Enrico Filziani, 1898.

Boudon-Machuel, Marion. *François du Quesnoy, 1597–1643*. Paris: Arthena, 2005.

Boucher, Bruce. "Bernini e l'architettura del cinquecento. La lezione di Baldassare Peruzzi e di Sebastiano Serlio." *Bollettino del Centro Internazionale di Studi di Architettura Andrea Palladio* 23 (1981): 27–43.

Brauer, Heinrich, and Rudolf Wittkower. *Die Ziechnungen des Gianlorenzo Bernini.* New York: Collectors Editions, 1970 (original ed. Berlin: Verlag Heinich Keller, 1931).

Brejon de Lavergnée, Arnauld. "Il testamento pittorico del Bernini. Il *Christus Patiens.*" In *Velázquez, Bernini, Luca Giordano. Le corti del Barocco,* ed. Fernando Checa Cremades, 85–87. Milan: Skira, 2004.

Briganti, Giuliano, ed. *Catalogo e stima dei dipinti e delle sculture di proprietà della famiglia Forti e provenienti dalla successione di Casa Giocondi erede di Gian Lorenzo Bernini, 20 febbraio 1964.* Rome: n.p., 1964.

Brotton, Jerry. *The Sale of the Late King's Goods: Charles I and His Art Collection.* London: Macmillan, 2006.

Bruno, Silvia. "Arte e teatro nelle residenze romane dei Barberini." In *Lo spettacolo del sacro, la morale del profano,* ed. Danilo Romei, 67–88. Florence: Edizioni Polistampa, 2005.

Buckley, Veronica. *Christina, Queen of Sweden: The Restless Life of a European Eccentric.* London: Fourth Estate, 2004.

Burbaum, Sabine. *Die Rivalität zwischen Francesco Borromini und Gianlorenzo Bernini.* Oberhausen: Athena, 1999.

Burke, Marcus B., and Peter Cherry. *Collections of Paintings in Madrid, 1601–1755.* Ed. Maria L. Gilbert. Los Angeles: Provenance Index of the Getty Information Institute, 1997.

Burke, Peter. *The Fabrication of Louis XIV.* New Haven: Yale University Press, 1992.

Busiri Vici, Andrea. "L'Arsenale di Civitavecchia di Gian Lorenzo Bernini." *Palladio* 6 (1956): 127–36.

Butterfield, Andrew, ed. *Bernini: The Modello for the Fountain of the Moor.* New York: Salander-O'Reilly, 2002.

Cacciotti, Beatrice. *La collezione di antichità del cardinale Flavio Chigi.* Rome: Aracne, 2004.

Caetani, Leone. "Vita e diario di Paolo Alaleone de Branca maestro delle cerimonie pontificie, 1582–1638." *Archivio della Società Romana di Storia Patria* 16 (1893): 5–93.

Calcaterra, Francesco. *Corti e cortigiani nella Roma barocca.* Rome: Gangemi, 2004.

Campbell, Thomas P., ed. *Tapestry in the Baroque: Threads of Splendor.* New York: Metropolitan Museum of Art, 2007.

Caperna, Maurizio. *La basilica di Santa Prassede. Il significato della vicenda architettonica.* Rome: Monaci Benedettini Vallombrosani, 1999.

Capucci, Martino. "Dalla biografia alla storia. Note sulla formazione della storiografia artistica nel seicento." *Studi secenteschi* 9 (1968): 81–125.

Carandini, Silvia. "Le metamorfosi di una nuvola. Gian Lorenzo Bernini drammaturgo, scenografo, personaggio e attore." In *Teatro e palcoscenico dall'Inghilterra all'Italia 1540–1640,* ed. Anna Maria Palombi Cataldi, 211–25. Rome: Bulzoni, 2001.

Cardella, Lorenzo. *Memorie storiche de' cardinali della Santa Romana Chiesa.* Rome, 1792–97.

Cardilli Alloisi, Luisa, ed. *La via degli angeli. Il restauro della decorazione scultorea di Ponte Sant'Angelo.* Rome: De Luca, 1988.

Careri, Giovanni. *Bernini: Flights of Love, the Art of Devotion.* Chicago: University of Chicago Press, 1995.

Carletta, A. "Bernini a teatro." *Don Chisciotte di Roma* 6, no. 305 (sabato, 5 novembre) (1898a): 1–2.

————. "La moglie di Bernini." *Don Chisciotte di Roma* 6, no. 319 (domenica, 20 novembre) (1898b): 1–2.

Carloni, Livia. "La Cappella Cornaro in Santa Maria della Vittoria. Nuove evidenze e acquisizioni sulla 'men cattiva opera' del Bernini." In *Gian Lorenzo Bernini. Regista del Barocco. I restauri,* ed. Claudio Strinati and Maria Grazia Bernardini, 37–46. Milan: Skira, 1999.

Carriò-Invernizzi, Diana. "La estatua de Felipie IV en Santa Maria Maggiore y la embajada romana de Pedro Antonio de Aragón (1664–1666)." *Roma moderna e contemporanea* 15 (2007): 255–70.

Carta, Marina. "L'architettura del ciborio berniniano. Le fasi di lavorazione del cantiere. Alcuni notizie di decorazione e di arredo nella Cappella del Santissimo Sacramento." In *L'ultimo Bernini 1665–1680. Nuovi argomenti, documenti e immagini,* ed. Valentino Martinelli, 37–68. Rome: Edizioni Quasar, 1996.

Carunchio, Tancredi. "Ipotesi 'barocche' in Sebastiano Serlio." In *Gian Lorenzo Bernini architetto e l'architettura europea del Sei–Settecento,* ed. Gianfranco Spagnesi and Marcello Fagiolo, 35–49. Rome: Istituto della Enciclopedia Italiana, 1983–84.

Casale, Gerardo. "Variazioni manieristiche e barocche del ciborio a tempietto." In *L'ultimo Bernini 1665–1680. Nuovi argomenti, documenti e immagini,* ed. Valentino Martinelli, 23–36. Rome: Edizioni Quasar, 1996.

Castellamonte, Amedeo di. *La Venaria Reale: Palazzo di piacere, e di caccia ideato dall'Altezza Reale di Carlo Emanuele II, Duca di Savoia.* Turin: Bartolomeo Zapatta, 1674.

Castellani, Giuseppe. *La Congregazione dei Nobili presso la Chiesa del Gesù in Roma.* Rome: n.p., 1954.

Cavallari-Murat, Augusto. "Professionalità di Bernini quale urbanista: Alcuni episodi e una confessione su Mirafiori." In *Gian Lorenzo Bernini architetto e l'architettura europea del Sei–Settecento,* ed. Gianfranco Spagnesi and Marcello Fagiolo, 323–60. Rome: Istituto della Enciclopedia Italiana, 1983–84.

Cavazzini, Patrizia. *Painting as Business in Early Seventeenth-Century Rome.* University Park: Pennsylvania State University Press, 2008.

Chaleix, Pierre. "A propos du baldaquin de l'église du Val-de-Grâce." *Bulletin de la Société de l'Histoire de l'Art Français* (1961): 211–14.

Chantelou, Paul Fréart de. *Diary of the Cavaliere Bernini's Visit to France.* Introduction by Anthony Blunt; annotated by George C. Bauer; translated by Margery Corbett. Princeton: Princeton University Press, 1985.

————. *Journal de voyage du Cavalier Bernin en France.* Ed. Milovan Stanić. Paris: Macula, L'insulaire, 2001.

————. *Bernini in Paris: Das Tagebuch des Paul Fréart de Chantelou über den Aufenthalt Gianlorenzo Berninis am Hof Ludwigs XIV.* Ed. Pablo Schneider and Philipp Zitzlsperger. Berlin: Akademie Verlag, 2006.

————. *Bernini in Francia: Paul de Chantelou e il Journal de voyage du cavalier Bernin en France.* Translated and edited by Daniela del Pesco. Naples: Electa, 2007.

Chardon, Henri. *Les frères Fréart de Chantelou. Amateurs d'art et collectionneurs manceaux.* Le Mans: E. Monnoyer, 1867.

Cherchi, Paolo. "The Seicento: Poetry, Philosophy, and Science." In *The Cambridge History of Italian Literature,* ed. Peter Brand and Lino Pertile, 301–17. Cambridge: Cambridge University Press, 1999.

Cipriani, Giovanni. *Gli obelischi egizi. Politica e cultura nella Roma barocca.* Florence: Olschki, 1993.

Clément, Pierre, ed. *Lettres, instructions et mémoires de Colbert*. Paris: Imprimerie impériale, 1865.

Clements, Robert J. *Michelangelo's Theory of Art*. New York: Gramercy, 1961.

Cohen, Elizabeth S. "Honor and Gender in the Streets of Early Modern Rome." *Journal of Interdisciplinary History* 22 (1992): 597–625.

Cole, Janie. "Cultural Clientelism and Brokerage Networks in Early Modern Florence and Rome: New Correspondence Between the Barberini and Michelangelo Buonarroti the Younger." *Renaissance Quarterly* 60 (2007): 729–88.

Coliva, Anna. "Casa Borghese. La committenza artistica del Cardinal Scipione." In *Bernini scultore. La nascita del barocco in casa Borghese*, ed. Anna Coliva and Sebastian Schütze, 389–420. Rome: De Luca, 1998.

———, ed. *Velázquez a Roma, Velázquez e Roma*. Milan: Skira, 1999.

———, ed. *Bernini scultore. La tecnica esecutiva*. Rome: De Luca, 2002.

Collins, Jeffrey. "Power and Art at Casino Borghese: Scipione, Gian Lorenzo, Maffeo." In *La imagen política*, ed. Cuauhtémoc Medina. Mexico City: Universidad Nacional Autónoma de México, Instituto de Investigaciones Estéticas, 2006.

Colzi, Roberto. "Che ora era? Raffronto tra le ore all'italiana e alla francese a Roma." *Studi romani* 43 (1995): 93–102.

Comanini, Gregorio. *The Figino, or On the Purpose of Painting*. Translated and edited by Ann Doyle-Anderson and Giancarlo Maiorino. Toronto: University of Toronto Press, 2001.

Connors, Joseph. *Borromini and the Roman Oratory: Style and Society*. New York: Architectural History Foundation; Cambridge: MIT Press, 1980.

———. "Bernini's S. Andrea al Quirinale: Payments and Planning." *Journal of the Society of Architectural Historians* 41 (1982): 15–37.

———. "Virgilio Spada's Defence of Borromini." *Burlington Magazine* 131 (1989): 76–90.

———. "Introduction." In *Francesco Borromini: Opus Architectonicum*. Milan: Edizioni Il Polifilo, 1998.

———. "Francesco Borromini: La vita 1599–1667." In *Borromini e l'universo barocco*, ed. Richard Bösel and Christoph L. Frommel, 7–21. Milan: Electa, 2000a.

———. "Poussin detrattore di Borromini." In *Francesco Borromini. Atti del convegno internazionale Roma 13–15 gennaio 2000*, ed. Christoph Luitpold Frommel and Elisabeth Sladek, 191–204. Milan: Electa, 2000b.

———. "Bernini e il Baldacchino di San Pietro." In *Petros eni, Pietro è qui*, 105–10 (cited as Connors, 2006).

Contini, Roberto. *Il Cigoli*. Soncino: Edizioni del Soncino, 1991.

Cope, Jackson I. "Bernini and Roman 'Commedie Ridicolose.'" *PMLA* 102 (1987): 177–86.

Cousinié, Frédéric. "De la *morbidezza* du Bernin au 'sentiment de la chair' dans la sculpture française." In *Le Bernin et l'Europe: Du baroque triomphant à l'âge romantique*, ed. Chantal Grell and Milovan Stanić, 283–302. Paris: Presses de l'Université de Paris–Sorbonne, 2002.

Coville, Henry. *Étude sur Mazarin et ses démêlés avec le pape Innocent X (1644–1648)*. Paris: Champion, 1914.

Cropper, Elizabeth. *The Domenichino Affair: Novelty, Imitation, and Theft in Seventeenth-Century Rome*. New Haven: Yale University Press, 2005.

Curzietti, Jacopo. "Antonio Raggi e il cantiere decorative di S. Maria dei Miracoli. Nuovi documenti e un'analisi della ultima fase produttiva dello scultore ticinese." *Storia dell'Arte* 113/114 (2006): 205–38.

————. "Gian Lorenzo Bernini e l'Elefante della Minerva. Una documentazione inedita." *Studi di Storia dell'Arte* 18 (2007): 333–42.

————. "'Con disegno del Cavalier Bernino.' Giulio Cartari e la decorazione della cappella Poli in S. Crisogono a Roma." *Storia dell'Arte* 120 (2008): 41–58.

D'Afflitto, Chiara, and Danilo Romei, eds. *I teatri del paradiso. La personalità, l'opera, il mecenatismo di Giulio Rospigliosi (Papa Clemente IX)*. Pistoia: Maschietto e Musolino and Protagon Editori Toscani, 2000.

D'Amelia, Marina. "La conquista di una dote. Regole del gioco e scambi femminili alla Confraternità dell'Annunziata a Roma (sec. XVII–XVIII)." In *Ragnatele di rapporti. Patronage e reti di relazione nella storia delle donne*, ed. Lucia Ferrante, Maura Palazzi, and Gianna Pomata, 305–43. Turin: Rosenberg and Sellier, 1988.

D'Onofrio, Cesare. *Gian Lorenzo Bernini, Fontana di Trevi: Commedia inedita*. Rome: Staderini Editore, 1963.

————. "Priorità della biografia di Domenico Bernini su quella del Baldinucci." *Palatino* 10 (1966a): 201–8.

————. "Un dialogo-recita di Gian Lorenzo Bernini e Lelio Guidiccioni." *Palatino* 10 (1966b): 127–34.

————. *Roma vista da Roma*. Rome: Edizioni Liber, 1967.

————. *Roma nel Seicento*. (Contains Fioravante Martinelli, *Roma ornata dall'architettura, pittura e scultura*, ca. 1660–63.) Florence: Vallecchi, 1969.

————. *Scalinate di Roma*. Rome: Staderini, 1973.

————. *Roma val bene un'abiura. Storie romane tra Cristina di Svezia, Piazza del Popolo e l'Accademia d'Arcadia*. Rome: Palombi, 1976.

————. *Gian Lorenzo Bernini e gli angeli di Ponte S. Angelo. Storia di un ponte*. Rome: Romana Società Editrice, 1981.

————. *Le fontane di Roma. Con documenti e disegni inediti*. 3rd ed. Rome: Romana Società Editrice, 1986.

————. *Gli obelischi di Roma. Storia e urbanistica di una città dall'età antica al XX secolo*. 3rd ed. Rome: Romana Società Editrice, 1992.

Damm, Heiko. "Gianlorenzo on the Grill: The Birth of the Artist in His 'Primo Parto di Divozione.'" In *Bernini's Biographies: Critical Essays,* ed. Maarten Delbeke, Evonne Levy, and Steven F. Ostrow, 223–49. University Park: Pennsylvania State University Press, 2006.

Dandelet, Thomas James. "Financing New Saint Peter's, 1506–1700." In *Sankt Peter in Rom 1506–2006,* ed. Georg Satzinger and Sebastian Schütze, 41–48. Munich: Hirmer, 2008.

De' Giovanni-Centelles, Guglielmo. "L'arcivernice del Cavalier Bernini: Una scoperta nel restauro romano di Santa Bibiana." *Strenna dei Romanisti* 63 (2002): 163–75.

De Marchi, Andrea G. "La verità sulla *Verità* di Bernini. Interferenze fra quadri e sculture." *Bollettino d'arte* 90, ser. 6, no. 133–34 (2005): 127–32.

Debenedetti, Elisa. "Alcuni disegni del Gesù." In *Studi sul Barocco romano. Scritti in onore di Maurizio Fagiolo dell'Arco,* 345–52. Milan: Skira, 2004.

Delbeke, Maarten. "The Pope, the Bust, the Sculptor, and the Fly: An Ethical Perspective on the Work of Gianlorenzo Bernini in the Writings of Pietro Sforza Pallavicino." *Bulletin de l'Institut Historique Belge de Rome* 70 (2000): 179–223.

————. "Art as Evidence, Evidence as Art: Bernini, Pallavicino, and the Paradoxes of Zeno." In *Estetica Barocca,* ed. Sebastian Schütze, 343–59. Rome: Campisano, 2004.

————. "Gianlorenzo Bernini as 'La fenice degl'ingegni,' or the History of an Epithet." *Marburger Jahrbuch für Kunstwissenschaft* 32 (2005): 245–53.

———. "Gianlorenzo Bernini's *Bel Composto*: The Unification of Life and Work in Biography and Historiography." In *Bernini's Biographies: Critical Essays*, ed. Maarten Delbeke, Evonne Levy, and Steven F. Ostrow, 251–74. University Park: University Park, 2006.

———. "Framing History: The Jubilee of 1625, the Dedication of the New Saint Peter's and the Baldaccino." In *Festival Architecture*, ed. Sarah Bonnemaison and Christine Macy, 129–54. London: Routledge, 2008.

Delbeke, Maarten, Evonne Levy, and Steven F. Ostrow, eds. *Bernini's Biographies: Critical Essays*. University Park: Pennsylvania State University Press, 2006.

———. "Prolegomena to the Interdisciplinary Study of Bernini's Biographies." In *Bernini's Biographies: Critical Essays*, ed. Maarten Delbeke, Evonne Levy, and Steven F. Ostrow, 1–72. University Park: Pennsylvania State University Press, 2006.

———. "Introduction" to the 2006 reprint of Filippo Baldinucci, *The Life of Bernini*, trans. Catherine Enggass. University Park: Pennsylvania State University Press, 1966.

Delcorno, Carlo. "Un avversario del Marino: Ferrante Carli." *Studi secenteschi* 16 (1975): 69–155.

Del Panta, Antonella. "Genealogia di Gian Lorenzo Bernini." *Palladio* 6, no. 11 (1993): 111–18.

del Pesco, Daniela. *Il Louvre di Bernini nella Francia di Luigi XIV*. Naples: Fratelli Fiorentino, 1984.

———. *Colonnato di San Pietro. "Dei Portici antichi e la loro diversità."* Con un'ipostesi di cronologia. Rome: II Università degli Studi di Roma, 1988.

Del Re, Niccolò. *La curia romana. Lineamenti storico-giuridici*. 3rd ed. Rome: Edizioni di Storia e letteratura, 1970.

Depping, Georges-Bernard, ed. *Correspondance administrative sous le règne de Louis XIV*. 4 vols. Paris: Imprimerie nationale, 1850–55.

Di Gioia, Elena Bianca, ed. *La Medusa di Gian Lorenzo Bernini. Studi e restauri*. Rome: Campisano, 2007.

Di Napoli Rampolla, Federica. "Cronologia delle ristrutturazioni della Cappella della beata Ludovica Albertoni a San Francesco a Ripa." In *Gian Lorenzo Bernini. Regista del Barocco. I restauri*, ed. Claudio Strinati and Maria Grazia Bernardini, 97–110. Milan: Skira, 1999.

Dickerson III, Charles D. "Bernini and Before: Modeled Sculpture in Rome, ca. 1600–1625." Ph.D. diss., New York University, 2006.

Dobler, Ralph-Miklas. "Die Vierungspfeiler von Neu-Sankt-Peter und ihre Reliquien." In *Sankt Peter in Rom 1506–2006*, ed. Georg Satzinger and Sebastian Schütze, 301–23. Munich: Hirmer, 2008.

Dombrowski, Damian. *Giuliano Finelli: Bildhauer zwischen Neapel und Rom*. Frankfurt: Peter Lang, 1997.

Dooley, Brendan. *Morandi's Last Prophecy and the End of Renaissance Politics*. Princeton: Princeton University Press, 2002.

Dreyer, Peter. "A Drawing by Bernini for M. and Mme. Chantelou." *Burlington Magazine* 136 (1994): 603–9.

Eamon, William. *Science and the Secrets of Nature: Books of Secrets in Medieval and Early Modern Culture*. Princeton: Princeton University Press, 1994.

Earth and Fire: Italian Terracotta Sculpture from Donatello to Canova. Ed. Bruce Boucher. New Haven: Yale University Press, 2001.

Effigies and Ecstasies: Roman Baroque Sculpture and Design in the Age of Bernini. Ed. Aidan Weston-Lewis. Edinburgh: National Gallery of Scotland, 1998.

"Éloge du Père Oliva." *Journal des Sçavans* [*Savans*], 1683: 43–45.

Enciclopedia dei Papi. 3 vols. Rome: Istituto della Enciclopedia Italiana, 2000.

Enggass, Robert. "Bernini, Gaulli, and the Frescoes of the Gesù." *Art Bulletin* 39 (1957): 303–5.

———. *The Painting of Baciccio. Giovanni Battista Gaulli, 1639–1709.* University Park: Pennsylvania State University Press, 1964.

Erben, Dietrich. "Die Pyramide Ludwigs XIV in Rom: Ein Schanddenkmal im Dienst diplomatischer Vorherrschaft." *Römisches Jahrbuch der Bibliotheca Hertziana* 31 (1996): 427–58.

Fabréga-Dubert, Marie-Lou. *La collection Borghèse au musée Napoléon.* 2 vols. Histoire des collections du musée du Louvre. Paris: Musée du Louvre et École nationale supérieure des beaux-arts, 2009.

Fagiolo, Marcello. "Bernini e la committenza Rospigliosi." In Sebastiano Roberto, *Gianlorenzo Bernini e Clemente IX Rospigliosi. Arte e architettura a Roma e in Toscana nel Seicento,* 7–31. Rome: Gangemi, 2004.

Fagiolo, Marcello, and Paolo Portoghesi, eds. *Roma Barocca: Bernini, Borromini, Pietro da Cortona.* Milan: Electa, 2006.

Fagiolo dell'Arco, Maurizio. *La festa barocca.* Rome: De Luca, 1997.

———. "Un modello di cantiere berniniano. La fabbrica di San Tommaso da Villanova a Castel Gandolfo." In *Bernini a Montecitorio. Ciclo di conferenze nel quarto centenario della nascita di Gian Lorenzo Bernini,* ed. Maria Grazia Bernardini, 9–29. Rome: Camera dei Deputati, 2001.

———. *L'immagine al potere. Vita di Giovan Lorenzo Bernini.* Rome: Laterza, 2001.

———. *Berniniana. Novità sul regista del Barocco.* Milan: Skira, 2002.

Fagiolo dell'Arco, Maurizio, and Michela Di Macco. "Bernini e Carlo Fontana: Arsenale di Civitavecchia." *Arte illustrata* 4 (1971): 26–41.

Fagiolo dell'Arco, Maurizio, and Marcello Fagiolo. *Bernini. Una introduzione al gran teatro del barocco.* Rome: Bulzoni, 1967.

Fahrner, Robert, and William Kleb. "The Theatrical Activity of Gian Lorenzo Bernini." *Educational Theatre Journal* 25, no. 1 (1973): 5–14.

Falaschi, Laura. "Il ciborio del Santissimo Sacramento in San Pietro in Vaticano, secondo i disegni e i progetti di Gian Lorenzo Bernini da Urbano VIII Barberini a Clemente X Altieri." In *L'ultimo Bernini, 1665–1680. Nuovi argomenti, documenti e immagini,* ed. Valentino Martinelli, 69–136. Rome: Edizioni Quasar, 1006.

Favero, Marcella. *Francesco Mochi. Una carriera di scultore.* Trent: UNI Service, 2008.

Fedini, Domenico. *La vita di S. Bibiana vergine e martire romana.* Seconda impressione. Rome: Dalla Libraria della Luna, 1630.

Fehl, Philipp P. "L'umiltà cristiana e il monumento sontuoso: La tomba di Urbano VIII del Bernini." In *Gian Lorenzo Bernini e le arti visive,* ed. Marcello Fagiolo, 185–208. Rome: Istituto della Enciclopedia Italiana, 1987.

Fehrenbach, Frank. "Bernini's Light." *Art History* 28 (2005): 1–42.

———. *Compendia mundi: Gianlorenzo Berninis Fontana dei Quattro Fiumi (1648–51) und Nicola Salvis Fontana di Trevi (1732–62).* Munich: Deutscher Kunstverlag, 2008.

Feliciangeli, Bernardino. *Il cardinale Angelo Giori da Camerino e Gianlorenzo Bernini.* Sanseverino-Marche: C. Bellabarba, 1917.

Ferrari, Oreste, and Serenita Papaldo. *Le sculture del Seicento a Roma.* Rome: Ugo Bozzi Editore, 1999.

Finocchiaro, Maurice. *Retrying Galileo, 1633–1992.* Berkeley: University of California Press, 1997.

Fiore, Francesco. "Palazzo Barberini. Problemi storiografici e alcuni documenti sulle vicende costruttive." In *Gian Lorenzo Bernini architetto e l'architettura europea del*

Sei–Settecento, ed. Gianfranco Spagnesi and Marcello Fagiolo, 167–92. Rome: Istituto della Enciclopedia Italiana, 1983–84.

Fittipaldi, Teodoro. "Il 'Quarto del Priore' e le sezioni storico-artistiche nella Certosa di San Martino di Napoli." *Arte cristiana* 72, no. 704 (1984): 267–335.

Fogelman, Peggy, Peter Fusco, and Marietta Cambareri. *Italian and Spanish Sculpture: Catalogue of the J. Paul Getty Museum Collection.* Los Angeles: J. Paul Getty Museum, 2002.

Fois, Mario. "Il generale Gian Paolo Oliva tra obbedienza al Papa e difesa dell'ordine." *Quaderni franzoniani: Semestrale di bibliografia e cultura ligure* 5, no. 2 (1992): 29–40.

———. "Oliva, Juan Pablo." In *Diccionario histórico de la Compañía de Jesús,* ed. Charles E. O'Neill and Joaquin Dominguez, 2:1633–42. Rome: Institutum Historicum Societatis Iesu, 2001.

Fontana, Carlo. *Il Tempio Vaticano (1694).* Ed. Giovanna Curcio. Milan: Electa, 2003.

Forte, S. L. "Il domenicano Giuseppe Paglia architetto siciliano a Roma." *Archivum Fratrum Praedicatorum* 33 (1963): 281–409.

Forti, Augusto. "Ricordi del Bernini in casa Forti." *Strenna dei Romanisti* 41 (1980): 196–204.

Fosi, Irene. "Fabio Chigi e la corte di Roma." In *Alessandro VII Chigi (1599–1667). Il papa senese di Roma moderna,* ed. Alessandro Angelini, Monika Butzek, and Bernardina Sani, 25–30. Siena and Florence: Maschietto e Musolino; Protagon Editori Toscani, 2000a.

———. "'Continuo con la solita cieca obbedienza': Governo e diplomazia nella carriera di Fabio Chigi (1629–1650)." In *Alessandro VII Chigi (1599–1667). Il papa senese di Roma moderna,* ed. Alessandro Angelini, Monika Butzek and Bernardina Sani, 96–100. Siena and Florence: Maschietto e Musolino; Protagon Editori Toscani, 2000b.

Fraschetti, Stanislao. *Il Bernini. La sua vita, la sua opera, il suo tempo.* Milan: Hoepli, 1900.

Fraser Jenkins, A. D. "Cosimo de' Medici's Patronage of Architecture and the Theory of Magnificence." *Journal of the Warburg and Courtauld Institutes* 33 (1970): 162–70.

Fratellini, Bianca Maria. "Appunti per un'analisi della commedia 'La Fiera' di M. Buonarroti il giovane in rapporto alla cultura di G.L. Bernini." In *Barocco romano e barocco italiano. Il teatro, l'effimero, l'allegoria,* ed. Marcello Fagiolo and Maria Luisa Madonna, 51–62. Rome: Gangemi Editore, 1985.

Frommel, Christoph Luitpold. "S. Andrea al Quirinale: Genesi e struttura." In *Gian Lorenzo Bernini architetto e l'architettura europea del Sei–Settecento,* ed. Gianfranco Spagnesi and Marcello Fagiolo, 211–54. Rome: Istituto della Enciclopedia Italiana, 1983–84.

———. "Palazzo Barberini e la nascita del barocco." In *Bernini dai Borghese ai Barberini. La cultura a Roma intorno agli Anni Venti,* ed. Olivier Bonfait and Anna Coliva, 92–103. Rome: De Luca, 2004.

Fumi, Luigi. "Cardinale Cecchini romano secondo la sua autobiografia." *Archivio della Società romana di storia patria* 10 (1887): 287–322.

Gaborit, Jean-René. "Le Bernin, Mochi et le buste de Richelieu du Musée du Louvre: Un problème d'attribution." *Bulletin de la Société de l'histoire de l'art français* (1977): 85–91.

Gampp, Axel Christoph. "Onde il Bernino è restato il factotum. Ein unbekannter Entwurf Berninis für ein Papstgrabmal in Kontext der Baugeschichte von Sant'Agnese." *Römisches Jahrbuch der Bibliotheca Hertziana* 32 (1997–98): 479–506.

Garcia Cueto, David. "Noticia de dos regalos para Felipe IV, obras de Gian Lorenzo Bernini." *Cuadernos de Arte de la Universidad de Granada* 36 (2005): 383–93.

Gardes, Gilbert. "Le monument équestre de Louis XIV à Lyon et les monuments équestres de ce roi aux XVIIe et XVIIIe siècles." In *L'art baroque à Lyon: Actes du Colloque (Lyon 27–29 octobre 1972),* ed. Daniel Ternois, 79–161. Lyon: Institut d'Histoire de l'Art, Université Lyon II, 1975.

Gardner, Paul, and Penelope Curtis et al. *Antinous: The Face of the Antique.* Leeds: Henry Moore Institute, 2006.

Gasbarri, Carlo. *L'Oratorio Romano dal Cinquecento al Novecento.* Rome: Arti Grafiche D'Urso, 1963.

Gaskell, Ivan, and Henry Lie, eds. *Sketches in Clay for Projects by Gian Lorenzo Bernini: Theoretical, Technical, and Case Studies.* Cambridge: Harvard University Art Musuems (*Harvard University Art Museums Bulletin* 6, no. 3), 1999.

Gérin, Charles. "L'Ambassade de Créquy à Rome et le traité de Pise 1662–1664." *Revue des Questions Historiques* 15, no. 28 (1880): 79–151.

———. *Louis XIV et le Saint-Siège.* 2 vols. Paris: Lecoffre, 1894.

Gian Lorenzo Bernini. Regista del Barocco. Ed. Maria Grazia Bernardini and Maurizio Fagiolo dell'Arco. Milan: Skira Editore, 1999.

Gian Lorenzo Bernini. Regista del Barocco. I restauri. Ed. Claudio Strinati and Maria Grazia Bernardini. Milan: Skira Editore, 1999.

Gigli, Giacinto. *Diario di Roma.* Ed. Manlio Barberito. Rome: Editore Colombo, 1994.

Giuliano, Antonio, ed. *La collezione Boncompagni Ludovisi. Algardi, Bernini e la fortuna dell'antico.* Venice: Marsilio, 1992.

Gloton, Marie Christine. *Trompe-l'oeil et décor plafonnant dans les églises romaines de l'âge baroque.* Rome: Edizioni di Storia e Letteratura, 1965.

Goldberg, Edward L. *After Vasari: History, Art, and Patronage in Late Medici Florence.* Princeton: Princeton University Press, 1988.

Goldfarb, Hilliard Todd, ed. *Richelieu: Art and Power.* Montreal: Montreal Museum of Fine Arts, 2002.

Goldstein, Carl. "Rhetoric and Art History in the Italian Renaissance and Baroque." *Art Bulletin* 73 (1991): 641–52.

Gonzalez-Palacios, Alvar. "Bernini as Furniture Designer." *Burlington Magazine* 112 (1970): 719–25.

———. "Bernini e la grande decorazione barocca." In *Gian Lorenzo Bernini. Regista del Barocco,* ed. Maria Grazia Bernardini and Maurizio Fagiolo dell'Arco, 185–92. Milan: Skira Editore, 1999.

Gorrini, Giacomo. "Lorenzo Bernini e le arti di Roma seicentesca nel giudizio dei diplomatici contemporanei." In *Atti del III Congresso Nazionale di Studi Romani,* ed. Carlo Galassi Paluzzi 2:307–20. Rome: Istituto di Studi Romani, Cappelli Editore, 1935.

Gould, Cecil. *Bernini in France: An Episode in Seventeenth-Century History.* Princeton: Princeton University University, 1982.

Grassi, Luigi, and Mario Pepe. *Dizionario di arte.* Turin: UTET, 1998.

Gregori, Mina. "Rubens, Bernini e lo stile concitato." *Paragone/Arte* 50, 3rd ser., nos. 24–25 (1999): 3–22.

Gregory Nazianzen, Saint. "On His Sister, St. Gorgonia." In *Funeral Orations by Saint Gregory Nazianzen and Saint Ambrose,* ed. Leo McCauley. The Fathers of the Church: A New Translation, vol. 22. New York: Fathers of the Church, Inc., 1953.

Grell, Chantal, and Milovan Stanić, eds. *Le Bernin et l'Europe: Du baroque triomphant à l'âge romantique.* Paris: Presses de l'Université de Paris–Sorbonne, 2002.

Guarini, Battista. *Il segretario.* Venice: R. Megietti, 1600.

Guarnacci, Mario. *Vitae et res gestae pontificum Romanorum et S.R.E. Cardinalium a Clemente X usque ad Clementum XIII . . .* Rome: Sumptibus Venantii Monaldini, 1751.

Guerrieri Borsoi, Maria Barbara. *Gli Strozzi a Roma: Mecenati e collezionisti nel Sei e Settecento.* Rome: Fondazione Marco Besso, Editore Colombo, 2004.

Guerzoni, Guido. "*Liberalitas, Magnificentia,* Splendor: The Classic Origins of Italian Renaissance Lifestyles." In "Economic Engagements with Art," ed. Neil De Marchi, supp., *History of Political Economy* 31, no. 4 (1999): 332–78.

Guidiccioni, Lelio. *Latin Poems. Rome 1633 and 1639.* Ed. with introduction, translation, and commentary by John Kevin Newman and Frances Stickney Newman. Hildesheim: Weidmann, 1992.

Habel, Dorothy Metzger. *The Urban Development of Rome in the Age of Alexander VII.* Cambridge: Cambridge University Press, 2002.

Hager, Helmut. "Zur Planungs- und Baugeschichte des Zwillingskirchen auf der Piazza del Popolo." *Römisches Jahrbuch für Kunstgeschichte* 11 (1967–68): 191–306.

———. "Bernini, Mattia de' Rossi, and the Church of S. Bonaventura at Monterano." *Architectural History* 21 (1978): 68–78, 108–17.

———. "Carlo Fontana: Pupil, Partner, Principal, Preceptor." In *The Artist's Workshop,* ed. Peter M. Lukehart, 122–55. Washington, D.C.: National Gallery of Art, 1993.

Hall, Michael. "Gianlorenzo Bernini's Third Design for the East Facade of the Louvre of 1665, Drawn by Mattia de Rossi." *Burlington Magazine* 149 (2007): 478–82.

Hammond, Frederick. "Bernini and the 'Fiera di Farfa.'" In *Gianlorenzo Bernini: New Aspects of His Art and Thought,* ed. Irving Lavin, 115–78. University Park: Pennsylvania State University Press and College Art Association, 1985.

———. *Music and Spectacle in Baroque Rome: Barberini Patronage Under Urban VIII.* New Haven: Yale University Press, 1994.

Harper, James Gordon. "The Barberini Tapestries of the Life of Pope Urban VIII: Program, Politics and 'Perfect History' for the Post-Exile Era." Ph.D. diss., University of Pennsylvania, 1998.

Haskell, Francis. "The Role of Patrons: Baroque Style Changes." In *Baroque Art: The Jesuit Contribution,* ed. Rudolf Wittkower and Irma B. Jaffe, 51–62. New York: Fordham University Press, 1972.

———. *Patrons and Painters: A Study in the Relations Between Italian Art and Society in the Age of the Baroque.* Rev. ed. New Haven: Yale University Press, 1980.

Haskell, Francis, and Nicholas Penny. *Taste and the Antique: The Lure of Classical Sculpture 1500–1900.* New Haven: Yale University Press, 1981.

Heckscher, William S. "Bernini's Elephant and Obelisk." *Art Bulletin* 29 (1947): 155–82.

Heiken, Grant, Renato Funicello, and Donatella De Rita. *The Seven Hills of Rome: A Geological Tour of the Eternal City.* Princeton: Princeton University Press, 2005.

Hendler, Sefy. "Echec à la berninienne: Le buste de Richelieu, une nouvelle approche." *Revue de l'art* 149 (2005): 59–69.

Herman, Eleanor. *Mistress of the Vatican: The True Story of Olimpia Maidalchini.* New York: William Morrow, HarperCollins, 2008.

Hermann Fiore, Kristina. "*Apollo e Dafne* del Bernini al tempo del Cardinale Scipione Borghese." In *Apollo e Dafne del Bernini nella Galleria Borghese,* ed. Kristina Hermann Fiore, 70–109. Cinisello Balsamo: Silvana Editoriale, 1997.

Hewitt, Barnard, ed. *The Renaissance Stage: Documents of Serlio, Sabbattini, and Furtten-bach*. Coral Gables: University of Miami Press, 1958.

Hibbard, Caroline M. *Charles I and the Popish Plot*. Chapel Hill: University of North Carolina Press, 1983.

Hibbard, Howard. "Un nuovo documento sul busto del Cardinale Scipione Borghese del Bernini." *Bollettino d'arte* 46 (1961): 101–5.

———. "Scipione Borghese's Garden Palace on the Quirinal." *Journal of the Society Architectural Historians* 23, no. 4 (1964): 163–92.

———. *Bernini*. Harmondsworth: Penguin, 1965.

———. *Carlo Maderno and Roman Architecture, 1580–1630*. University Park: Pennsylvania State University Press, 1971.

———. "Ludovica Albertoni: L'arte e la vita." In *Gian Lorenzo Bernini e le arti visive*, ed. Marcello Fagiolo, 149–62. Rome: Istituto della Enciclopedia Italiana, 1987.

Hibbard, Howard, and Irma B. Jaffe. "Bernini's *Barcaccia*." *Burlington Magazine* 106 (1964): 159–70.

Hill, Michael. "Cardinal Dying: Bernini's Bust of Scipione Borghese." *Australian Journal of Art* 14 (1998): 9–24.

———. "The Patronage of a Disenfranchised Nephew: Cardinal Scipione Borghese and the Restoration of San Crisogono in Rome, 1618–1628." *Journal of the Society of Architectural Historians* 60, no. 4 (2001): 432–49.

Hipp, Elisabeth. "Poussin's *The Plague at Ashdod*: A Work of Art in Multiple Contexts." In *Piety and Plague: From Byzantium to the Baroque*, ed. Franco Mormando and Thomas Worcester, 177–217. Kirksville, Mo.: Truman State University Press, 2007.

Hoog, Simone. "La statue équestre de Louis XIV par Le Bernin: dernier acte." *Revue du Louvre et des musées de France* 39, no. 2 (1989): 23–28.

Hook, Judith. "Urban VIII: The Paradox of a Spiritual Monarchy." In *The Courts of Europe: Politics, Patronage, and Royalty, 1400–1800*, ed. A. G. Dickens, 213–31. New York: McGraw-Hill, 1977.

Houghton, W. B., Jr. "The English Virtuoso in the Seventeenth Century, Part I." *Journal of the History of Ideas* 3, no. 1 (1942): 51–73.

Howard, Peter. "Preaching Magnificence in Renaissance Florence." *Renaissance Quarterly* 61 (2008): 325–69.

Huse, Norbert. "Ein Jugendwerk des Gianlorenzo Bernini." *Mitteilungen des Kunsthistorischen Institutes in Florenz* 13 (1967): 165–72.

Imparato, Francesco. "Documenti relativi al Bernini e ai suoi contemporanei." *Archivio storico dell'arte* 3 (1890): 136–43.

Infelise, Mario. "Roman *avvisi*: Information and politics in the Seventeenth Century." In *Court and Politics in Papal Rome, 1492–1700*, ed. Gianvittorio Signorotto and Maria Antonietta Visceglia, 212–28. Cambridge: Cambridge University Press, 2002.

Jarrard, Alice. "Inventing in Bernini's Shop in the late 1660s: Projects for Cardinal Rinaldo d'Este." *Burlington Magazine* 144 (2002): 396–408.

———. *Architecture as Performance in Seventeenth-Century Europe: Court Ritual in Modena, Rome, and Paris*. Cambridge: Cambridge University Press, 2003.

Jobst, Christoph. "Cortona und Bernini in der *Cappella del Santissimo Sacramento* von Sankt Peter. Altarbild und Sakramentsabernakel im Konflikt?" In *Sankt Peter in Rom 1506–2006*, ed. Georg Satzinger and Sebastian Schütze, 375–91. Munich: Hirmer, 2008.

Kalveram, Katrin. *Die Antikensammlung des Kardinals Scipione Borghese*. Worms: Werner-sche Verlagsgesellschaft, 1995.

Karsten, Arne. "Kunst der Diplomatie. Gianlorenzo Berninis Frankreichreise vor dem Hintergrund der Korsenaffäre 1662/1664." In *Bernini in Paris: Das Tagebuch des Paul Fréart de Chantelou über den Aufenthalt Gianlorenzo Berninis am Hof Ludwigs XIV.*, ed. Pablo Schneider and Philipp Zitzlsperger, 304–12. Berlin: Akademie Verlag, 2006.

———. *Bernini: Il Creatore della Roma Barocca*. Rome: Salerno, 2007.

Kauffmann, Hans. *Giovanni Lorenzo Bernini: Die figurlichen Kompositionen*. Berlin: Gebr. Mann Verlag, 1970.

Kemp, Martin, ed. *Leonardo on Painting*. New Haven: Yale University Press, 1989.

Kenseth, Joy, ed. *The Age of the Marvelous*. Hanover, N.H.: Hood Museum of Art, Dartmouth College, 1991.

Kerviler, René. *Le chancelier Pierre Séguier, Second Protecteur de l'Academie Française. Etudes sur sa vie privée, politique et litéraire*. Paris: Didier, 1874.

Kessler, Hans-Ulrich. *Pietro Bernini (1562–1629)*. Munich: Hirmer, 2005.

Kieven, Elisabeth. "'Il gran teatro del mondo.' Nicodemus Tessin the Younger in Rome." *Konsthistorisk Tidskrift* 72 (2003): 4–15.

Kirwin, W. Chandler. *Powers Matchless: The Pontificate of Urban VIII, the Baldachin, and Gian Lorenzo Bernini*. New York: Peter Lang, 1997.

Kitao, Timothy K. *Circle and Oval in the Square of Saint Peter's: Bernini's Art of Planning*. New York: New York University Press, 1974.

Klaits, Joseph. *Printed Propaganda Under Louis XIV: Absolute Monarchy and Public Opin-ion*. Princeton: Princeton University Press, 1976.

Koortborjian, Michael. "*Disegni* for the Tomb of Alexander VII." *Journal of the Warburg and Courtauld Institutes* 54 (1991): 268–73.

Krautheimer, Richard. *The Rome of Alexander VII, 1655–1667*. Princeton: Princeton University Press, 1985.

Krems, Eva-Bettina. "Die 'magnifica modestia' der Ludovisi auf dem Monte Pincio in Rom. Von der Hermathena zu Berninis Marmorbuste Gregors XV." *Marburger Jahrbuch für Kunstwissenschaft* 29 (2002): 105–63.

Kris, Ernst, and Otto Kurz. *Legend, Myth, and Magic in the Image of the Artist: A Histori-cal Experiment*. Rev. ed. New Haven: Yale University Press, 1976.

Kuhn, Rudolf. "Gian Paolo Oliva und Gian Lorenzo Bernini." *Römische Quartalschrift für Christliche Altertumskunde und Kirchengeschichte* 64 (1969): 229–33.

La Sena, Pietro. *Cleombrotus; sive De ijs qui in aquis pereunt, philologica dissertatio*. Rome: Facciotti, 1637.

Lafranconi, Matteo. "L'Accademia di San Luca nel primo seicento. Presenze artisti-che e strategie culturali dai Borghese al Barberini." In *Bernini dai Borghese ai Barberini. La cultura a Roma intorno agli Anni Venti*, ed. Olivier Bonfait and Anna Coliva, 38–45. Rome: De Luca, 2004.

Lanetta, Letizia. "La 'questione' del travertino per il Colonnato di San Pietro. Appunti, spunti, precisazioni dai manoscritti della Bibliothèque Nationale di Parigi." In *L'ultimo Bernini 1665–1680. Nuovi argomenti, documenti e immagini*, ed. Valentino Martinelli, 3–20. Rome: Edizioni Quasar, 1996.

Laurain-Portemer, Madeleine. "Mazarin et le Bernin: à propos du 'Temps qui décou-vre la Vérité.'" *Gazette des Beaux-Arts* 74 (1969): 185–200.

———. "Fortuna e sfortuna di Bernini nella Francia di Mazzarino." In *Gian Lorenzo Bernini e le arti visive*, ed. Marcello Fagiolo, 113–38. Rome: Istituto della Enci-clopedia Italiana, 1987.

Lavin, Irving. Review of *Gian Lorenzo Bernini, Fontana di Trevi, Commedia inedita*, ed. Cesare d'Onofrio. *Art Bulletin* 46 (1964): 568–73.

———. "Five New Youthful Sculptures by Gianlorenzo Bernini and a Revised Chronology of His Early Works." *Art Bulletin* 50 (1968a): 223–48.

———. *Bernini and the Crossing of Saint Peter's.* New York: New York University Press, 1968b.

———. "Bernini's Death." *Art Bulletin* 54 (1972): 158–86.

———. "Afterthoughts on 'Bernini's Death.'" *Art Bulletin* 55 (1973): 429–36.

———. "On the Pedestal of Bernini's Bust of the Savior." *Art Bulletin* 60 (1978a): 548–49.

———. "Calculated Spontaneity: Bernini and the Terracotta Sketch." *Apollo* 107, no. 195 (1978b): 398–405.

———. *Bernini and the Unity of the Visual Arts.* New York: Morgan Library and Oxford University Press, 1980.

———, ed. *Drawings by Gianlorenzo Bernini from the Museum der Bildenden Kunste Leipzig, German Democratic Republic.* With contributions by Pamela Gordon, Linda Klinger, Steven Ostrow, Sharon Cather, Nicola Courtright, and Ilana Dreyer. Princeton: The Art Musuem, Princeton University, 1981.

———. "Bernini's Memorial Plaque for Carlo Barberini." *Journal of the Society of Architectural Historians* 42 (1983): 6–10.

———, ed. *Gianlorenzo Bernini: New Aspects of His Art and Thought.* University Park: Pennsylvania State University Press and College Art Association, 1985.

———. "Bernini and Antiquity: The Baroque Paradox." In *Antikenrezeption in Hochbarock*, ed. Herbert Beck and Sabine Schulze, 9–36. Berlin: Mann, 1989.

———. "High and Low Before Their Time: Bernini and the Art of Social Satire." In *Modern Art and Popular Culture: Readings in High and Low,* ed. Kirk Varnedoe and Adam Gopnik, 18–50. New York: Museum of Modern Art and Harry N. Abrams, 1990.

———. "Bernini's Portraits of No-body." In *Past-Present: Essays on Historicism in Art from Donatello to Picasso,* 101–36. Berkeley and Los Angeles: University of California Press, 1993a.

———. "Bernini's Image of the Sun King." In *Past-Present: Essays on Historicism in Art from Donatello to Picasso,* 139–200. Berkeley and Los Angeles: University of California Press, 1993b.

———. *Bernini e l'immagine del principe cristiano ideale.* Modena: Panini, 1998a.

———. *Bernini e il Salvatore. La "buona morte" nella Roma del seicento.* Rome: Donzelli Editore, 1998b.

———. "Bernini's Image of the Ideal Christian Monarch." In *The Jesuits: Cultures, Sciences and the Arts, 1540–1773,* ed. John W. O'Malley et al., 442–79. Toronto: University of Toronto Press, 1999.

———. "Bernini's Bust of the Savior and the Problem of the Homeless in Seventeenth-Century Rome." *Italian Quarterly* 37, no. 143–46 (2000): 209–51.

———. "La mort de Bernini: Visions de rédemption." In *Baroque: Vision jésuite. Du Tintoret à Rubens,* ed. Alain Tapié, 105–19. Caen: Musée des Beaux Arts de Caen, 2003.

———. "The Young Bernini." In *Studi sul Barocco romano. Scritti in onore di Maurizio Fagiolo dell'Arco,* 39–56. Milan: Skira, 2004. (Same article published in Italian in the same year: "Bernini giovane." In *Bernini dai Borghese ai Barberini. La cultura a Roma intorno agli anni Venti,* ed. Olivier Bonfait and Anna Coliva, 135–48. Rome: De Luca, 2004.)

———. "Bernini at St. Peter's: Singularis in Singulis, in Omnibus Unicus." In
St. Peter's in the Vatican, ed. William Tronzo, 111–243. Cambridge: Cambridge
University Press, 2005a.

———. "Il dono regale. Bernini e i suoi ritratti di sovrani." Lettere italiane, no. 4
(2005b): 535–54.

———. "Il Busto di Medusa di Bernini: Un doppio senso terrificante." In La Medusa
di Gian Lorenzo Bernini. Studi e restauri, ed. Elena Bianca Di Gioia, 61–119;
120–32 (English translation, "Bernini's Bust of the Medusa: An Awful Pun")
and 133–34 (bibliography). Rome: Campisano, 2007.

———. "The Baldacchino. Borromini vs. Bernini: Did Borromini Forget Himself?"
In Sankt Peter in Rom 1506–2006, ed. Georg Satzinger and Sebastian Schütze,
275–300. Munich: Hirmer, 2008.

Leonardi, Valentino. "Ricordi: Stanislao Fraschetti." L'arte 5 (1902): 135–36.

Leone, Stephanie. Architecture and Representation in Early Modern Rome: The Palazzo
Pamphilj in the Piazza Navona. London: Harvey Miller; Turnhout: Brepols, 2006.

Levy, Evonne. "Chapter 2 of Domenico Bernini's Vita of His Father: Mimeses." In Ber-
nini's Biographies: Critical Essays, ed. Maarten Delbeke, Evonne Levy, and Steven F.
Ostrow, 159–80. University Park: Pennsylvania State University Press, 2006.

Lightbrown, Ronald W. "The Journey of the Bernini Bust of Charles I to England."
The Connossieur 169 (1968): 217–20.

———. "Bernini's Busts of English Patrons." In Art the Ape of Nature: Studies in
Honor of H. W. Janson, ed. Moshe Barasch and Lucy Freeman Sandler, 439–76.
New York: Harry N. Abrams, 1981.

Lingo, Estelle. François Duquesnoy and the Greek Ideal. New Haven: Yale University
Press, 2007.

Loh, Maria H. "New and Improved: Repetition as Originality in Italian Baroque Prac-
tice and Theory." Art Bulletin 86, no. 3 (2004): 477–504.

Lorizzo, Loredana. "Bernini's 'apparato effimero' for the Canonisation of St Elisabeth
of Portugal in 1625." Burlington Magazine 145 (2003): 354–60.

Loskoutoff, Yvan. "Portait du cardinal Antoine Barberini d'après les lettres inédites du
père Duneau S.J. au cardinal Mazarin." In Papes, princes et savants dans l'Europe
moderne. Mélanges à la mémoire de Bruno Neveu, ed. Jean-Louis Quantin and Jean-
Claude Waquest, 172–90. Geneva: Droz, 2006.

Lyons, John D. "Plotting Bernini: A Triumph over Time." In Bernini's Biographies:
Critical Essays, ed. Maarten Delbeke, Evonne Levy, and Steven F. Ostrow,
143–58. University Park: Pennsylvania State University Press, 2006.

MacDougall, Elisabeth Blair. "A Circus, a Wild Man, and a Dragon: Family History
and the Villa Mattei." Journal of the Society of Architectural Historians 42 (1983):
121–30.

Magnanimi, Giuseppina. "Interventi berniniani a Palazzo Barberini." In Gian Lorenzo
Bernini architetto e l'architettura europea del Sei–Settecento, ed. Gianfranco Spag-
nesi and Marcello Fagiolo, 167–93. Rome: Istituto della Enciclopedia Italiana,
1983–84.

Maher, Michael W. "Reforming Rome: The Society of Jesus and Its Congregations at
the Church of the Gesù." Ph.D. diss., University of Minnesota, 1997.

Malanima, Paolo. La fine del primato: Crisi e riconversione nell'Italia del seicento. Milan:
Mondadori, 1998.

Malgouyres, Philippe. "A propos du buste du Salvator Mundi pour la reine Christine."
In Le Bernin et l'Europe: Du baroque triomphant à l'âge romantique, ed. Chantal

Grell and Milovan Stanić, 181–89. Paris: Presses de l'Université de Paris–Sorbonne, 2002.

Marconi, Nicoletta. *Edificando Roma Barocca: Macchine, apparati, maestranze e cantieri tra XVI e XVIII secolo.* Città di Castello: Edimond, 2004.

Marder, Tod A. "Bernini and Alexander VII: Criticism and Praise of the Pantheon in the Seventeenth Century." *Art Bulletin* 71 (1989): 628–45.

———. "The Evolution of Bernini's Designs for the Facade of Sant'Andrea al Quirinale: 1658–1676." *Architectura* 20, no. 2 (1990): 108–32.

———. "Alexander VII, Bernini, and the Urban Setting of the Pantheon in the Seventeenth Century." *Journal of the Society of Architectural Historians* 50 (1991): 273–92.

———. "Bernini's Commission for the Equestrian Statue of Constantine in St. Peter's: A Preliminary Reading." In *Architectural Progress in the Renaissance and Baroque: Sojourns in and out of Italy: Essays in Architectural History Presented to Hellmut Hager on His Sixty-sixth Birthday,* ed. Henry A. Millon and Susan Scott Munshower, 280–307. University Park: Pennsylvania State University, Department of Art History, 1992.

———. *Bernini's Scala Regia at the Vatican Palace.* Cambridge: Cambridge University Press, 1997.

———. *Bernini and the Art of Architecture.* New York: Abbeville Press, 1998a.

———. "Rapporti fra Cortona e Bernini architetti." In *Pietro da Cortona. Atti del convegno internazionale Roma-Firenze, 12–15 novembre 1997,* ed. Christoph Luitpold Frommel and Sebastian Schütze, 270–78. Milan: Electa, 1998b.

———. "Il nuovo linguaggio architettonico di Gian Lorenzo Bernini." In *Gian Lorenzo Bernini. Regista del Barocco,* ed. Maria Grazia Bernardini and Maurizio Fagiolo dell'Arco, 127–36. Milan: Skira Editore, 1999a.

———. "L'immagine del principe." In *Modena 1598: L'invenzione di una capitale,* ed. Claudia Conforti, Giovanna Curcio, and Massimo Bulgarelli, 39–53. Milan: Electa, 1999b.

———. "Symmetry and Eurythmy at the Pantheon: The Fate of Bernini's Perceptions from the Seventeenth Century to the Present Day." In *Antiquity and Its Interpreters,* ed. Alina Payne, Ann Kuttner, and Rebekah Smick, 217–26. Cambridge: Cambridge University Press, 2000a.

———. "Borromini e Bernini a Piazza Navona." In *Francesco Borromini. Atti del convegno internazionale Roma 13–15 gennaio 2000,* ed. Christoph Luitpold Frommel and Elisabeth Sladek, 140–45. Milan: Electa, 2000b.

———. "Bernini's Neptune and Triton Fountain for the Villa Montalto." In *Bernini dai Borghese ai Barberini: La cultura a Roma intorno agli anni venti,* ed. Olivier Bonfait and Anna Coliva, 118–27. Rome: De Luca, 2004.

———. "Bernini enfant prodige del ritratto." In *Bernini pittore,* ed. Tomaso Montanari, 211–21. Cinisello Balsamo: Silvana Editoriale, 2007.

———. "A Finger Bath in Rosewater: Cracks in Bernini's Reputation." In *Sankt Peter in Rom 1506–2006,* ed. Georg Satzinger and Sebastian Schütze, 427–34. Munich: Hirmer, 2008.

Marías, Fernando. 2003. "Don Gaspar de Haro, marqués del Carpio, coleccionista de dibujos." In *Arte y diplomacia de la monarquia hispanica en el siglo XVII,* ed. Jose Luis Colomer, 209–19. Madrid: Fernando Villaverde Ediciones, 2003.

Marini, Gaetano. *Degli archiatri pontifici.* Rome, 1784.

Mariti, Luciano. *Commedia ridicolosa. Comici di professione, dilettanti, editoria teatrale nel Seicento. Storia e testi.* Rome: Bulzoni, 1978.

I marmi vivi. Bernini e la nascita del ritratto barocco. Ed. Andrea Bacchi, Tomaso Montanari, Beatrice Paolozzi Strozzi, and Dimitrios Zikos. Florence: Giunti, 2009.

Marseglia, Paola. "Villa Strozzi sul Viminale." *Roma moderna e contemporanea* 6, no. 1/2 (1998): 135–55.

Martinelli, Fioravante. *Roma ornata dall'architettura, pittura e scultura.* See D'Onofrio, 1969.

Martinelli, Valentino. "Novità berniniane, 3. Le sculture per gli Altieri." *Commentari* 10 (1959): 204–26.

———, ed. *Le statue berniniane del Colonnato di San Pietro.* Rome: De Luca, 1987.

———. *Gianlorenzo Bernini e la sua cerchia. Studi e contributi (1950–1990).* Naples: Edizioni scientifiche italiane, 1994.

———, ed. *L'ultimo Bernini 1665–1680. Nuovi argomenti, documenti e immagini.* Rome: Edizioni Quasar, 1996.

Martinori, Edoardo. *La moneta. Vocabolario generale.* Rome: Istituto Italiano di Numismatica and Multigrafica, 1977 (originally published in 1914).

Marzot, Giulio. *L'ingegno e il genio del seicento.* Florence: La Nuova Italia, 1944.

Mascardi, Agostino. *Dell'arte historica.* Ed. Adolfo Bartoli. Florence: Le Monnier, 1859.

Masetti Zannini, G. L. "Gian Lorenzo Bernini e un incendio a Santa Marta (28 novembre 1634)." *Alma Roma* 30, nos. 5–6 (1989): 103–14.

Matteoli, Anna. *Lodovico Cardi-Cigoli, pittore e architetto.* Pisa: Giardini, 1980.

Mazio, Paolo. "Memorie inedite della vita di Gianlorenzo Bernini." *Il Saggiatore: Giornale romano di storia, letteratura, belle arti, filologia e varietà* 1 (1844): 339–44.

McGuiness, Frederick J. *Right Thinking and Sacred Oratory in Counter-Reformation Rome.* Princeton: Princeton University Press, 1995.

McPhee, Sarah. "Bernini's Books." *Burlington Magazine* 142 (2000): 442–48.

———. *Bernini and the Bell Towers: Architecture and Politics at the Vatican.* New Haven: Yale University Press, 2002.

———. "Costanza Bonarelli: Biography Versus Archive." In *Bernini's Biographies: Critical Essays,* ed. Maarten Delbeke, Evonne Levy, and Steven F. Ostrow, 315–76. University Park: Pennsylvania State University Press, 2006.

———. "The Long Arm of the Fabbrica: Saint Peter's and the City of Rome." In *Sankt Peter in Rom 1506–2006,* ed. Georg Satzinger and Sebastian Schütze, 353–73. Munich: Hirmer, 2008.

Mendelsohn, Leatrice, Alice B. Kramer, and Carl Goldstein. "Vasari's Rhetoric." *Art Bulletin* 74 (1992): 521-22.

Menichella, Anna. *Matthia de' Rossi, discepolo prediletto del Bernini.* Rome: Istituto Nazionale di Studi Romani, 1985.

Mérot, Alain, ed. *Les conférences de l'Académie royale de peinture et de sculpture au XVIIe siècle.* Paris: École Nationale Supérieure des Beaux-Arts, 1996.

Merz, Jörge Martin. *Pietro da Cortona and Roman Baroque Architecture. Incorporating a Draft by the Late Anthony Blunt.* New Haven: Yale University Press, 2008.

Michelini Tocci, Luigi. "Bernini nelle medaglie e nelle monete." In *Bernini in Vaticano,* 281–310. Rome: De Luca, 1981.

Migliorato, Alessandro. "Un Laocoonte inedito e altre note per Pietro Bernini." *Commentari d'arte* 7, nos. 18–19 (2001): 28–41.

Minozzi, Marina. "La decorazione di Ponte Sant'Angelo." In *Gian Lorenzo Bernini. Regista del Barocco. I restauri,* ed. Claudio Strinati and Maria Grazia Bernardini, 77–84. Milan: Skira, 1999.

Miranda, Salvador. "The Cardinals of the Holy Roman Church." Documented Web site (Florida International University Library): http://www.fiu.edu/~mirandas/cardinals.htm.

Mirollo, James V. *The Poet of the Marvelous: Giambattista Marino.* New York: Columbia University Press, 1963.

Mirot, Léon. "Le Bernin en France. Les travaux du Louvre et les statues de Louis XIV." *Mémoires de la société de l'histoire de Paris et de l'Ile-de-France* 31 (1904): 161–288.

Mochi Onori, Lorenza, Sebastian Schütze, and Francesco Solinas, eds. *I Barberini e la cultura europea del Seicento.* Rome: De Luca, 2007.

Moffitt, John F. "Bernini's *Cathedra Petri* and the *Constitutum Constantini.*" *Source: Notes in the History of Art* 26, no. 2 (2007): 23–31.

Montagu, Jennifer. "Bernini Sculptures Not by Bernini." In *Gianlorenzo Bernini: New Aspects of His Art and Thought,* ed. Irving Lavin, 25–62. University Park: Pennsylvania State University Press and College Art Association, 1985.

———. *Roman Baroque Sculpture: The Industry of Art.* New Haven: Yale University Press, 1989.

———. *Gold, Silver, and Bronze: Metal Sculpture of the Roman Baroque.* Princeton: Princeton University Press, 1996.

———. "Innovation and Exchange: Portrait Sculptors of the Early Roman Baroque." In *Bernini and the Birth of Baroque Portrait Sculpture,* ed. Andrea Bacchi, Catherine Hess, and Jennifer Montagu, 45–63. Los Angeles: J. Paul Getty Museum; Ottawa: National Gallery of Canada, 2008.

Montanari, Tomaso. "Gian Lorenzo Bernini e Sforza Pallavicino." *Prospettiva* 87–88 (1997): 42–68.

———. "Sulla fortuna poetica di Bernini. Frammenti del tempo di Alessandro VII e di Sforza Pallavicino." *Studi secenteschi* 39 (1998a): 127–64.

———. "Bernini e Cristina di Svezia. Alle origini della storiografia berniniana." In *Gian Lorenzo Bernini e i Chigi tra Roma e Siena,* ed. Alessandro Angelini, 331–477. Siena: Banca Monte dei Paschi di Siena, 1998b.

———. "Un Bernini giovane fra i disegni del cardinal Leopoldo de' Medici." *Bollettino d'arte* ser. VII, nos. 103–4 (1998c): 33–50.

———. "Pierre Cureau de La Chambre e la prima biografia di Gian Lorenzo Bernini." *Paragone/Arte* 50, no. 24–25 (1999): 103–32.

———. "Gian Lorenzo Bernini: Busto di papa Gregorio XV Ludovisi (cat. 19)." In *Due collezionisti alla scoperta dell'Italia. Dipinti e sculture dal Museo Jacquemart-André di Parigi,* ed. Andrea Di Lorenzo, 116–19. Cinisello Balsamo: Silvana, 2002.

———. "Da Luigi XIV a Carlo II. Metamorfosi dell'ultimo capolavoro di Gian Lorenzo Bernini." In *Arte y diplomacia de la monarquia hispanica en el siglo XVII,* ed. José Luis Colomer, 403–14. Madrid: Fernando Villaverde Ediciones, 2003a.

———. "Bernini e Rembrandt, il teatro e la pittura. Per una rilettura degli autoritratti berniniani." In *Bernini e la pittura,* ed. Daniela Gallavotti Cavallero, 187–202. Rome: Gangemi, 2003b.

———. "A Contemporary Reading of Bernini's 'Meraviglioso Composto': Unpublished Poems on the Four River Fountain and the Cornaro Chapel." In *Poetry on Art: Renaissance to Romanticism,* ed. Thomas Frangenberg, 177–98. Donington: Shaun Tyas, 2003c.

———. "'Theatralia' di Giovan Battista Doni. Una nuova fonte per il teatro di Bernini." In *Estetica barocca,* ed. Sebastian Schütze, 301–20. Rome: Campisano, 2004a.

———. *Gian Lorenzo Bernini.* Rome: Gruppo Editoriale L'Espresso, 2004b.

———. "'Dar todo a uno es obra del diablo.' Gian Lorenzo Bernini artista di corte?" In *Velázquez, Bernini, Luca Giordano. Le corti del Barocco,* ed. Fernando Checa Cremades, 89–99. Milan: Skira, 2004c.

———. "Il 'bel composto.' Nota filologica su un nodo della storiografia berniniana." *Studi secenteschi* 46 (2005a): 195–210.

———. "Introduction." In *Giovan Pietro Bellori. The Lives of the Modern Painters, Sculptors and Architects. A New Translation and Critical Edition,* ed. Alice Sedgwick Wohl and Helmut Wohl, 1–39. Cambridge: Cambridge University Press, 2005b.

———. "Percorsi per cinquant'anni di studi berniniani." *Studiolo. Revue d'histoire de l'art de l'Académie de France à Rome* 3 (2005c): 269–98.

———. "At the Margins of the Historiography of Art: The *Vite* of Bernini Between Autobiography and Apologia." In *Bernini's Biographies: Critical Essays,* ed. Maarten Delbeke, Evonne Levy, and Steven F. Ostrow, 73–109. University Park: Pennsylvania State University Press, 2006.

———. *Bernini pittore.* Cinisello Balsamo: Silvana Editoriale, 2007.

———. "Il colore del marmo. I busti di Bernini tra scultura e pittura. Ritratto e storia. Funzione e stile (1610–1638)." In *Marmi vivi. Bernini e la nascita del ritratto barocco.* Ed. Andrea Bacchi, Tomaso Montanari, Beatrice Paolozzi Strozzi, and Dimitrios Zikos, 71–135. Florence: Giunti, 2009.

Morello, Giovanni. "Bernini e i lavori a S. Pietro nel 'diario' di Alessandro VII." In *Bernini in Vaticano,* 321–40. Rome: De Luca, 1981.

———. "I rapporti tra Alessandro VII e Gian Lorenzo Bernini negli autografi del papa (con disegni inediti)." In *Documentary Culture: Florence and Rome from Grand-Duke Ferdinand I to Pope Alexander VII. Papers from a Colloquium held at the Villa Spelman, Florence, 1990,* ed. Elizabeth Cropper, Giovanna Perini, and Francesco Solinas, 185–207. Bologna: Nuova Alfa Editoriale, 1992.

———. "L'immagine di Cristo e i crocifissi di San Pietro." In *La Passione di Cristo secondo Bernini: Dipinti e Sculture del Barocco Romano,* ed. Giovanni Morello, Francesco Petrucci, and Claudio Strinati, 24–38. Rome: Ugo Bozzi, 2007.

———. "Alessandro VII e Bernini a San Pietro." In *Sankt Peter in Rom 1506–2006,* ed. Georg Satzinger and Sebastian Schütze, 393–403. Munich: Hirmer, 2008.

Morello, Giovanni, Francesco Petrucci, and Claudio Strinati, eds. *La Passione di Cristo secondo Bernini. Dipinti e sculture del barocco romano.* Rome: Ugo Bozzi, 2007.

Moreno, Paolo. *Lisippo: L'arte e la fortuna.* Milan: Fabbri, 1995.

Moreno, Paolo, and Chiara Stefani. *The Borghese Gallery.* Milan: Touring Club Italiano, 2000.

Mormando, Franco. *The Preacher's Demons: Bernardino of Siena and the Social Underworld of Early Renaissance Italy.* Chicago: University of Chicago Press, 1999.

———. "Response to the Plague in Early Modern Italy: What the Primary Sources, Printed and Painted, Reveal." In *Hope and Healing: Painting in Italy in a Time of Plague, 1500–1800,* ed. Gauvin Bailey et al., 1–44. Worcester, Mass.: Worcester Art Museum, 2005.

———. "Pestilence, Apostasy, and Heresy in Seventeenth-Century Rome: Deciphering Michael Sweerts's *Plague in an Ancient City.*" In *Piety and Plague: From Byzantium to the Baroque,* ed. Franco Mormando and Thomas Worcester, 237–312. Kirksville, Mo.: Truman State University Press, 2007.

Moroni, Gaetano. "Mirandola, Lodovico Pico, Cardinale." *Dizionario di erudizione storico-ecclesiastica,* 45:211–12.

Morris, Kathleen M. "A Chronological and Comparative Study of Contemporary Sources on Gian Lorenzo Bernini." Ph.D. diss., University of Virginia, 2005.

Morrissey, Jake. *The Genius in the Design: Bernini, Borromini, and the Rivalry That Transformed Rome.* New York: William Morrow, 2005.

Mullan, Elder. *The Nobles' Sodality of Our Lady of the Assumption of the Gesù in Rome: From the Archives*. St. Louis: Queen's Work Press, 1918.

Murat, Inès. *Colbert*. Charlottesville: University Press of Virginia, 1984.

Murata, Margaret. *Operas for the Papal Court, 1631–1668*. Ann Arbor: UMI Research Press, 1981.

Napoleone, Caterina. "Bernini e il cantiere della Cappella Cornaro." *Antologia di Belle Arti* 55–58 (1998): 172–86.

Nava Cellini, Antonia. "Ipotesi sulla 'Medusa' Capitolina e sulle probabili 'Teste' di Gian Lorenzo Bernini." *Paragone/Arte*, no. 457 (1988): 29–34.

Negro, Angela. "I due angeli di Sant'Andrea delle Fratte." In *Gian Lorenzo Bernini. Regista del Barocco. I restauri*, ed. Claudio Strinati and Maria Grazia Bernardini, 67–76. Milan: Skira, 1999.

———. *Bernini e il "bel composto." La cappella de Sylva in Sant'Isidoro*. Rome: Campisano, 2002.

Nelson, Jonathan K., and Richard J. Zeckhauser. *The Patron's Payoff: Conspicuous Commissions in Italian Renaissance Art*. Princeton: Princeton University Press, 2008.

Neri, Achille. "Saggio della corrispondenza di Ferdinando Raggi agente della repubblica genovese a Roma." *Rivista europea*, anno 9, vol. 5, fasc. 4 (1878): 657–95.

Newman, John K. "Empire of the Sun: Lelio Guidiccioni and Pope Urban VIII." *International Journal for the Classical Tradition* 1, no. 1 (1994): 62–70.

Niderst, Alain. "*Le Mercure Galant* (1672–1710)." In *Dictionnaire des journaux*, ed. Jean Sgard, 2:846–47, cat. 919. Paris: Universitas, 1991.

Noehles, Karl. "Teatri per le Quarant'ore e altari barocchi." In *Barocco romano e barocco italiano. Il teatro, l'effimero, l'allegoria*, ed. Marcello Fagiolo and Maria Luisa Madonna, 88–99. Rome: Gangemi, 1985.

Nussdorfer, Laurie. *Civic Politics in the Rome of Urban VIII*. Princeton: Princeton University Press, 1992.

Oberli, Matthias. *Magnificentia principis: Das Mäzenatentum des Prinzen und Kardinals Maurizio von Savoyen (1593–1657)*. Weimar: VDG, 1999.

Oliva, Giovanni Paolo. *Prediche dette nel Palazzo Apostolico (Tomo Primo)*. Rome: Casoni (part 1); Mascardi (part 2), 1659.

———. *Prediche dette nel Palazzo Apostolico (Tomo Secondo)*. Rome: Dragondelli, 1664.

———. *Prediche dette nel Palazzo Apostolico (Tomo Terzo)*. Rome: Ignatio de' Lazzari, 1674.

———. *Lettere*. 2 vols. 2nd ed. Bologna: Longhi, 1703.

Onians, John. *Bearers of Meaning: The Classical Orders in Antiquity, the Middle Ages, and the Renaissance*. Princeton: Princeton University Press, 1988.

Ostrow, Steven F. "Gianlorenzo Bernini, Girolamo Lucenti, and the Statue of Philip IV in S. Maria Maggiore: Patronage and Politics in Seicento Rome." *Art Bulletin* 73 (1991): 89–118.

———. *Art and Spirituality in Counter-Reformation Rome: The Sistine and Pauline Chapels in S. Maria Maggiore*. Cambridge: Cambridge University Press, 1996.

———. "Paolo Sanquirico: A Forgotten *Virtuoso* of Seicento Rome." *Storia dell'Arte* 92 (1998): 27–59.

———. "Playing with the Paragone: The Reliefs of Pietro Bernini." *Zeitschrift für Kunstgeschichte* 67 (2004): 329–64.

———. "Bernini's Voice: From Chantelou's *Journal* to the *Vite*." In *Bernini's Biographies: Critical Essays*, ed. Maarten Delbeke, Evonne Levy, and Steven F. Ostrow, 111–41. University Park: Pennsylvania State University Press, 2006.

———. "Bernini e il paragone." In *Bernini pittore,* ed. Tomaso Montanari, 223–33. Cinisello Balsamo: Silvana Editoriale, 2007.

———. "'Sculptors Pursue Likeness:' The Typology and Function of Seventeenth-Century Portrait Sculpture in Rome." In *Bernini and the Birth of Baroque Portrait Sculpture,* ed. Andrea Bacchi, Catherine Hess, and Jennifer Montagu, 65–83. Los Angeles: J. Paul Getty Museum; Ottawa: National Gallery of Canada, 2008.

———. "The 'Confessio' in Post-Tridentine Rome." In *Arte e committenza nel Lazio nell'età di Cesare Baronio,* ed. Patrizia Tosini, 19–32. Rome: Gangemi, 2009.

Palma Venetucci, Beatrice, ed. *Villa Doria Pamphilj. Storia della collezione.* Rome: De Luca, 2001.

The Papacy: An Encyclopedia. Ed. Philippe Levillain. New York: Routledge, 2002.

Pascoli, Lione. *Vite de' pittori, scultori e l'architetti moderni.* 2 vols. Rome: Antonio de' Rossi, 1730–36.

Passeri, Giovanni Battista. *Vite de' pittori, scultori ed architetti che anno lavorato in Roma morti dal 1641 fino al 1673.* Rome, 1772.

Pastor, Ludwig von. *The History of the Popes.* Vols. 26–32. Translated by Ernest Graf. St. Louis: Herder, 1937–40.

Patrignani, Giuseppe Antonio. *Menologio di pie memorie d'alcuni religiosi della Compagnia di Gesù.* 4 vols. Venice, 1730.

Payne, Alina. *The Architectural Treatise in the Italian Renaissance: Architectural Invention, Ornament, and Literary Culture.* Cambridge: Cambridge University Press, 1999.

Pecchiai, Pio. "Il Bernini furioso." *Strenna dei Romanisti* 10 (1949): 181–86.

Pellisson-Fontanier, Paul, and Pierre Joseph Olivet. *Histoire de l'Académie française par Pellisson et d'Olivet avec une Introduction, des éclaircissements et notes par M. Ch.-L. Livet.* Paris: Didier, 1858.

Perlove, Shelley K. *Bernini and the Idealization of Death: The Blessed Ludovica Albertoni and the Altieri Chapel.* University Park: Pennsylvania State University Press, 1990.

Perrault, Charles. *Memoirs of My Life.* Ed. and trans. Jeanne Morgan Zarucchi. Columbia: University of Missouri Press, 1989.

Perrini, Alberto. *Gian Lorenzo Bernini, La Verità discoperta dal Tempo: "comedia ridiculosa." Restauro drammaturgico in due tempi.* Soveria Mannelli: Rubbettino, 2007.

Petrucci, Francesco. "Gian Lorenzo Bernini per casa Chigi. Precisazioni e nuove attribuzioni." *Storia dell'Arte* 90 (1997): 176–200.

———. "Il ritrovato busto del Salvatore di Gian Lorenzo Bernini." *Bollettino d'arte* 88, no. 124 (2003): 53–66.

———. "Bernini pubblico e Bernini privato. La Fontana dei Fiumi e il tema cristologico." In *Velázquez, Bernini, Luca Giordano. Le corti del Barocco,* 67–83. Milan: Skira, 2004.

———. *Bernini pittore. Dal disegno al 'maraviglioso composto'* Rome: Bozzi Editore, 2006.

———. *Pittura di Ritratto a Roma. Il Seicento.* 3 vols. Rome: Andreina e Valneo Budai Editori, 2008.

Petros eni. Pietro è qui. Exhibition catalogue, Braccio di Carlo Magno, Vatican City, October 11, 2006–March 8, 2007. Rome: Edindustria, 2006.

Pierguidi, Stefano. "'Il nome del grandissimo figlio aveva evidentemente assorbito il nome del grande padre.' Considerazioni intorno al giovane Bernini." *Bollettino d'arte* 145 (2008): 103–14.

Piles, Roger de. *The Art of Painting and the Lives of the Painters.* London, 1706.

Pinto, John A. *The Trevi Fountain.* New Haven: Yale University Press, 1986.

Pirotta, Luigi. "Gian Lorenzo Bernini, principe dell'Accademia di S. Luca." *Strenna dei Romanisti* 29 (1968): 295–305.

Portoghesi, Paolo. *The Rome of Borromini: Architecture as Language.* New York: George Braziller, 1968.

————. "Bernini e Borromini: I due rivali." In *Bernini a Montecitorio,* ed. Maria Grazia Bernardini, 31–44. Rome: Camera dei Deputati, 2001.

Preimesberger, Rudolf. "Bernini a S. Agnese in Agone." *Colloqui del Sodalizio tra Studiosi dell'arte* 2 (1970–72): 44–55.

————. "Obeliscus Pamphilius: Beiträge zu Vorgeschichte und Ikonographie des Vierströmebrunnens auf Piazza Navona." *Münchner Jahrbuch der bildenden Kunst* 25 (1974): 77–162.

————. "Das dritte Papstgrabmal Berninis." *Römisches Jahrbuch für Kunstgeschichte* 17 (1978): 157–81.

————. "Themes from Art Theory in the Early Works of Bernini." In *Gianlorenzo Bernini: New Aspects of His Art and Thought,* ed. Irving Lavin, 1–24. University Park: Pennsylvania State University Press and College Art Association, 1985.

————. "Berninis Cappella Cornaro. Eine Bild-Wort-Synthese des siebzehnten Jahrhunderts? Zu Irving Lavins Bernini-Buch." *Zeitschrift für Kunstgeschichte* 49, no. 2 (1986): 190–219.

————. "Il San Longino del Bernini in San Pietro in Vaticano: Dal bozzetto alla statua." In *Bernini a Montecitorio. Ciclo di conferenze nel quarto centenario della nascita di Gian Lorenzo Bernini,* ed. Maria Grazia Bernardini, 95–112. Rome: Camera dei Deputati, 2001.

————. "Bernini Portraits, Stolen and Nonstolen, in Chantelou's *Journal* and the Bernini *Vite.*" In *Bernini's Biographies: Critical Essays,* ed. Maarten Delbeke, Evonne Levy, and Steven F. Ostrow, 201–22. University Park: Pennsylvania State University Press, 2006.

————. "Ein ehernes Zeitalter in Sankt Peter?" In *Sankt Peter in Rom 1506–2006,* ed. Georg Satzinger and Sebastian Schütze, 325–35. Munich: Hirmer, 2008a.

————. "Three Popes in an Epigraphic Context." In *Center 28: National Gallery of Art. Center for Advanced Study in the Visual Arts. Record of Activities and Research Reports. June 2007–May 2008.* Washington, D.C.: National Gallery of Art, Center for Advanced Study in the Visual Arts, 2008b.

Previtali, Giovanni. "Il Costantino messo alla berlina o bernina su la porta di San Pietro." *Paragone/Arte* 13, no. 145 (1962): 55–58.

Quinterio, Francesco. "Introduzione al cantiere berniniano." In *Gian Lorenzo Bernini architetto e l'architettura europea del Sei–Settecento,* ed. Gianfranco Spagnesi and Marcello Fagiolo, 361–78. Rome, 1983.

Raatschen, Gudrun. "Merely Ornamental? Van Dyck's Portraits of Henrietta Maria." In *Henrietta Maria: Piety, Politics, and Patronage,* ed. Erin Griffey, 139–63. London: Ashgate, 2008.

Raggio, Olga. "Bernini and the Collection of Cardinal Flavio Chigi." *Apollo* 117 (1983): 368–79.

Raspe, Martin. "The Final Problem: Borromini's Failed Publication Project and His Suicide." *Annali di architettura* 13 (2001): 121–36.

Ray, Stefano. "Bernini e la tradizione architettonica del Cinquecento romano." In *Gian Lorenzo Bernini architetto e l'architettura europea del Sei–Settecento,* ed. Gianfranco Spagnesi and Marcello Fagiolo, 13–34. Rome: Istituto della Enciclopedia Italiana, 1983–84.

Rice, Louise. "Urban VIII, the Archangel Michael, and a Forgotten Project for the Apse Altar of St. Peter's." *Burlington Magazine* 134 (1992): 428–34.

———. *The Altars and Altarpieces of New St. Peter's: Outfitting the Basilica*. Cambridge: Cambridge University Press, 1997.

———. "Bernini and the Pantheon Bronze." In *Sankt Peter in Rom 1506–2006*, ed. Georg Satzinger and Sebastian Schütze, 337–52. Munich: Hirmer, 2008.

Rietbergen, Peter. "A Vision Come True: Pope Alexander VII, Gianlorenzo Bernini, and the Colonnades of St. Peter's." *Mededelingen van het Nederlands Historisch Instituut te Rome* 44–45 (1983): 111–63.

———. *Power and Religion in Baroque Rome: Barberini Cultural Policies*. Leiden: Brill, 2006.

Rinne, Katherine Wentworth. "Secret Life of Roman Fountains." *Places (Journal of the Design History Foundation, New York)* 12 (1999): 72–77.

———. "Hydraulic Infrastructure and Urbanism in Early Modern Rome." *Papers of the British School at Rome* 73 (2005): 199–232.

Roberto, Sebastiano. *Gianlorenzo Bernini e Clemente IX Rospigliosi. Arte e architettura a Roma e in Toscana nel Seicento*. Rome: Gangemi, 2004.

Roccasecca, Pietro. "Teaching in the Studio of the 'Accademia del Disegno dei pittori, scultori e architetti di Roma' (1594–1636)." In *The Accademia Seminars: The Accademia di San Luca in Rome, c. 1590–1635*, ed. Peter M. Lukehart, 123–59. New Haven: Yale University Press for the National Gallery of Art, Washington, D.C., 2009.

Rocco, Fiammetta. *The Miraculous Fever-Tree: Malaria and the Quest for a Cure That Changed the World*. New York: HarperCollins, 2003.

Rockwell, Peter, Stanley Rosenfeld, and Heather Hanley. *The Compleat Marble Sleuth*. Sunny Isles Beach, Fla.: Rockrose, 2004.

Rodén, Marie-Louise, ed. *Cristina di Svezia a Roma*. Vatican City: Biblioteca Apostolica Vaticana, 1989.

———, ed. *Politics and Culture in the Age of Christina. Acta from a Conference held at the Wenner-Gren Center in Stockholm, May 4–6, 1995*. Stockholm: Suecoromana, 1997.

———. *Church Politics in Seventeenth-Century Rome: Cardinal Decio Azzolino, Queen Christina of Sweden*. Stockholm: Almqvist and Wiksell International, 2000.

Romei, Danilo, ed. *Lo spettacolo del sacro, la morale del profano. Su Giulio Rospigliosi (Papa Clemente IX). Atti del Convegno Internazionale (Pistoia, 22–23 settembre 2000)*. Florence: Polistampa, 2005.

Roosen, William. "Early Modern Diplomatic Ceremonial: A Systems Approach." *Journal of Modern History* 52 (1980): 452–76.

Rosa, Mario. "The 'World's Theatre': The Court of Rome and Politics in the First Half of the Seventeenth Century." In *Court and Politics in Papal Rome, 1492–1700*, ed. Gianvittorio Signorotto and Maria Antonietta Visceglia, 78–98. Cambridge: Cambridge University Press, 2002.

Roser, Hannes. "Sankt-Peter in den *Sacri trofei romani* des Francesco Maria Torrigio." In *Sankt Peter in Rom 1506–2006*, ed. Georg Satzinger and Sebastian Schütze, 257–73. Munich: Hirmer, 2008.

Rowland, Ingrid D. *The Ecstatic Journey: Athanasius Kircher in Baroque Rome*. Chicago: University of Chicago Library, 2000.

———. "The Architecture of Love in Baroque Rome." In *Erotikon: Essays on Eros, Ancient and Modern*, ed. Shadi Bartsch and Thomas Bartscherer, 144–60. Chicago: University of Chicago Press, 2005.

Rubin, Patricia Lee. *Giorgio Vasari: Art and History*. New Haven: Yale University Press, 1995.

Russo, M. Teresa. "Bernini e la Congregazione dell'Oratorio." *Strenna dei Romanisti* 37 (1976): 51–60.

Sabbatini, Nicola. *Practica di fabricar scene, e machine ne' teatri*. Pesaro: Flaminio Concordia, 1637.

San Juan, Rose Marie. *Rome: A City Out of Print*. Minneapolis: University of Minnesota Press, 2001.

Santoni, Barbara Tellini, and Alberto Manodoro Sagredo, eds. *Luoghi della cultura nella Roma di Borromini*. Rome: Retablo, 2004.

Sarmant, Thierry, and Raphaël Masson, eds. *Architecture et beaux-arts à l'apogée du règne de Louis XIV. Édition critique de la correspondance du Marquis de Louvois, Surintendant des Bâtiments du Roi, Arts et Manufactures de France, 1683–1691*. Vol. 1: 1683–84. Vol. 2: 1685. Paris: CTHS, 2007–9.

Saslow, James M., trans. and ed. *The Poetry of Michelangelo: An Annotated Translation*. New Haven: Yale University Press, 1991.

Satzinger, Georg, and Sebastian Schütze, eds. *Sankt Peter in Rom 1506–2006: Beitrage der internationalen Tagung vom 22.–25. Februar 2006 in Bonn*. Munich: Hirmer, 2008.

Savina, Barbara. "Bernini, Finelli e l'altare di S. Agostino." *Storia dell'Arte* 100 (2000): 117–22.

Saviotti, Alfredo. "Feste e spettacoli nel Seicento." *Giornale storico della letteratura italiana* 41, no. 1 (1903): 42–77.

Schiavo, Armando. *Il viaggio del Bernini in Francia nei documenti dell'Archivio Segreto Vaticano*. Rome: Casa dei Crescenzi, 1957.

———. *Il Palazzo della Cancelleria*. Rome: Staderini Editore, 1964.

———. *Villa Ludovisi and Palazzo Margherita*. Rome: Editrice Roma Amor per Banca Nazionale del Lavoro, 1981.

Schlegel, Ursula. "Bernini und Guido Reni." *Jahrbuch der Berliner Museen*, no. 27 (1985): 101–45.

———. "Il giovane Bernini." In *Bernini a Montecitorio*, ed. Maria Grazia Bernardini, 45–58. Rome: Camera dei Deputati, 2001.

Schütze, Sebastian. *Kardinal Maffeo Barberini und die Entstehung des römischen Hochbarocks*. Munich: Hirmer, 2007.

———. "'Werke als Kalküle ihres Wirkungsanspruchs.' Die Cathedra Petri und ihr Bedeutungswandel im konfessionellen Zeitalter." In *Sankt Peter in Rom 1506–2006*, ed. Georg Satzinger and Sebastian Schütze, 405–25. Munich: Hirmer, 2008.

Scott, John Beldon. "Urban VIII, Bernini, and the Countess Matilda." In *L'Âge d'or du mécénat (1598–1661). Actes du colloque international, Centre National de la Recherche Scientifique*, ed. Roland Mousnier and Jean Mesnard, 119–27. Paris: Éditions du Centre national de la recherche scientifique, 1985.

———. "The Art of the Painter's Scaffold: Pietro da Cortona in the Barberini Salone." *Burlington Magazine* 135 (1993): 327–37.

Segarra Lagunes, Maria Margarita. *Il Tevere e Roma. Storia di una simbiosi*. Rome: Gangemi, 2004.

Serlio, Sebastiano. *On Architecture (Tutte l'opere d'architettura et prospettiva)*. Ed. Vaughan Hart and Peter Hicks. 2 vols. New Haven: Yale University Press, 1996–2001.

Sgard, Jean. "Donneau de Visé, Jean (1638–1710)." *Dictionnaire des journalists,* ed. Jean Sgard, 1:321–24. Oxford: Voltaire Foundation, 1999.

Signorotto, Gianvittorio. "The *squadrone volante*: 'Independent' Cardinals and European Politics in the Second Half of the Seventeenth Century." In *Court and Politics in*

Papal Rome, 1492–1700, ed. Gianvittorio Signorotto and Maria Antonietta Visce-
glia, 177–211. Cambridge: Cambridge University Press, 2002.

Slawinski, Maurice. "The Seventeenth-Century Stage." In *A History of Italian The-
ater,* ed. Joseph Farrell and Paolo Puppa, 127–42. Cambridge: Cambridge
University Press, 2006.

Smith, Christine, and Joseph F. O'Connor. *Building the Kingdom: Giannozzo Manetti
on the Material and Spiritual Edifice.* Tempe: Arizona Center for Medieval and
Renaissance Studies, 2006.

Smuts, Malcolm. "Religion, European Politics, and Henrietta Maria's Circle, 1625–
41." In *Henrietta Maria: Piety, Politics, and Patronage,* ed. Erin Griffey, 13–37.
London: Ashgate, 2008.

Smyth-Pinney, Julia M. "The Geometries of S. Andrea al Quirinale." *Journal of the
Society Architectural Historians* 48, no. 1 (1989): 53–65.

Sohm, Philip. *Style in the Art Theory of Early Modern Italy.* Cambridge: Cambridge
University Press, 2001.

———. "Caravaggio's Deaths." *Art Bulletin* 84 (2002): 449–68.

Solinas, Francesco. "'Portare Roma a Parigi,' mecenati, artisti ed eruditi nella
migrazione culturale." In *Documentary Culture: Florence and Rome from Grand-
Duke Ferdinand I to Pope Alexander VII. Papers from a Colloquium held at the Villa
Spelman, Florence, 1990,* ed. Elizabeth Cropper, Giovanna Perini, and Francesco
Solinas, 227–61. Bologna: Nuova Alfa Editoriale, 1992.

———. "Lo stile dei Barberini." In *I Barberini e la cultura europea del
Seicento,* ed. Lorenza Mochi Onori, Sebastian Schütze, and Francesco Solinas,
227–61. Rome: De Luca, 2007.

Soussloff, Catherine. "Critical Topoi in the Sources on the Life of Gianlorenzo Ber-
nini." Ph.D. diss., Bryn Mawr College, 1982.

———. "Old Age and Old-Age Style in the 'Lives' of Artists: Gianlorenzo Bernini."
Art Journal 46 (1987): 115–21.

———. "*Imitatio Buonarroti.*" *Sixteenth Century Journal* 20 (1989): 581–602.

———. "Lives of Poets and Painters in the Renaissance." *Word and Image* 6 (1990):
154–62.

Spagnesi, Gianfranco, and Marcello Fagiolo, eds. *Gian Lorenzo Bernini architetto e
l'architettura europea del Sei–Settecento.* Rome: Istituto della Enciclopedia Italiana,
1983–84.

Sparti, Donatella Livia. "Ciro Ferri and Luca Giordano in the Gallery of Palazzo Medici
Riccardi." *Mitteilungen des Kunsthistorischen Institutes in Florenz* 47 (2003): 159–221.

Spear, Richard E. "Scrambling for *Scudi*: Notes on Painters' Earnings in Early Baroque
Rome." *Art Bulletin* 85 (2003): 310–20.

Spike, Michèle K. *Tuscan Countess: The Life and Extraordinary Times of Matilda of
Canossa.* New York: Vendome Press, 2004.

Spini, Giorgio. "Historiography: The Art of History in the Italian Counter Reforma-
tion." In *The Late Italian Renaissance 1525–1630,* ed. Eric Cochrane, 91–133.
New York: Harper and Row, 1970.

Stalla, Robert. "Architektur im Dienst der Politik: Borrominis Kirchenbau der Propa-
ganda Fide in Rom: Ein Jesuitischer Bautypus für die Zentrale der Weltmission."
Römisches Jahrbuch der Bibliotheca Hertziana 29 (1994): 289–341.

Stanić, Milovan. "Le génie de Gianlorenzo Bernin d'après le 'Journal' de Chante-
lou. Un chapitre italophile de la littérature artistique du Grand Siècle." In *La*

naissance de la théorie de l'art en France 1640–1720 (Revue d'esthétique, v. 31–32), 109–18. Paris: Jean Michel Place, 1997.

———. "Wer war Paul Fréart de Chantelou." In Paul Fréart de Chantelou, *Das Tagebuch des Paul Fréart de Chantelou über den Aufenthalt Gianlorenzo Berninis am Hof Ludwigs XIV,* ed. Pablo Schneider and Philipp Zitzlsperger, 273–90. Berlin: Akademie Verlag, 2006.

Stevens, Denis, ed. *The Letters of Claudio Monteverdi.* Rev. ed. Oxford: Clarendon Press, 1995.

Stinger, Charles L. *The Renaissance in Rome.* Bloomington: Indiana University Press, 1998.

Stolpe, Sven. *Christina of Sweden.* Ed. Alec Randall. New York: Macmillan, 1966.

Stone, David M. "Bad Habit: Scipione Borghese, Wignacourt, and the Problem of Cigoli's Knighthood." In *Celebratio Amicitiae: Essays in Honor of Giovanni Bonello,* ed. Maroma Camilleri and Theresa Vella, 207–29. Valletta: Fondazzjoni Patrimonju Malti, 2006.

Stone, Nicholas. *Diary of Nicholas Stone Junior.* Ed. A.-J. Finberg. *Walpole Society* 7 (1919): 158–200.

Storey, Tessa. *Carnal Commerce in Counter-Reformation Rome.* Cambridge: Cambridge University Press, 2008.

Strinati, Claudio, and Maria Grazia Bernardini, eds. *Gian Lorenzo Bernini. Regista del Barocco. I restauri.* Milan: Skira Editore, 1999.

Strunck, Christina. *Berninis unbekanntes Meisterwerk: Die Galleria Colonna in Rom und die Kunstpatronage des römischen Uradels.* Munich: Hirmer, 2007.

Summers, David. *Michelangelo and the Language of Art.* Princeton: Princeton University Press, 1981.

Summerscale, Anne. *Malvasia's Life of the Carracci: Commentary and Translation.* University Park: Pennsylvania State University Press, 2000.

Sutherland Harris, Ann. "Angelo de' Rossi, Bernini, and the Art of Caricature." *Master Drawings* 13, no. 2 (1975): 158–60, 195–204.

———, ed. *Selected Drawings of Gian Lorenzo Bernini.* New York: Dover, 1977.

———. "La dittatura di Bernini." In *Gian Lorenzo Bernini e le arti visive,* ed. Marcello Fagiolo, 43–58. Rome: Istituto della Enciclopedia Italiana, 1987.

———. "Bernini's Four Rivers Fountain as Permanent Theatre." In *Art and Pageantry in the Renaissance and Baroque. Part 2: Theatrical Spectacle and Spectacular Theatre,* ed. Barbara Wisch and Susan Scott Munshower, 488–515. University Park: Pennsylvania State University Press, 1990.

———. "La Cattedra di San Pietro in Vaticano: Dall'idea alla realizzazione." In *Bernini in Montecitorio,* ed. Maria Grazia Bernardini, 113–28. Rome: Camera dei Deputati, 2001.

———. "I disegni di ritratto di Gian Lorenzo Bernini." In *Bernini pittore,* ed. Tomaso Montanari, 172–81. Cinisello Balsamo: Silvana Editoriale, 2007.

Tamburini, Elena. "Naturalezza d'artificio nella finzione scenica berniniana. La *Comica del cielo* di Giulio Rospigliosi (1668)." *Rassegna di architettura e urbanistica* 33, nos. 98, 99, 100 (1999–2000): 106–47.

———. "Strumenti retorici e sinestesie. La messinscena berniniana della *Comica del cielo* (1668)." In *Lo spettacolo del sacro, la morale del profano. Su Giulio Rospigliosi (Papa Clemente IX). Atti del Convegno Internazionale (Pistoia, 22–23 settembre 2000),* ed. Danilo Romei, 97–112. Florence: Edizioni Polistampa, 2005.

Tapié, Alain, ed. *Baroque, vision jésuite: Du Tintoret à Rubens*. Paris: Somogy; Caen: Musée des beaux-arts de Caen, 2003.

Taviani, Ferdinando. *La commedia dell'arte e la società barocca. La fascinazione del teatro*. Rome: Bulzoni, 1970.

Terzaghi, Maria Cristina. "Bernini padre, figlio e cognato: nuovi dati e aperture." In *Decorazione e collezionismo a Roma nel Seicento. Vicende di artisti, committenti, mercanti*, ed. Francesca Cappelletti, 101–6. Rome: Gangemi, 2003.

Tesauro, Emanuele. *Il cannocchiale aristotelico, o sia Idea dell'arguta et ingeniosa elocutione che serve a tutta l'arte oratoria, lapidaria, et simbolica, esaminata co' principij del divino Aristotele*. Ed. Maria Luisa Doglio. Savigliano: Artistica Piemontese, 2000 (facsimile reprint of the Turin 1670 edition).

Tessin der Jungere, Nicodemus. "Osservationi dal discorso del Sig.or Cav.ro Bernini." In Björn R. Kommer, *Nicodemus Tessin der Jungere und das Stockholmer Schloss*, 158–61. Heidelberg: Carl Winter Universitatsverlag, 1974.

Testa, Laura. "Documenti inediti sullo scomparso 'San Sebastiano' Aldobrandini del giovane Gian Lorenzo Bernini." *Bollettino d'arte* 86, no. 117 (2001): 131–35.

Testi, Fulvio. *Lettere*. 2 vols. Ed. Maria Luisa Doglio. Bari: Laterza, 1967.

Thoenes, Christof. "Bernini architetto tra Palladio e Michelangelo." In *Gian Lorenzo Bernini architetto e l'architettura europea del Sei–Settecento,* ed. Gianfranco Spagnesi and Marcello Fagiolo, 105–34. Rome: Istituto della Enciclopedia Italiana, 1983–84.

Tiberia, Vitaliano. "Santa Bibiana." In *Gian Lorenzo Bernini. Regista del Barocco. I restauri,* ed. Claudio Strinati and Maria Grazia Bernardini, 13–18. Milan: Skira, 1999.

———. *Gian Lorenzo Bernini, Pietro da Cortona, Agostino Ciampelli in Santa Bibiana a Roma. I restauri*. Todi: Ediart, 2000.

Tonkovich, Jennifer. "Two Studies for the Gesù and a 'Quarantore' Design by Bernini." *Burlington Magazine* 140 (1998): 34–37.

Tratz, Helga. "Werkstatt und Arbeitsweise Berninis." *Römisches Jahrbuch für Kunstgeschichte* 23 (1988): 395–485.

———. "Die Ausstattung des Langhauses von St. Peter unter Innozenz X." *Römisches Jahrbuch der Bibliotheca Hertziana* 27–28 (1991): 337–74.

Tronzo, William, ed. *St. Peter's in the Vatican*. Cambridge: Cambridge University Press, 2005.

Tufari, Raffaele. *La Certosa di San Martino a Napoli*. Naples: G. Ranucci, 1854.

Tuzi, Stefania. "Cigoli, Bernini e i progetti per la basilica di S. Pietro." In *Bernini e la Toscana: Da Michelangelo al barocco mediceo e al neocinquecentismo,* ed. Oronzo Brunetti et al., 21–39. Rome: Gangemi, 2002.

Ulivi, Michela. "La Cappella della beata Ludovica Albertoni nella chiesa di San Francesco a Ripa." In *Gian Lorenzo Bernini. Regista del Barocco. I restauri,* ed. Claudio Strinati and Maria Grazia Bernardini, 85–96. Milan: Skira, 1999.

Van Eck, Caroline. *Classical Rhetoric and the Visual Arts in Early Modern Europe*. Cambridge: Cambridge University Press, 2007.

Vanuxem, J. "Quelques témoignages français sur le Bernini et son art: L'abbé de La Chambre." In *Actes des journées internationales d'étude du Baroque,* 153–67. Toulouse: Publications de la faculté des Lettres et Sciences Humaines, 1965.

Varriano, John. *Italian Baroque and Rococo Architecture*. New York: Oxford University Press, 1986.

Vasari, Giorgio. "The Life of Michelangelo Buonarroti" (1568 edition). In *Lives of the Artists, a Selection*, trans. George Bull, 1:325–442. Harmondsworth: Penguin, 1965.

Vasco Rocca, Sandra. *Santa Bibiana*. Rome: Istituto di Studi Romani and Palombi Editori, 1983.

Verdier, Thierry. *Augustin-Charles d'Aviler: Architecte du roi en Languedoc, 1653–1701*. Montpellier: Presses du Languedoc, 2003.

Vicini Mastrangeli, Angela. "La Galleria Giustiniani della Biblioteca Casanatense." In *I Giustiniani e l'antico*, ed. Giulia Fusconi, 499–509. Rome: L'Erma di Bretschneider, 2001.

Villa, Eleonora. "Uno sconosciuto episodio della ritrattistica del Seicento: Clemente X, Bernini e Gaulli; e altre novità sulle committenze Rospigliosi, Altieri e Odescalchi." In *L'ultimo Bernini 1665–1680. Nuovi argomenti, documenti e immagini*, ed. Valentino Martinelli, 137–80. Rome: Edizioni Quasar, 1996.

Vincent, Monique. *Donneau di Visé et Le Mercure Galant*. Lille: Atelier National Reproduction des Thèses, Université de Lille III; distributed by Aux Amateurs de Livres, Paris, 1987.

Visceglia, Maria Antonietta. "La giusta statera de' porporati. Sulla composizione e rappresentazione del sacro collegio nella prima metà del Seicento." *Roma moderna e contemporanea* 4 (1996): 167–211.

Waddy, Patricia. "The Design and Designers of the Palazzo Barberini." *Journal of the Society of Architectural Historians* 35 (1976): 151–85.

———. *Seventeenth-Century Roman Palaces*. New York: Architectural History Foundation; Cambridge: MIT Press, 1990.

Wassilowsky, Günther, and Hubert Wolf. *Päpstliches Zeremoniell in der frühen Neuzeit: Das Diarium des Zeremonienmeisters Paolo Alaleone de Branca während des Pontifikats Gregors XV*. Münster: Rhema, 2007.

Wasserman, Jack. "The Quirinal Palace in Rome." *Art Bulletin* 45 (1963): 205–44.

Weil, Mark S. "The Devotion of the Forty Hours and Roman Baroque Illusions." *Journal of the Warburg and Courtauld Institutes* 37 (1974a): 218–48.

———. *The History and Decoration of the Ponte S. Angelo*. University Park: Pennsylvania State University Press, 1974b.

———. "L'orazione delle Quarantore come guida allo sviluppo del linguaggio barocco." In *Il barocco romano e l'Europa*, ed. Marcello Fagiolo and Maria Luisa Madonna, 675–94. Rome: Istituto Poligrafico e Zecca dello Stato, Libreria dello Stato, 1992.

Whitaker, Lucy, and Martin Clayton. *The Art of Italy in the Royal Collection. Renaissance and Baroque*. London: Royal Collections Publications, 2007.

Wiedman, Gerhard. *Roma barocca*. Milan: Jaca Book, 2002.

Wiles, Bertha Harris. *The Fountains of Florentine Sculptors and Their Followers from Donatello to Bernini*. New York: Hacker Art Books, 1975 (originally published in 1933).

Williams, Robert. "'Always Like Himself': Character and Genius in Bernini's Biographies." In *Bernini's Biographies: Critical Essays*, ed. Maarten Delbeke, Evonne Levy, and Steven F. Ostrow, 181–99. University Park: Pennsylvania State University Press, 2006.

Wittkower, Rudolf. Review of *Vita di Bernini scritta da Filippo Baldinucci*, ed. Sergio Samek Ludovici. *Burlington Magazine* 91 (1949): 298.

———. *Bernini's Bust of Louis XIV*. London: Oxford University Press, 1951.

———. "Bernini Studies, II: The Bust of Mr. Baker." *Burlington Magazine* 95 (1953): 19–22, 139–41.

———. "The Vicissitudes of a Dynastic Monument: Bernini's Equestrian Statue of Louis XIV." In *De Artibus Opuscula XL: Essays in Honor of Erwin Panofsky,* ed. Millard Meiss, 497–531. New York: New York University Press, 1961.

———. "Francesco Borromini: His Character and Life." In *Studies in the Italian Baroque,* 153–76, 289–94. Boulder: Westview Press, 1975.

———. *Bernini: The Sculptor of the Roman Baroque.* 3rd ed. London: Phaidon Press, 1981.

Wittkower, Rudolf, and Margot Wittkower. *Born Under Saturn: The Character and Conduct of Artists: A Documented History from Antiquity to the French Revolution.* New York: Random House, 1963.

Wohl, Hellmut. *The Aesthetics of Italian Renaissance Art: A Reconsideration of Style.* Cambridge: Cambridge University Press, 1999.

Wolfe, Karin E. "Cardinal Antonio Barberini the Younger (1608–1671): Aspects of His Art Patronage." Ph.D. diss., University of London, 1998.

———. "Francesco Borromini e le committenze barberiniane." In *Francesco Borromini. Atti del convegno internazionale Roma 13–15 gennaio 2000,* ed. Christoph Luitpold Frommel and Elisabeth Sladek, 77–85. Milan: Electa, 2000.

———. "Ten Days in the Life of a Cardinal Nephew at the Court of Pope Urban VIII: Antonio Barberini's Diary of December 30." In *I Barberini e la cultura europea del Seicento,* ed. Lorenza Mochi Onori, Sebastian Schütze, and Francesco Solinas, 253–64. Rome: De Luca, 2007.

———. "Protector and Protectorate: Cardinal Antonio Barberini's Art Diplomacy for the French Crown at the Papal Court." In *Art and Identity in Early Modern Rome,* ed. Jill Burke and Michael Bury, 113–32. Aldershot: Ashgate, 2008.

———. "Cardinal Antonio Barberini (1608–1671) and the Politics of Art in Baroque Rome." In *The Possessions of a Cardinal: Politics, Piety, and Art, 1450–1700,* ed. Mary Hollingsworth and Carol M. Richardson, 265–93. University Park: Pennsylvania State University Press, 2010.

Zarucchi, Jeanne Morgan. "Louis XIV and Bernini: A Duel of Egos." *Source: Notes in the History of Art* 25, no. 2 (2006): 32–38.

Zeri, Federico. "Bernini contro Bernini." In *Mai di traverso. Storie di quadri, di libri, di persone,* 94–97. Milan: Longanesi, 1982.

Zitzlsperger, Philipp. *Gianlorenzo Bernini: Die Papst- und Herrscherporträts. Zum Verhältnis von Bildnis und Macht.* Munich: Hirmer, 2002.

Zollikofer, Kaspar. *Berninis Grabmal für Alexander VII. Fiktion und Repräsentation.* Worms: Wernersche Verlagsgesellschaft, 1994.

———. "'Bisogna dissegnar' all'occhio . . .': Berninis Projekt für die Chorseite von Santa Maria Maggiore in Rom." In *Diletto e maraviglia: Ausdruck und Wirkung in der Kunst von der Renaissance bis zum Barock,* ed. Christine Gottler, Ulrike Muller Hofstede, Kristine Patz, and Kaspar Zollikofer, 206–37. Emsdetten: Imorde, 1998.

Index

All page numbers refer to the pagination of this
edition. (In the Introduction and commentary,
instead, citations of Domenico's biography all
refer to the original 1713 pagination.). Unless
otherwise specified, all churches, palaces, and
other edifices and institutions are in Rome.